GW01458556

DESTINATION ROME

TECTUM
PUBLISHERS

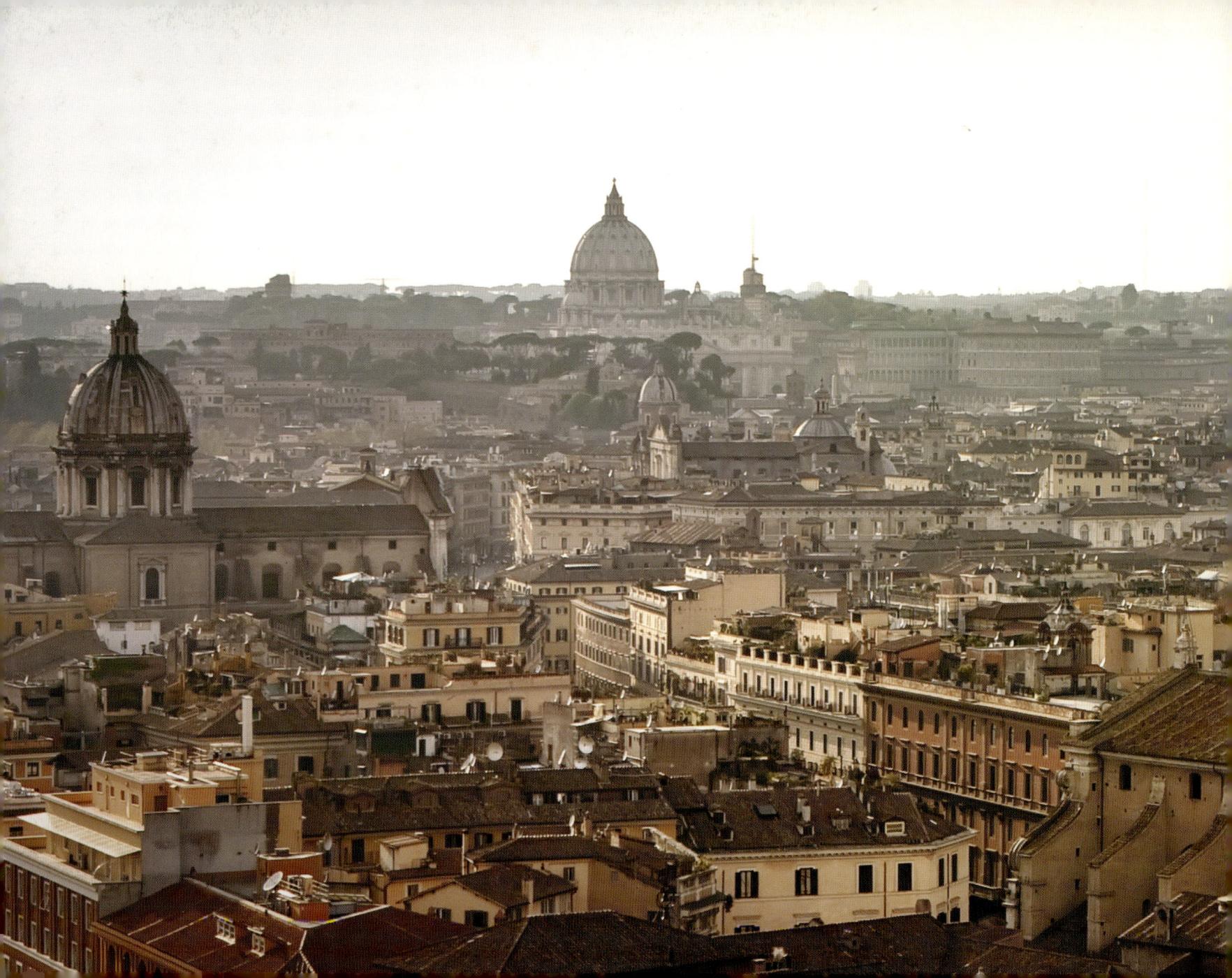

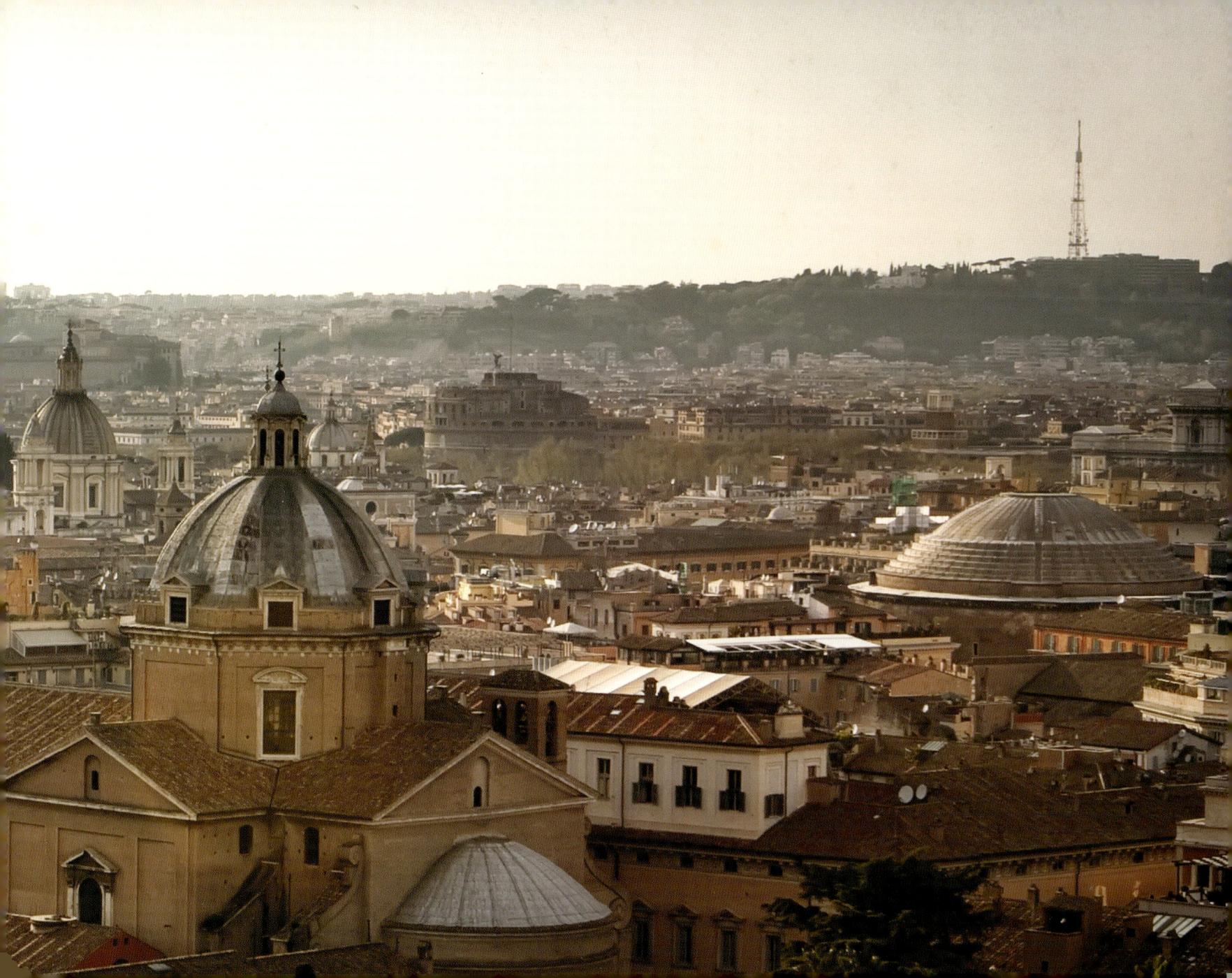

DESTINATION
ROME

© 2011 Tectum Publishers
 Godefriduskaai 22
 2000 Antwerp
 Belgium
 info@tectum.be
 + 32 3 226 66 73
 www.tectum.be
ISBN: 978-90-79761-67-8
WD: 2011/9021/06
(127)

Photography: Dreamstime & Corbis, Ville Miettinen (p228, picture left)
Design: Gunter Segers

No part of this book may be reproduced in any form, by print, photo print,
microfilm or any other means without written permission from the publisher.

Printed in China.

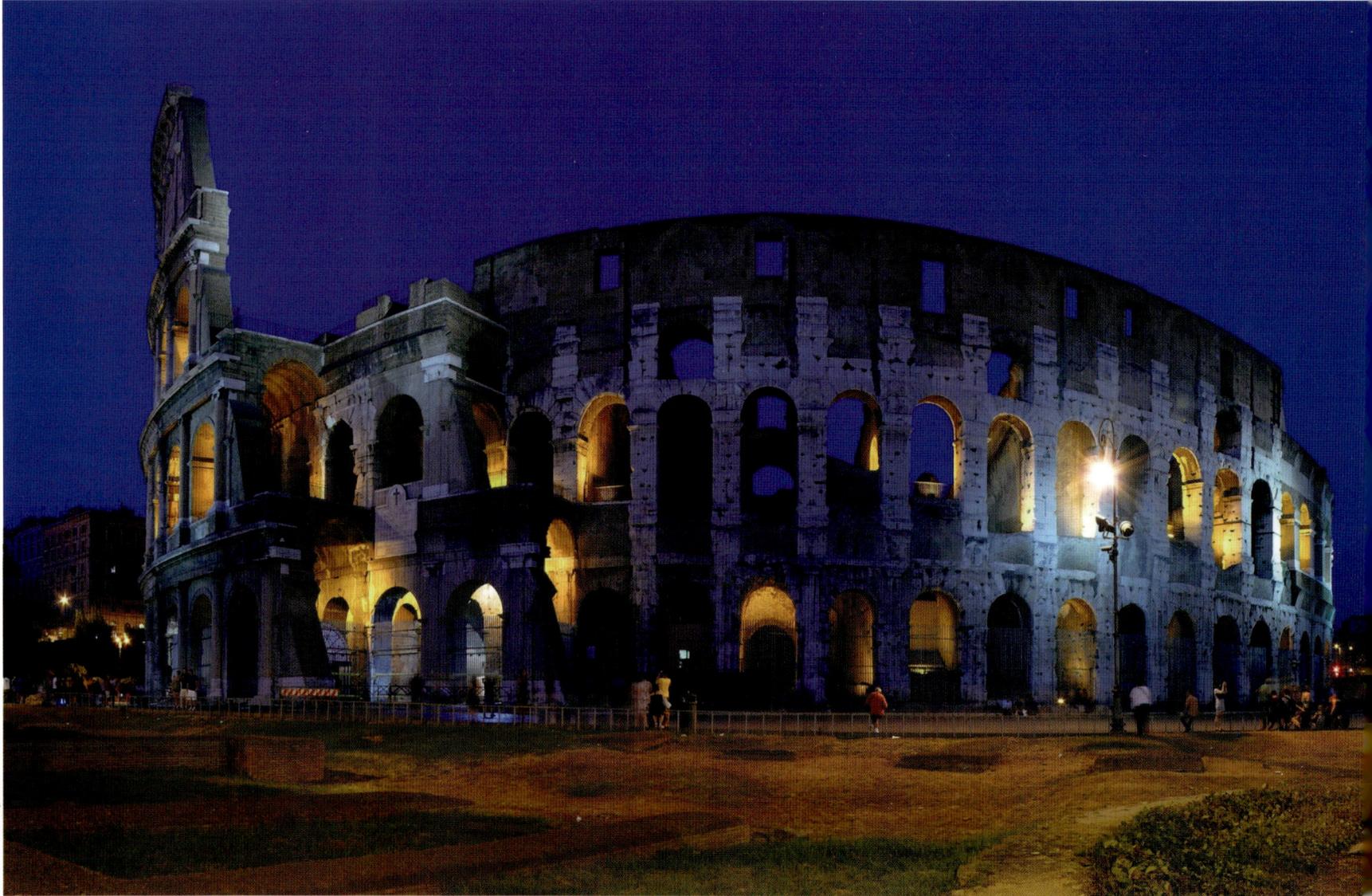

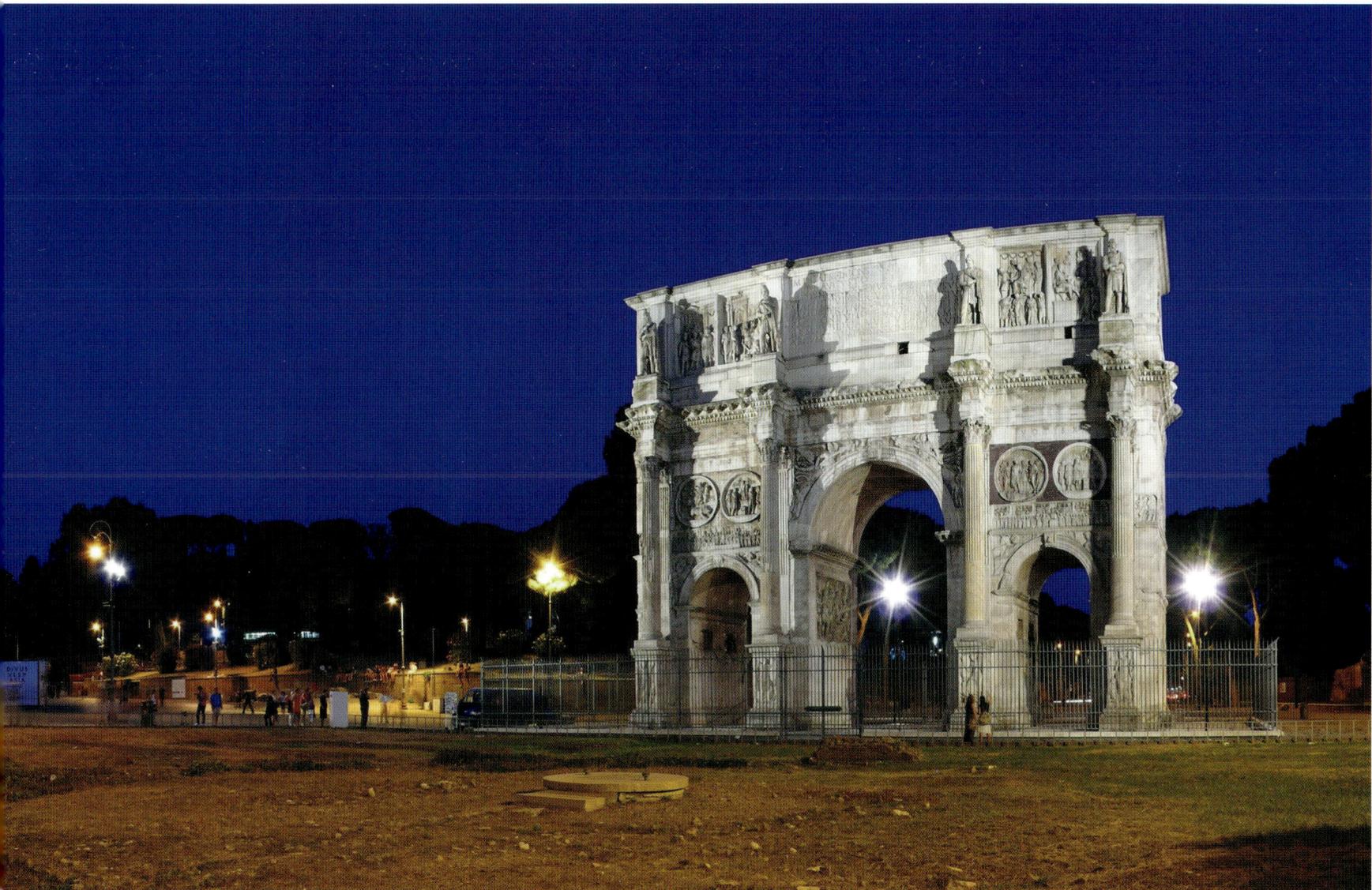

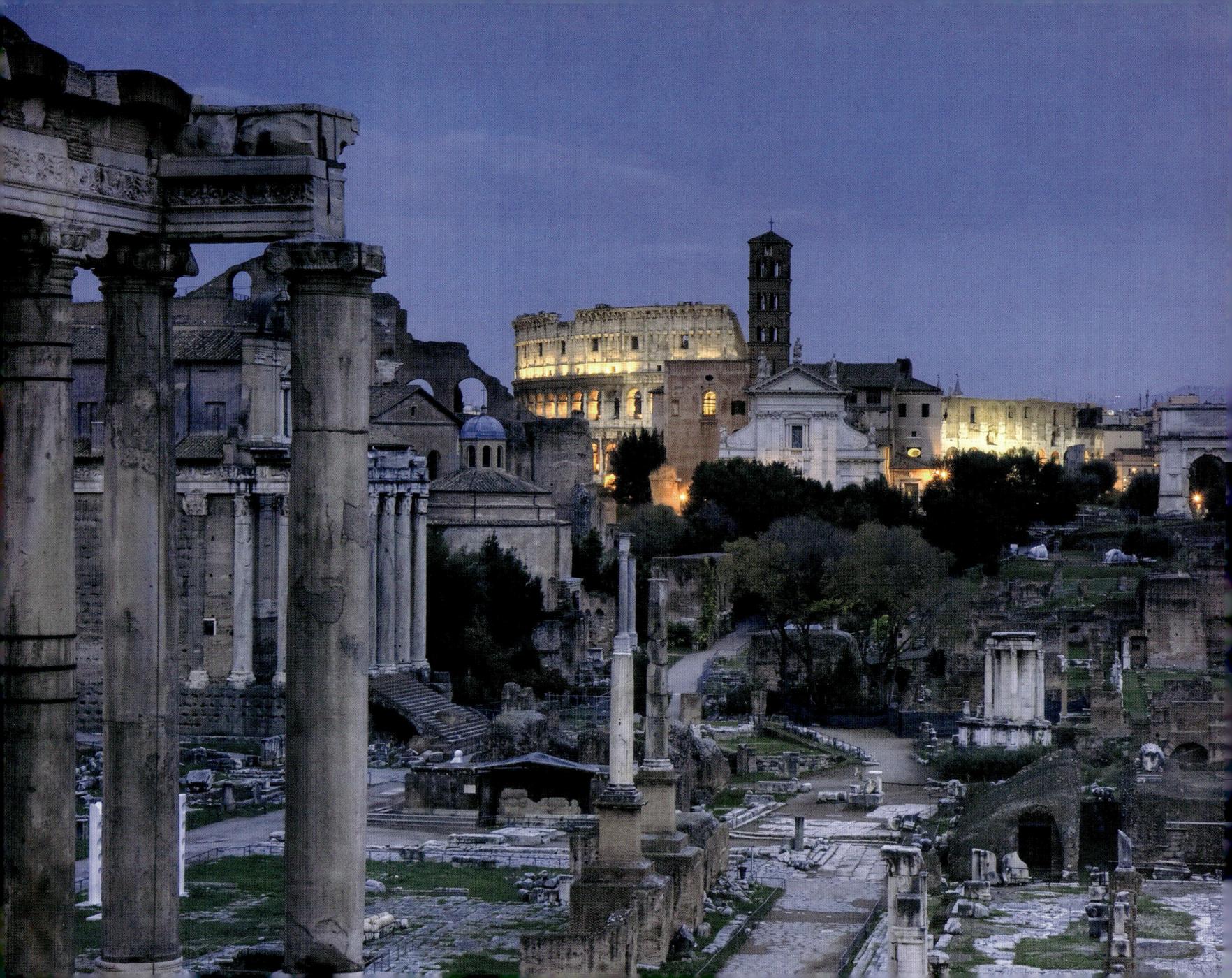

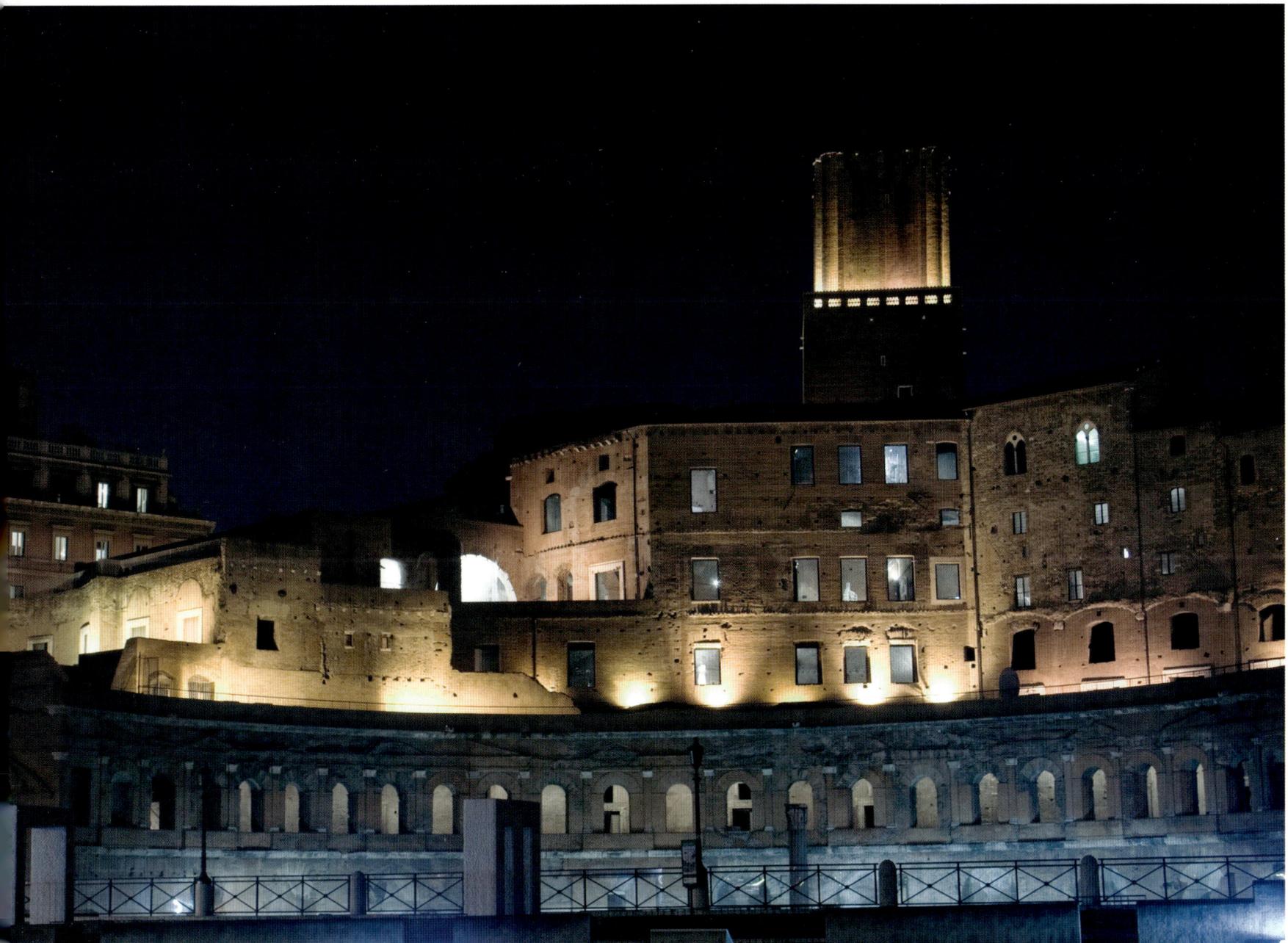

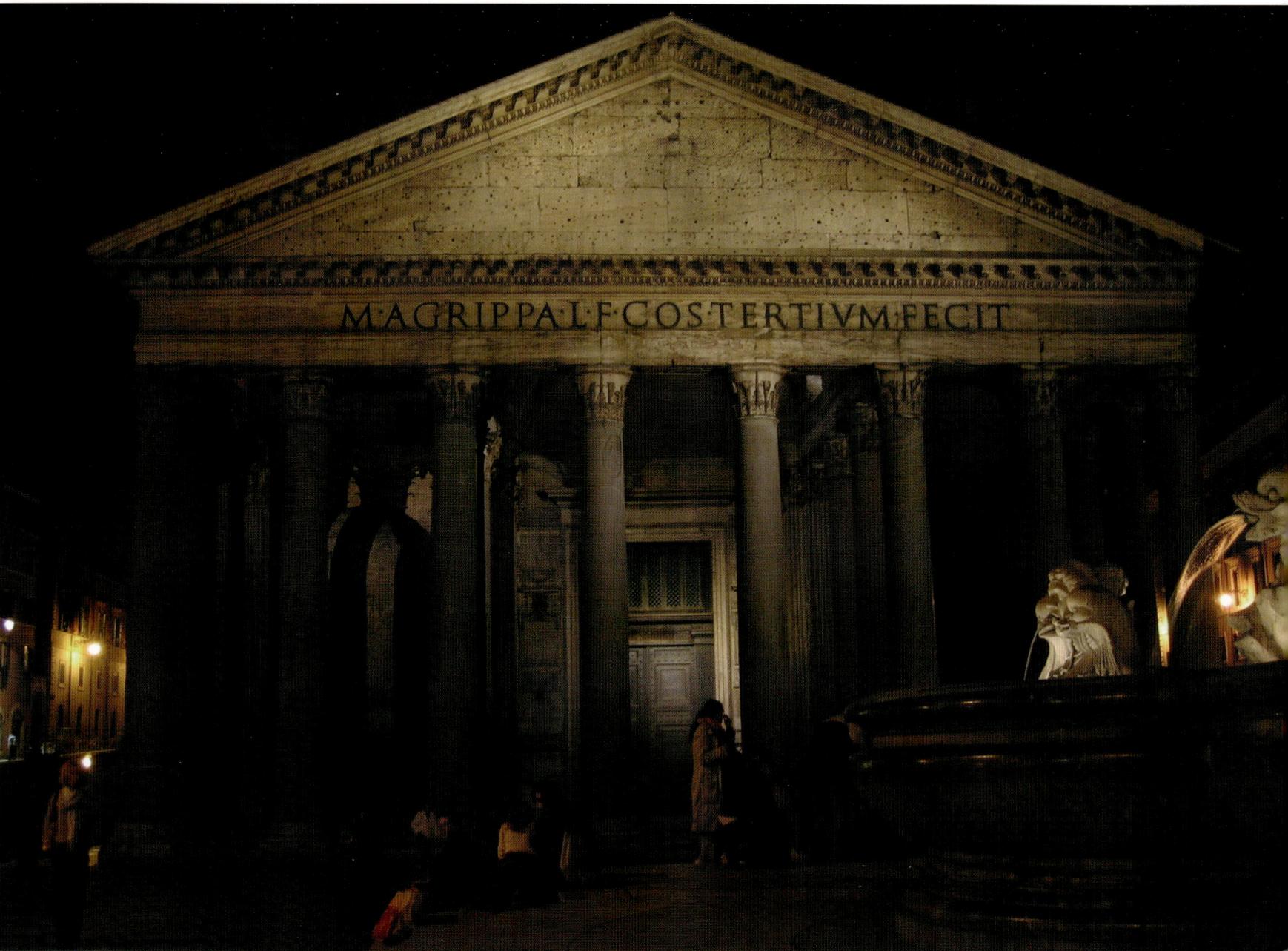

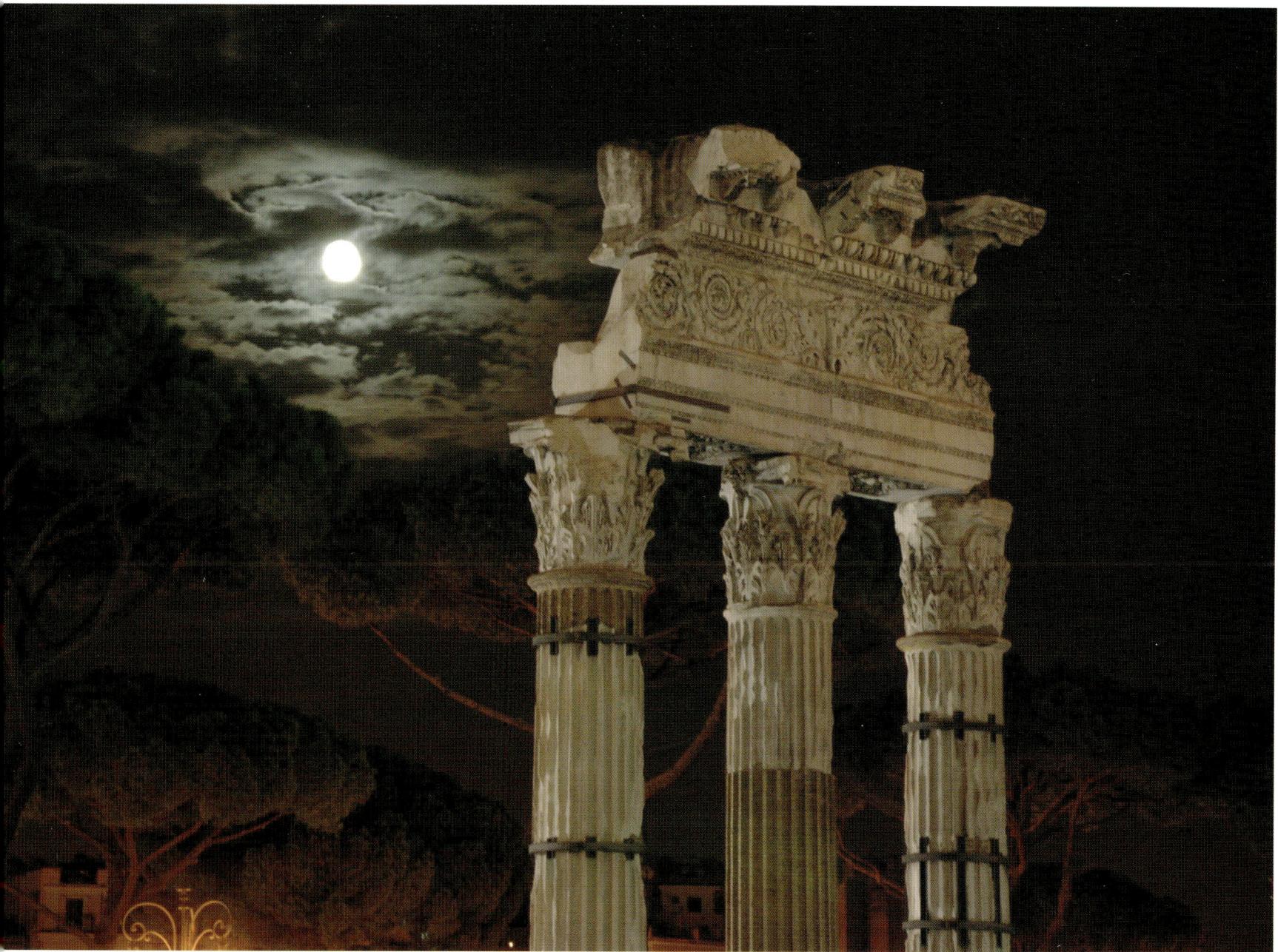

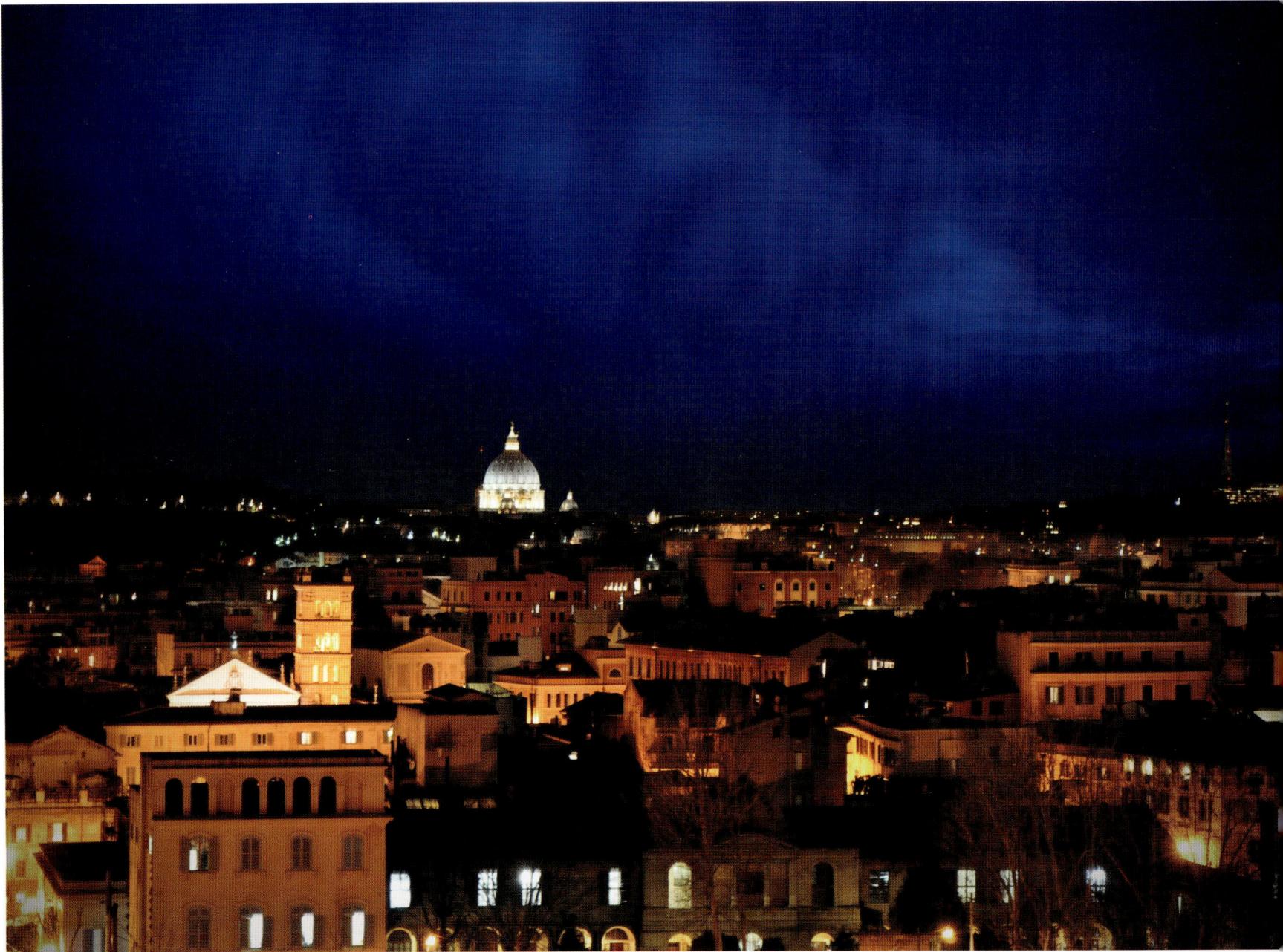

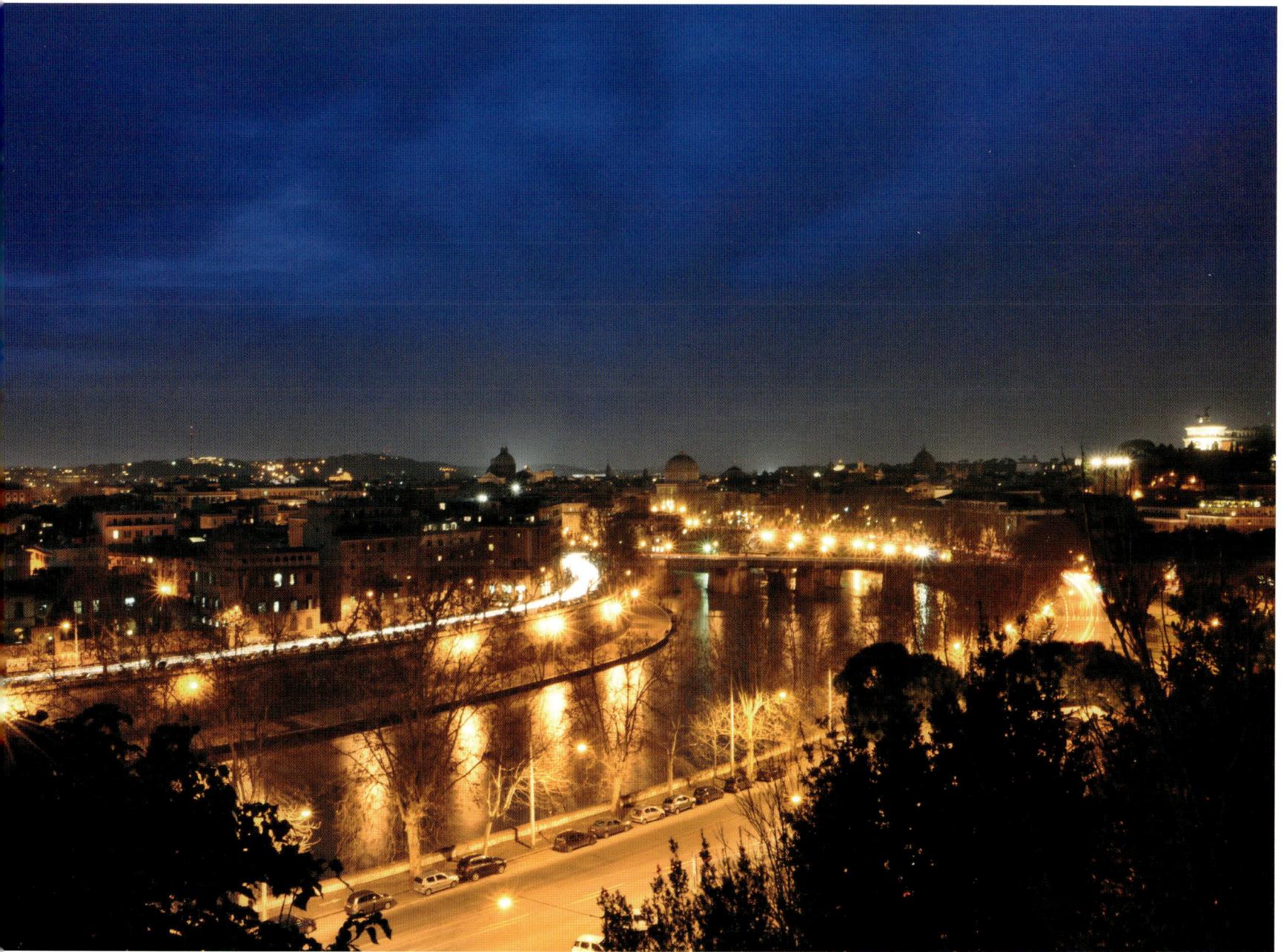

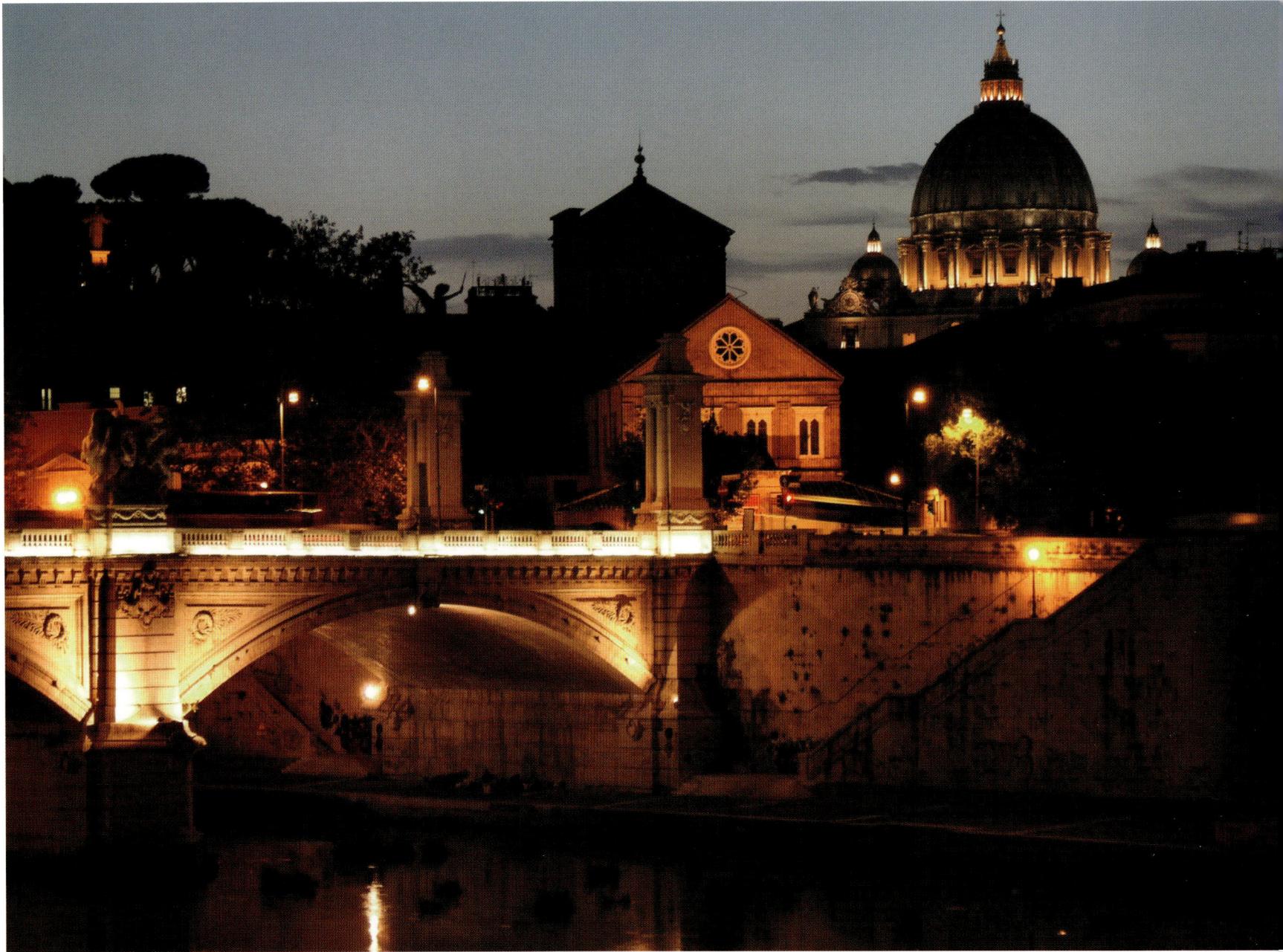

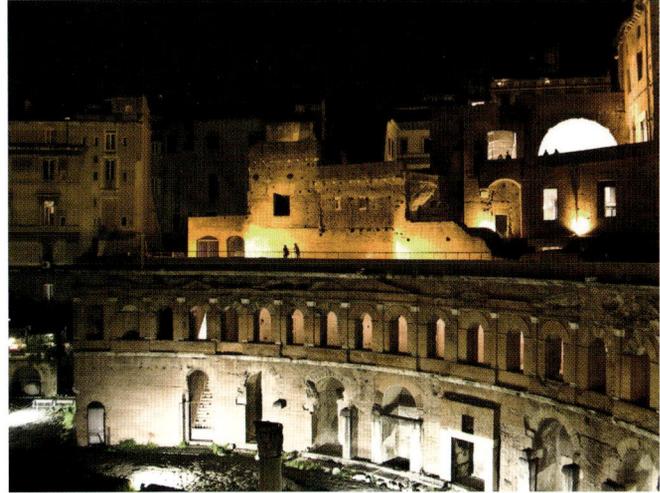
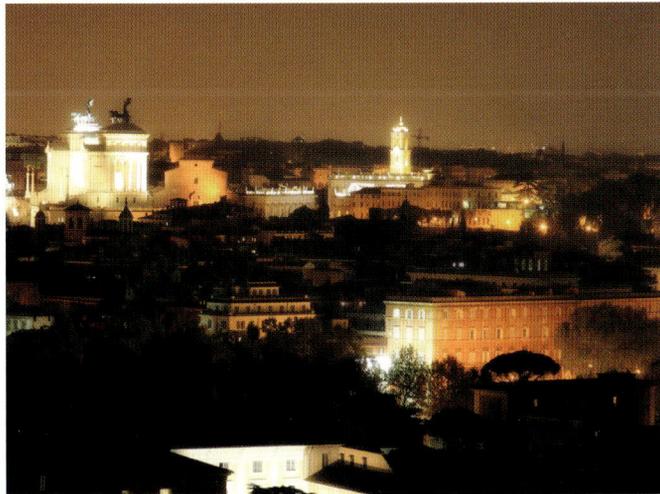
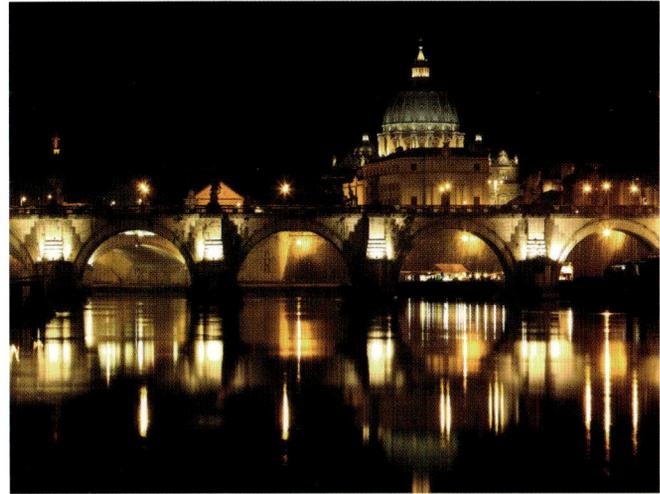

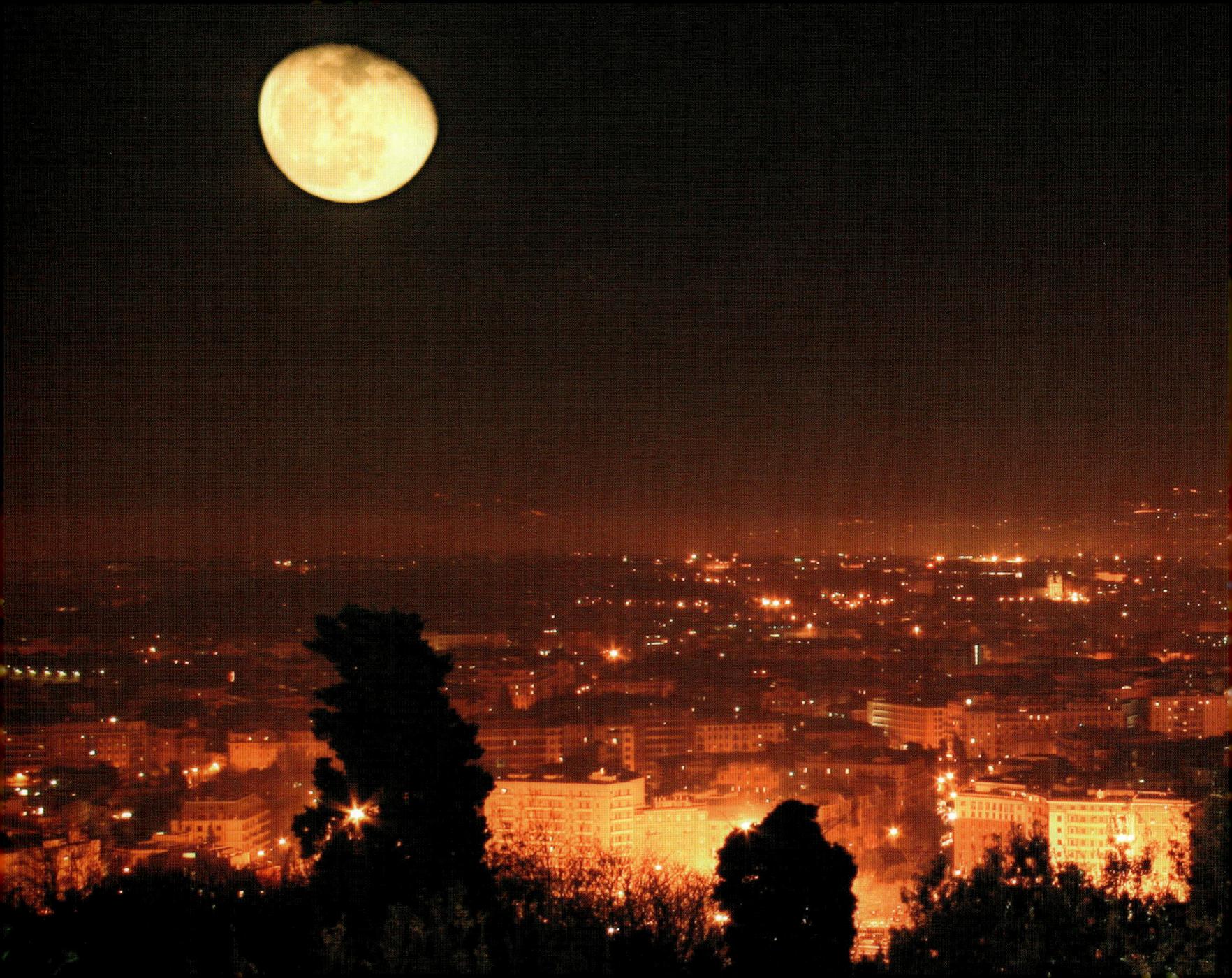

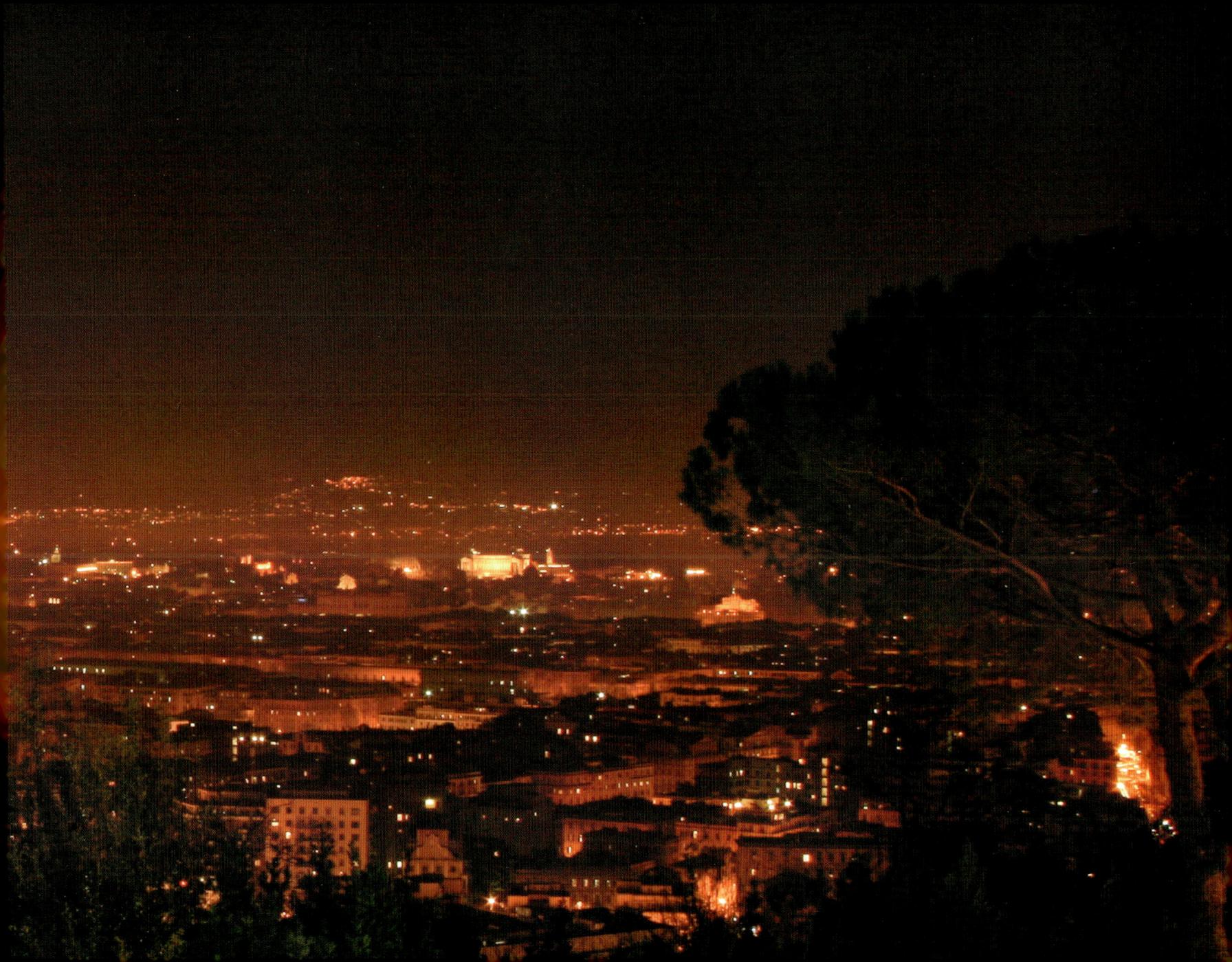

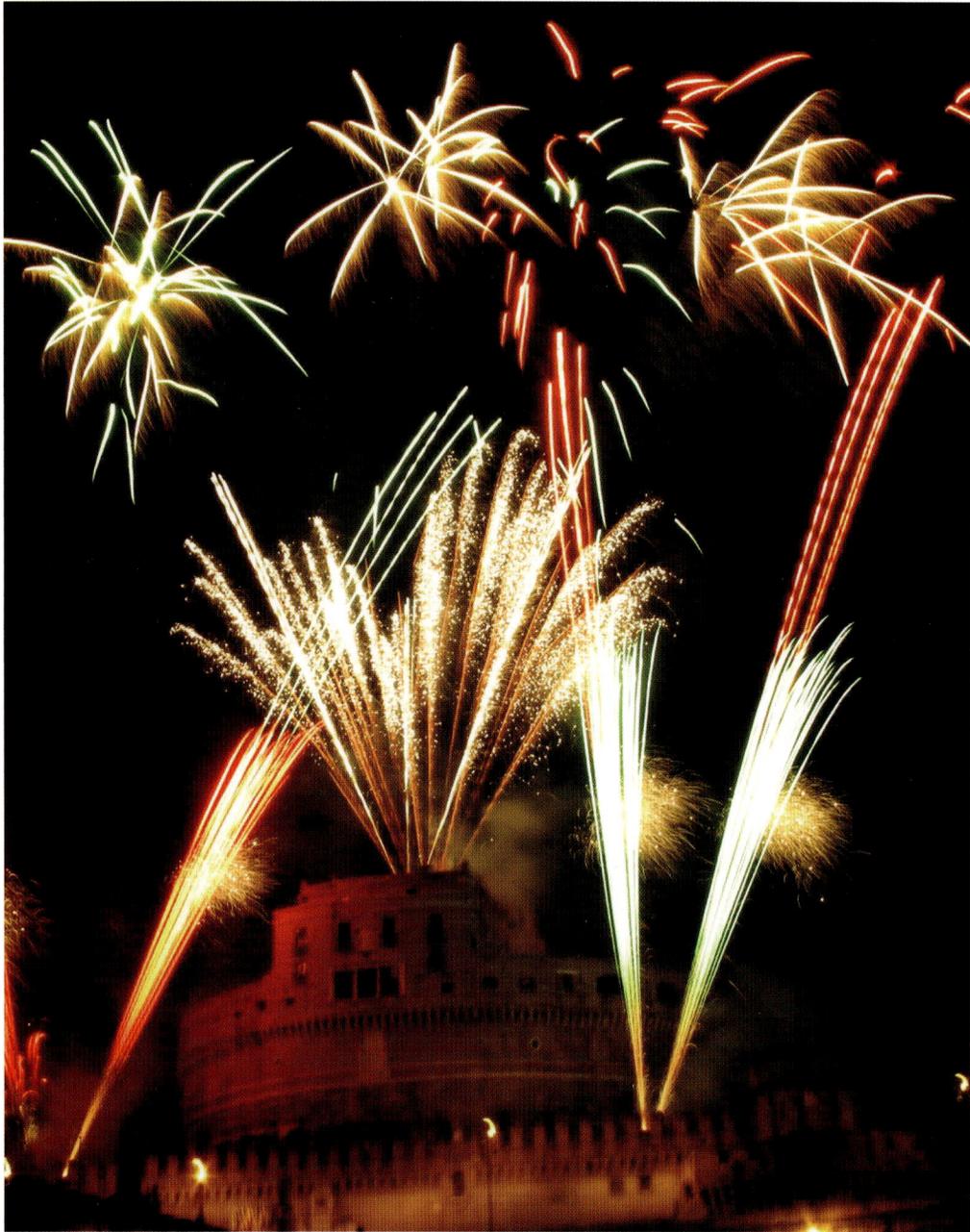

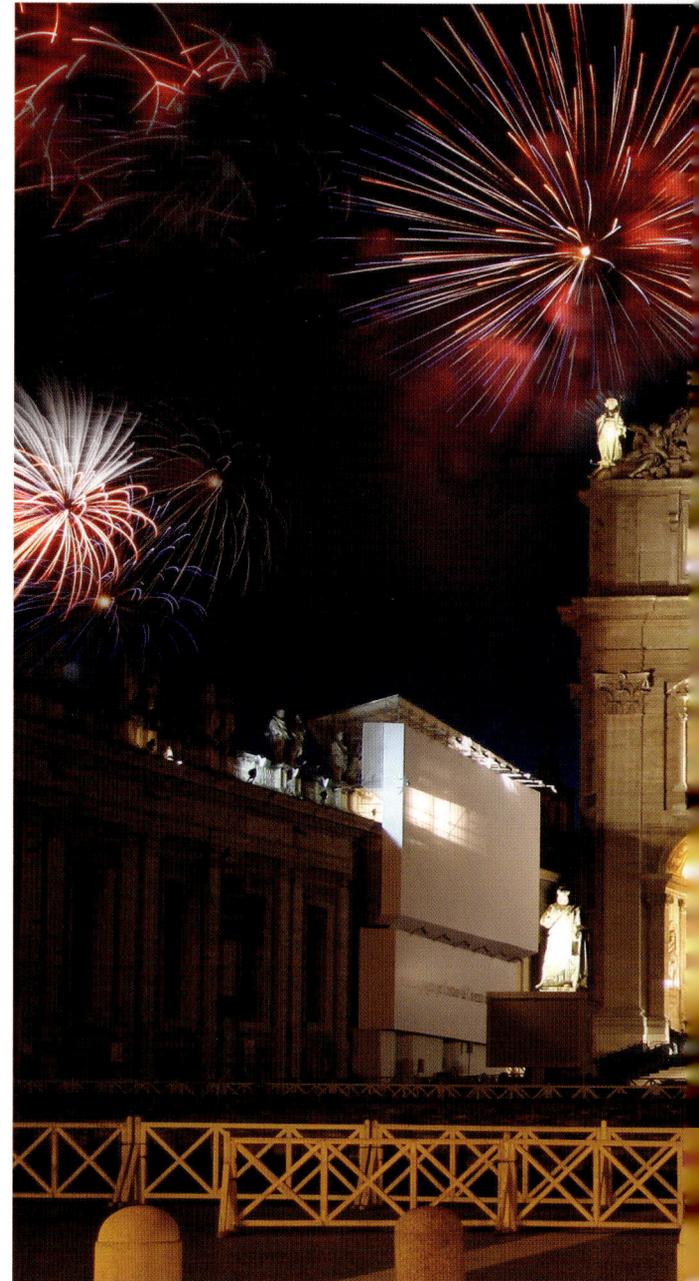

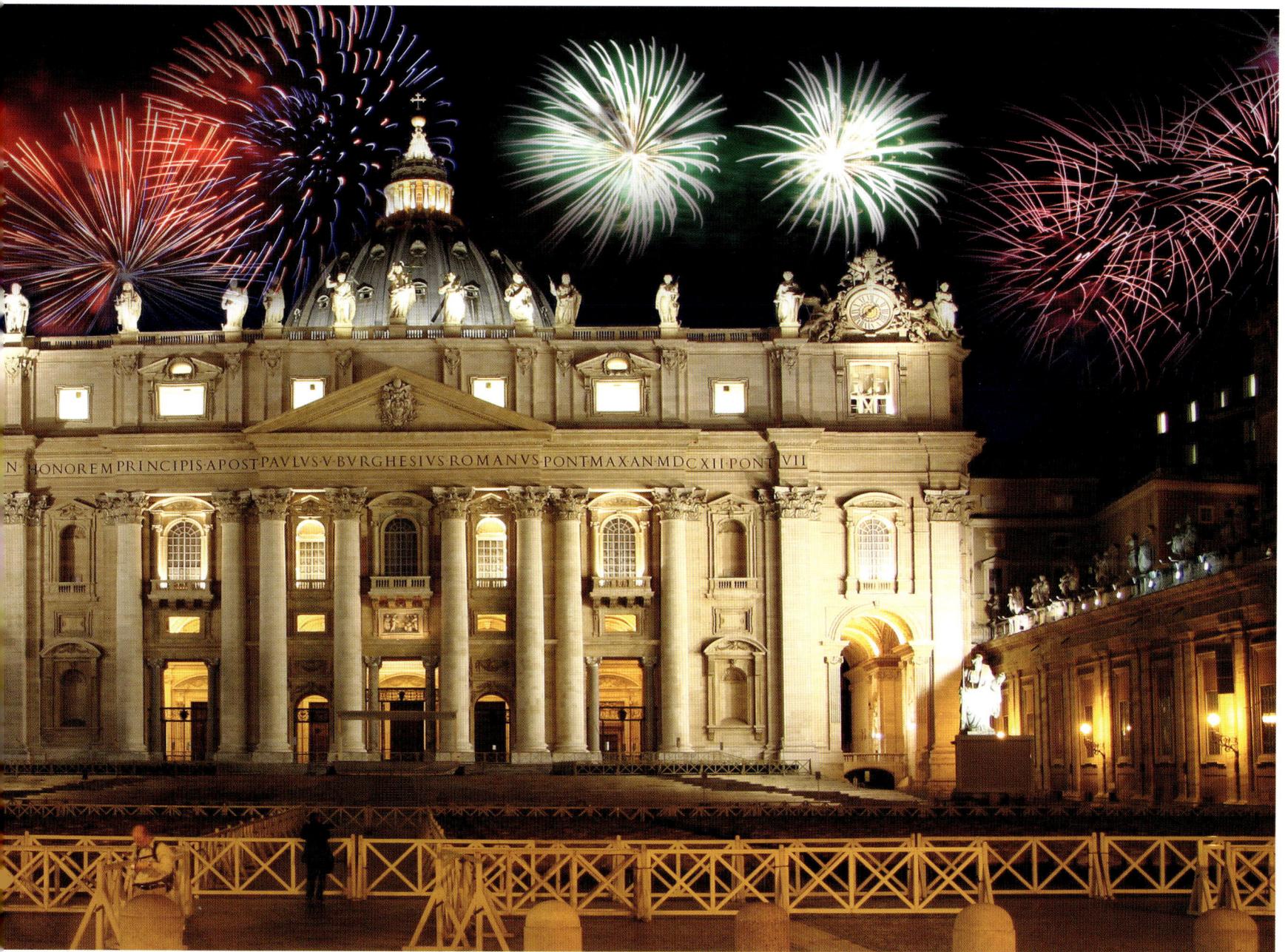

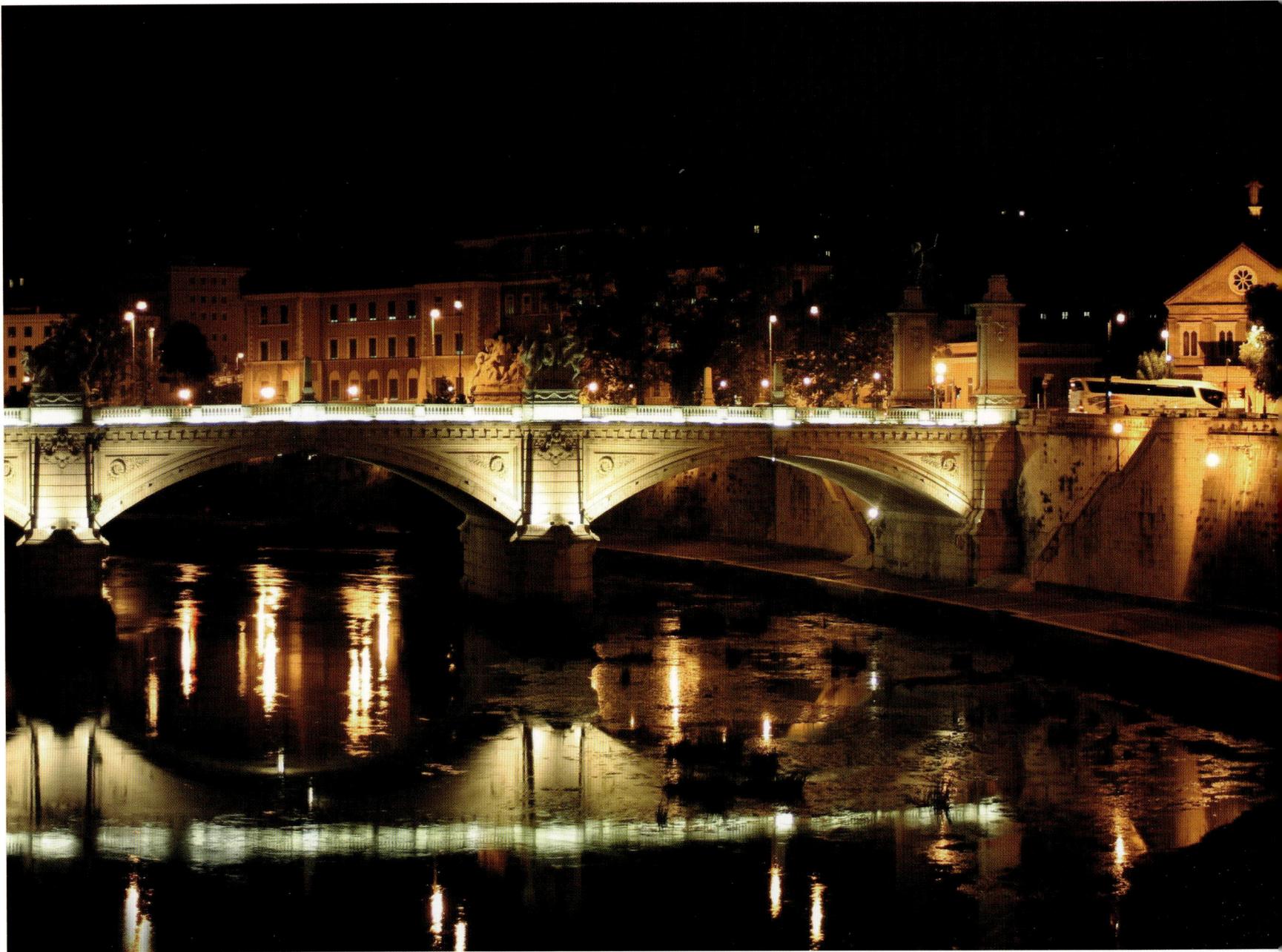

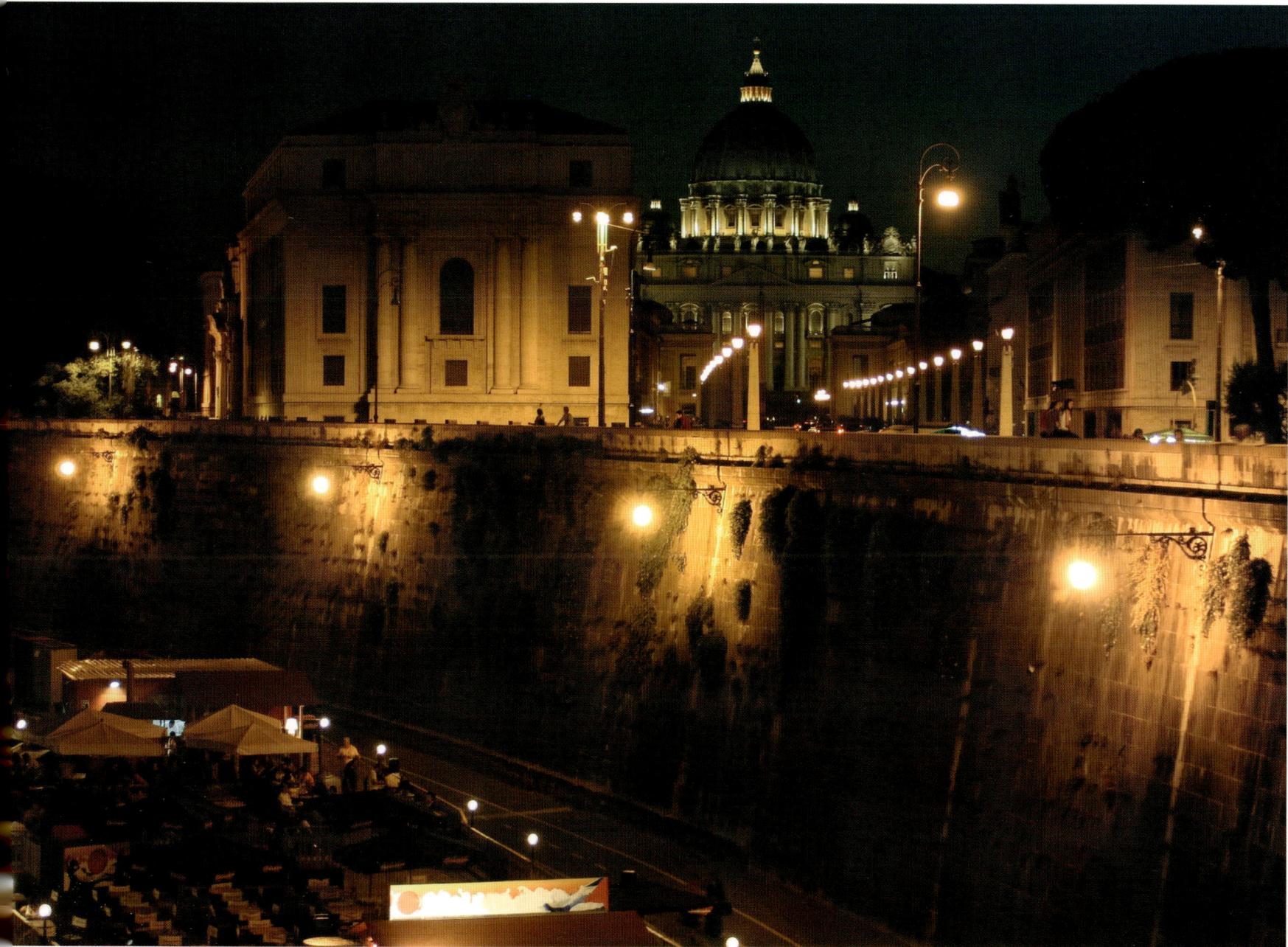

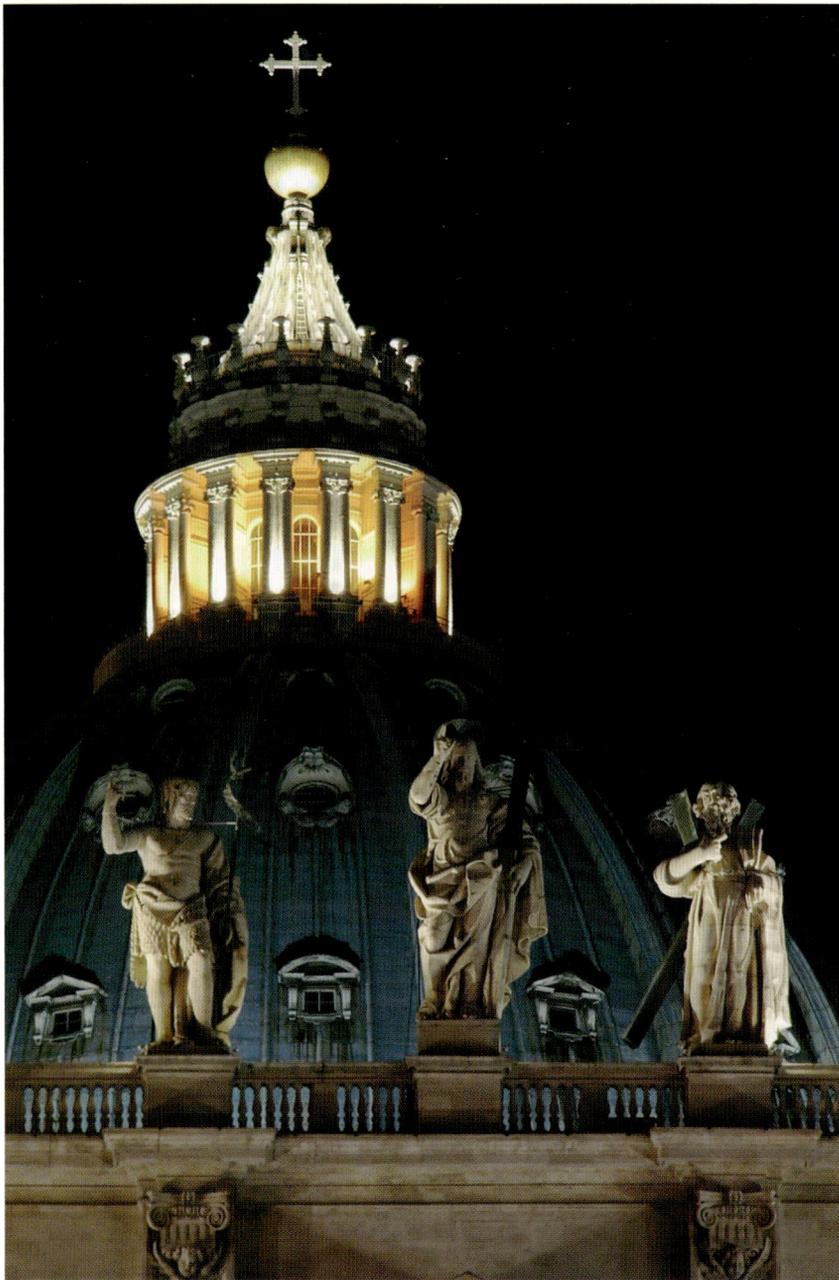
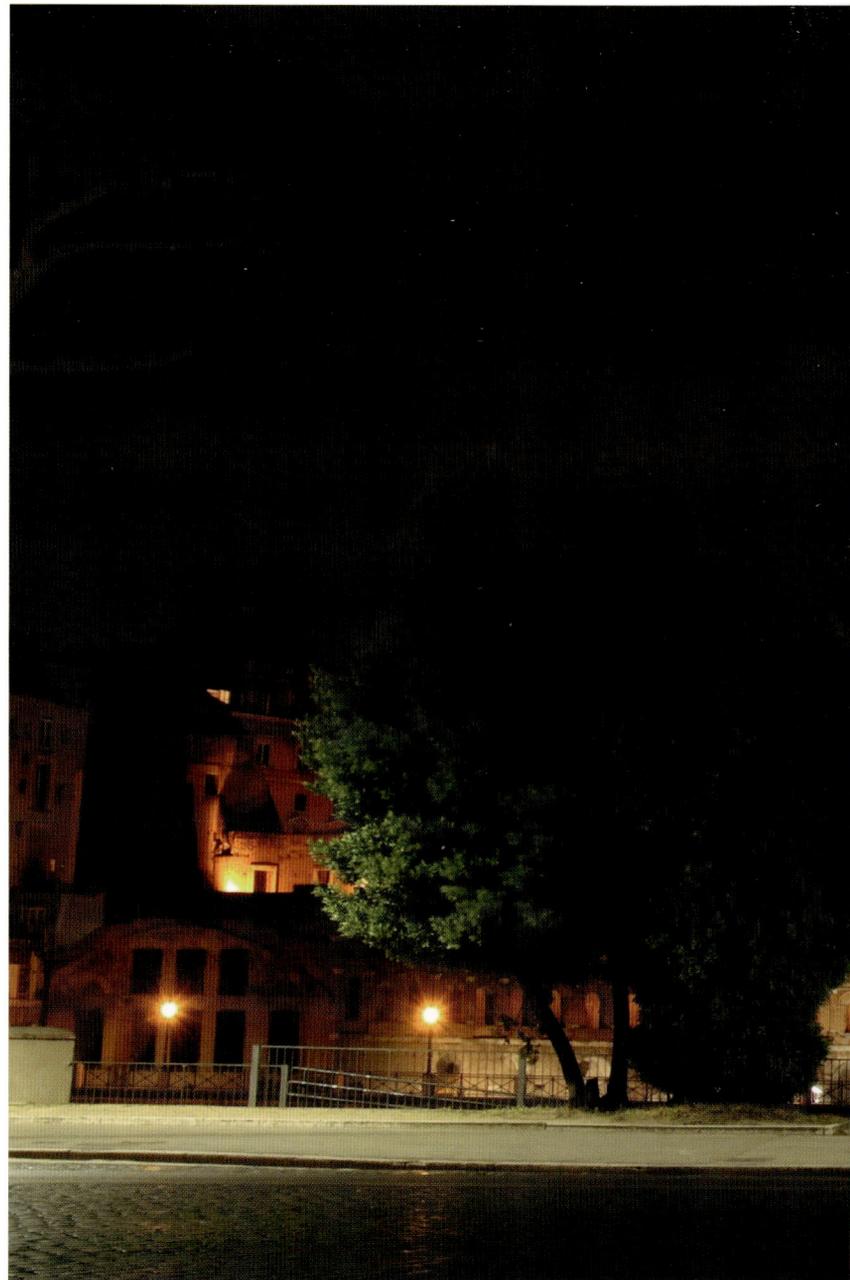

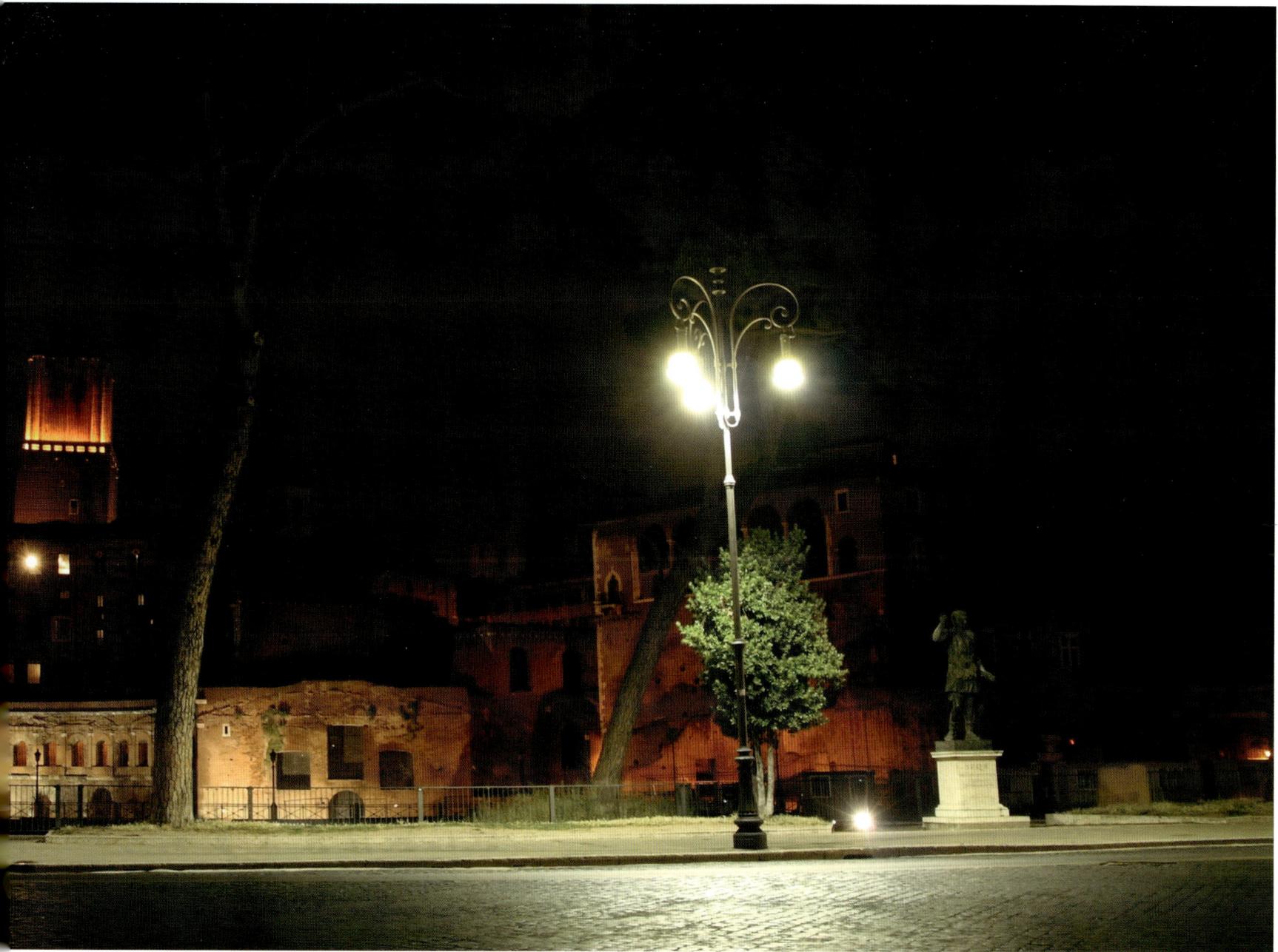

"Rome was not built in a day."

Proverb

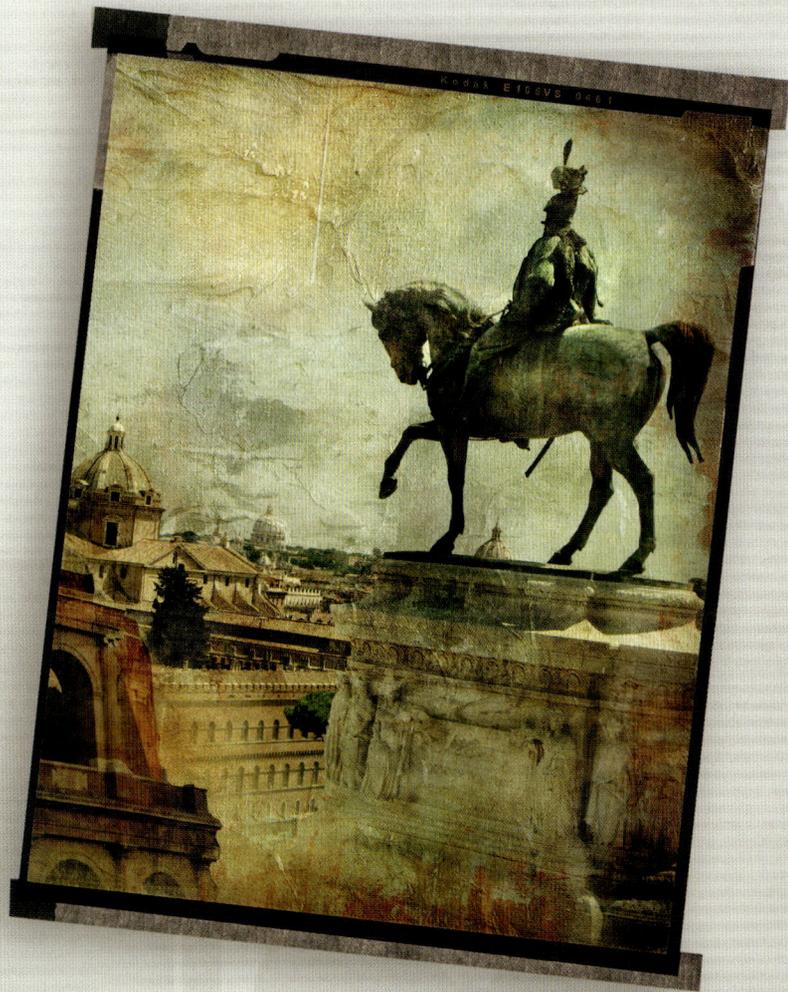

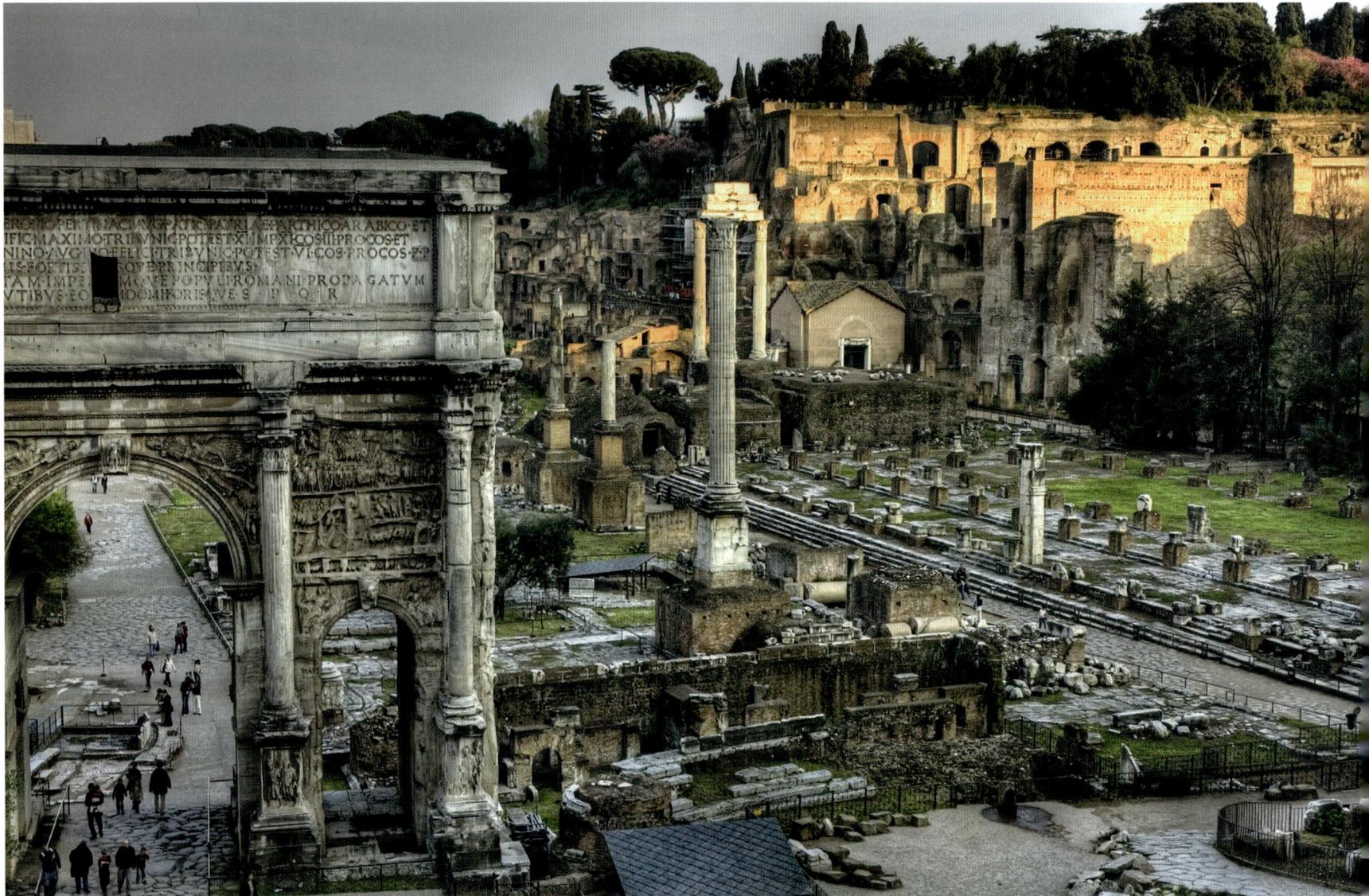

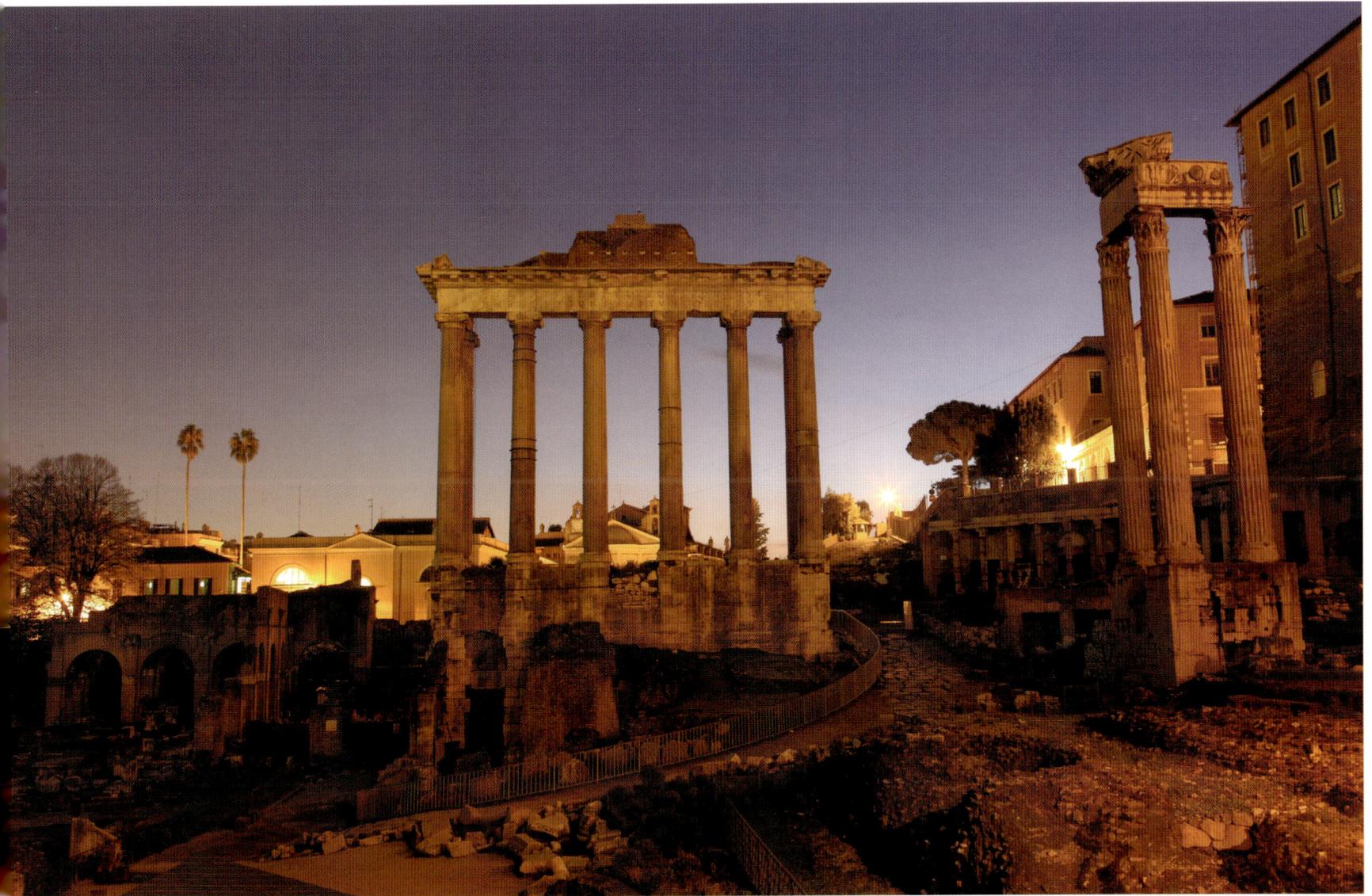

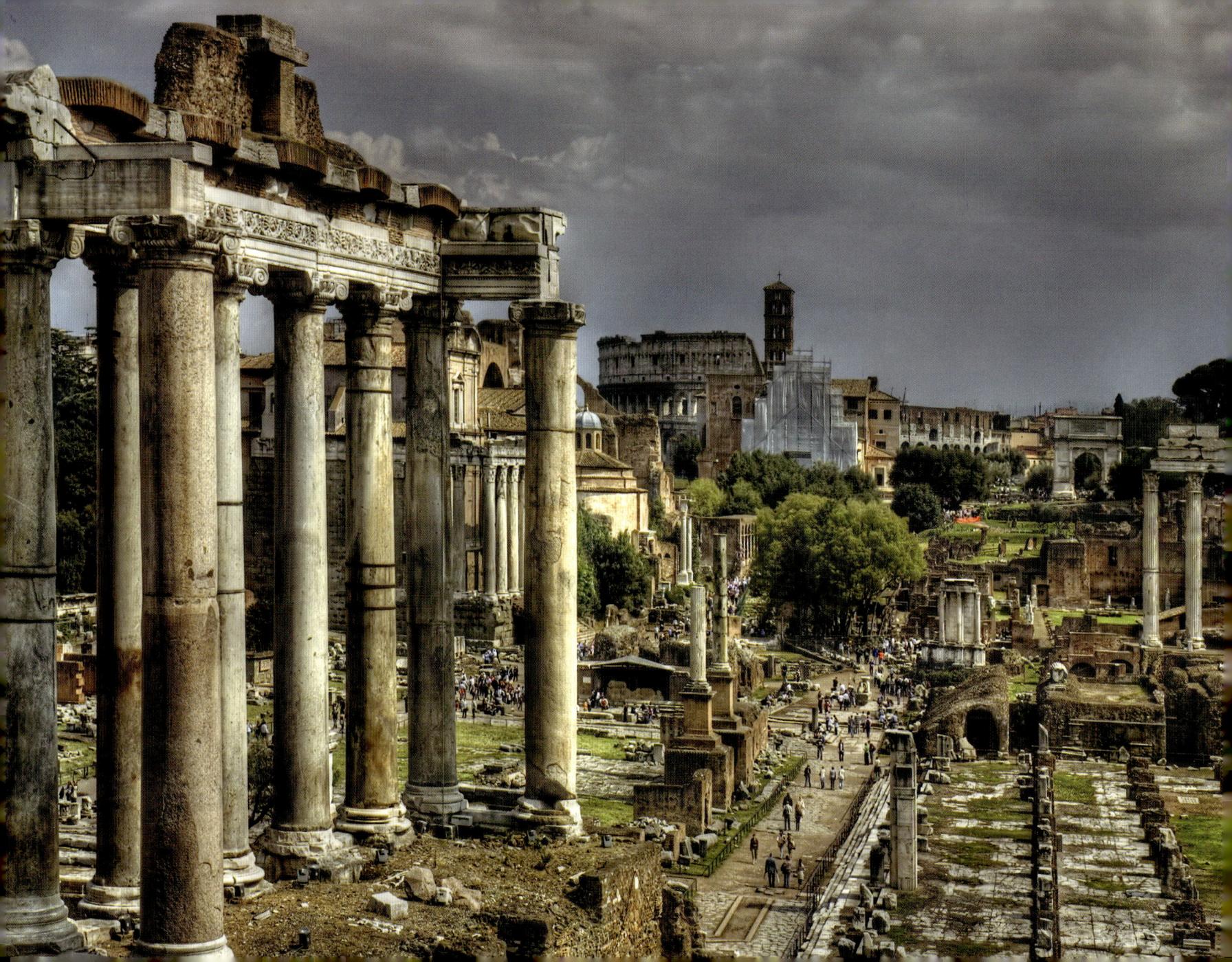

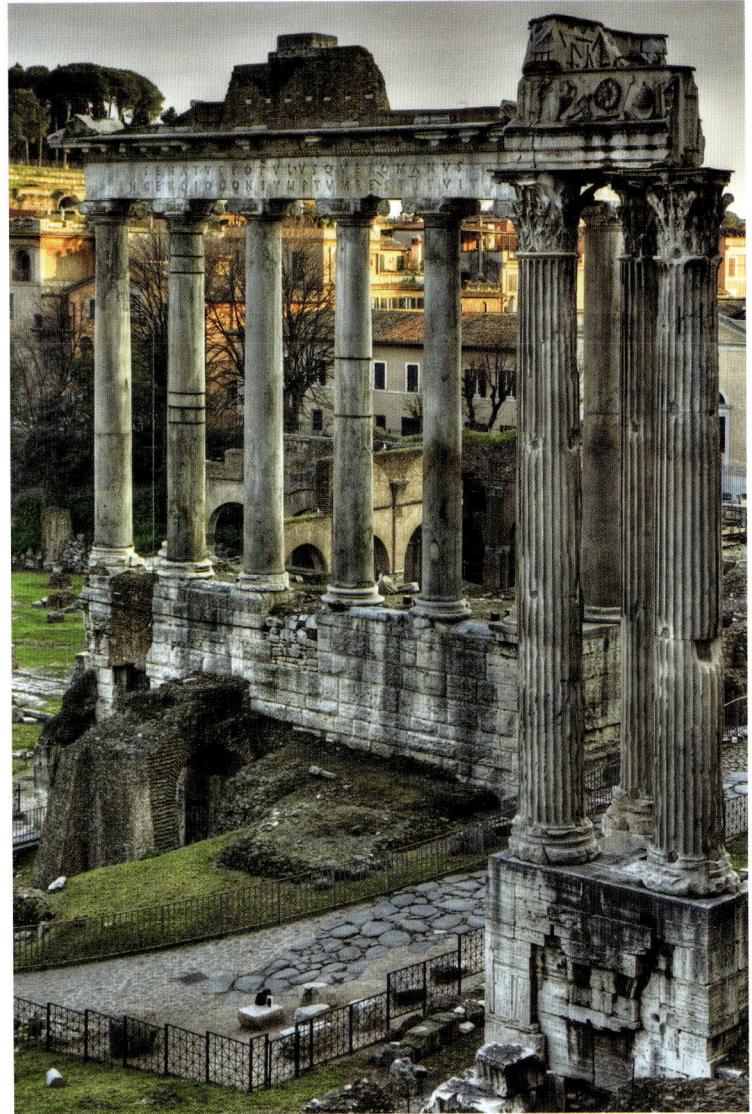

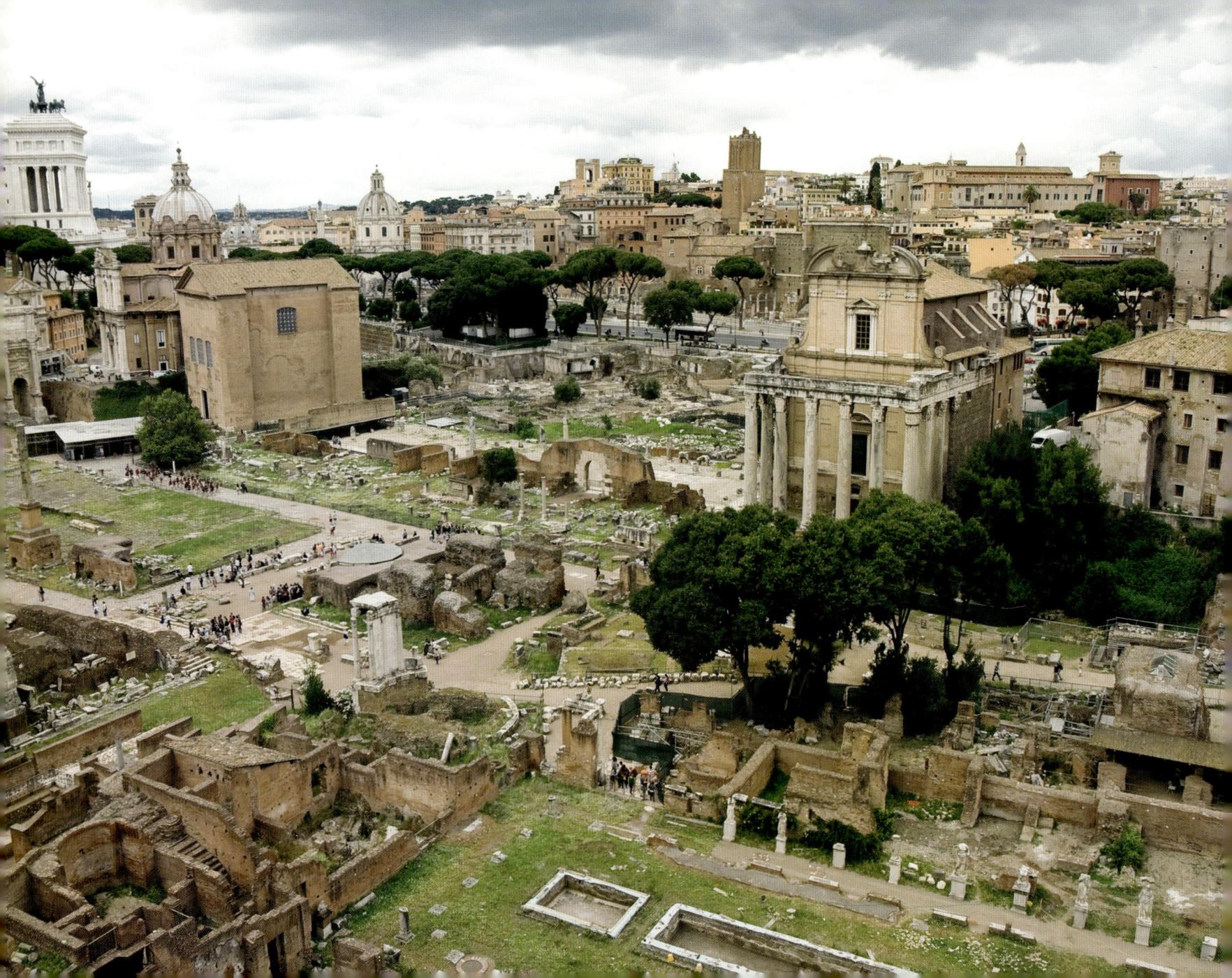

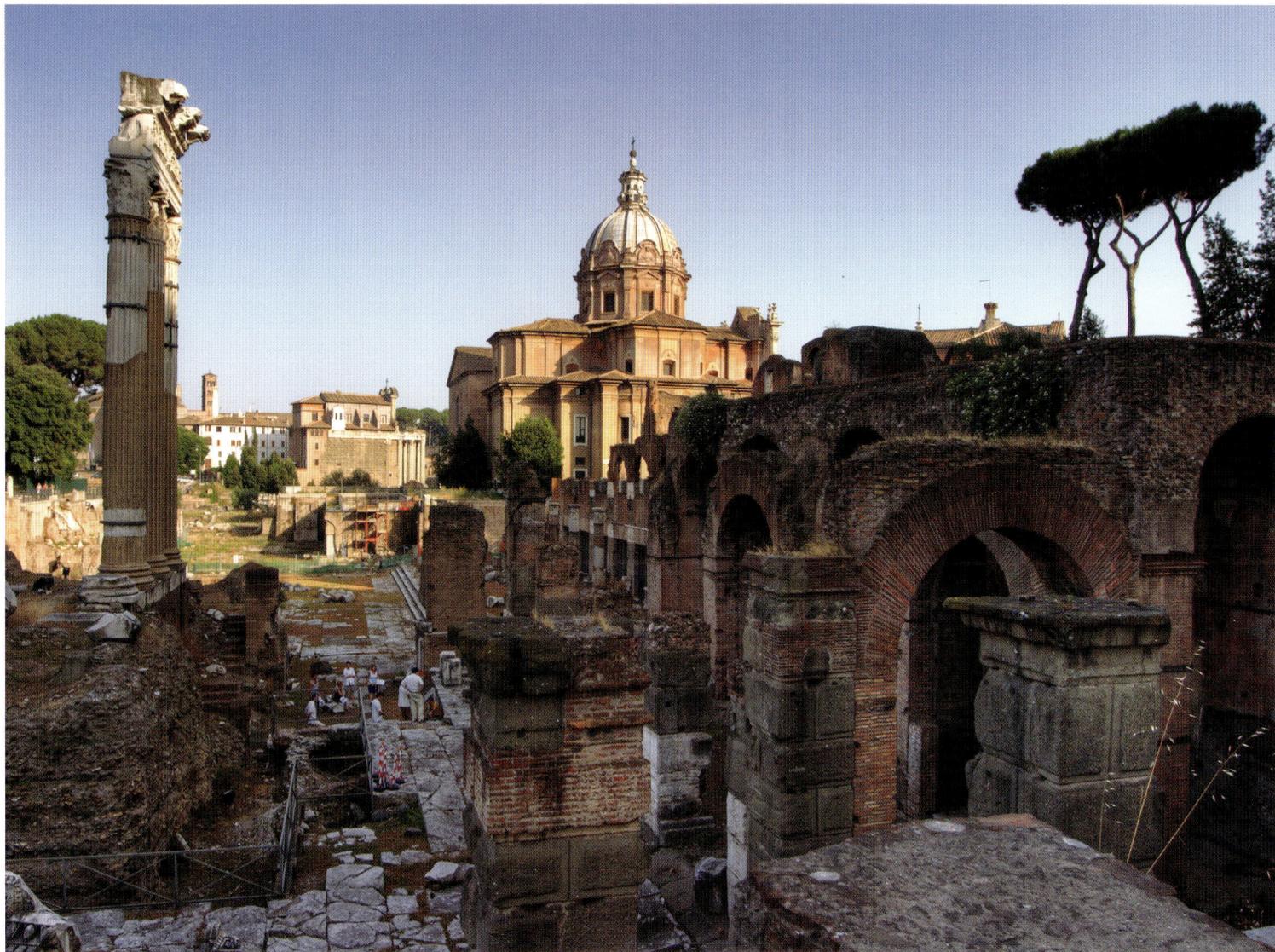

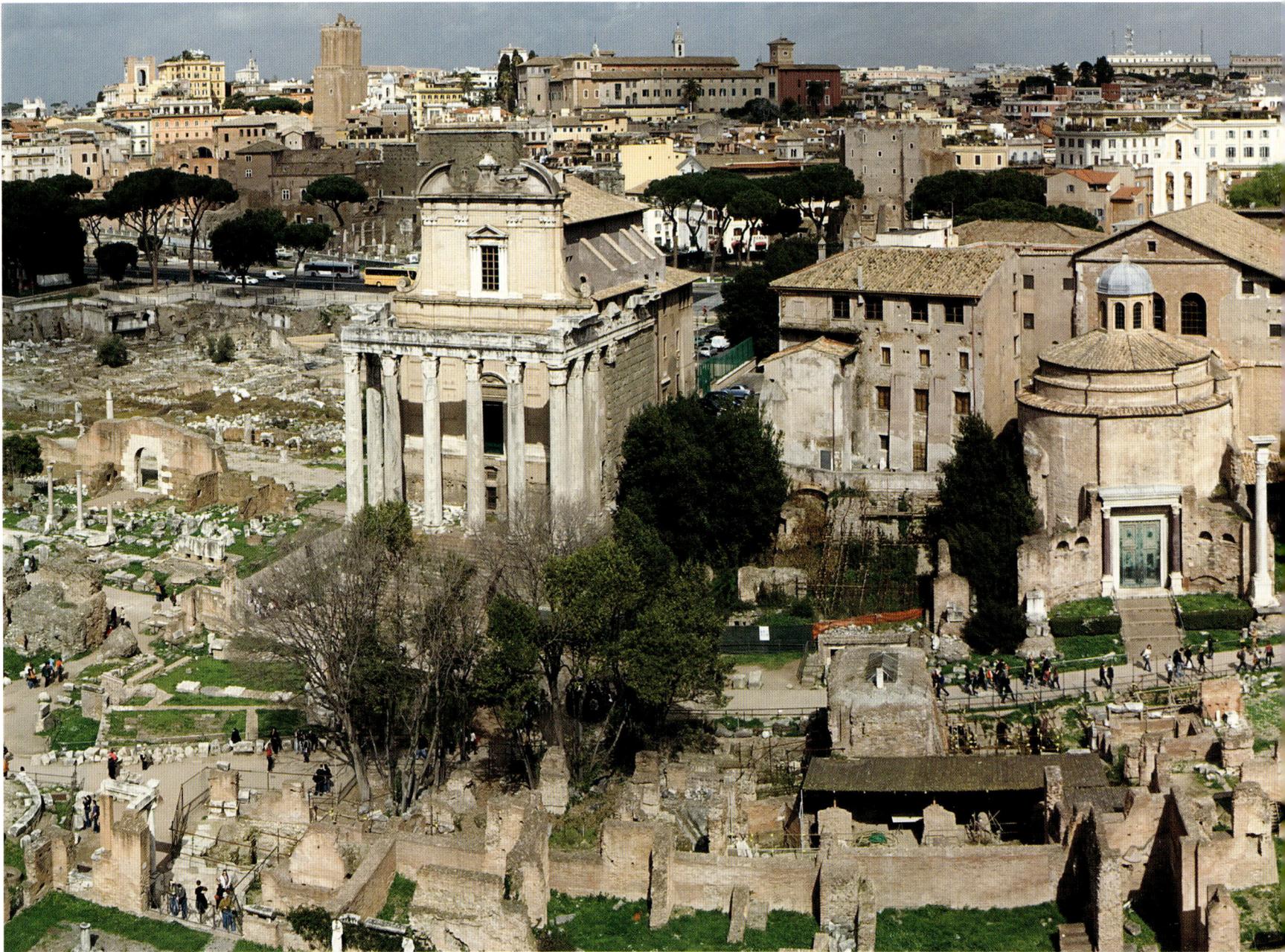

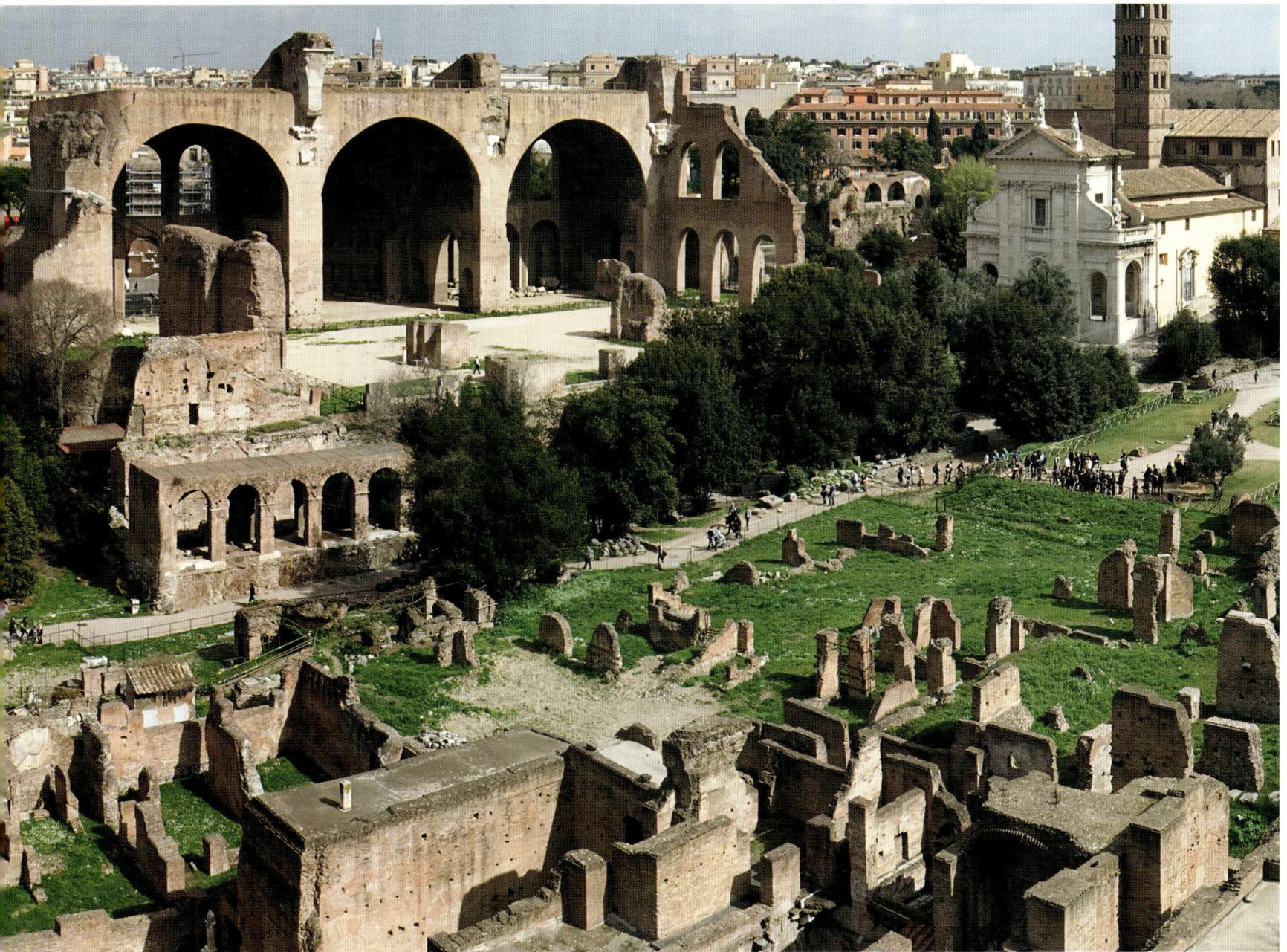

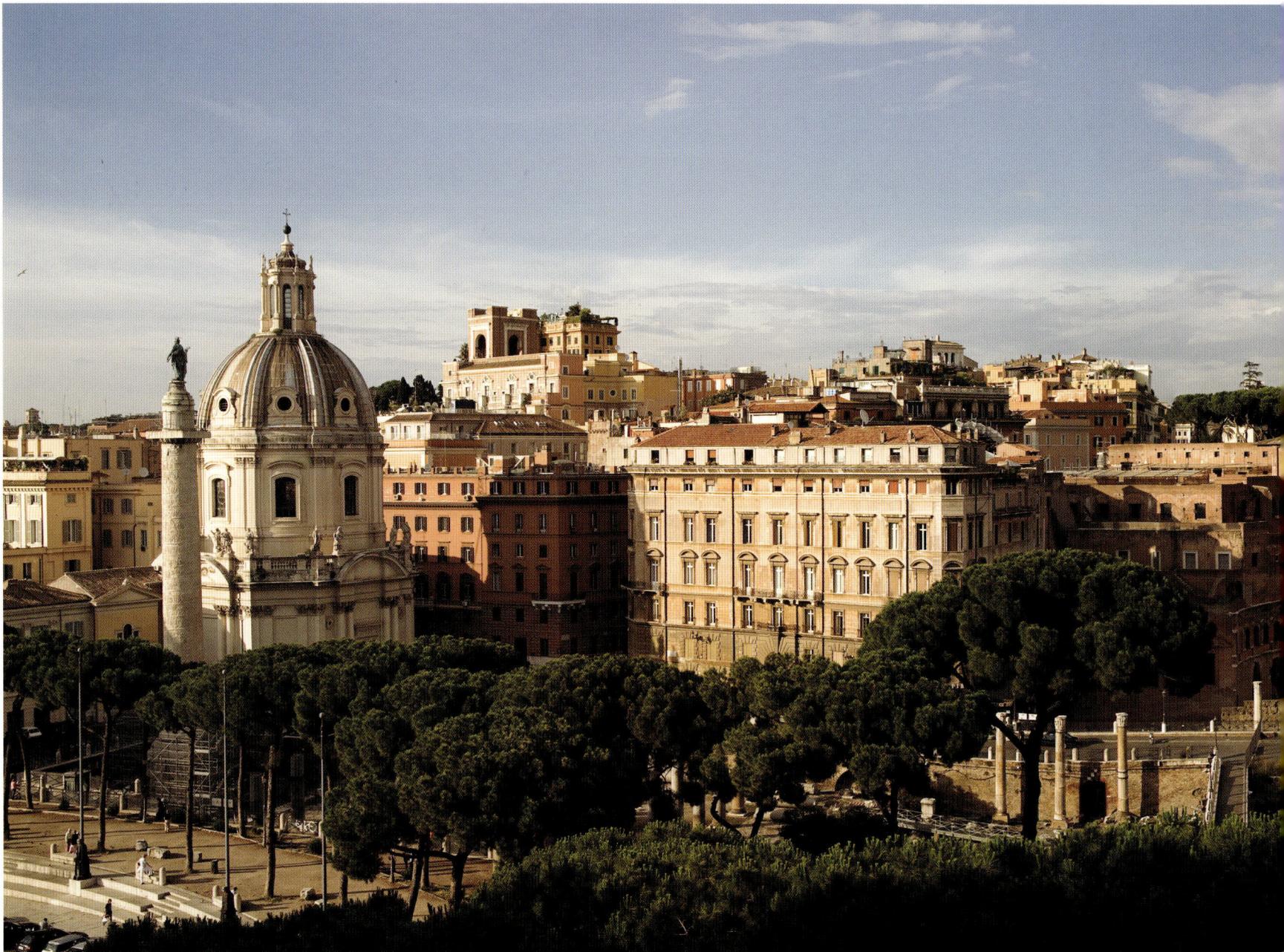

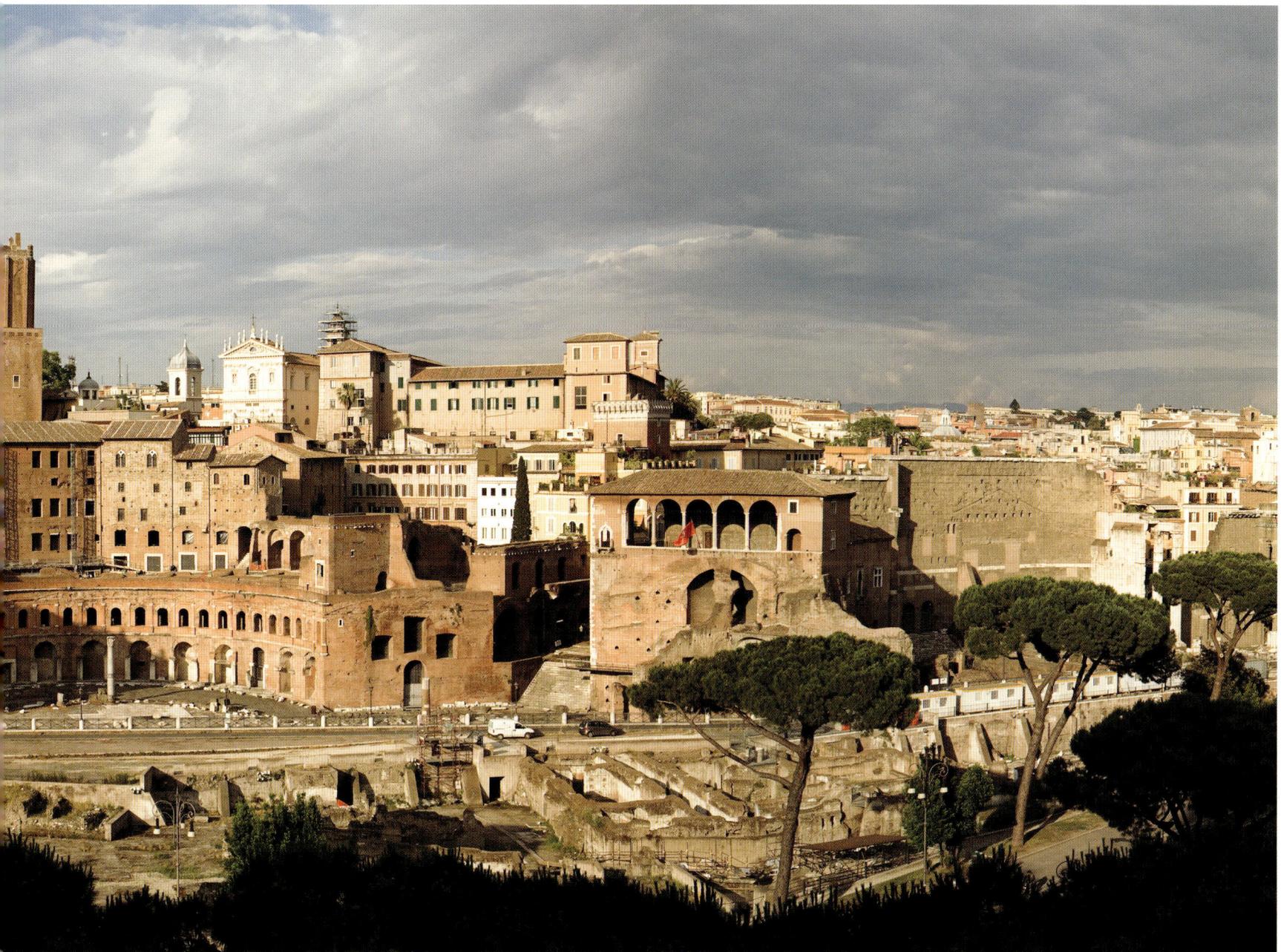

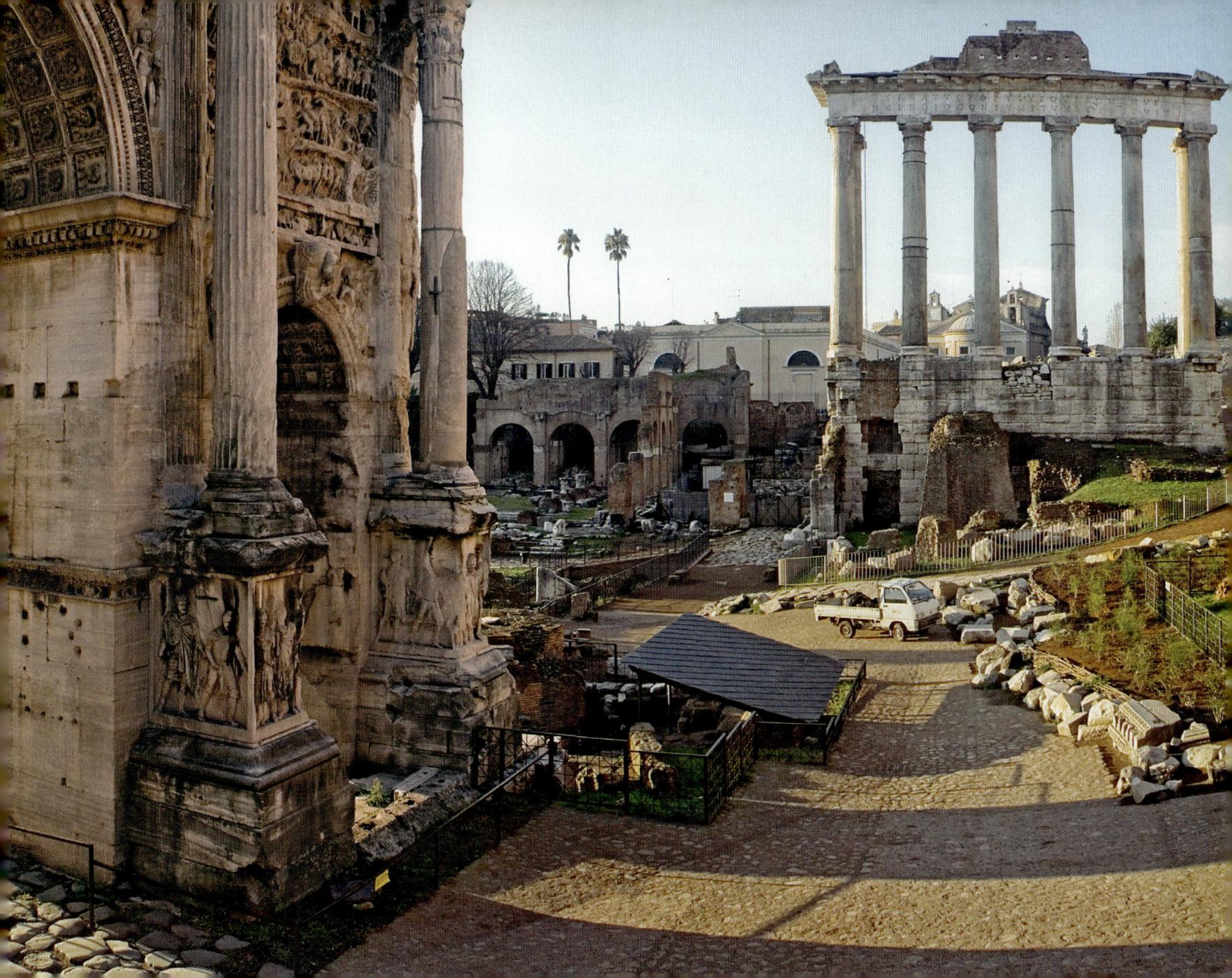

"Rome has not seen a modern building in more than half a century. It is a city frozen in time."

Richard Meier

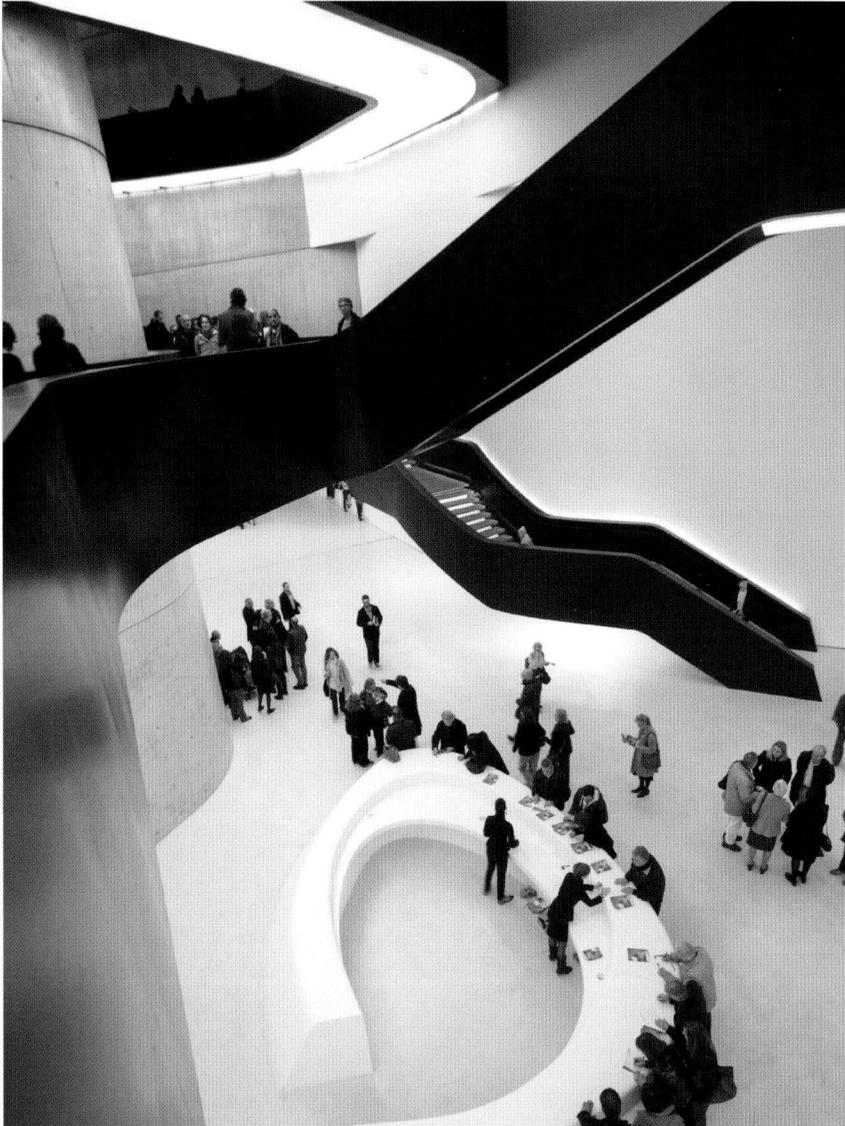

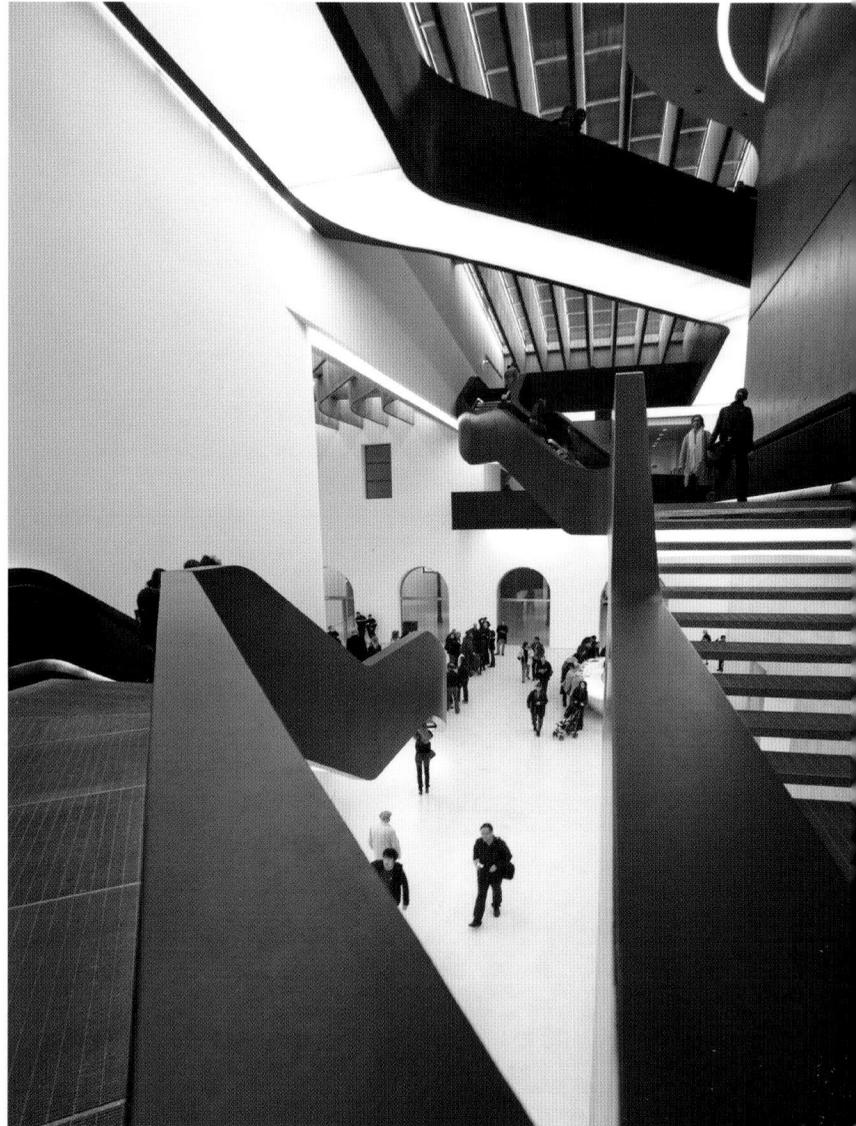

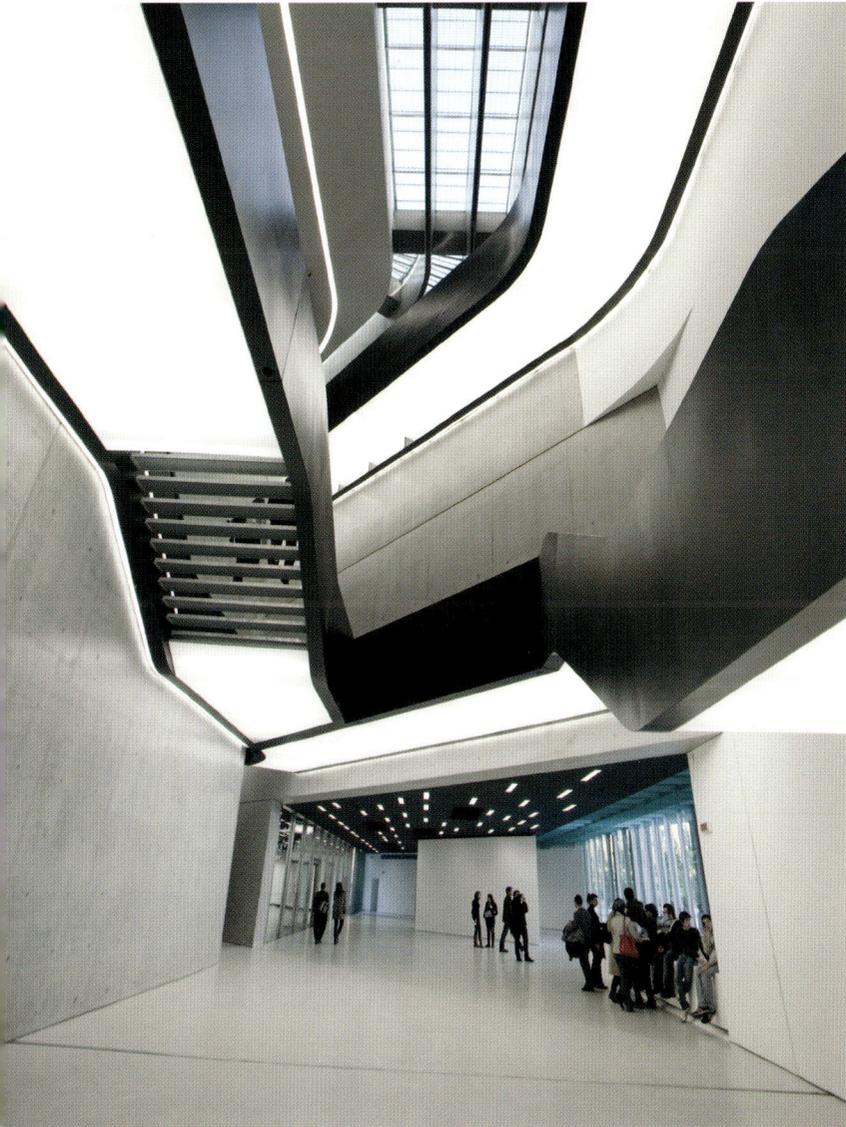
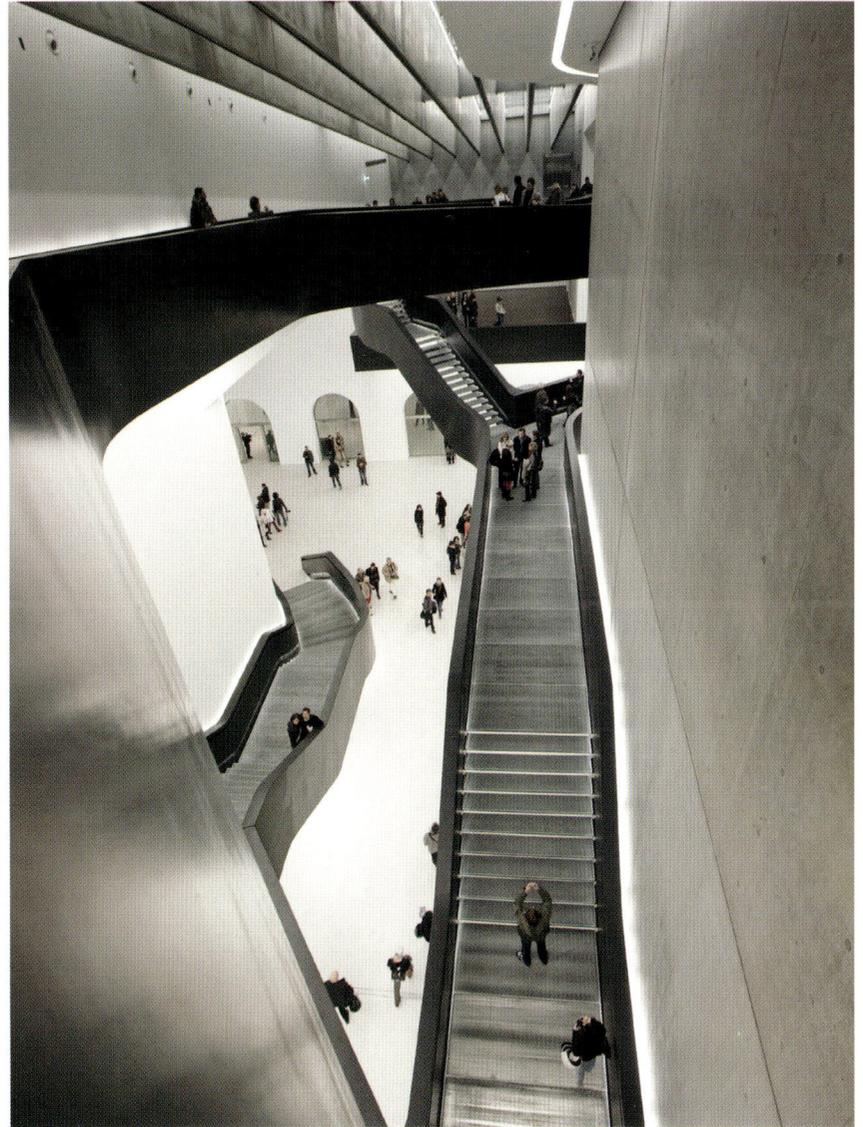

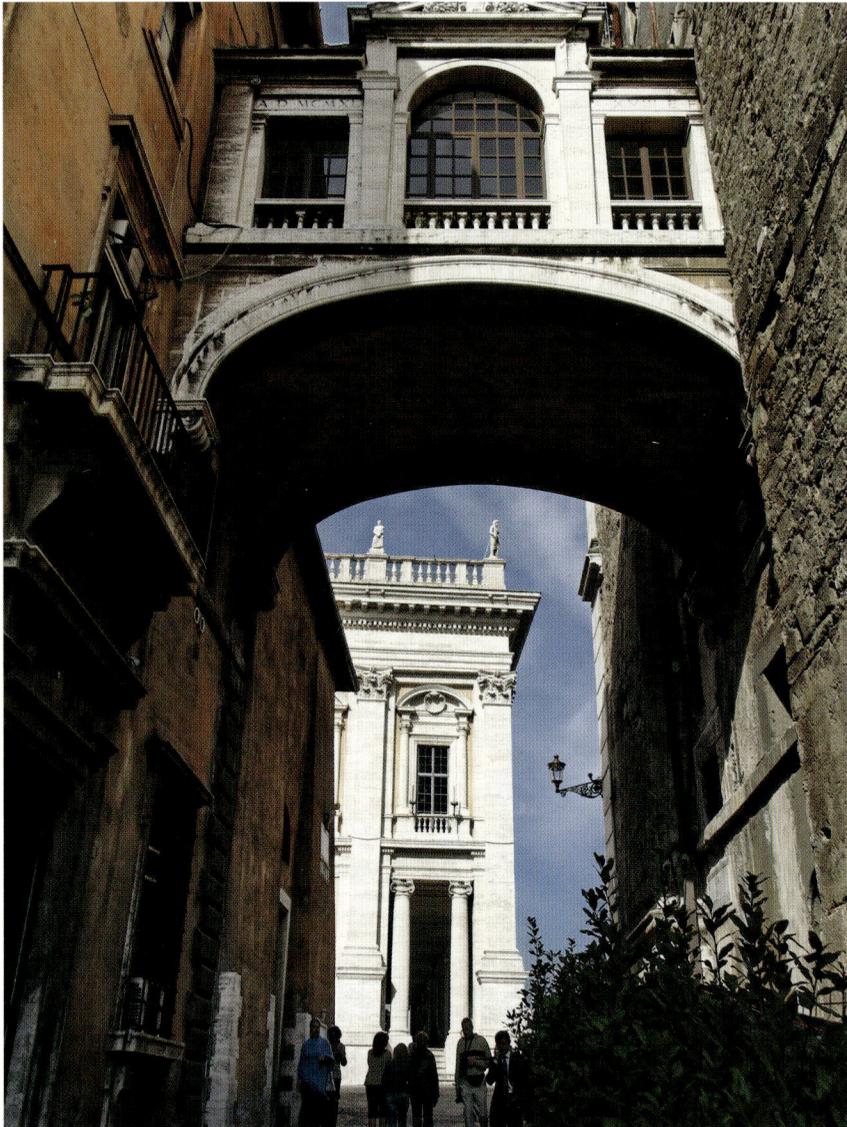

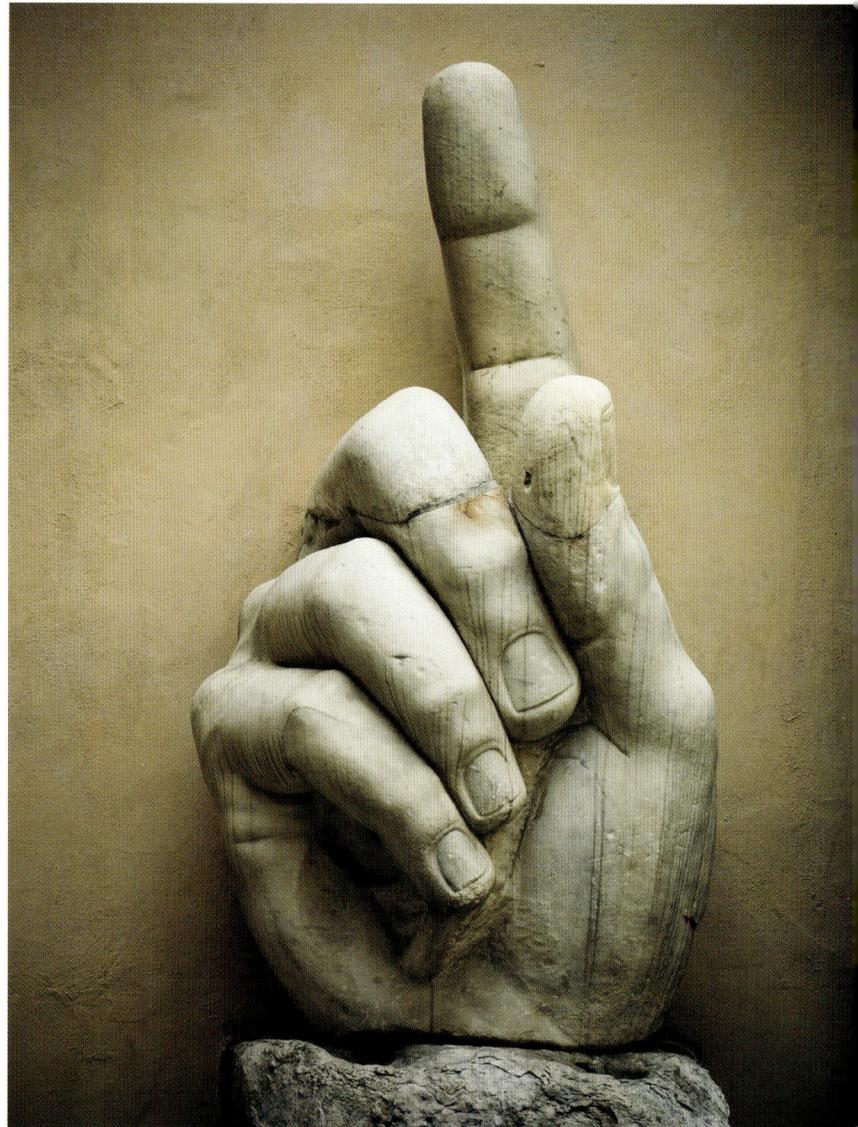

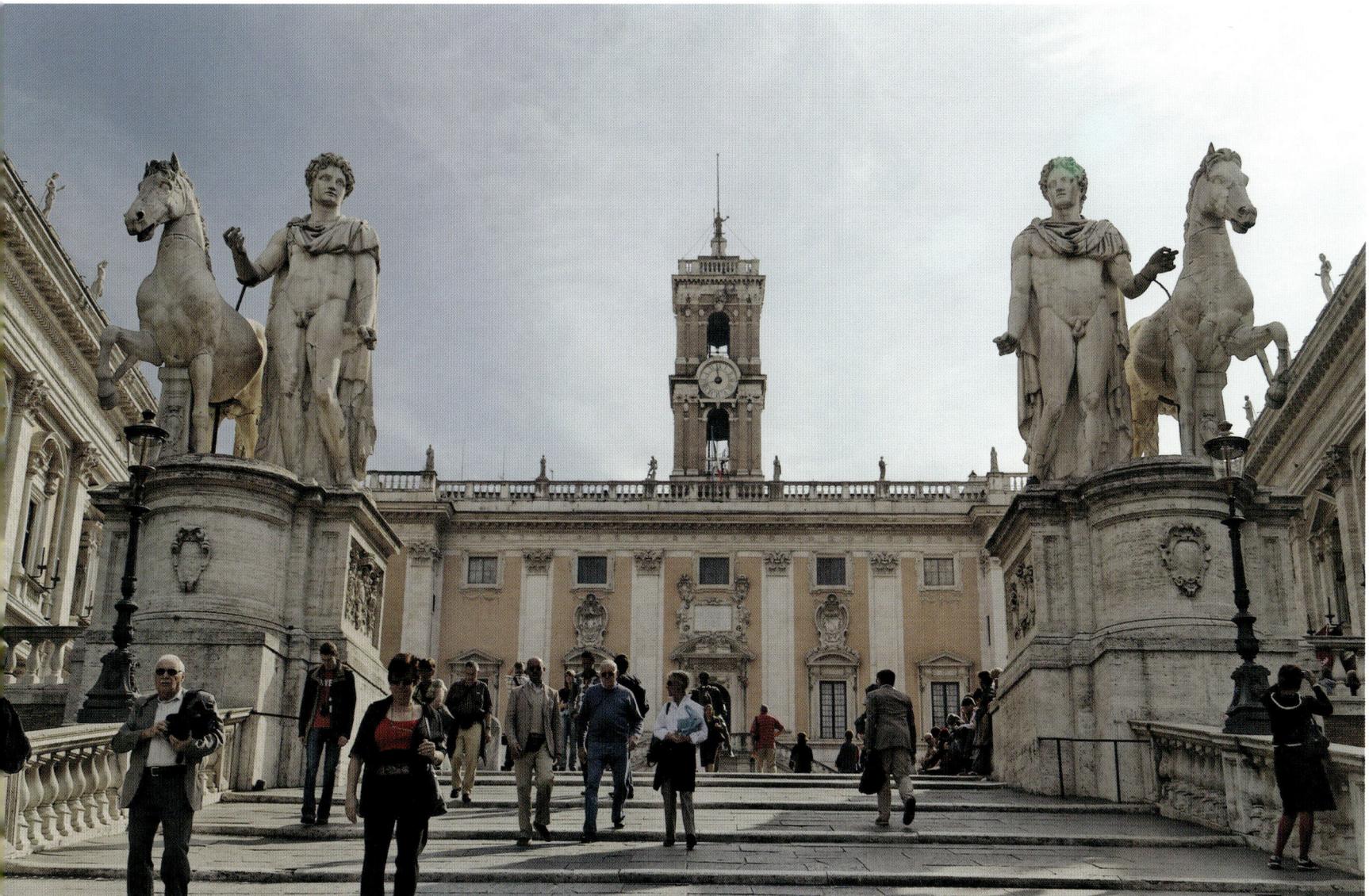

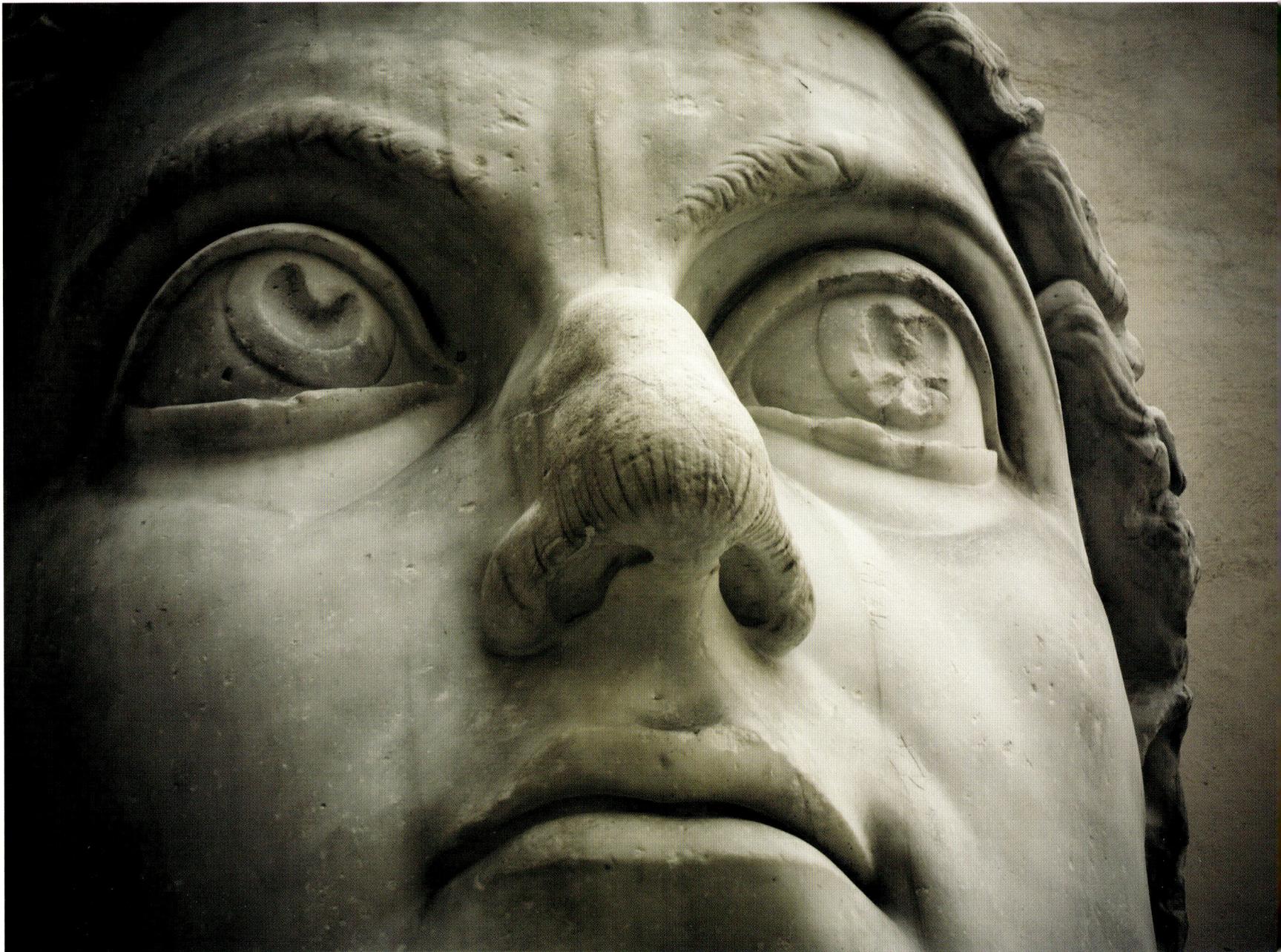

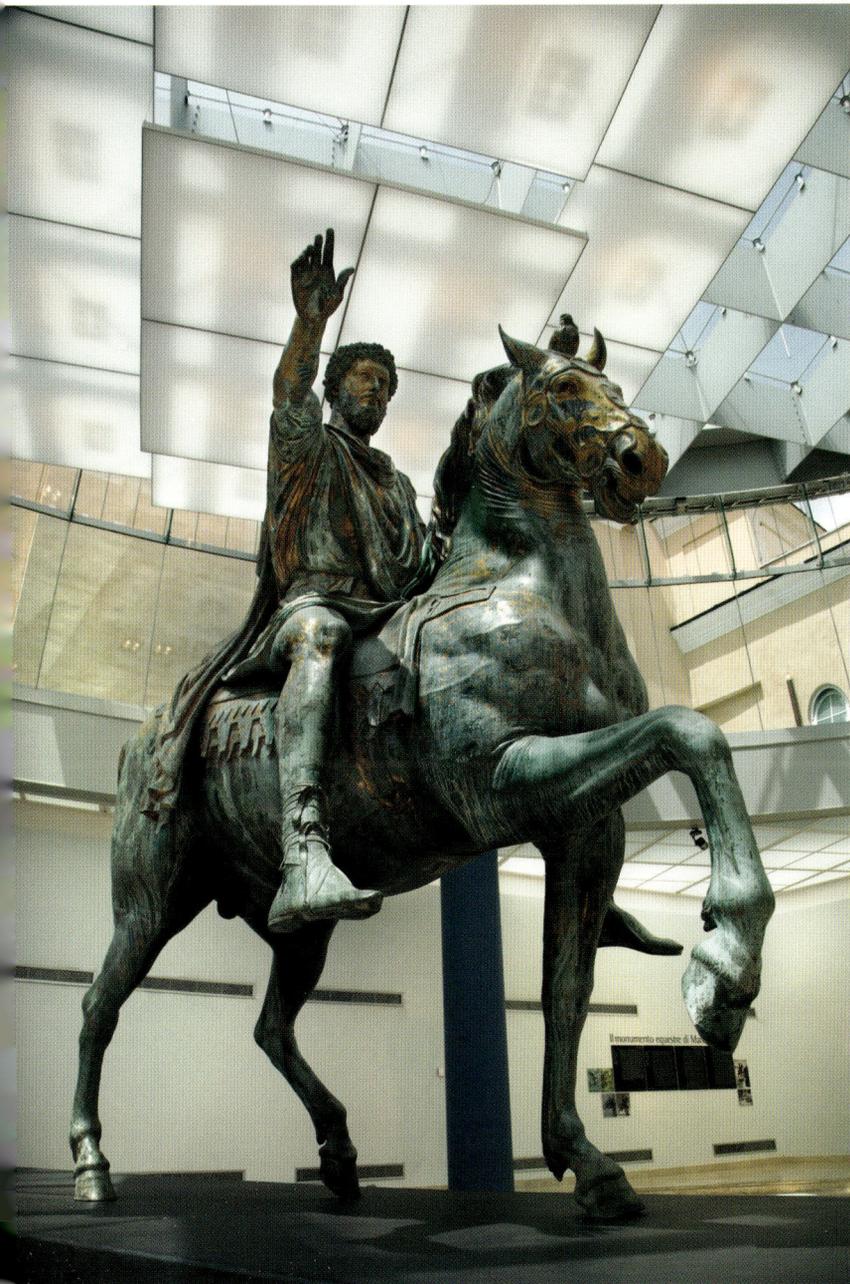
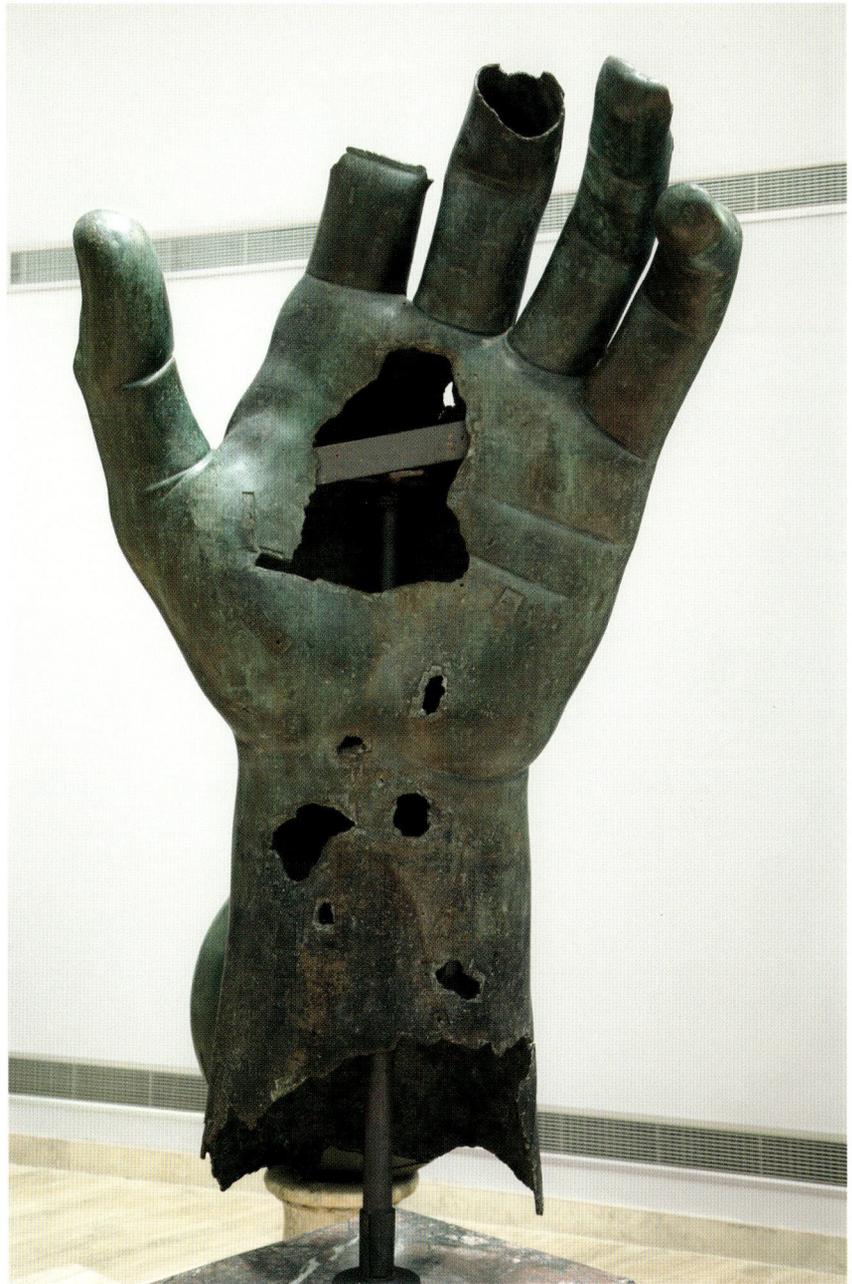

Shopping

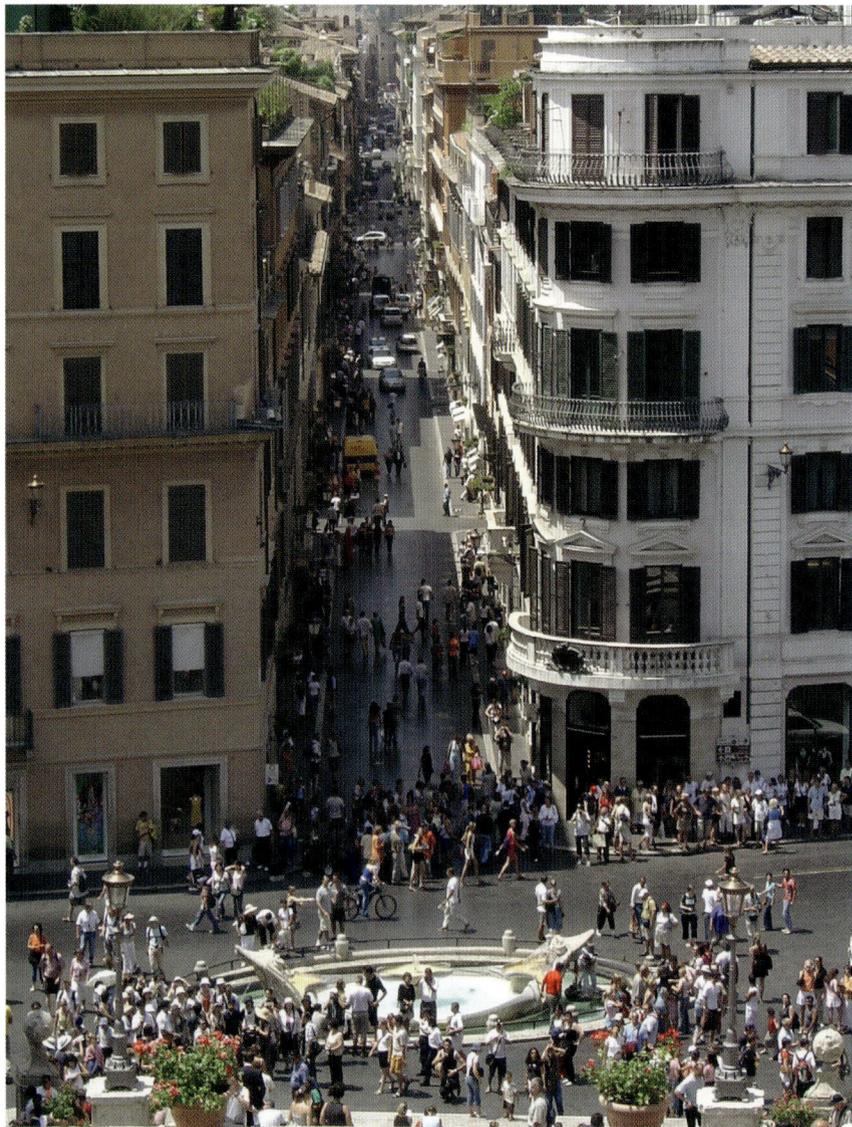

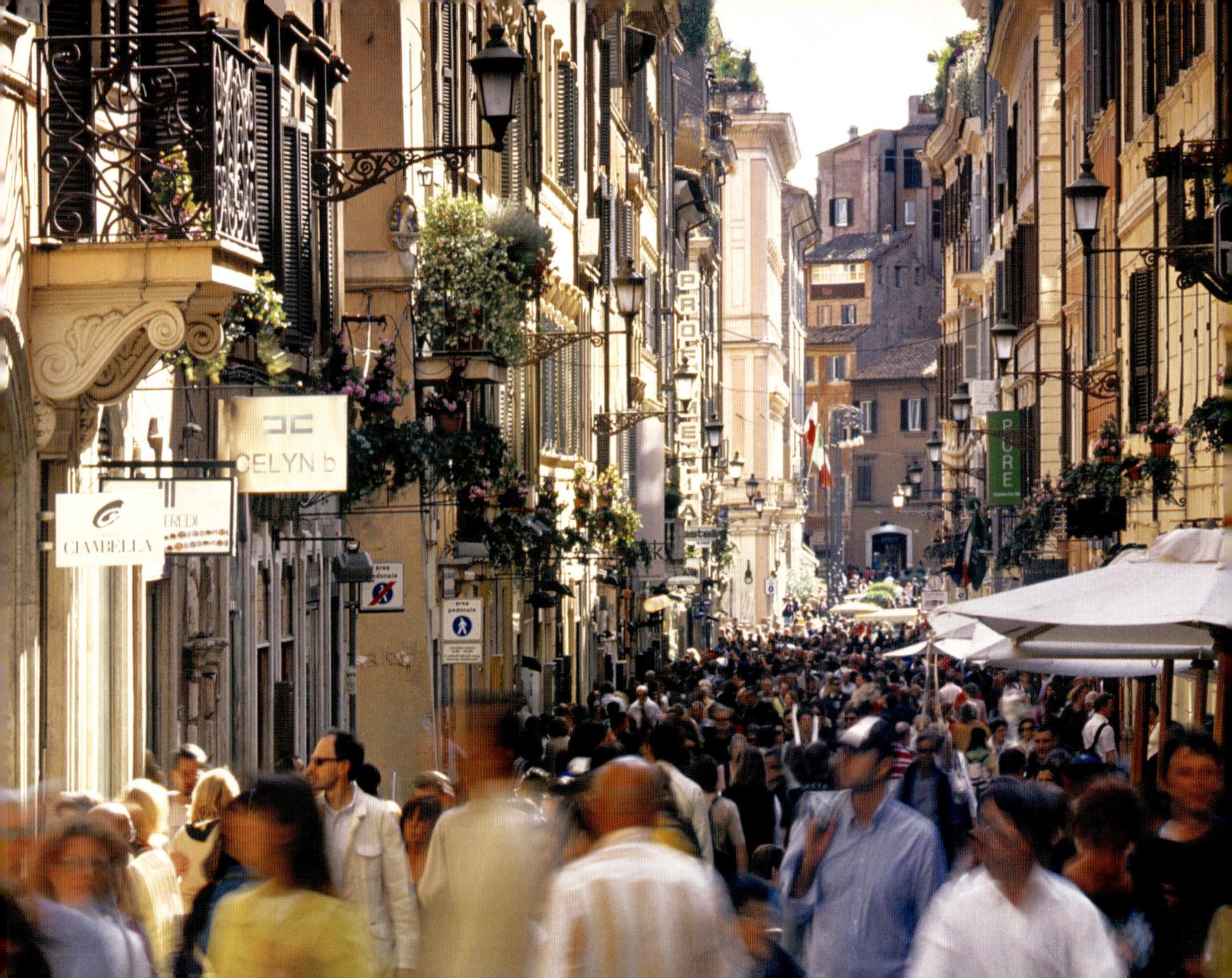

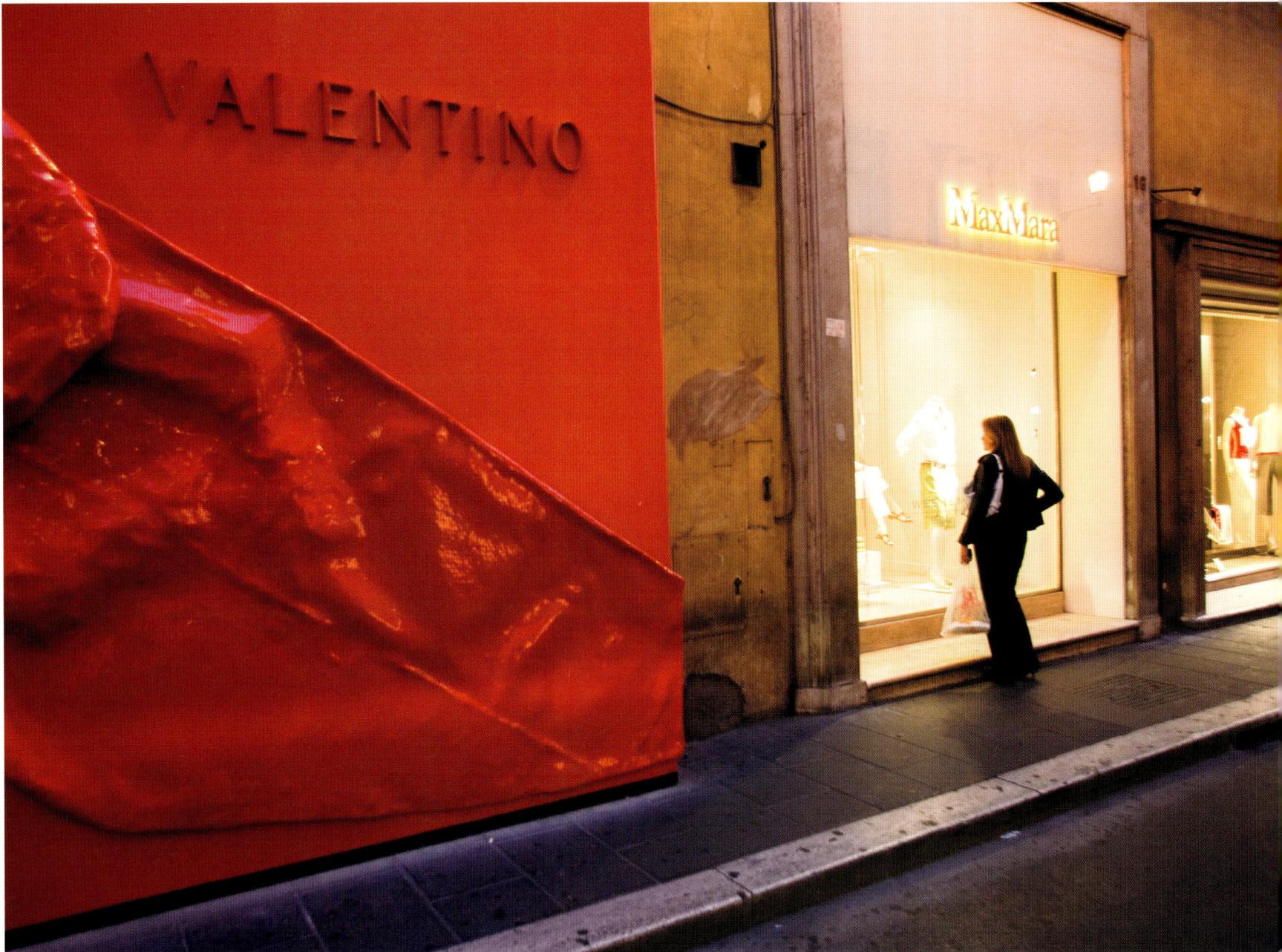

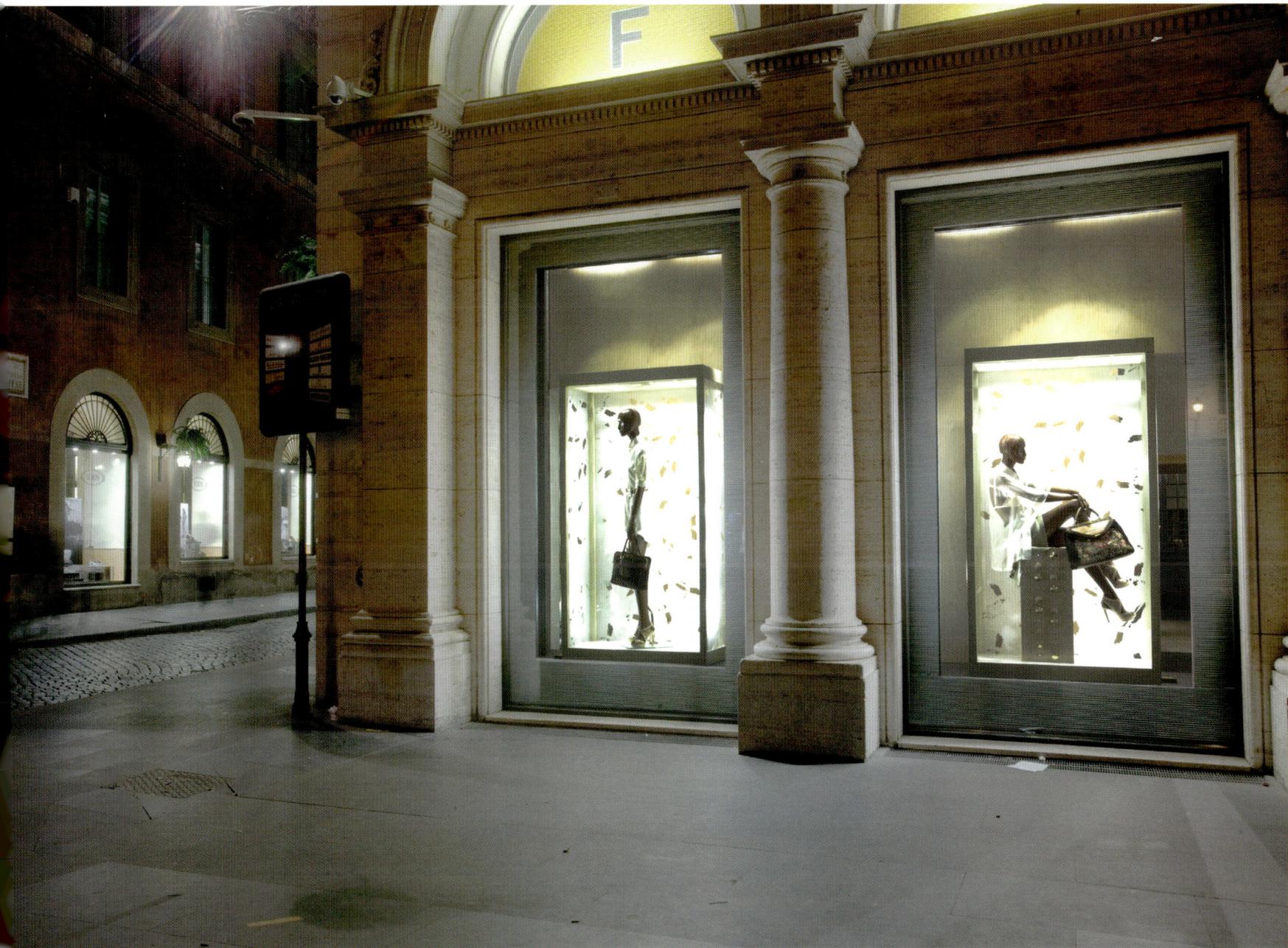

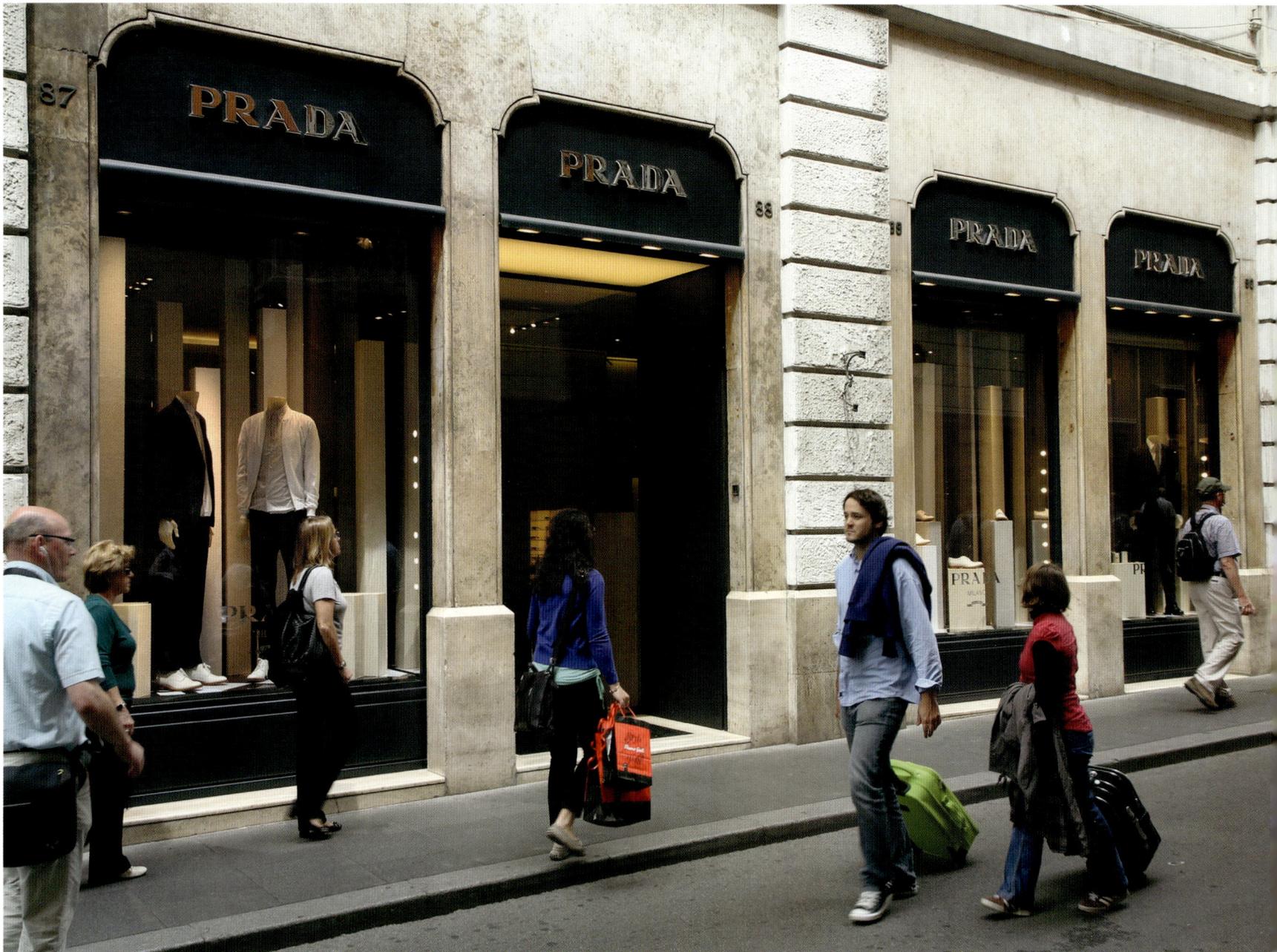

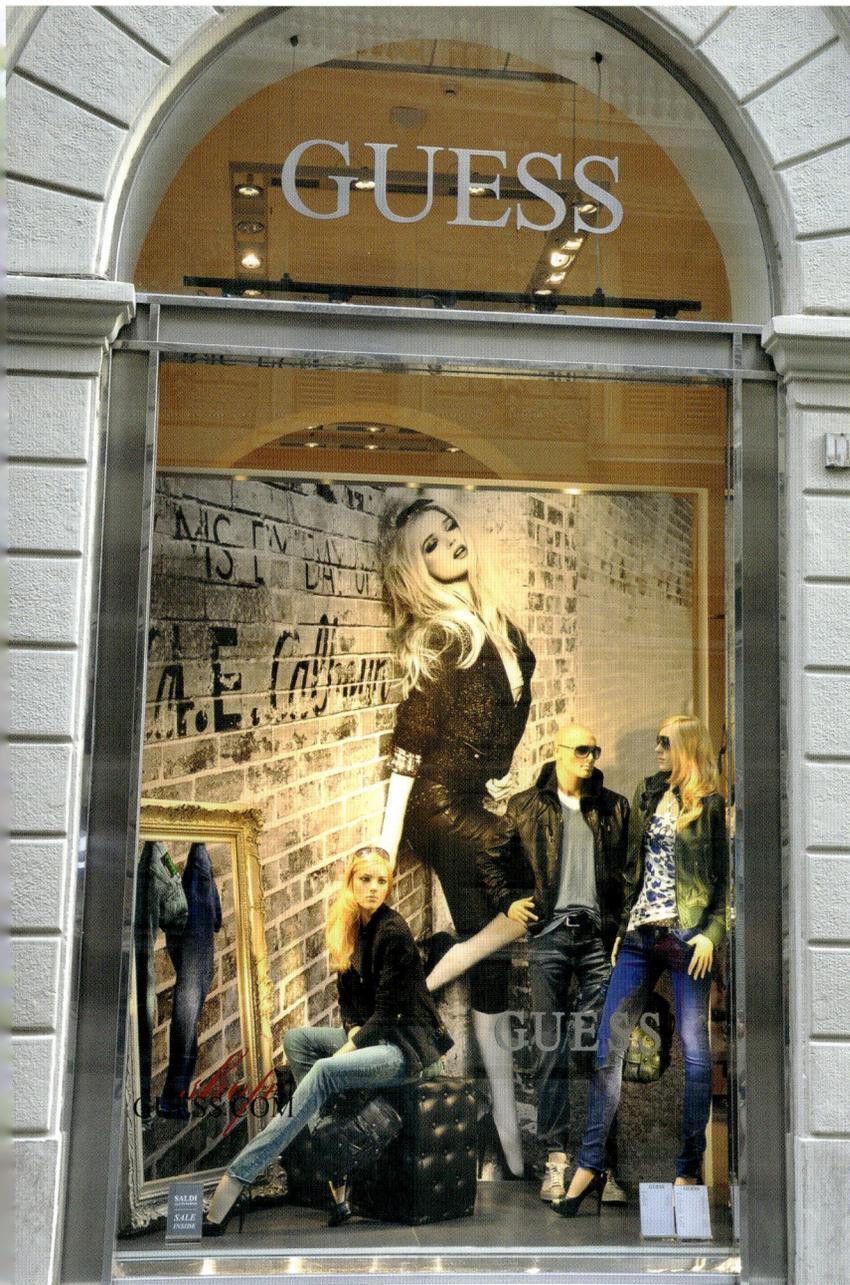
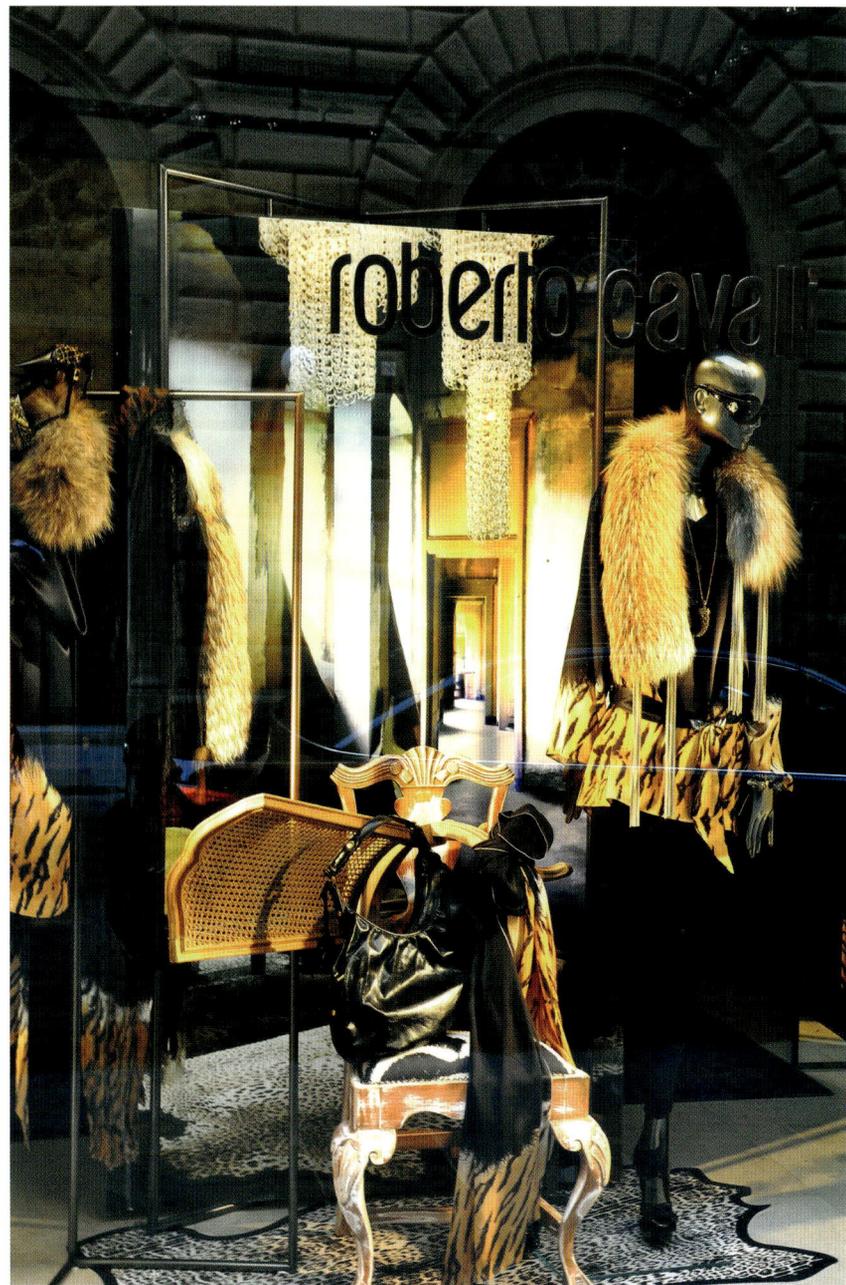

Ara Pacis Museum

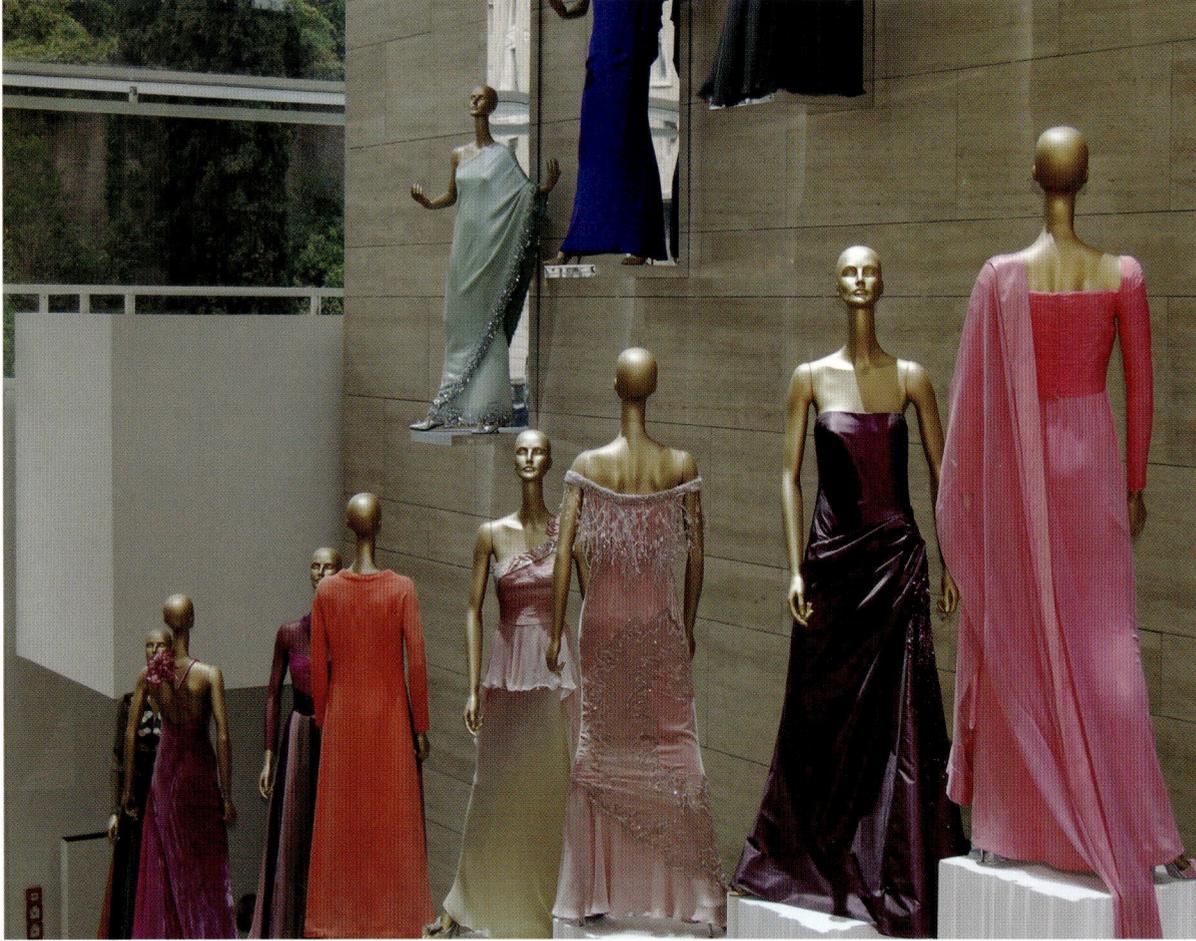

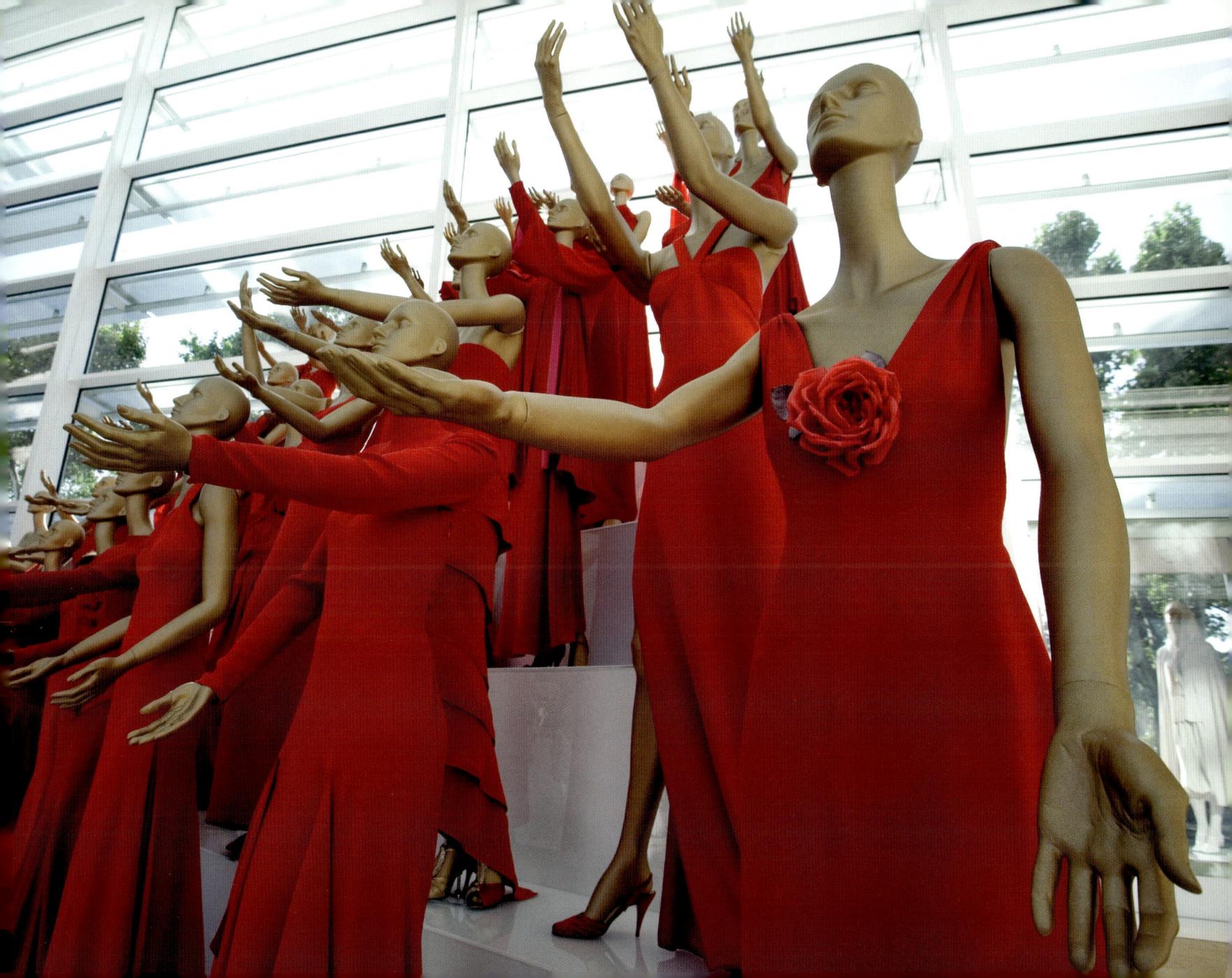

"Rome is a poem pressed into service as a city."

Anatole Broyard

Castel Saint Angelo

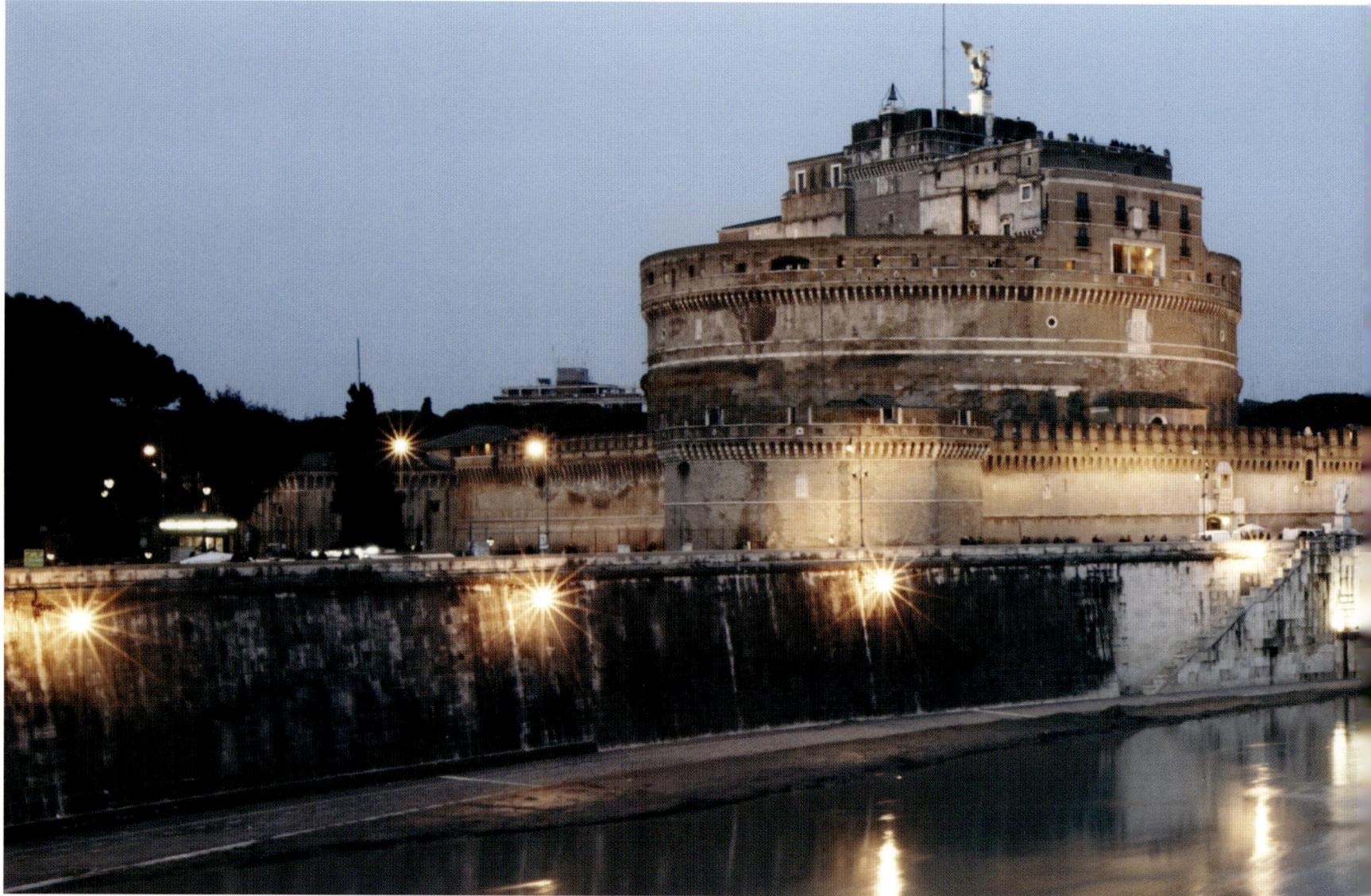

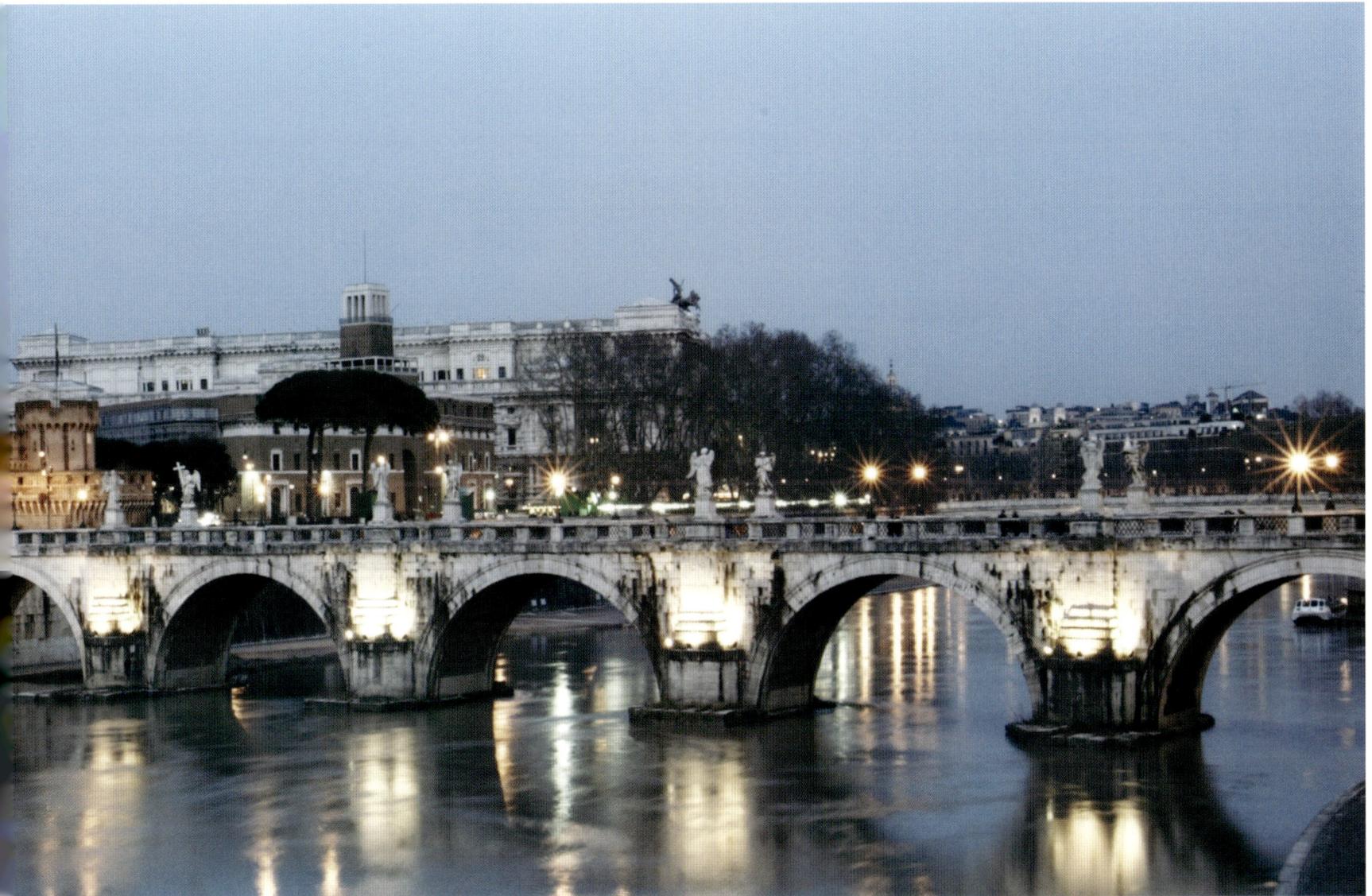

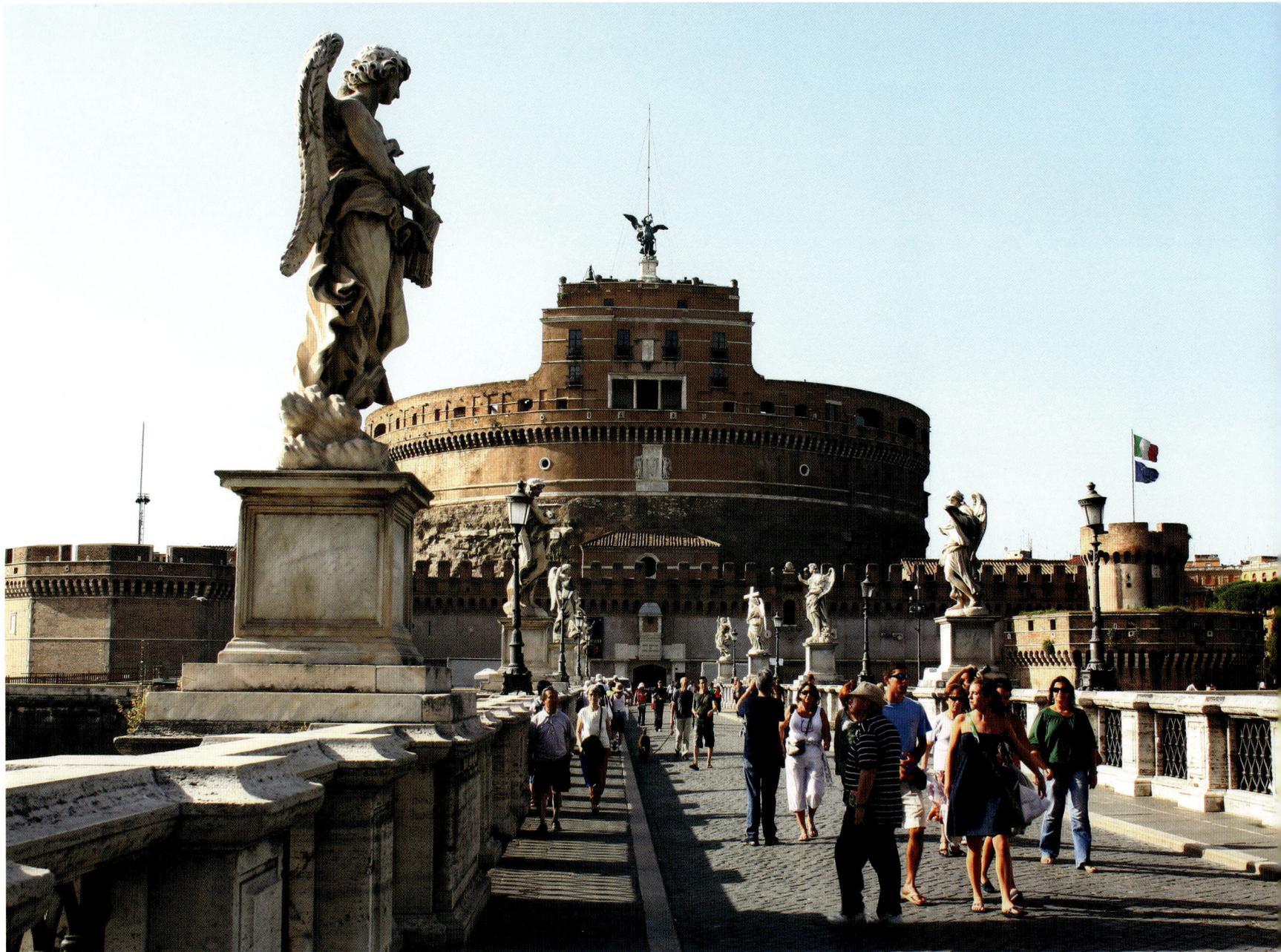

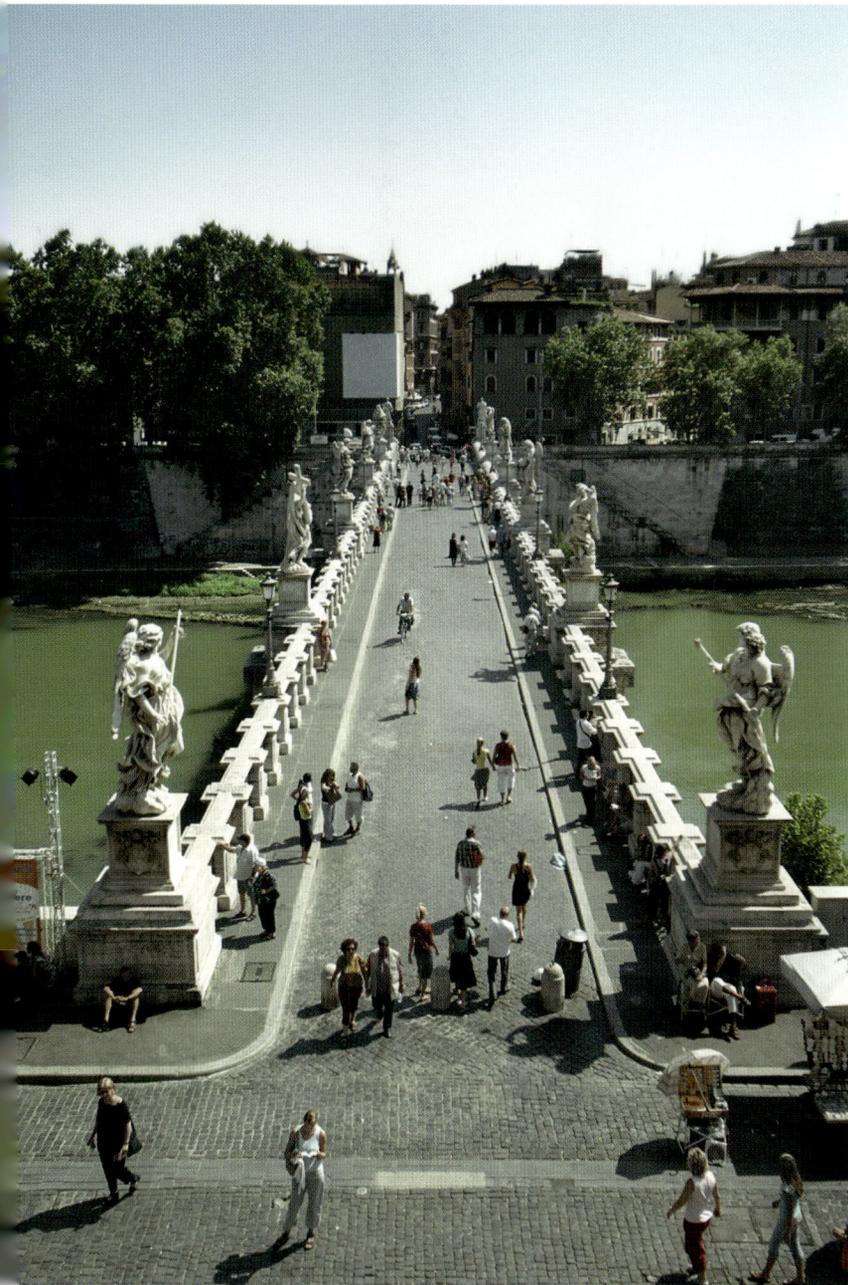
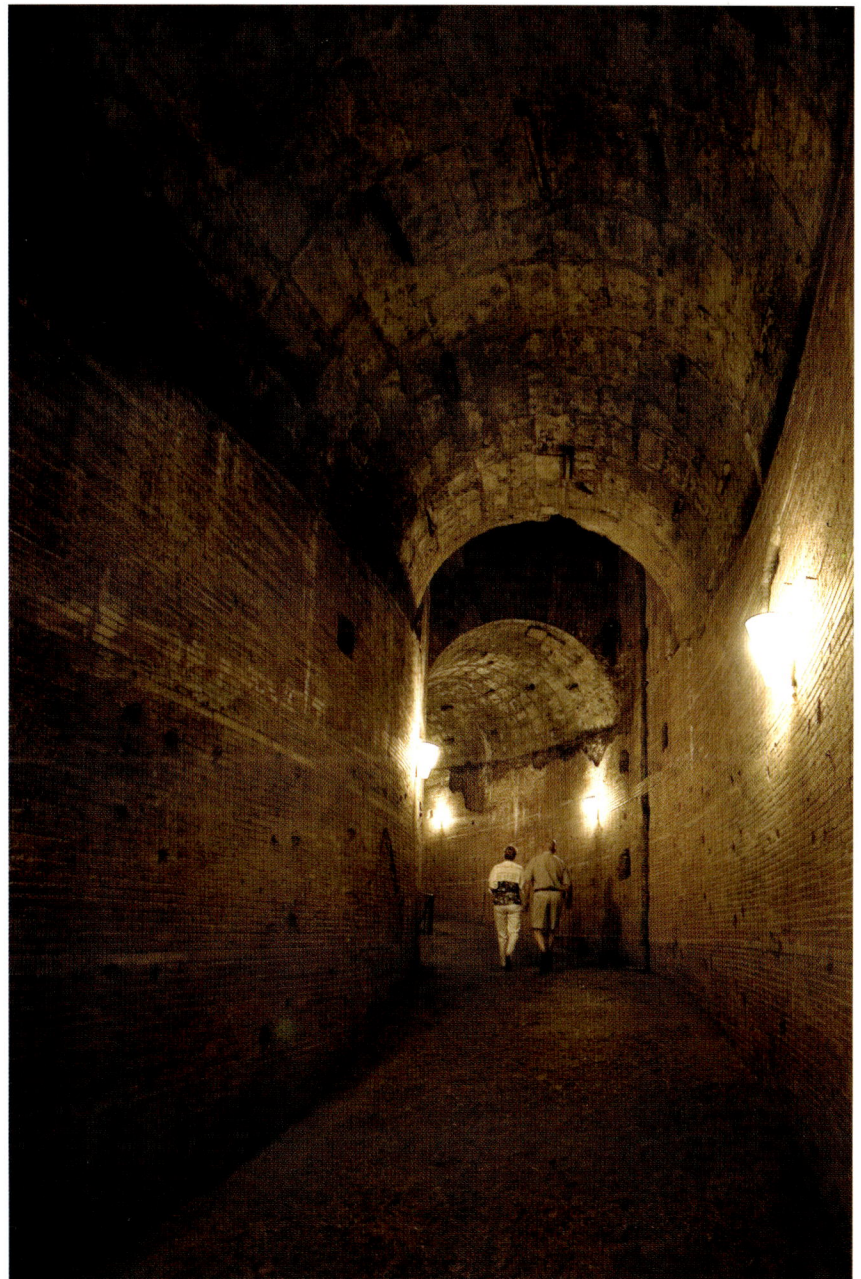

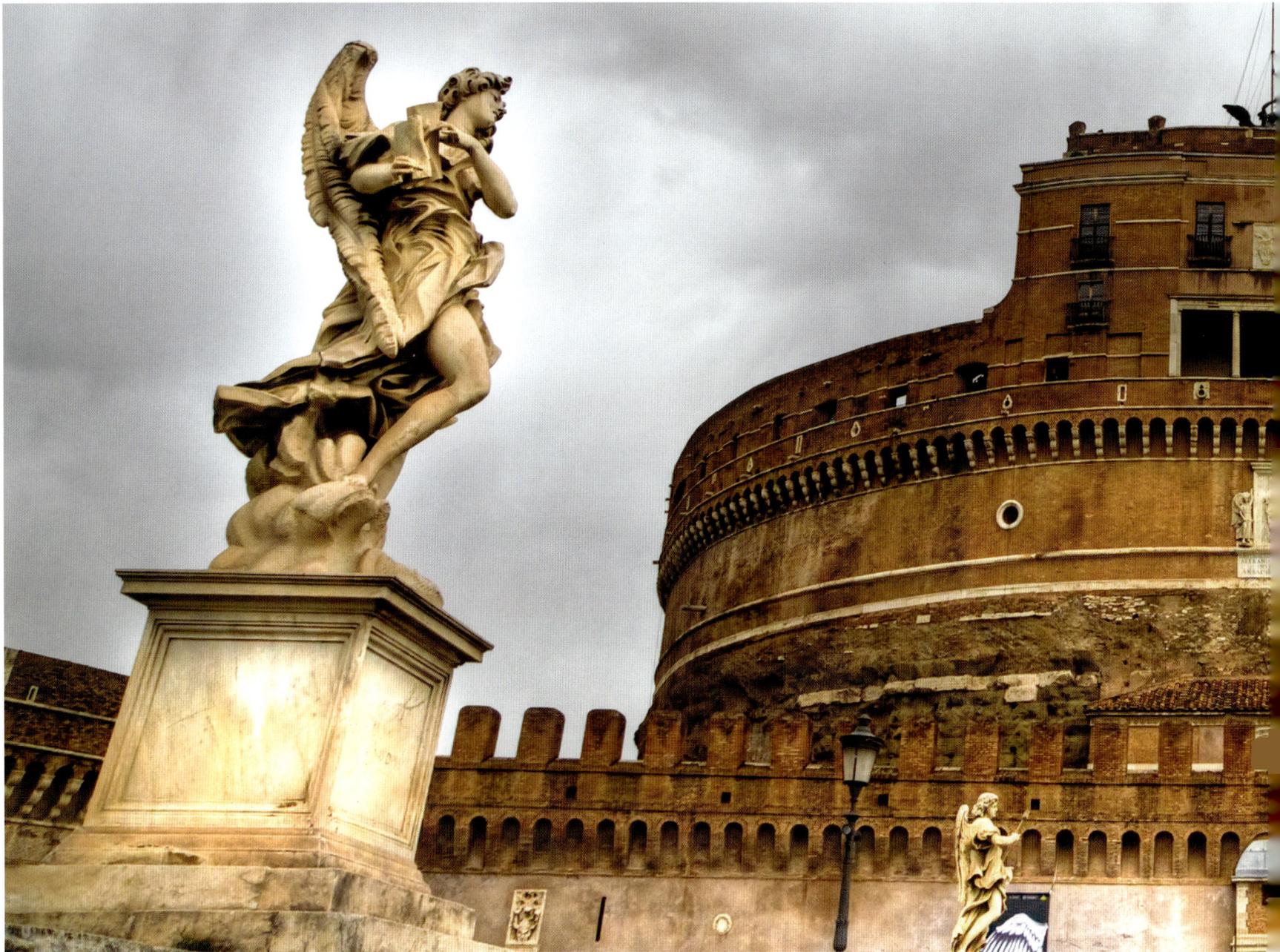

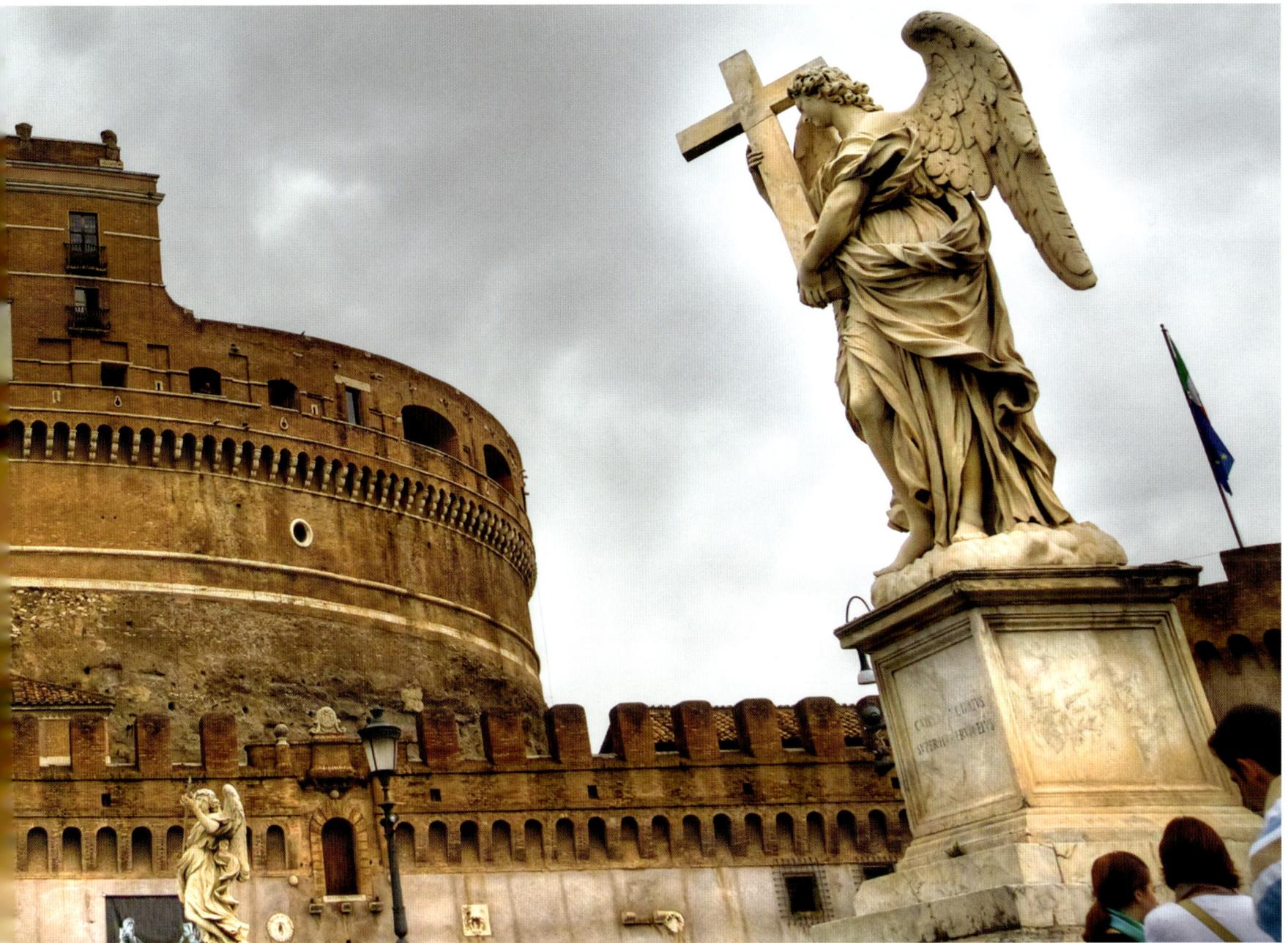

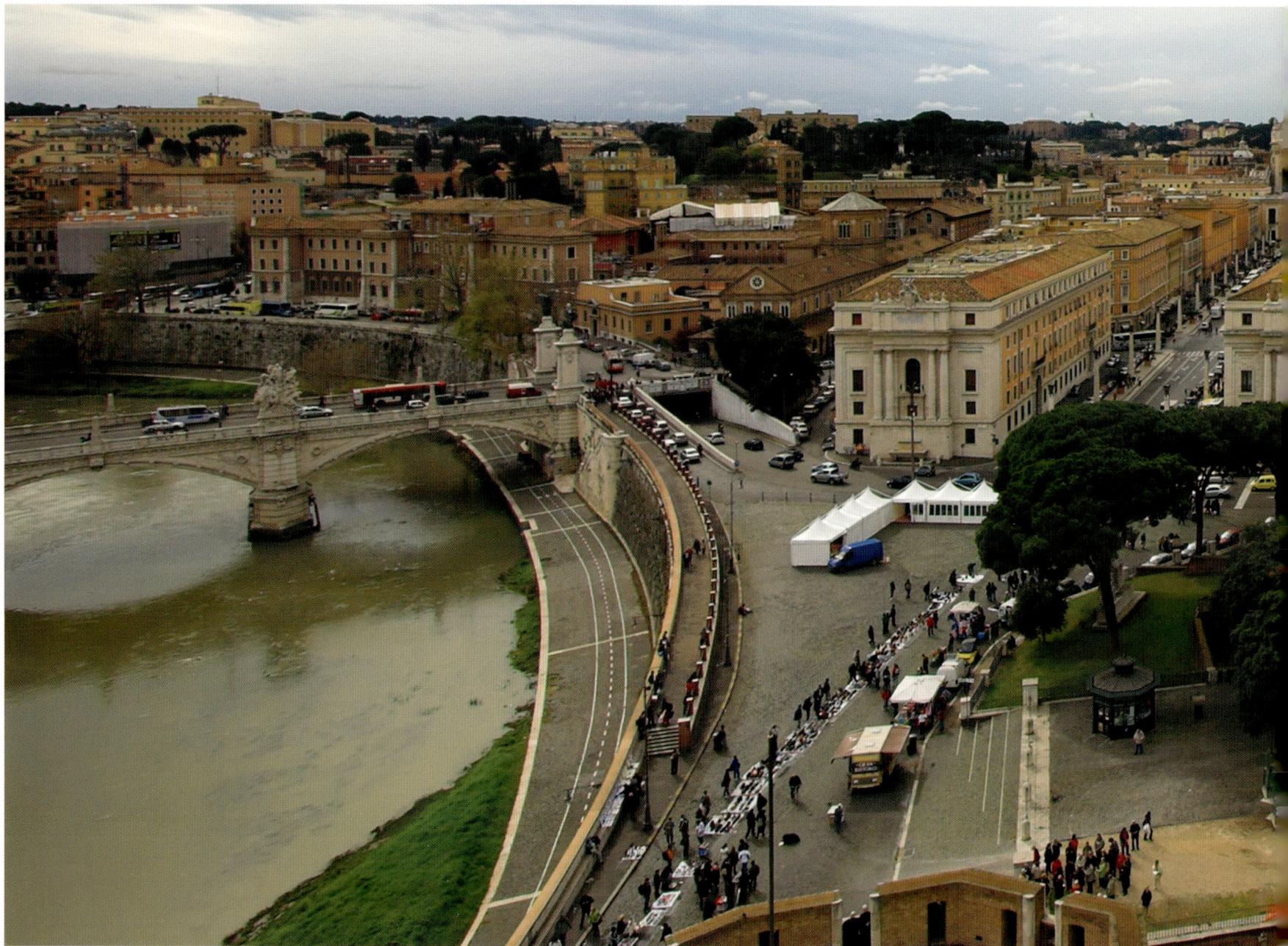

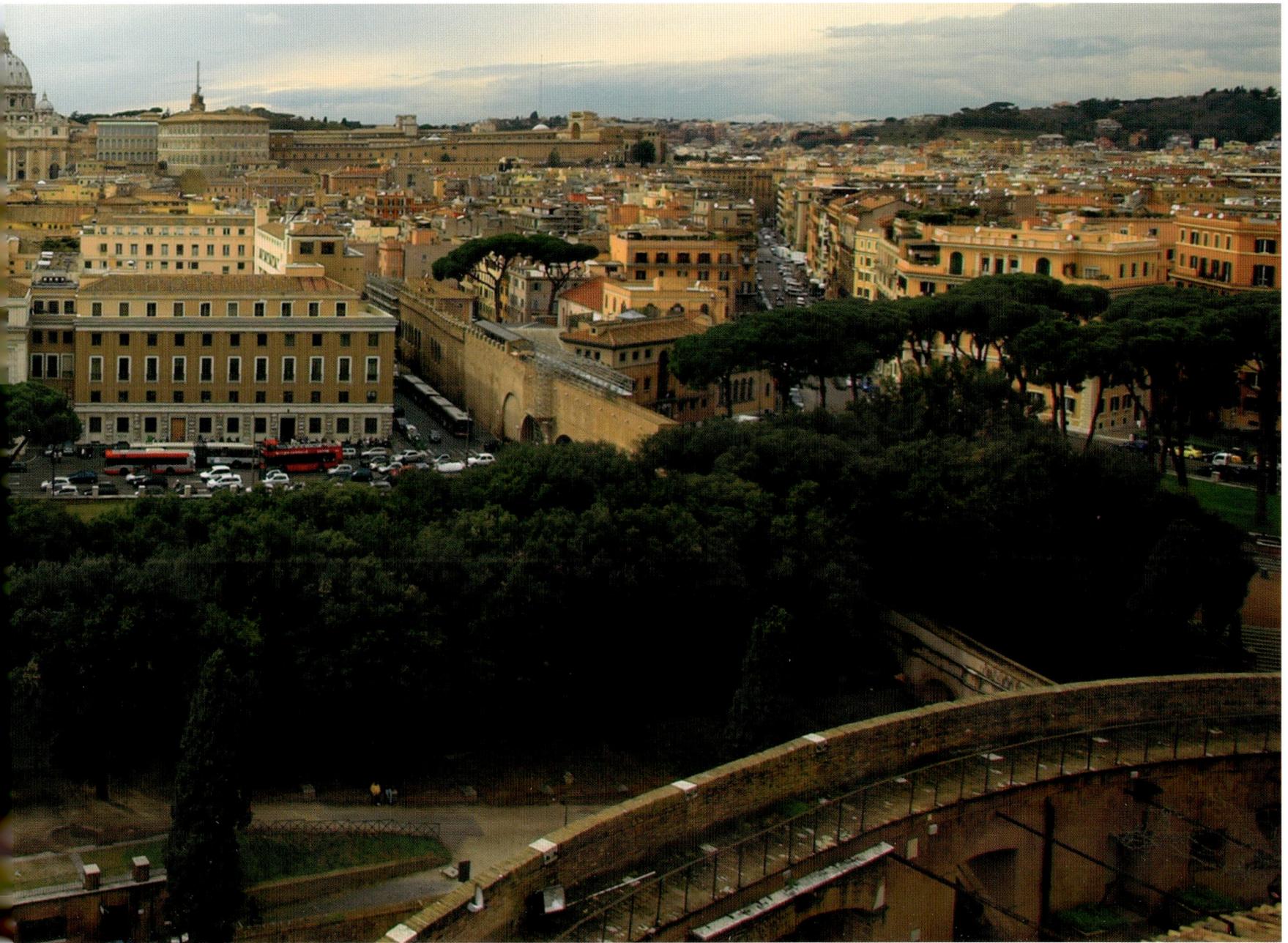

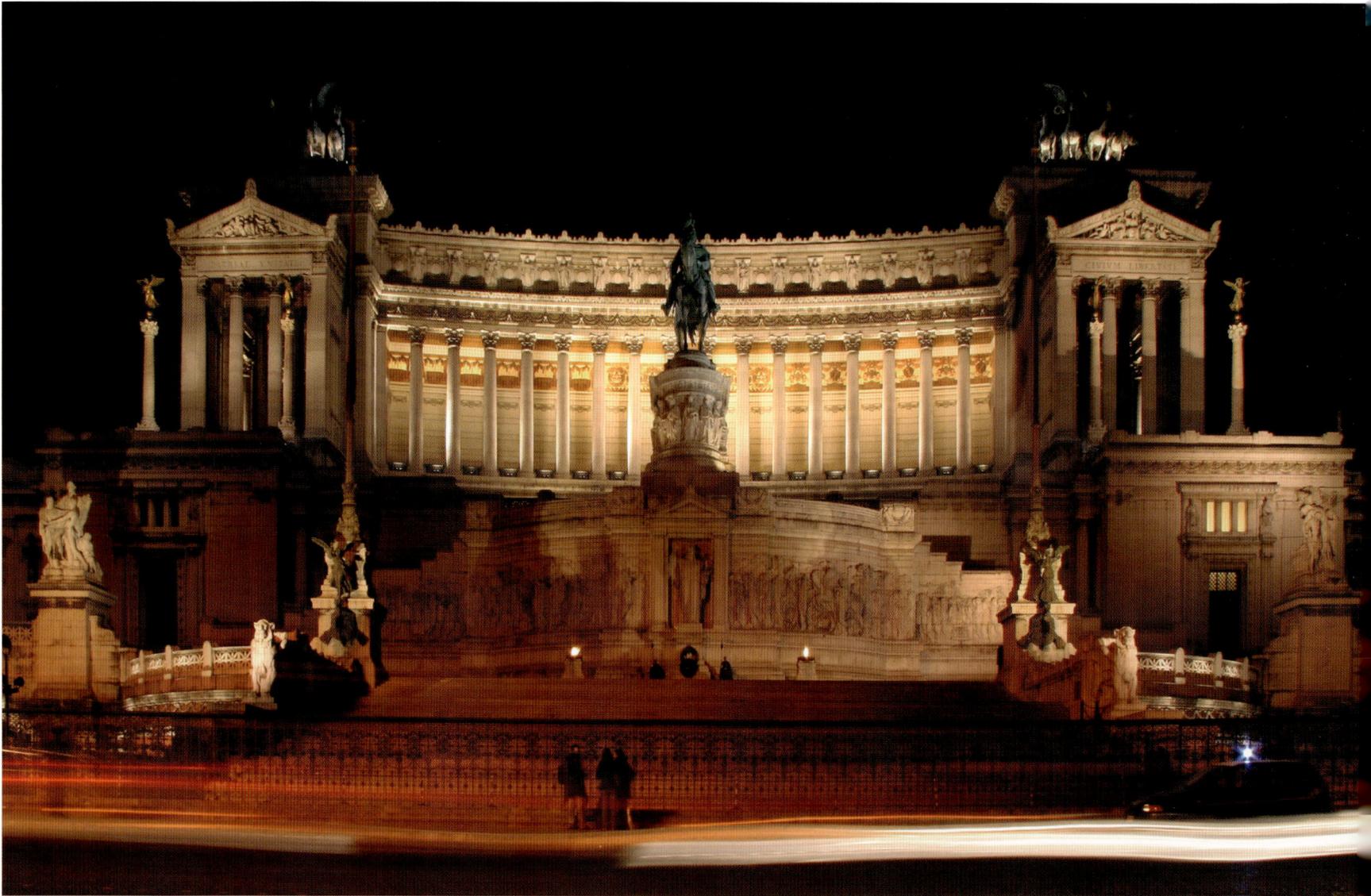

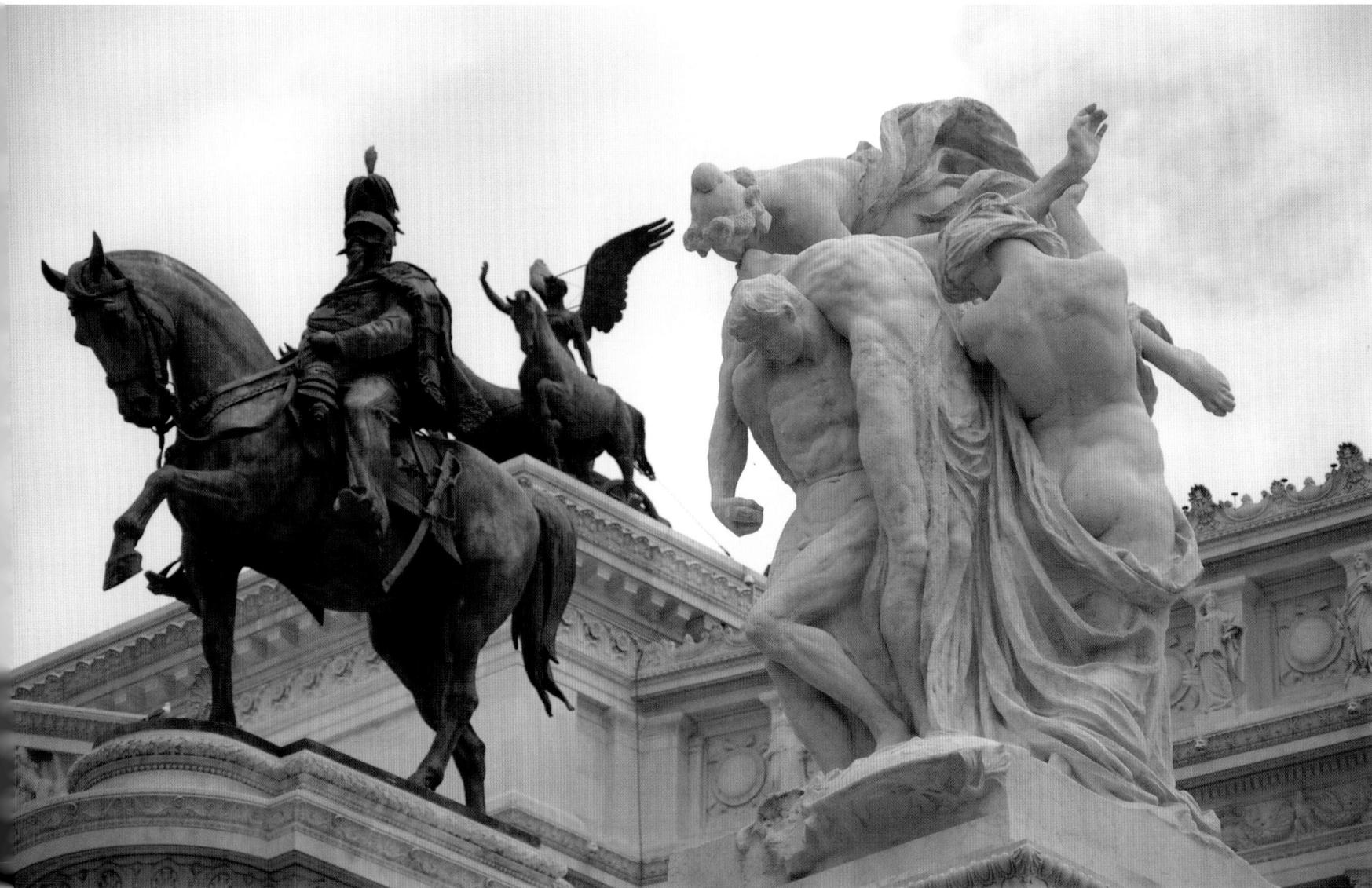

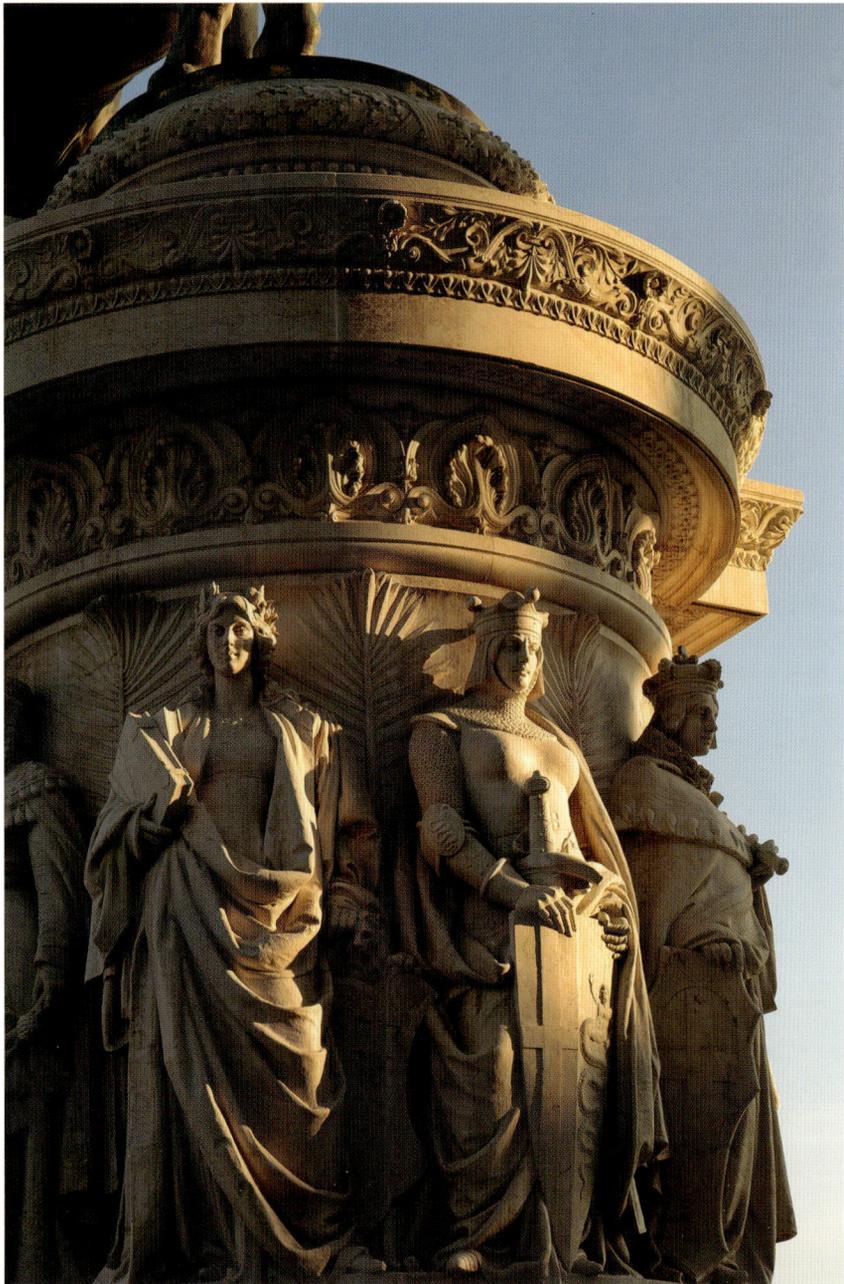

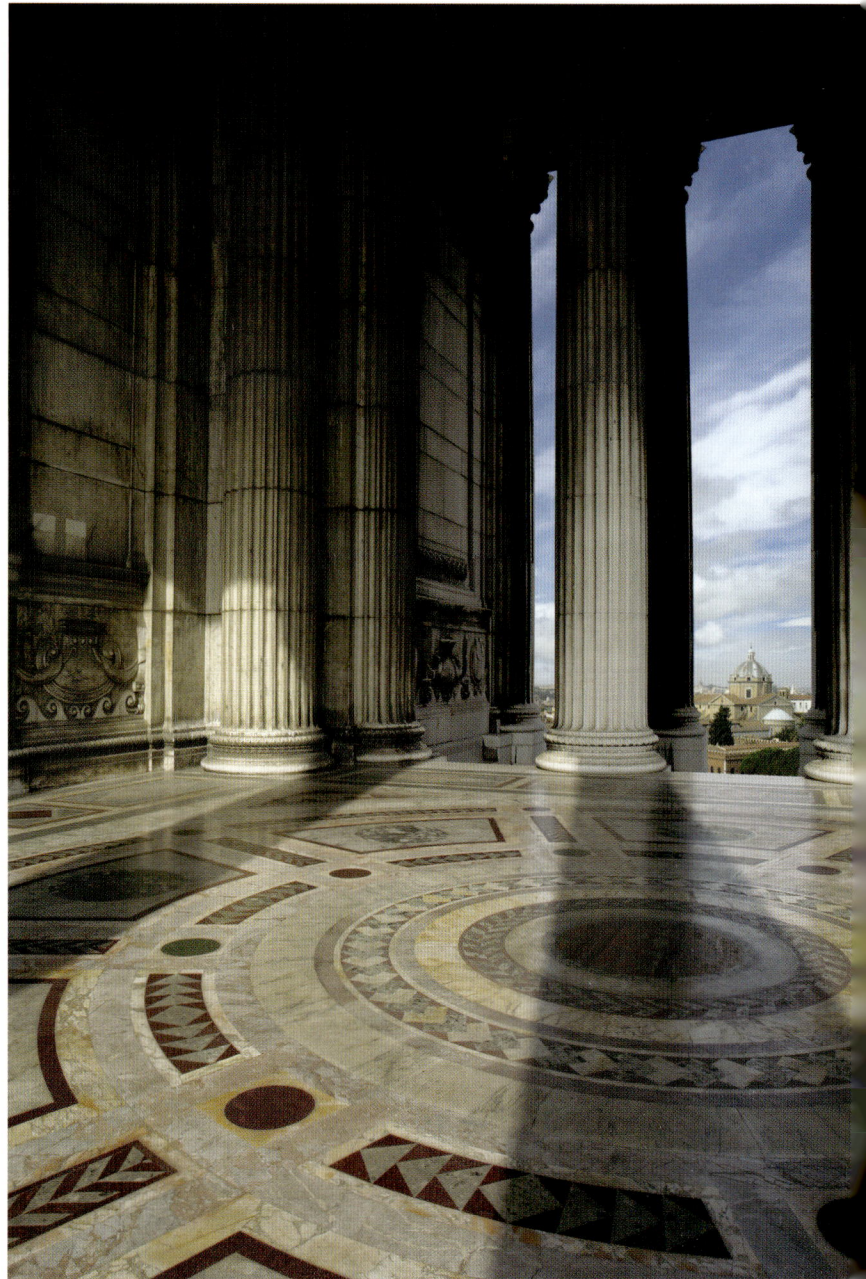

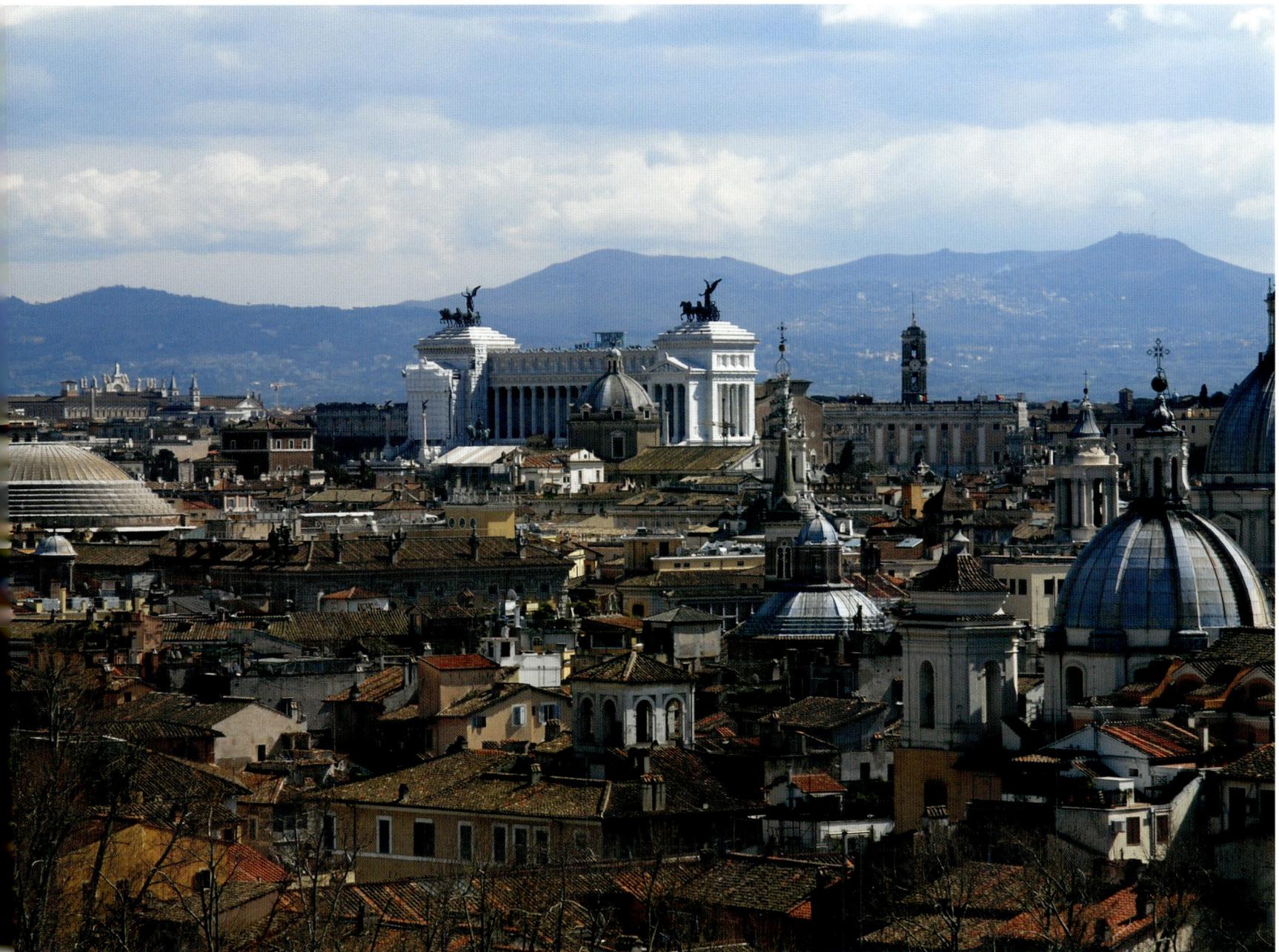

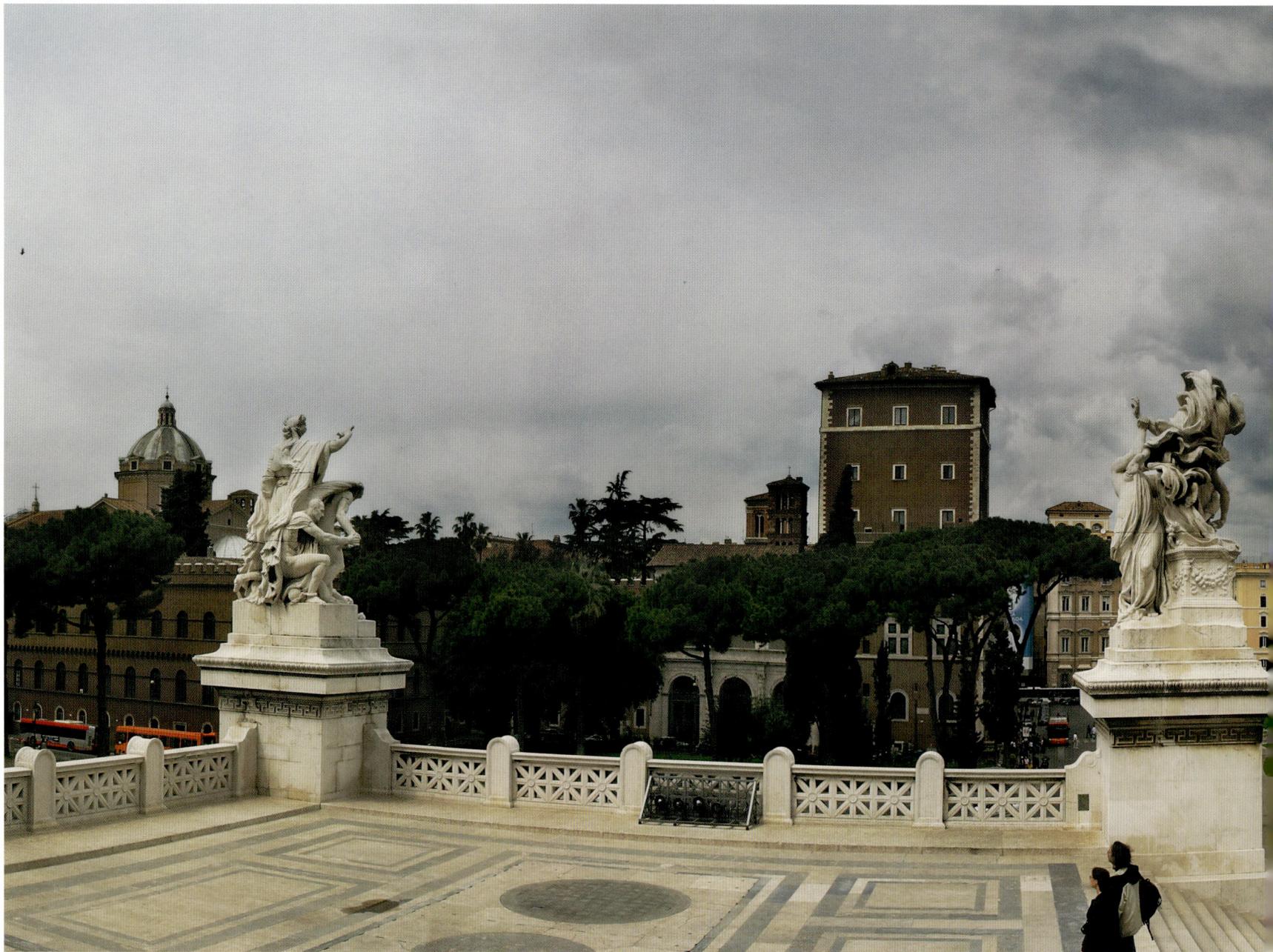

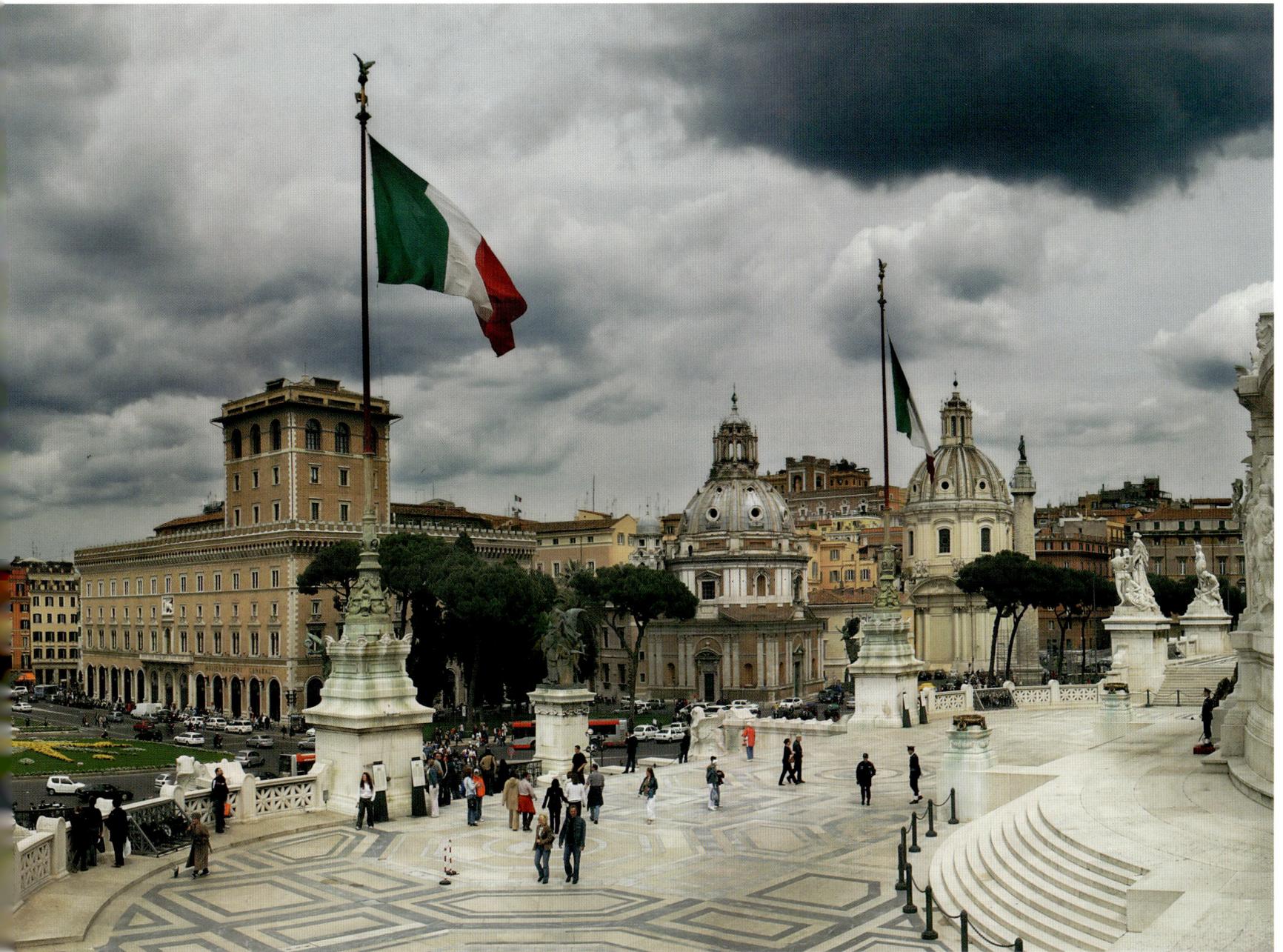

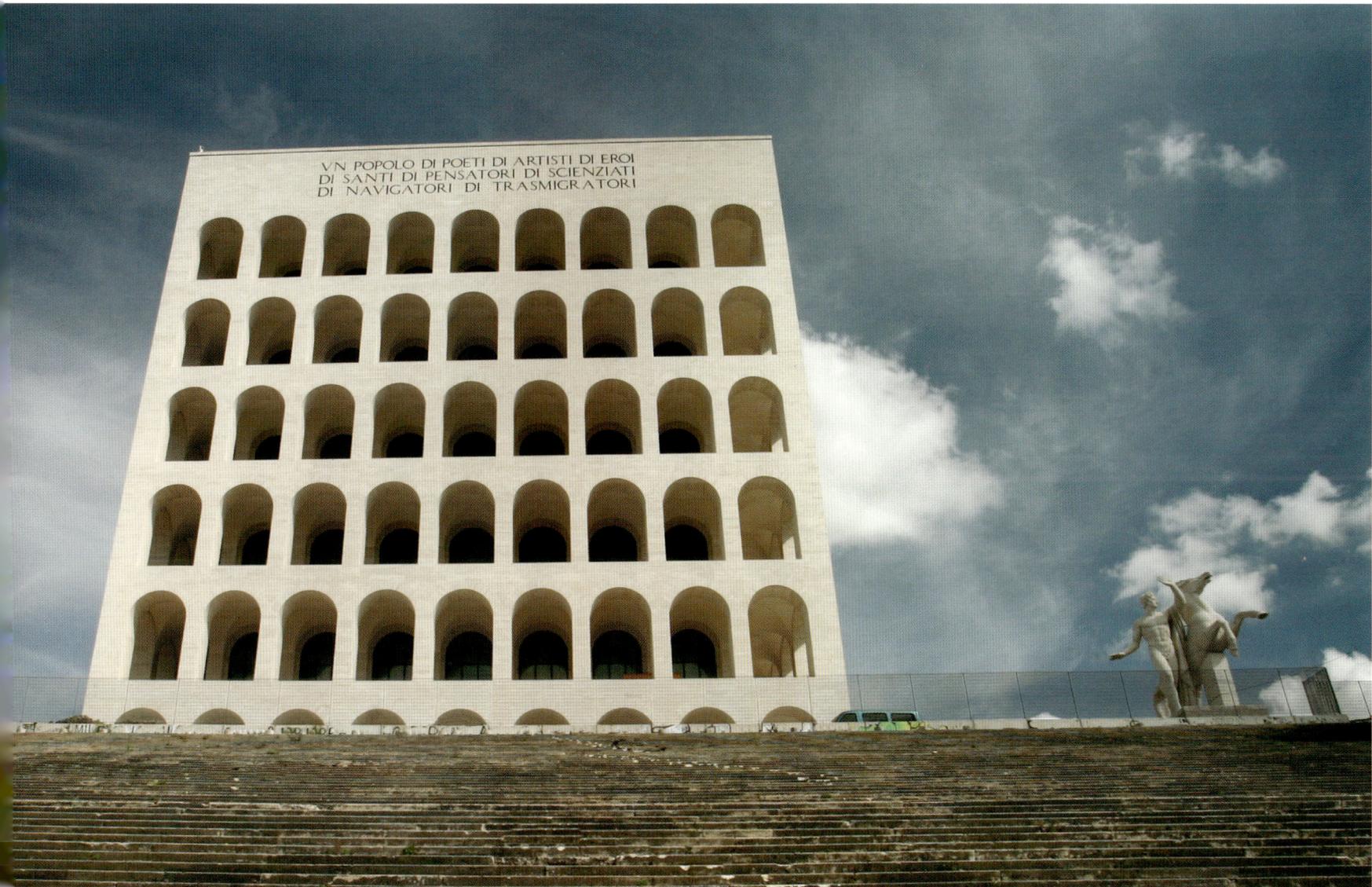

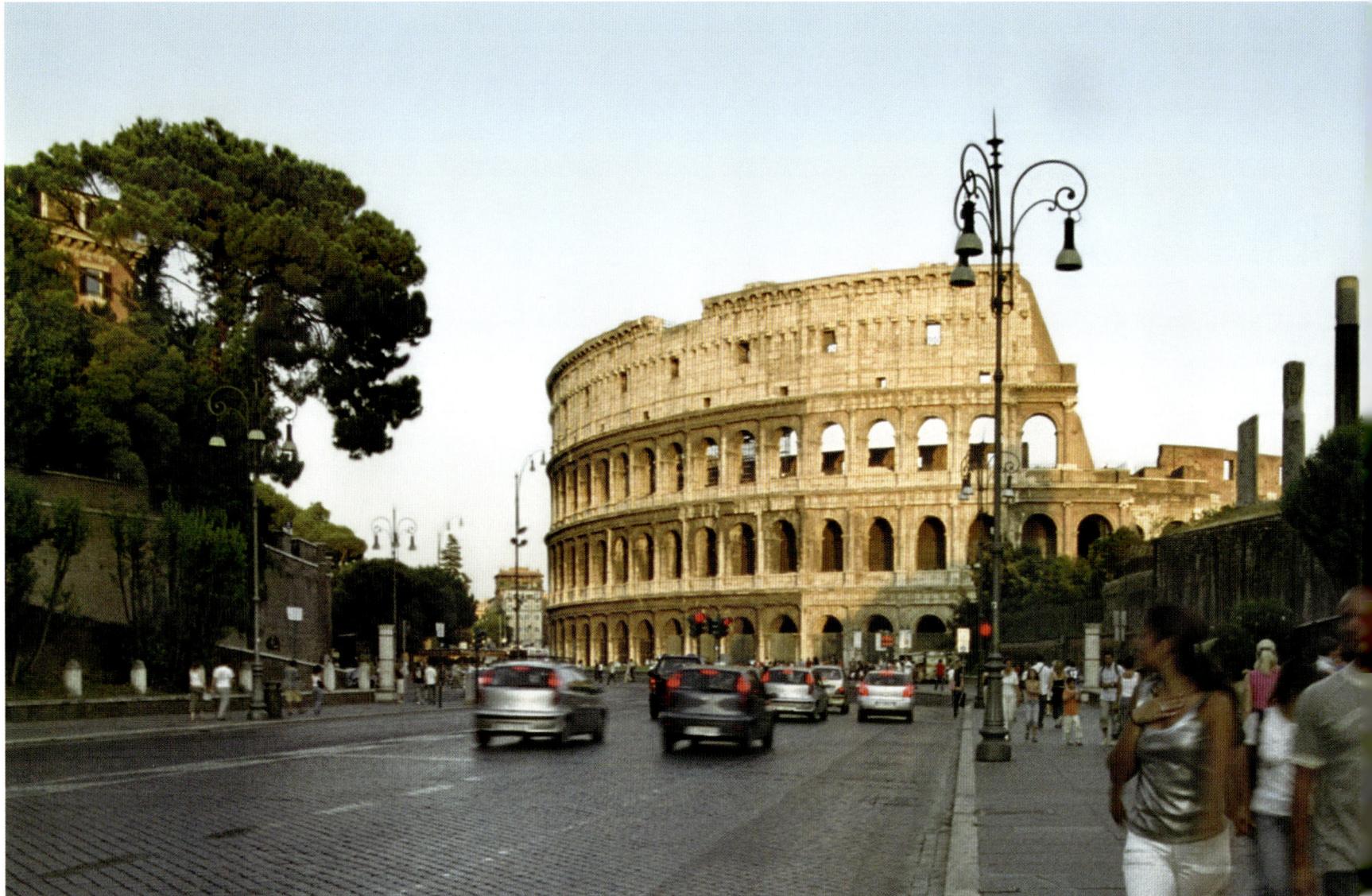

Colosseum

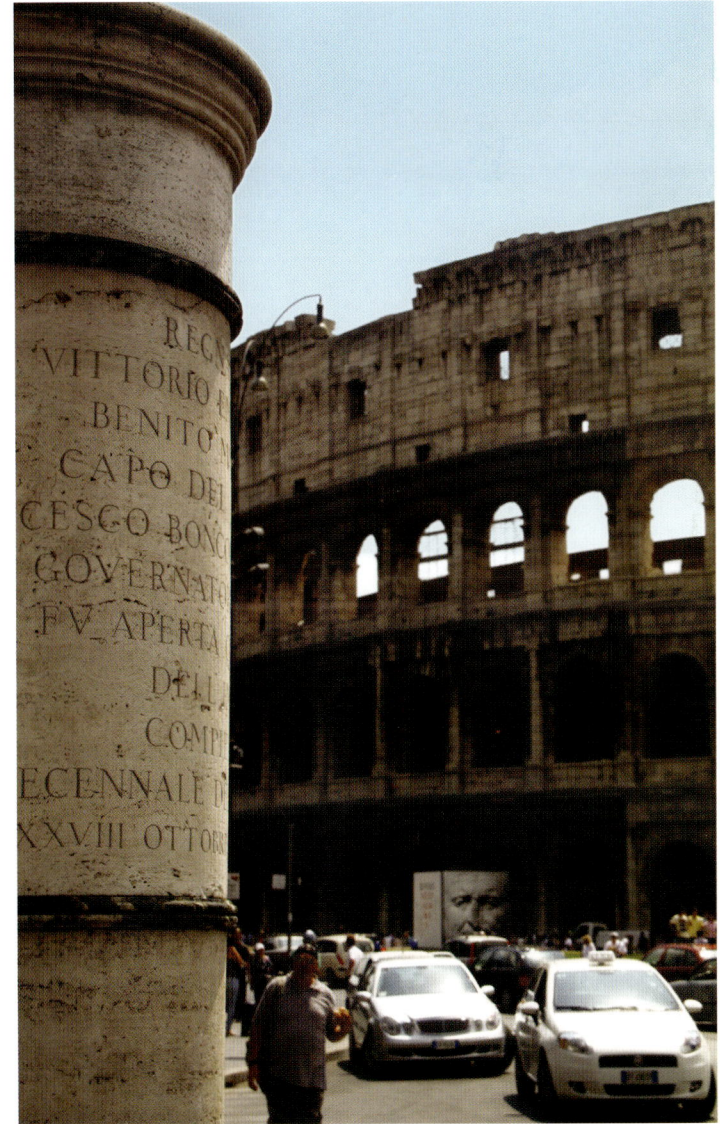

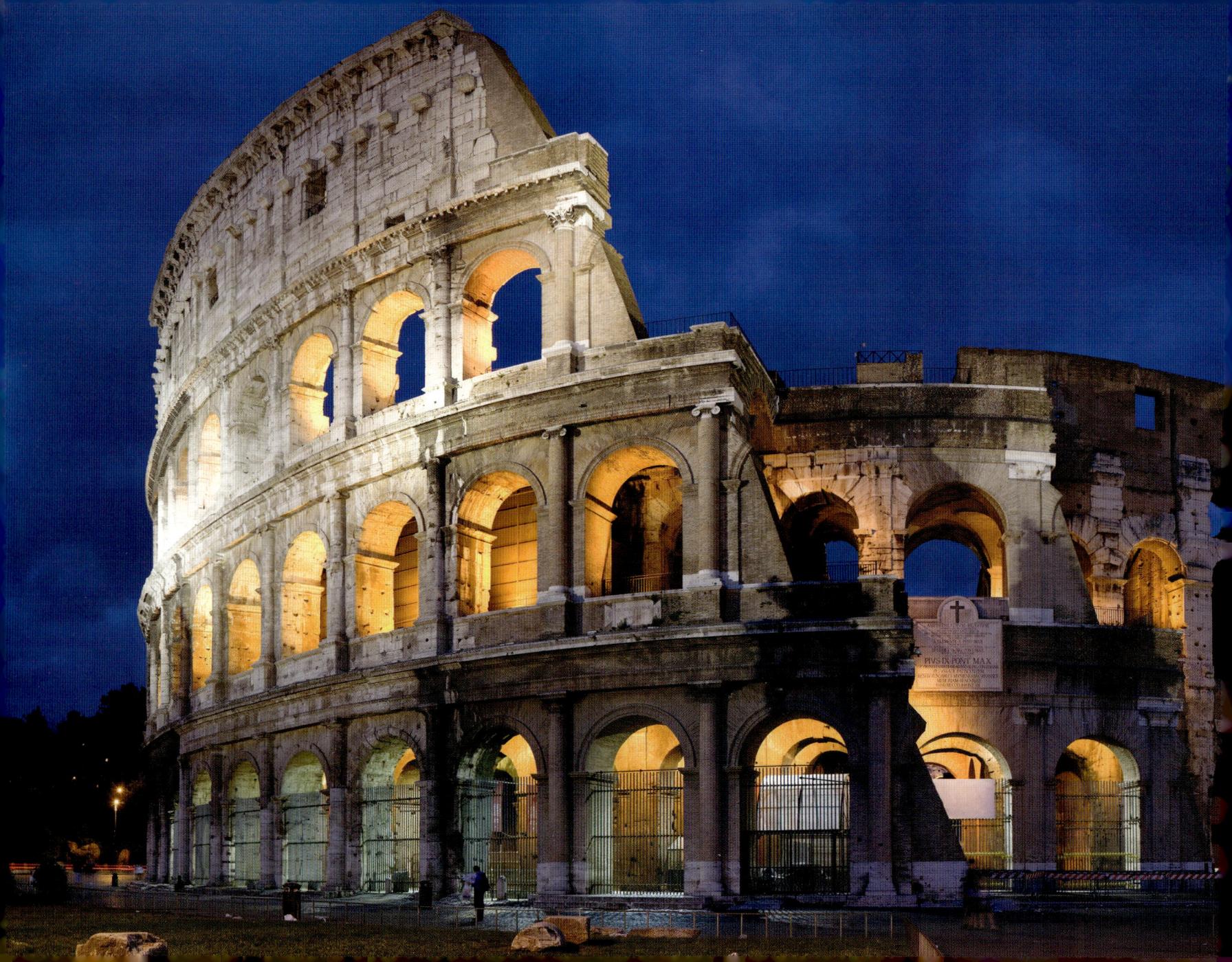

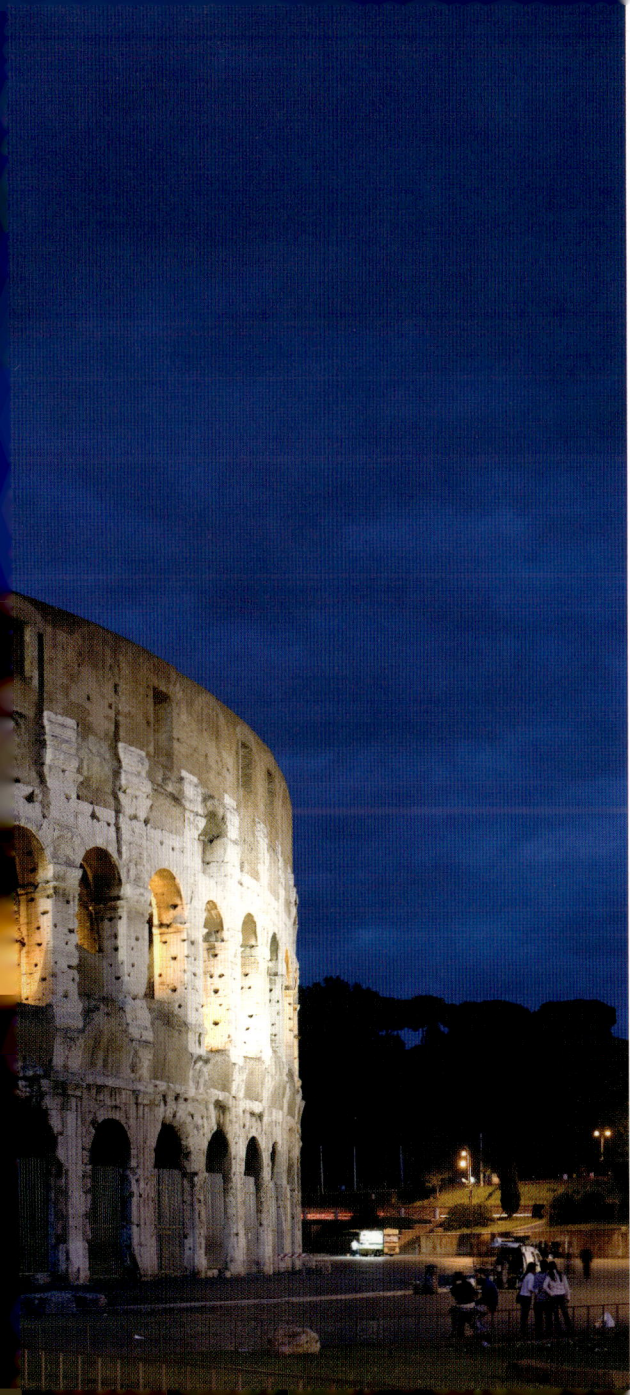

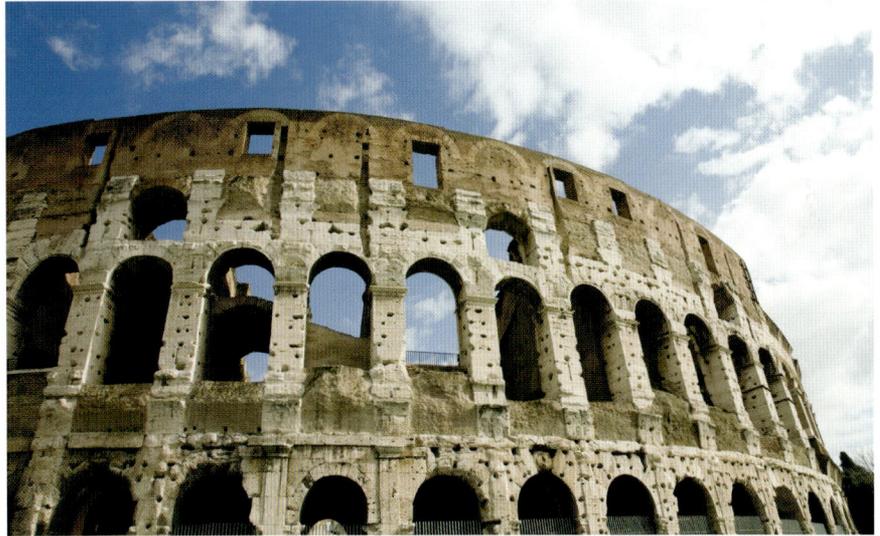

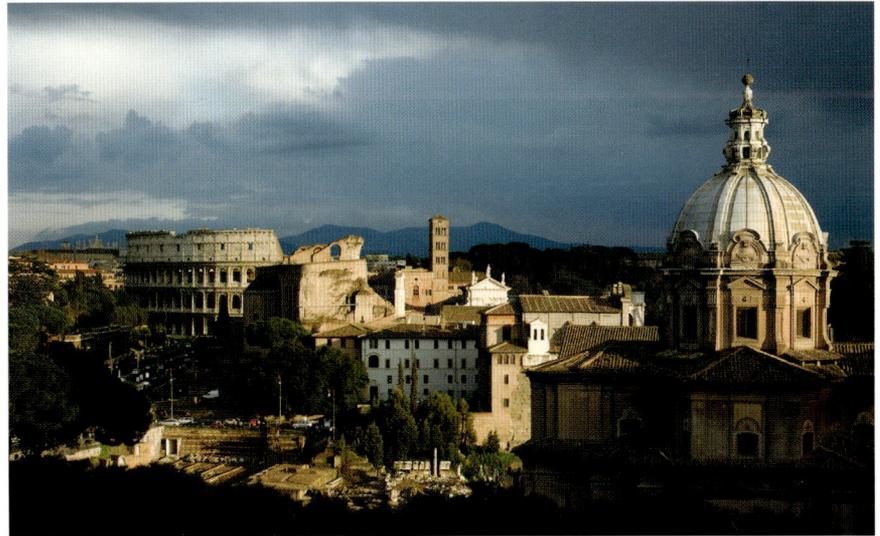

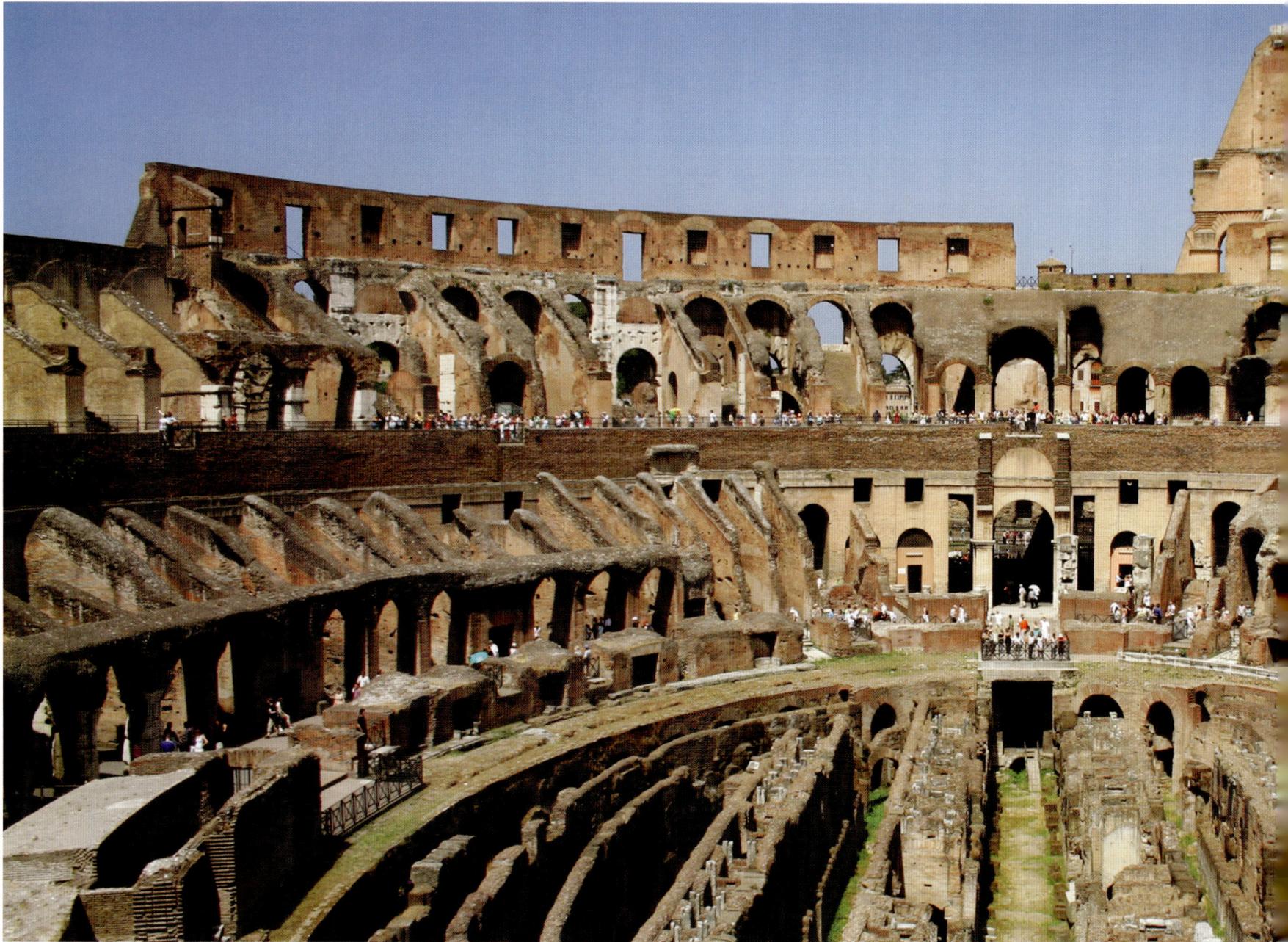

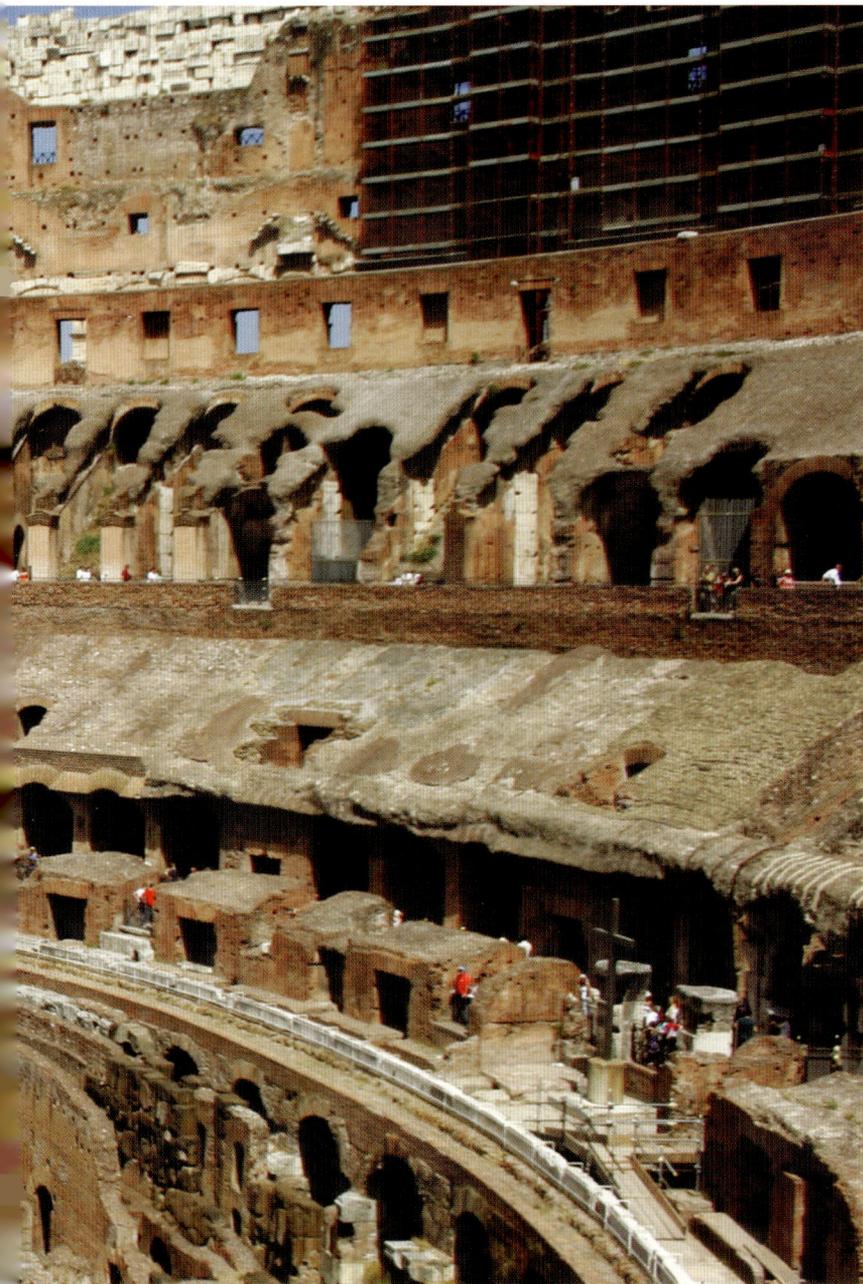
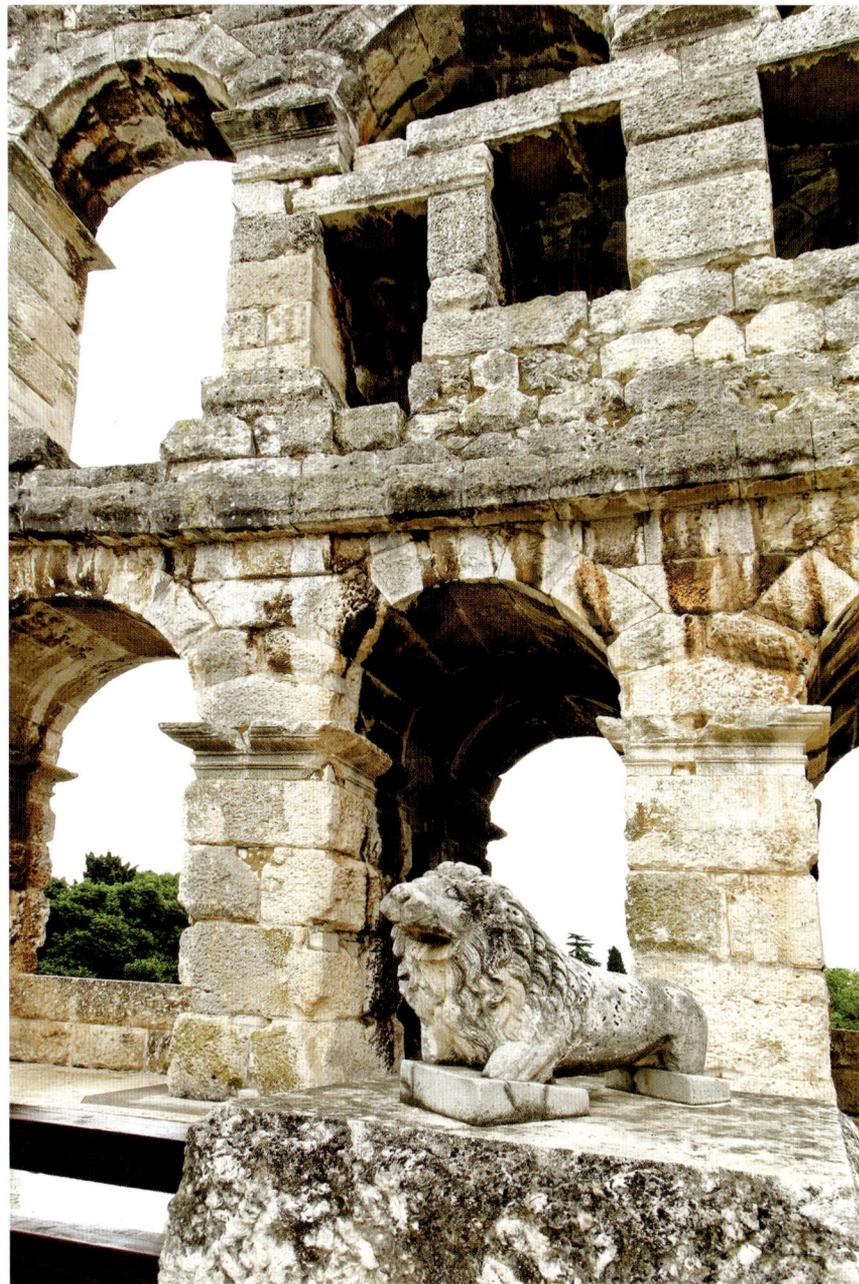

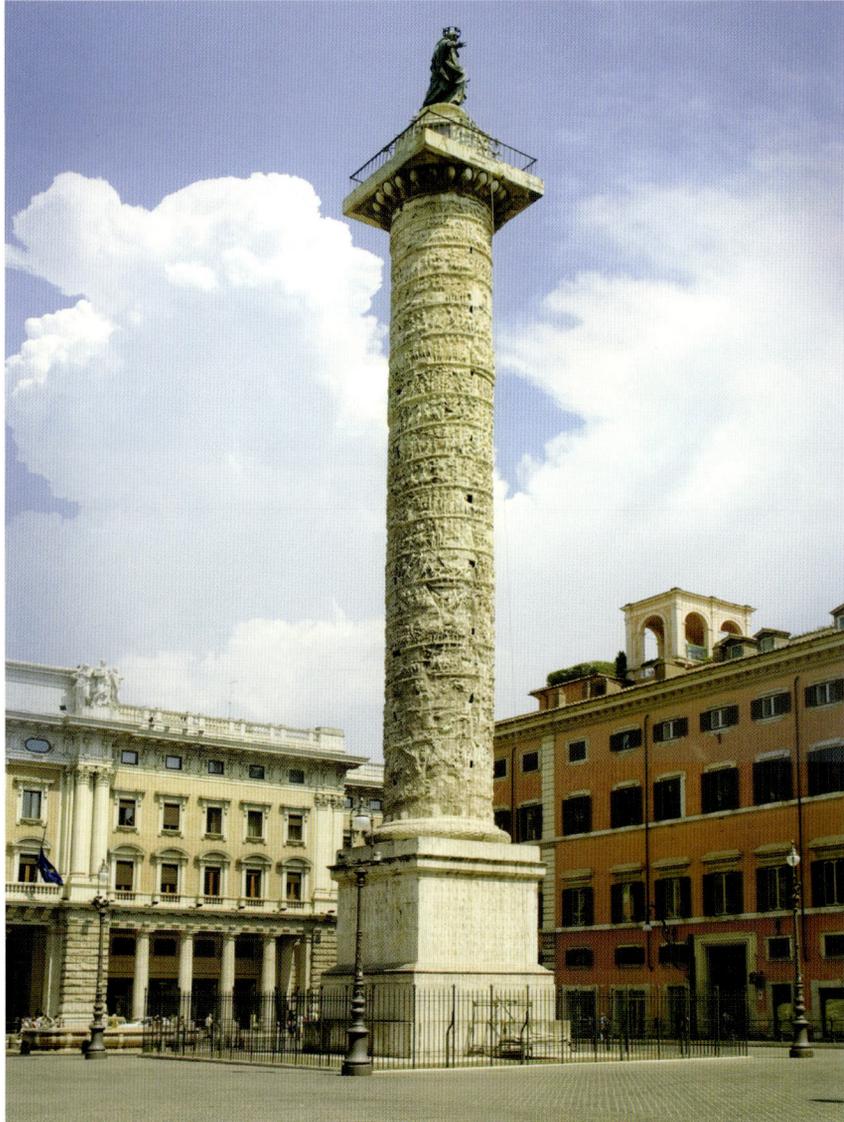

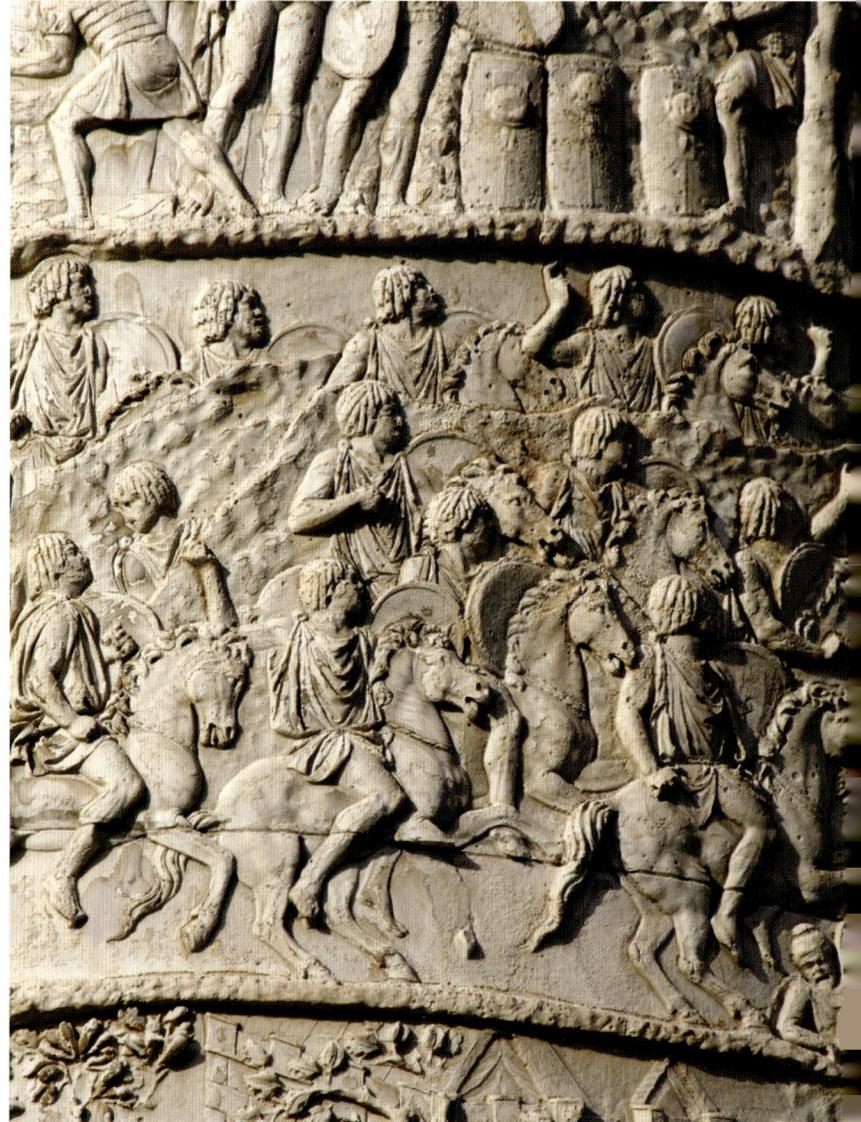

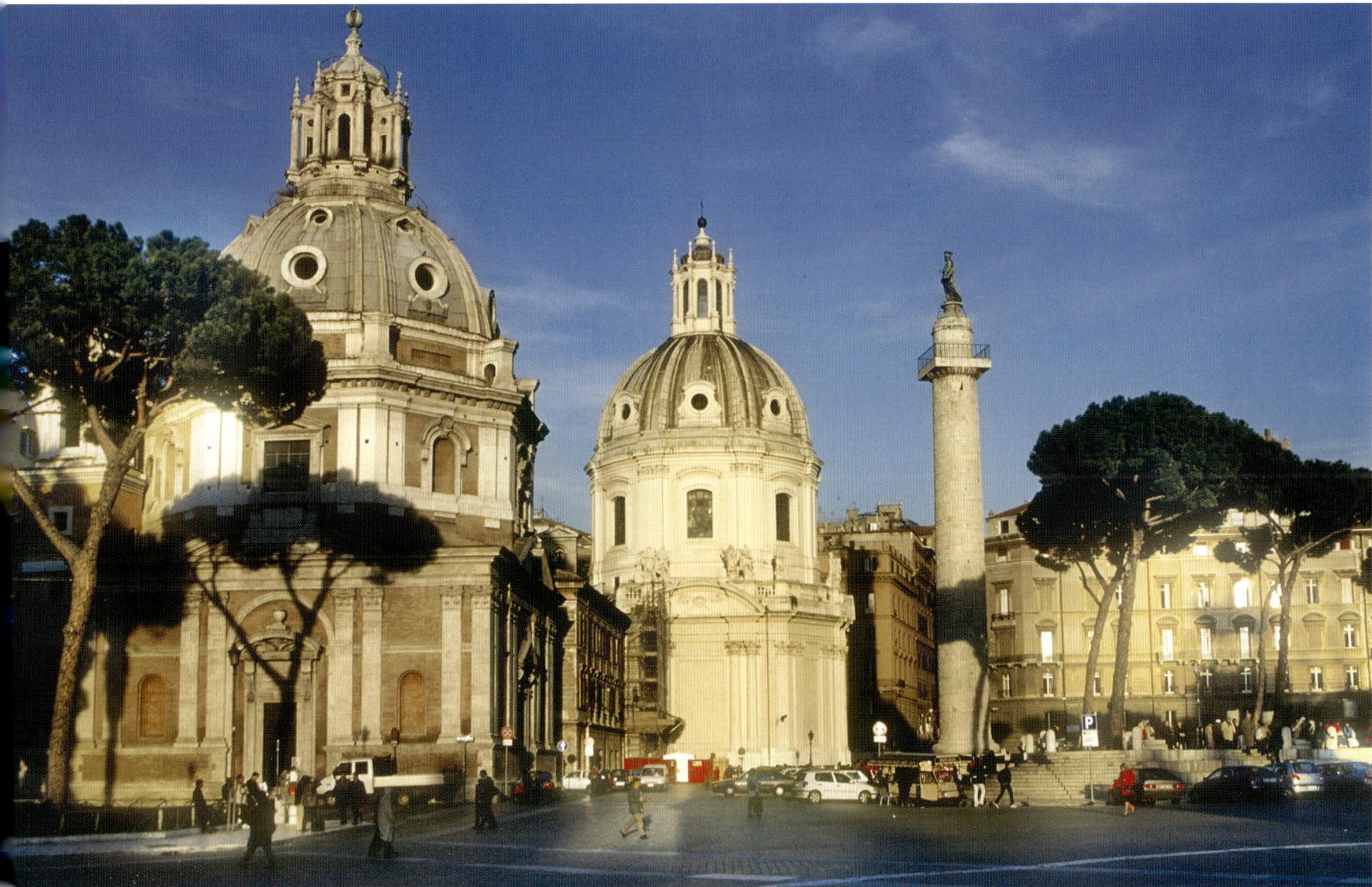

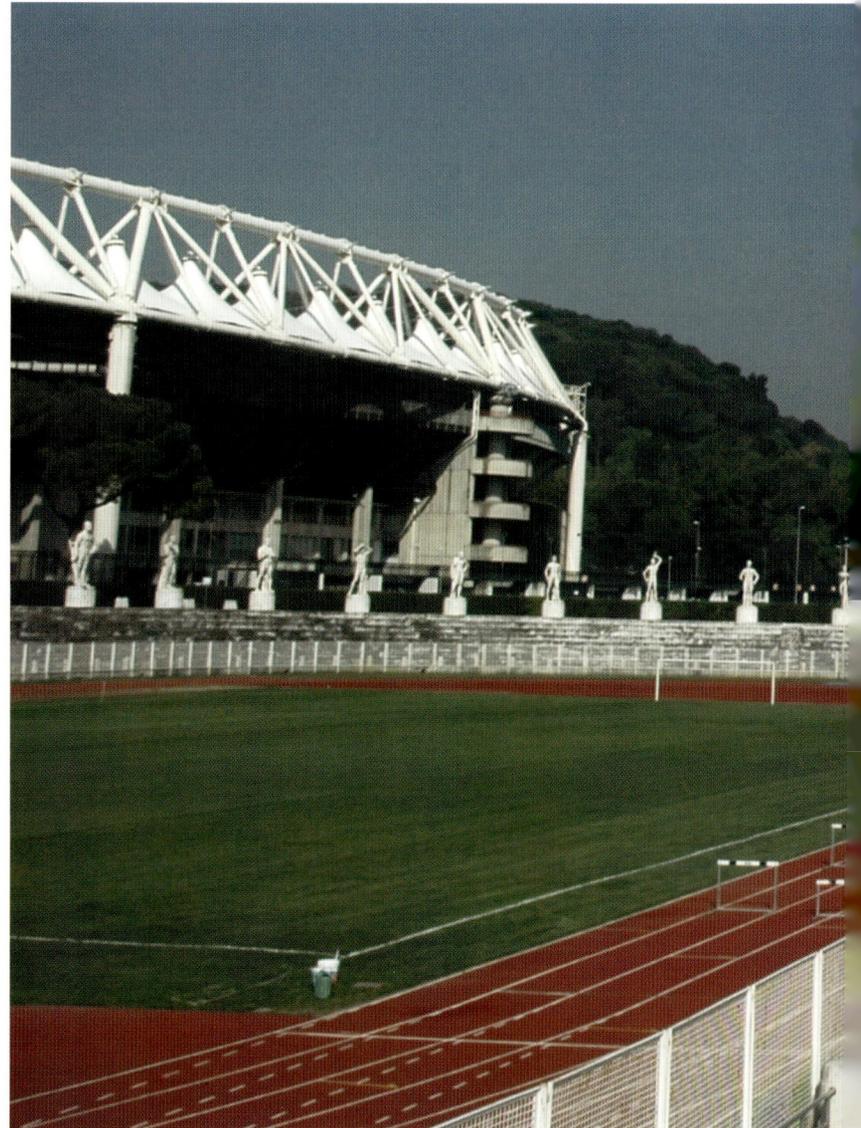

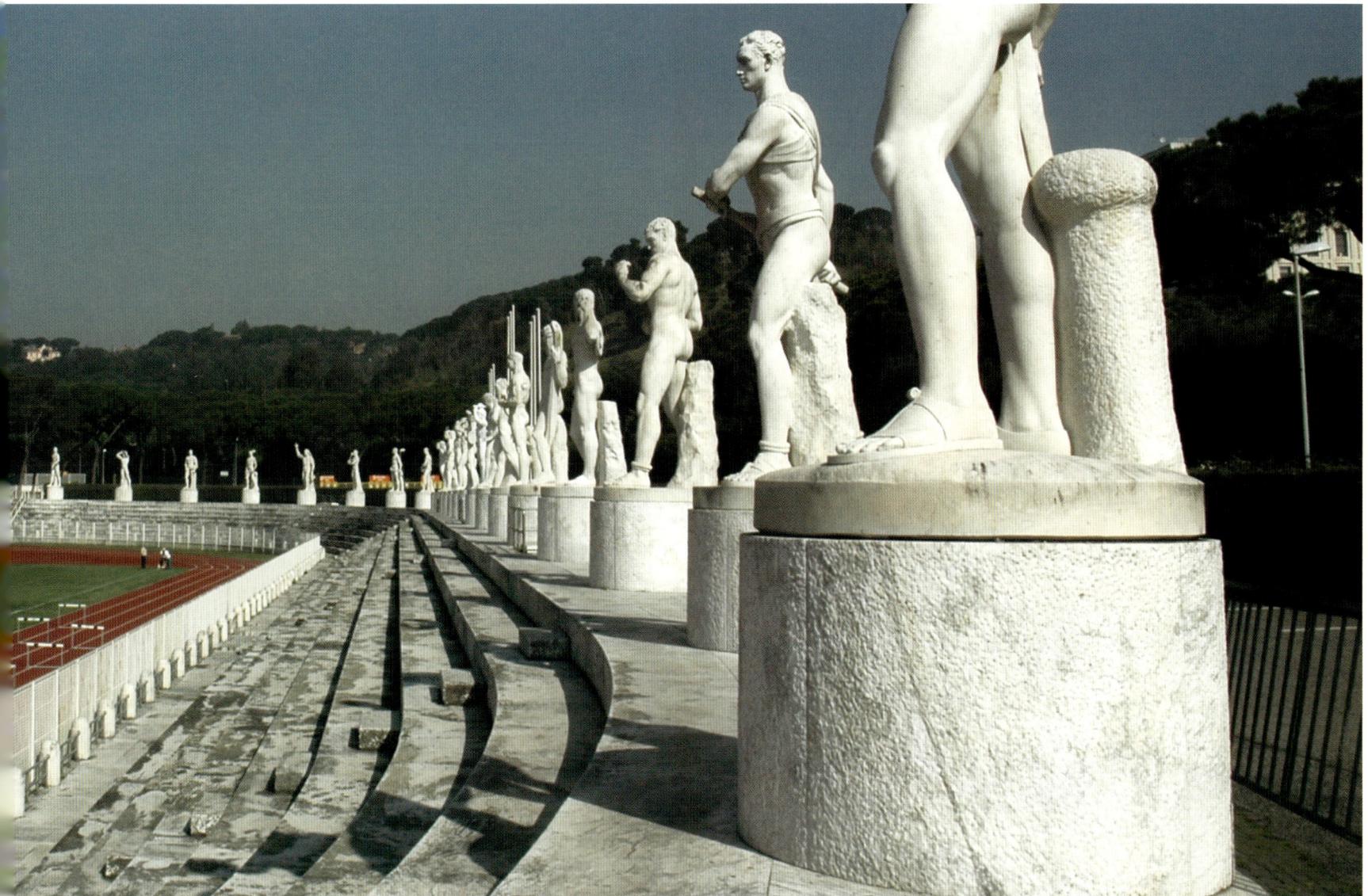

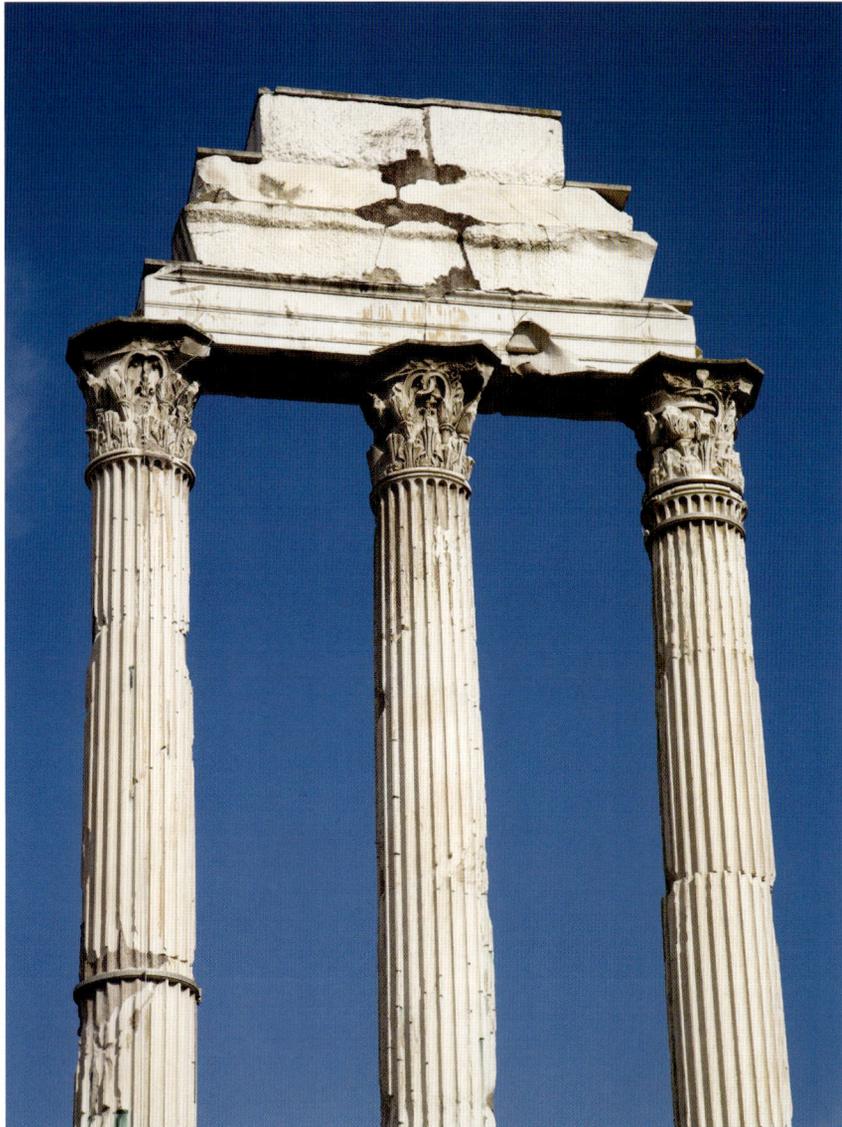

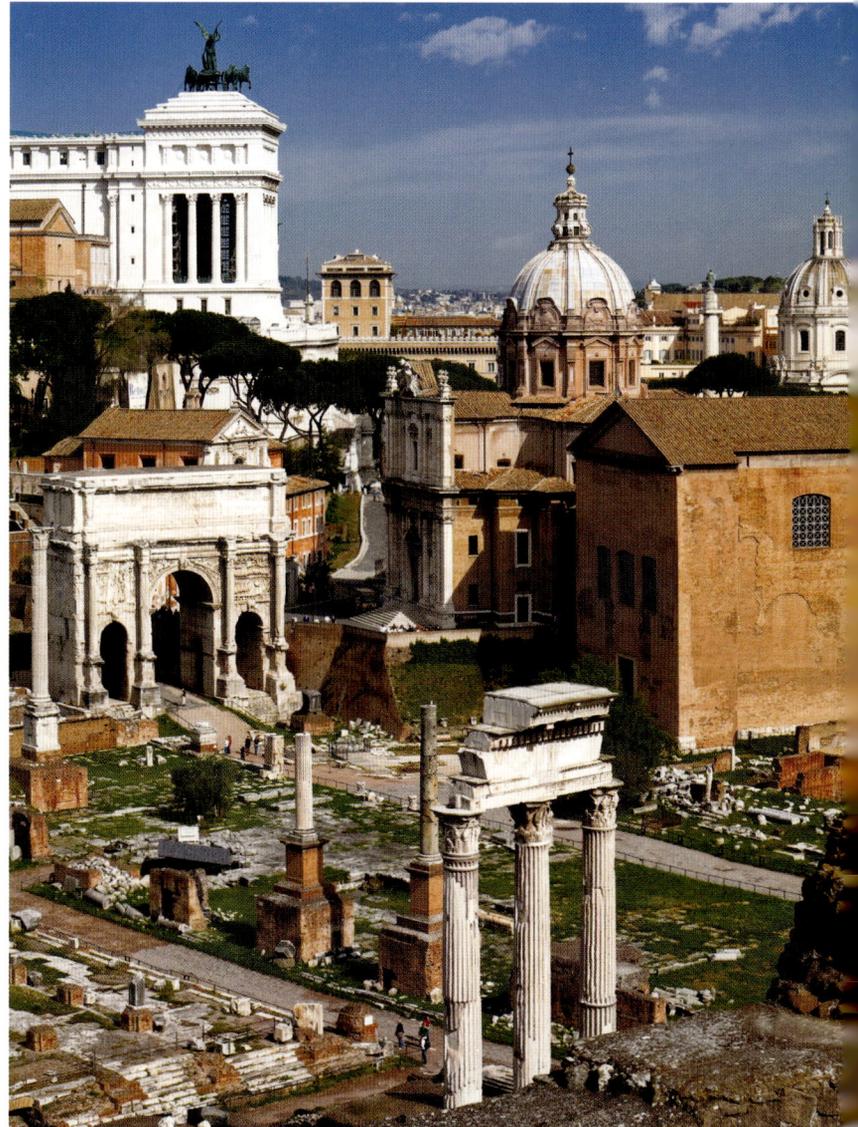

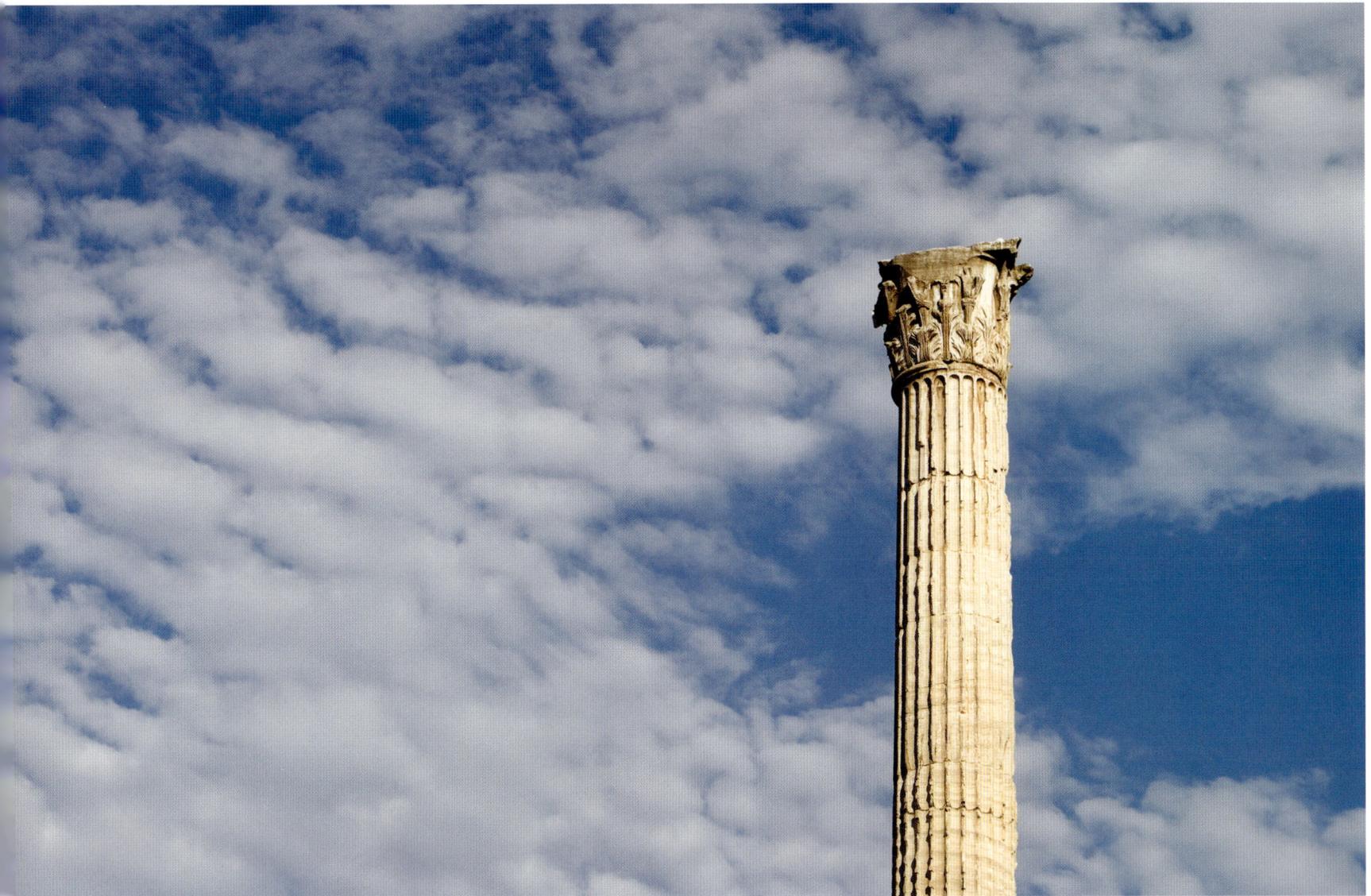

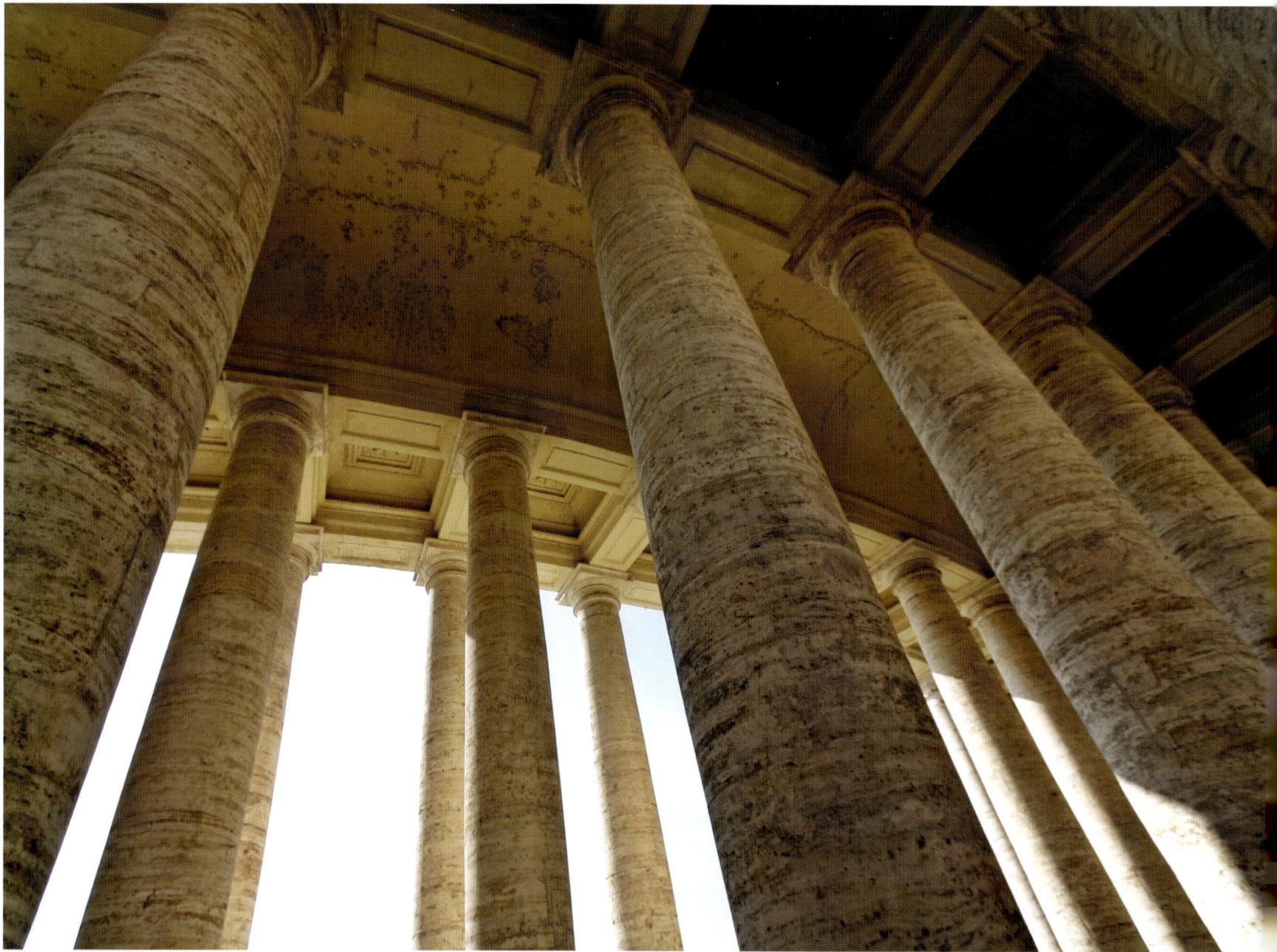

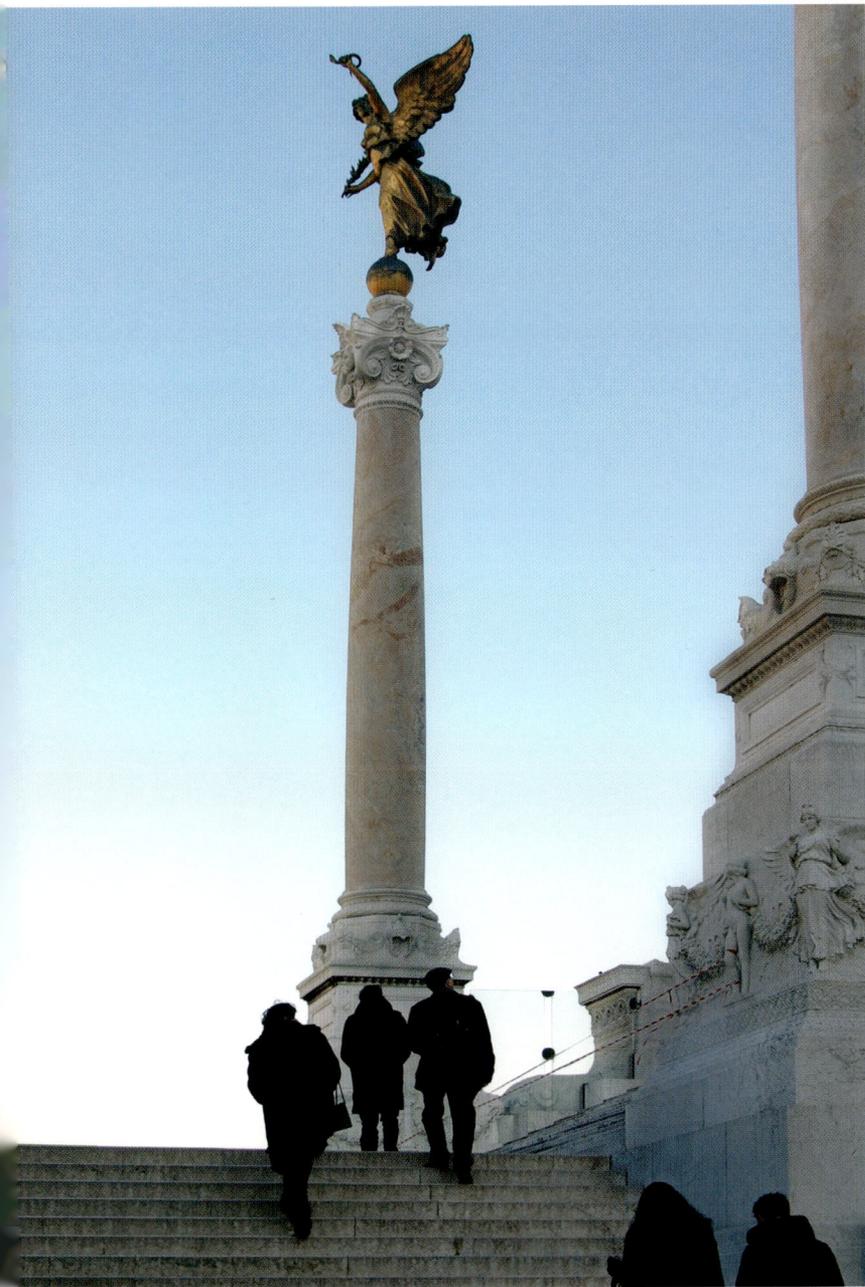
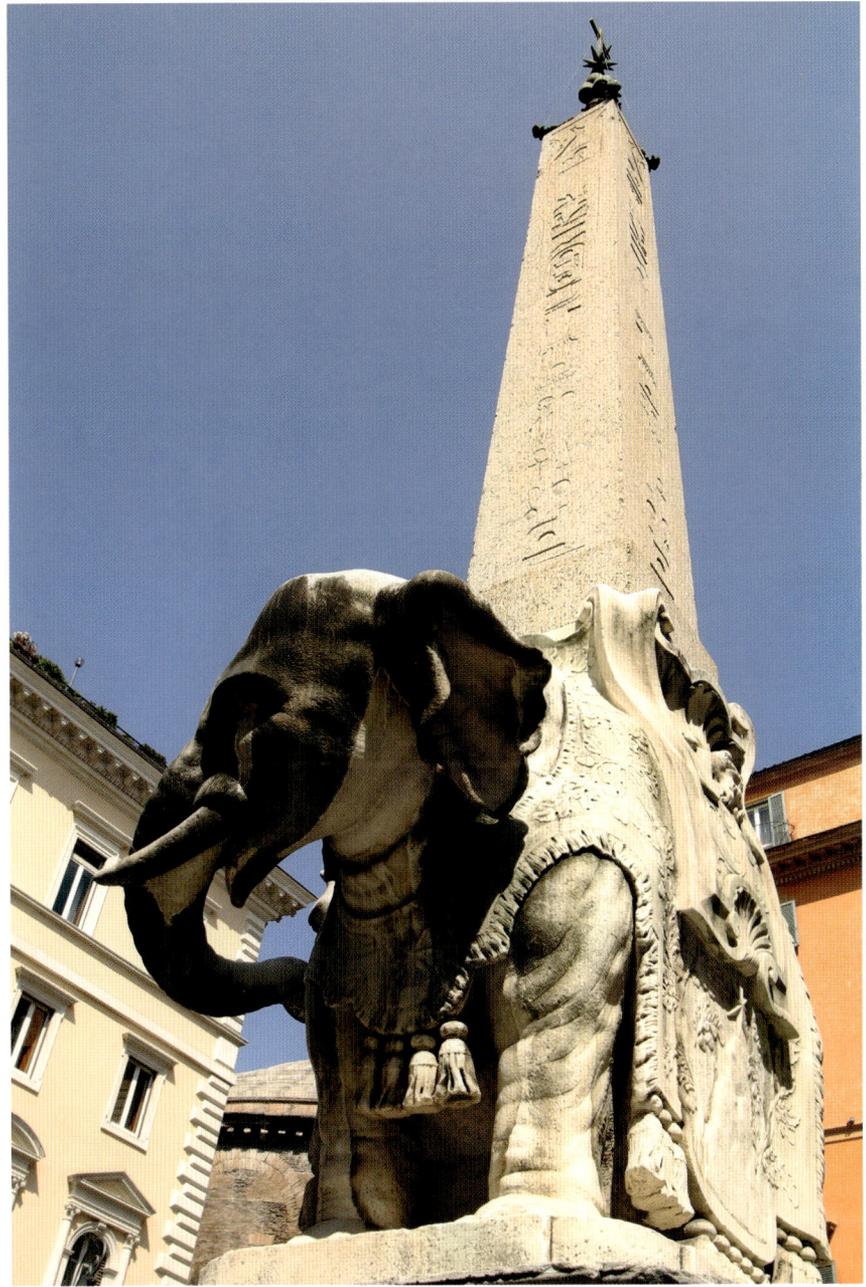

"O Rome! My country!

City of the soul!"

Lord Byron

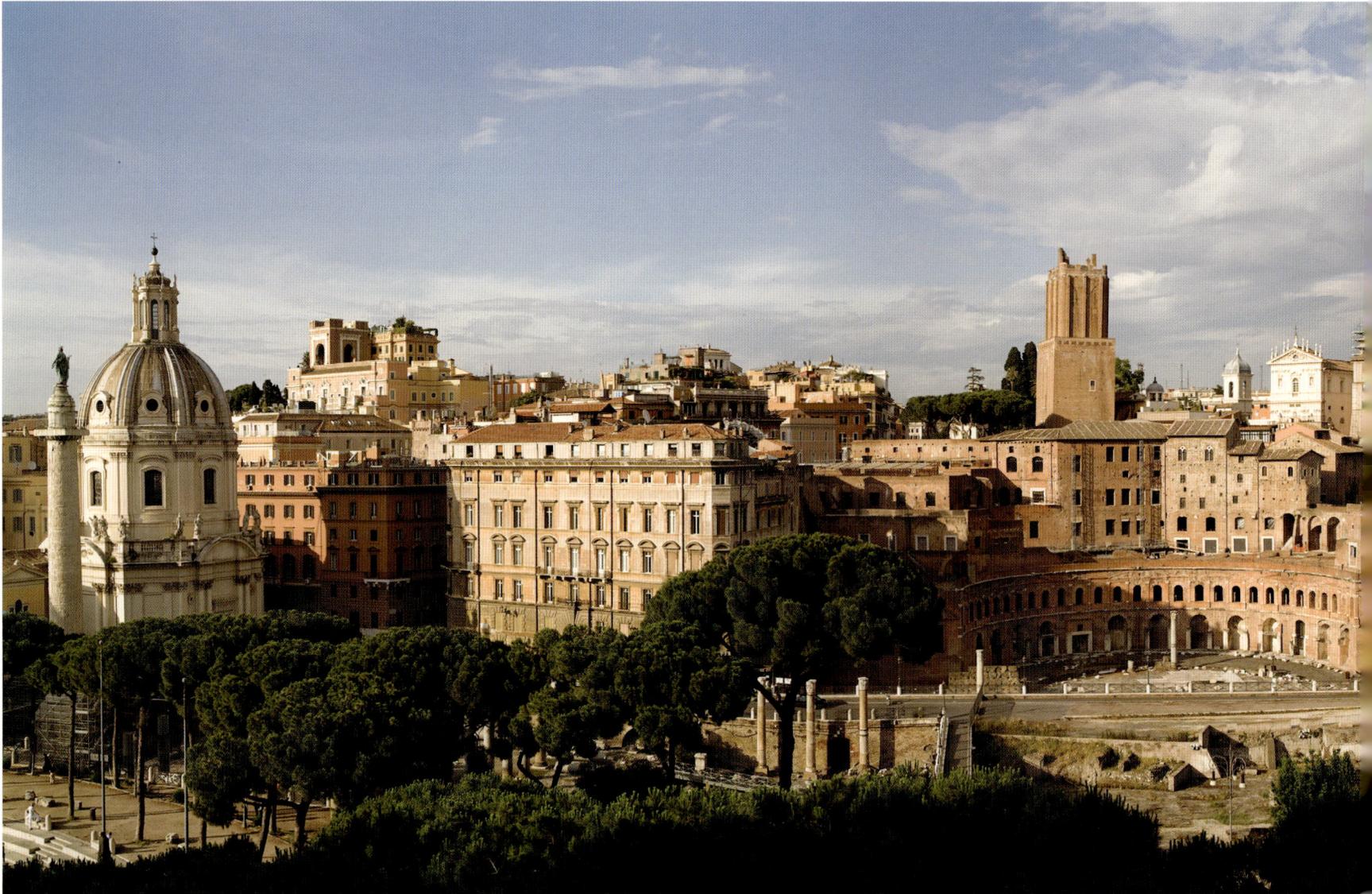

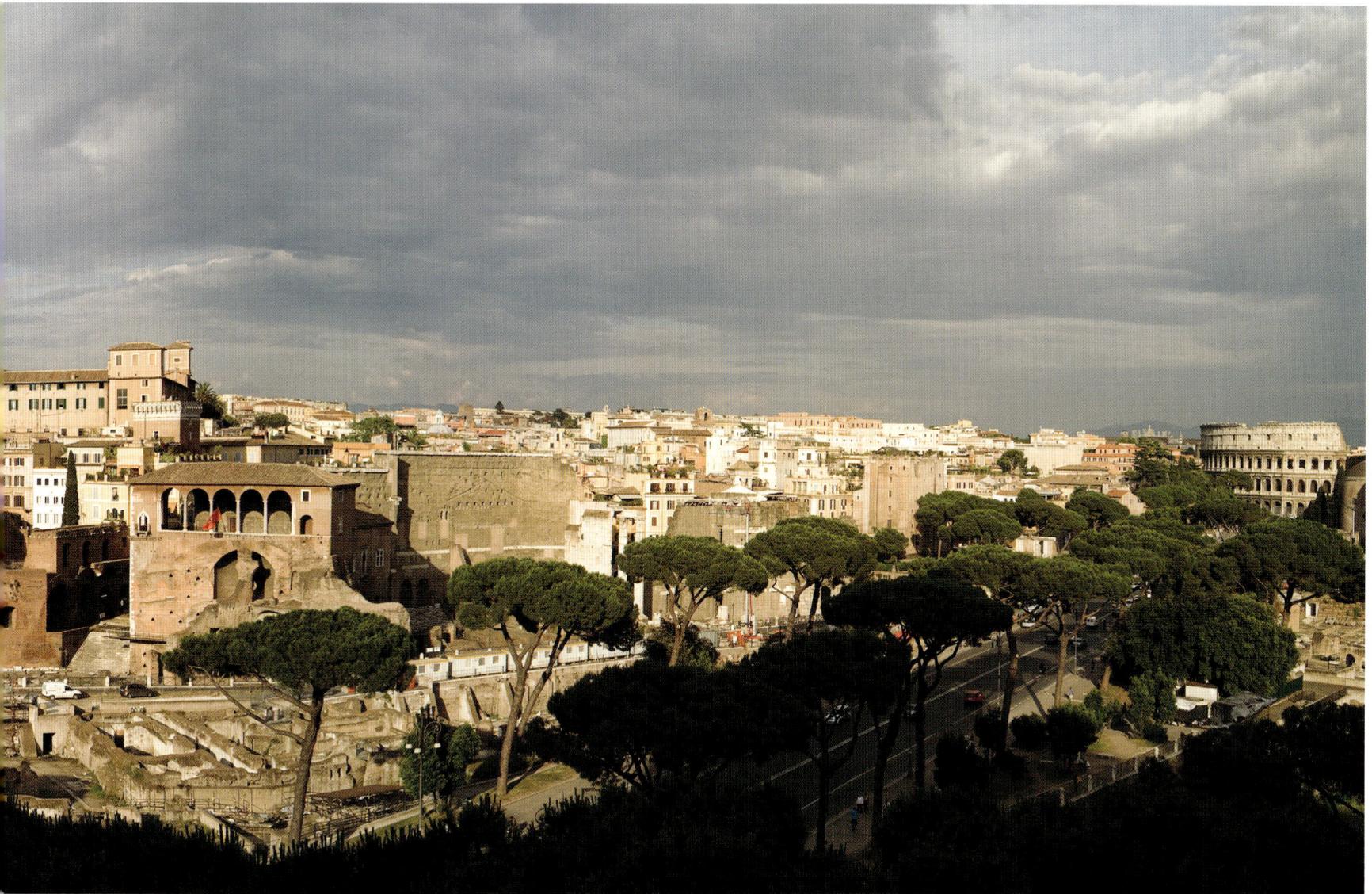

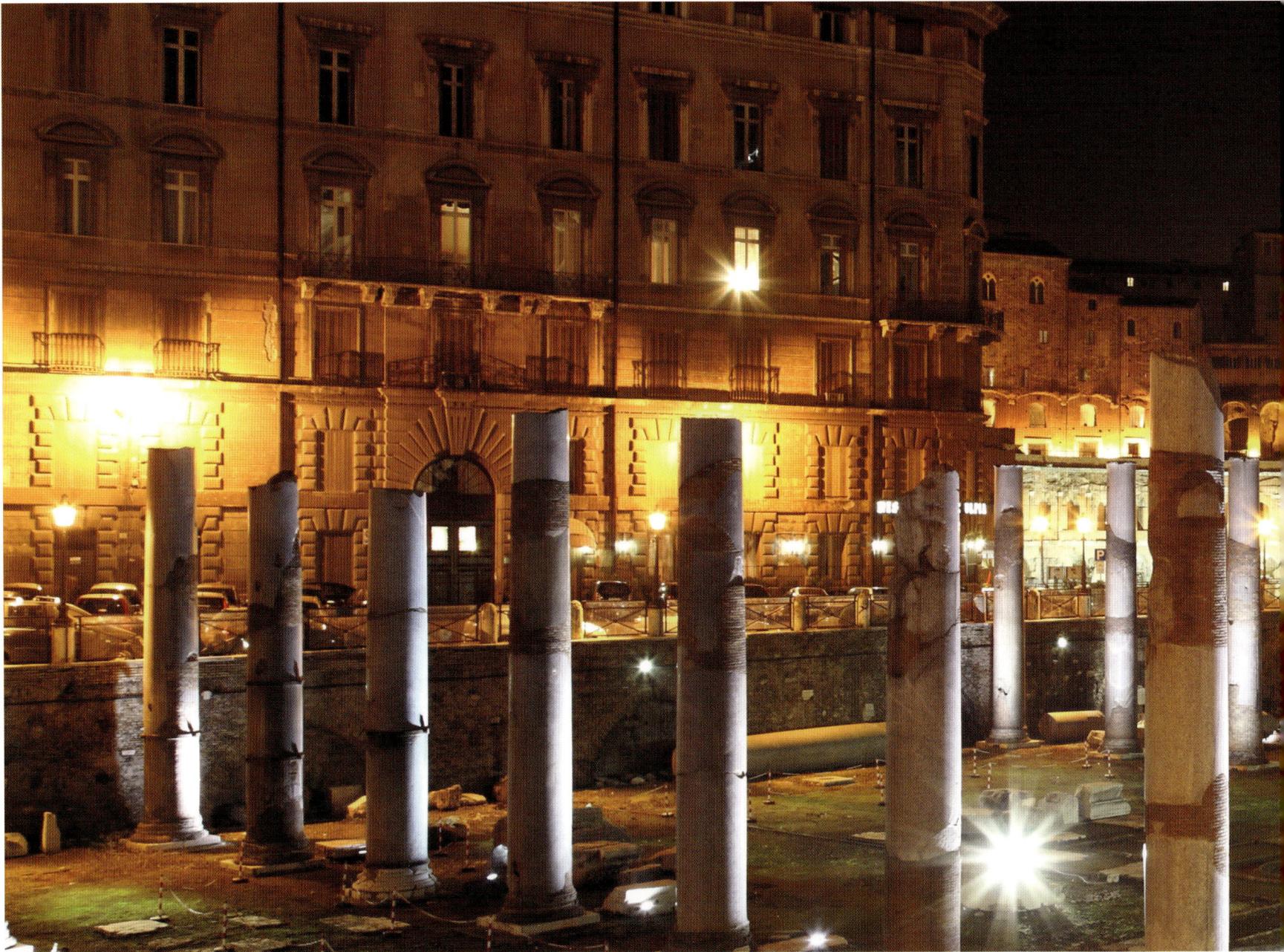

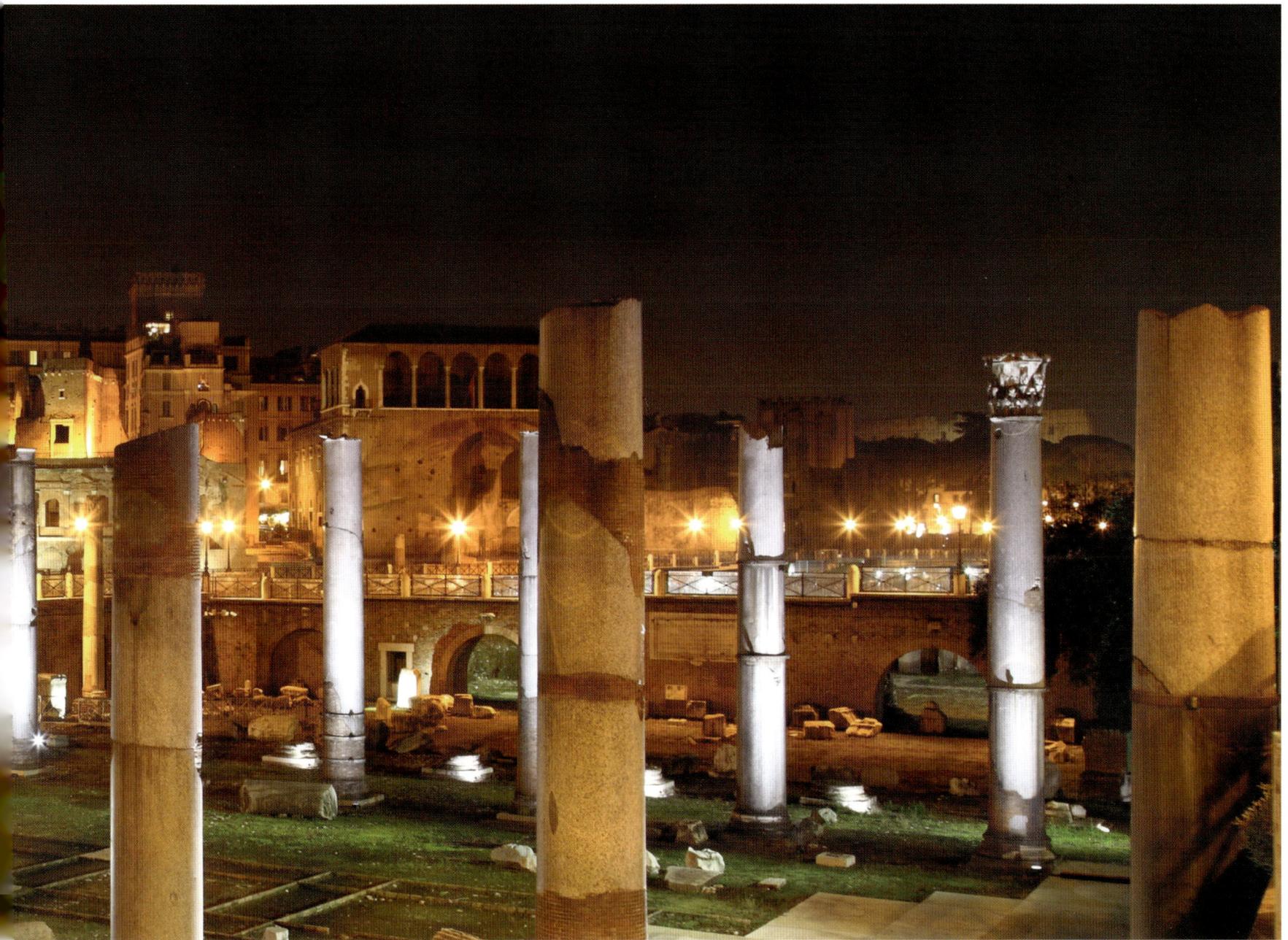

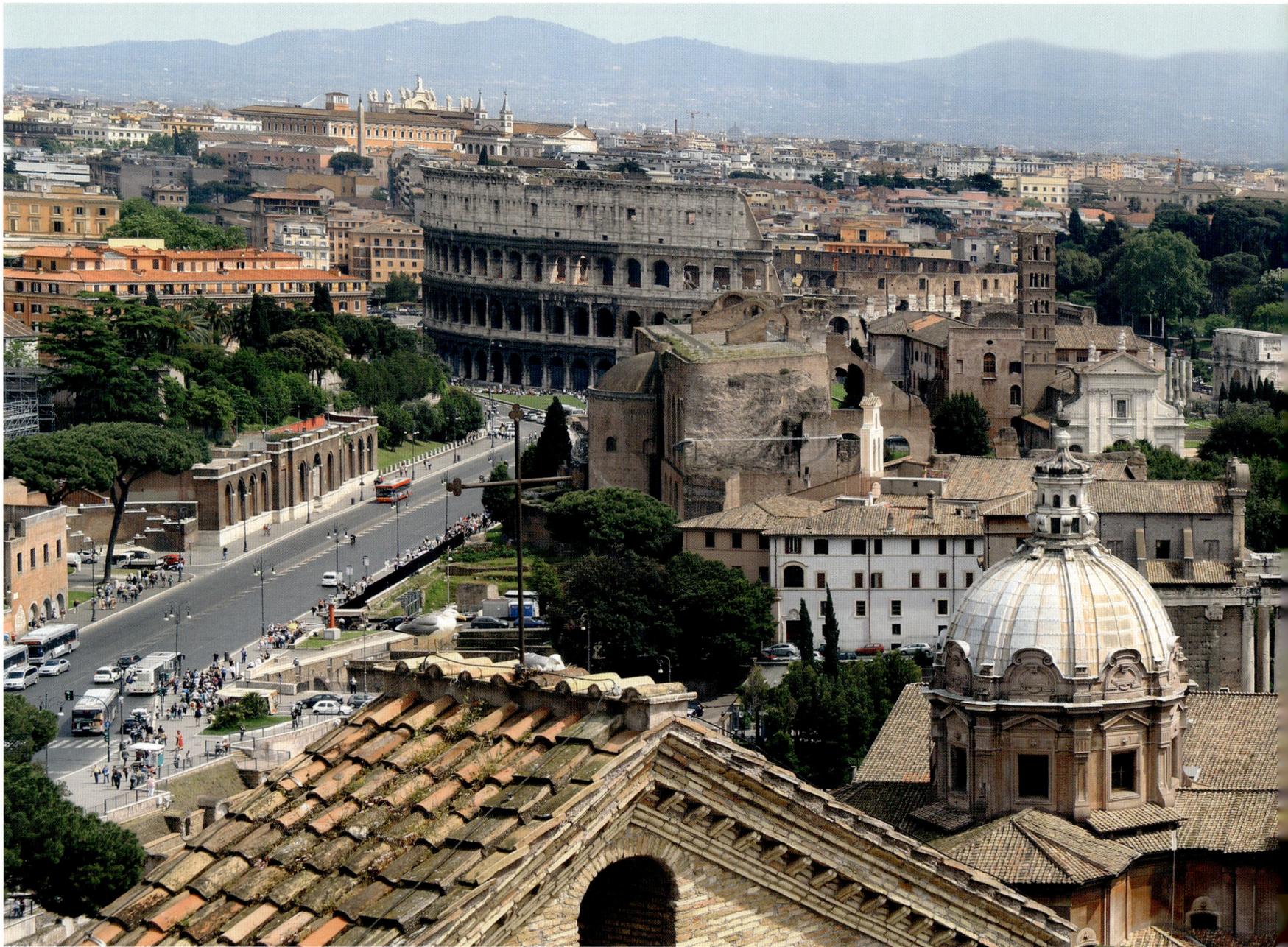

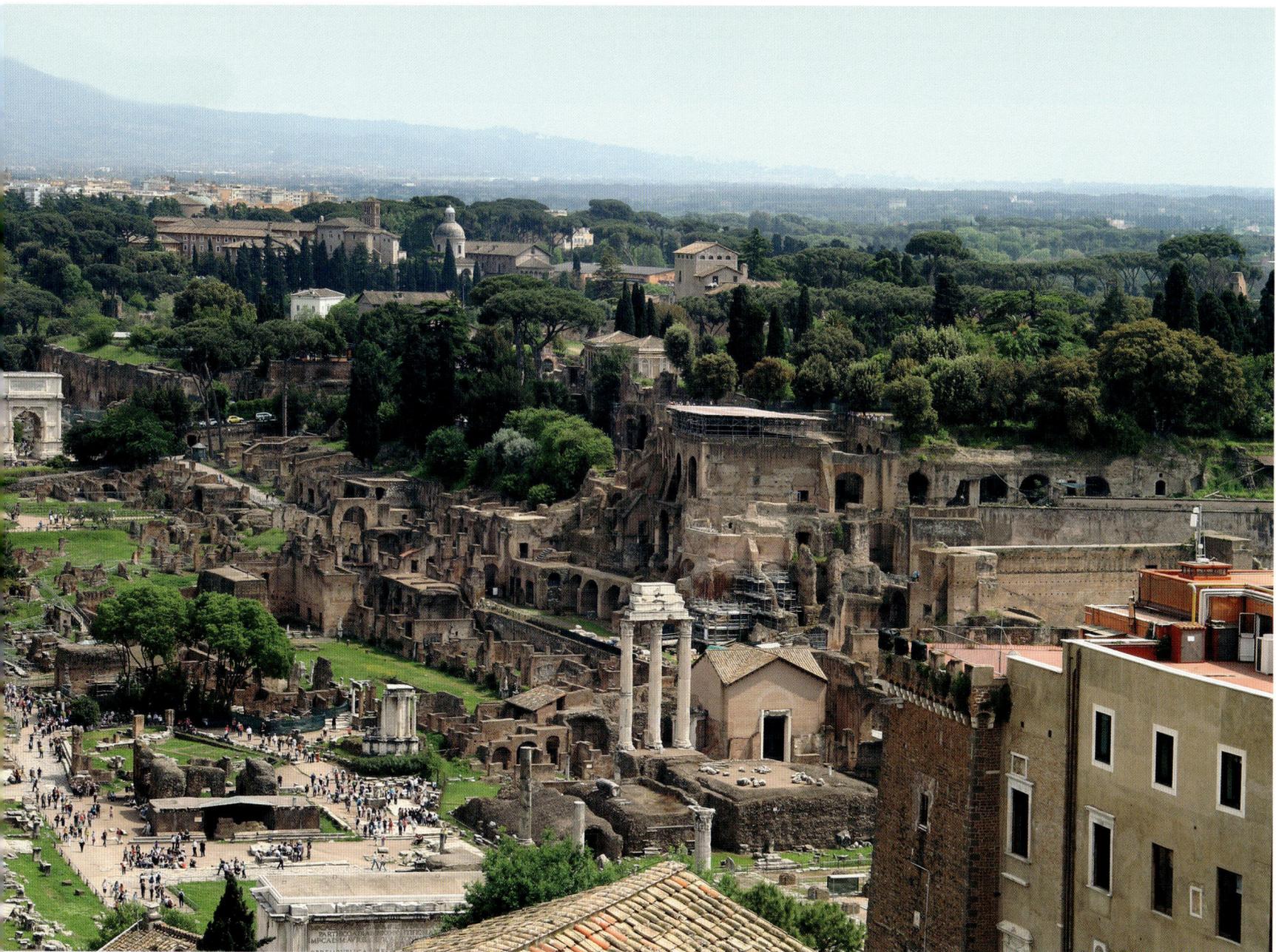

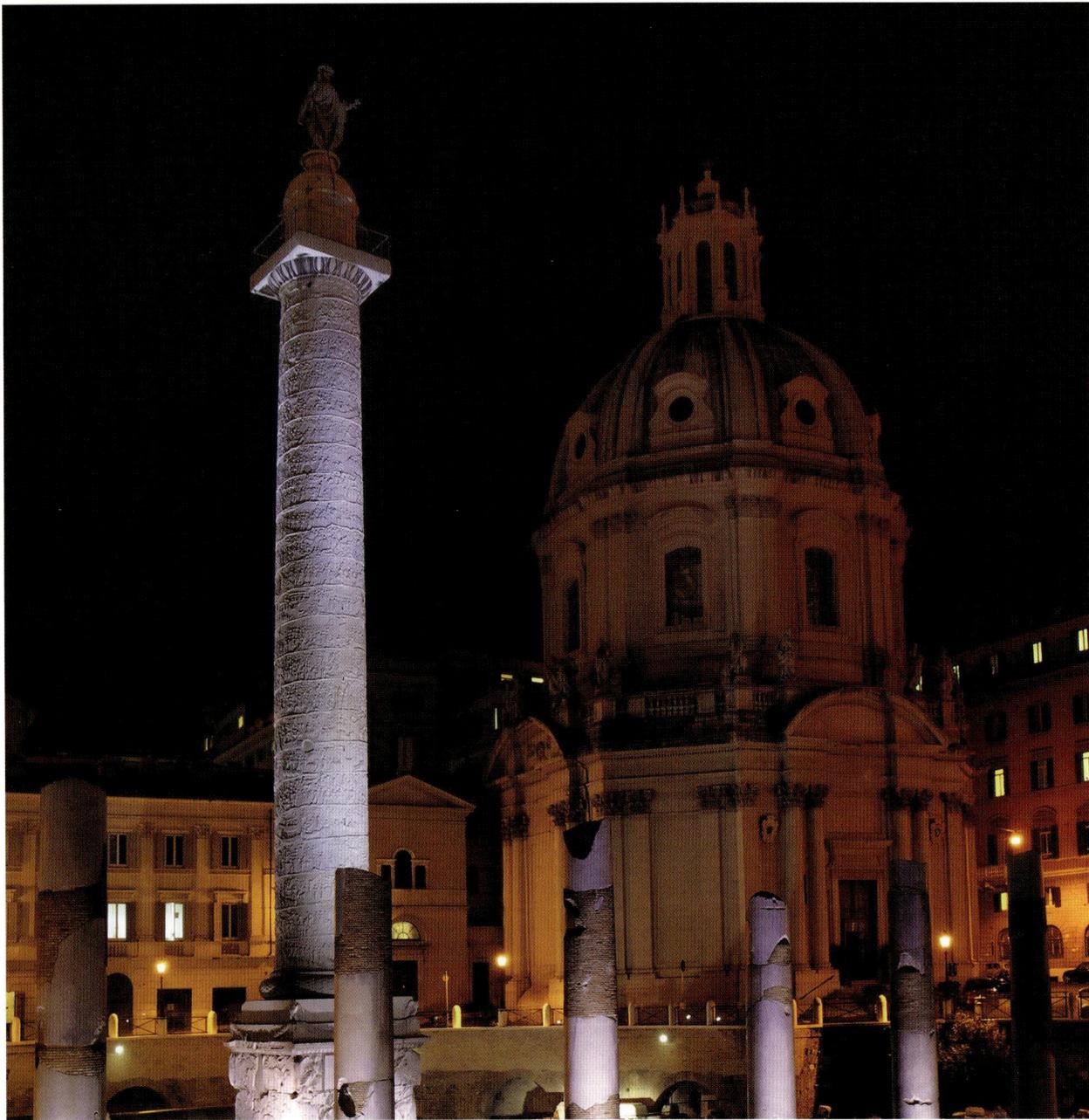

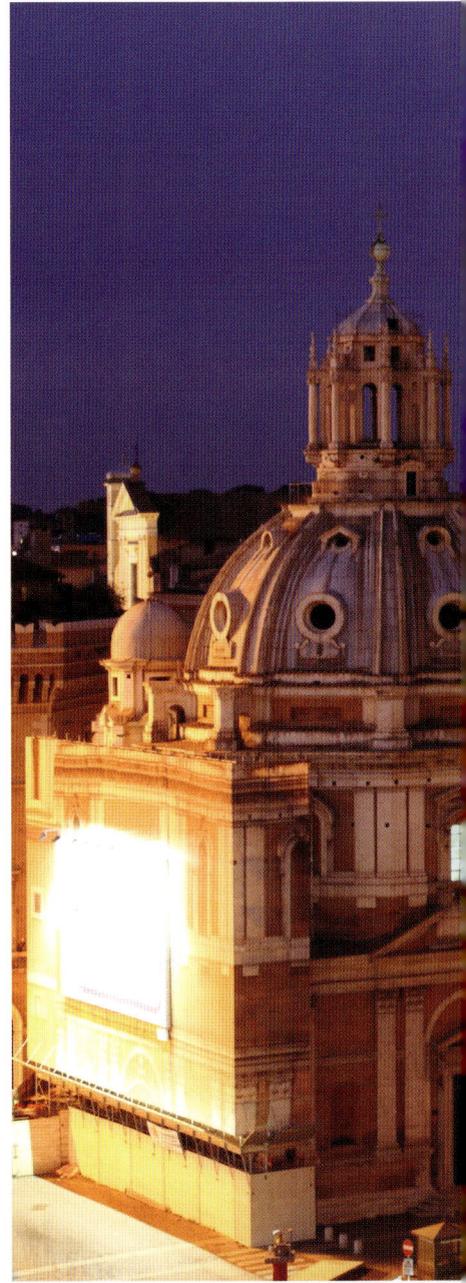

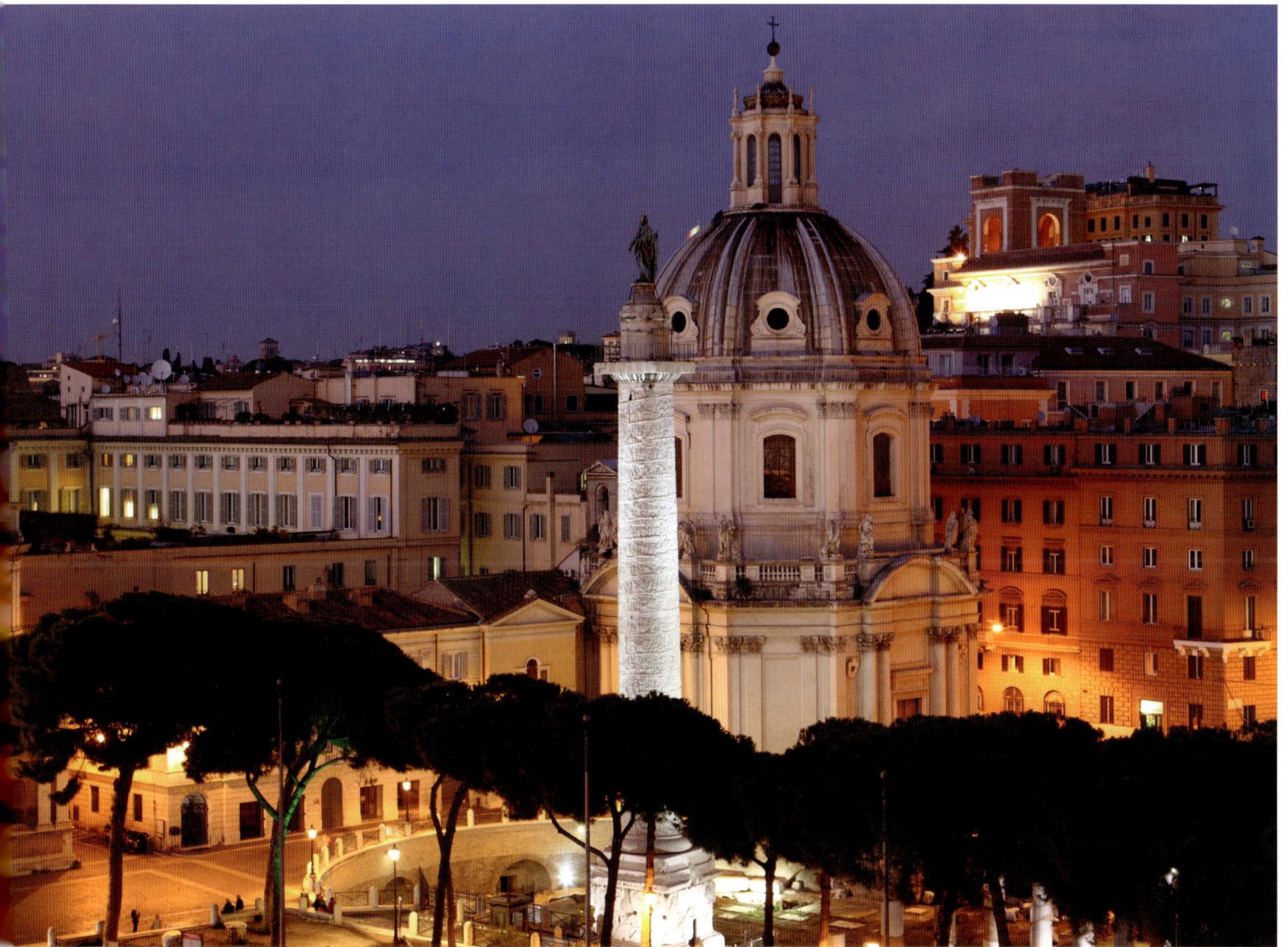

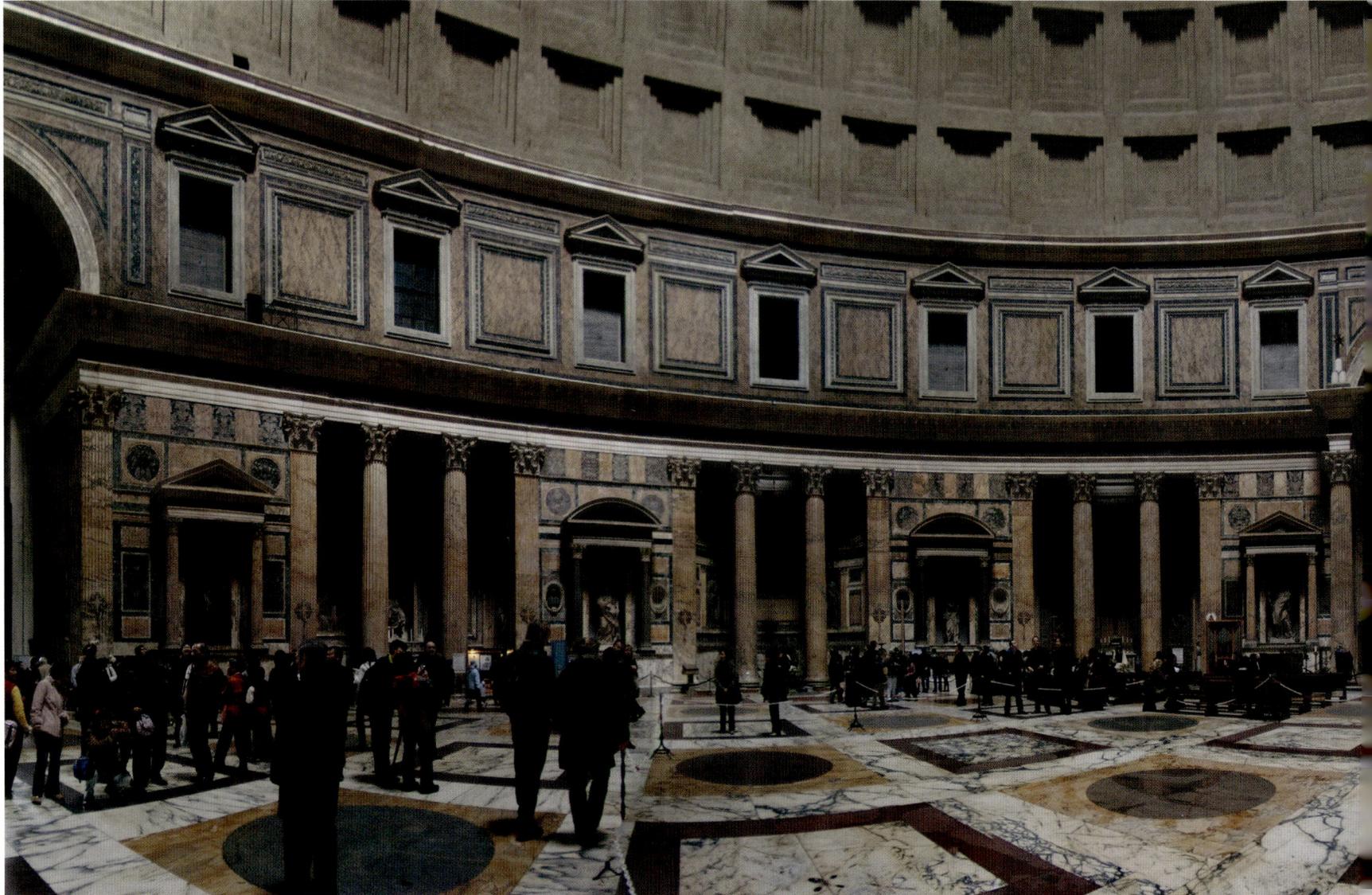

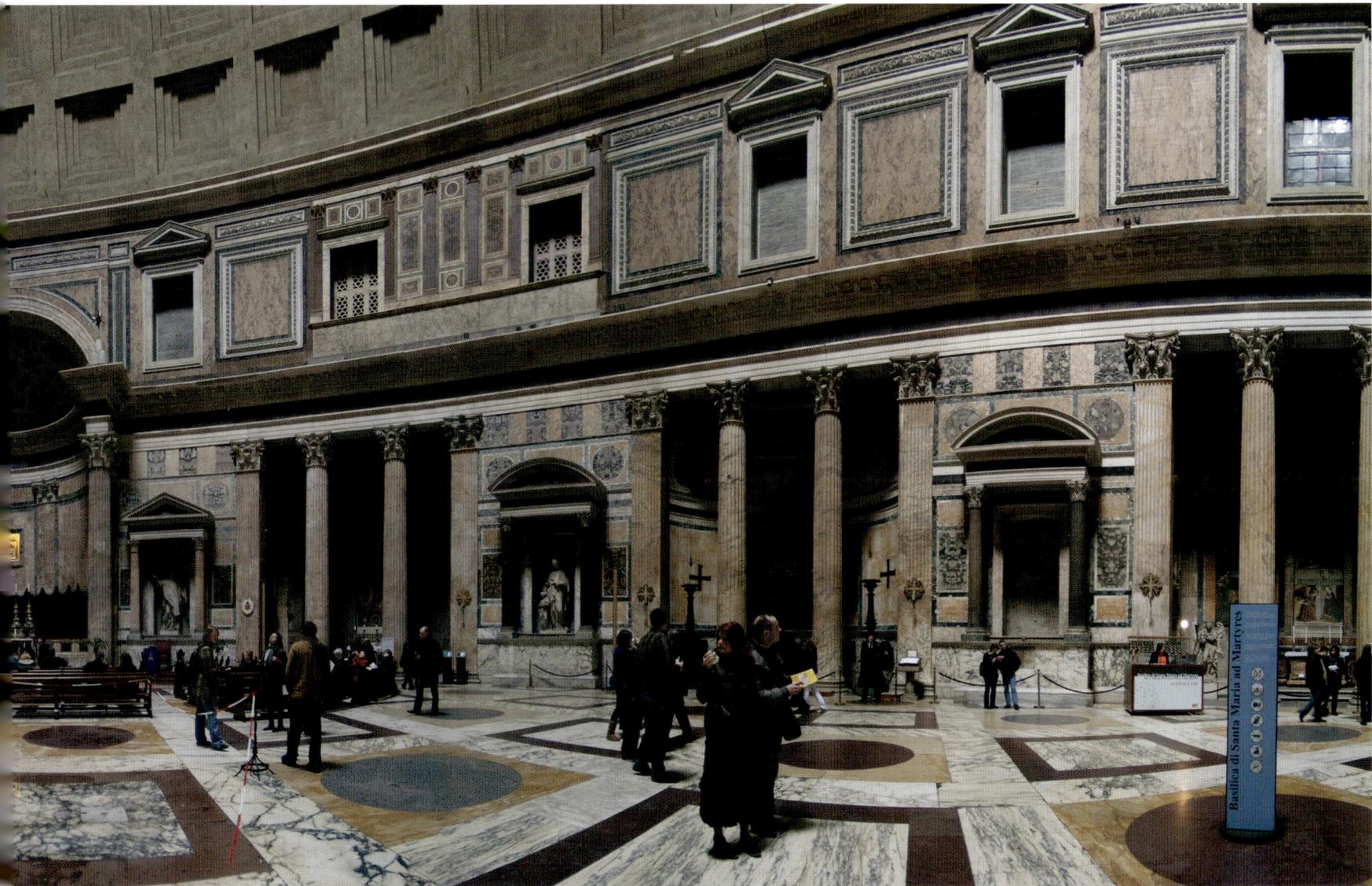

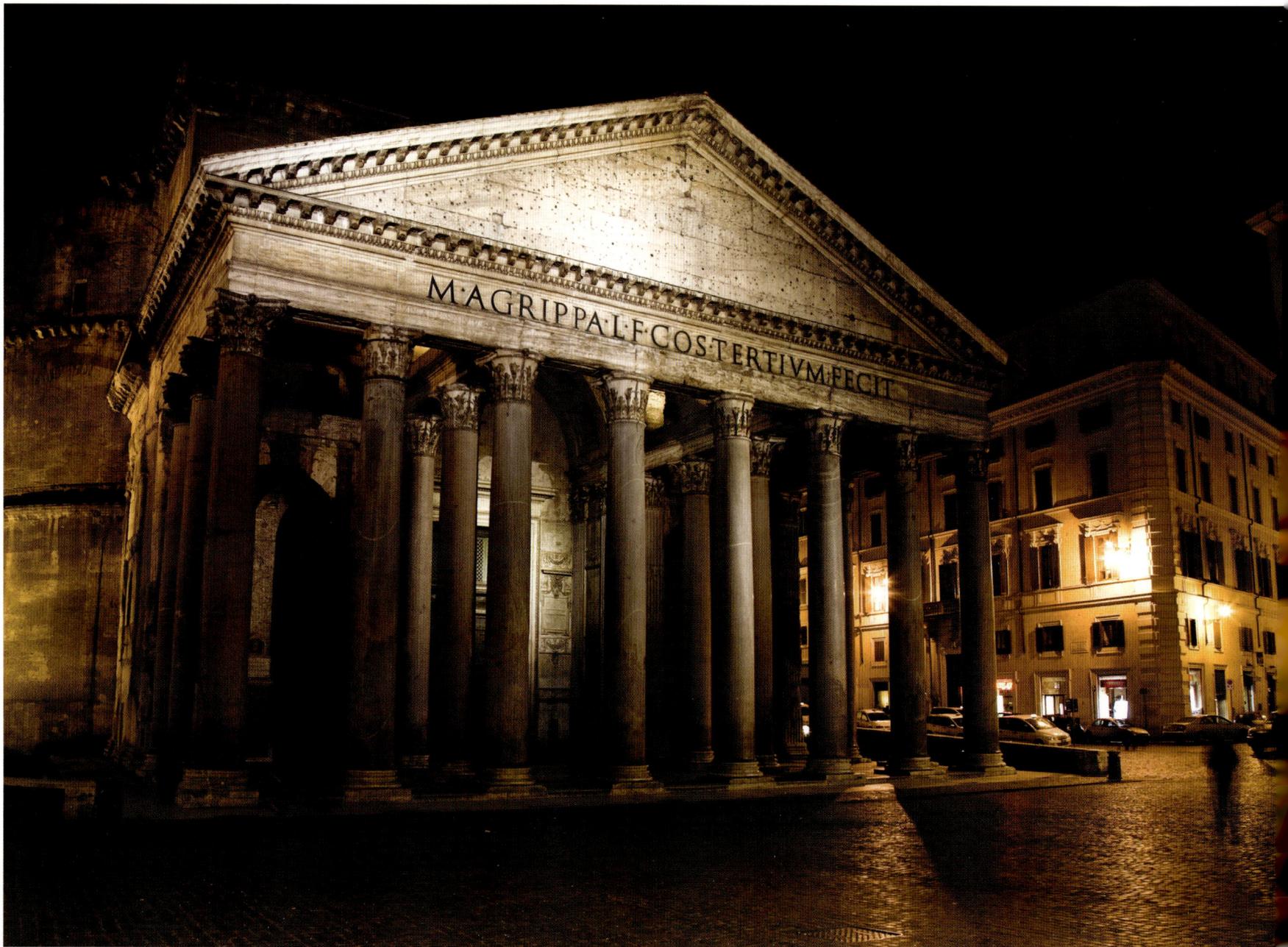

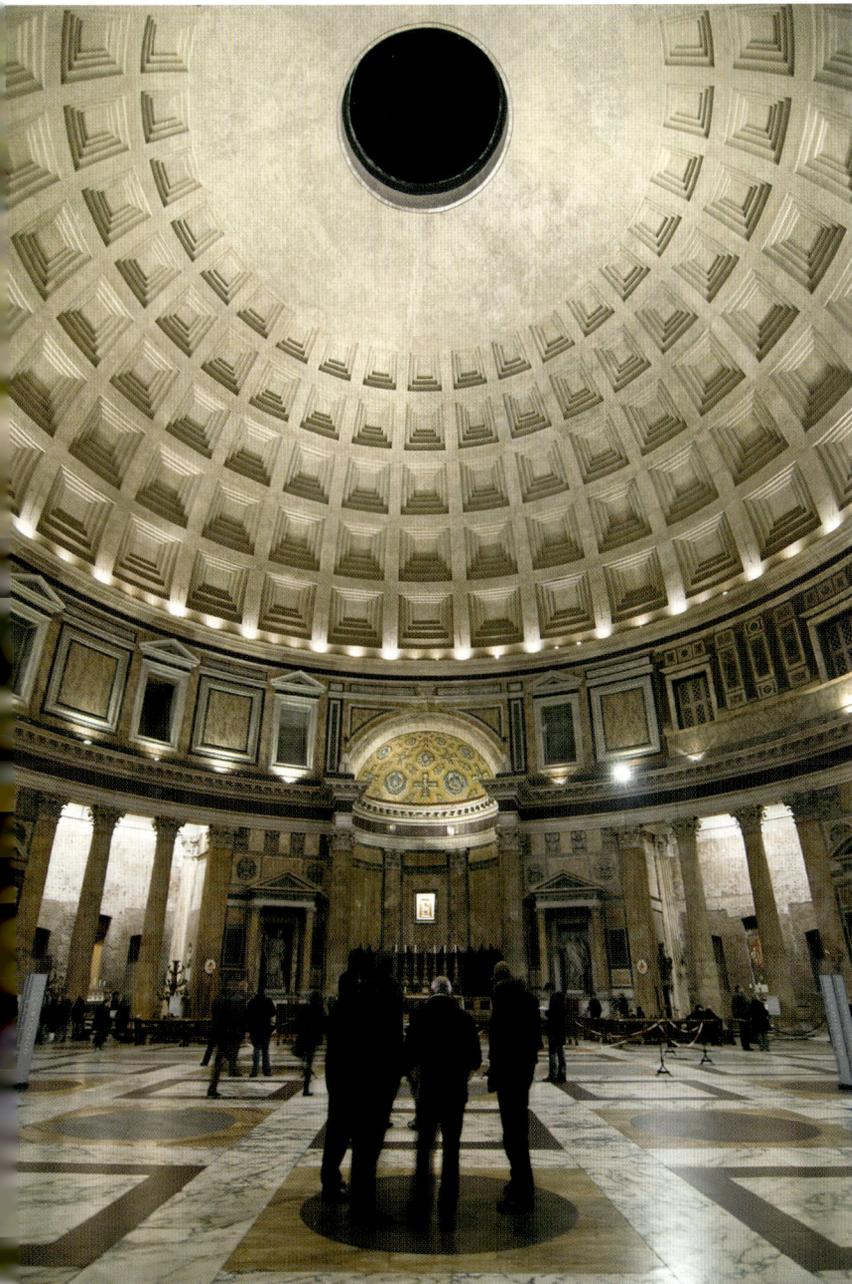
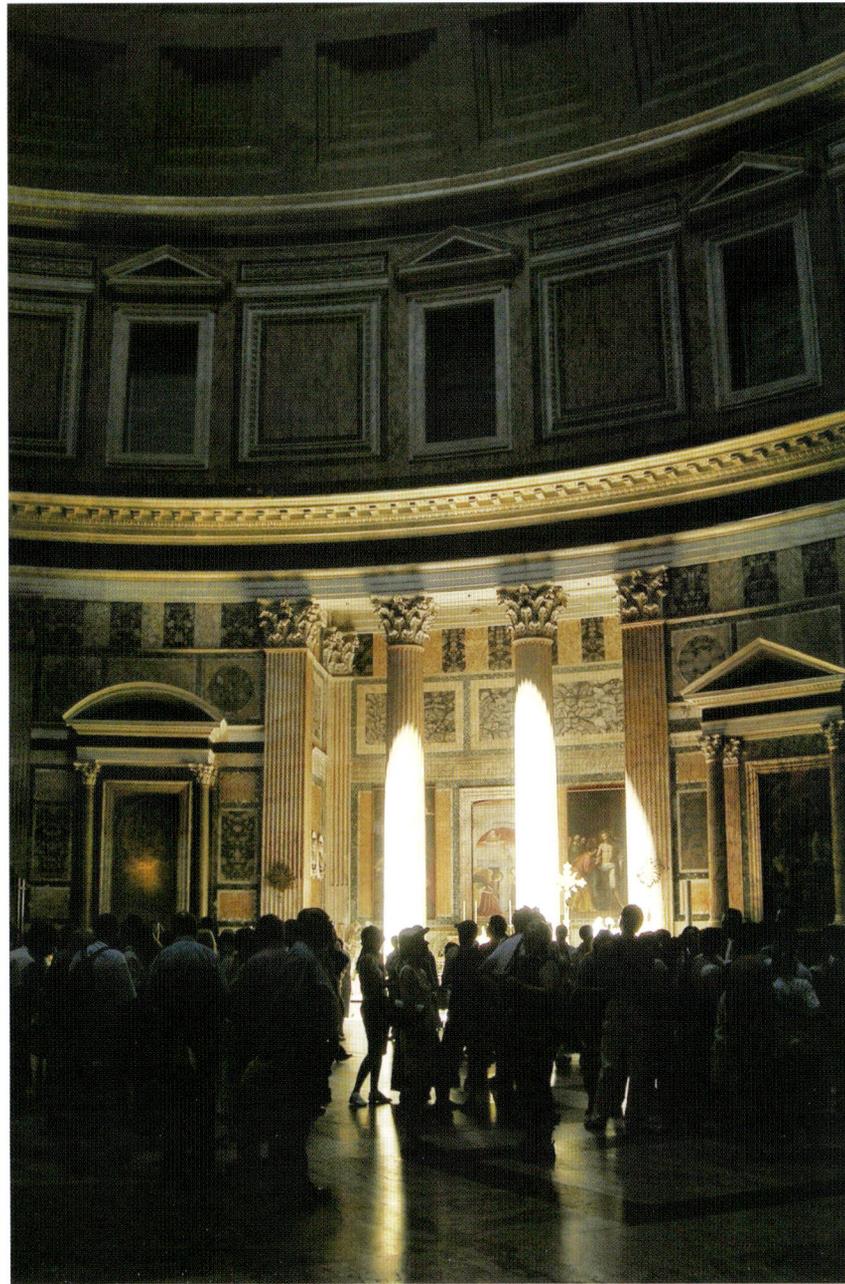

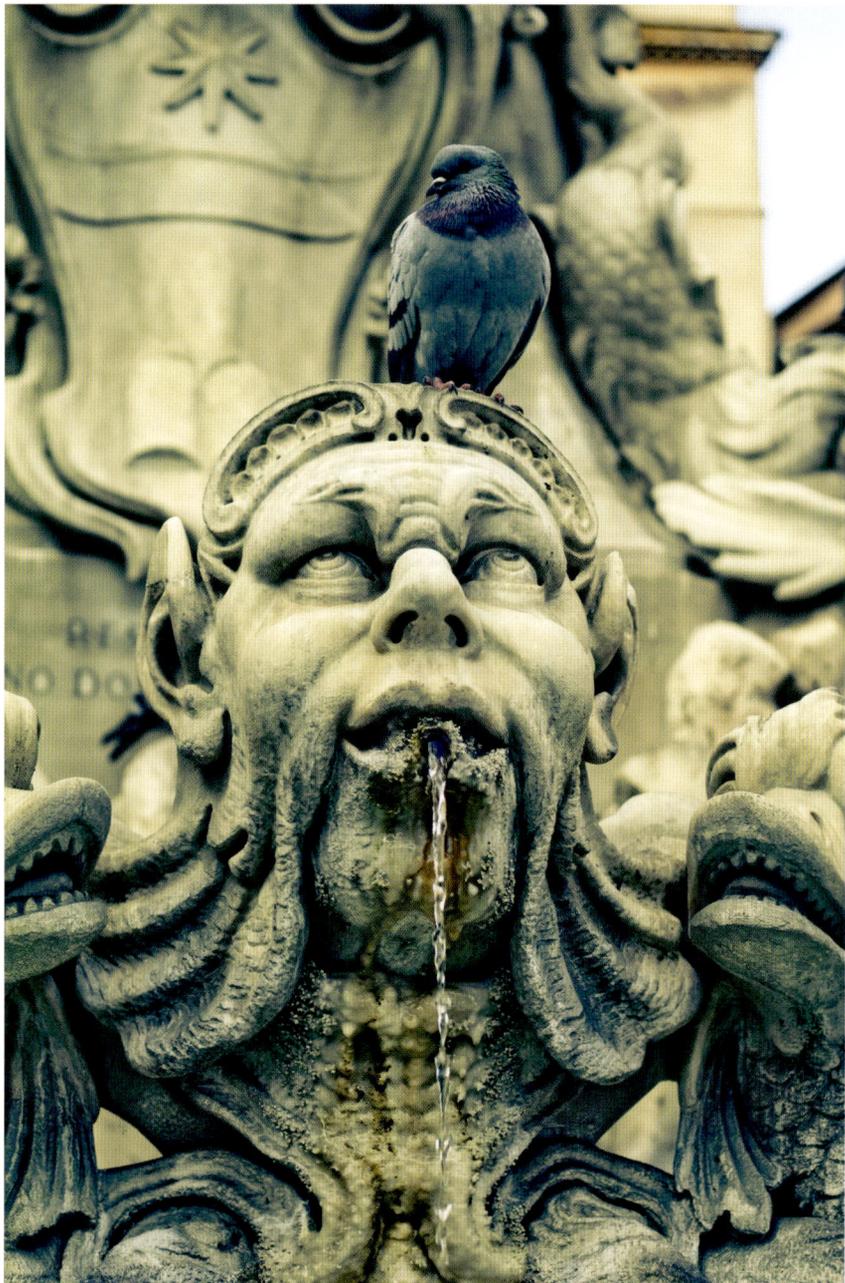
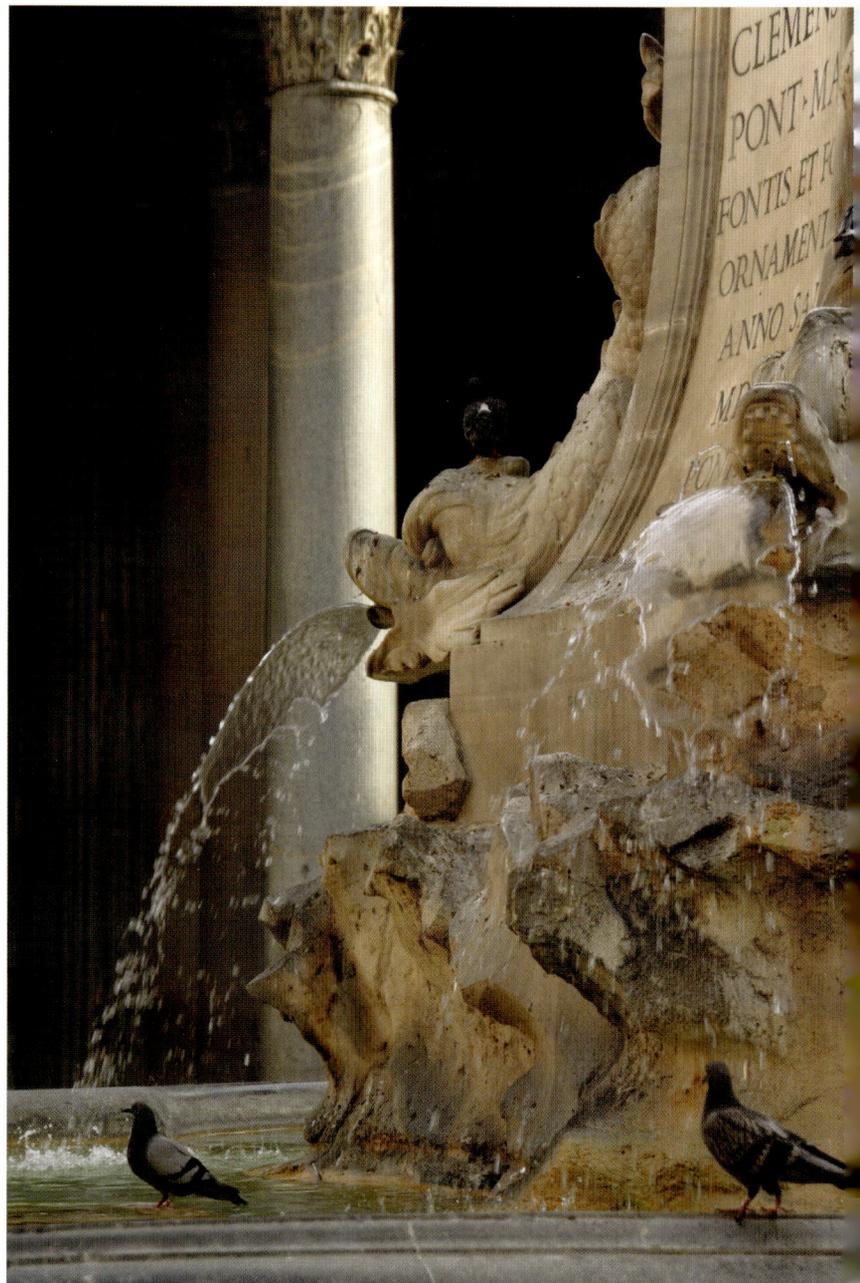

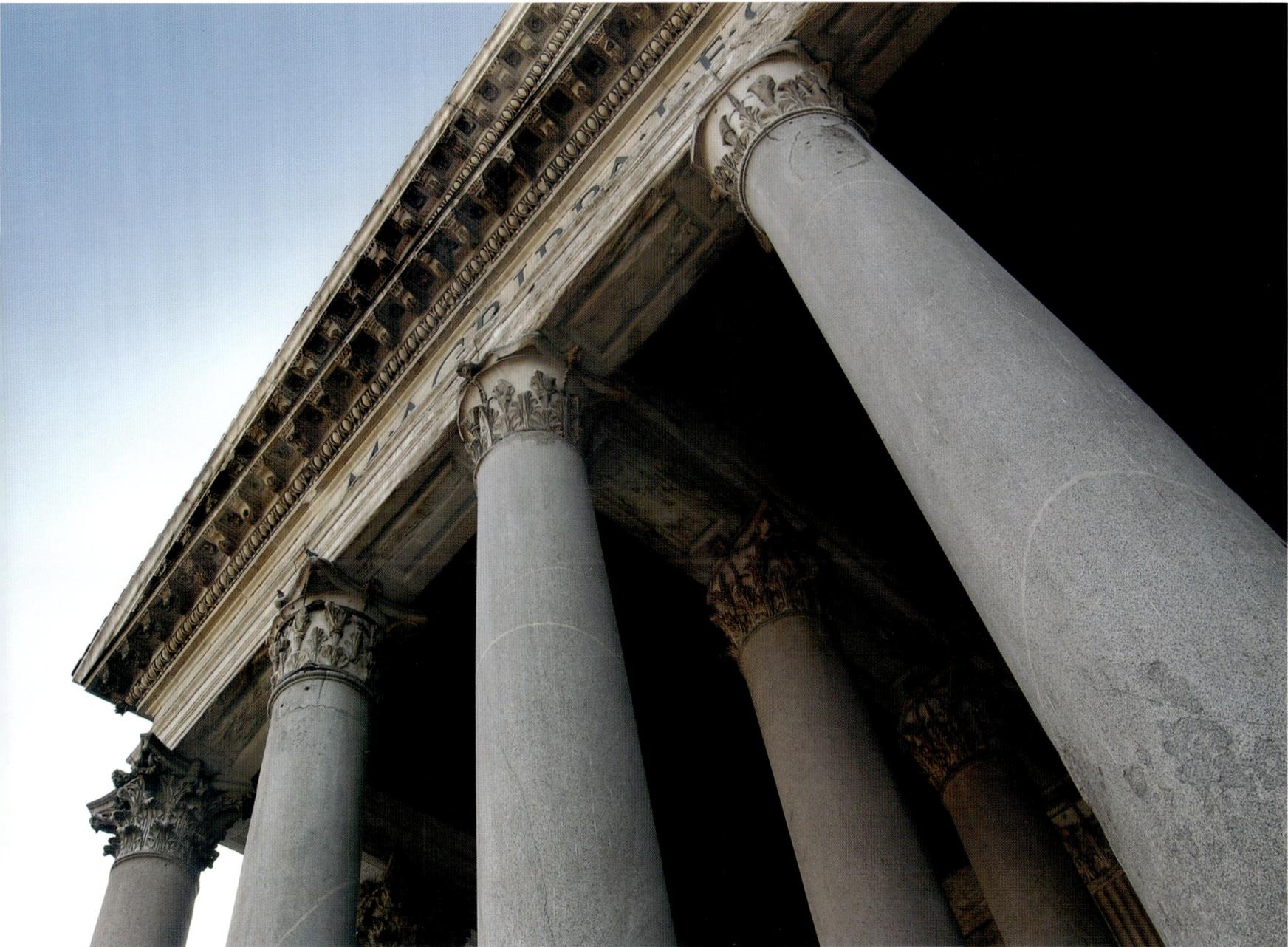

Bars & Restos

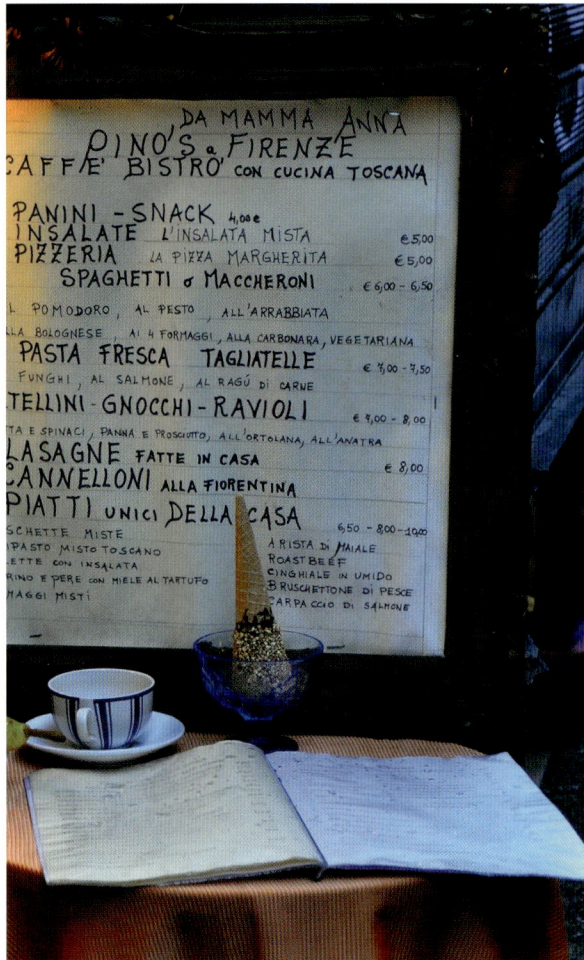

DA MAMMA ANNA
DINO'S a FIRENZE
CAFFE' BISTRO' CON CUCINA TOSCANA

PANINI - SNACK 4.00 €
INSALATE L'INSALATA MISTA €5.00
PIZZERIA LA PIZZA MARGHERITA €5.00
SPAGHETTI o MACCHERONI €6.00 - 6.50
L POMODORO, AL PESTO, ALL'ARRABBIATA
ALLA BOLOGNESE, AI 4 FORMAGGI, ALLA CARBONARA, VEGETARIANA
PASTA FRESCA TAGLIATELLE €7.00 - 7.50
FUNGHI, AL SALMONE, AL RAGÚ DI CARNE
TELLINI - GNOCCHI - RAVIOLI €7.00 - 8.00
TA E SPINACI, PANNA E PROSCIUTTO, ALL'ORTOLANA, ALL'ANATRA
LASAGNE FATTE IN CASA €8.00
CANNELLONI ALLA FIORENTINA
PIATTI UNICI DELLA CASA 6.50 - 8.00 - 10.00
SCHETTE MISTE A RISTA DI MAIALE
PASTO MISTO TOSCANO ROASTBEEF
LETTE CON INSALATA CINGHIALE IN UMIDO
RINO E PERE CON MIELE AL TARTUFO BRUSCHETTONE DI PESCE
MAGGI MISTI CARPACCIO DI SALMONE

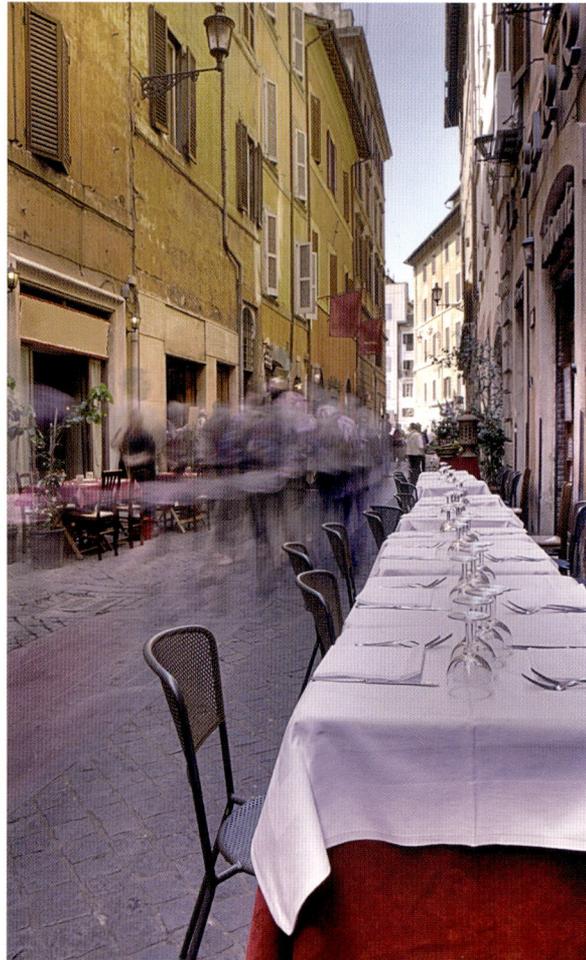

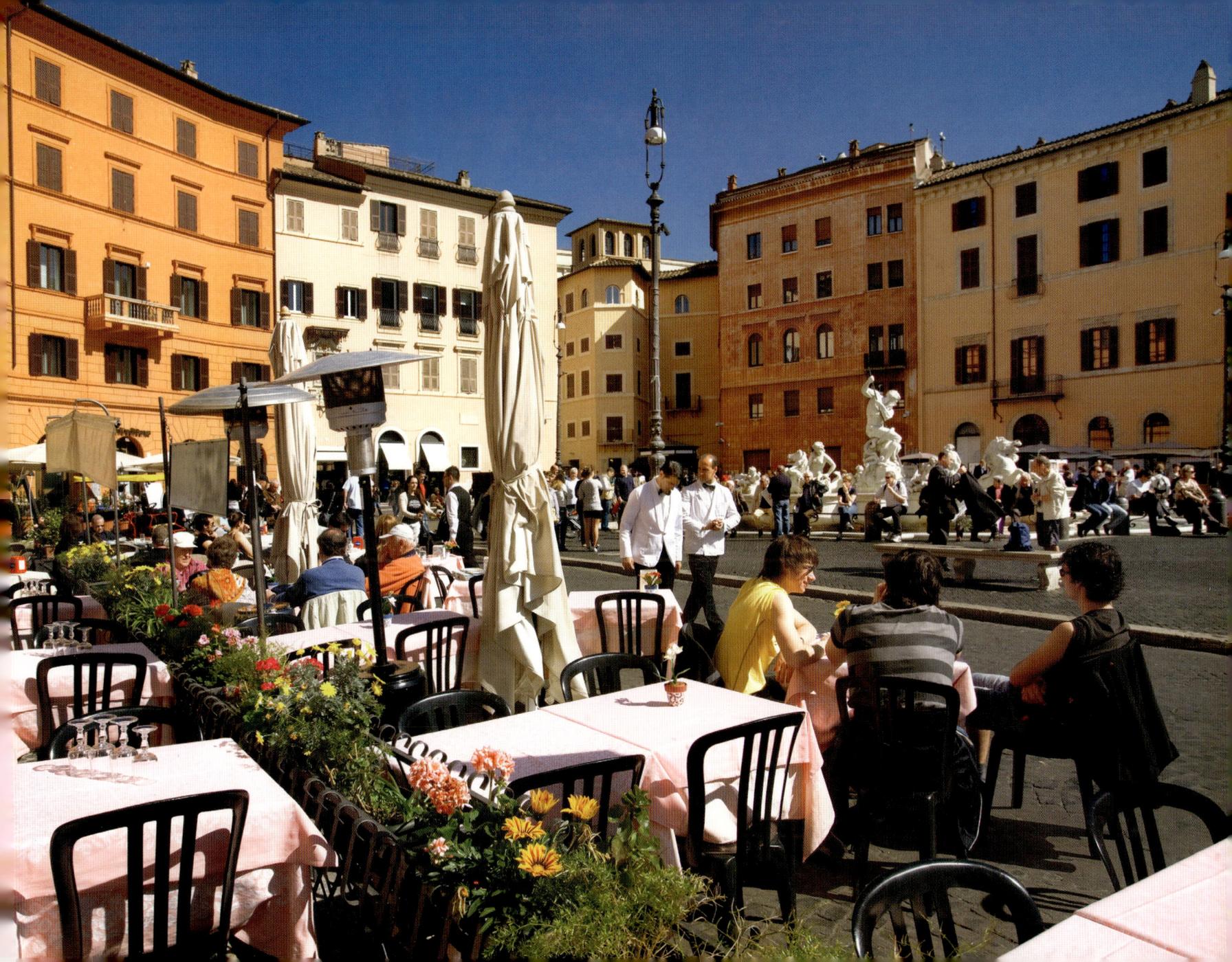

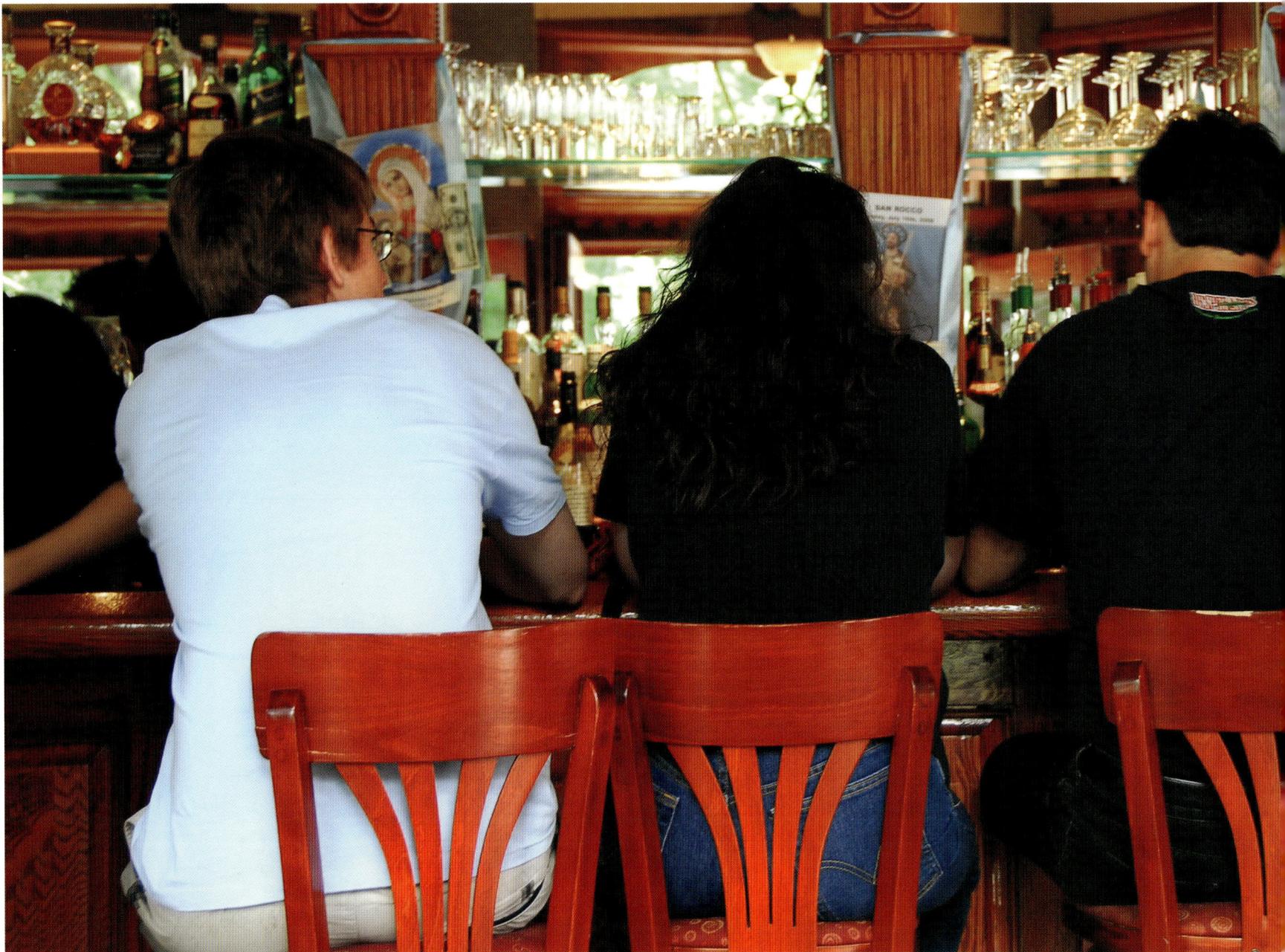

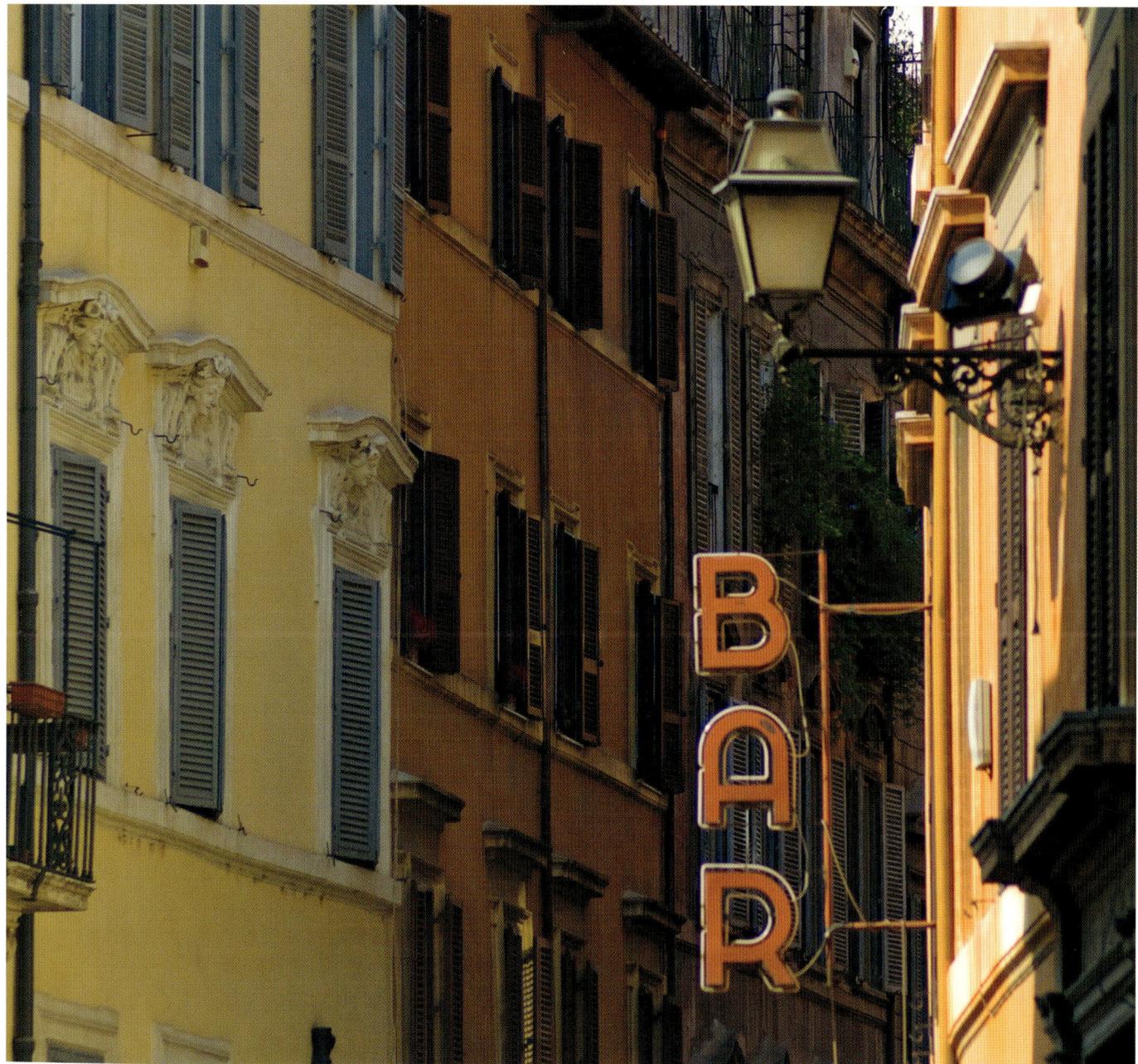

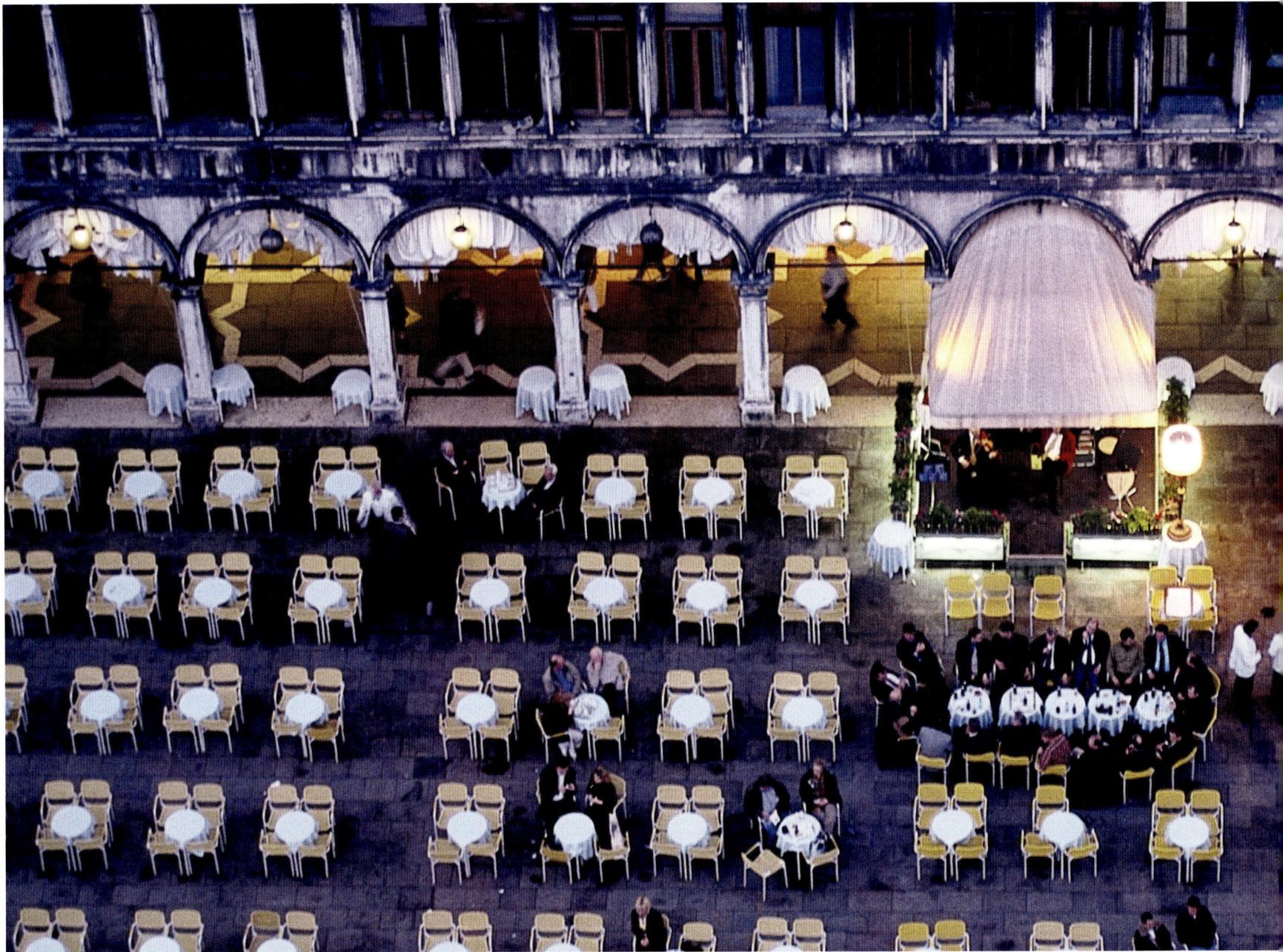

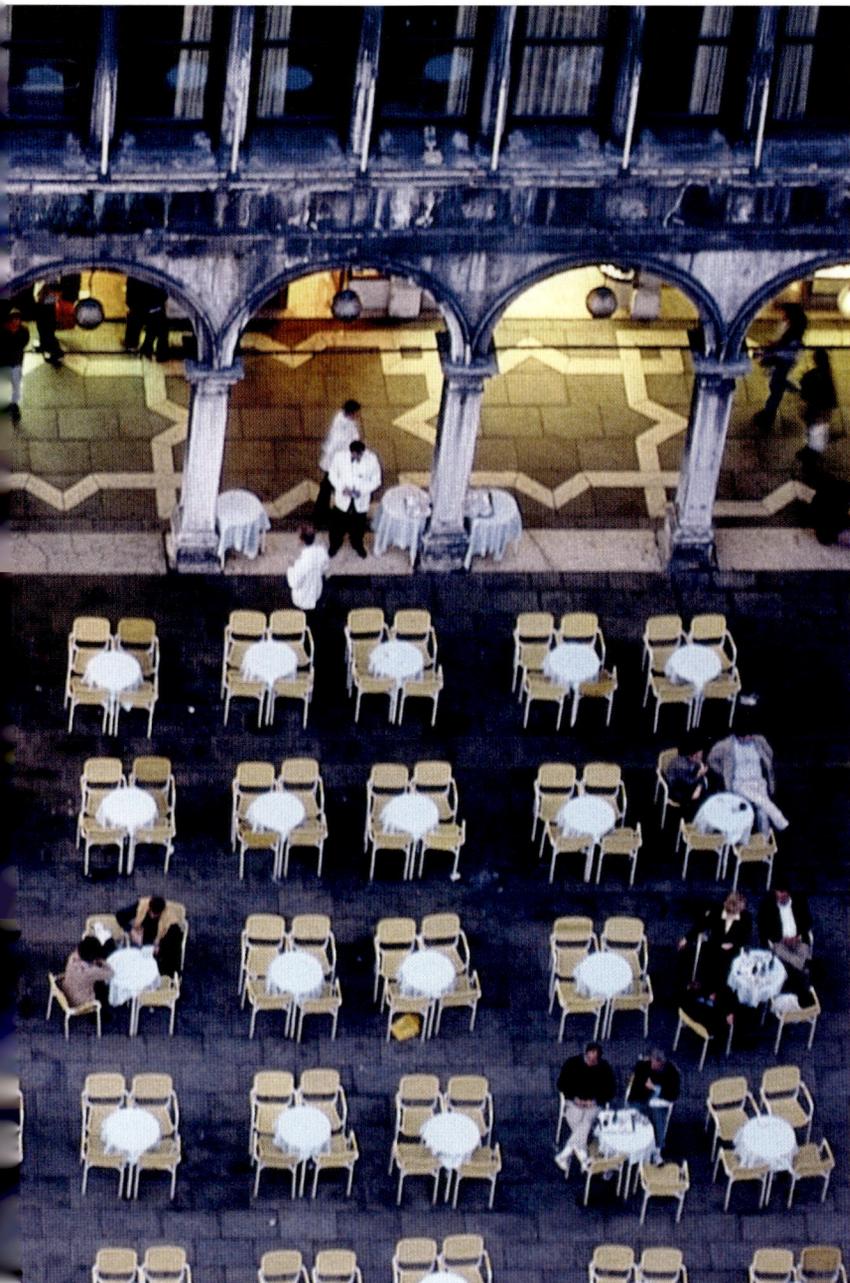
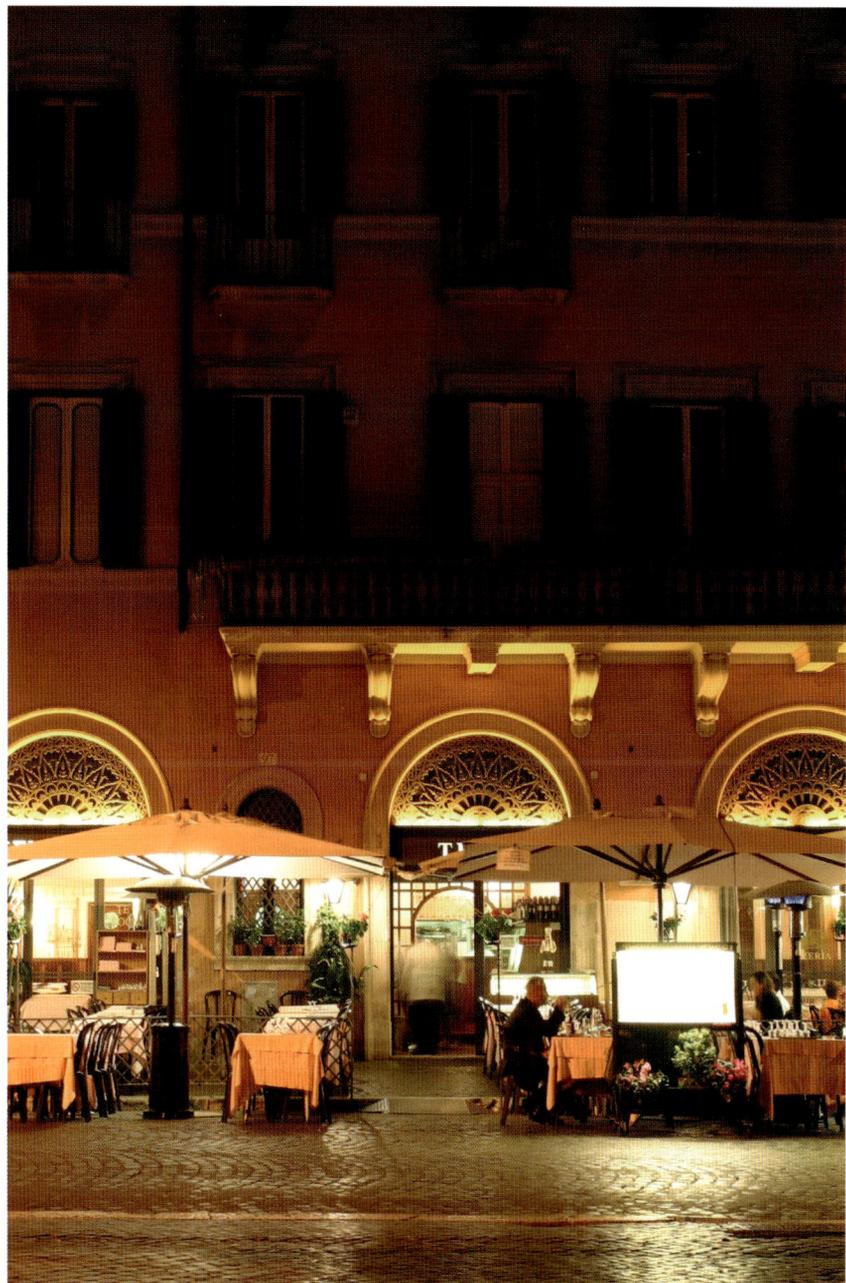

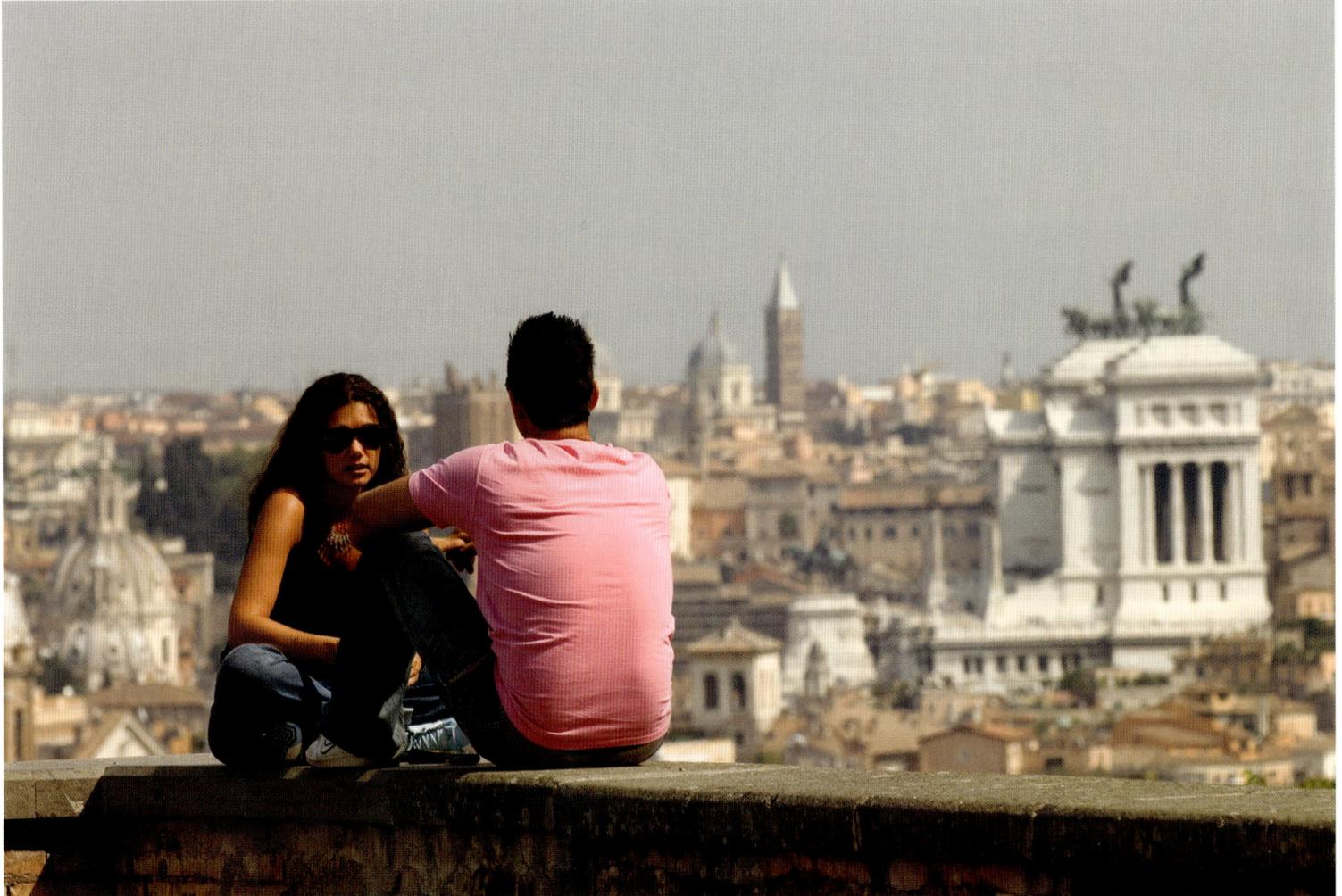

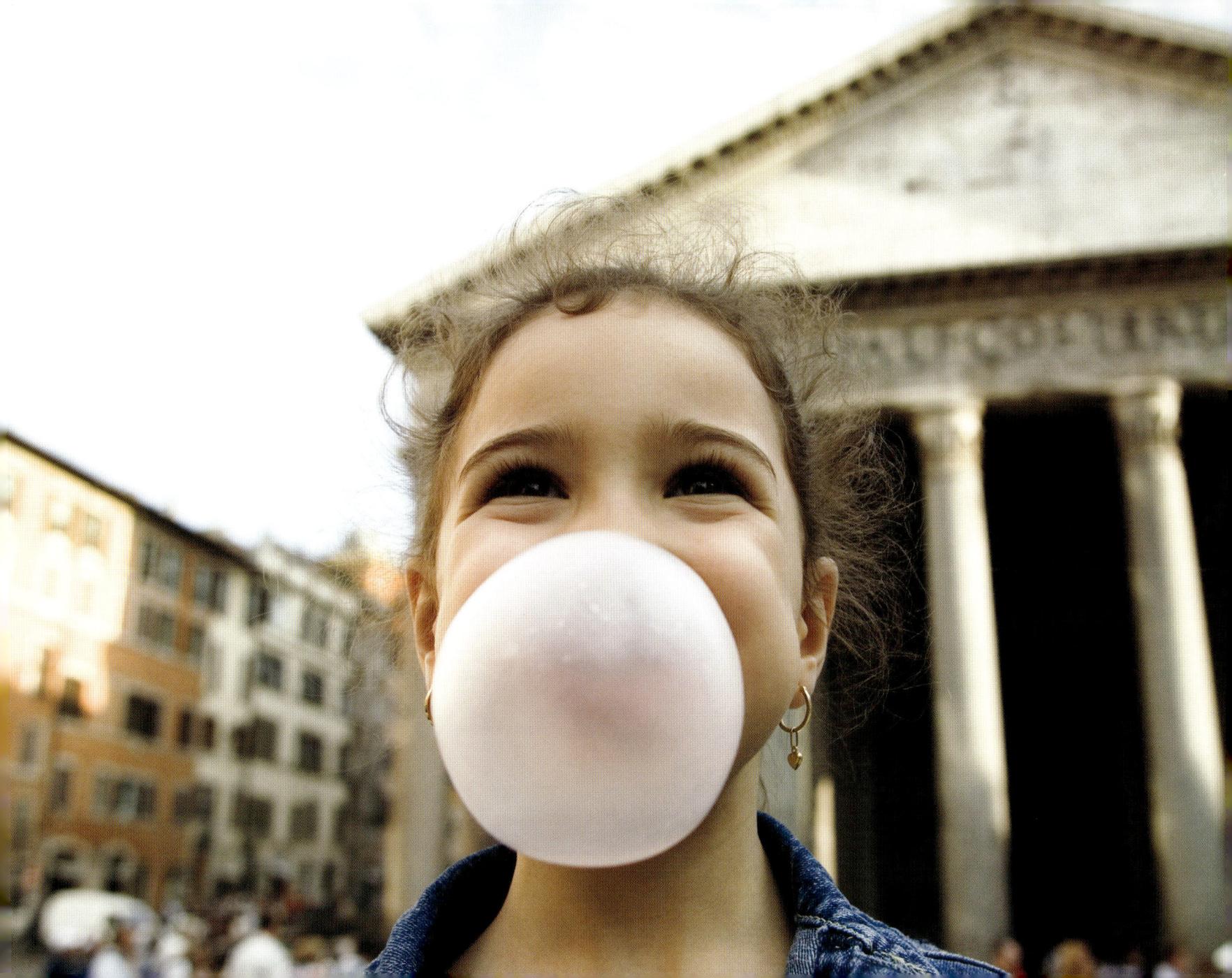

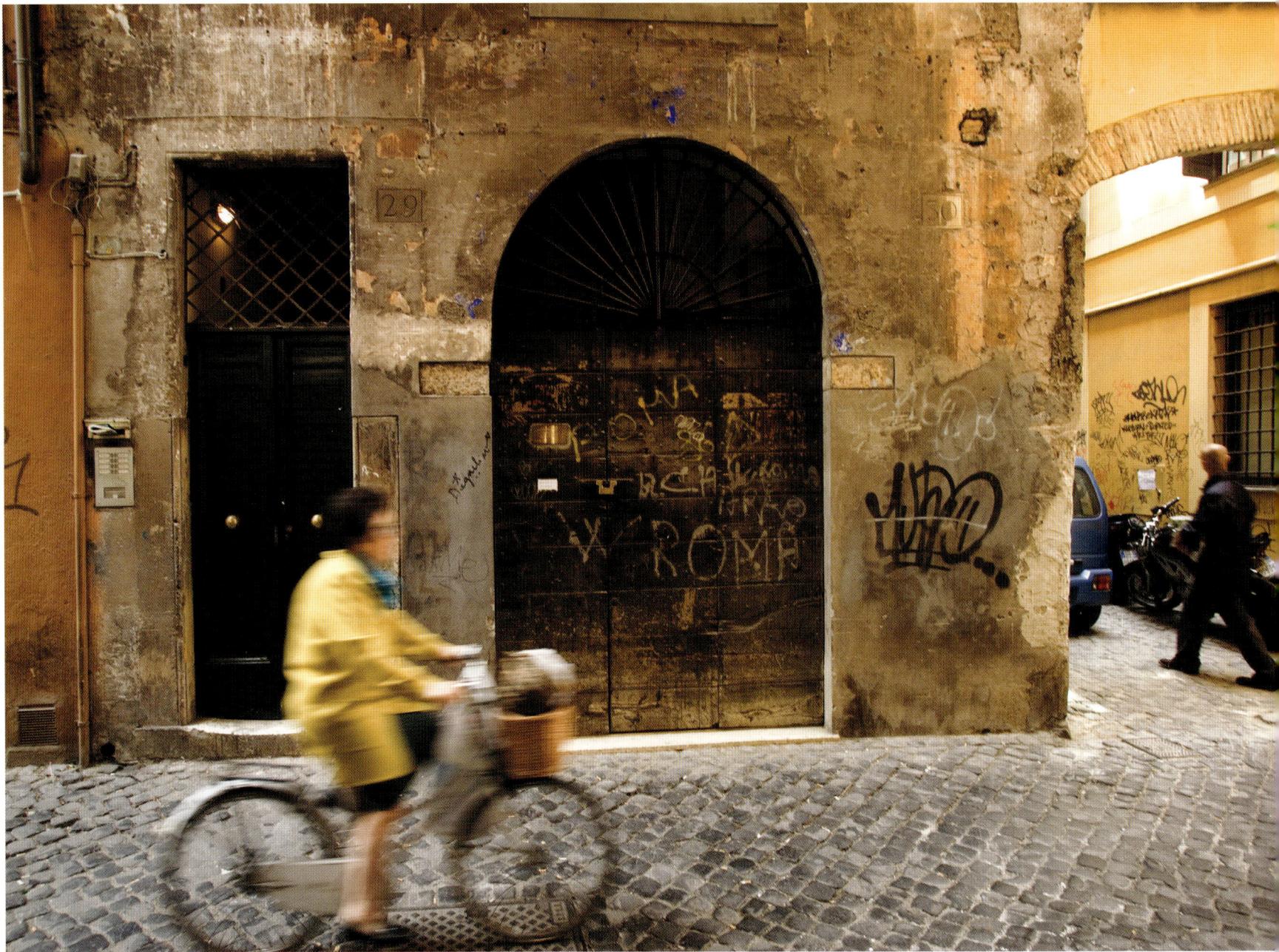

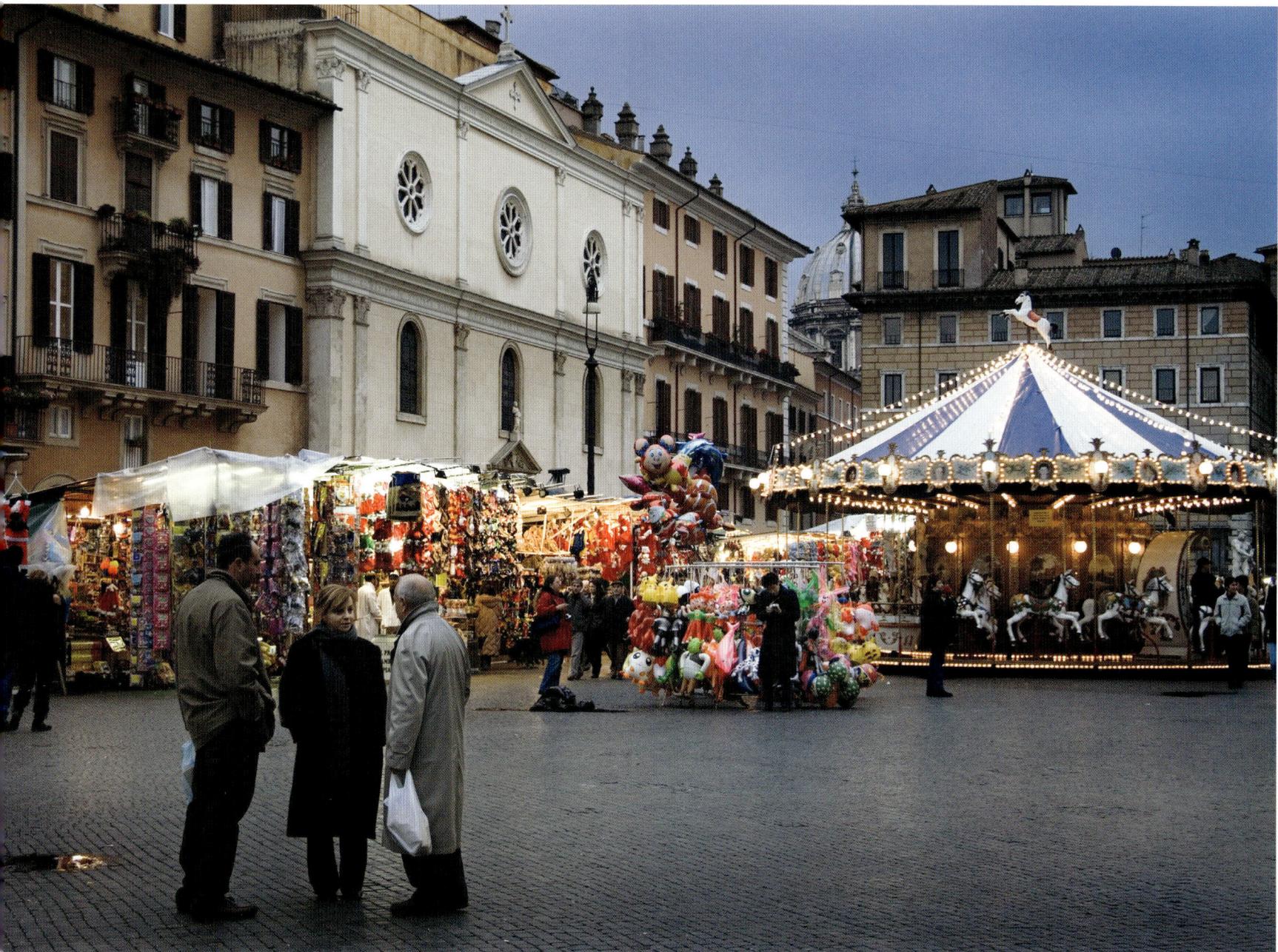

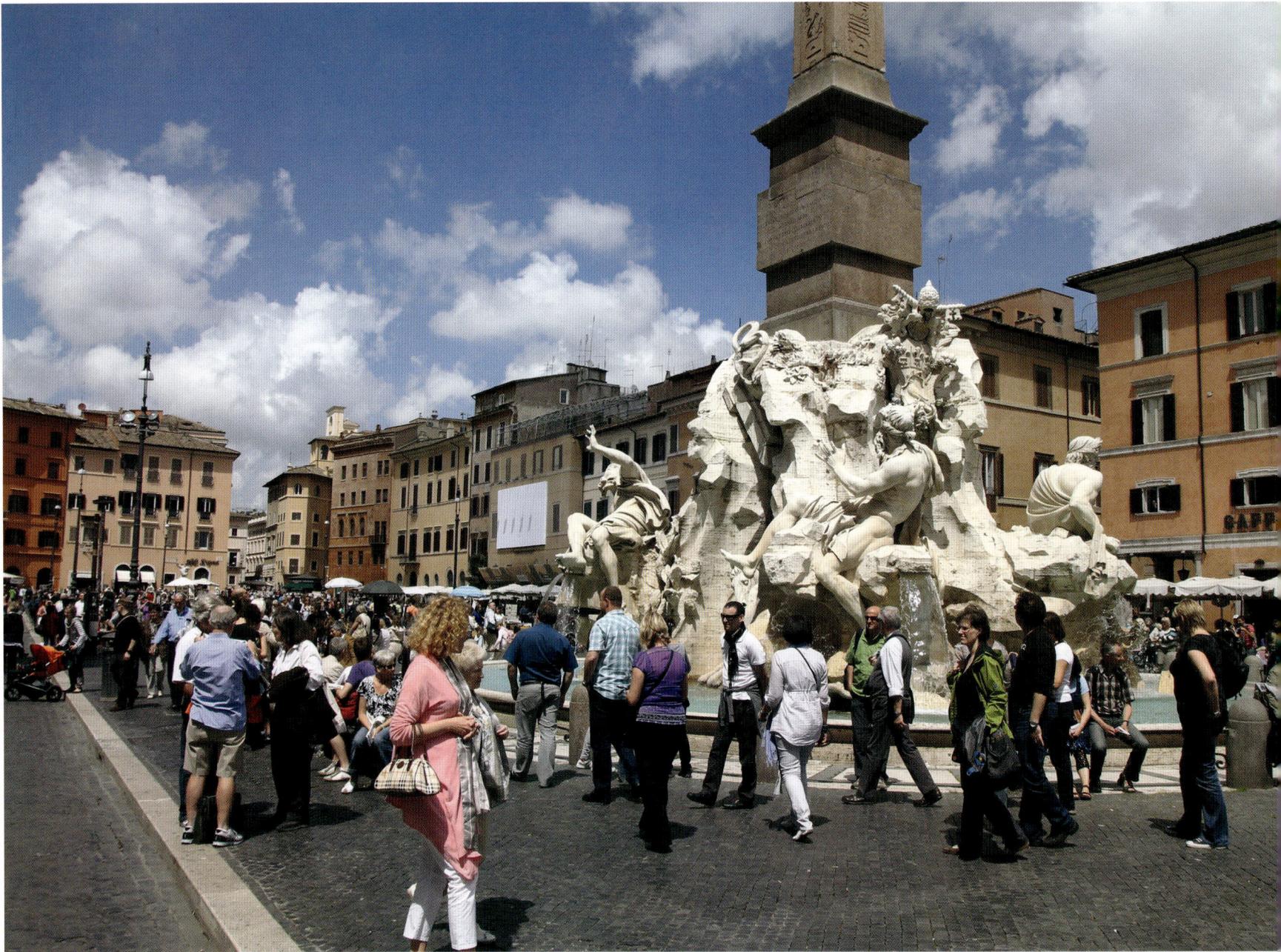

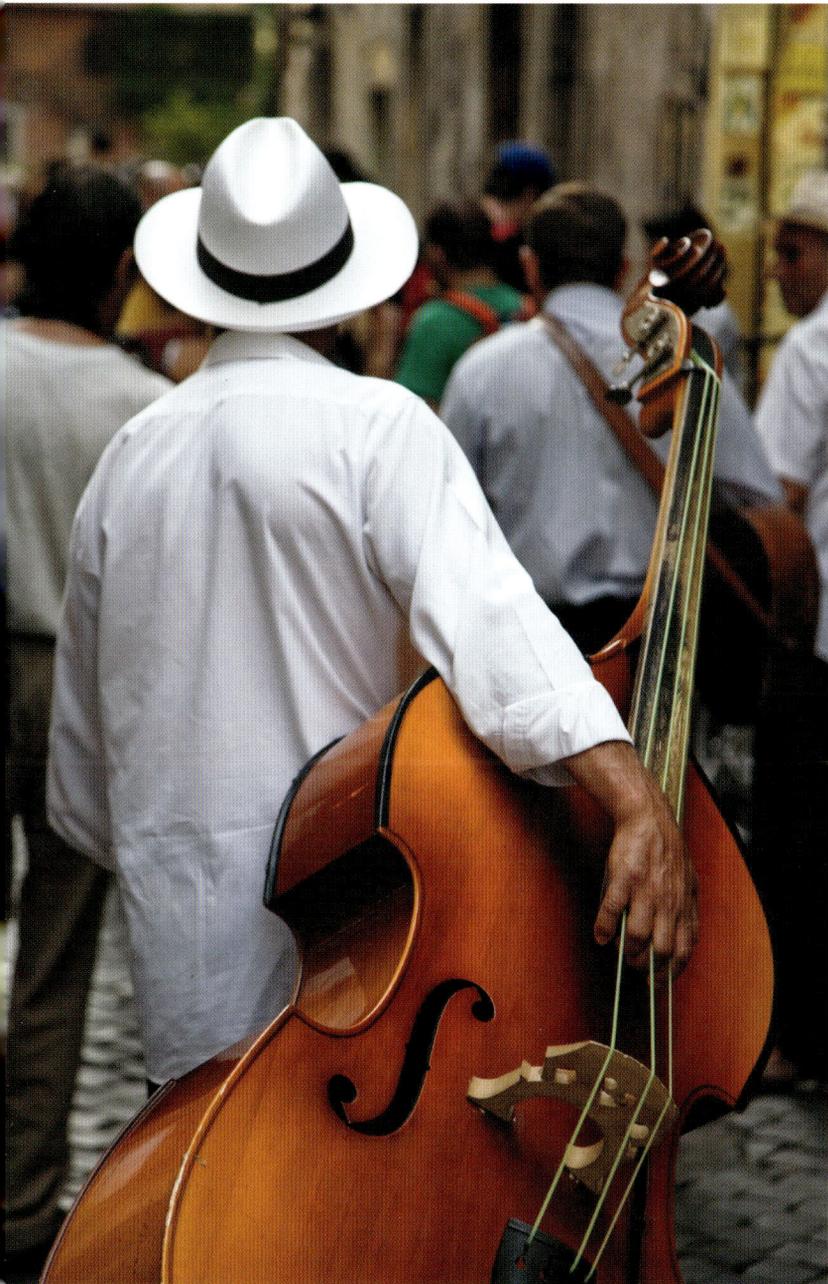
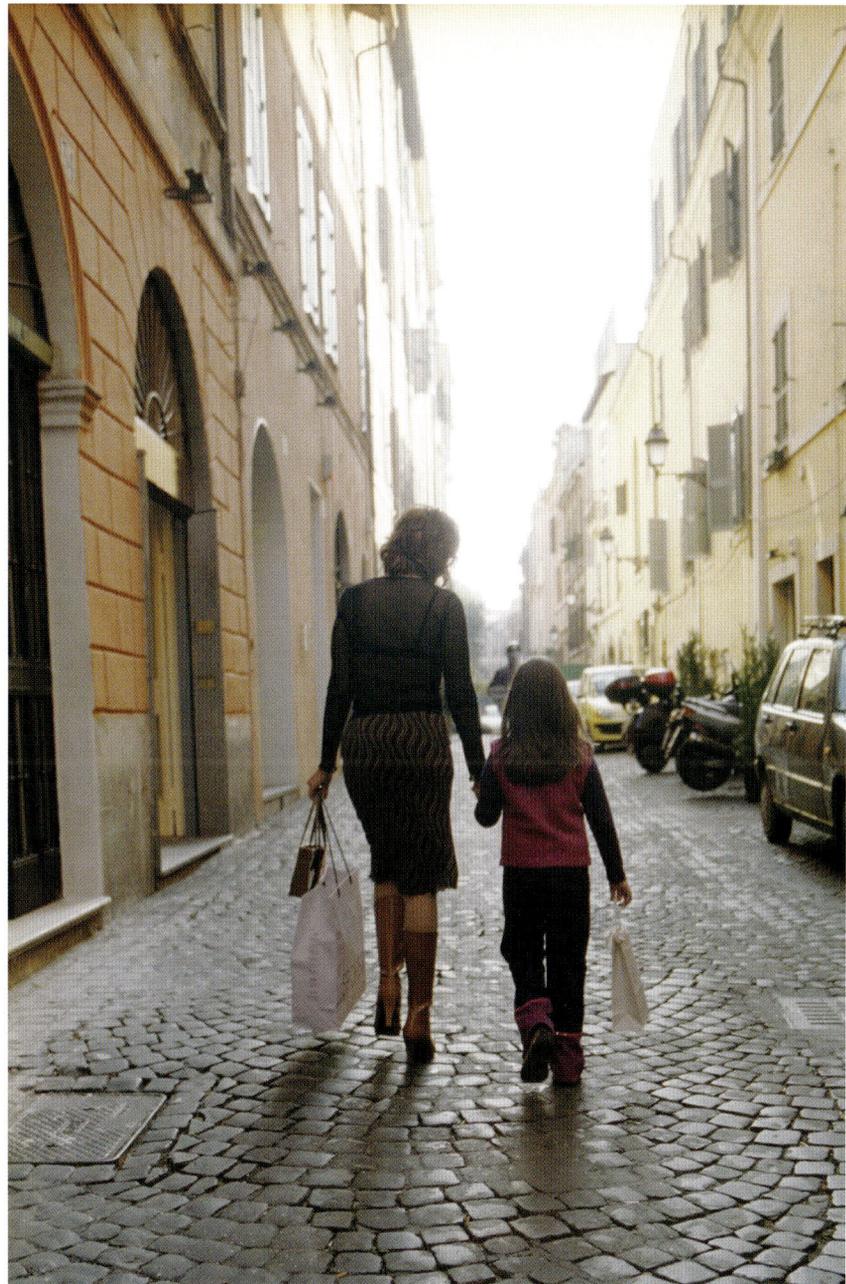

Piazza del Popolo

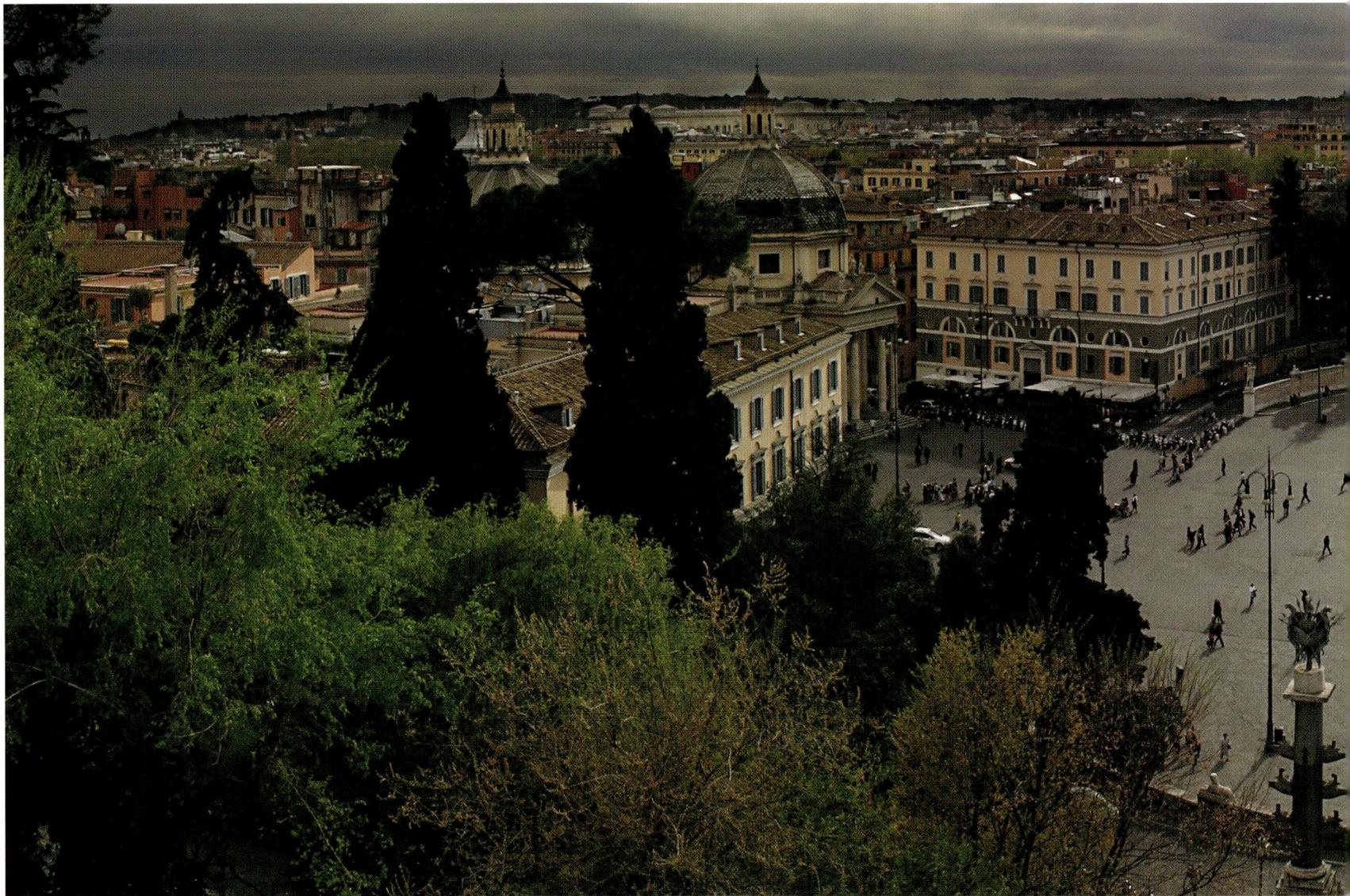

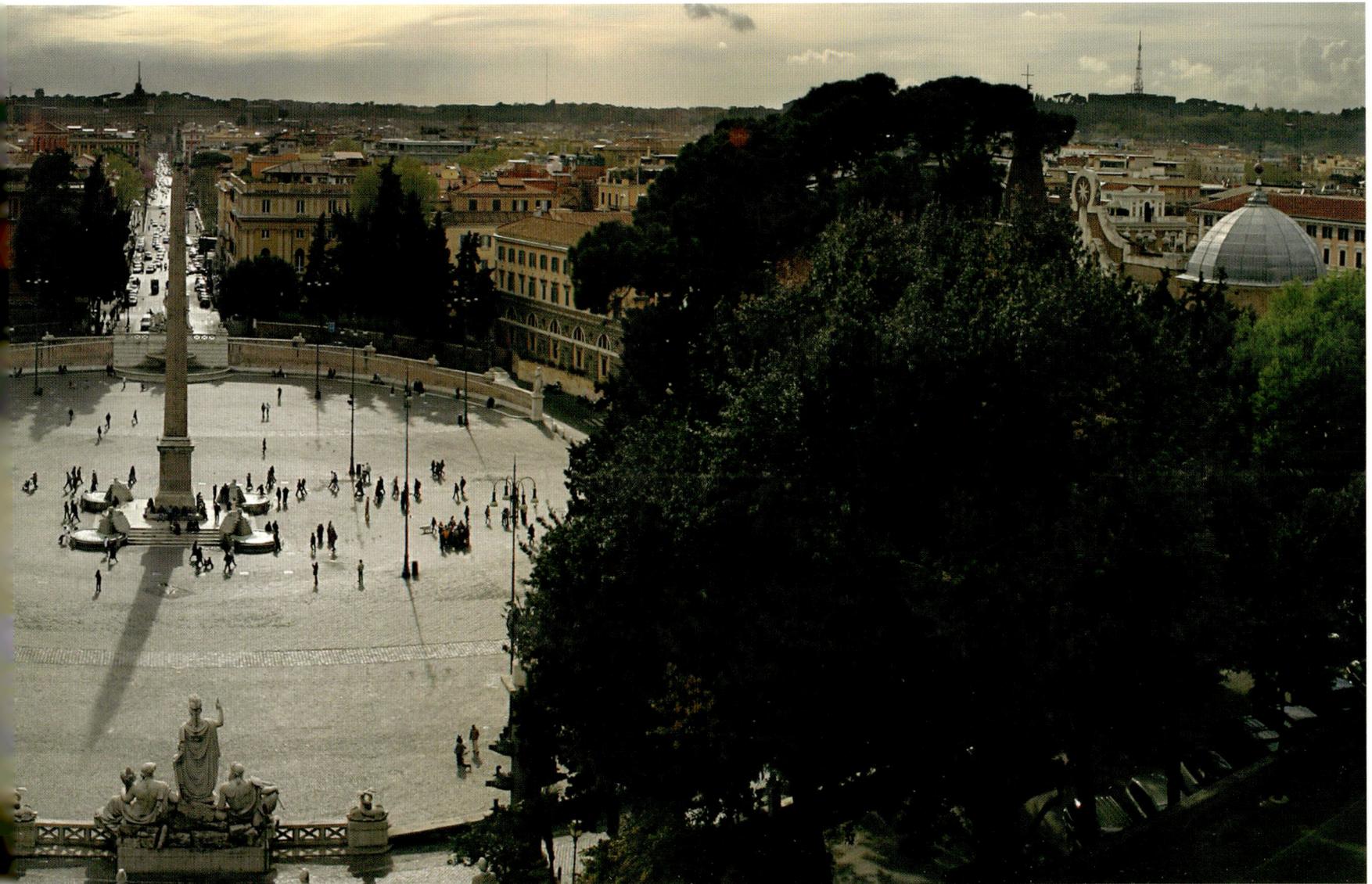

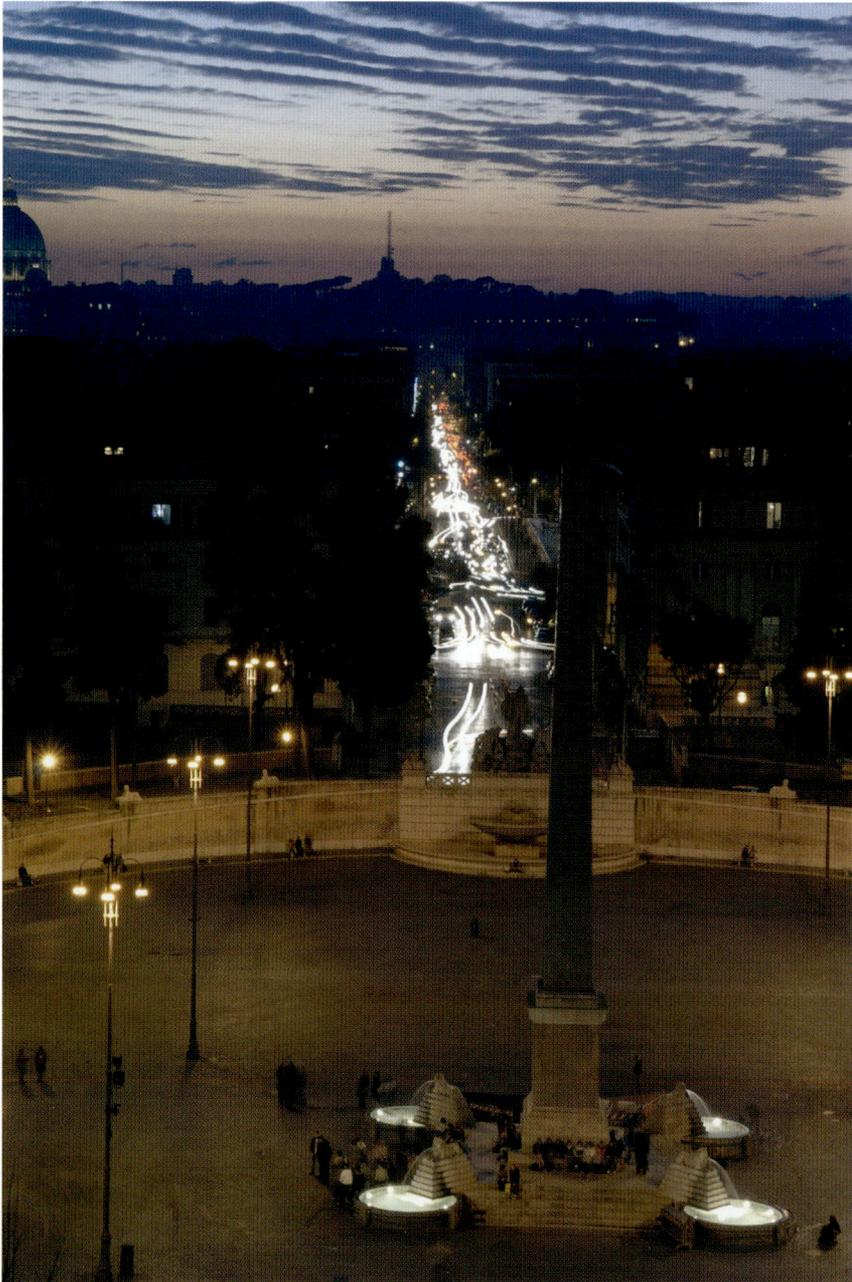

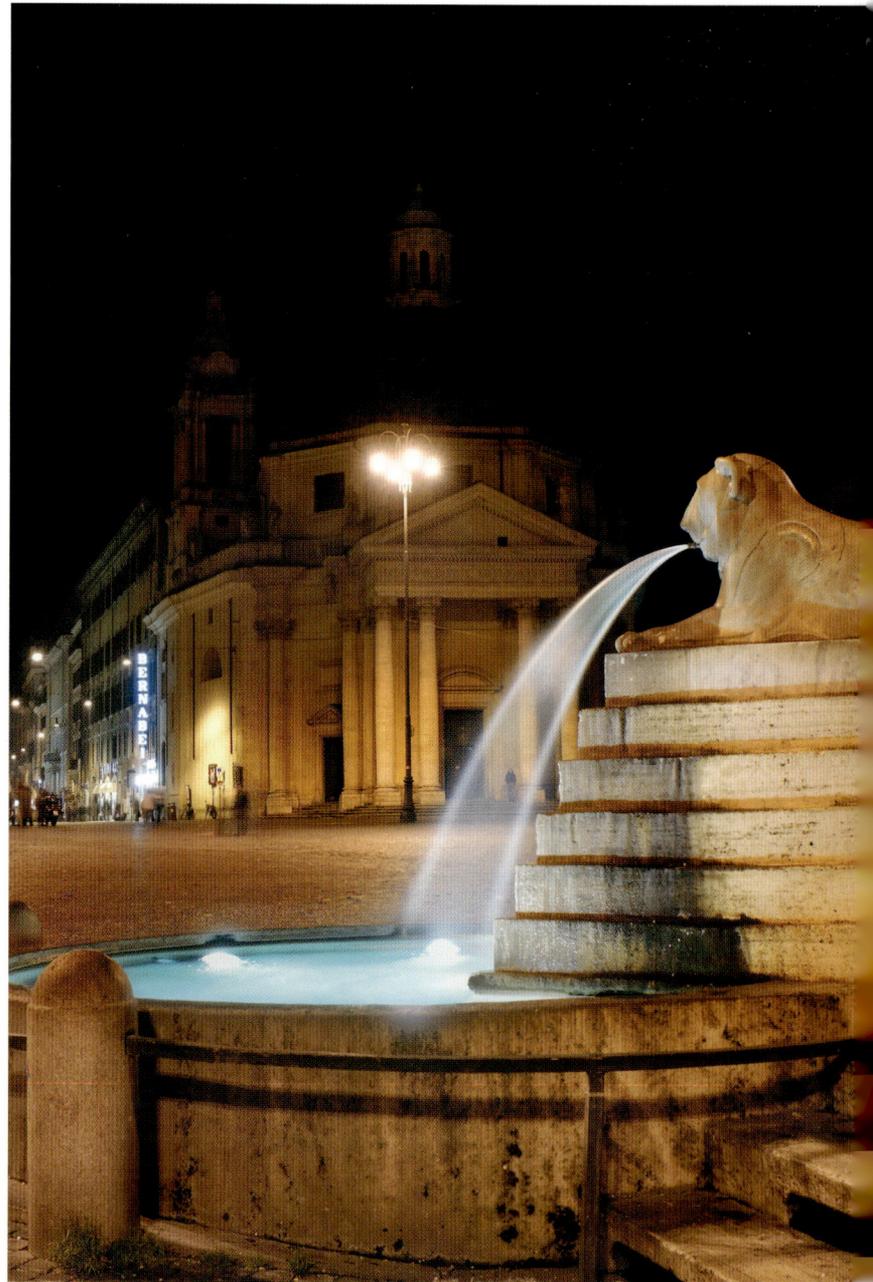

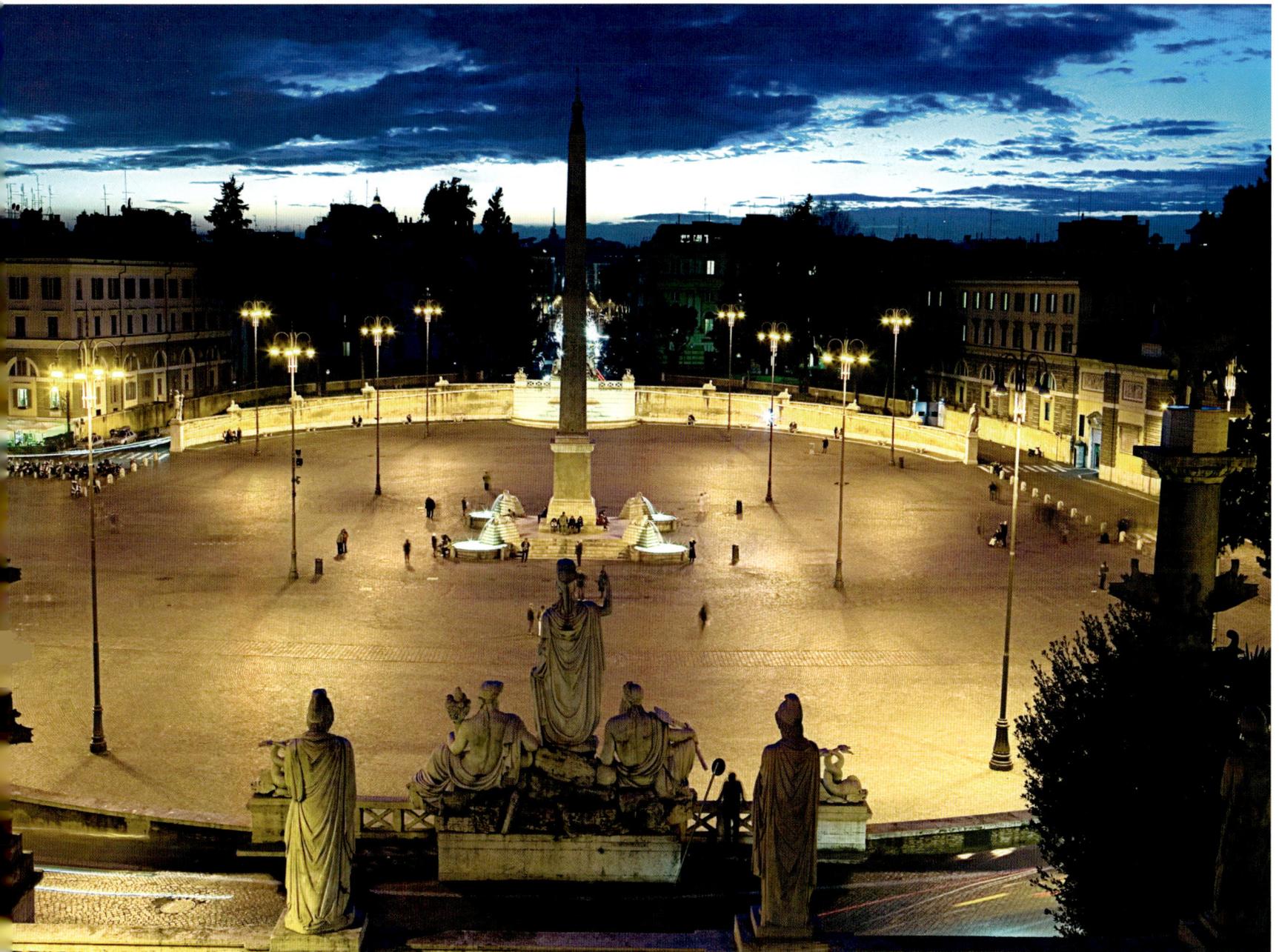

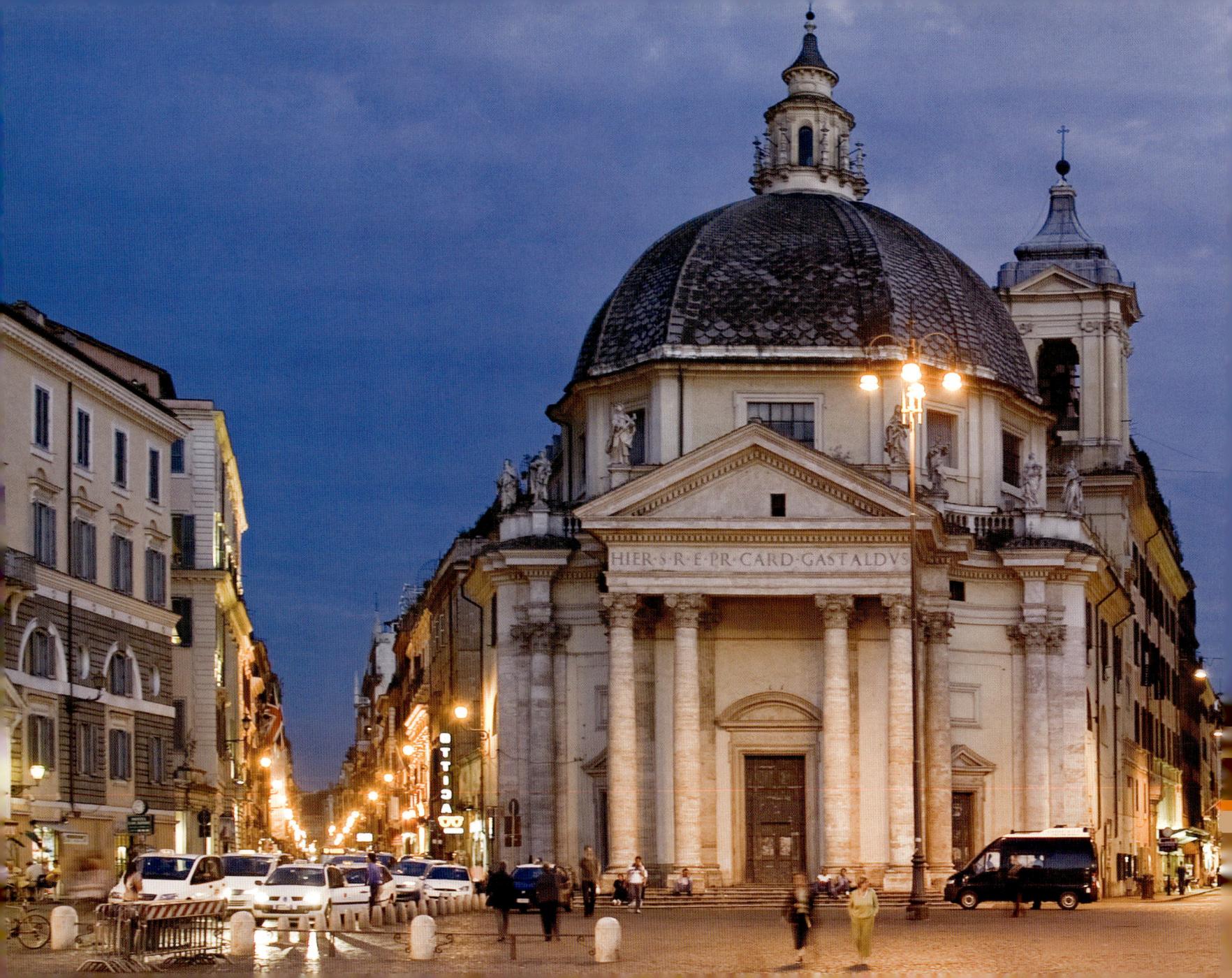

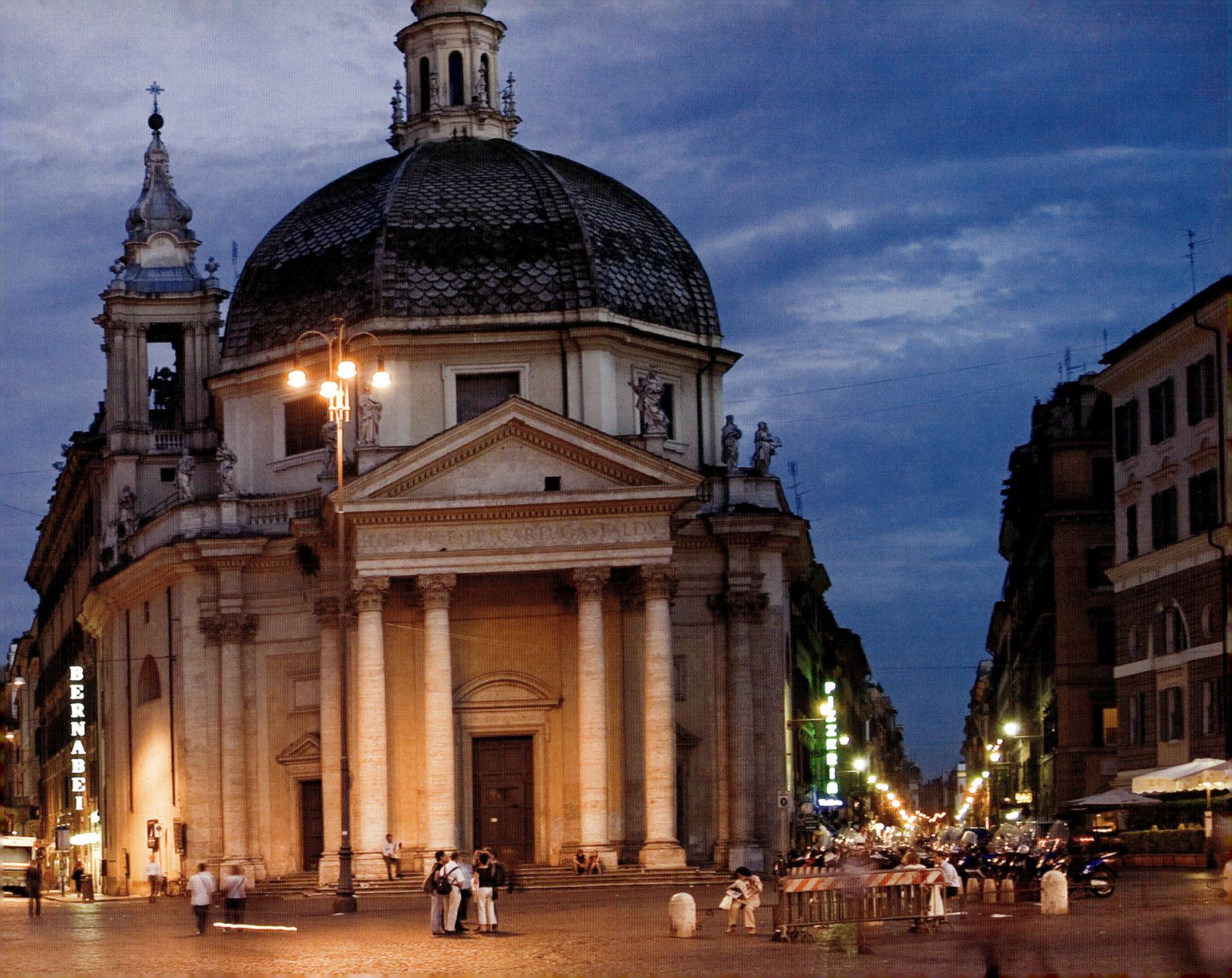

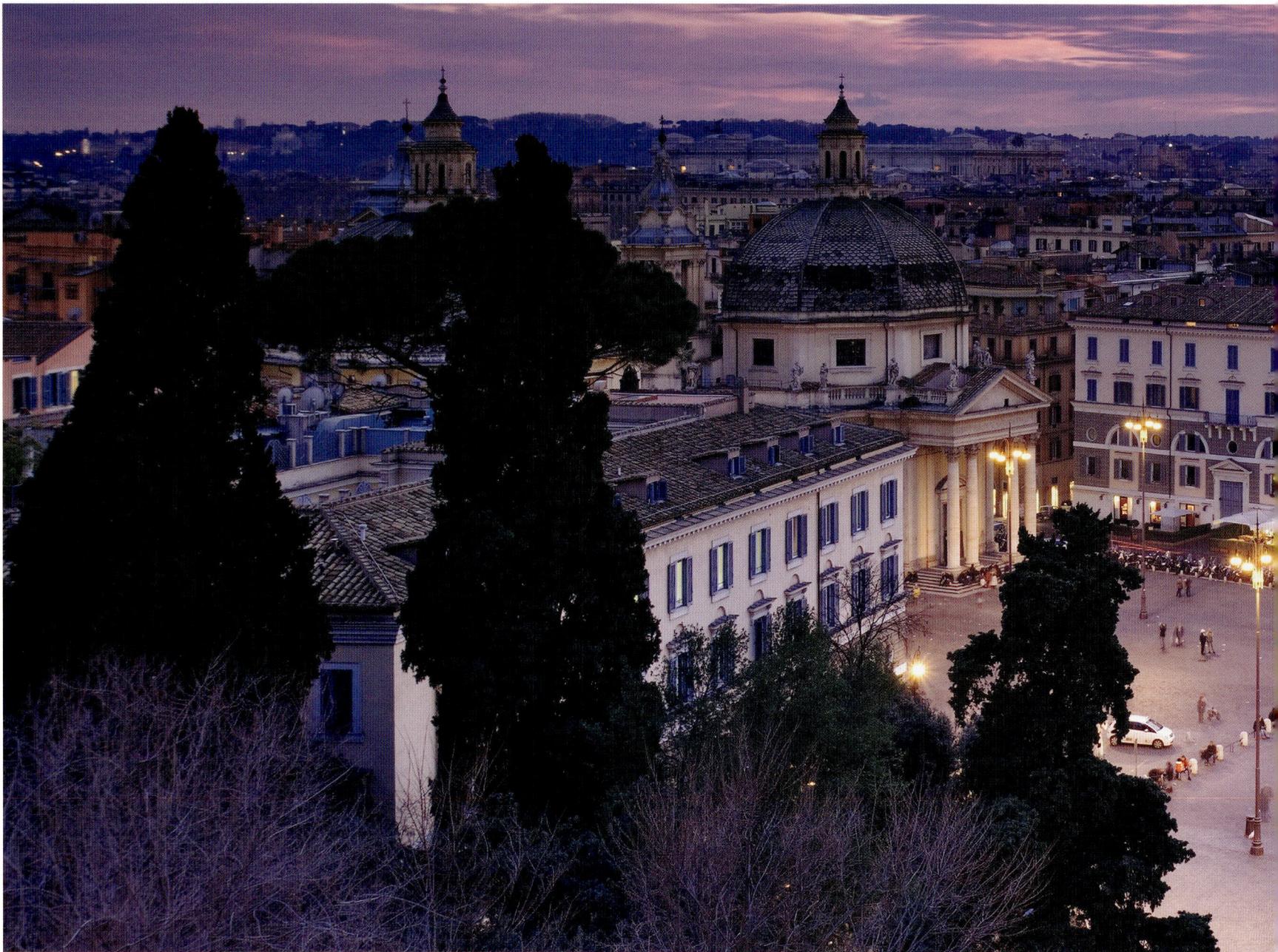

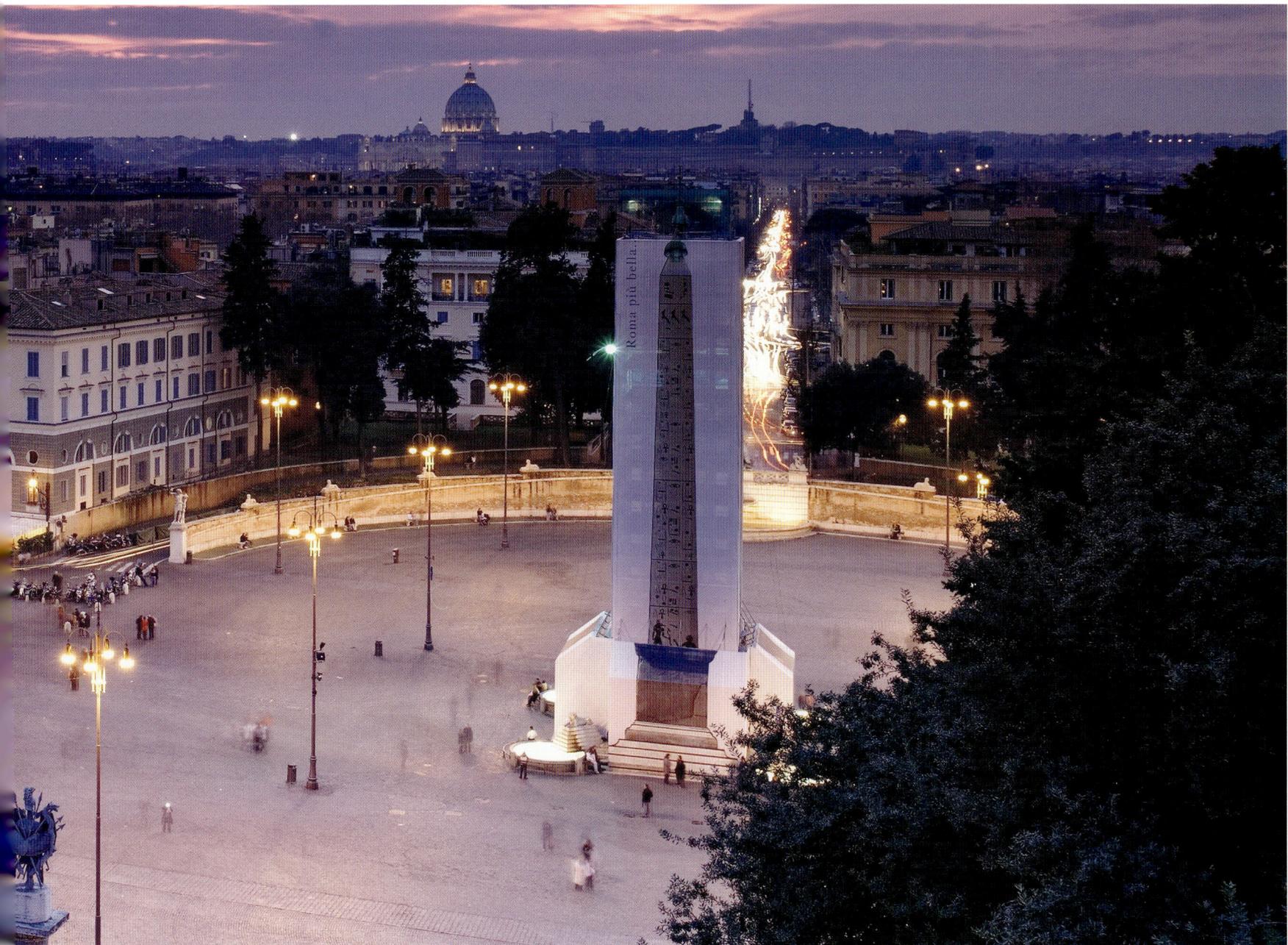

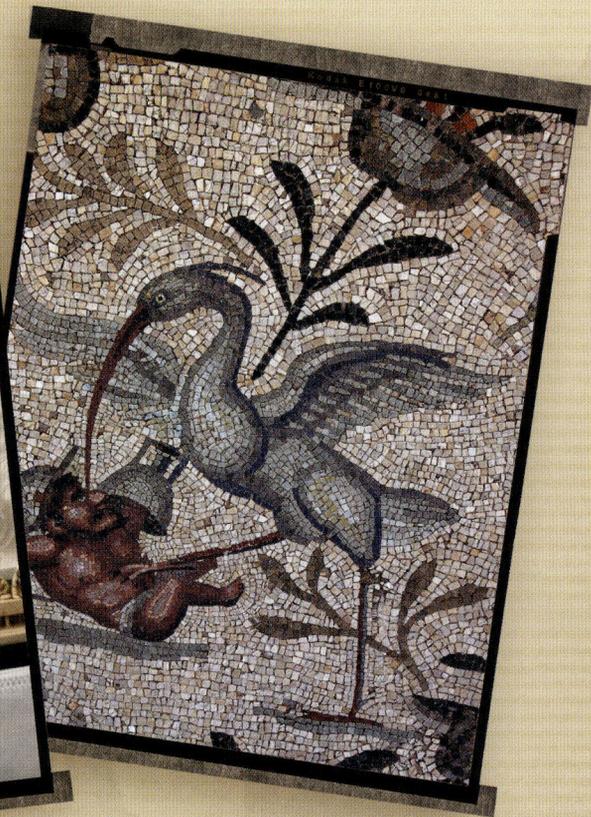

"I found Rome a city of bricks and left it a city of marble."

Augustus

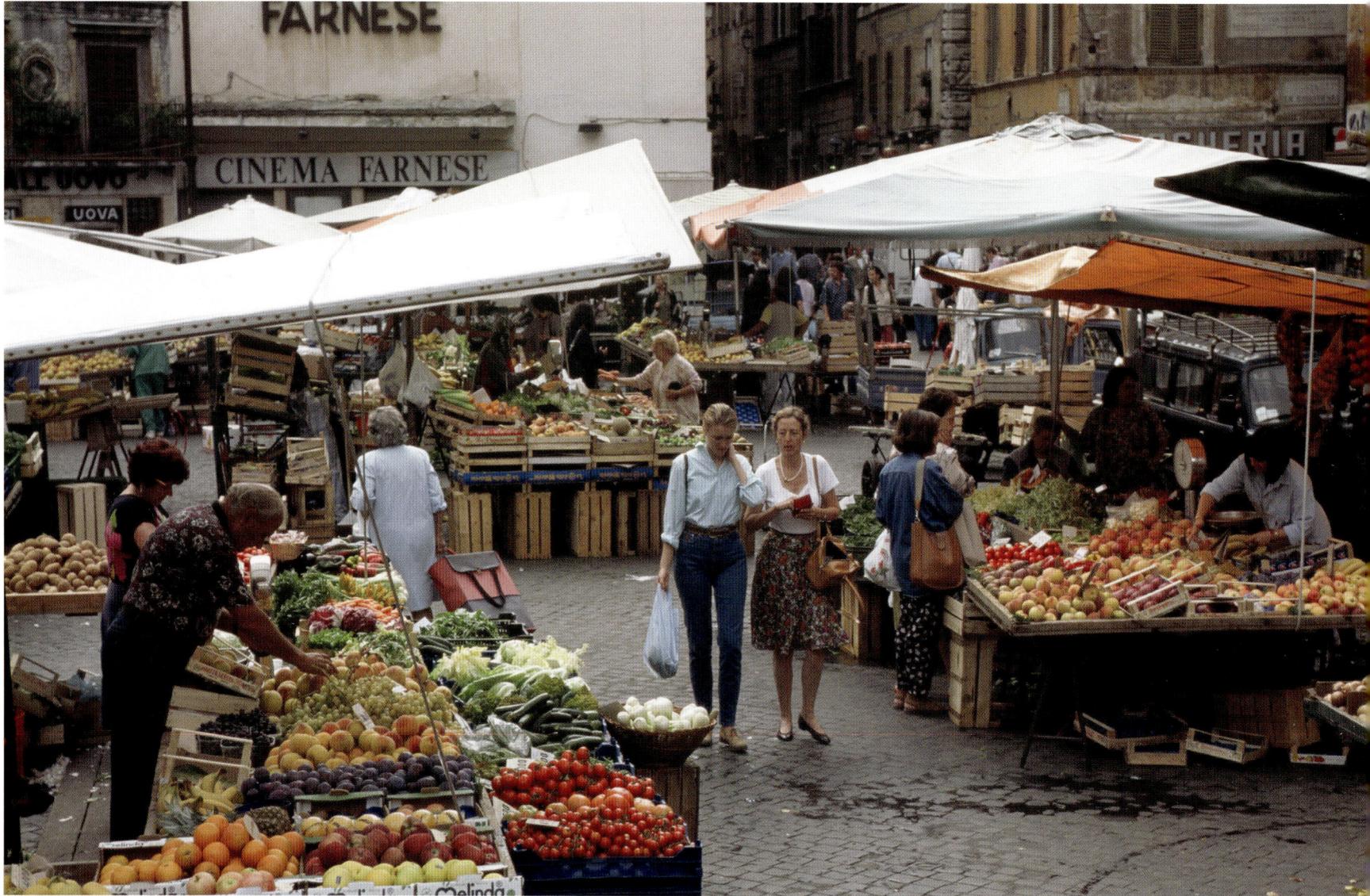

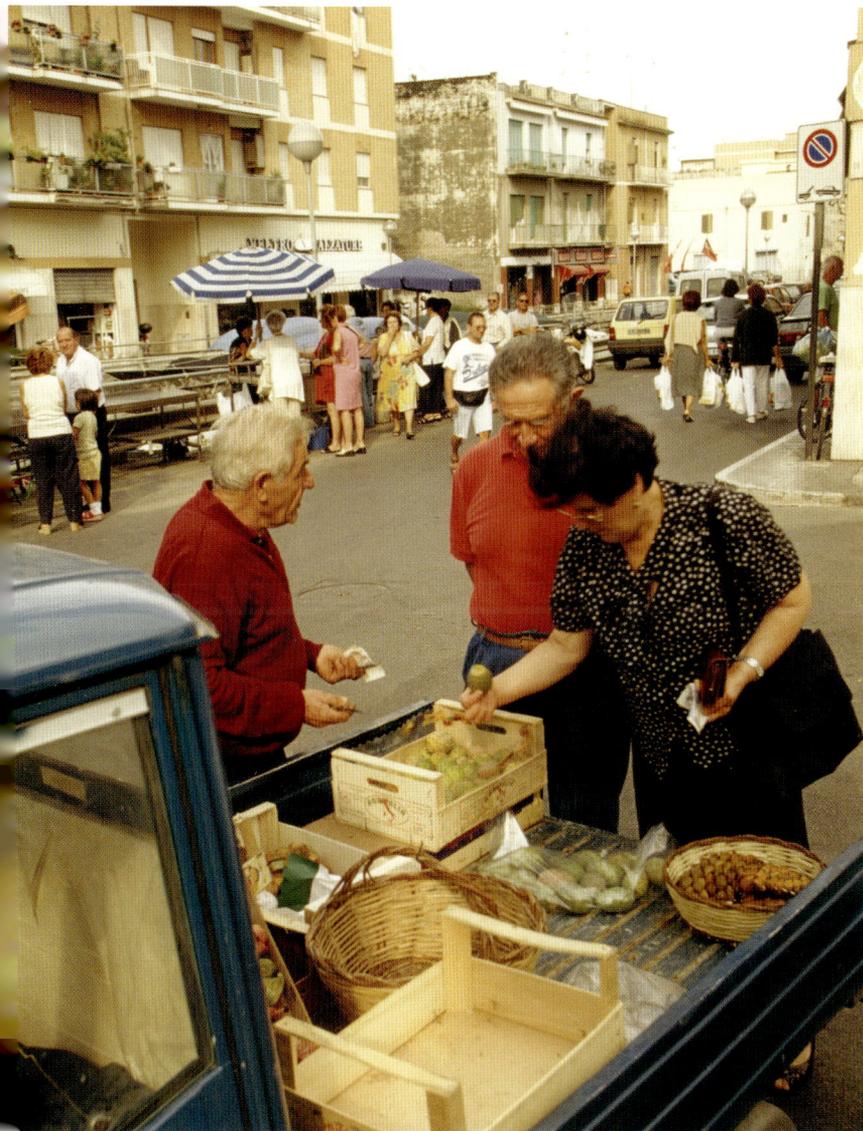

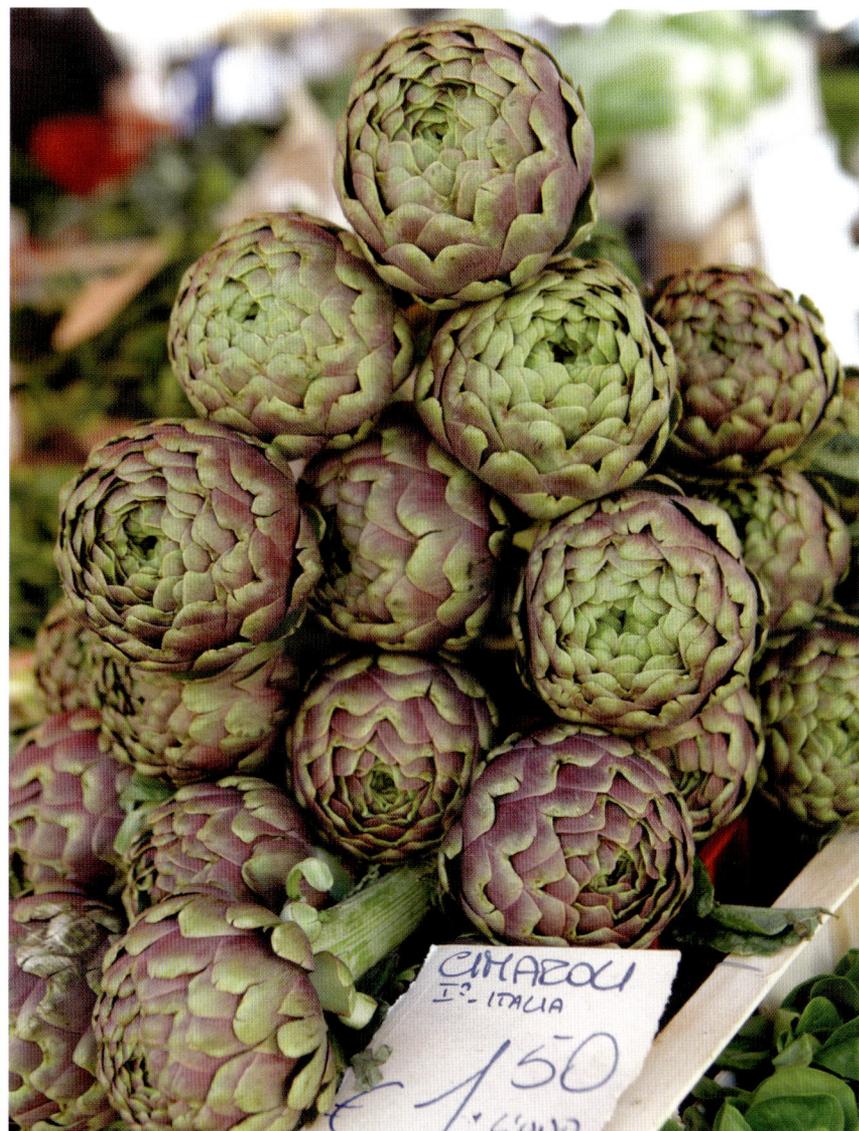

CIMAROLI
I° ITALIA
€ 1.50
L'UNO

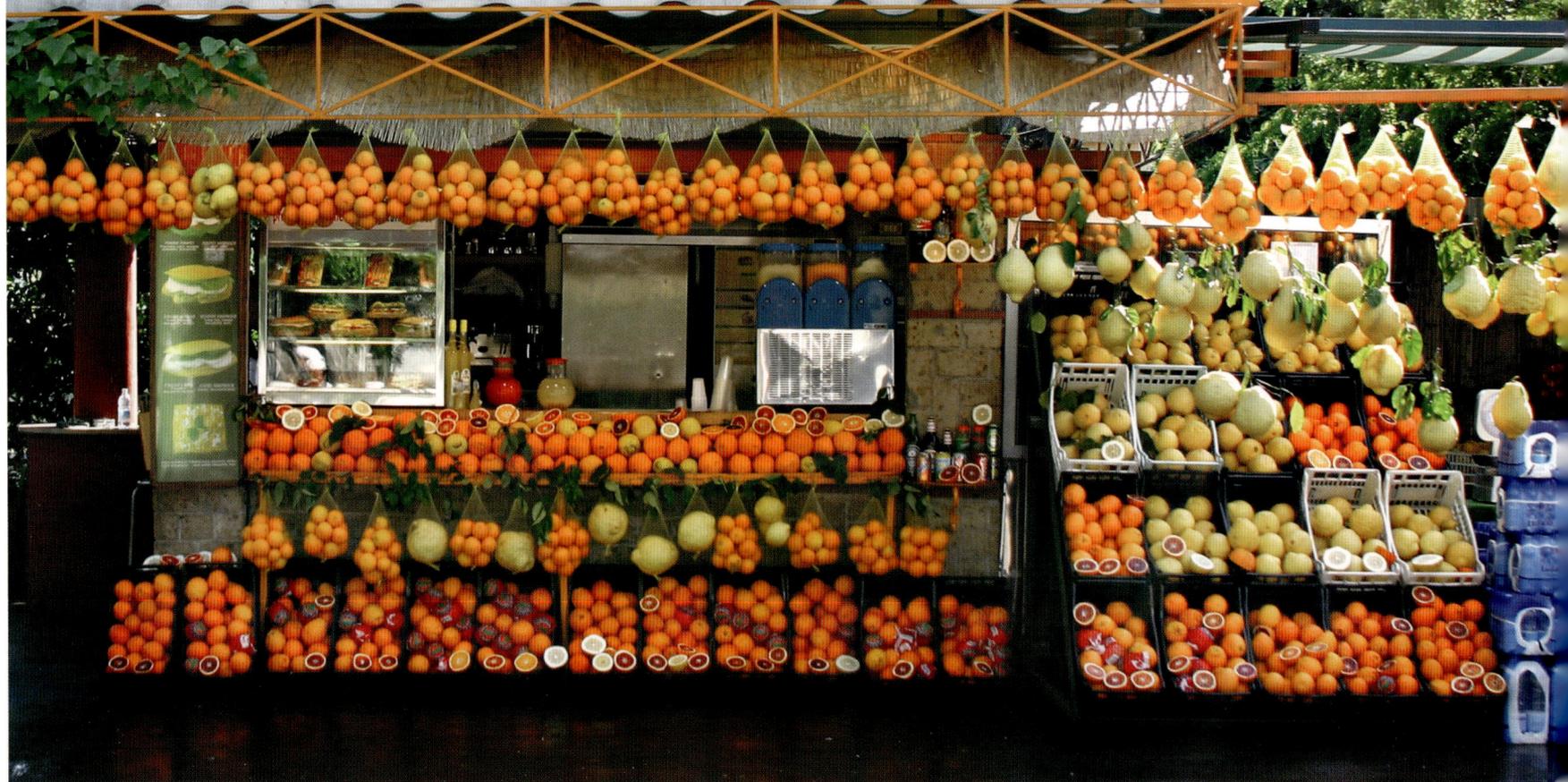

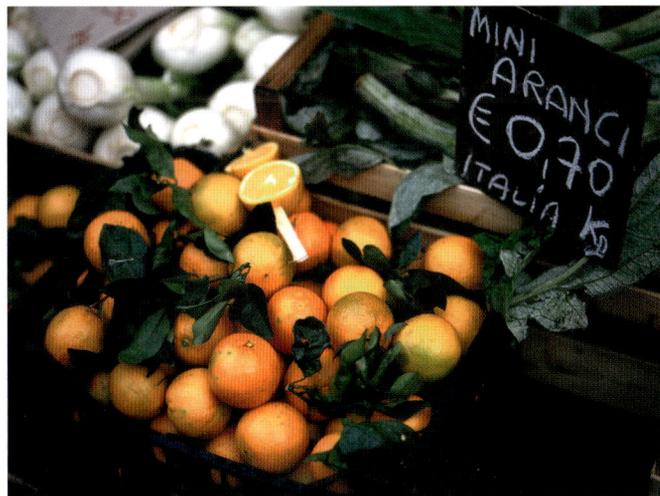
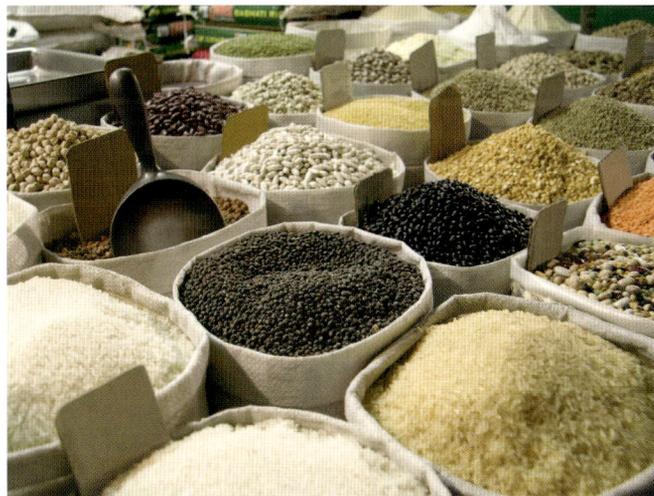

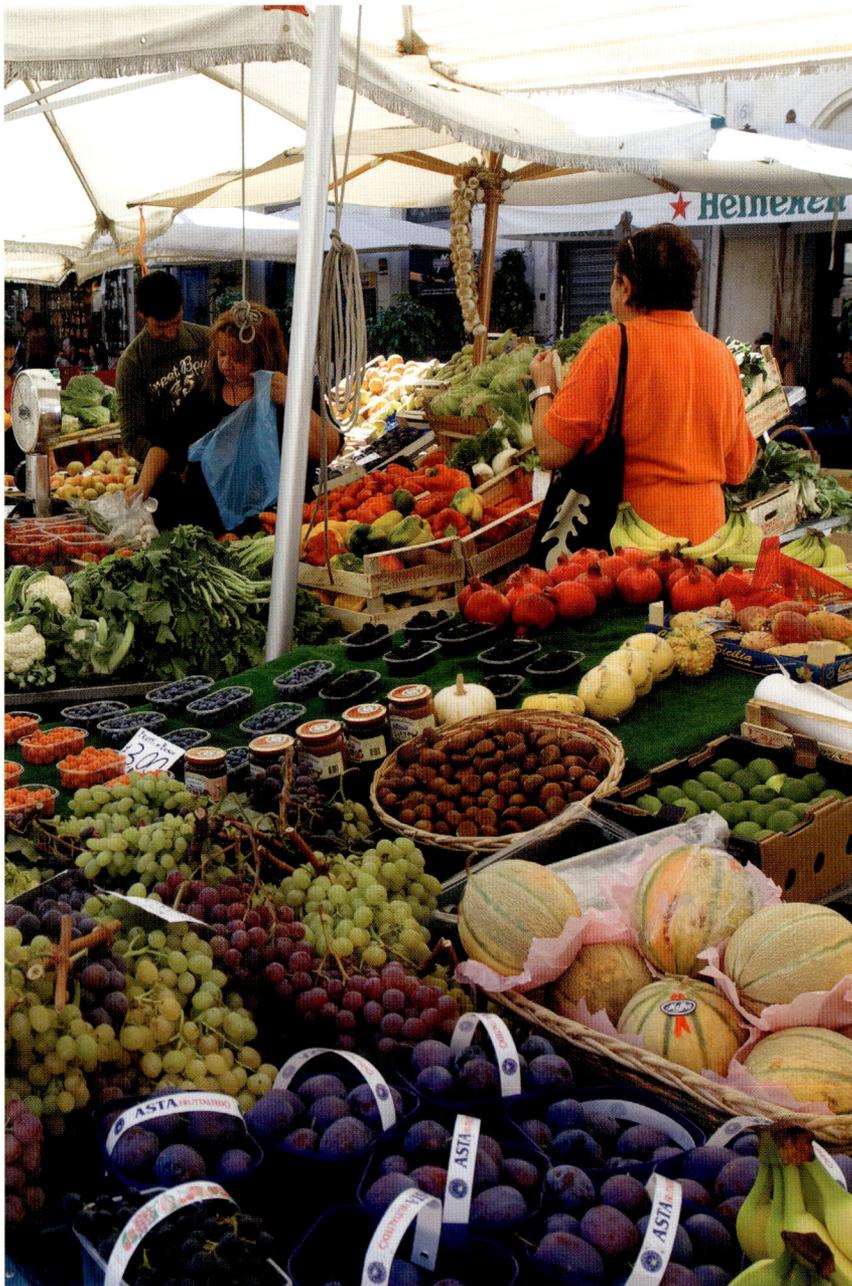
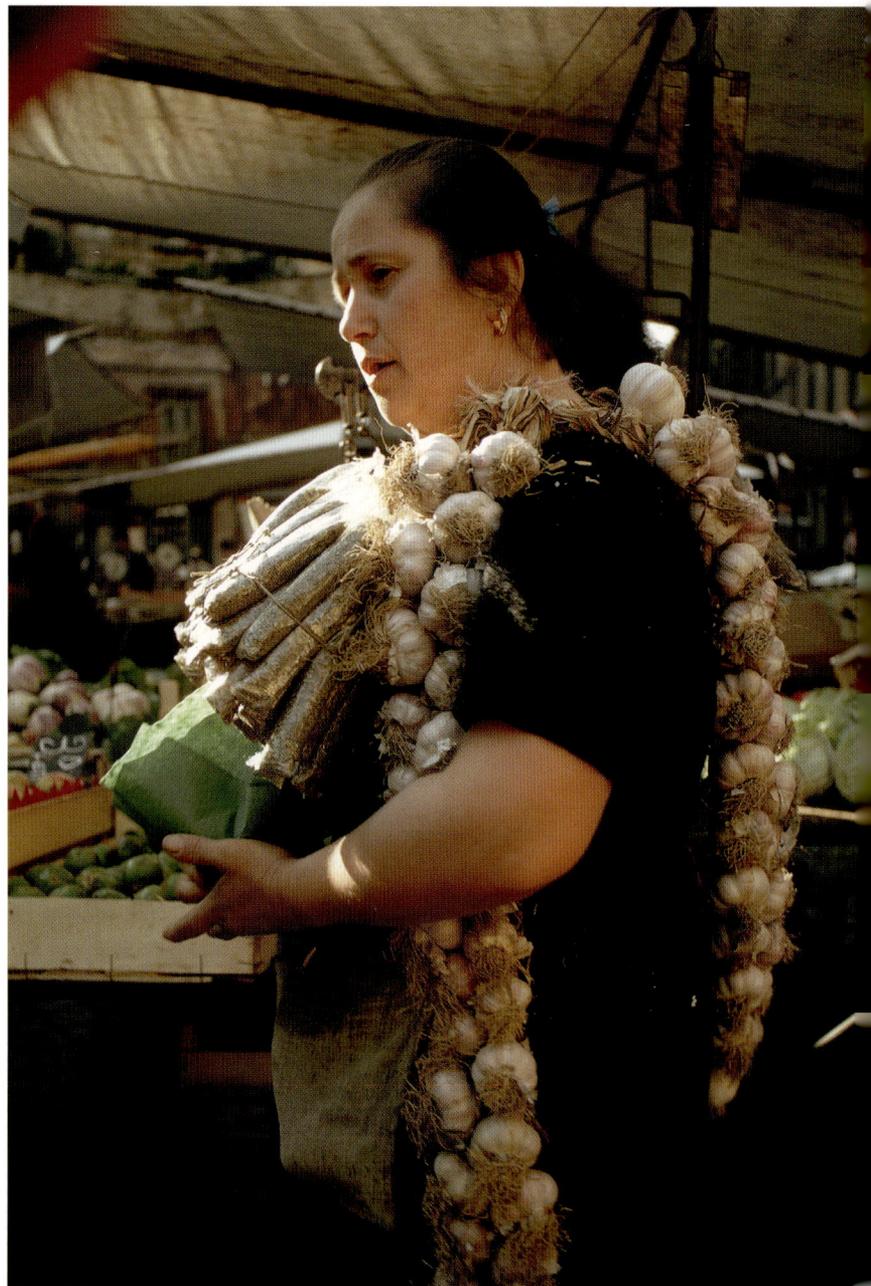

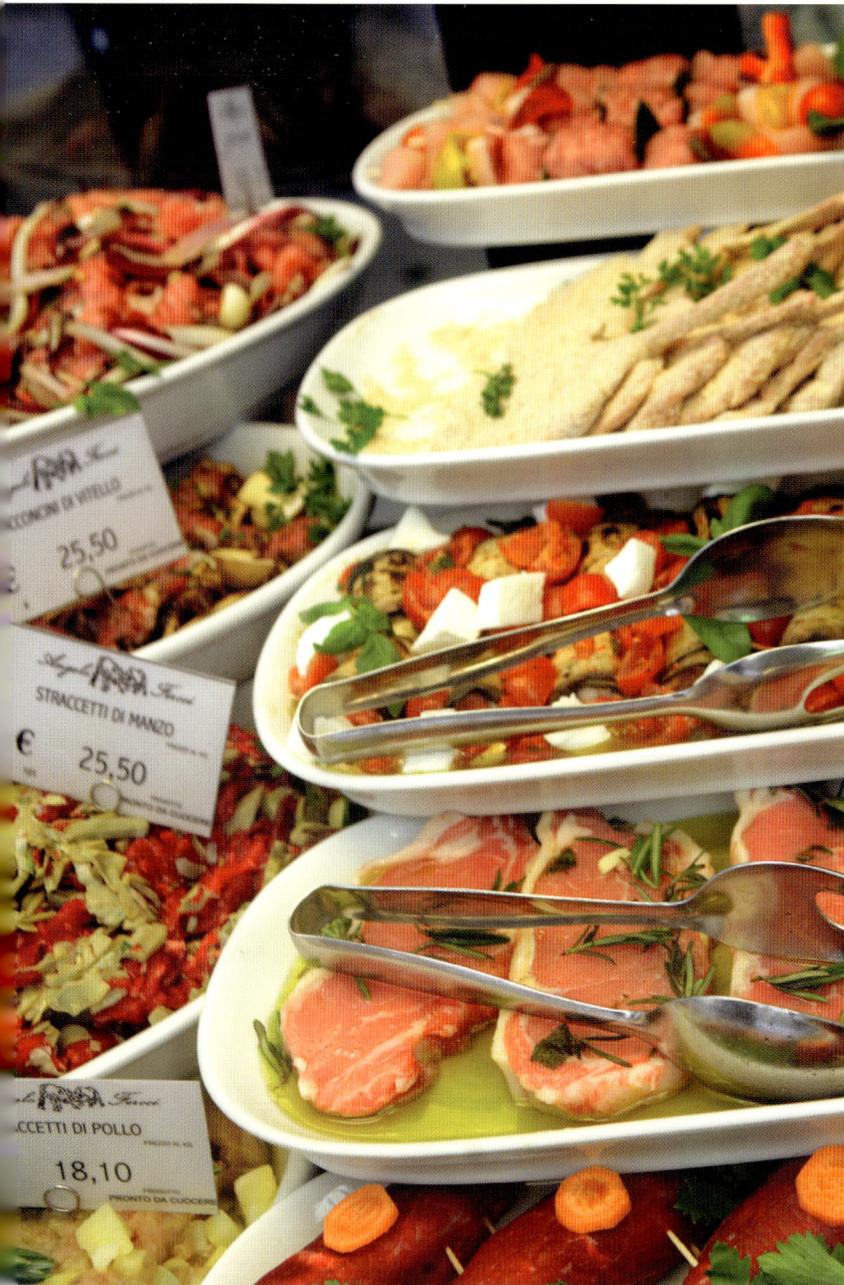

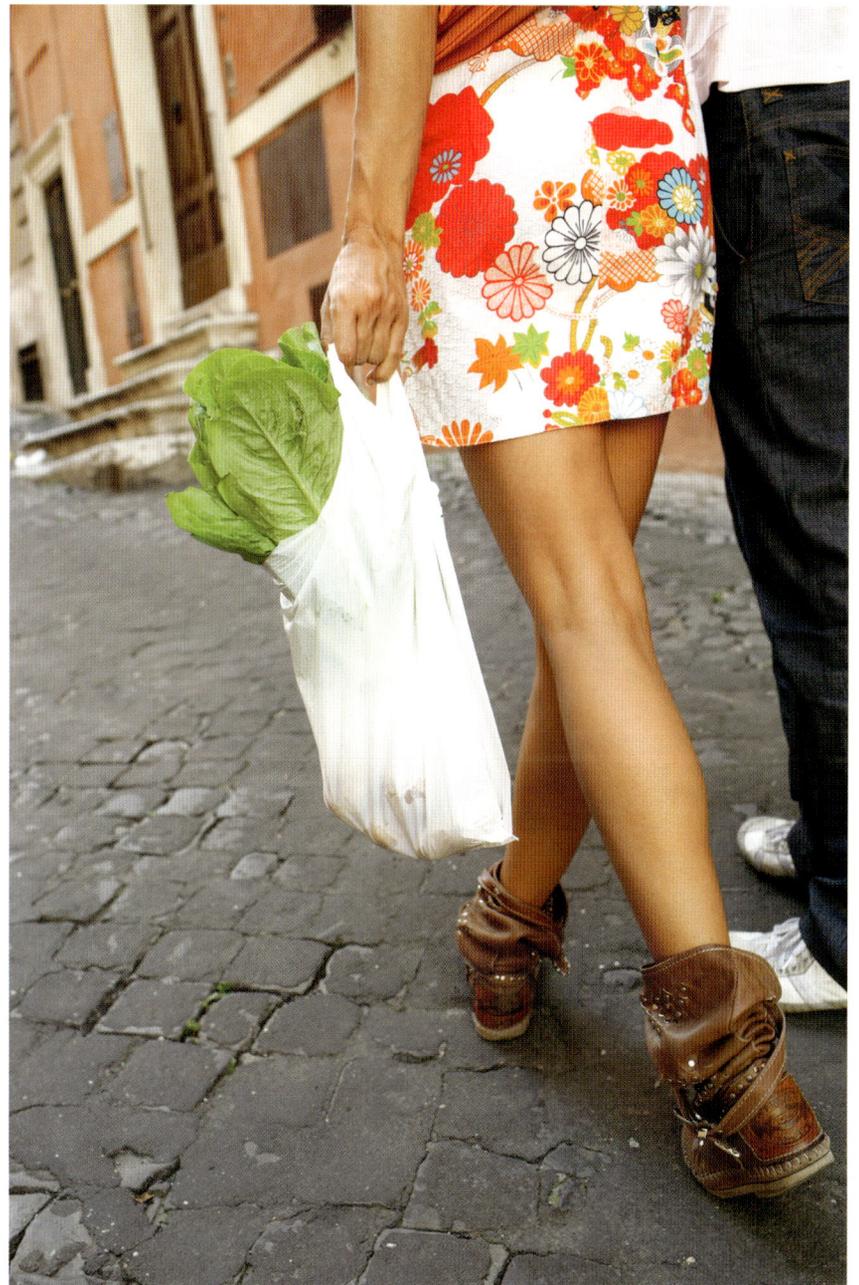

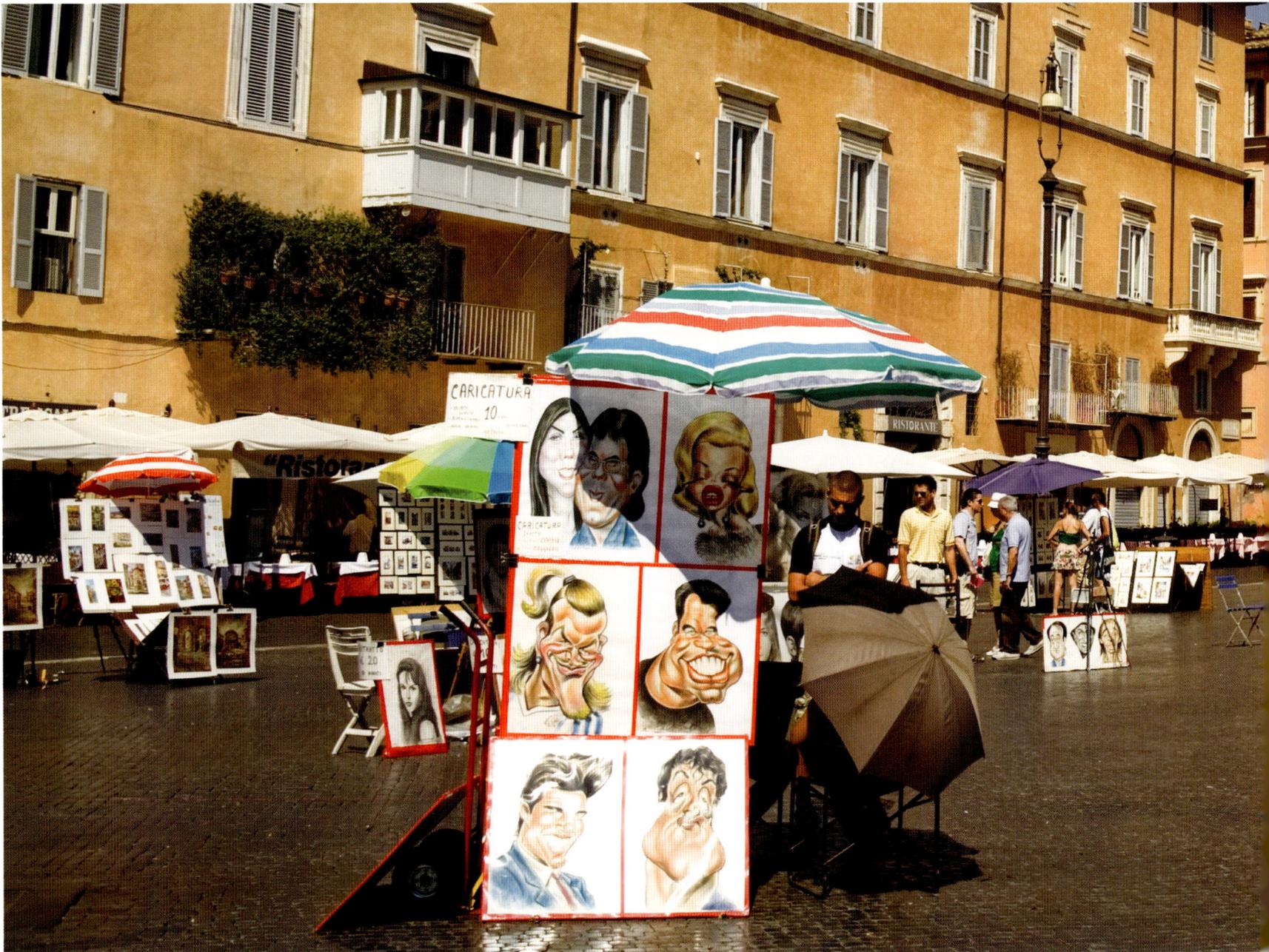

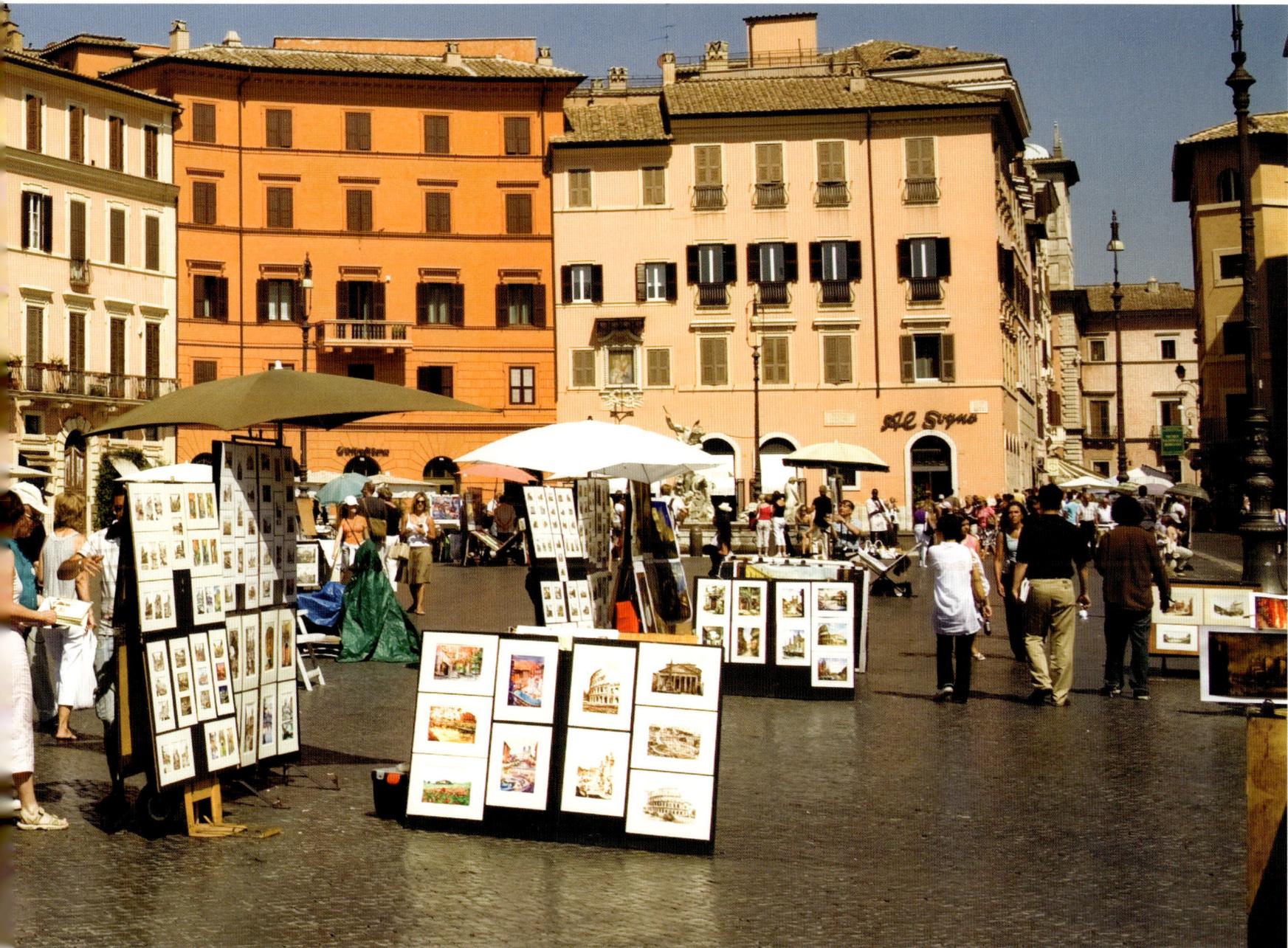

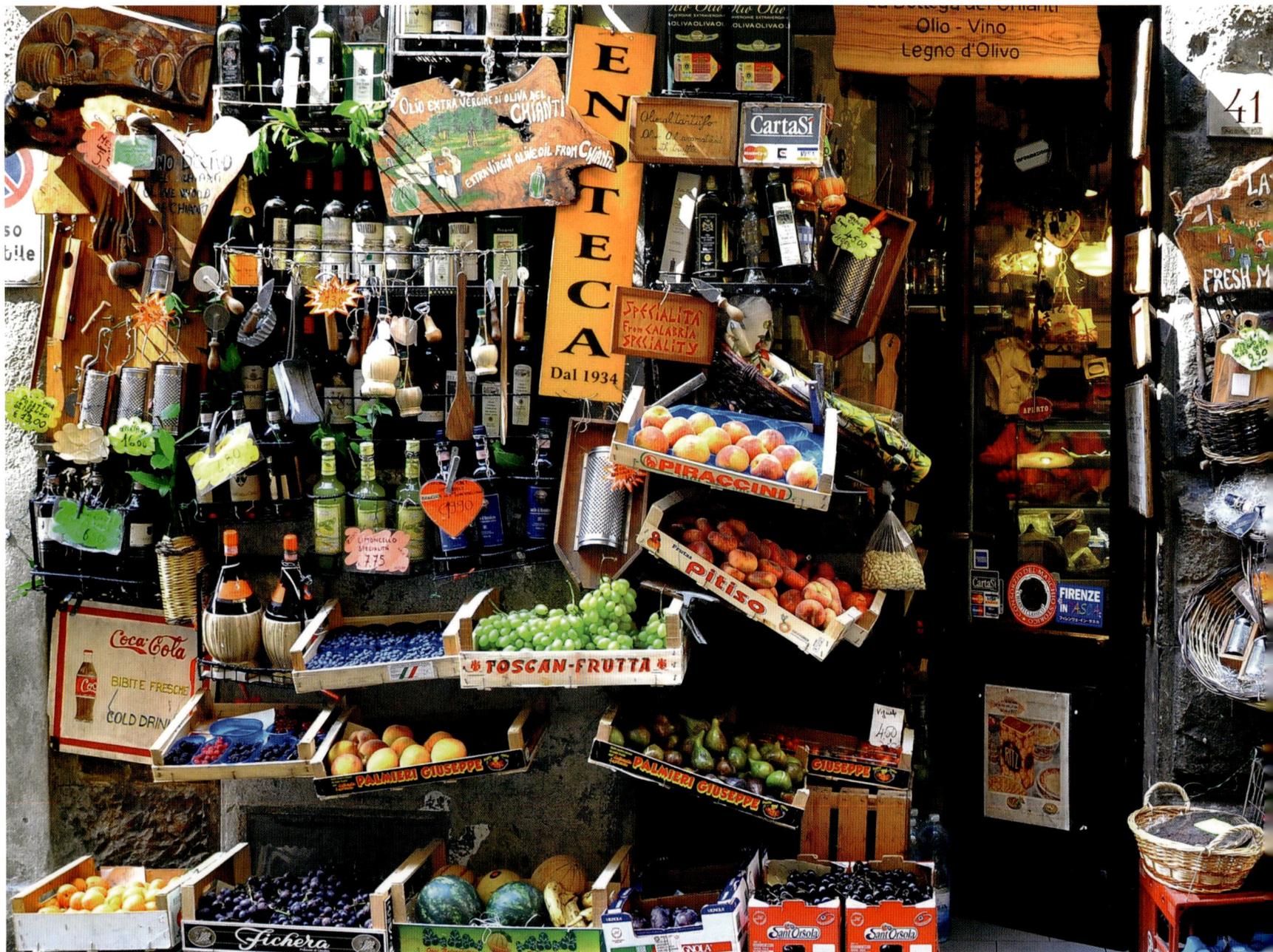

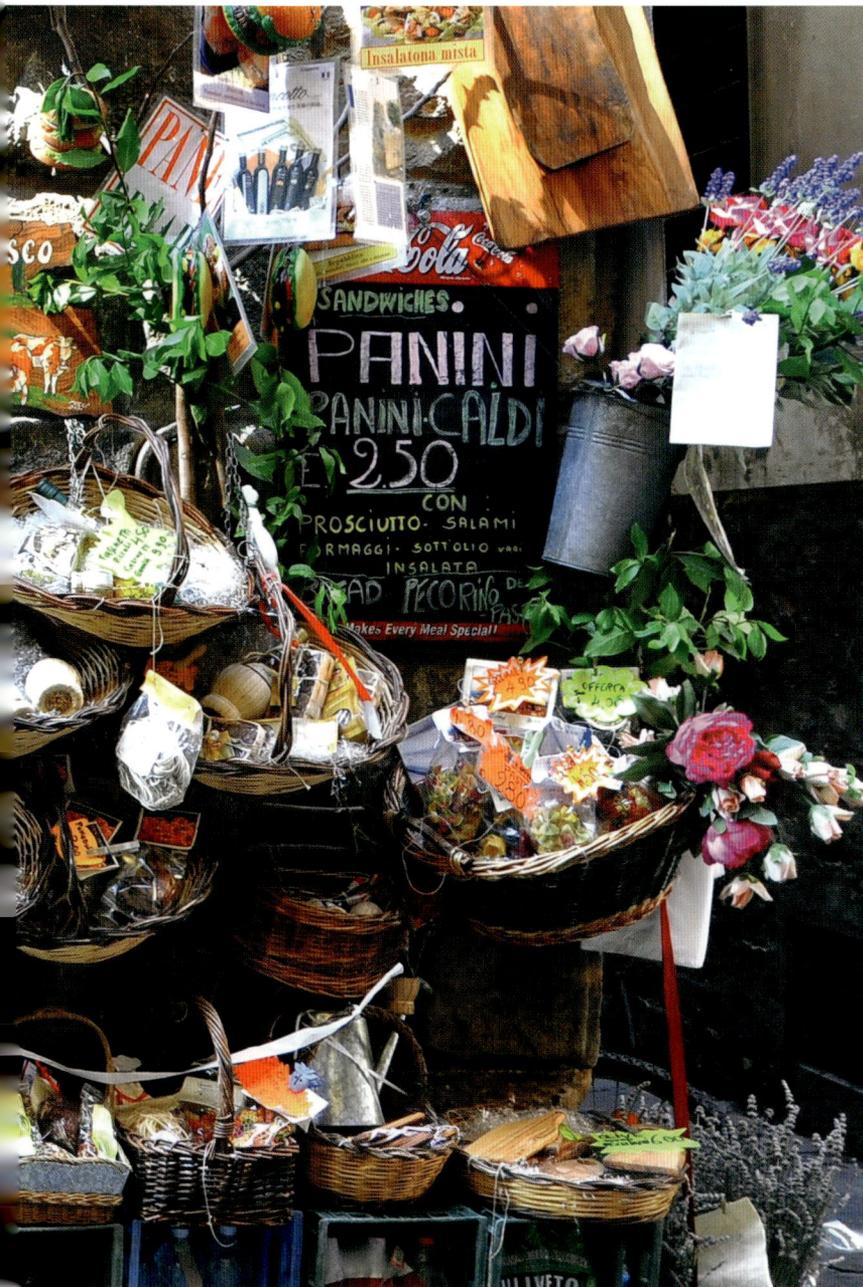

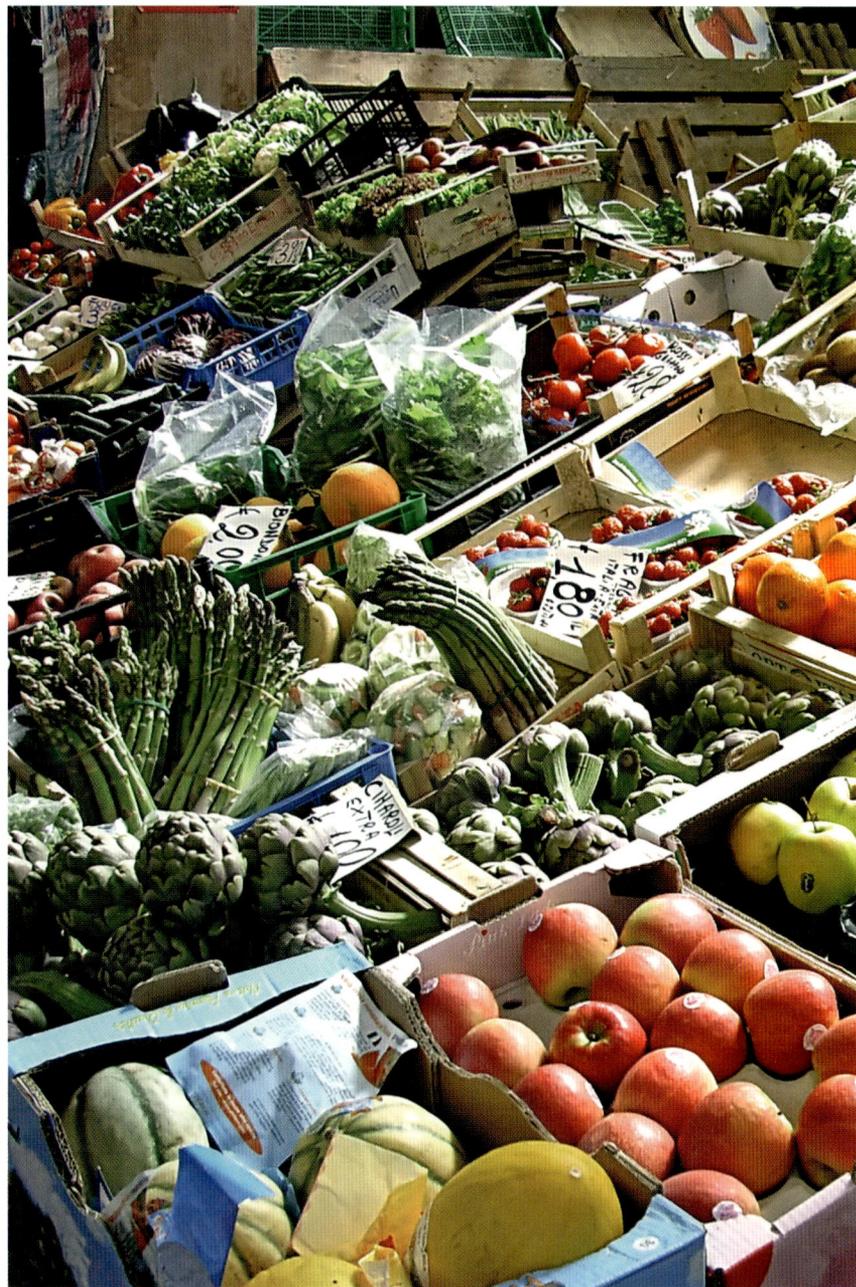

"Wealth conquered Rome after Rome had conquered the world"

Italian Proverb

Roofs of Rome

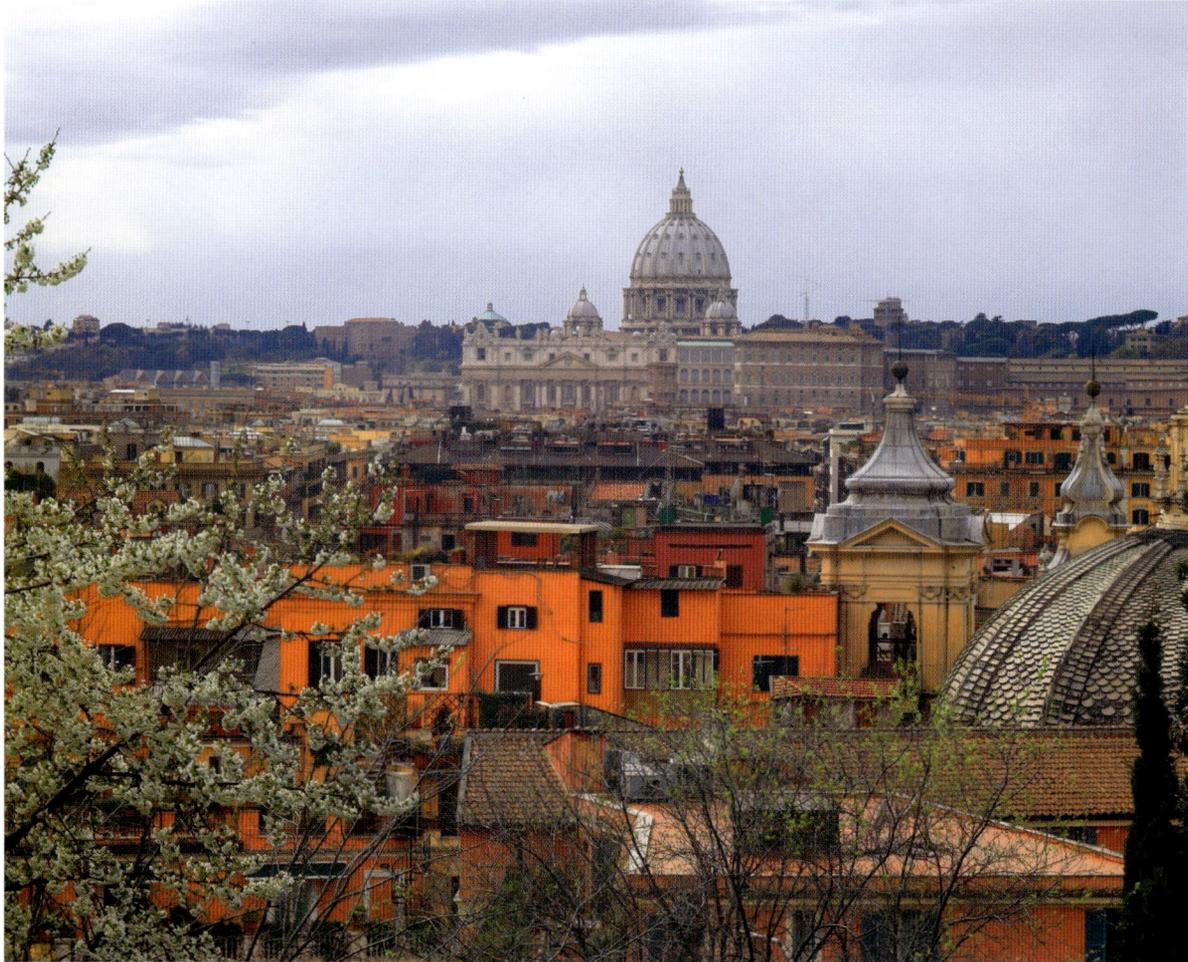

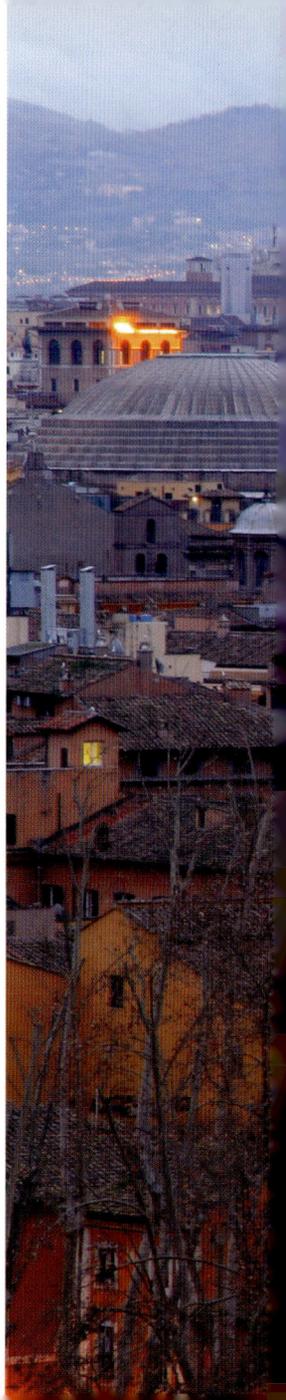

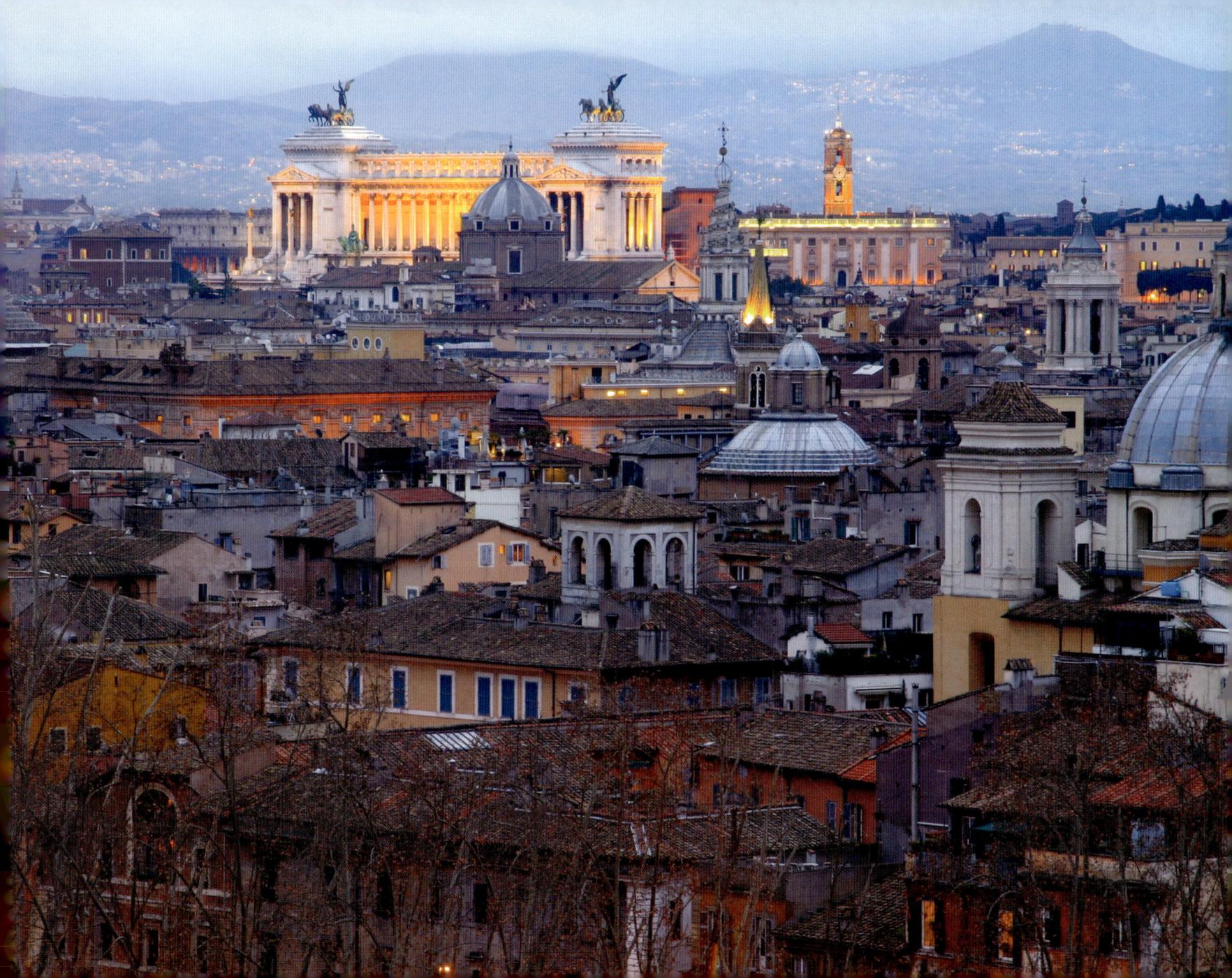

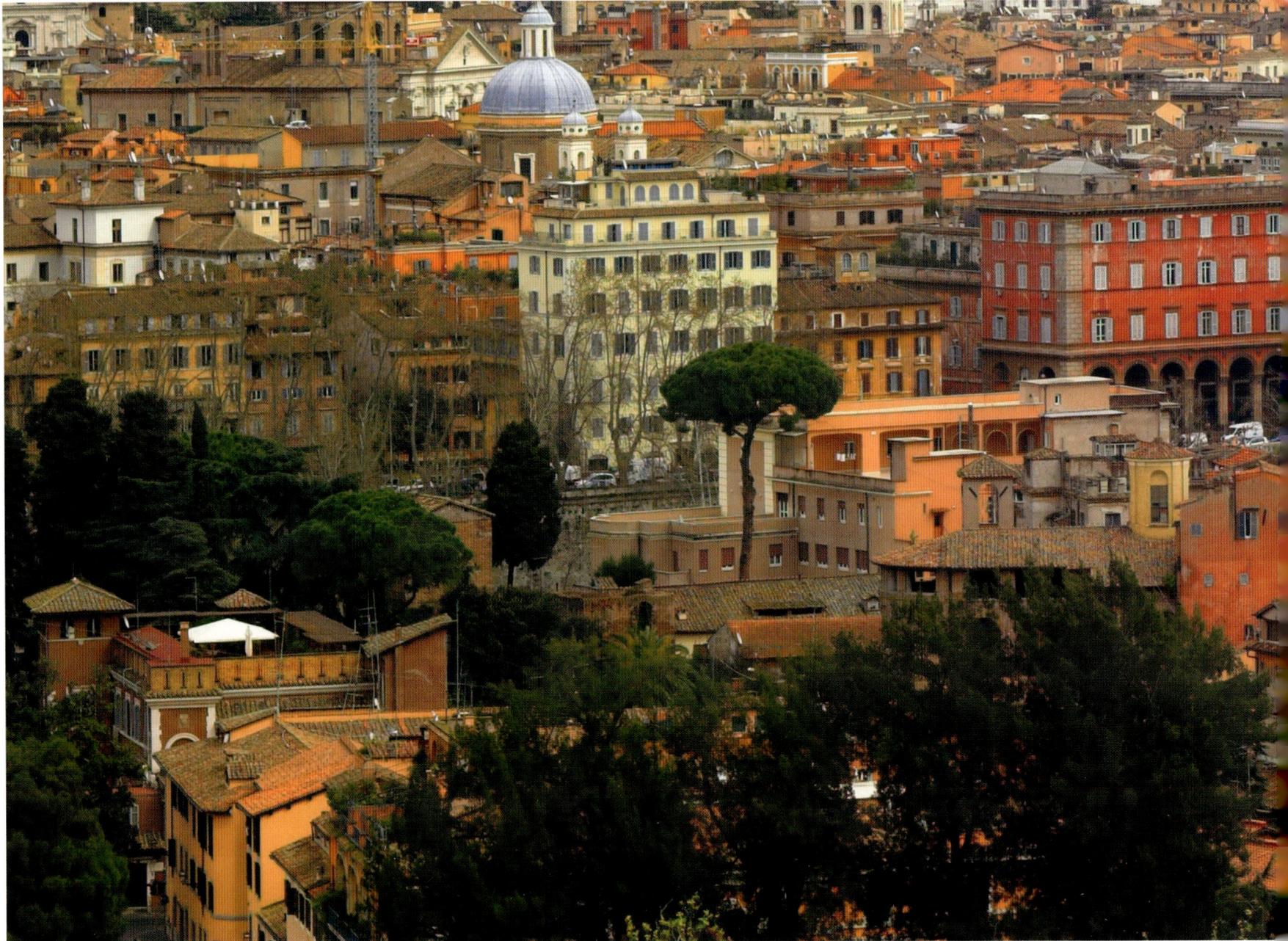

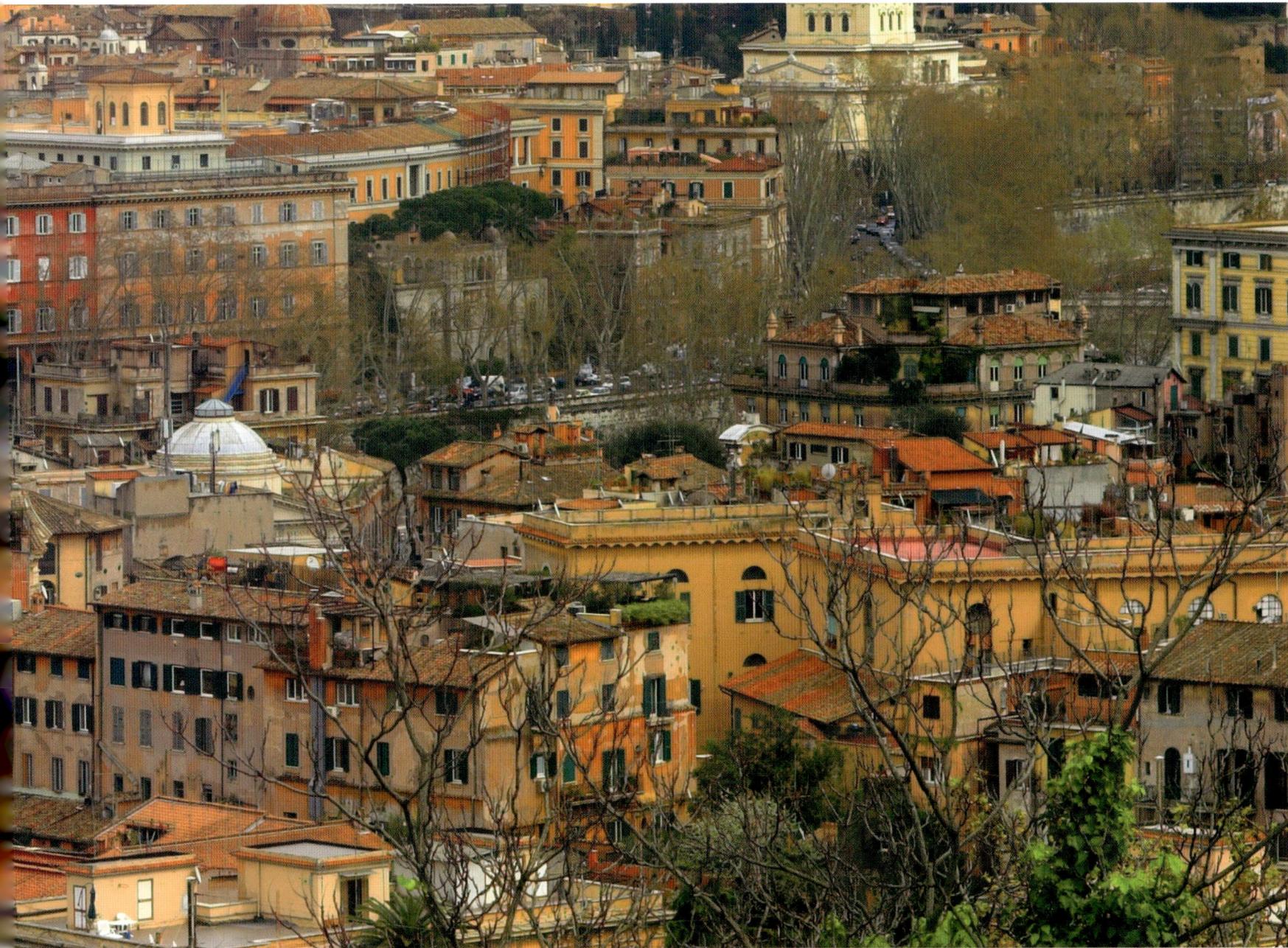

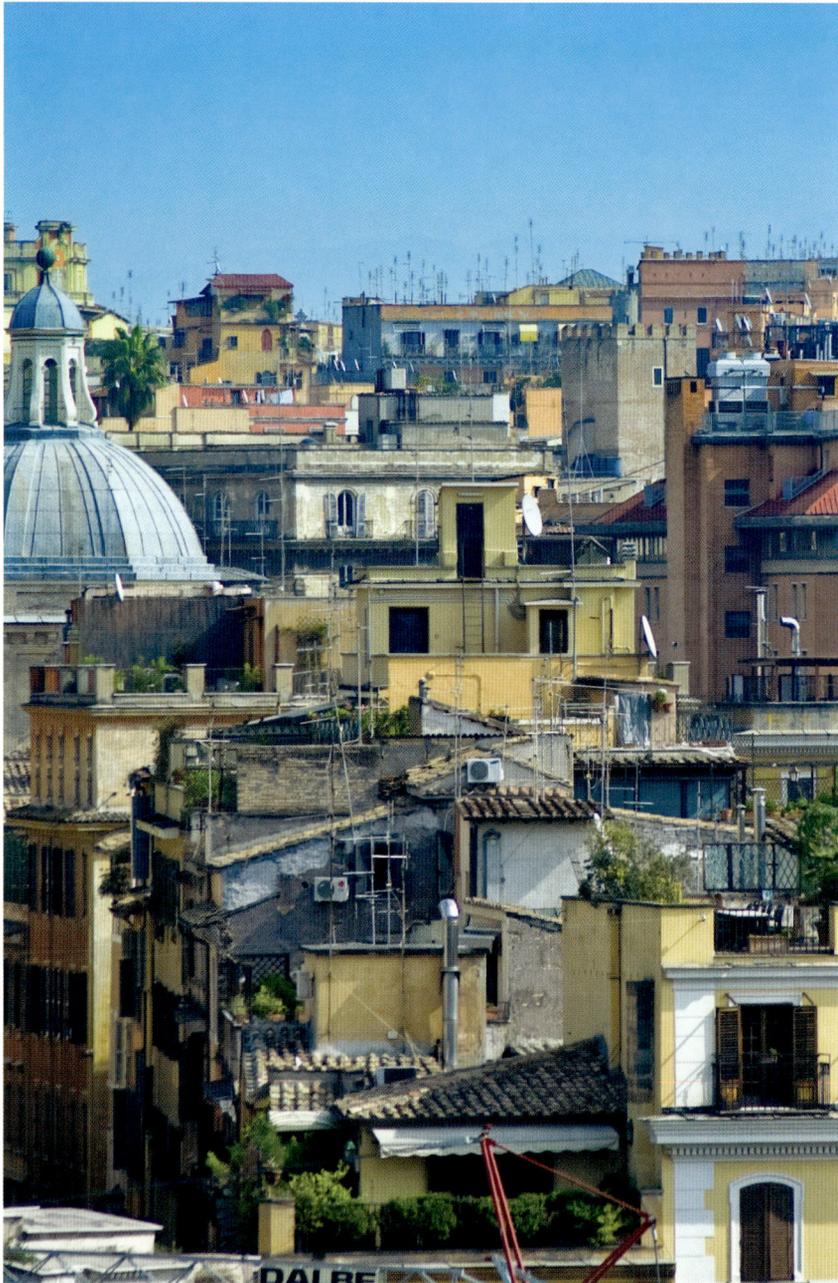

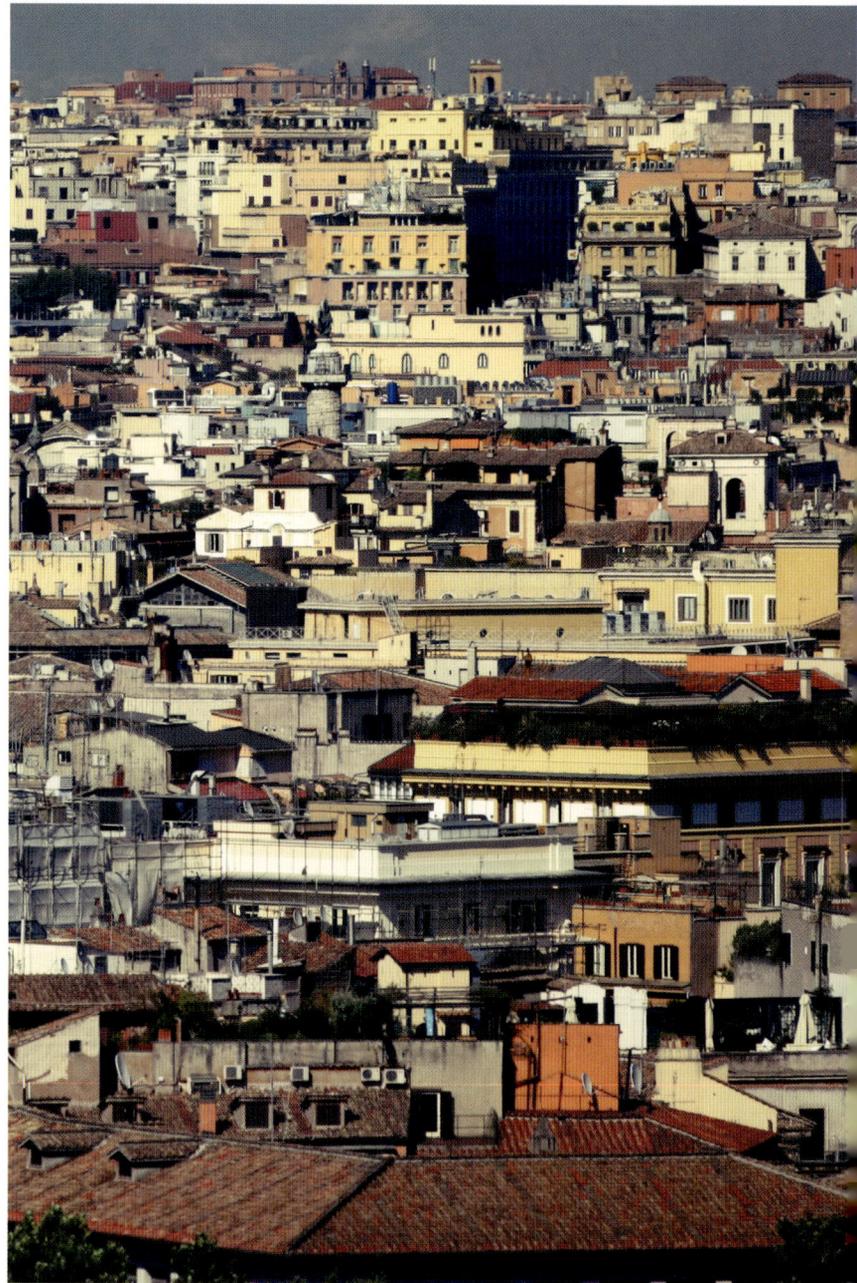

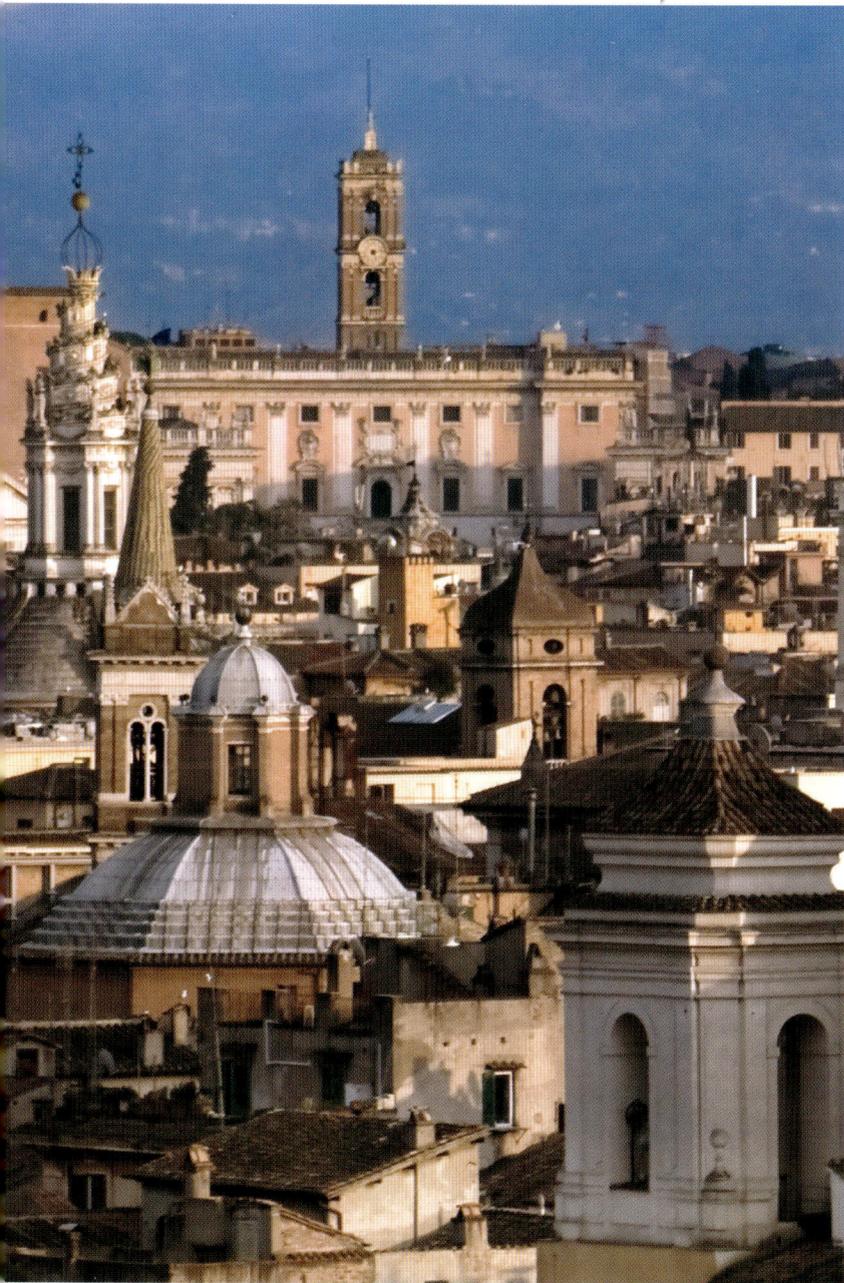

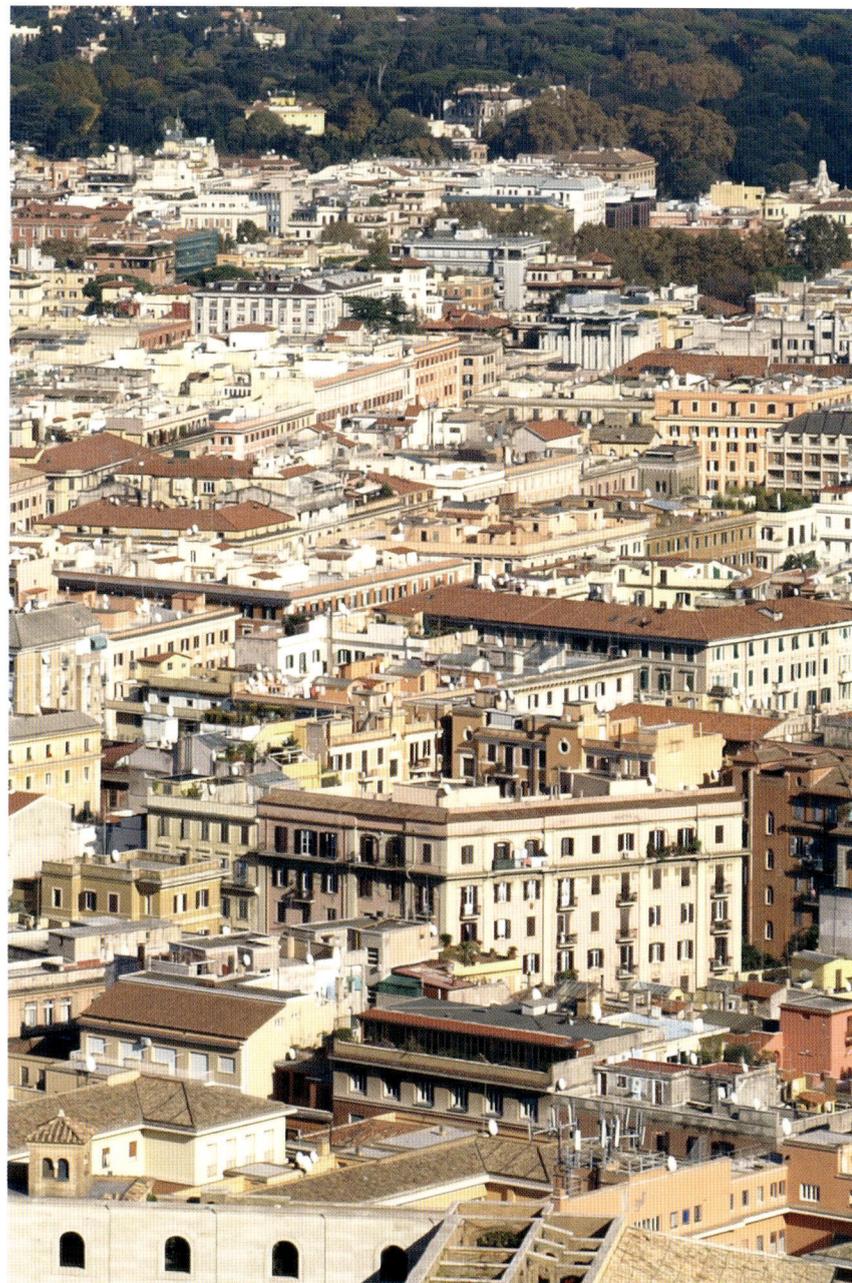

Spanish steps

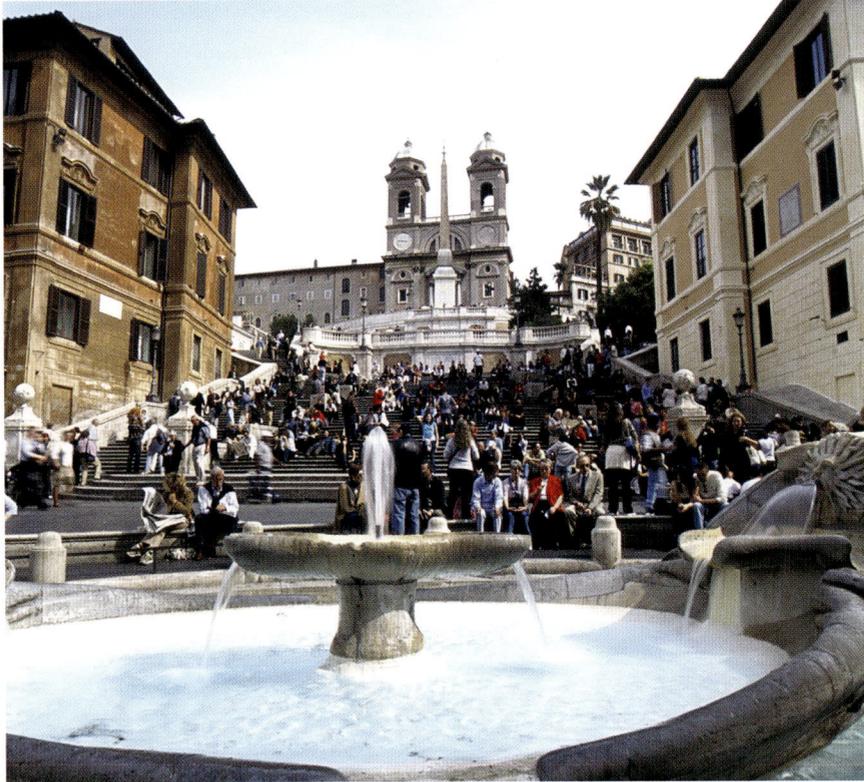

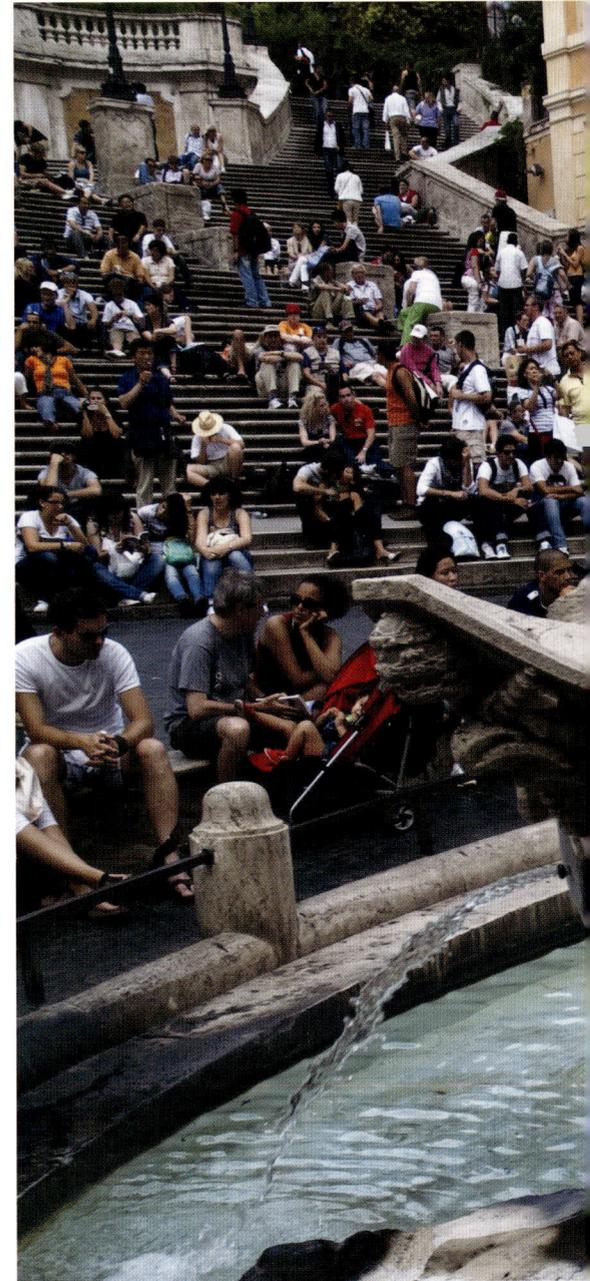

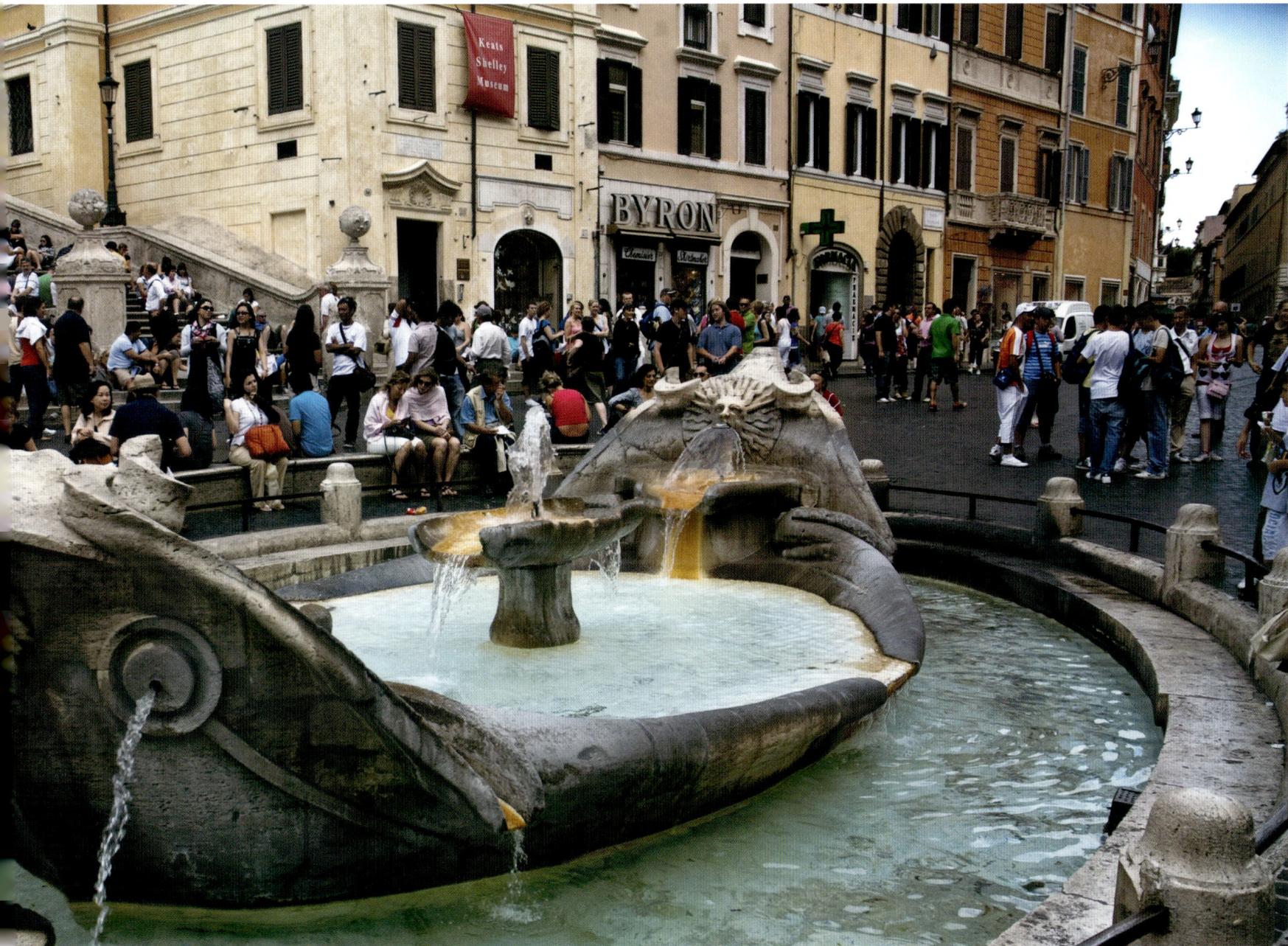

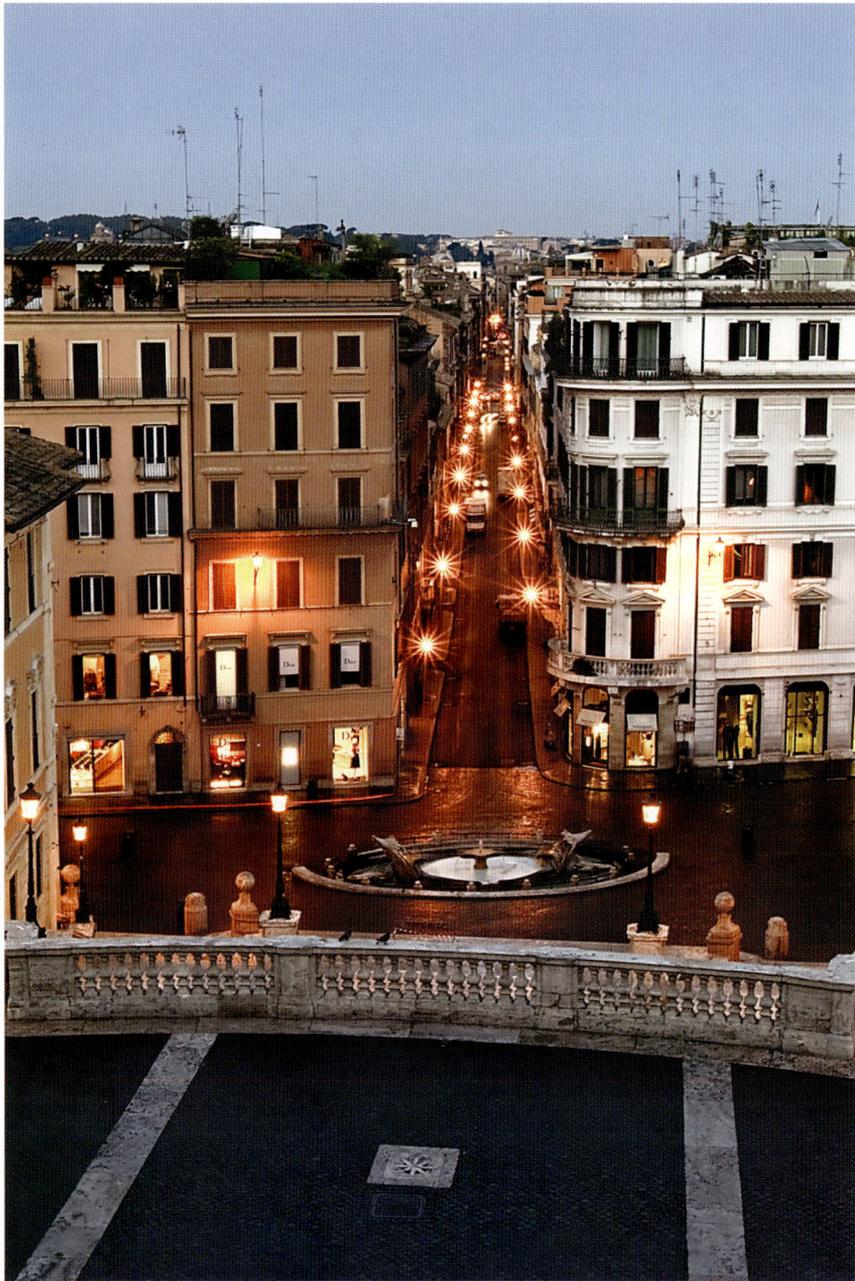
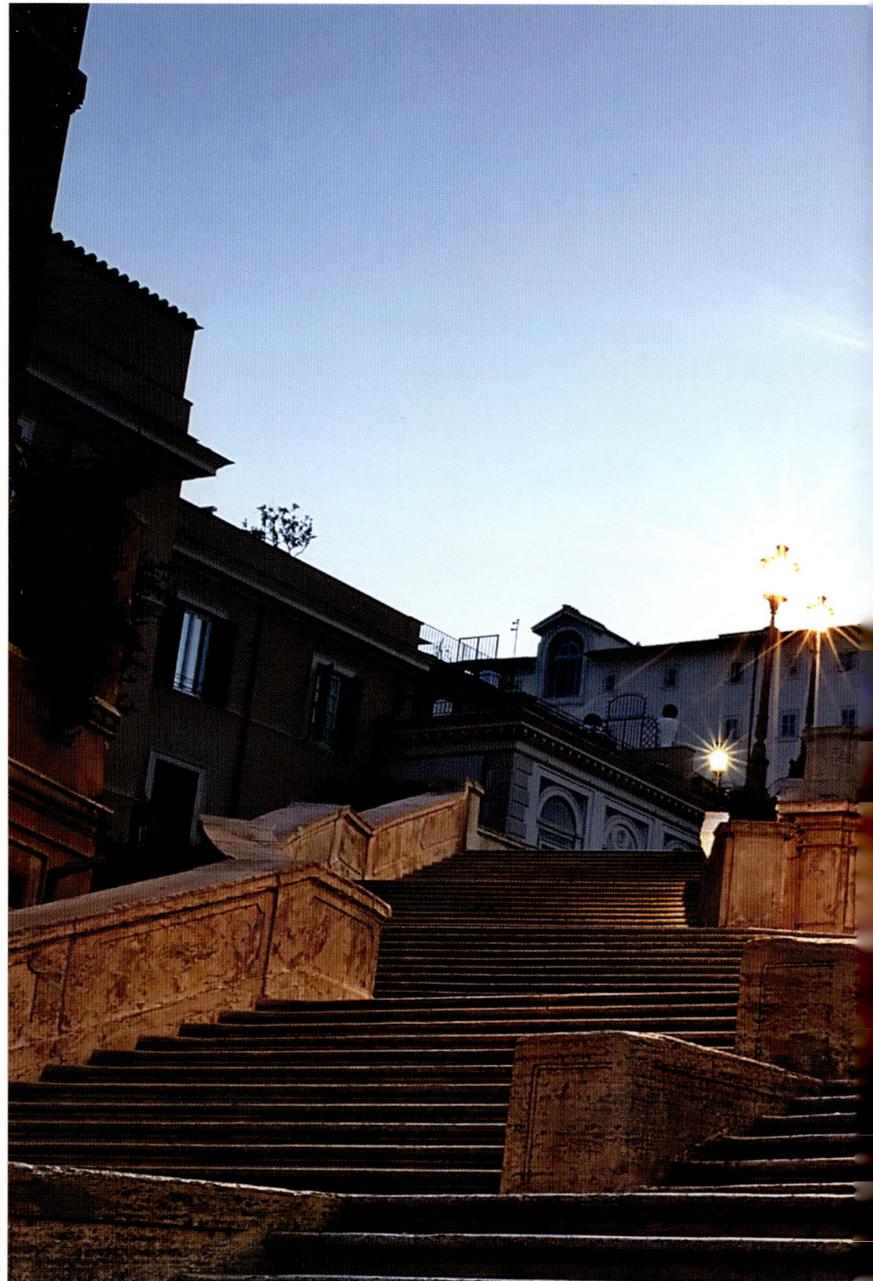

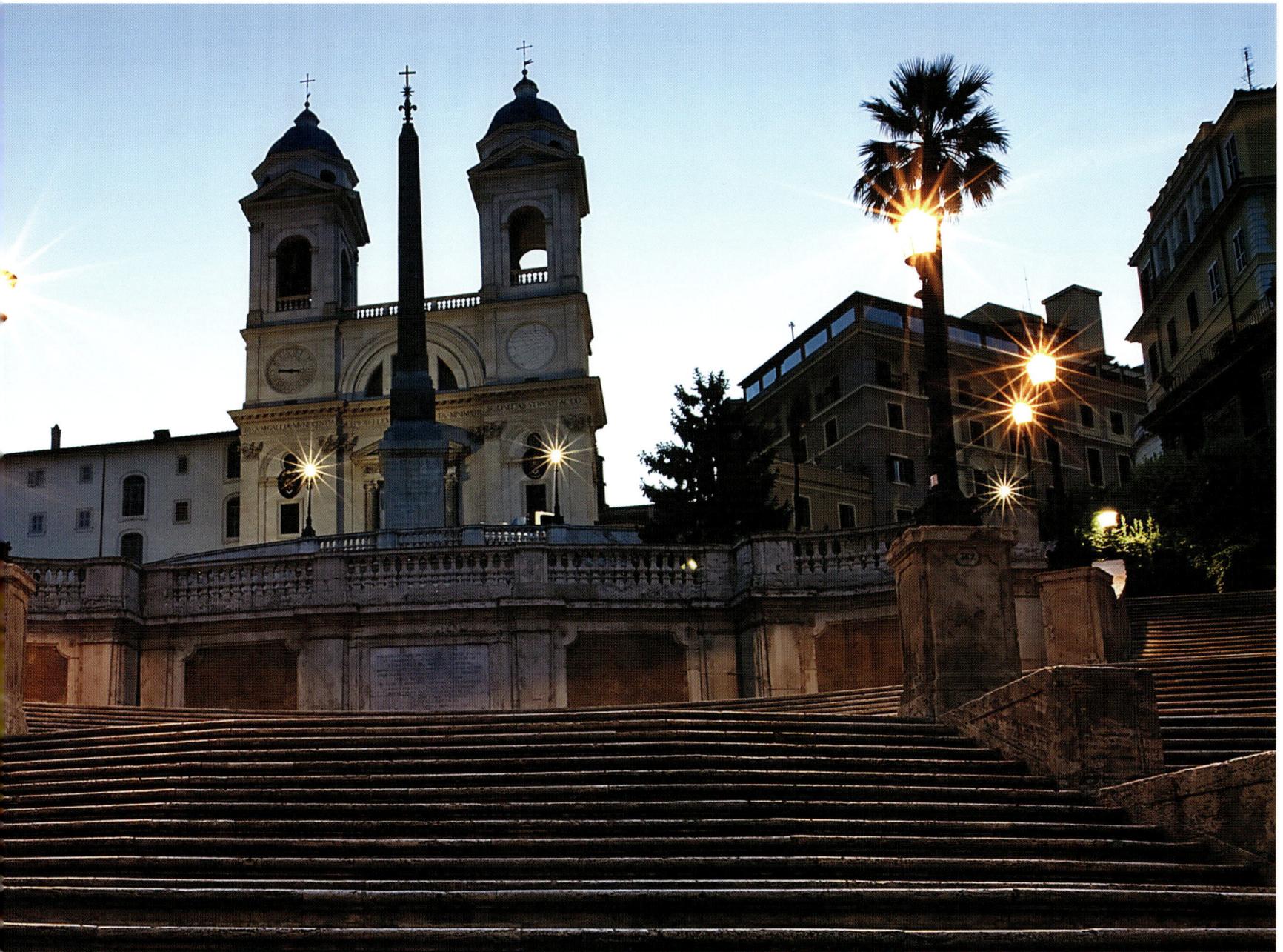

Campidoglio

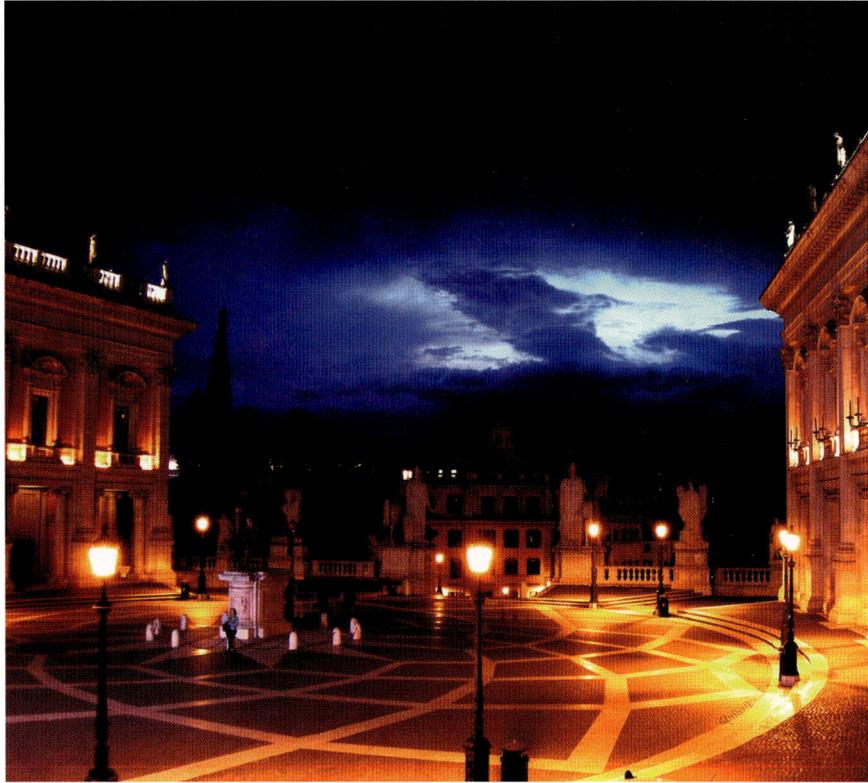

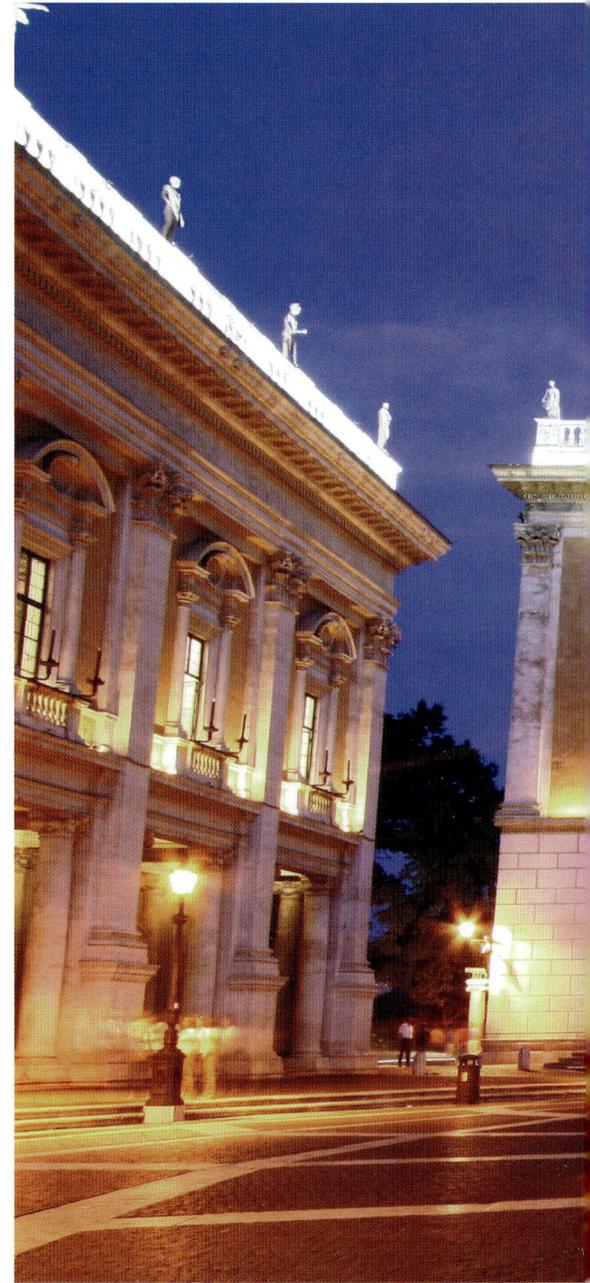

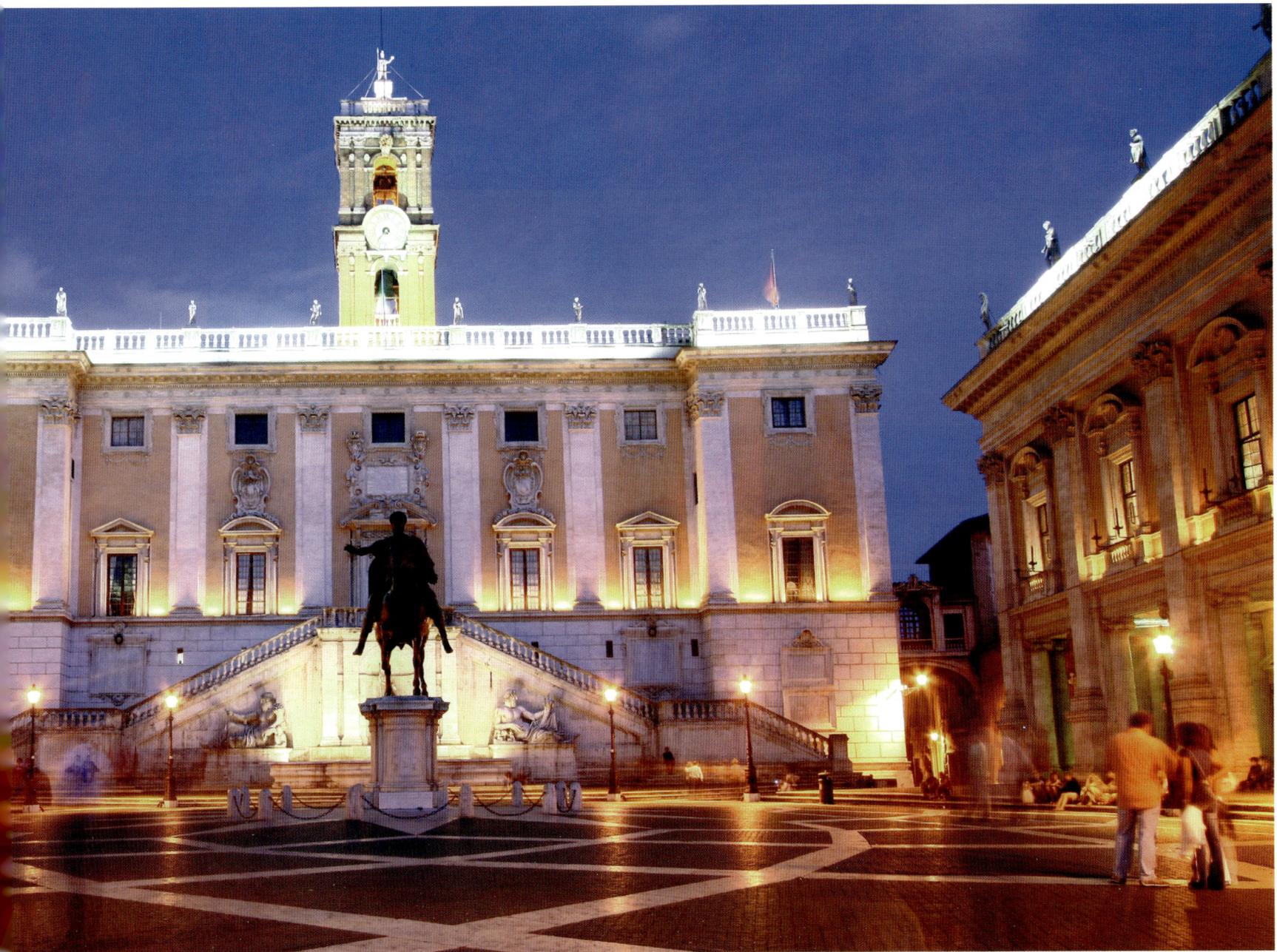

Church of the Gesù

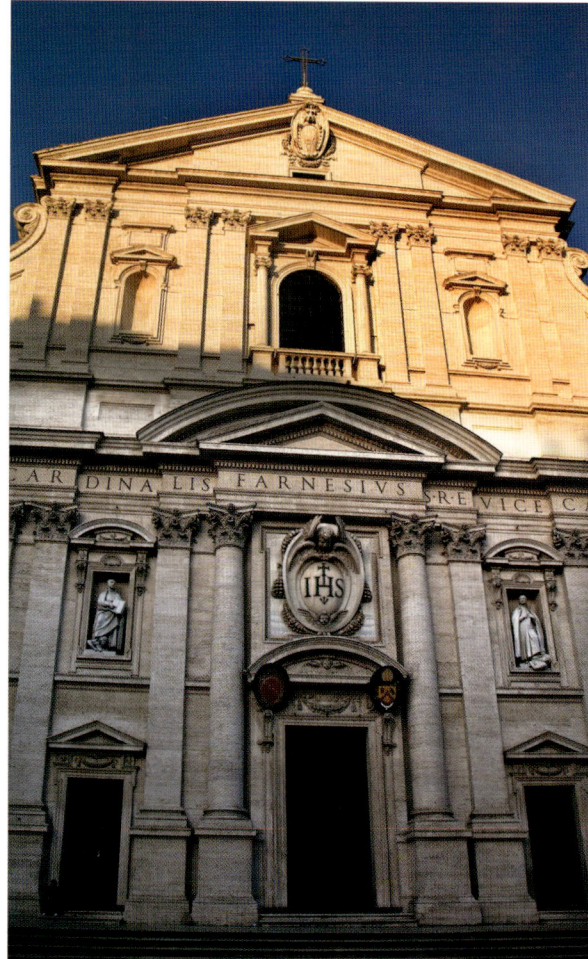

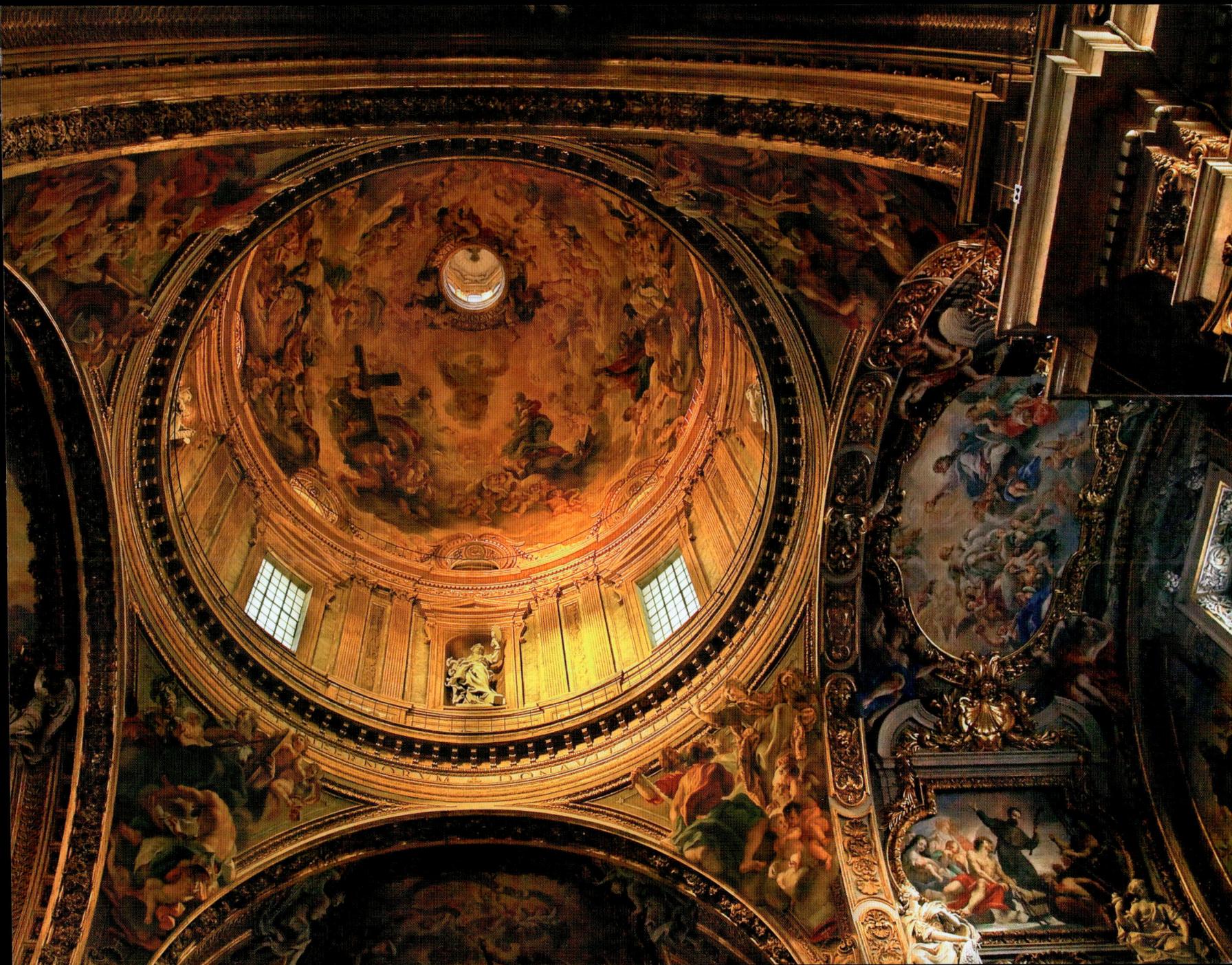

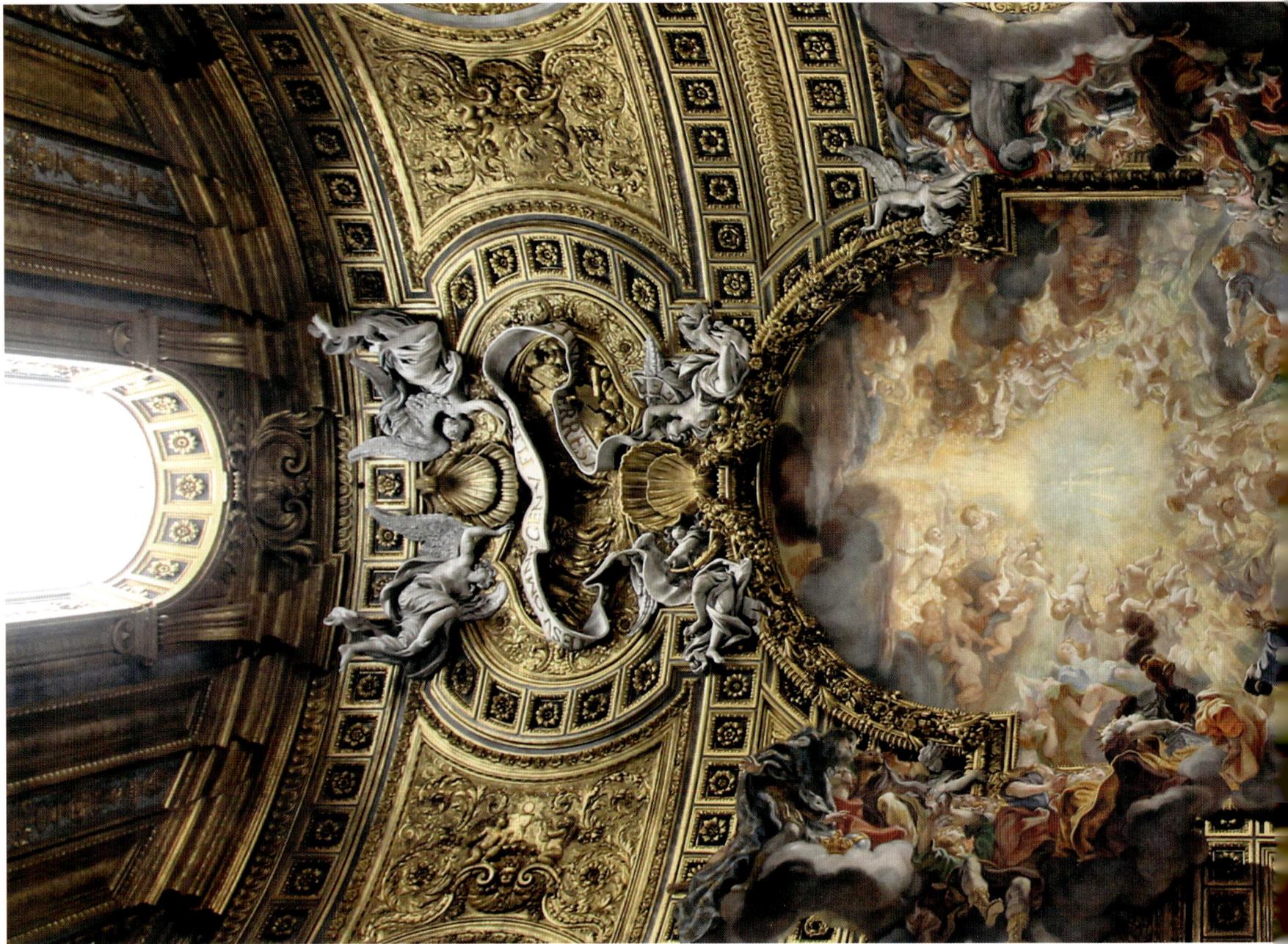

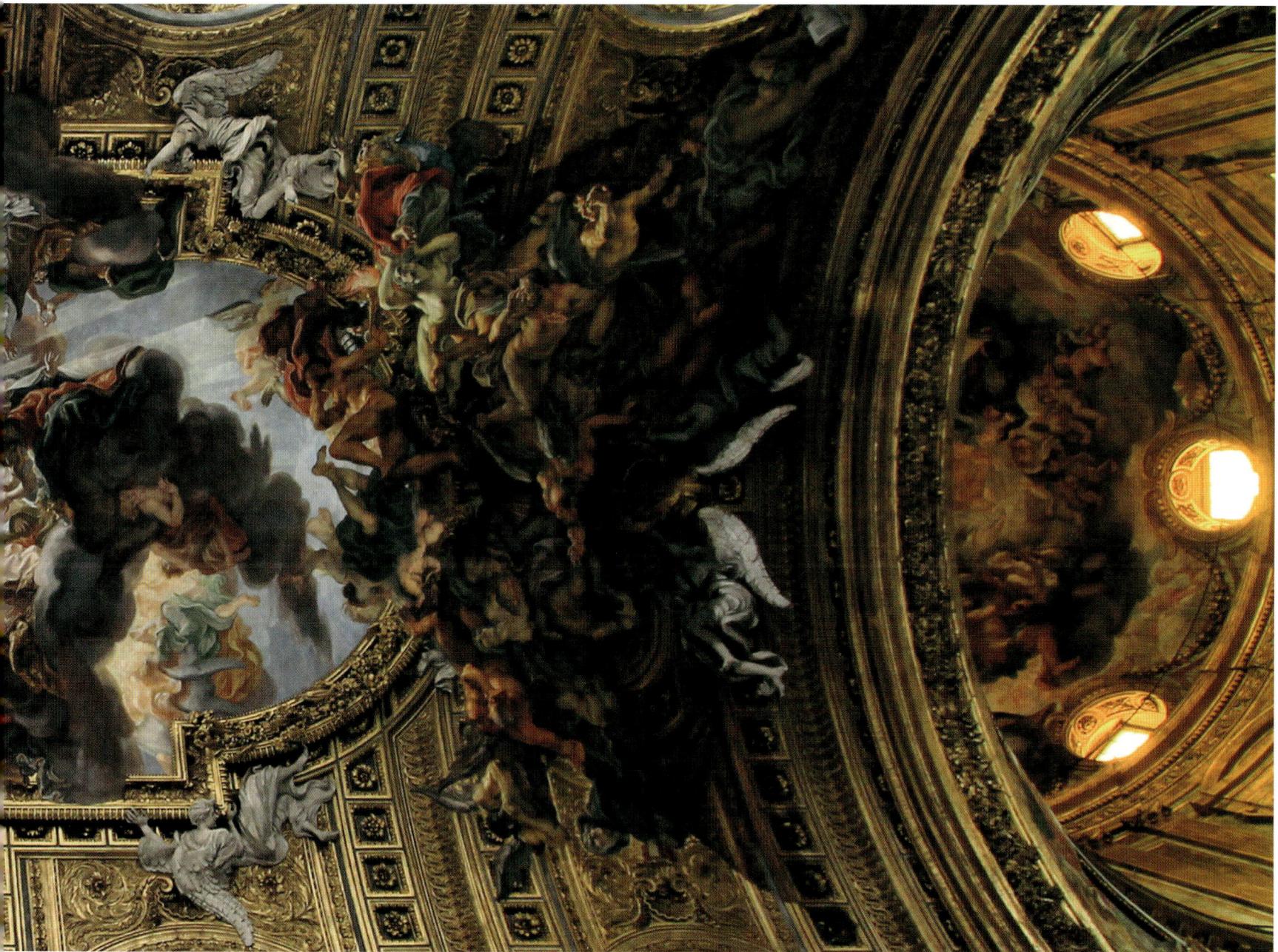

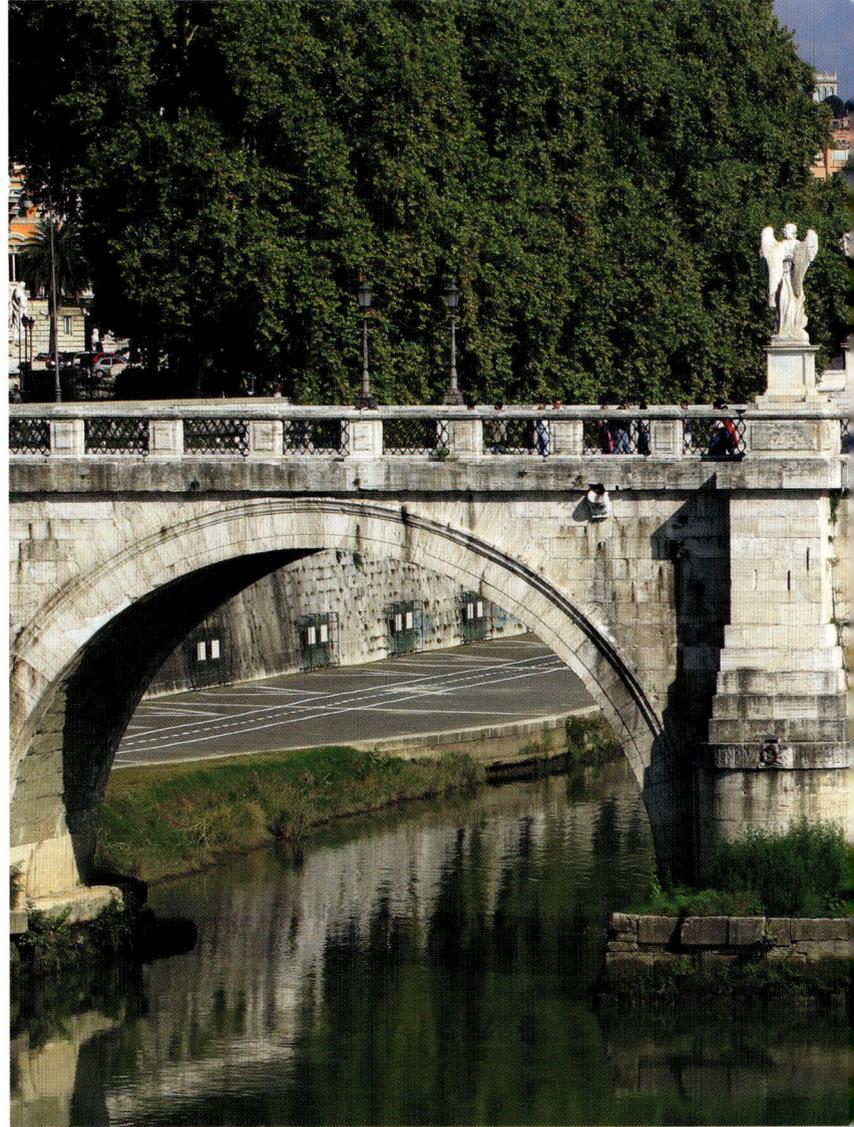

Bridges

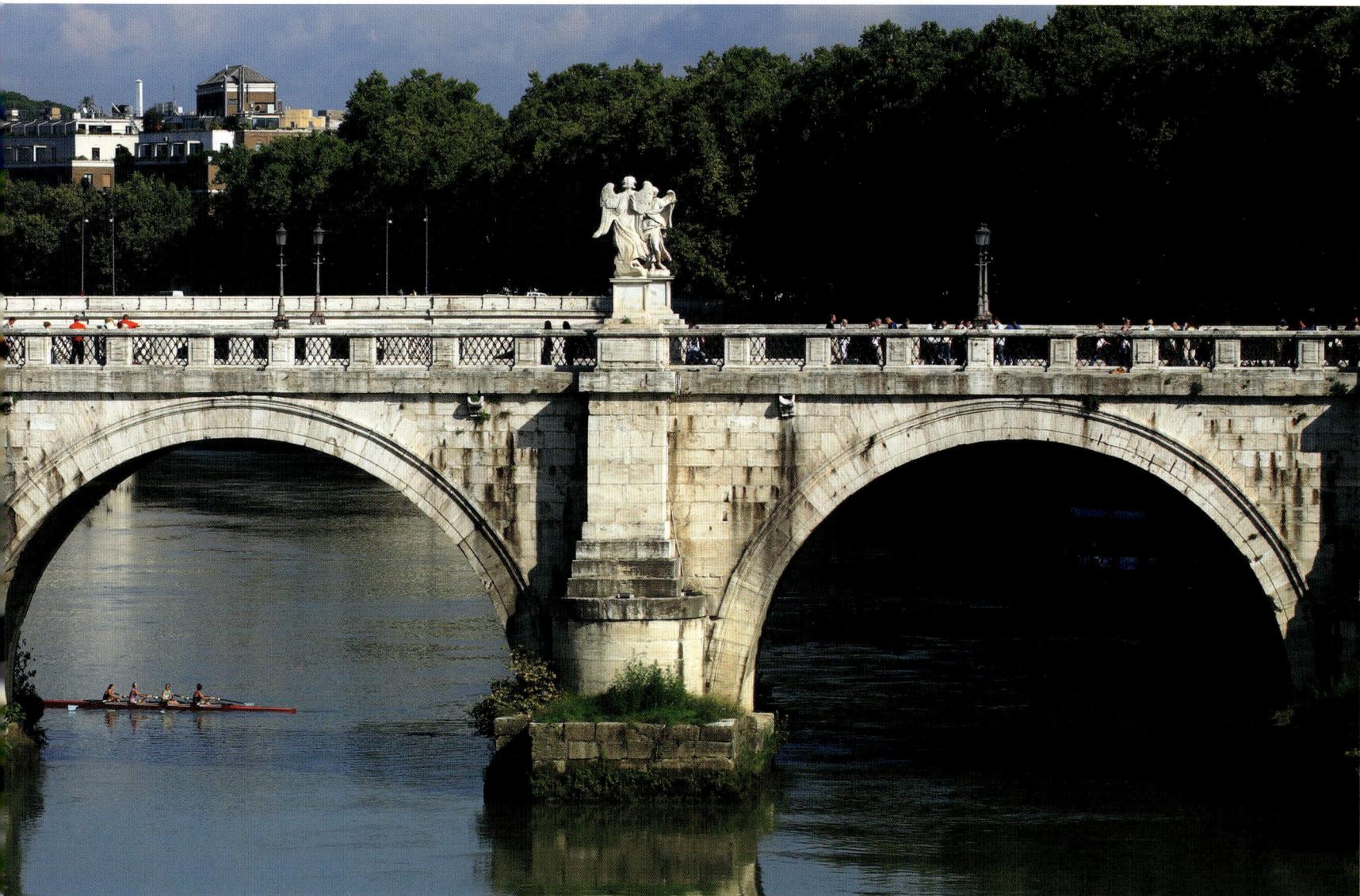

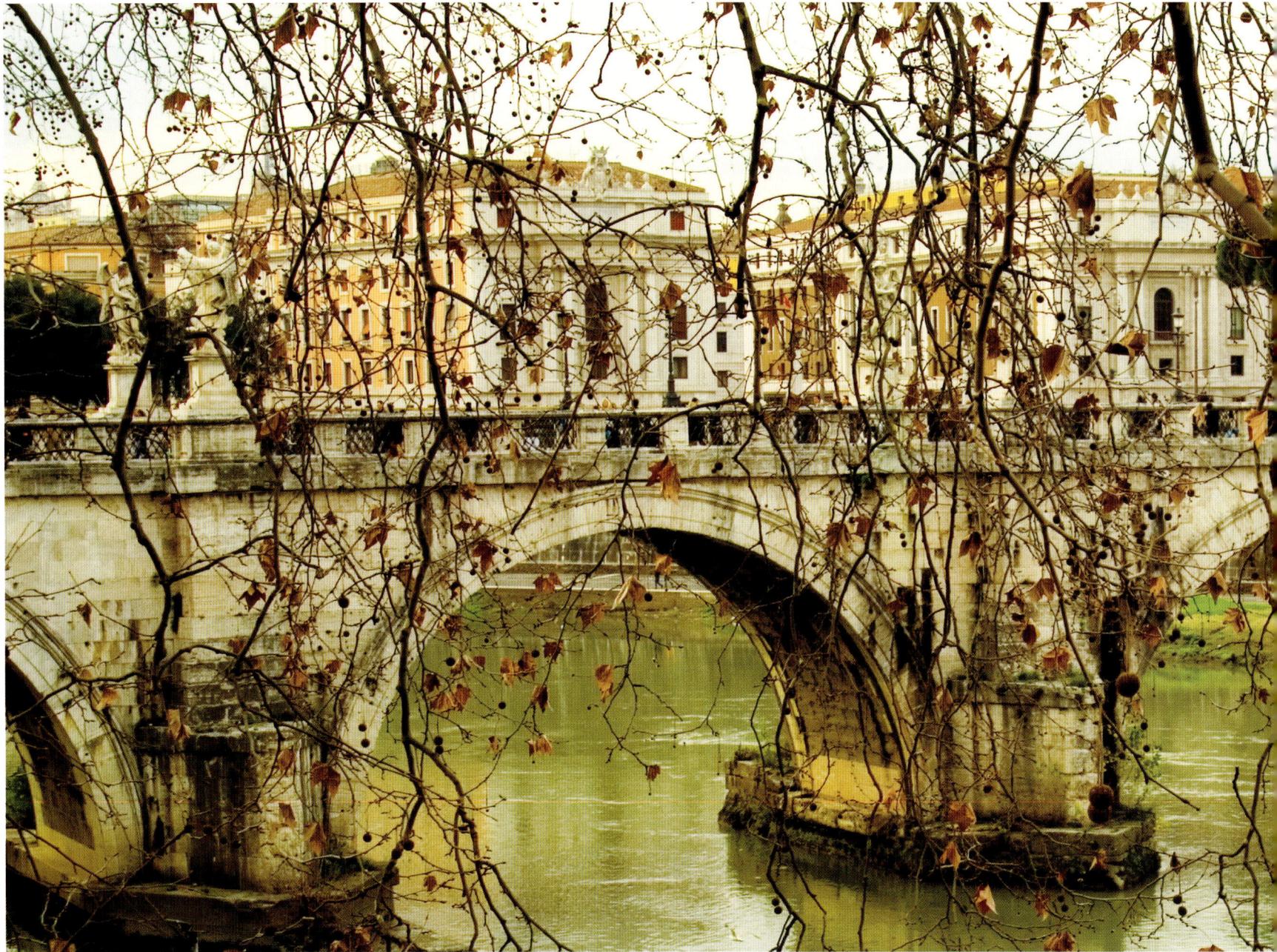

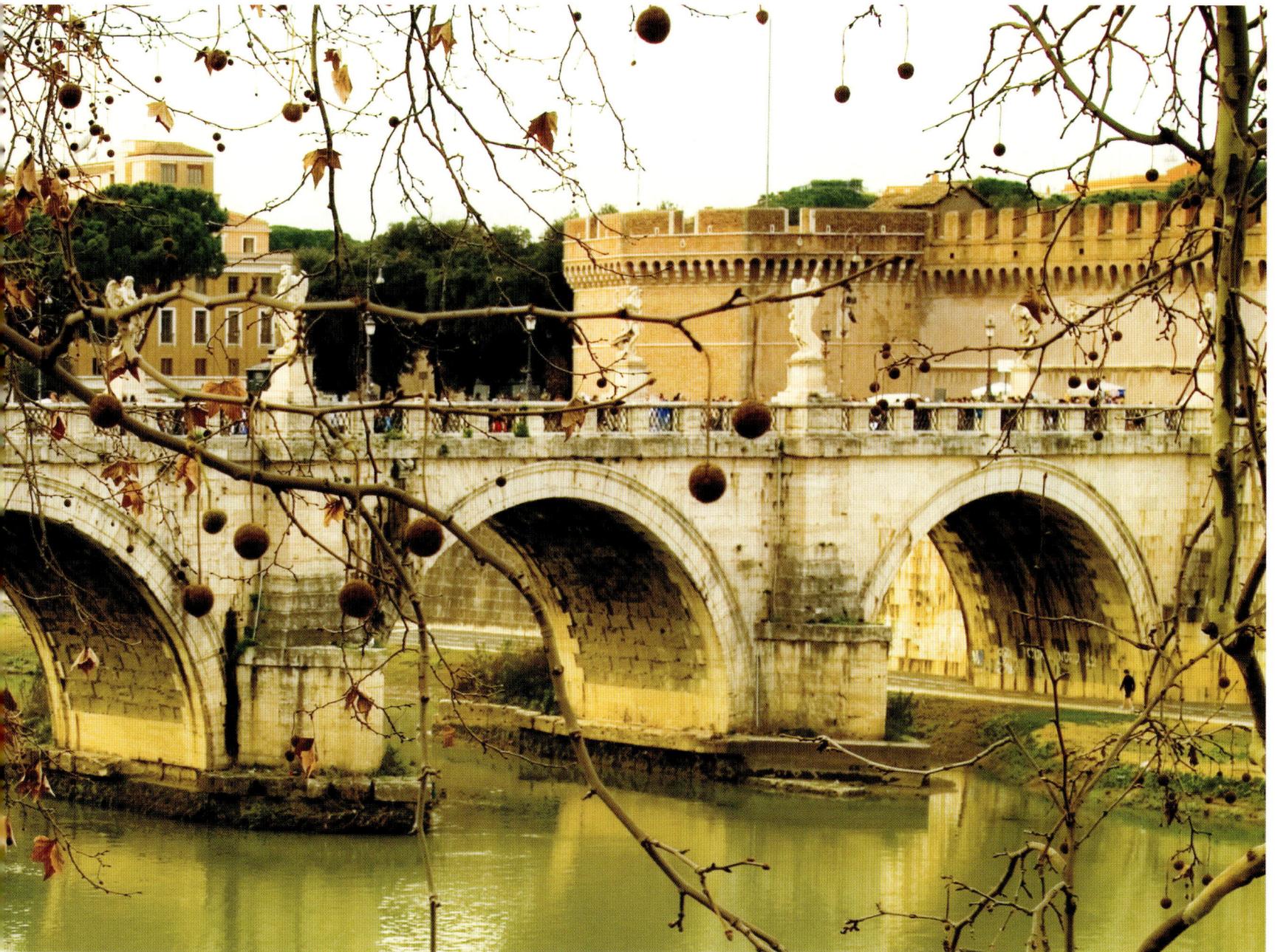

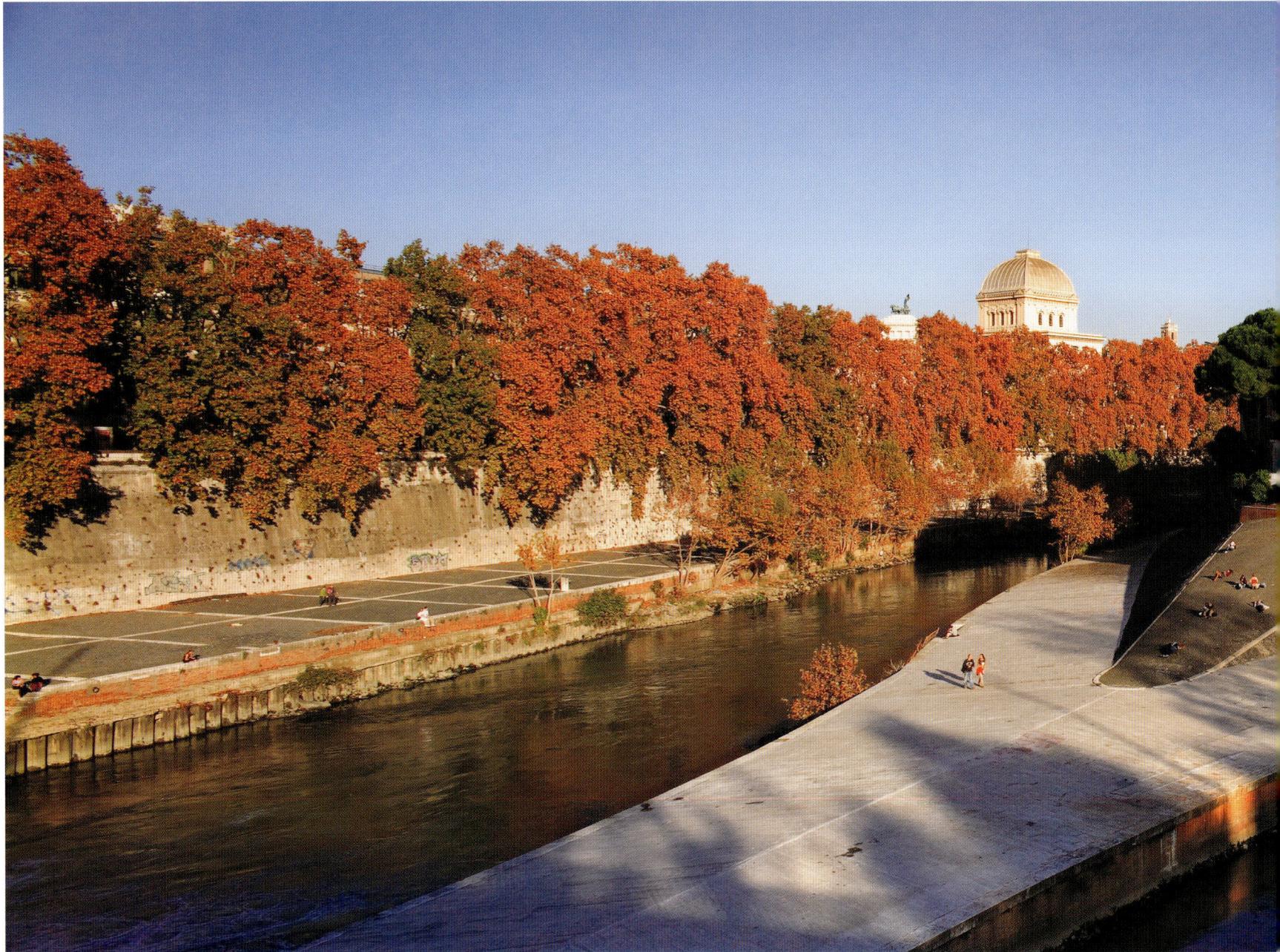

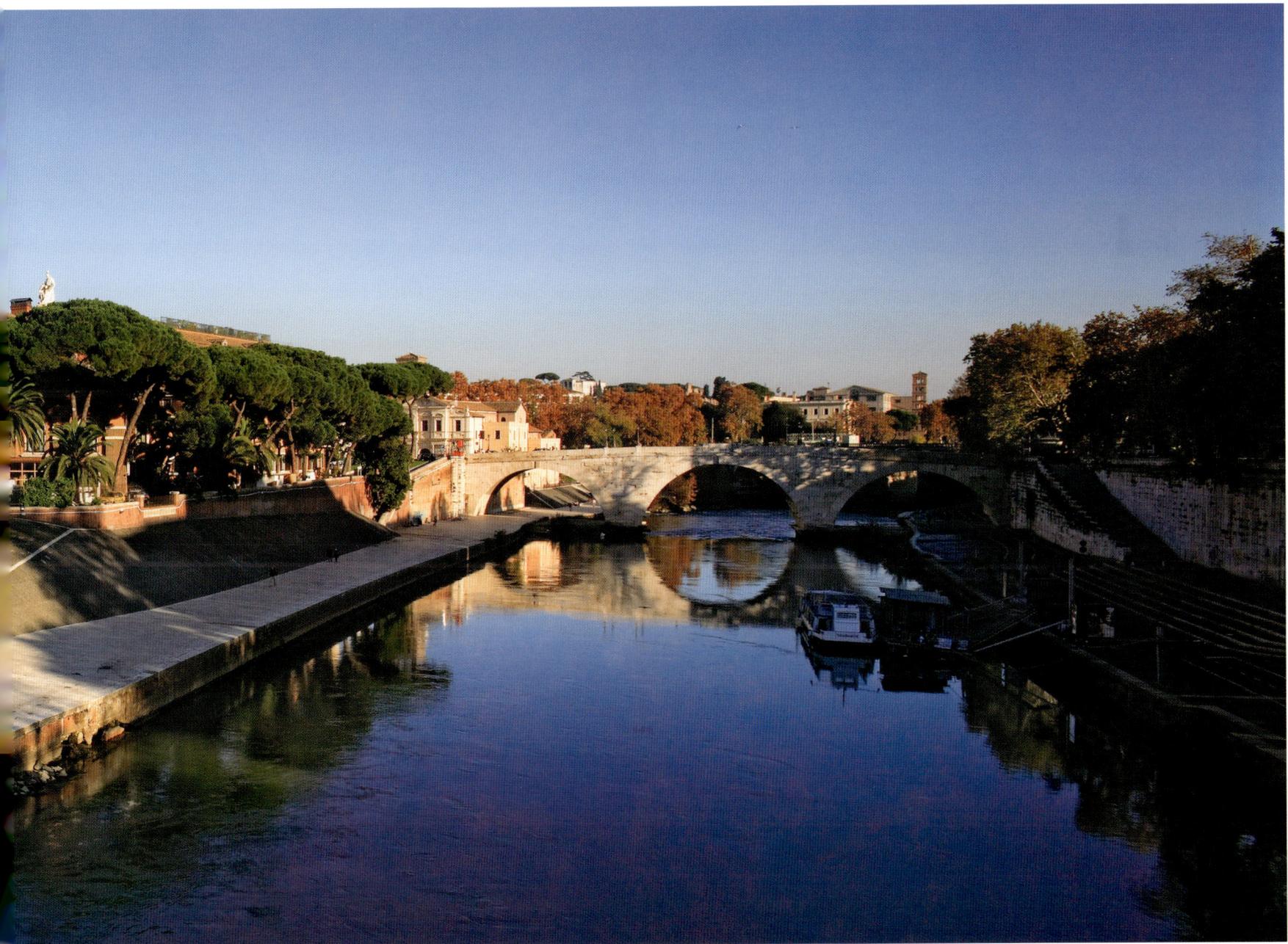

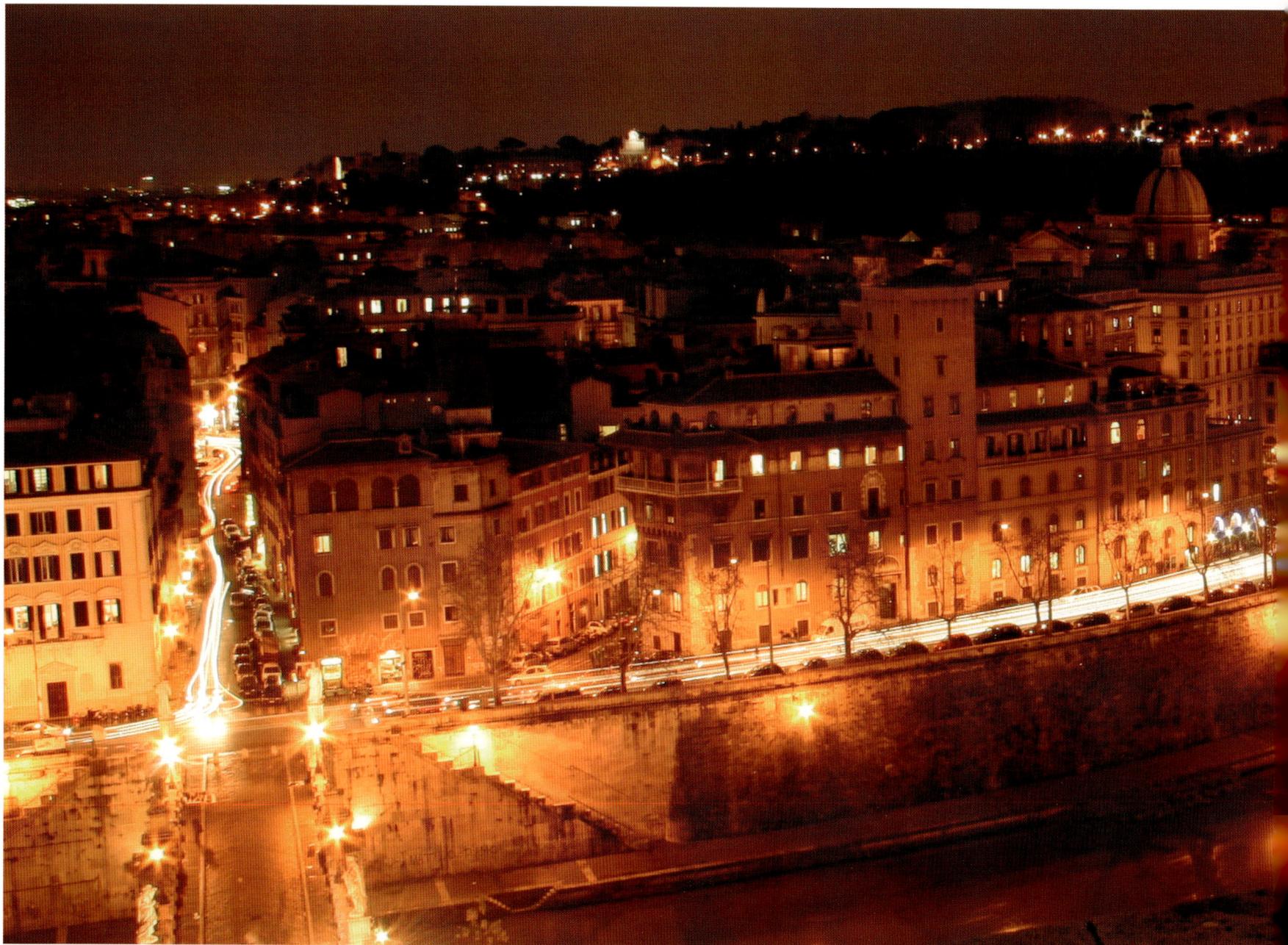

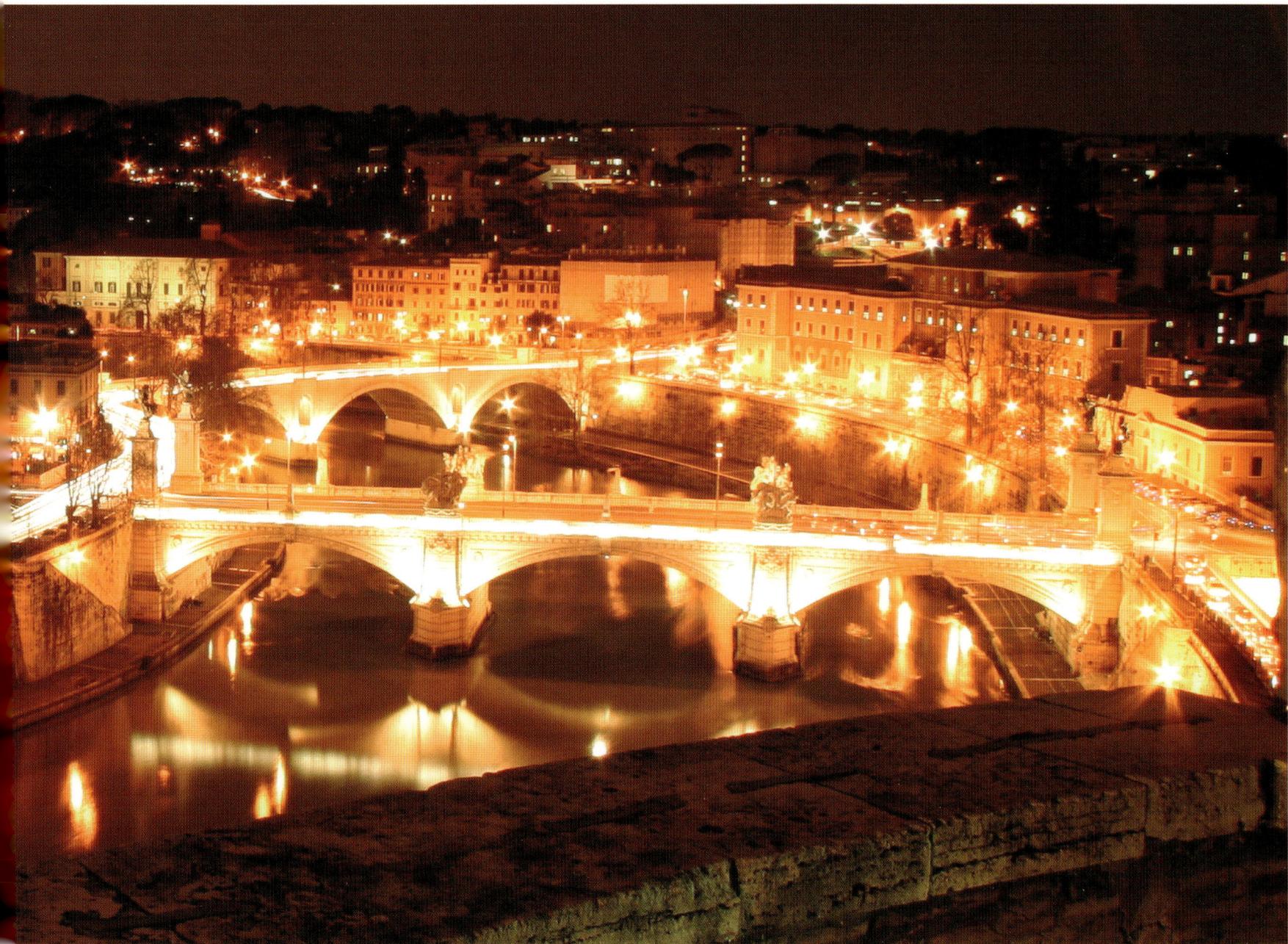

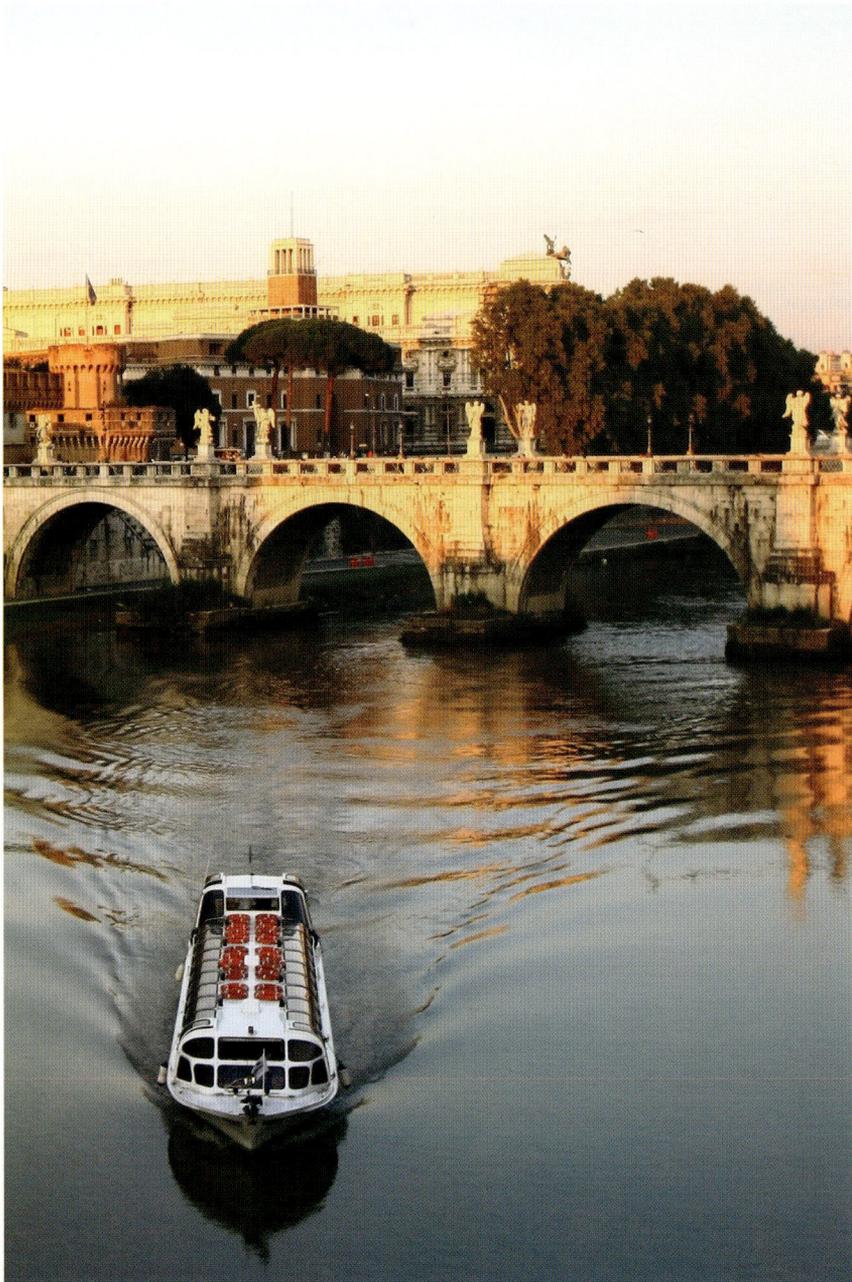
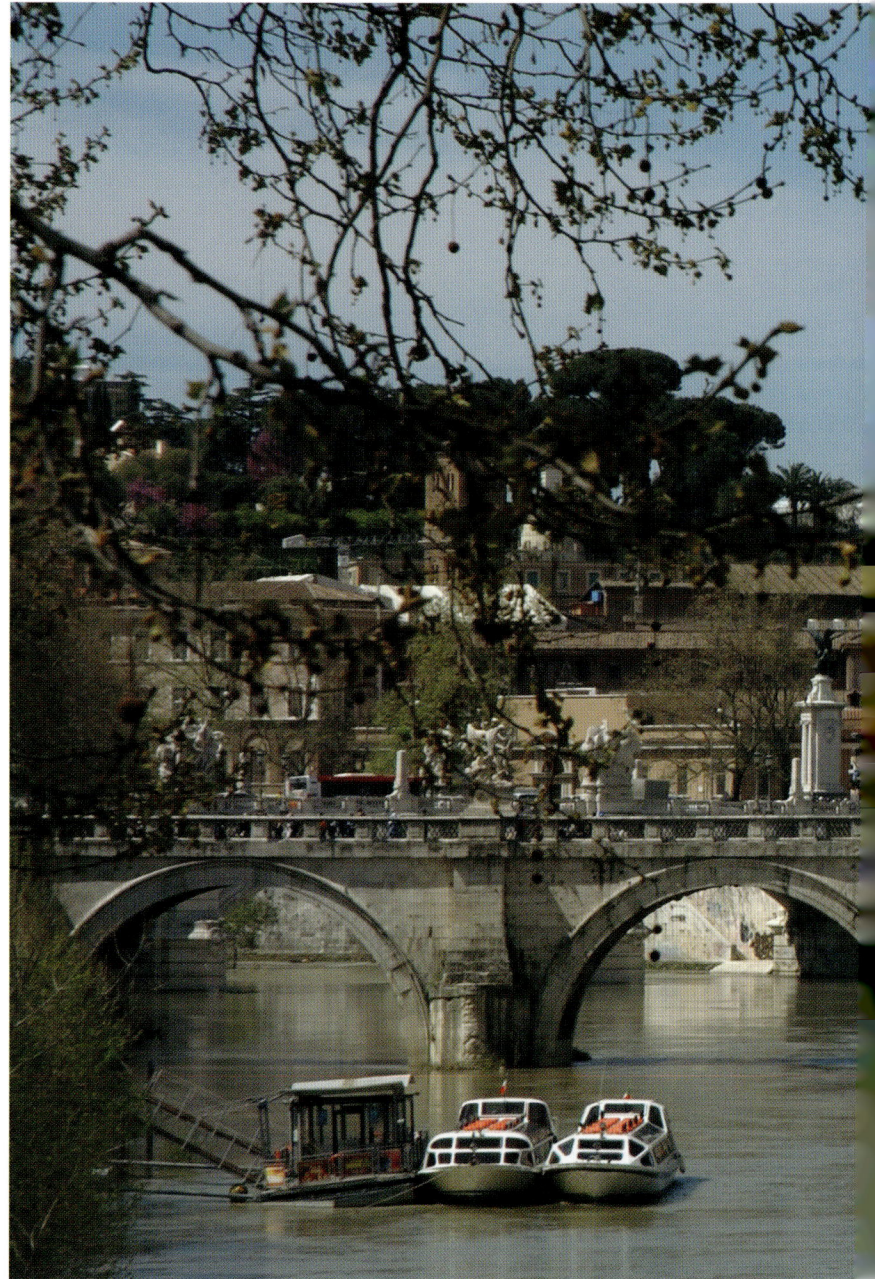

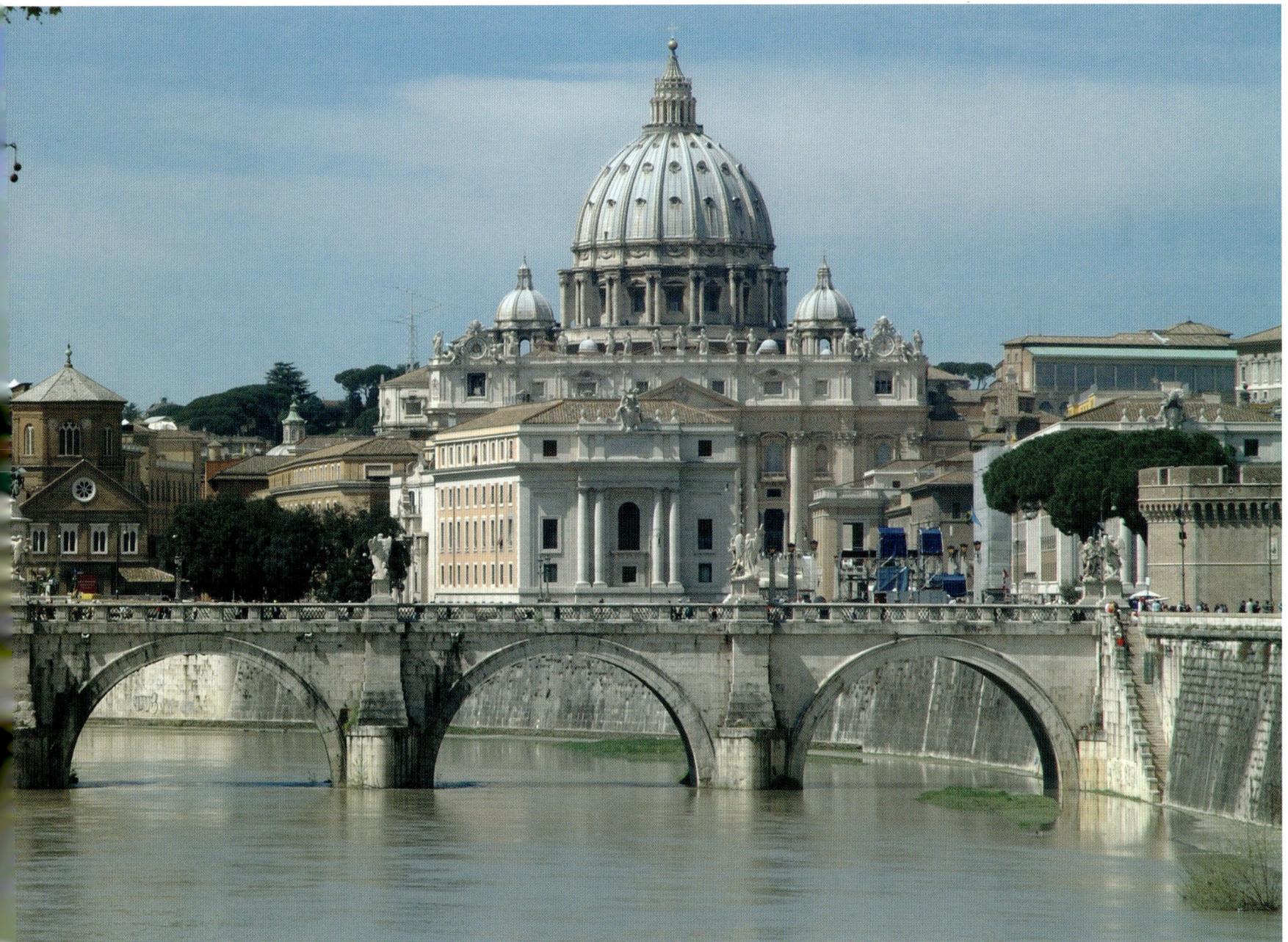

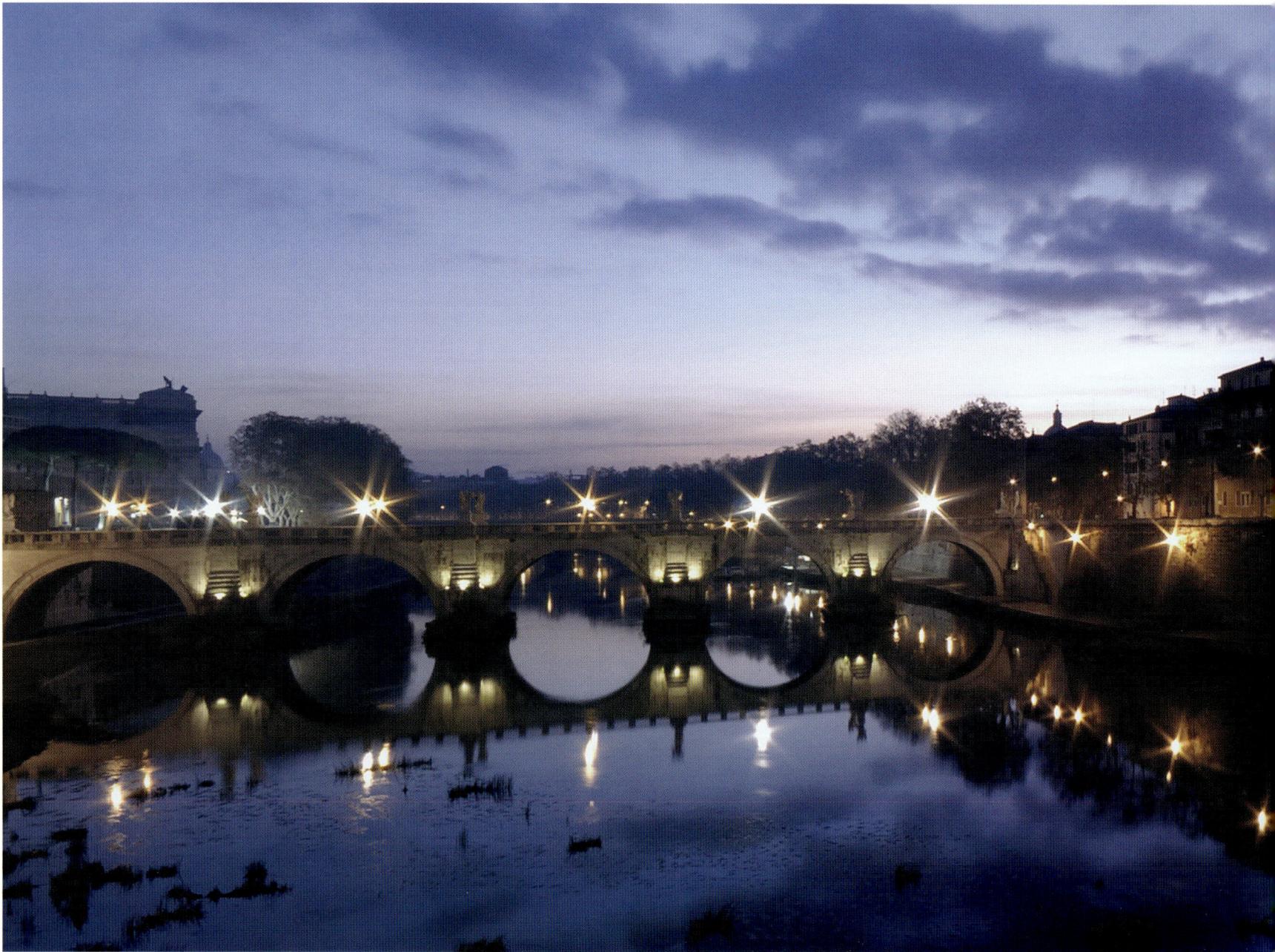

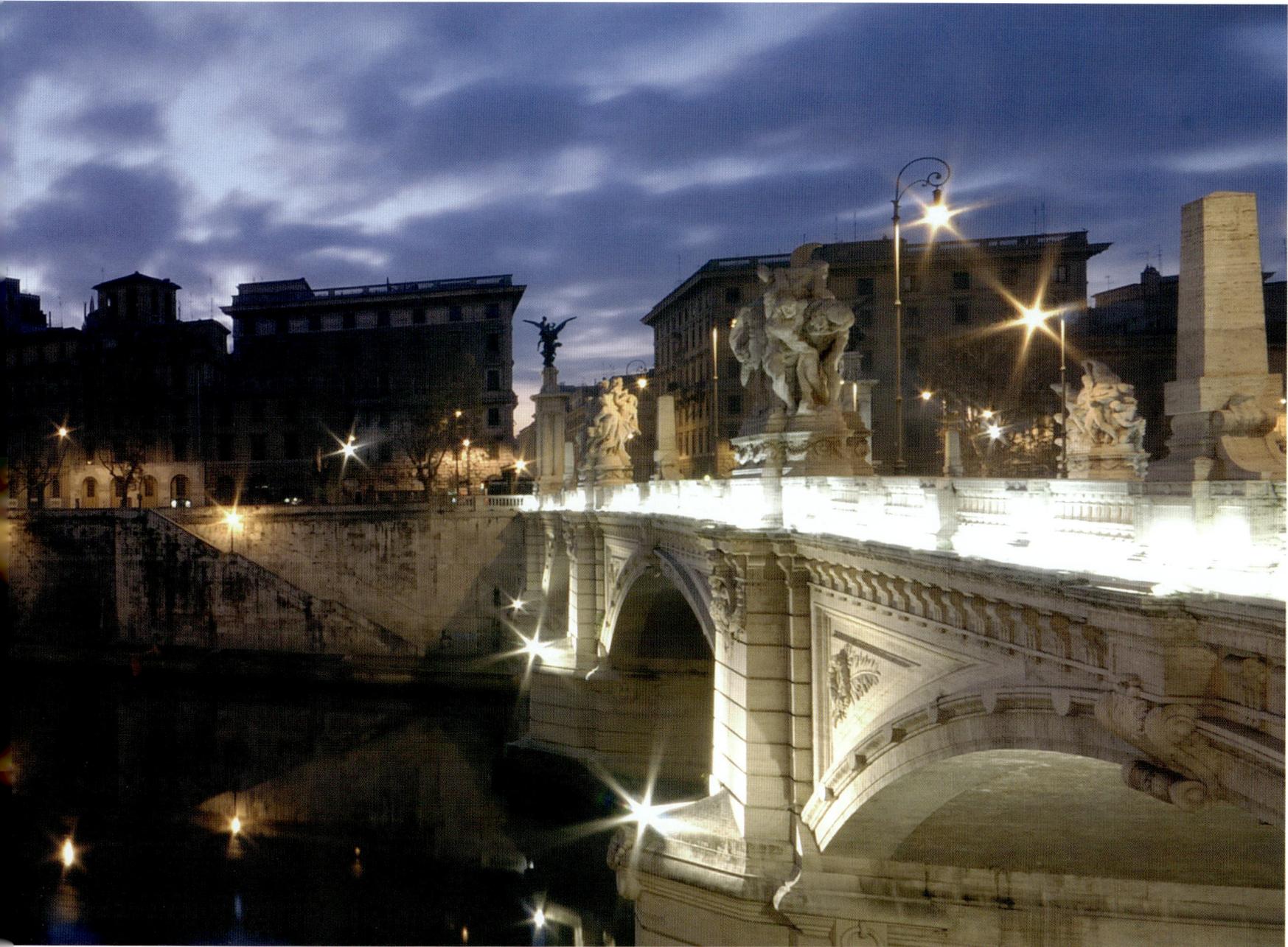

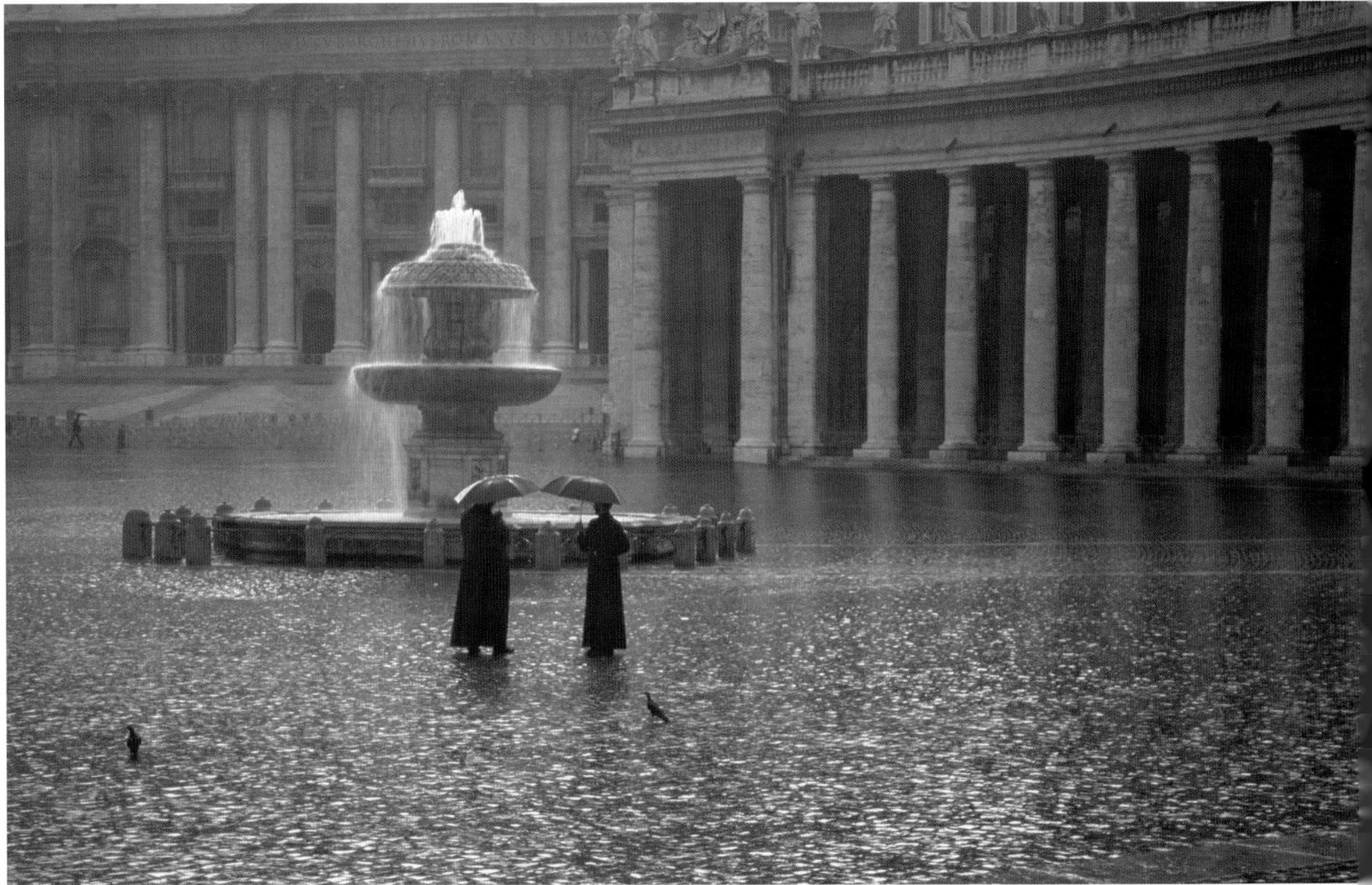

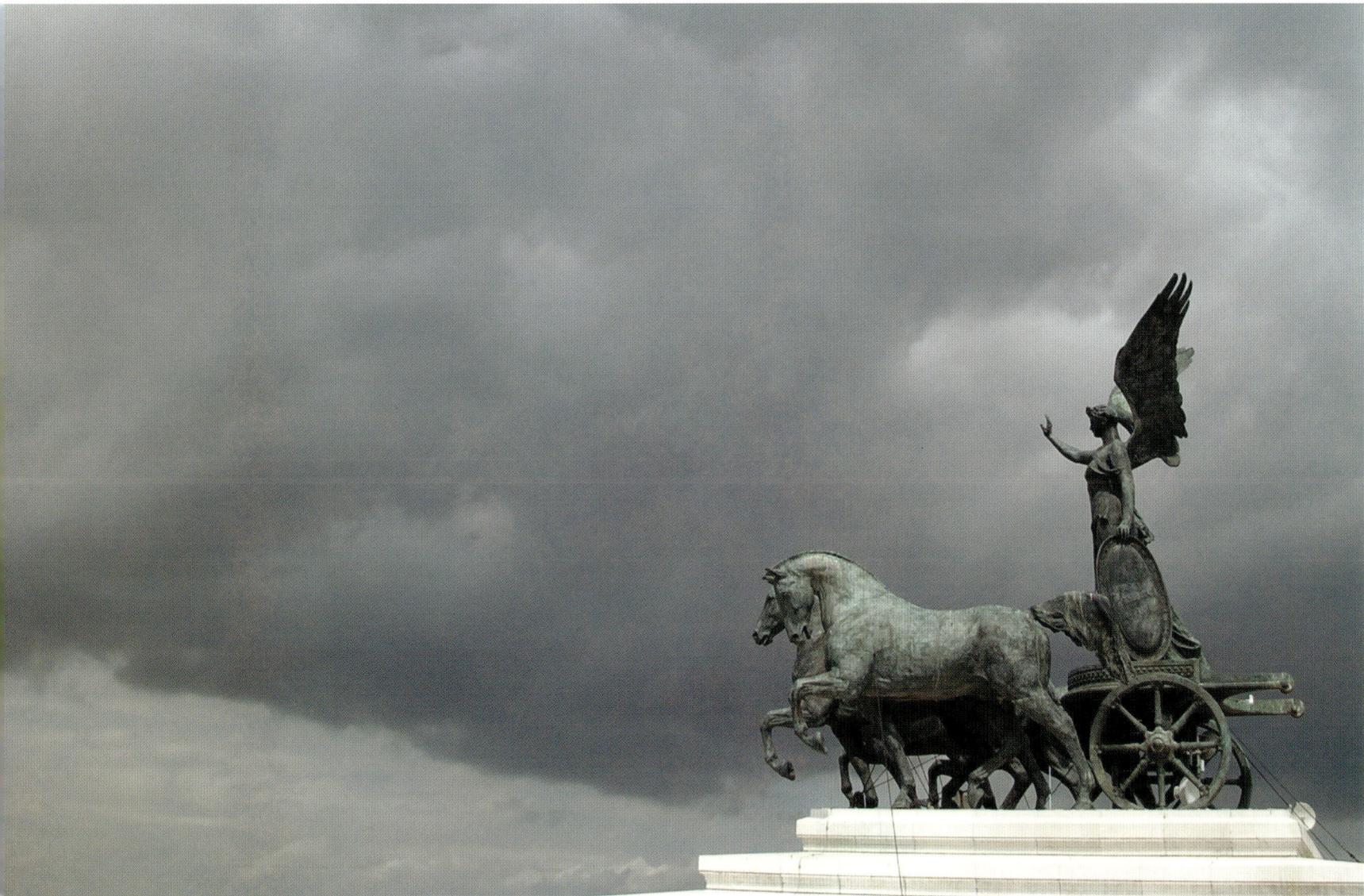

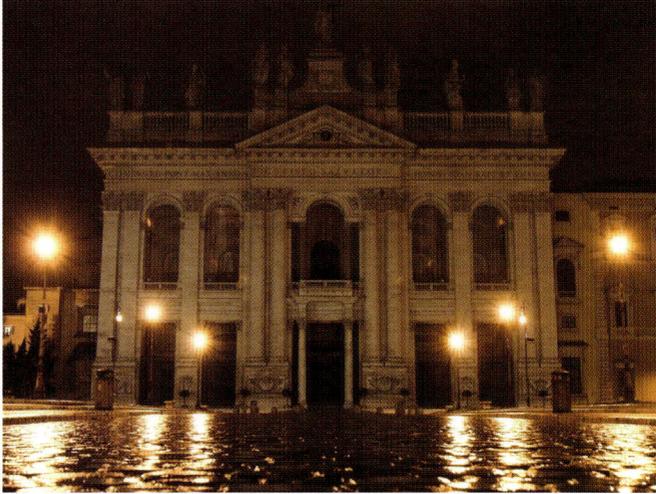
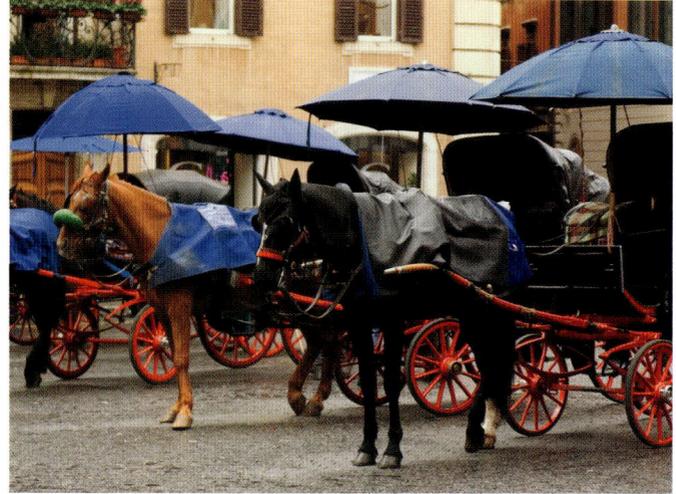

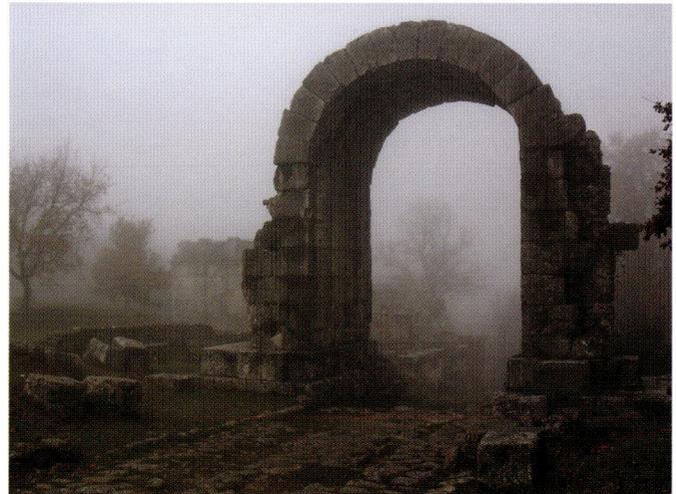

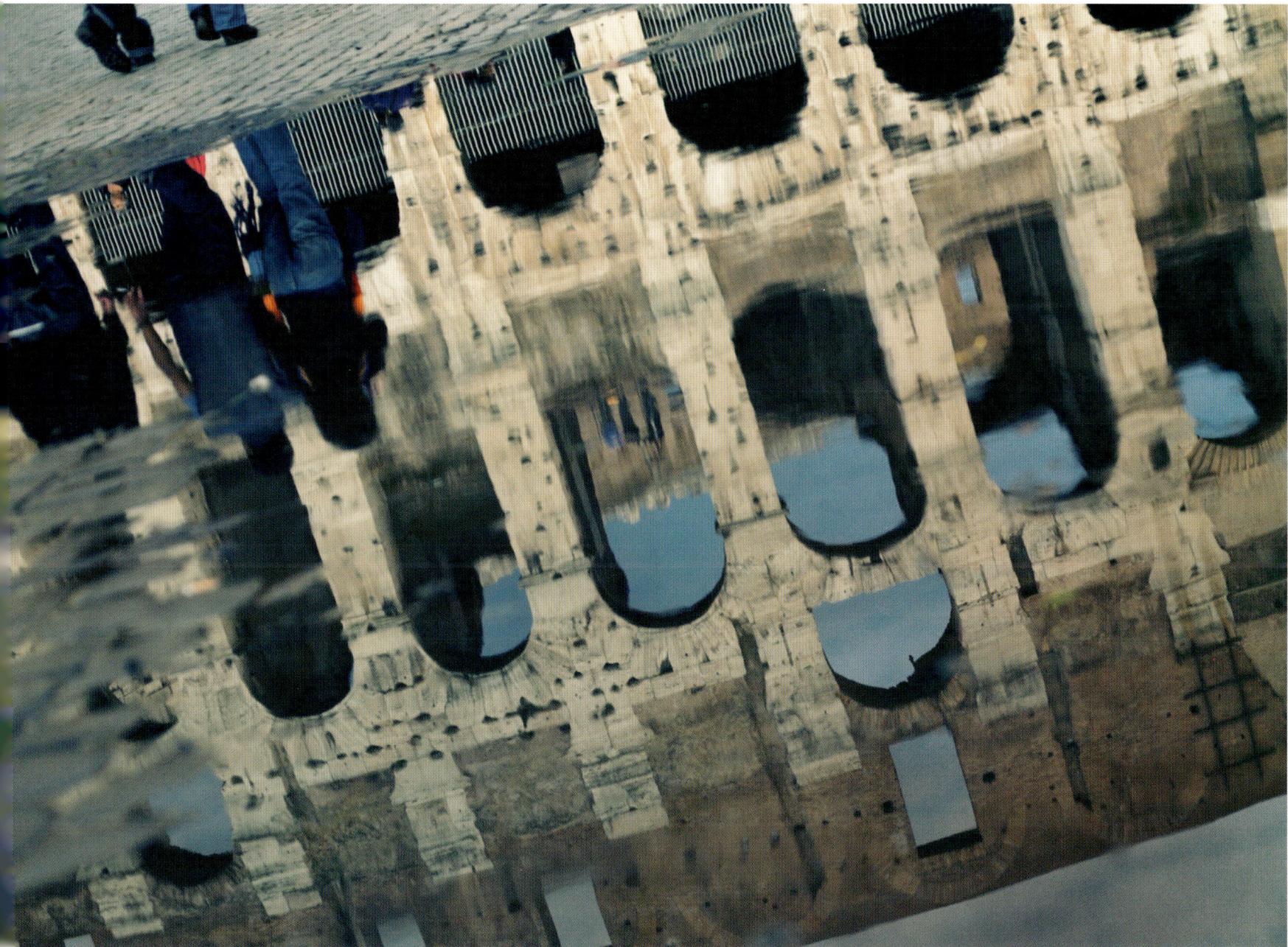

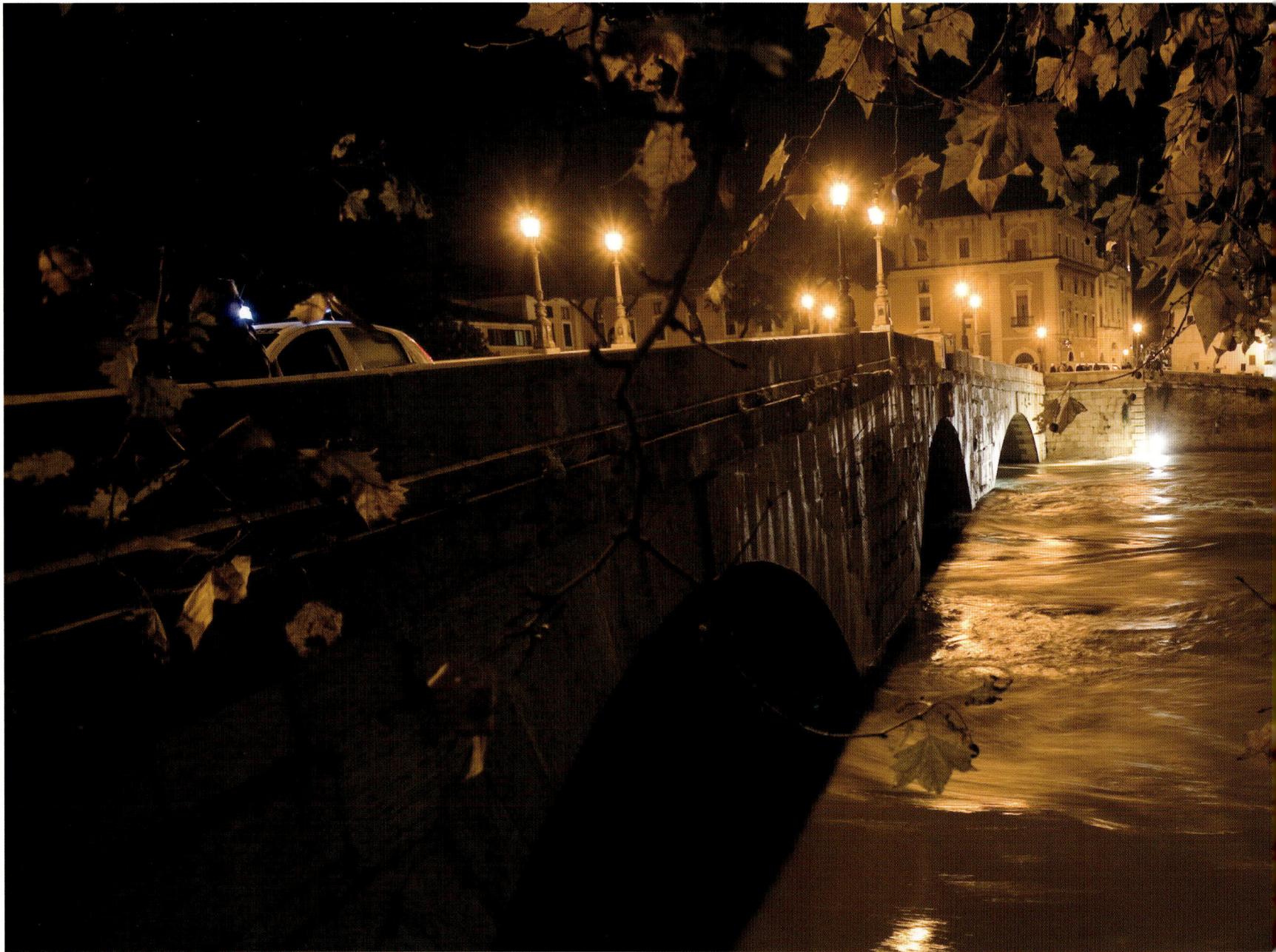

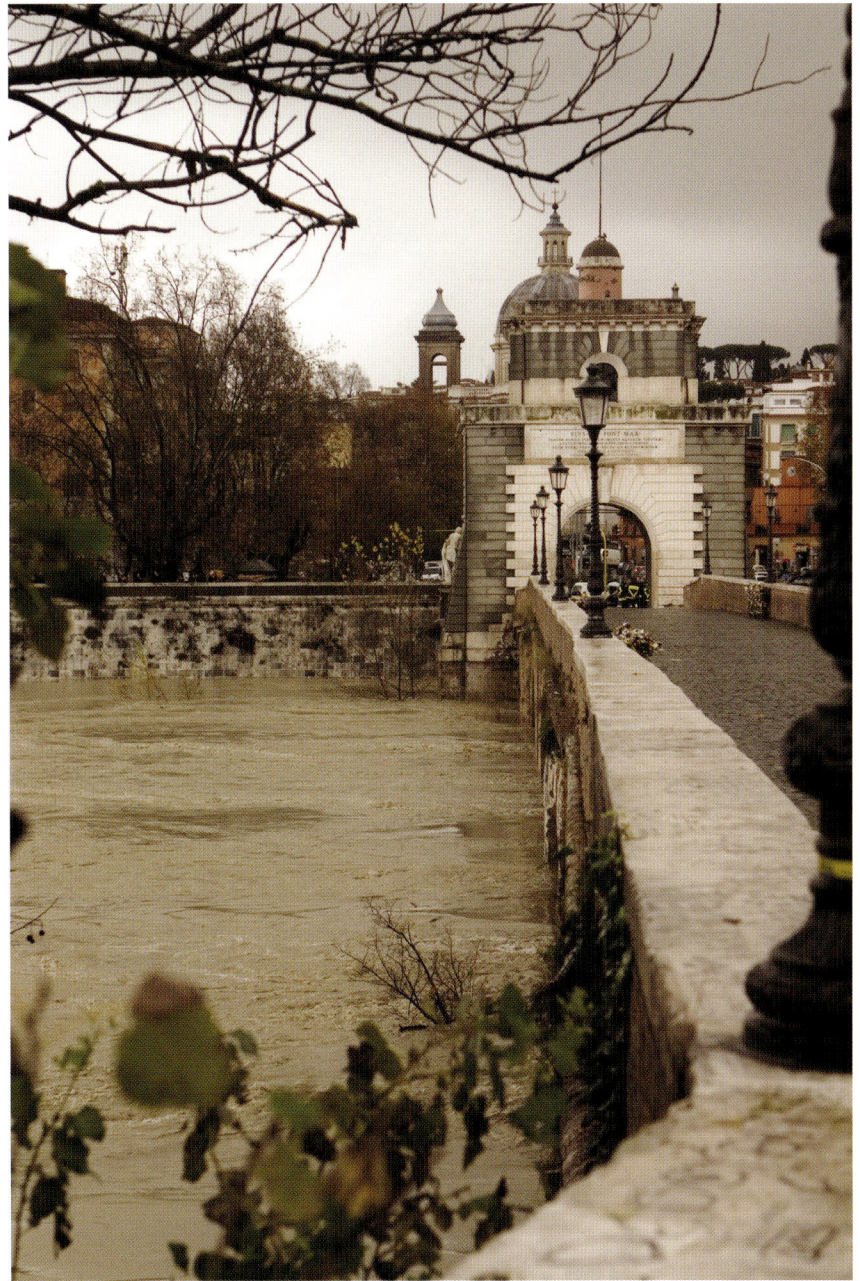

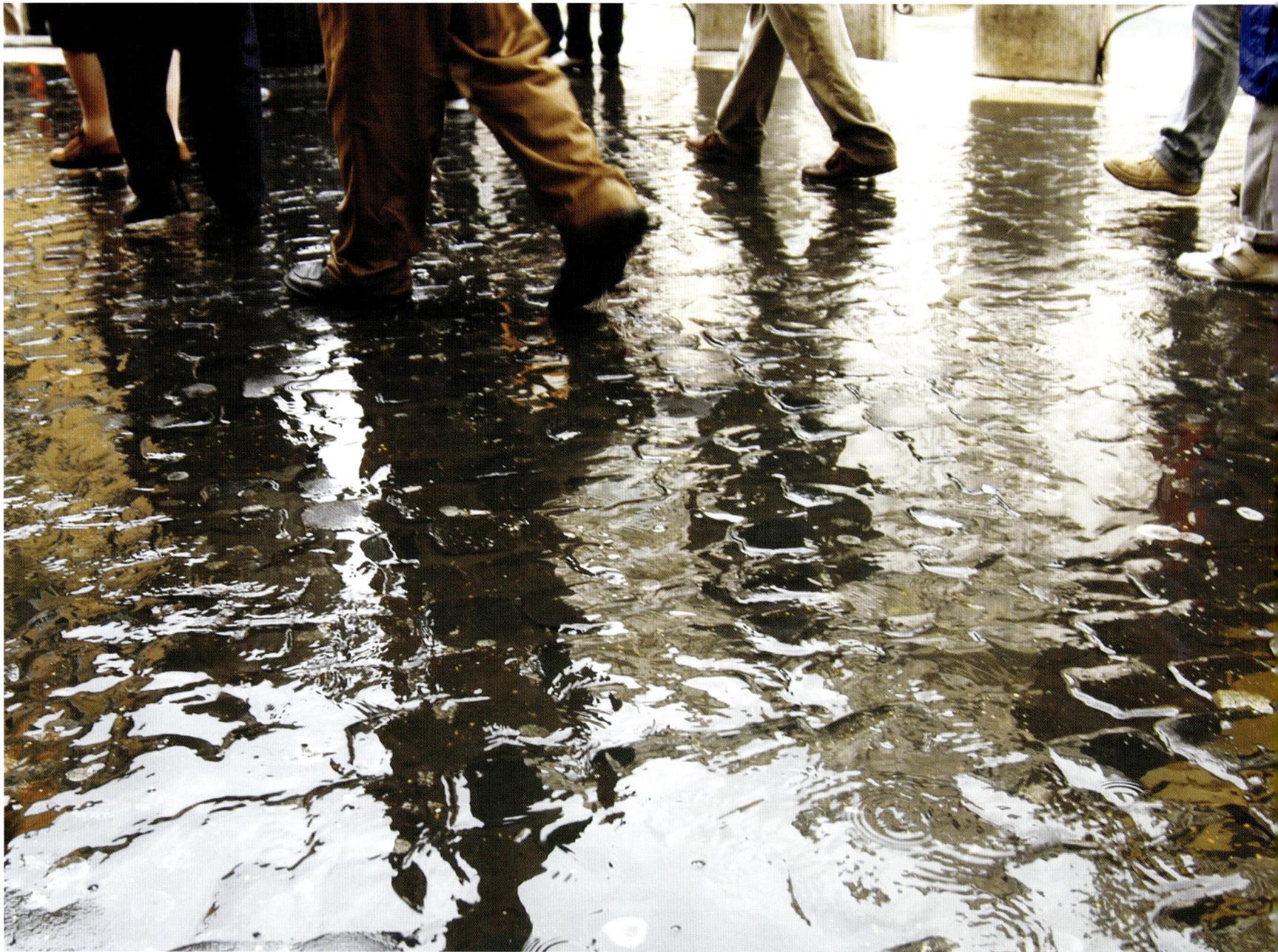

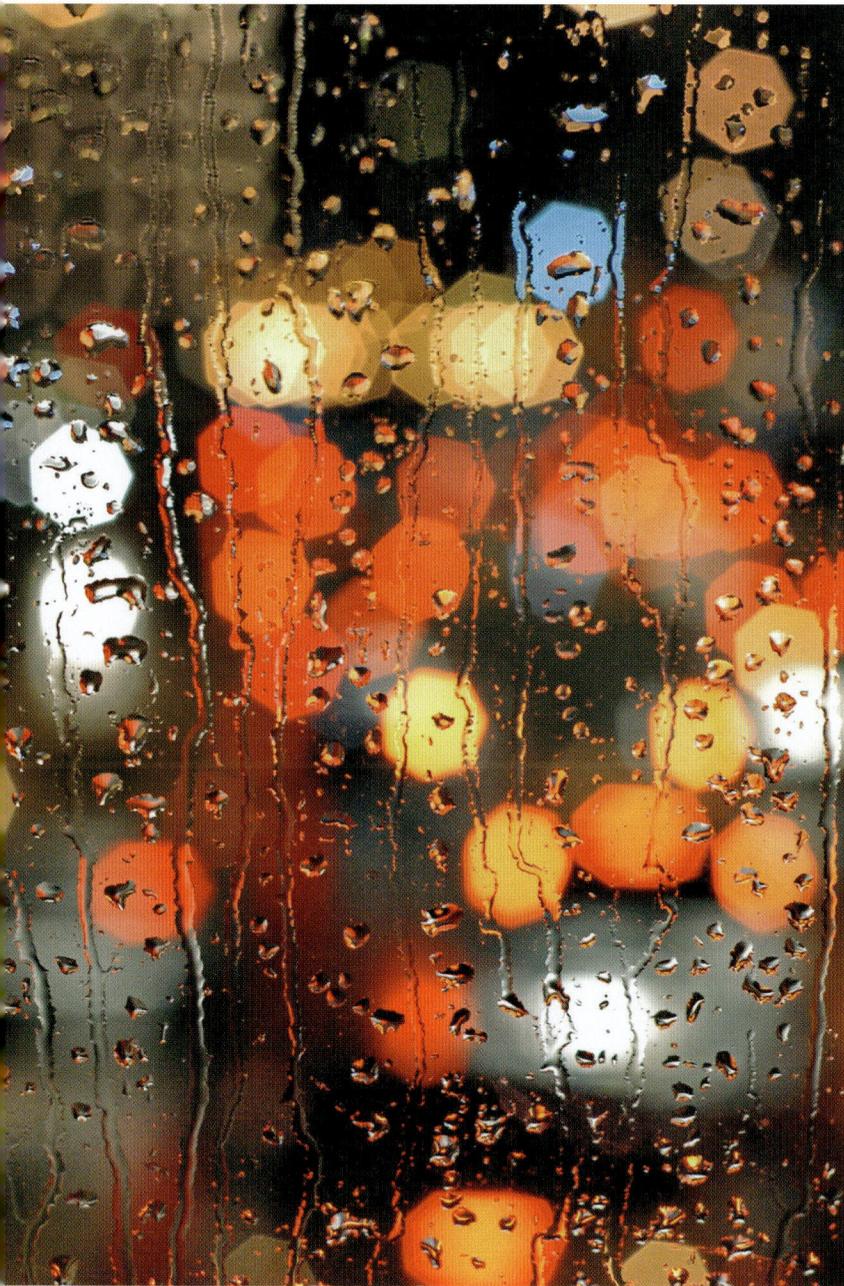
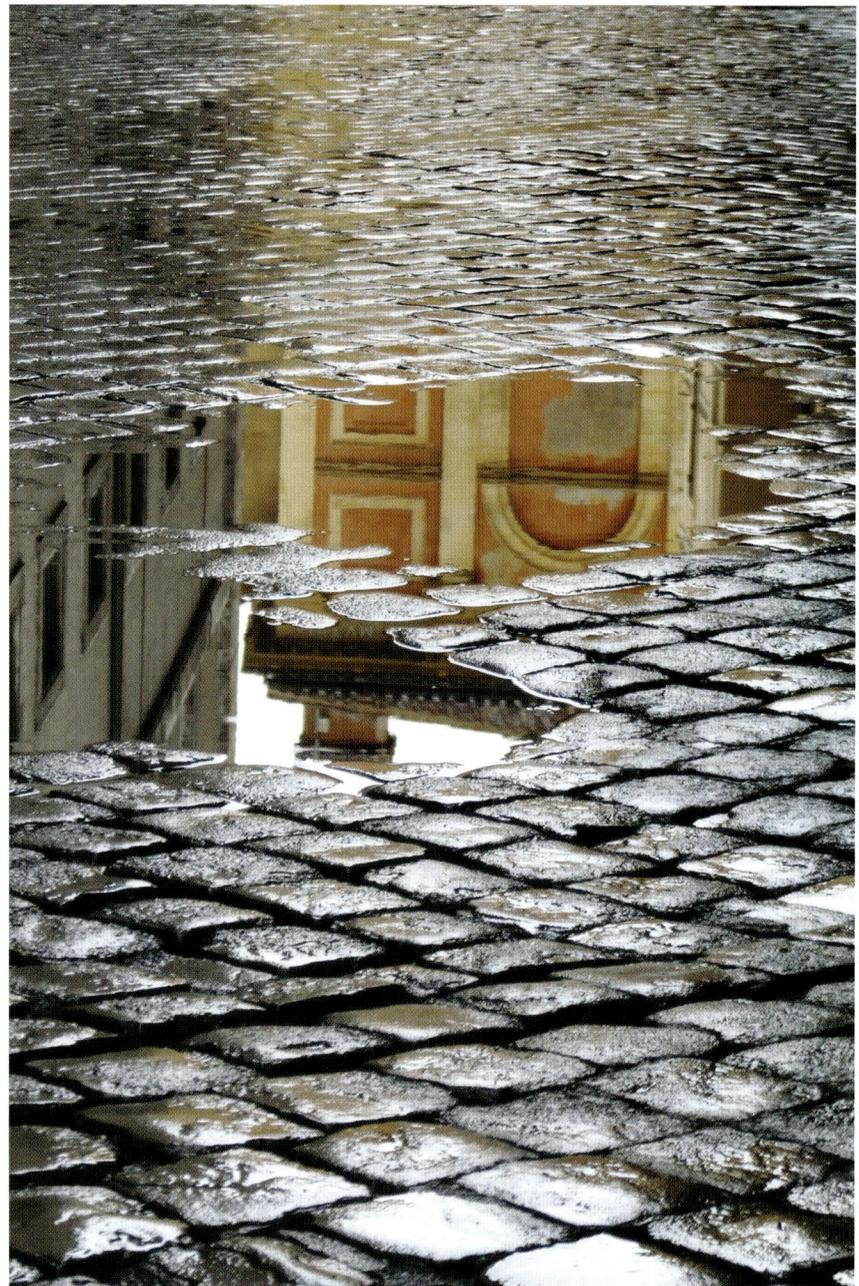

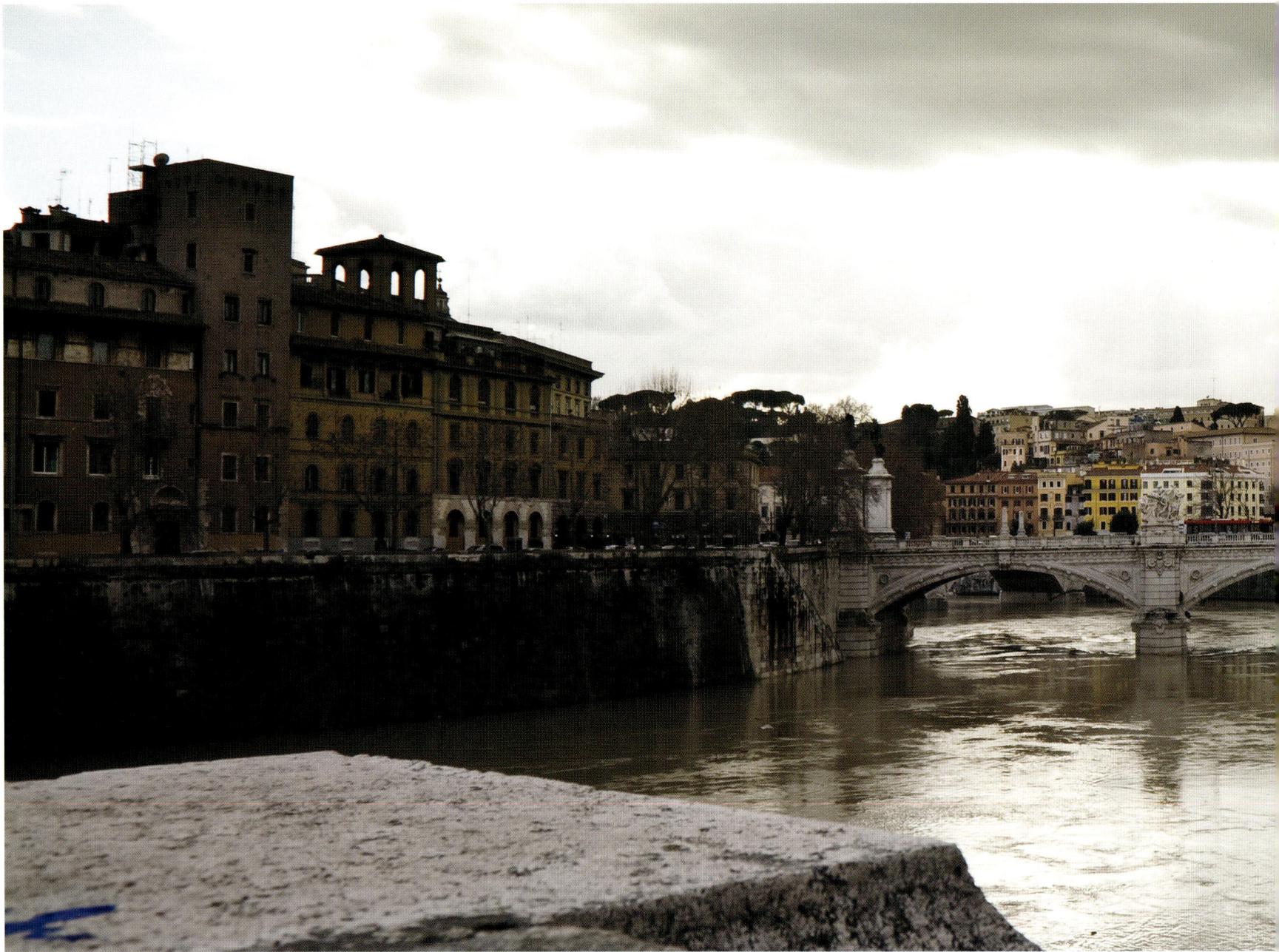

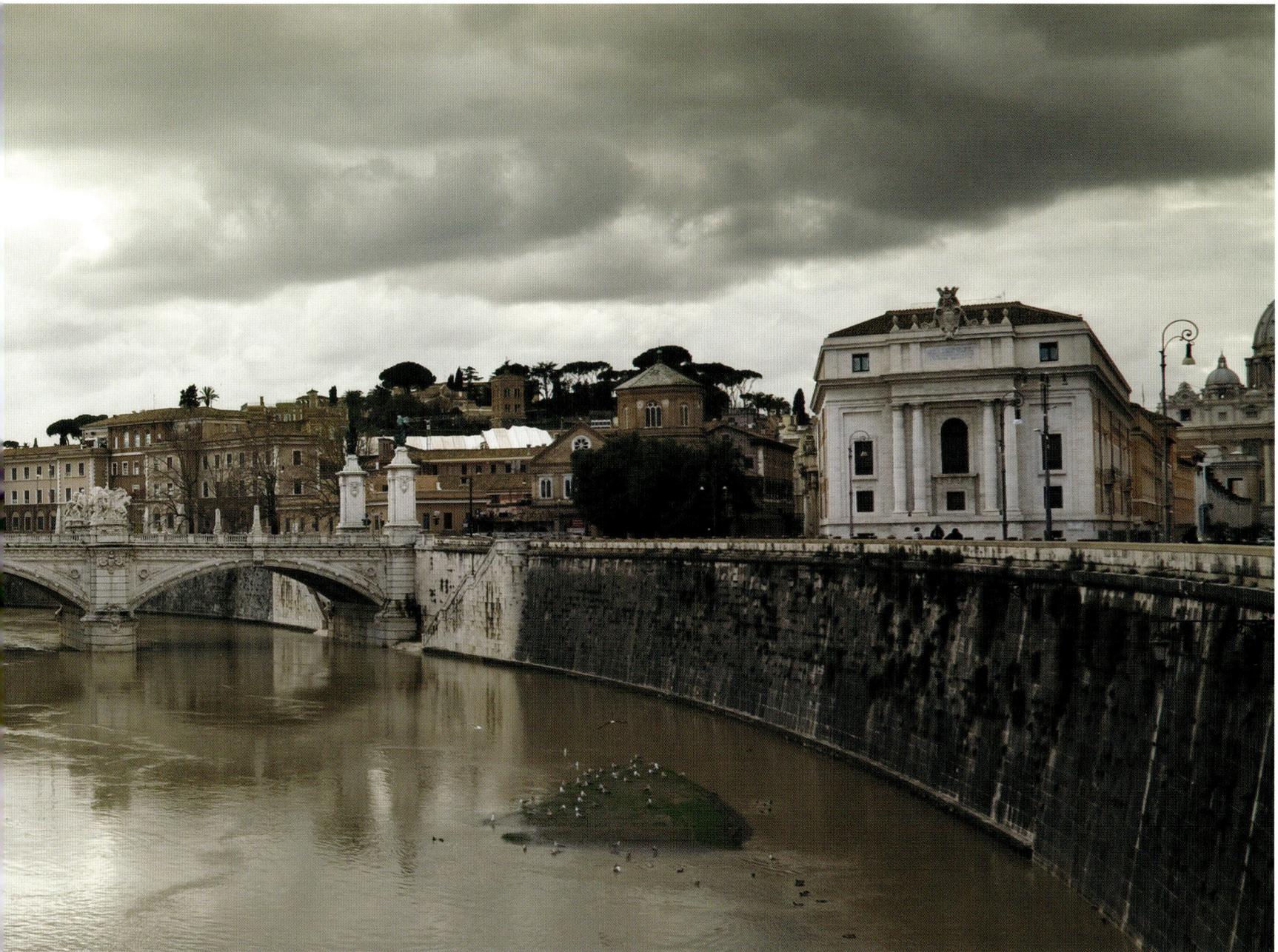

Rome in the snow

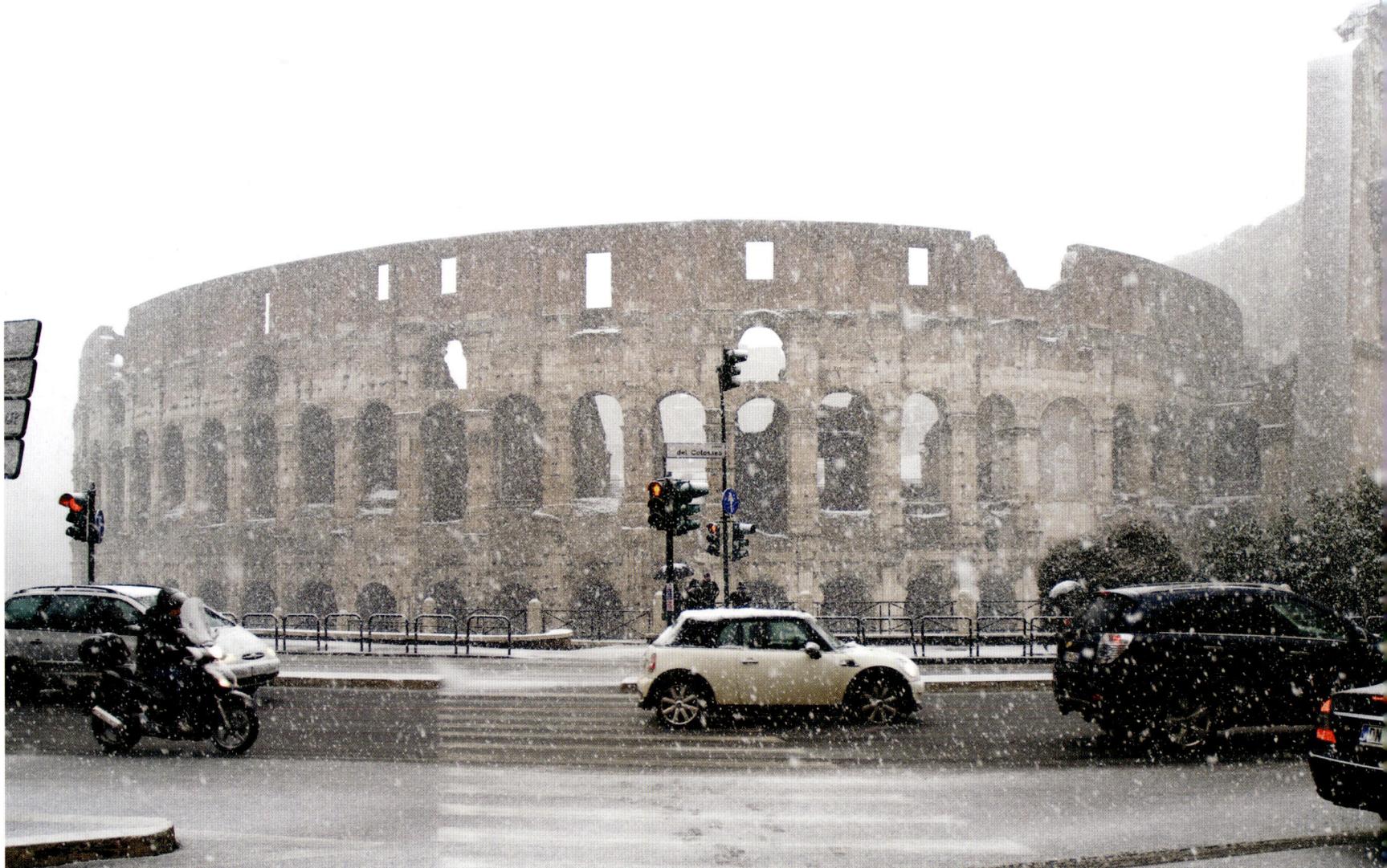

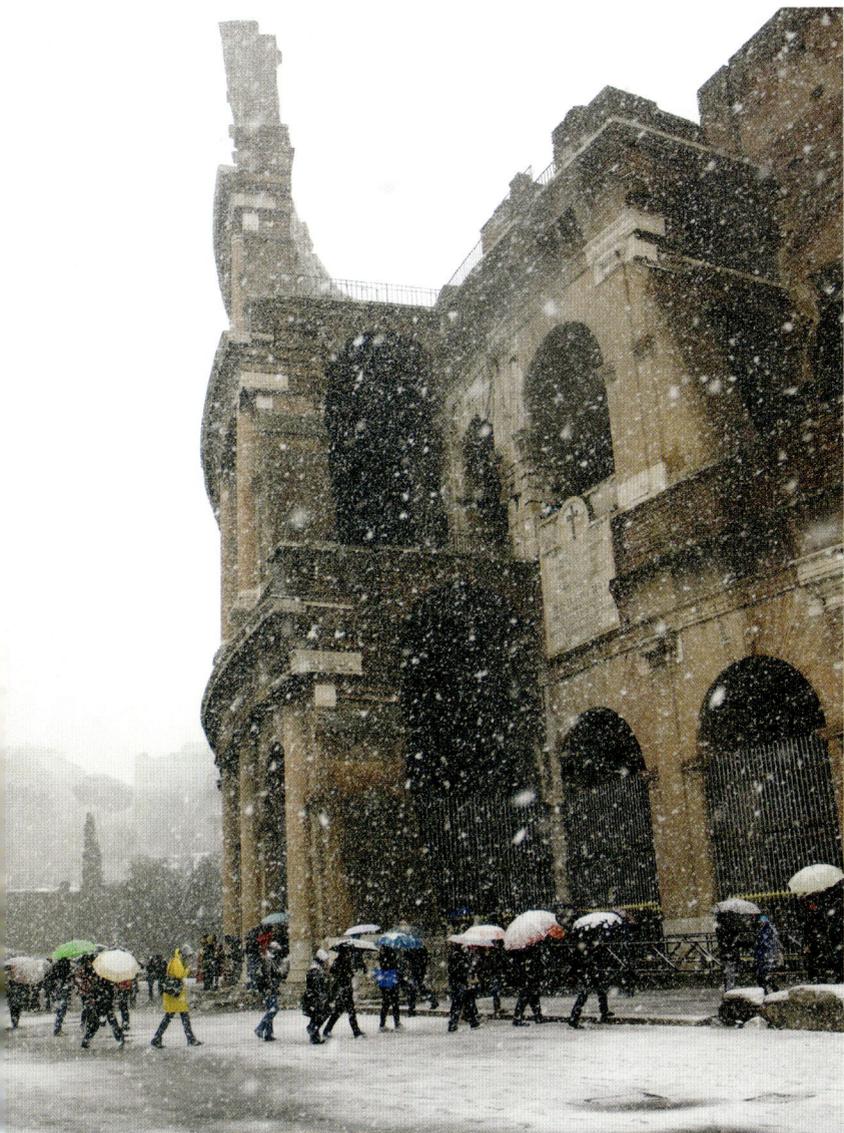

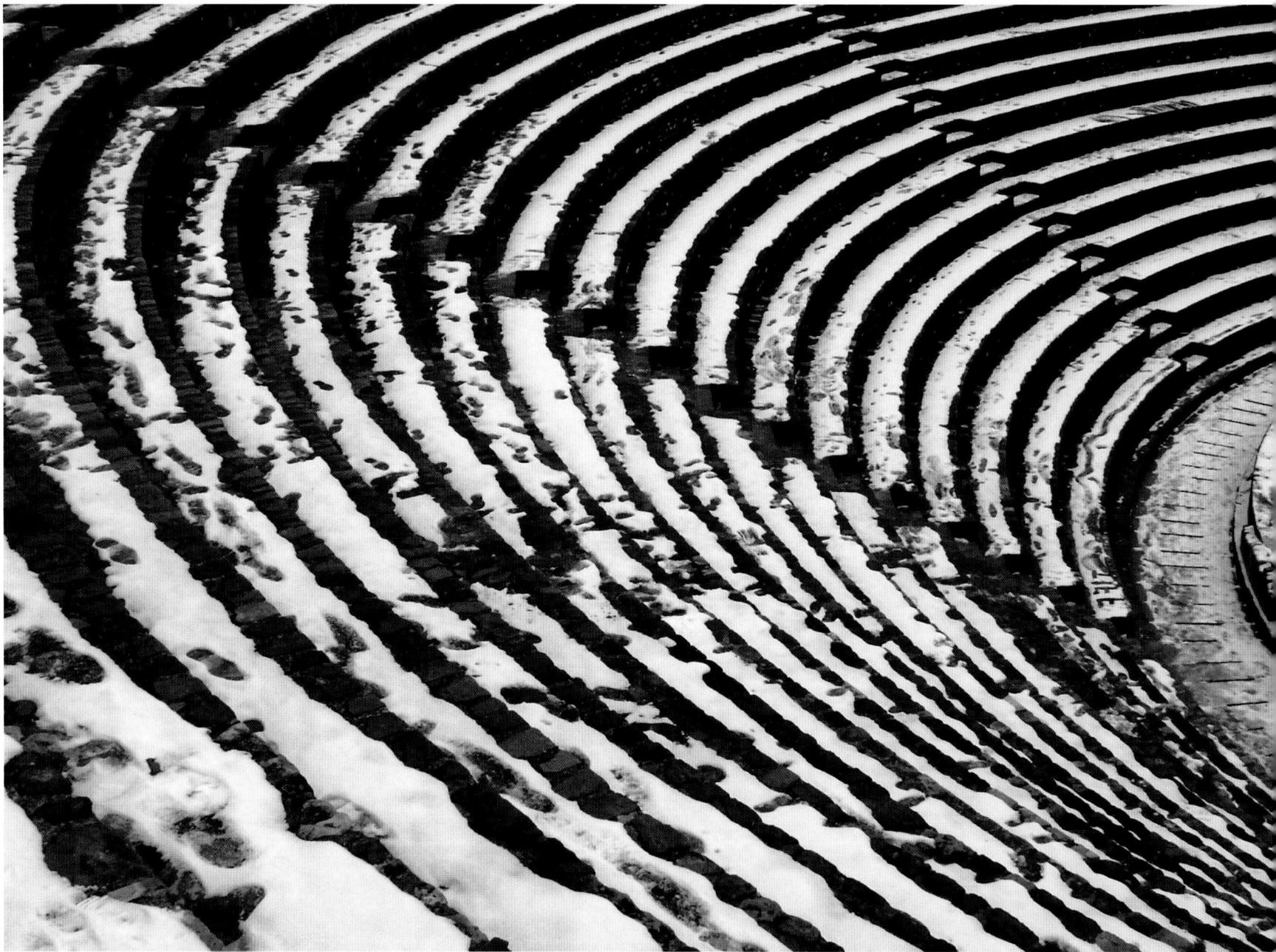

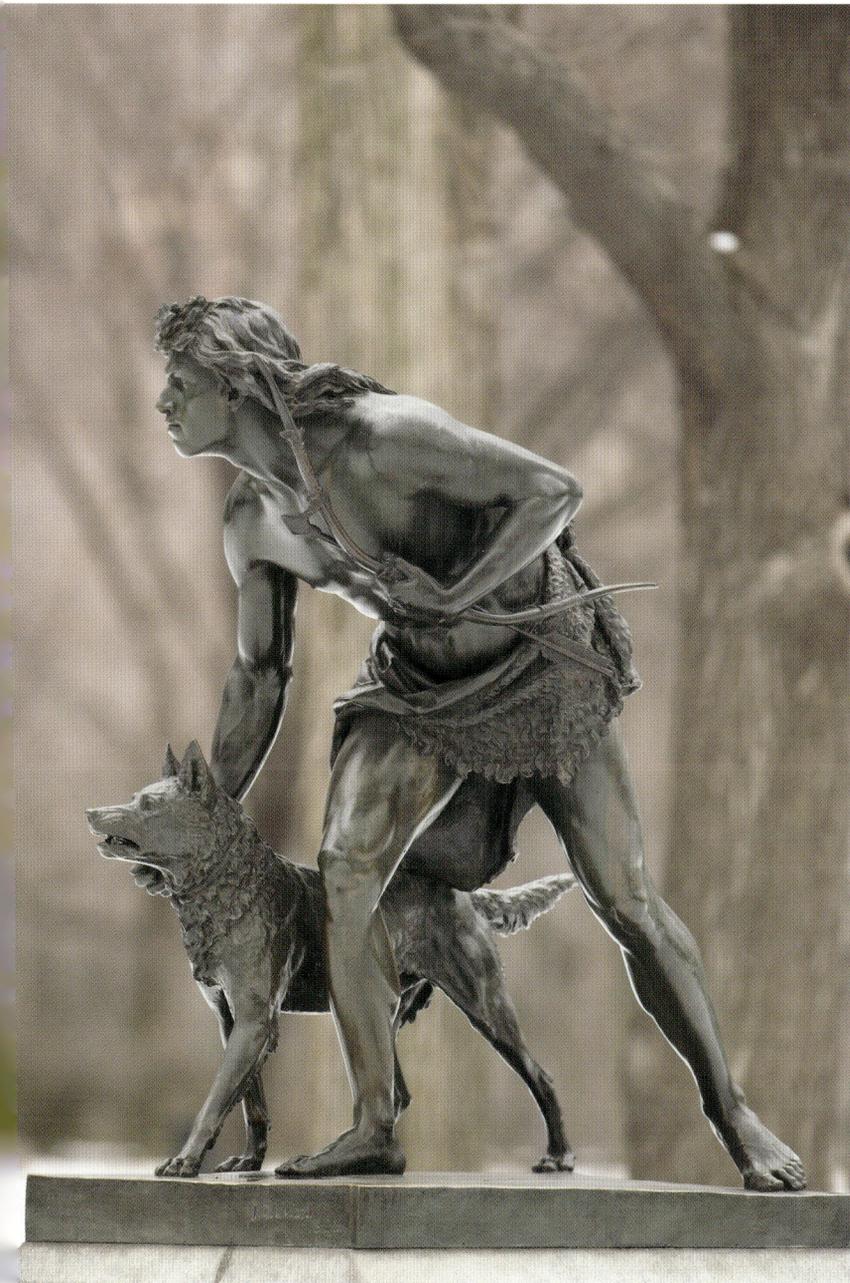

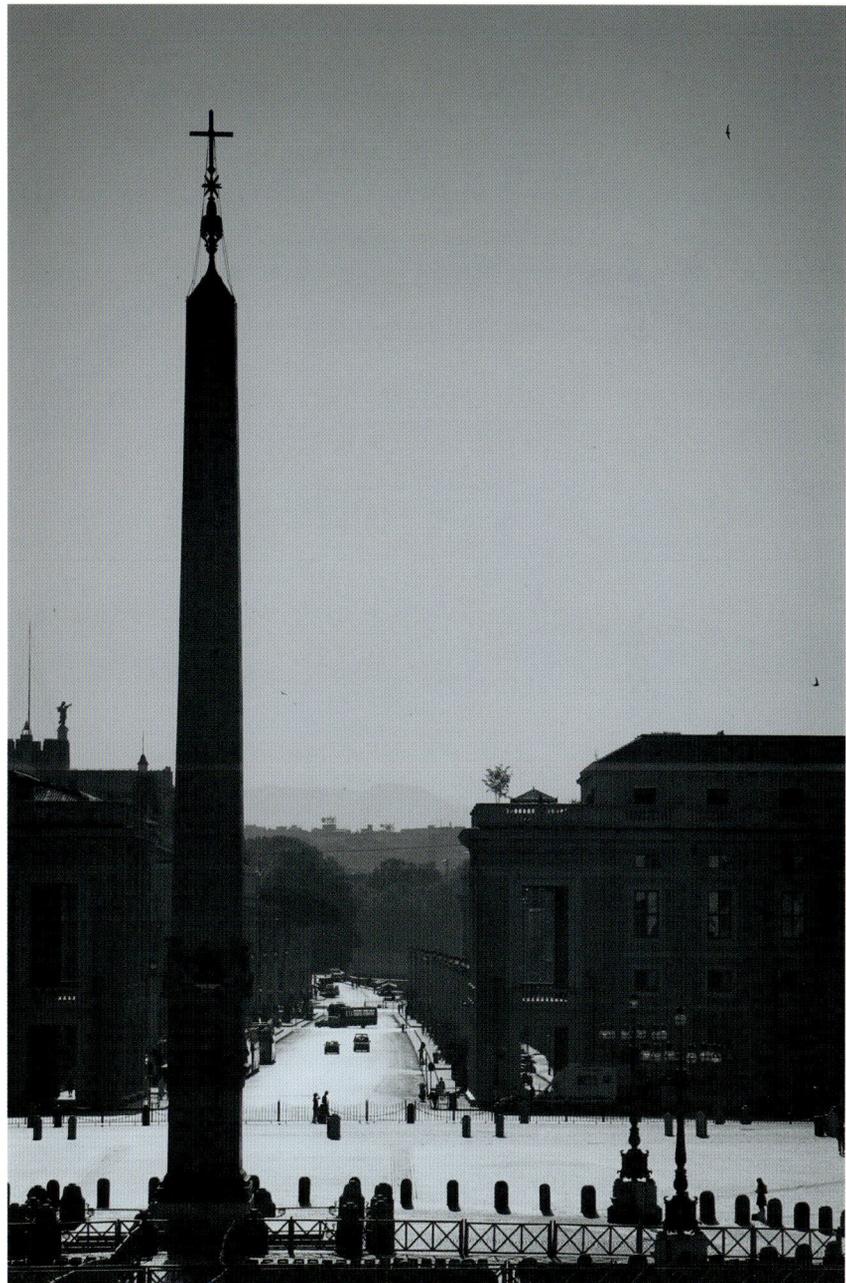

"You cheer my heart, who build

as if Rome would be eternal."

Augustus Caesar

Rome Cityscapes

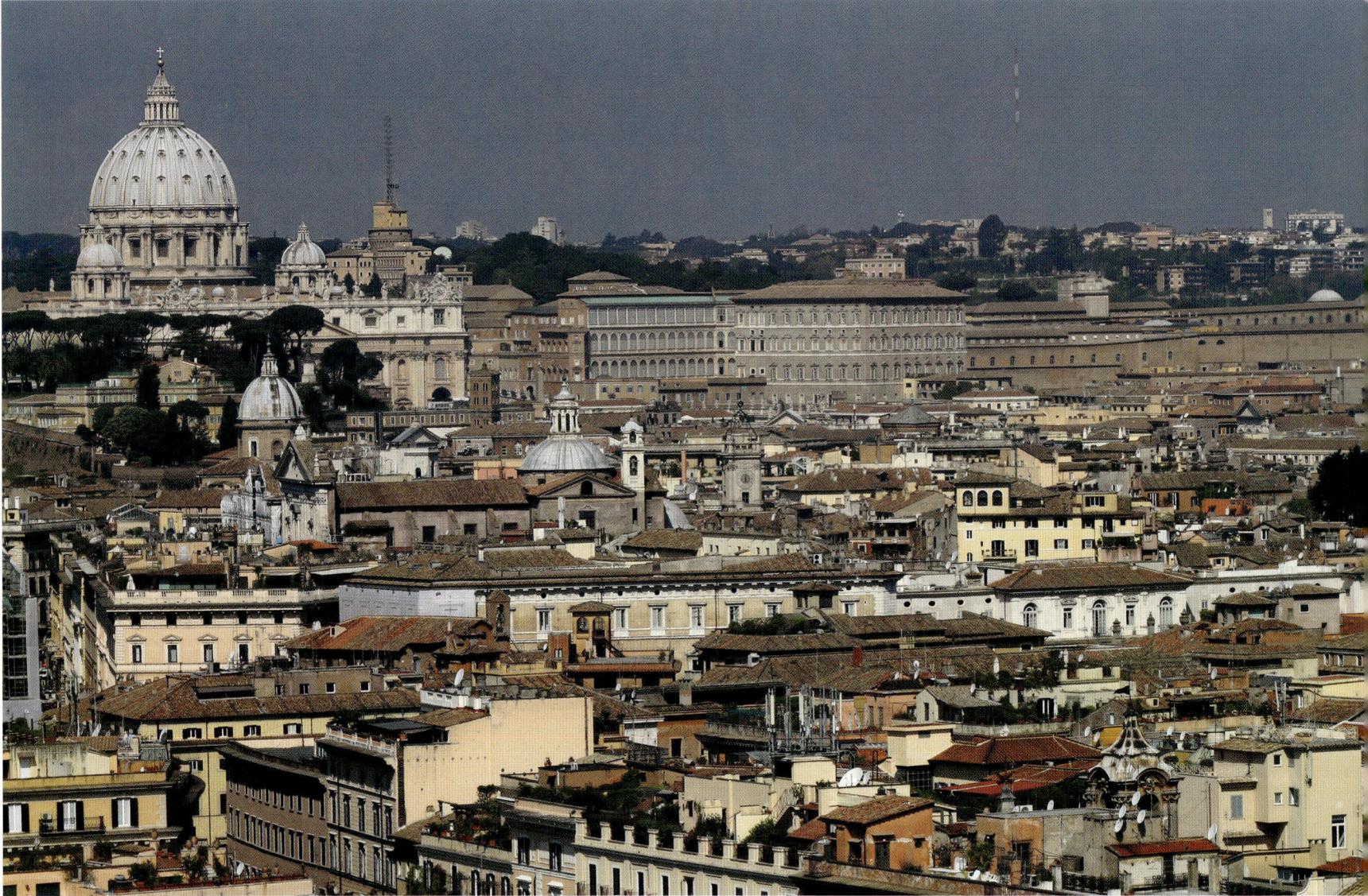

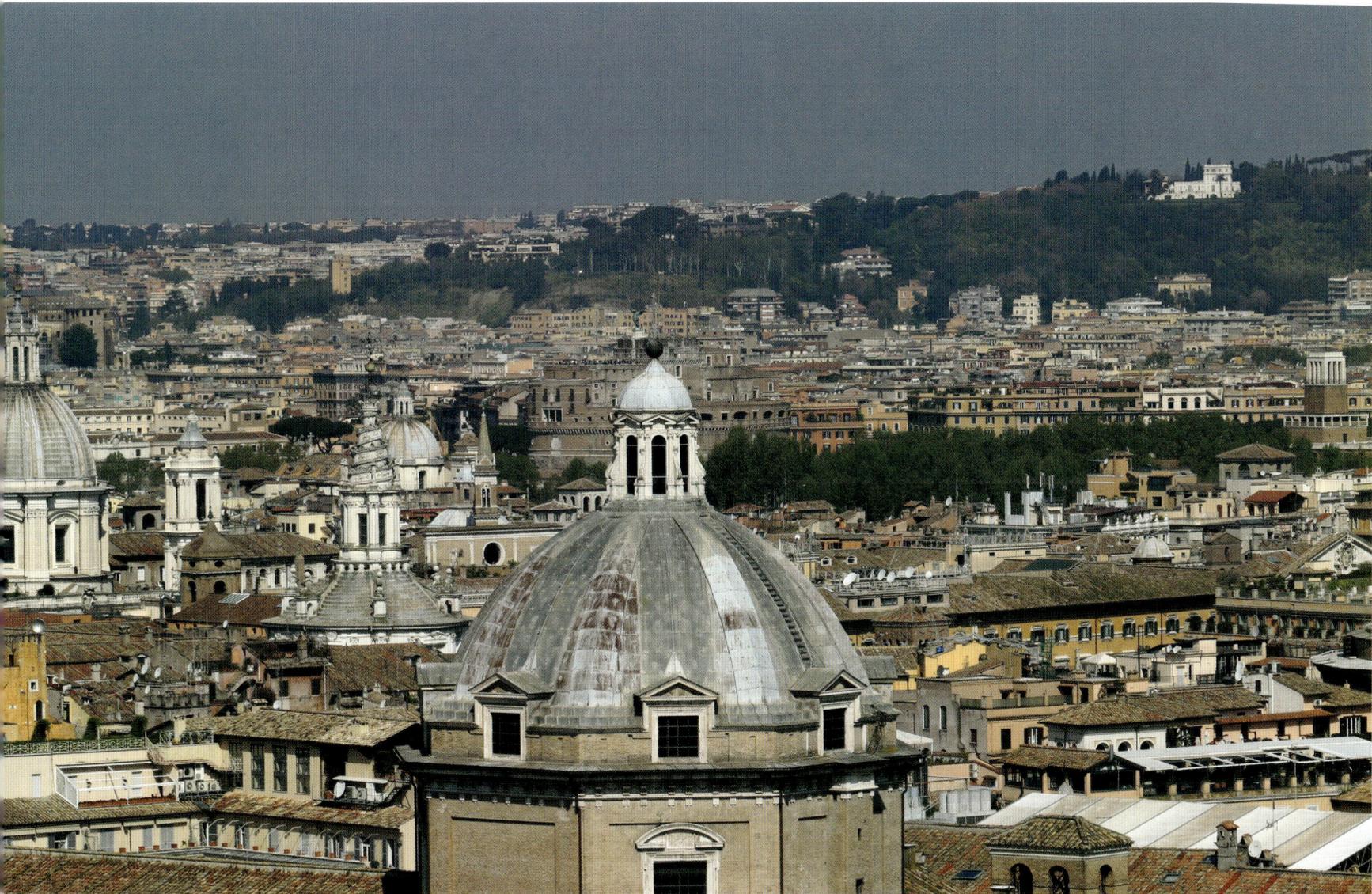

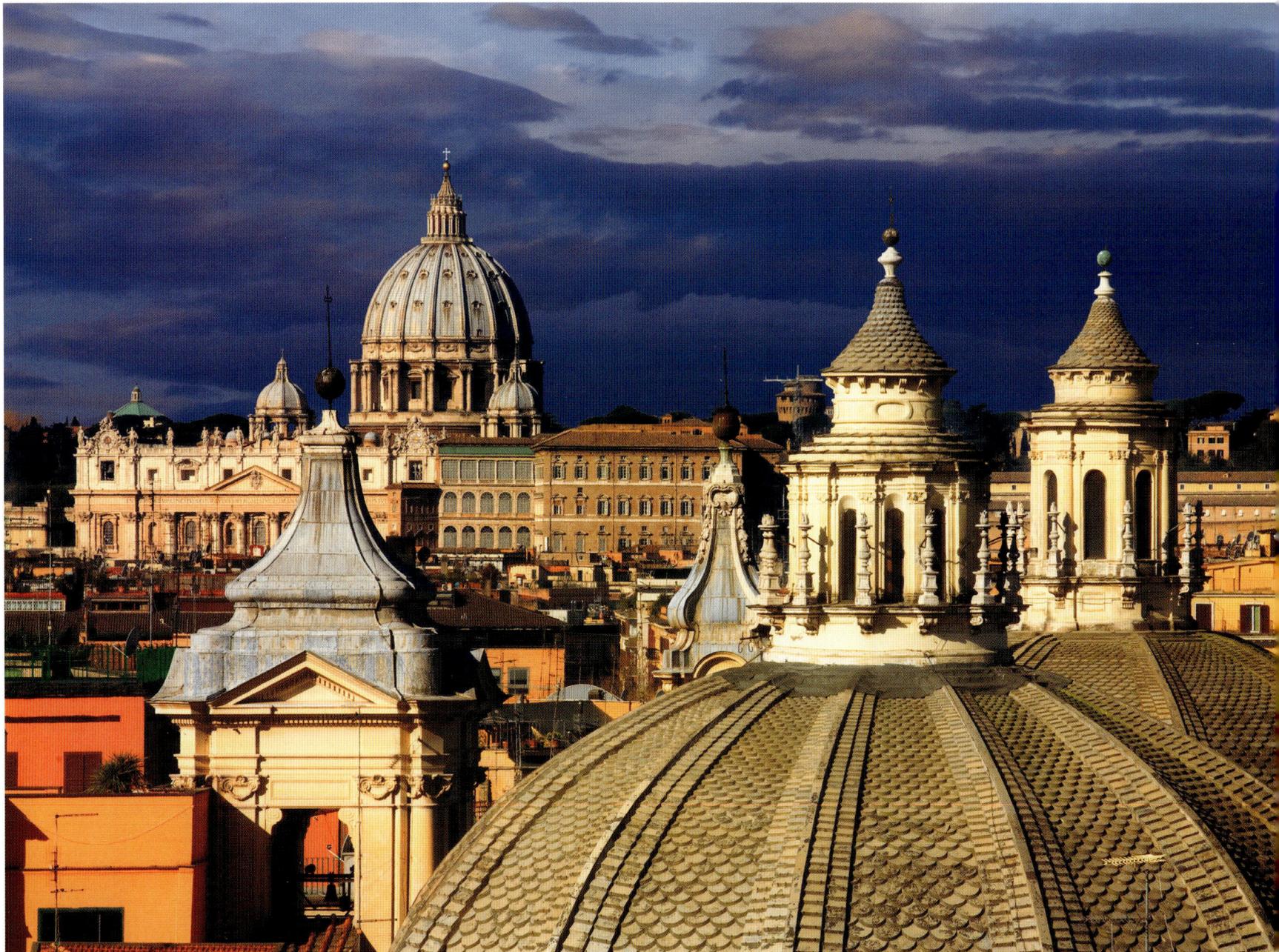

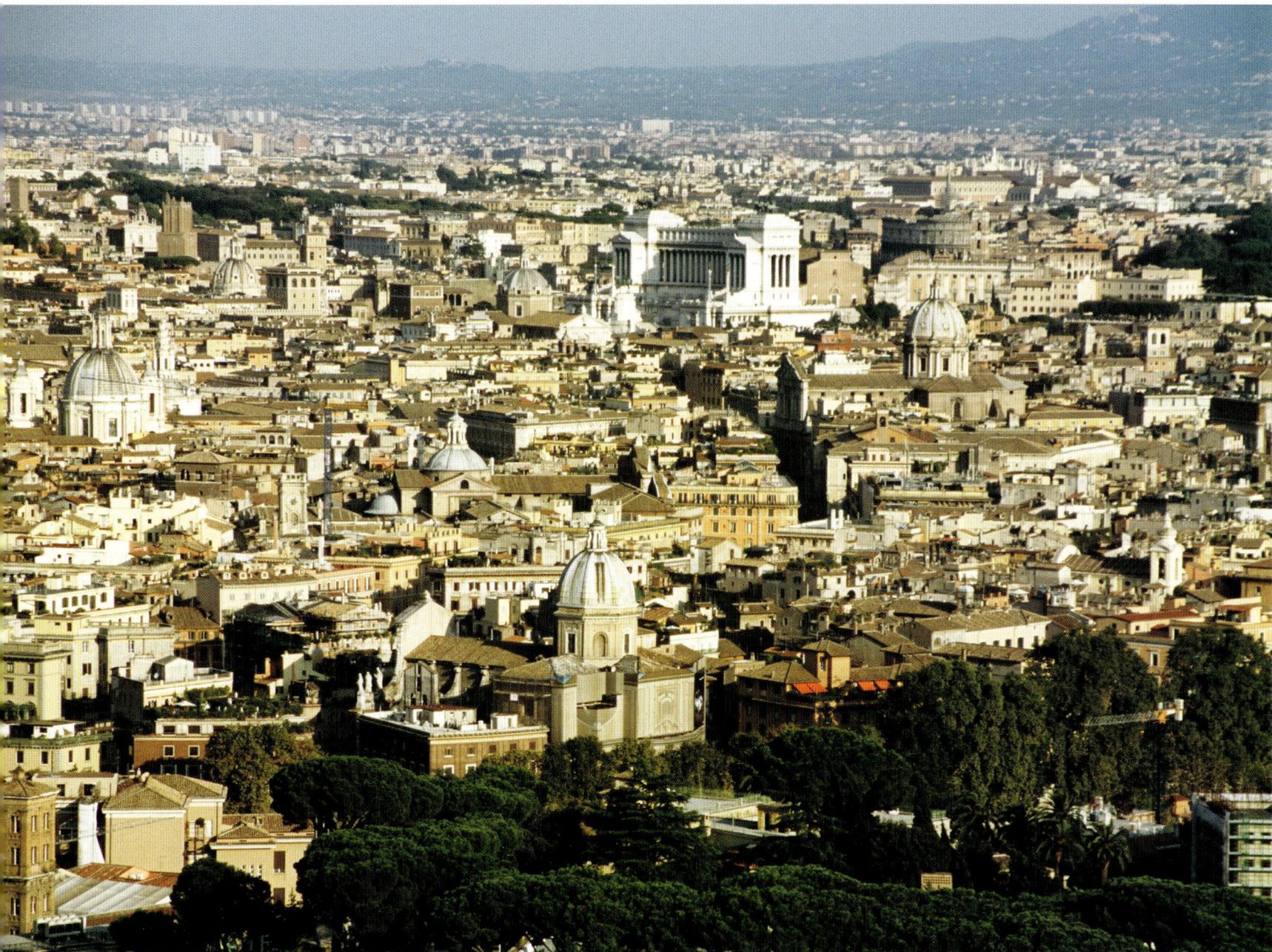

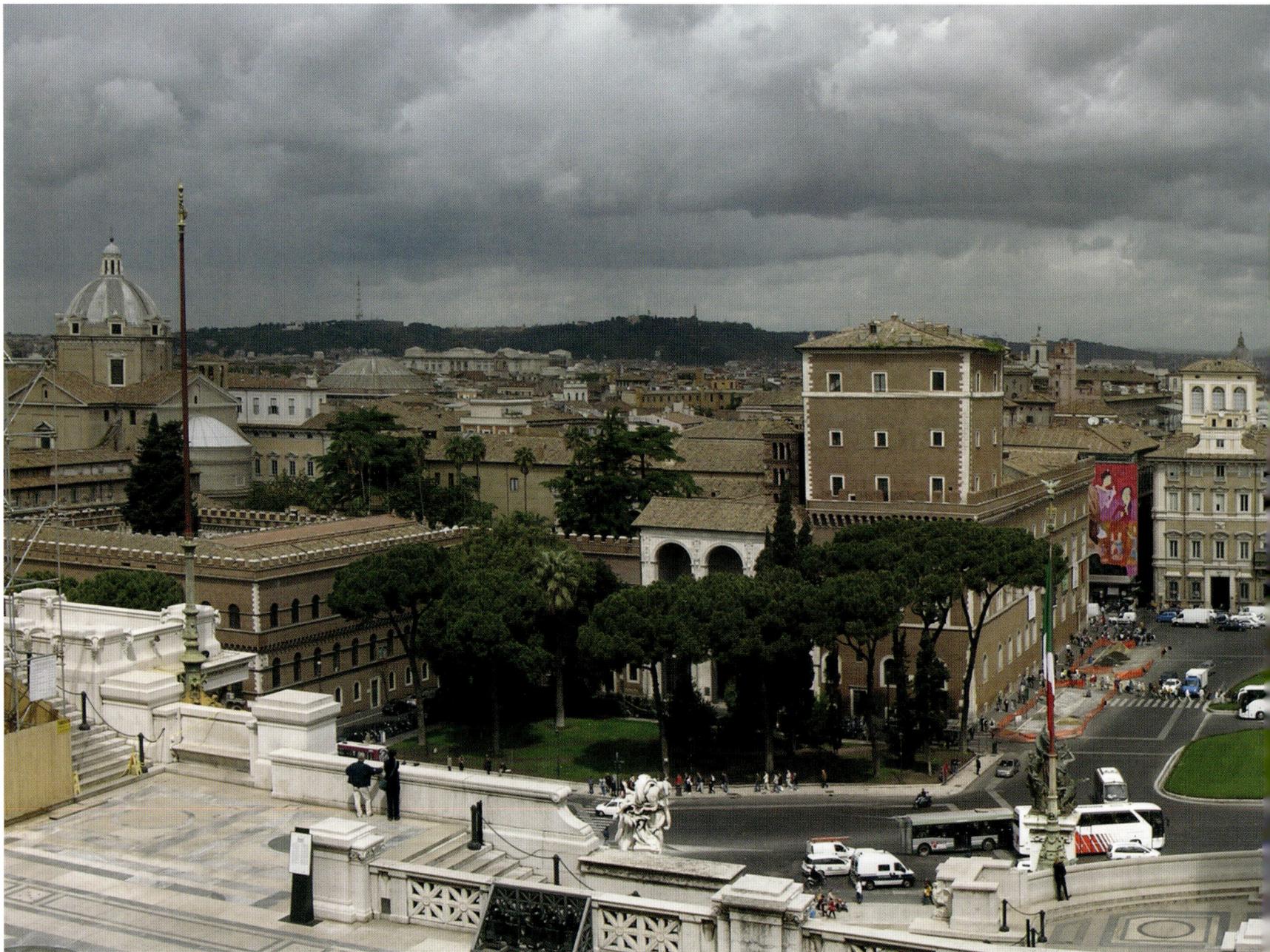

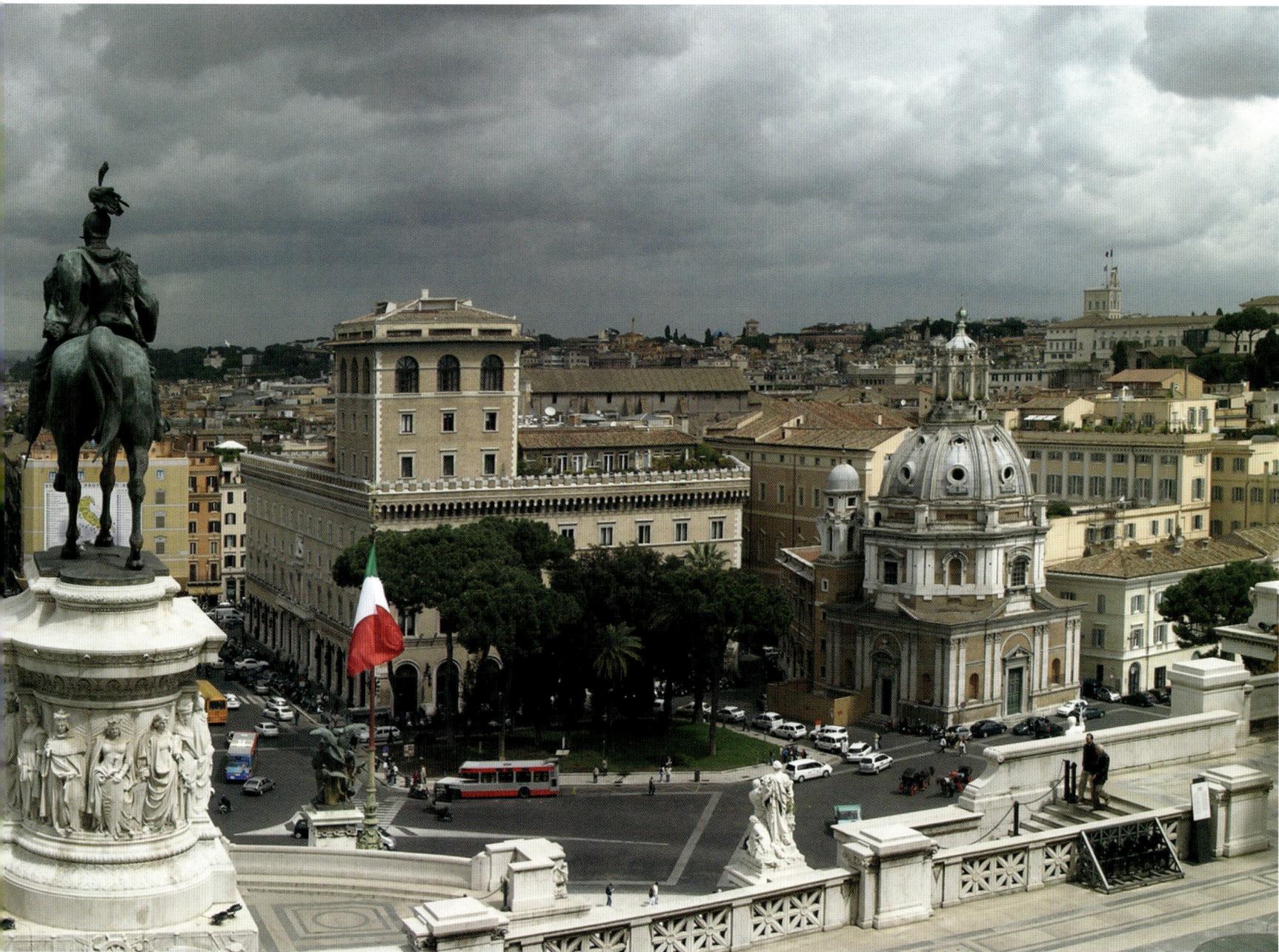

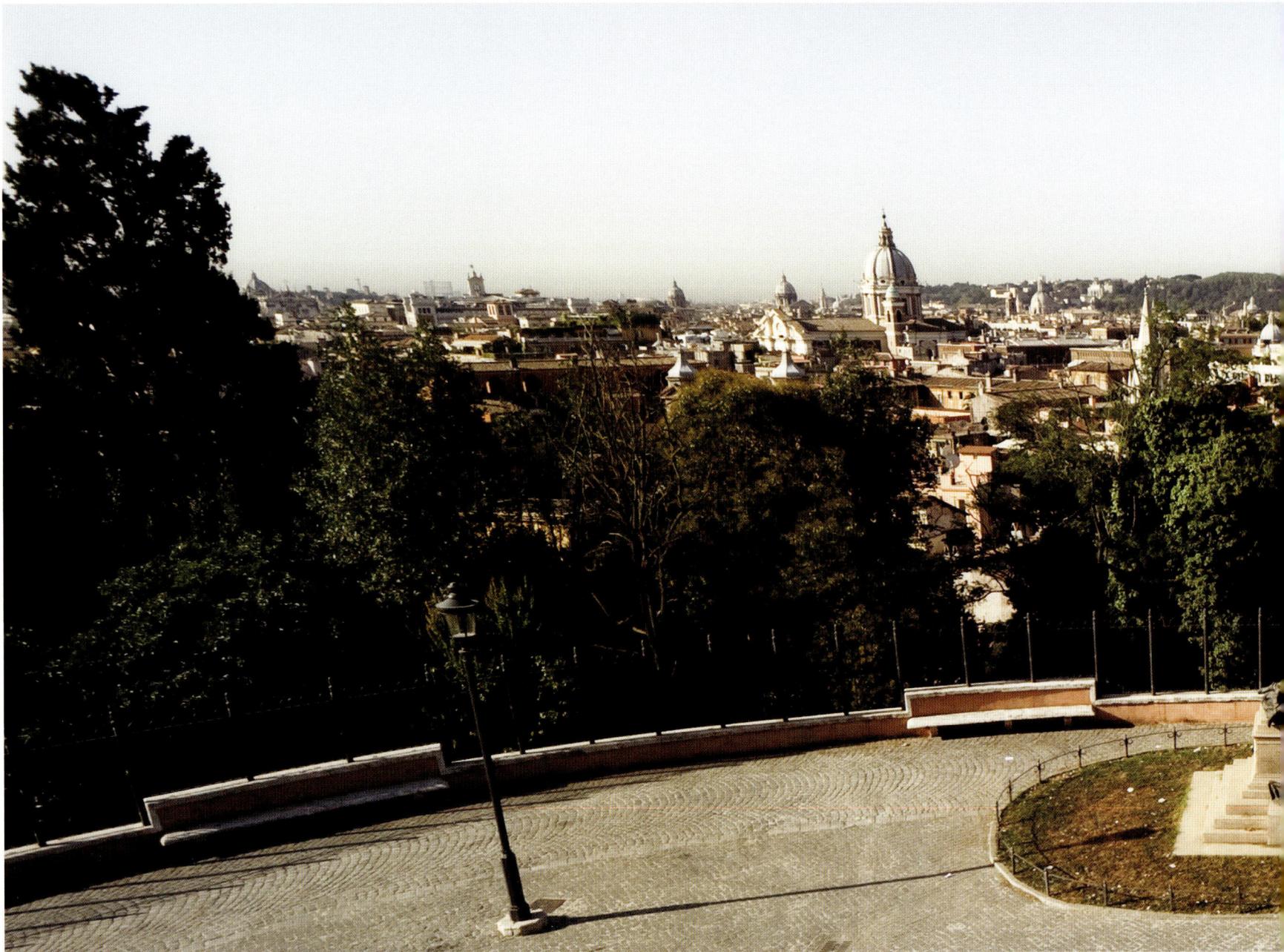

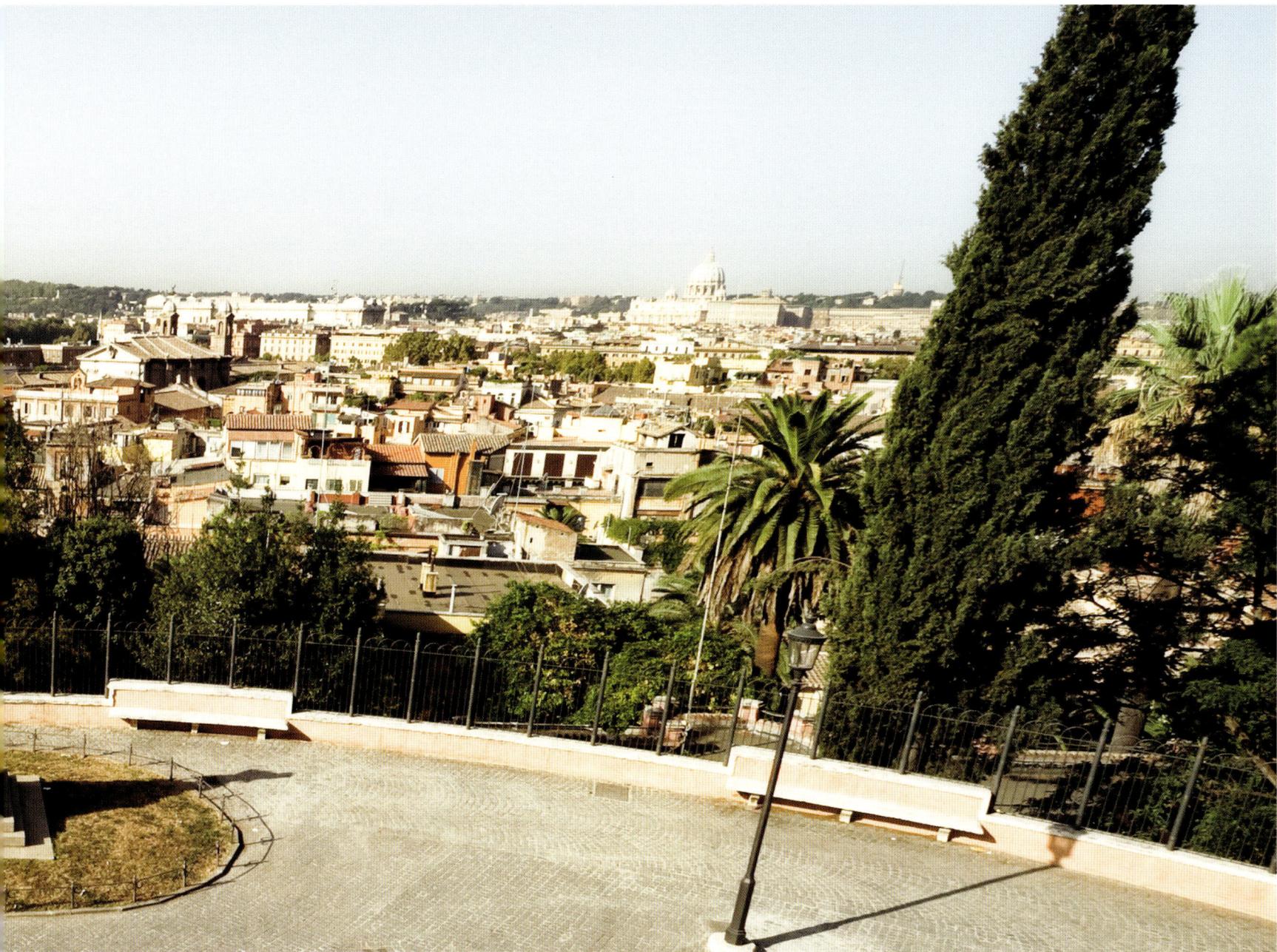

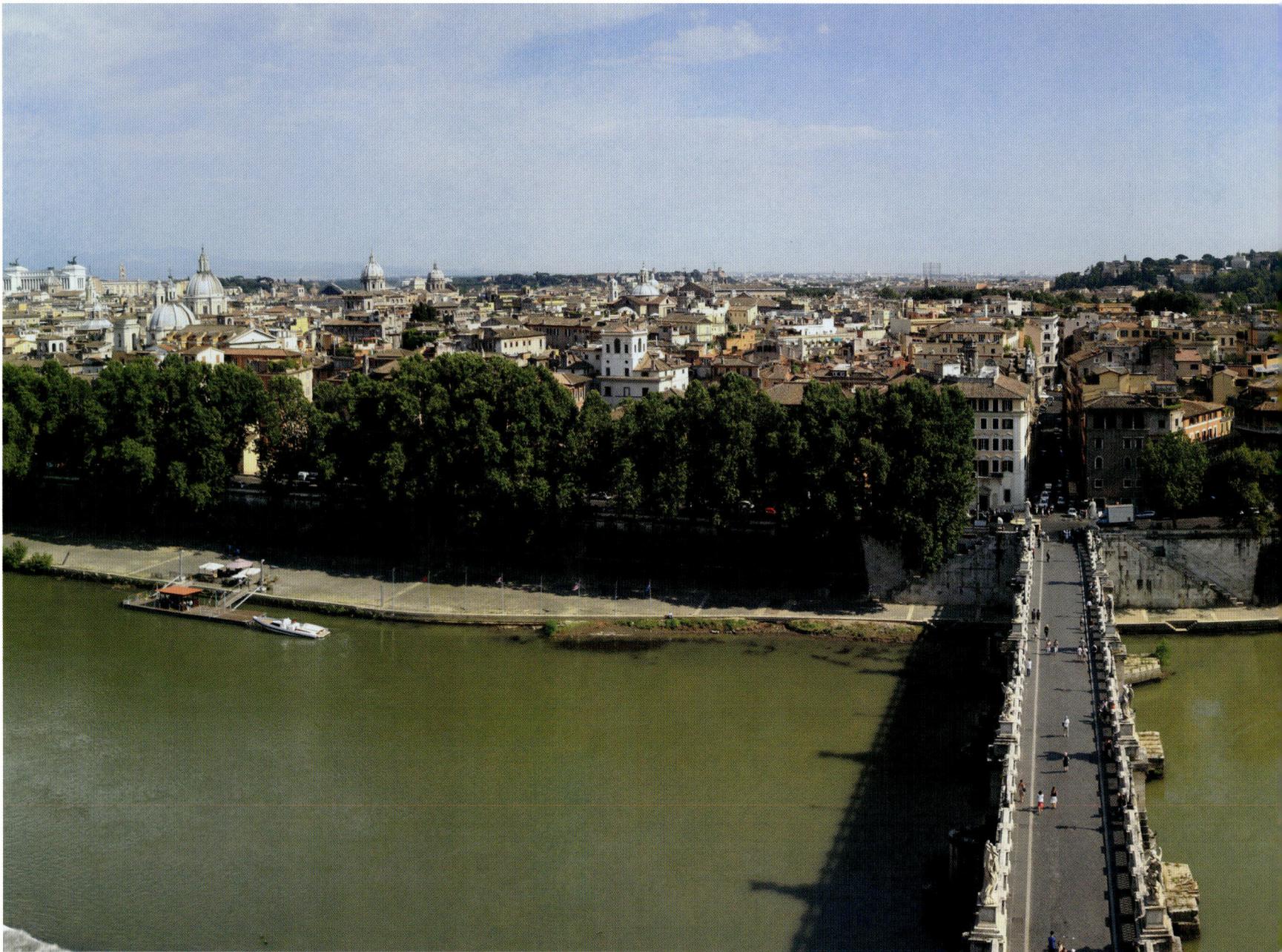

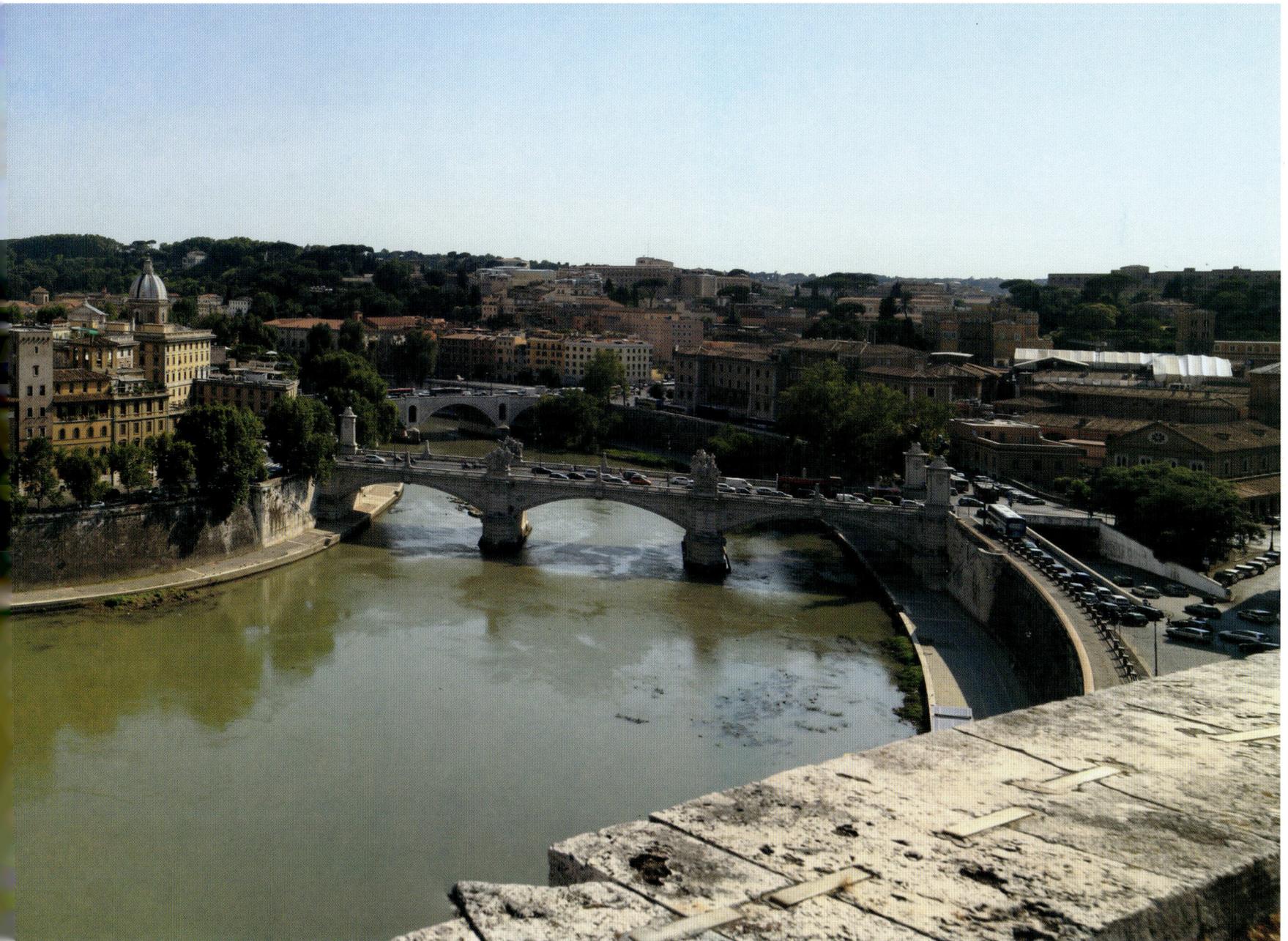

"Rome is a world, and it would take years to become a true citizen of it."

from "Letters from Italy" by Johann Wolfgang von Goethe

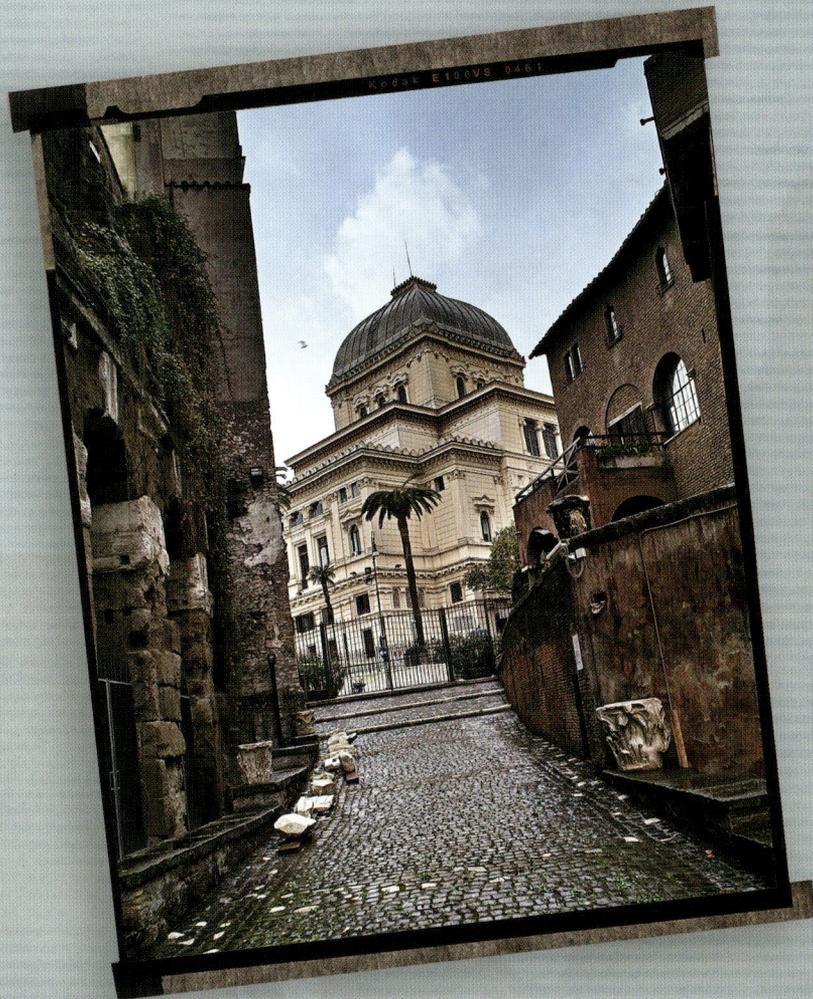

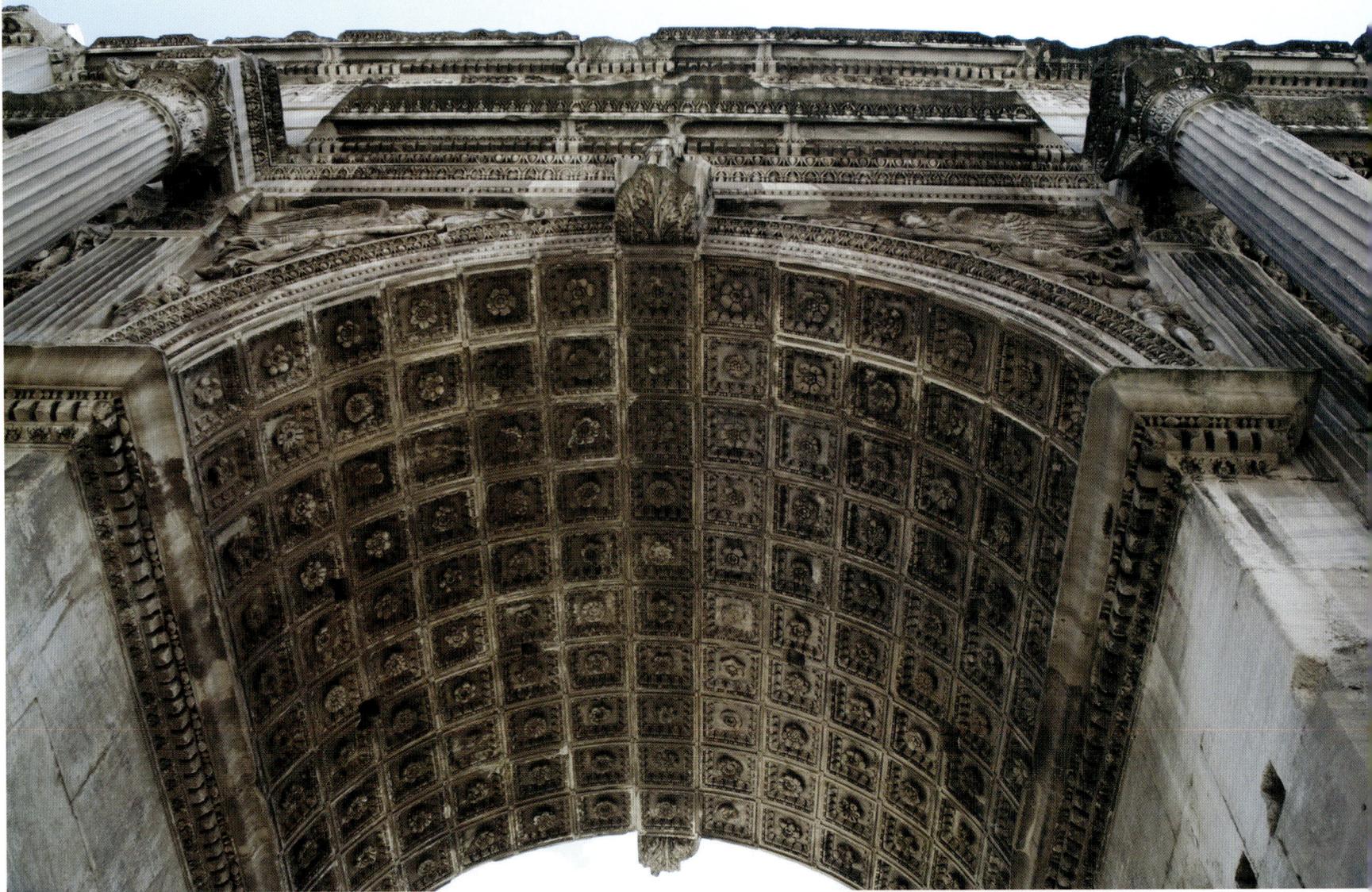

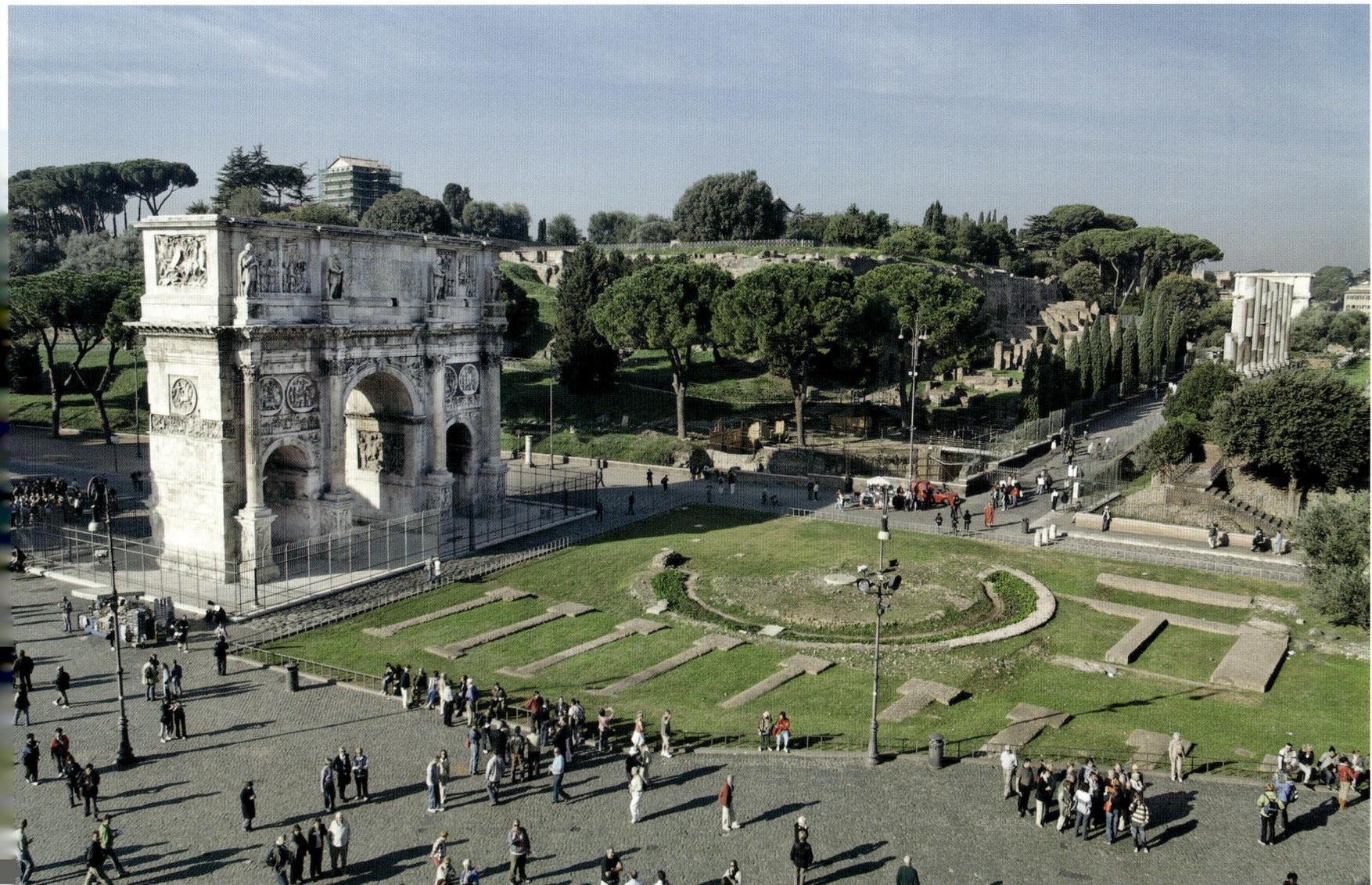

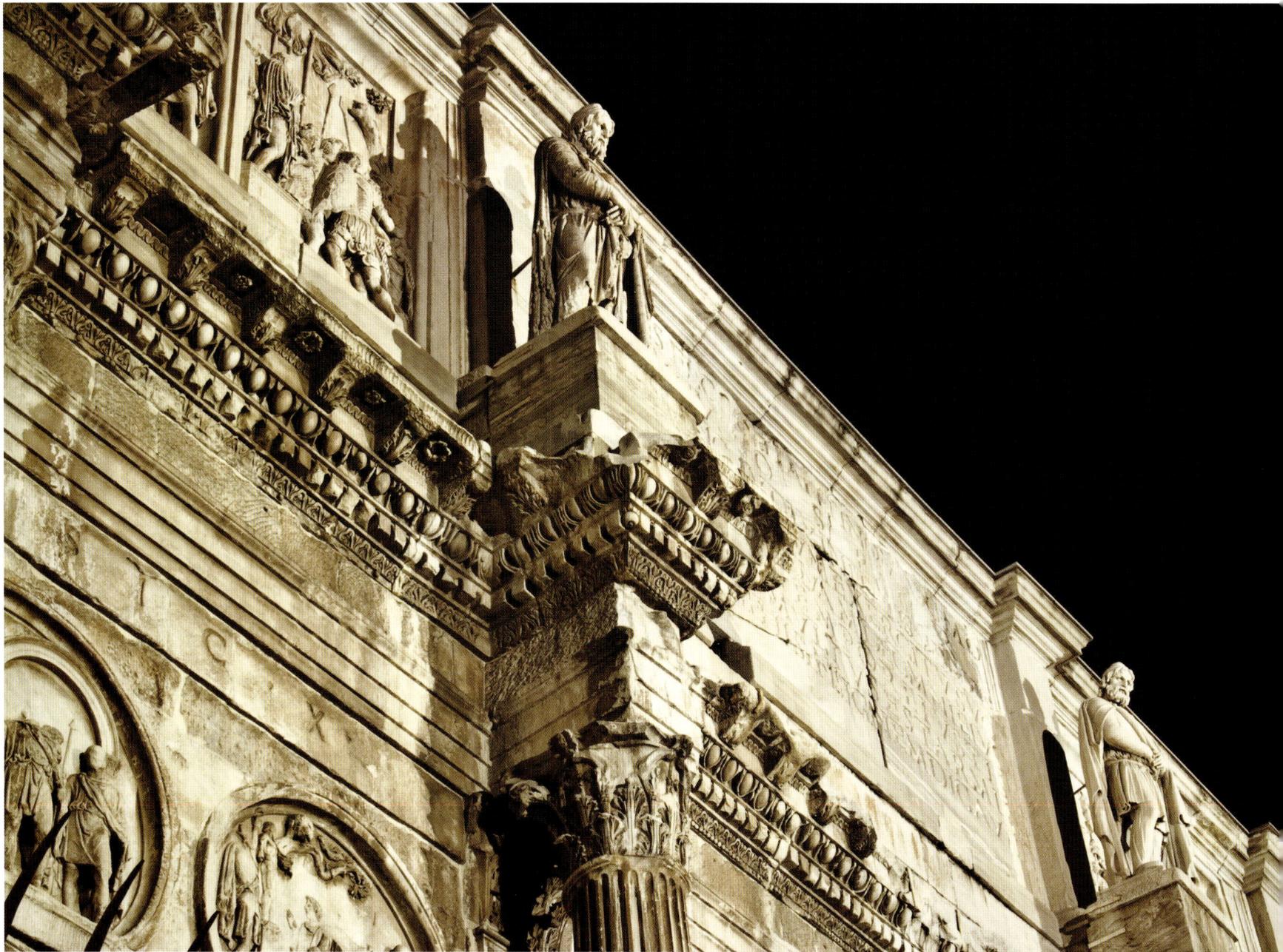

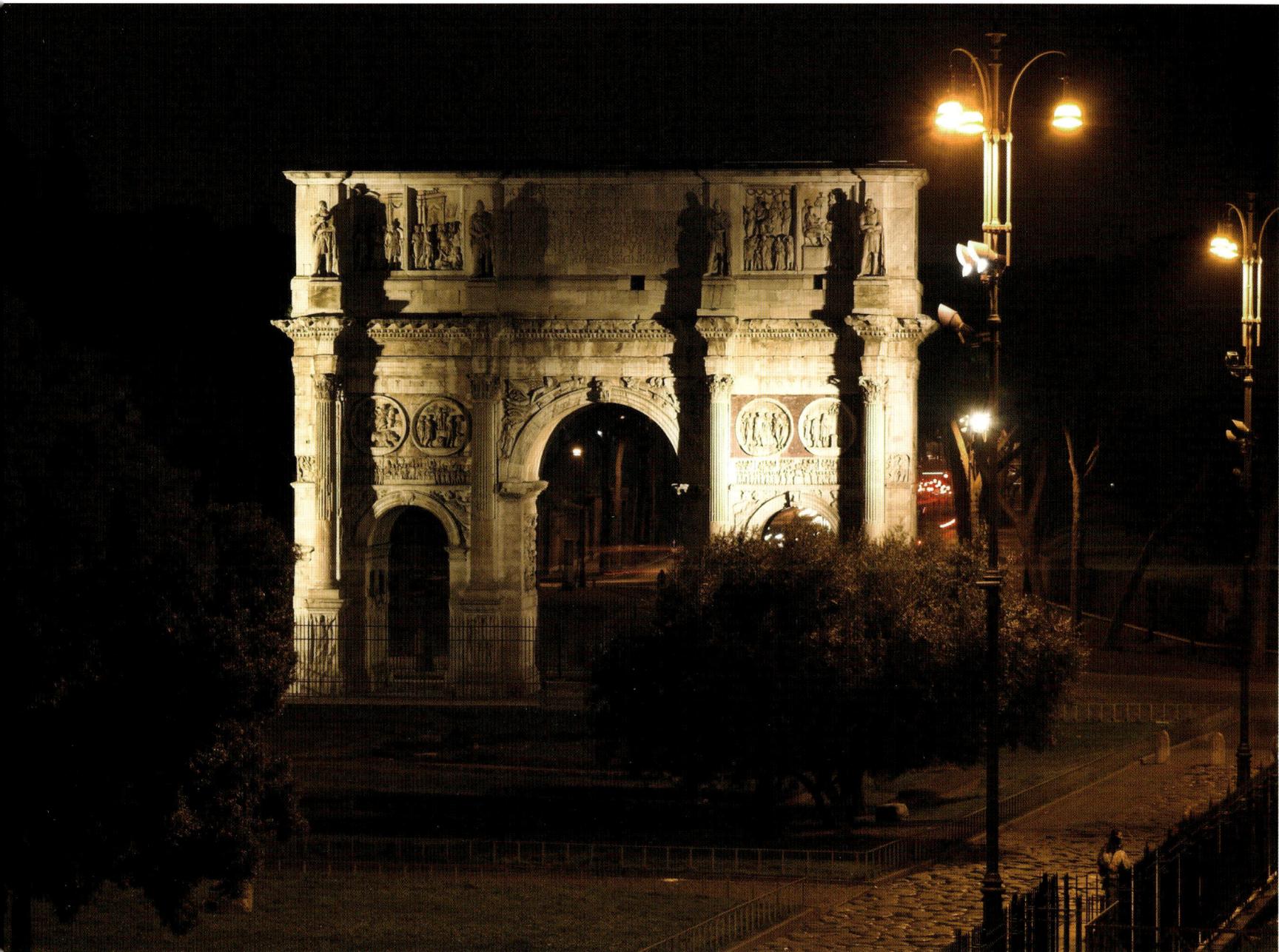

"When they are at Rome, they do there as they see done."

Robert Burton

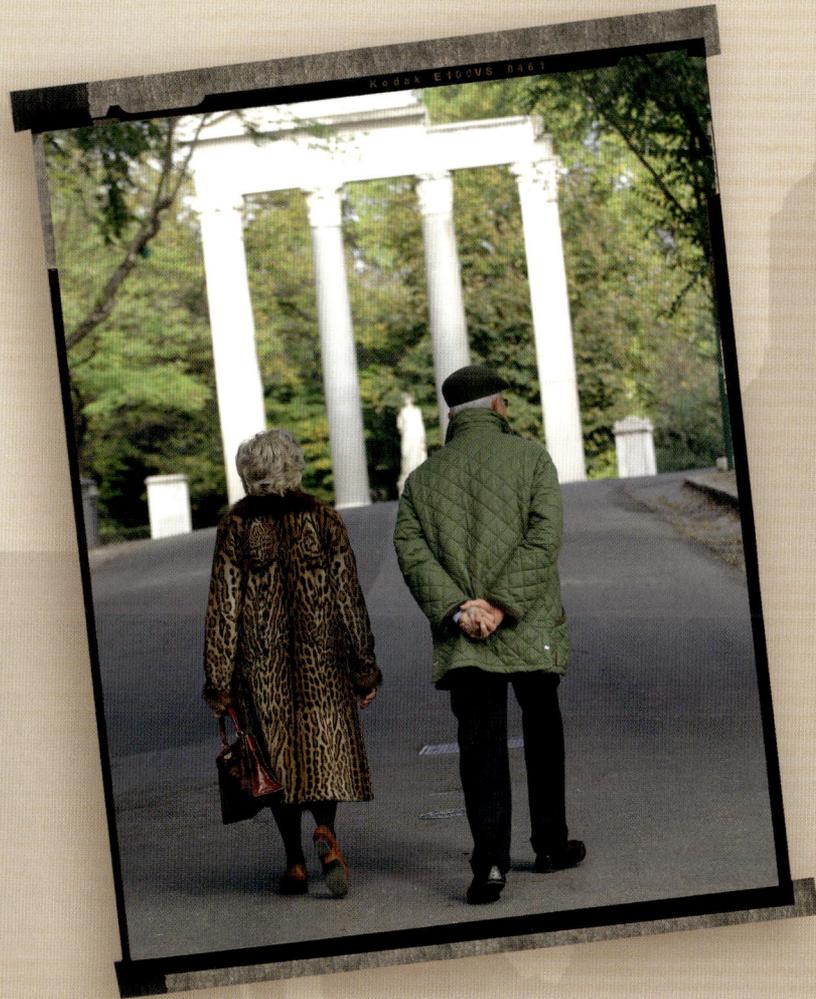

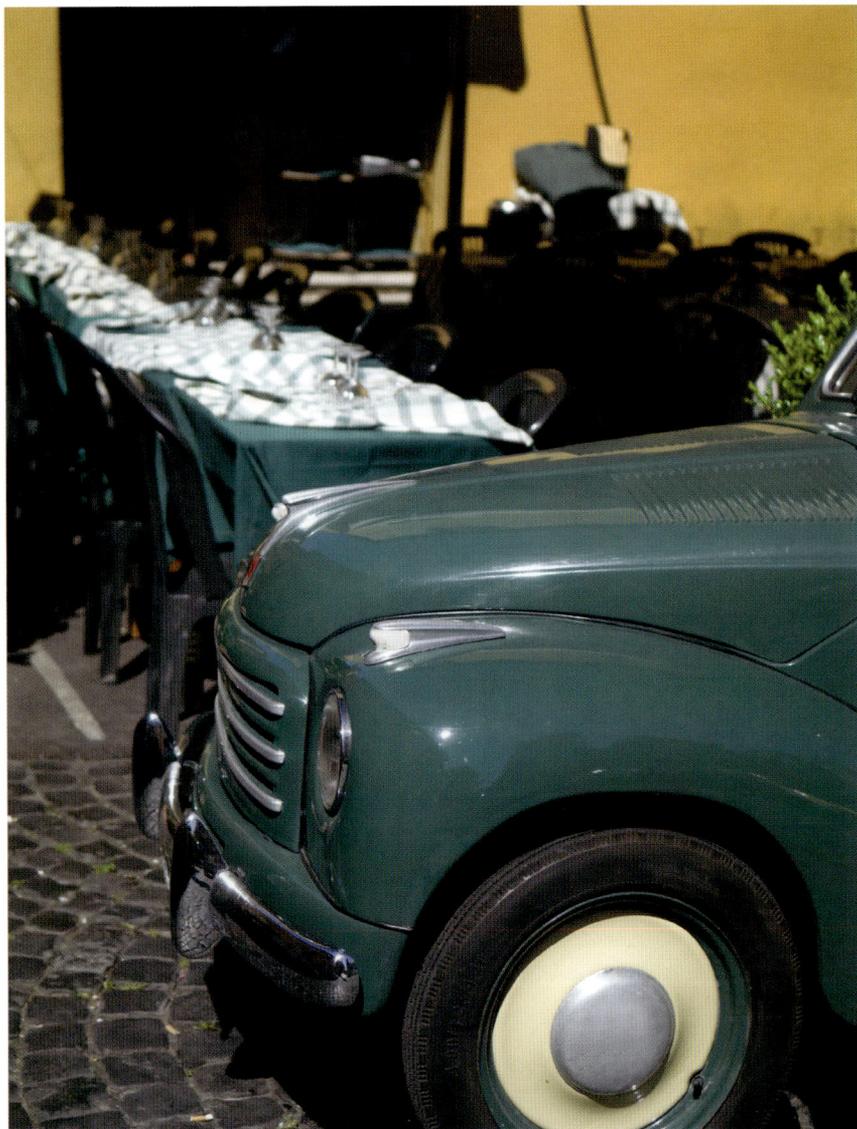

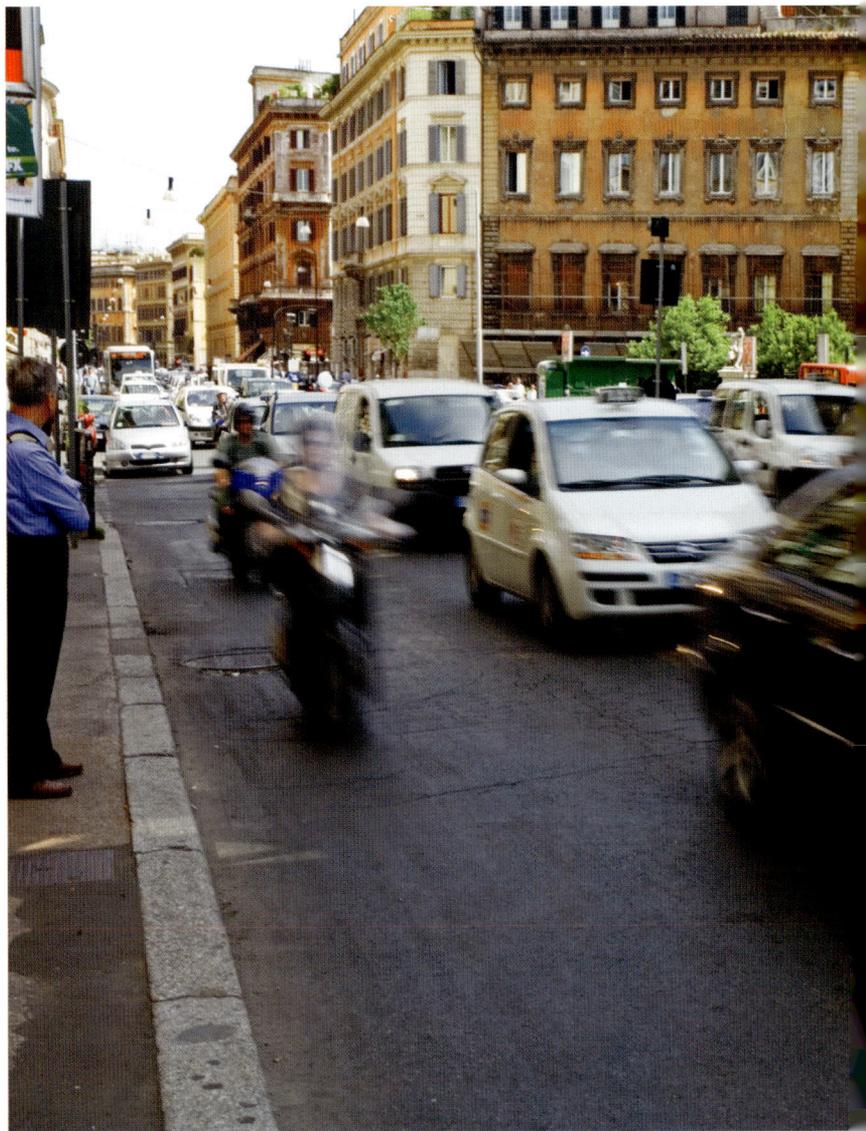

Traffic

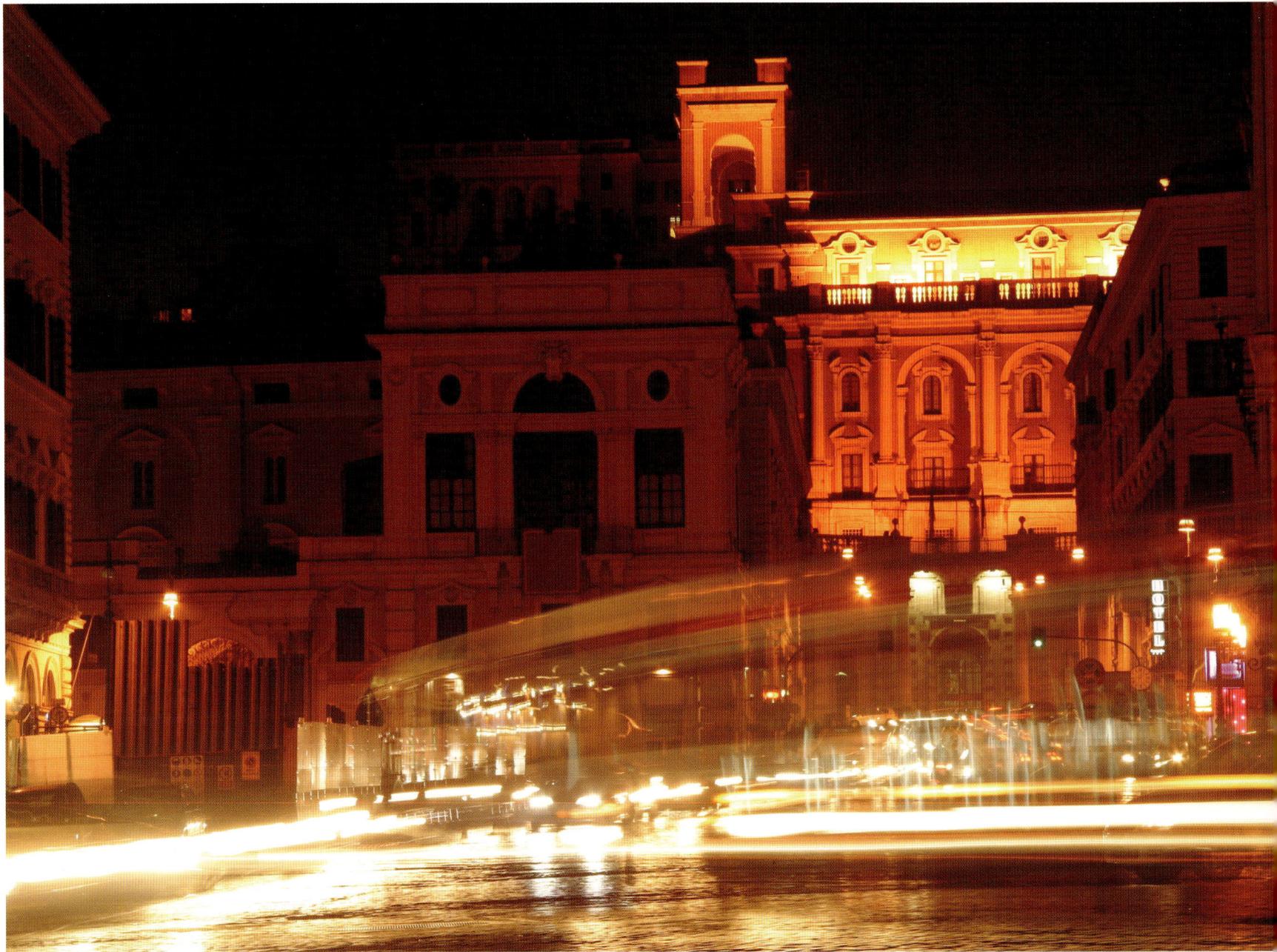

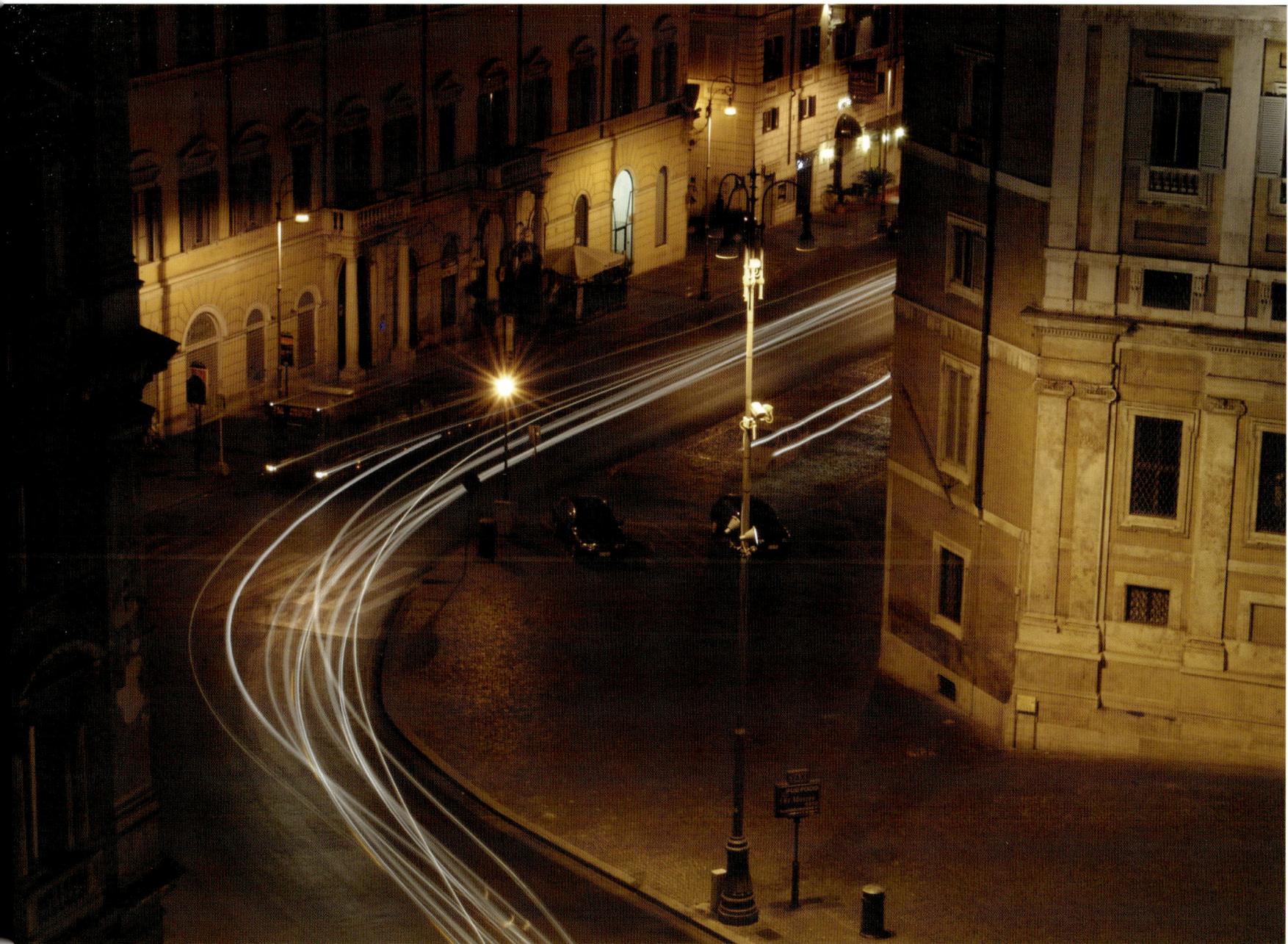

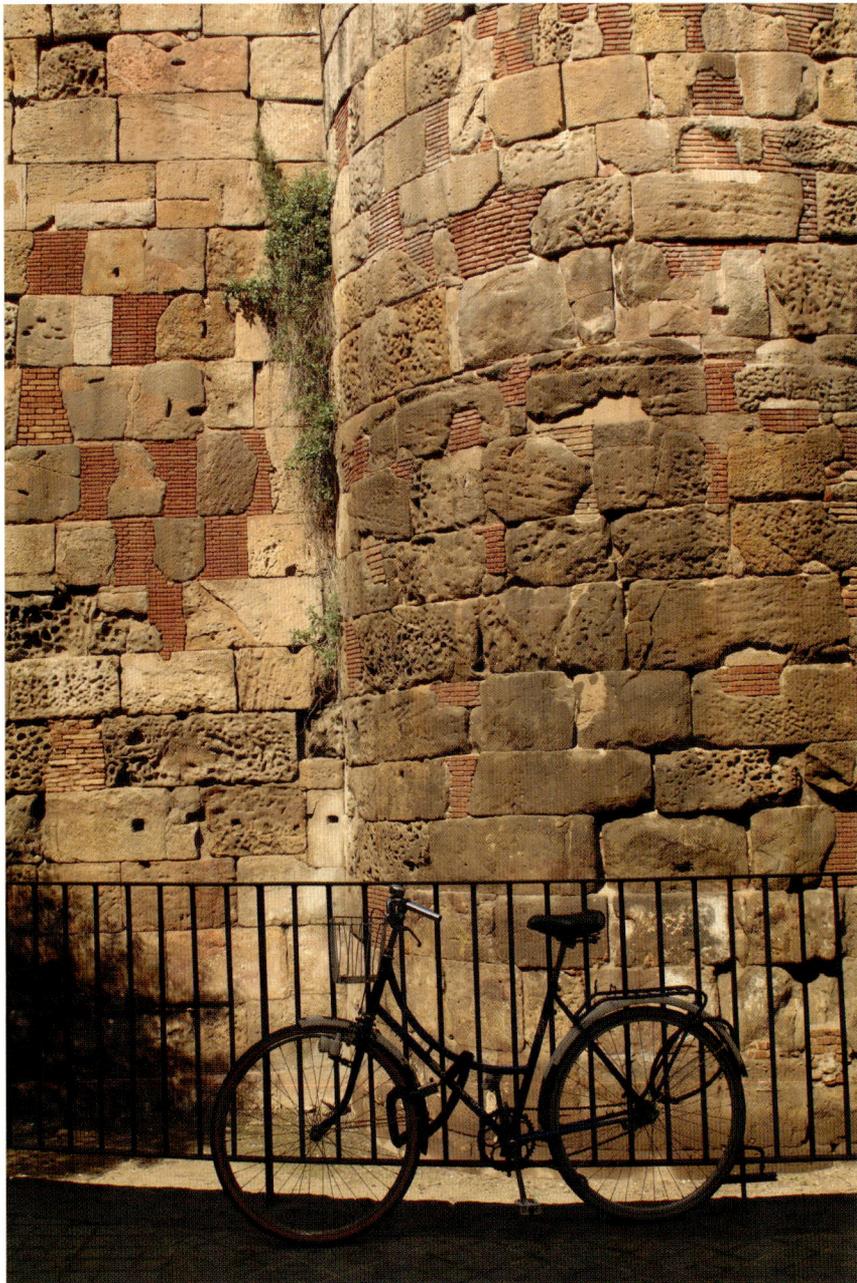
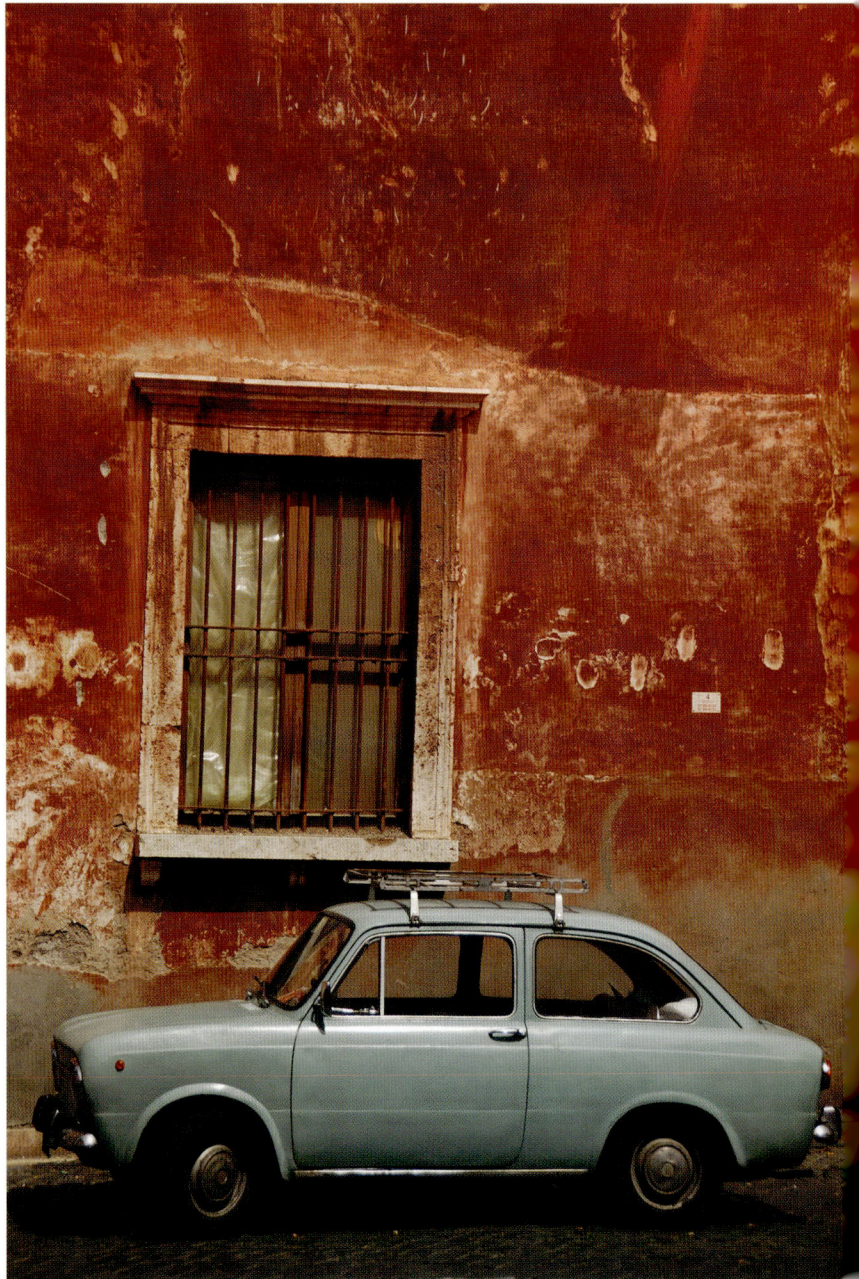

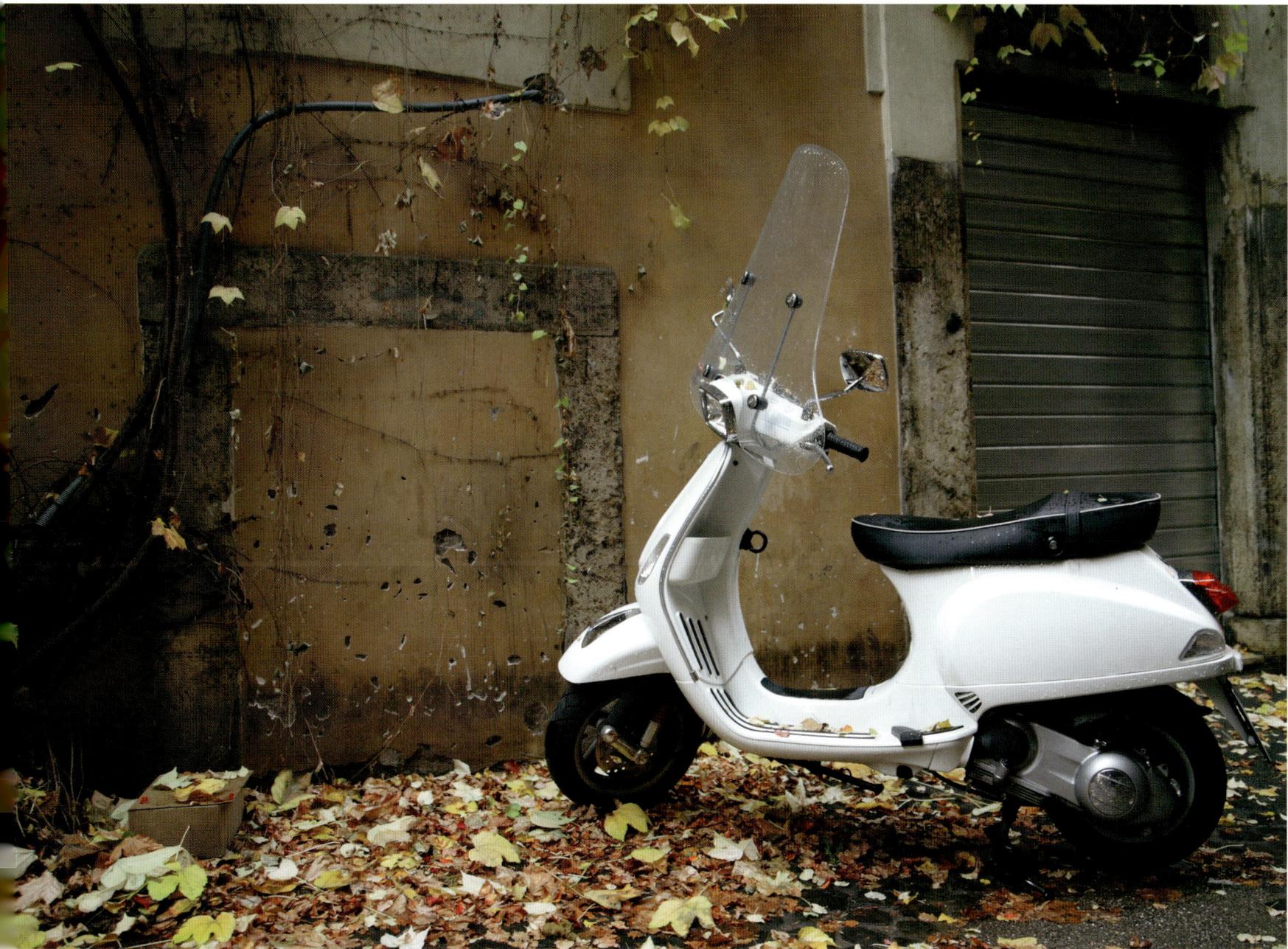

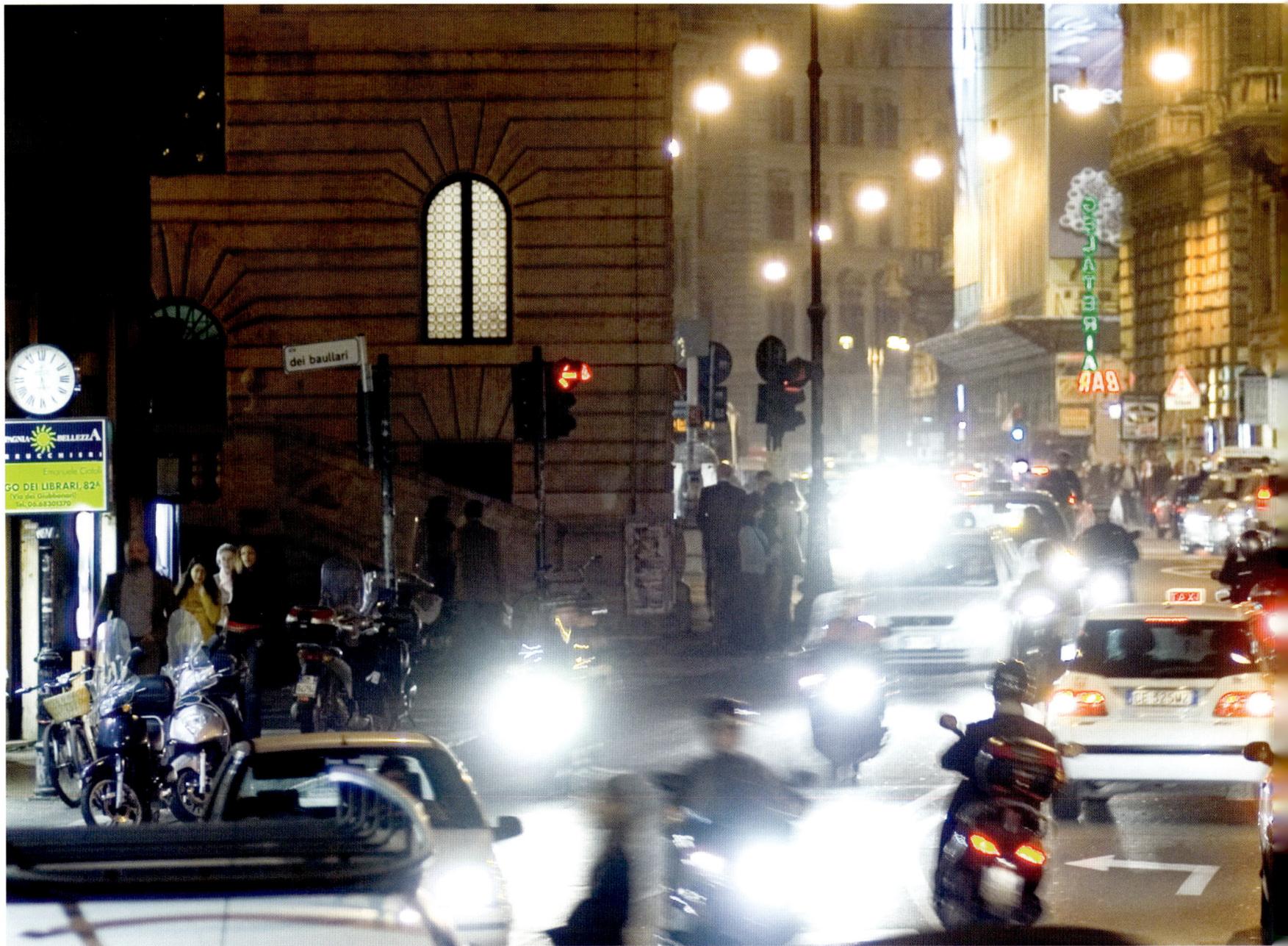

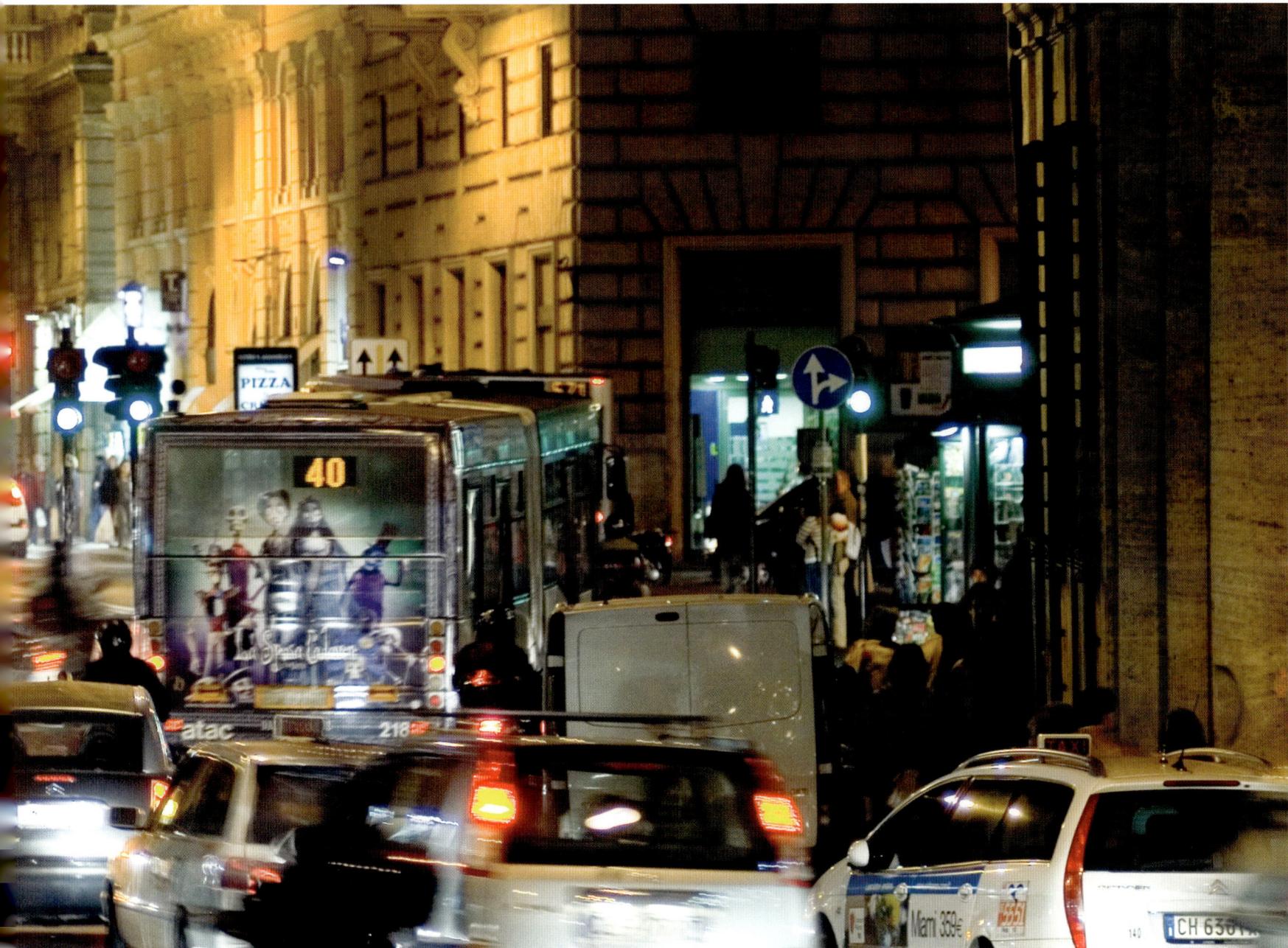

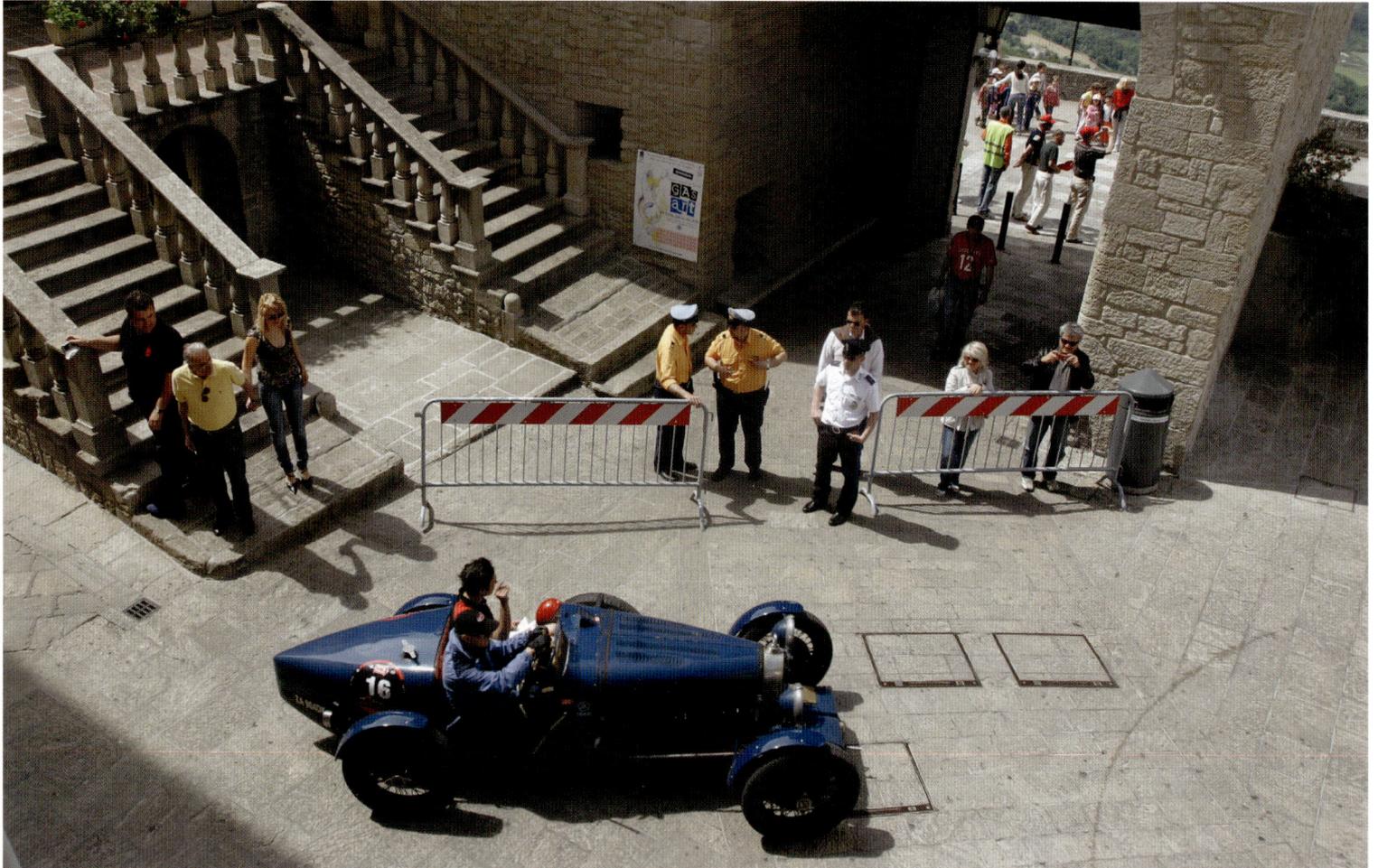

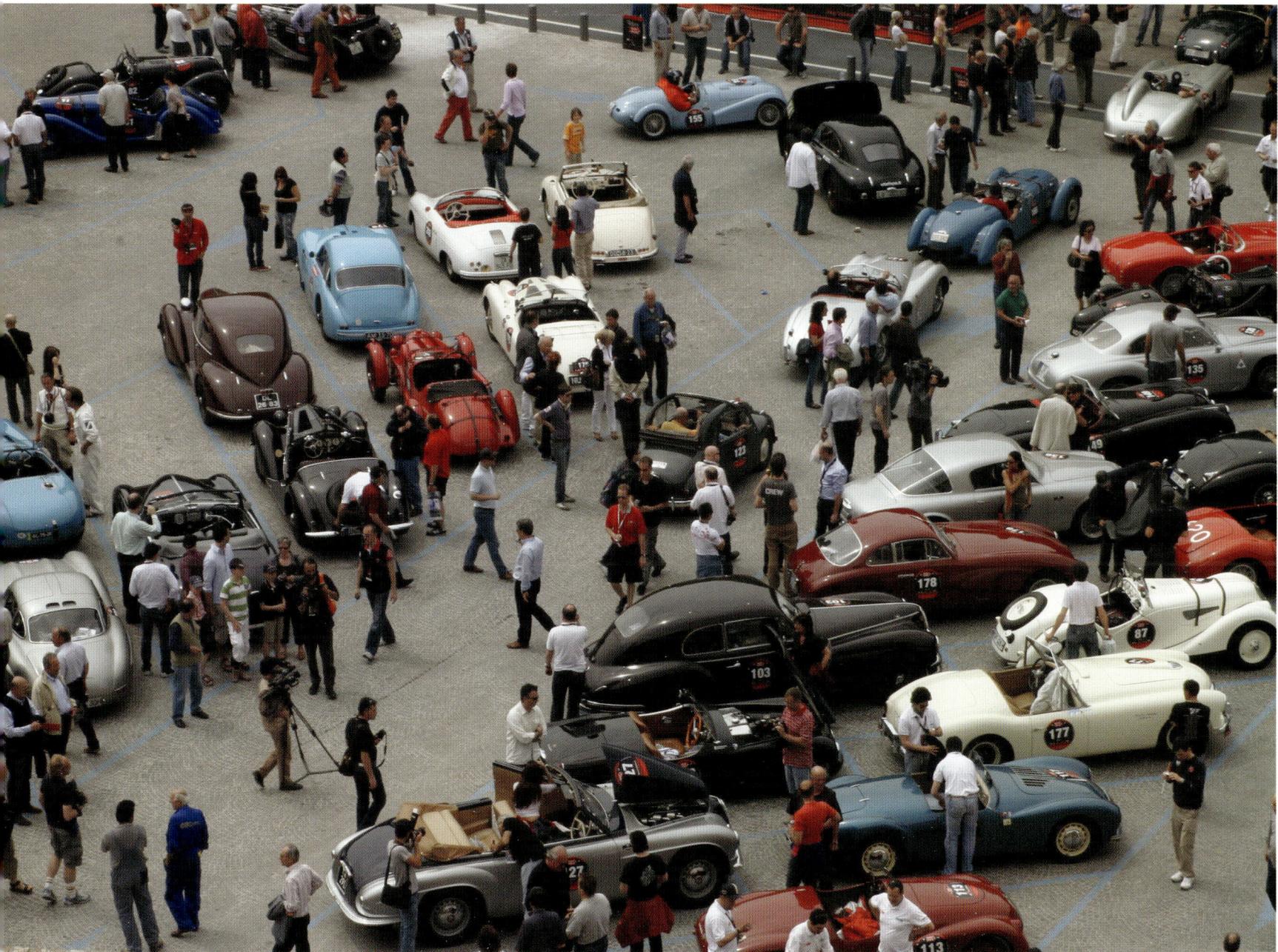

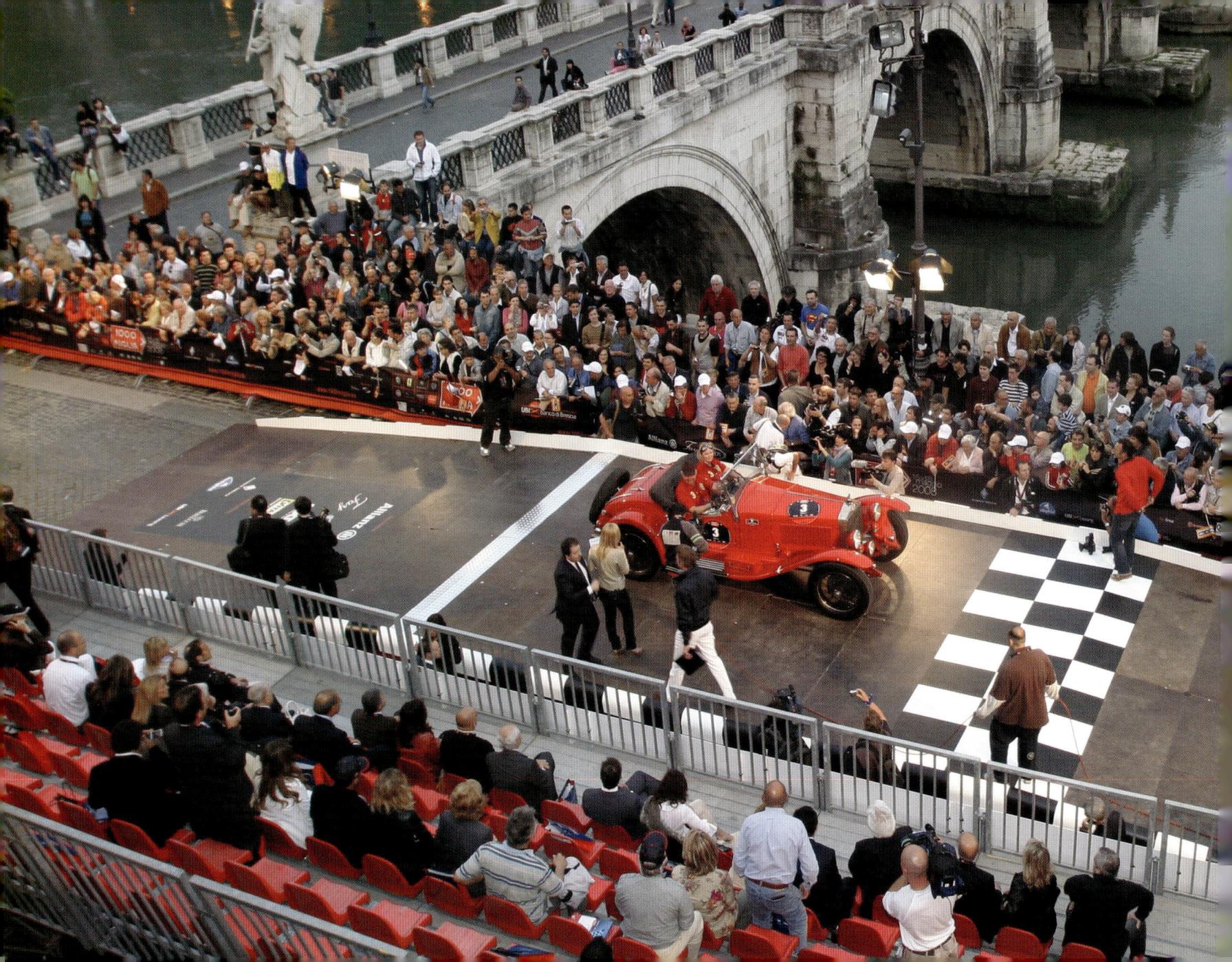

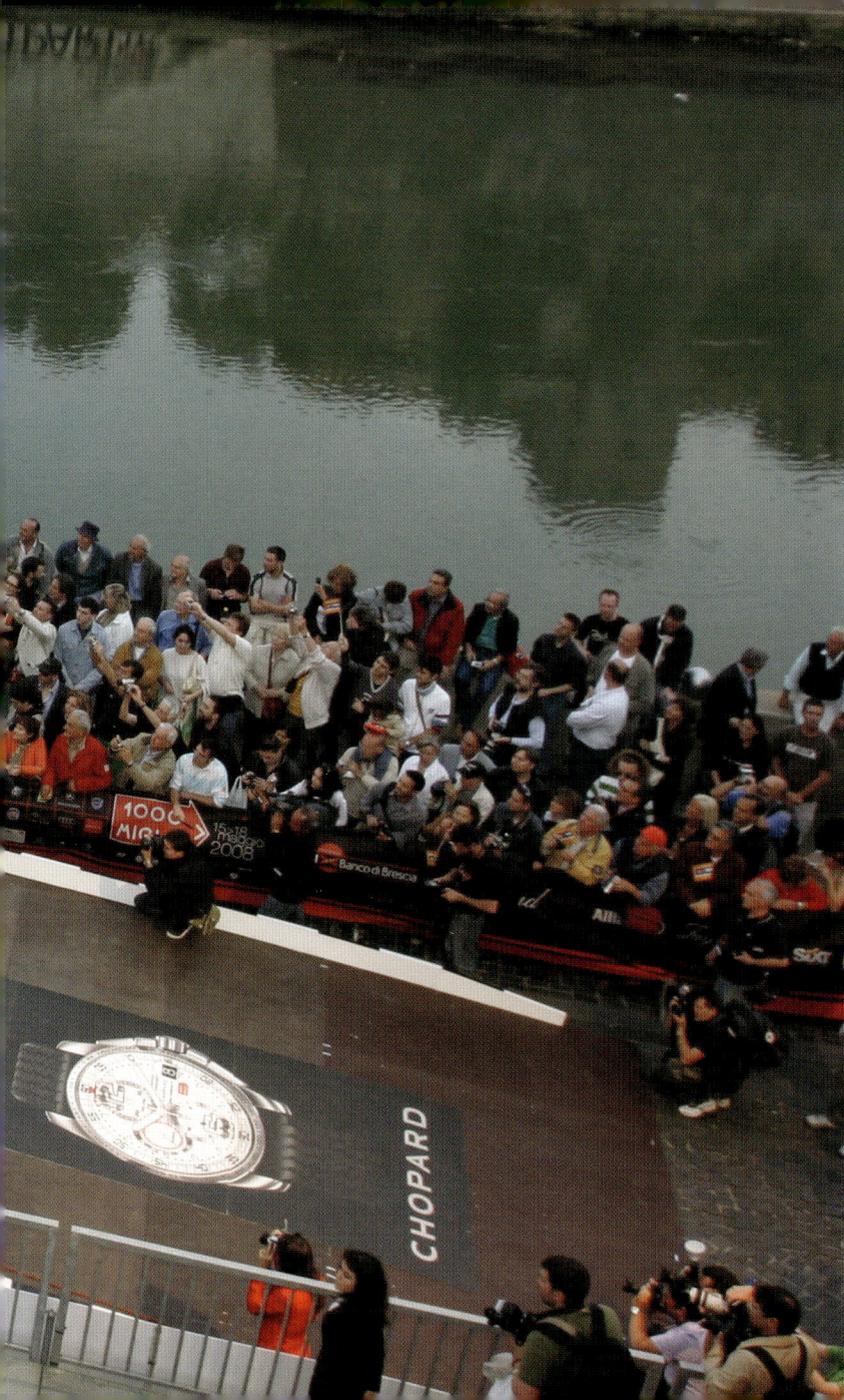
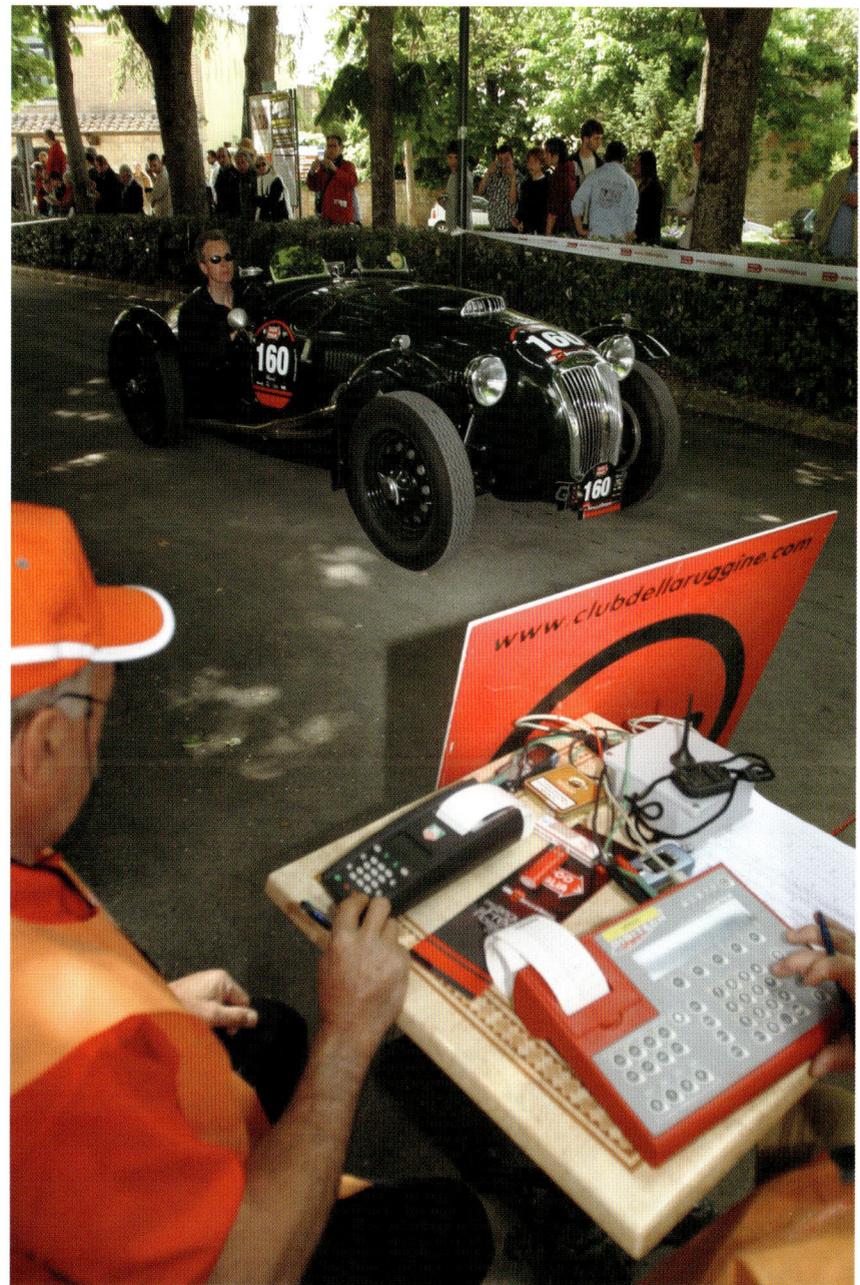

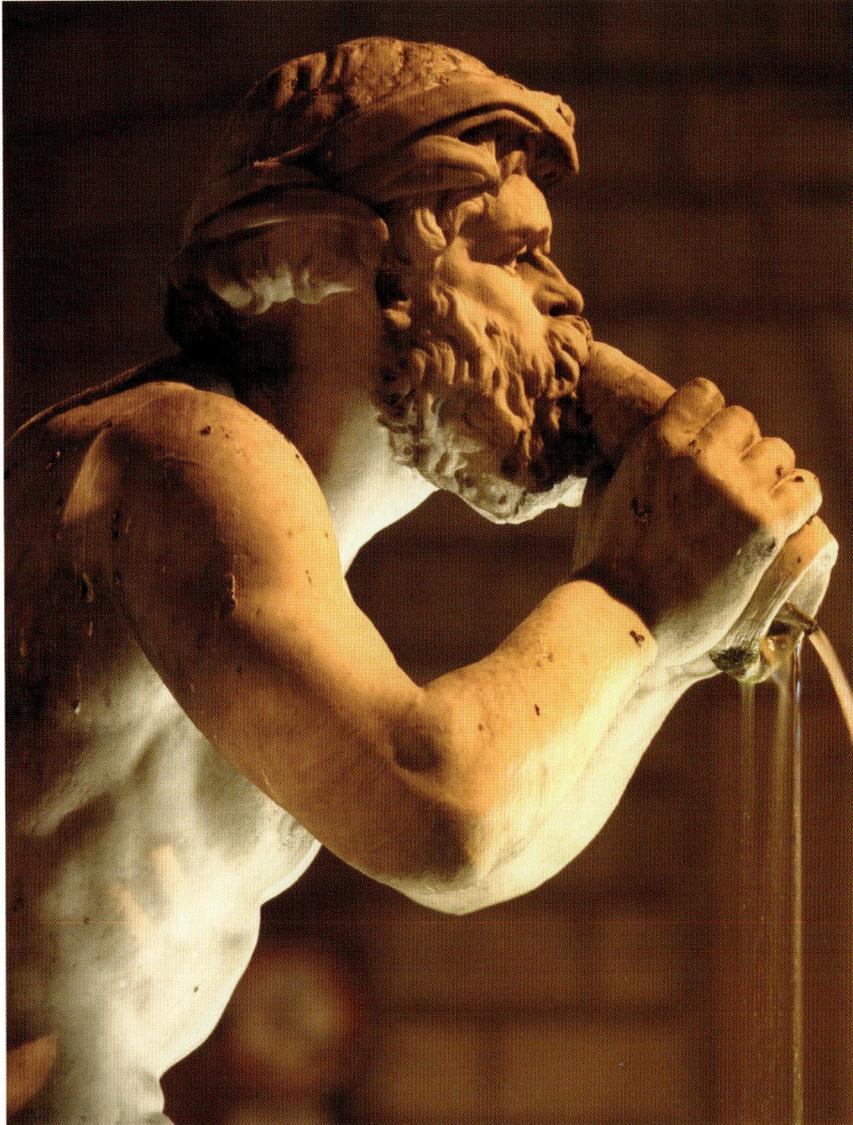

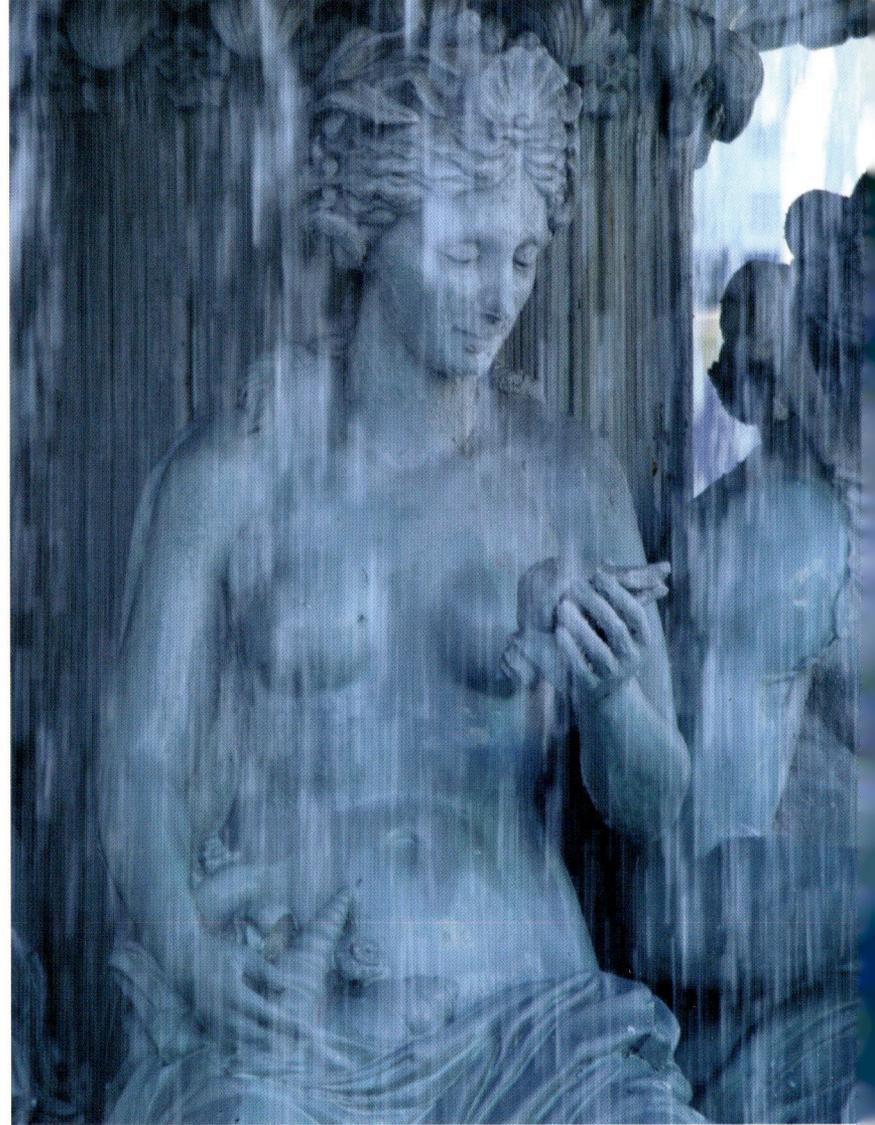

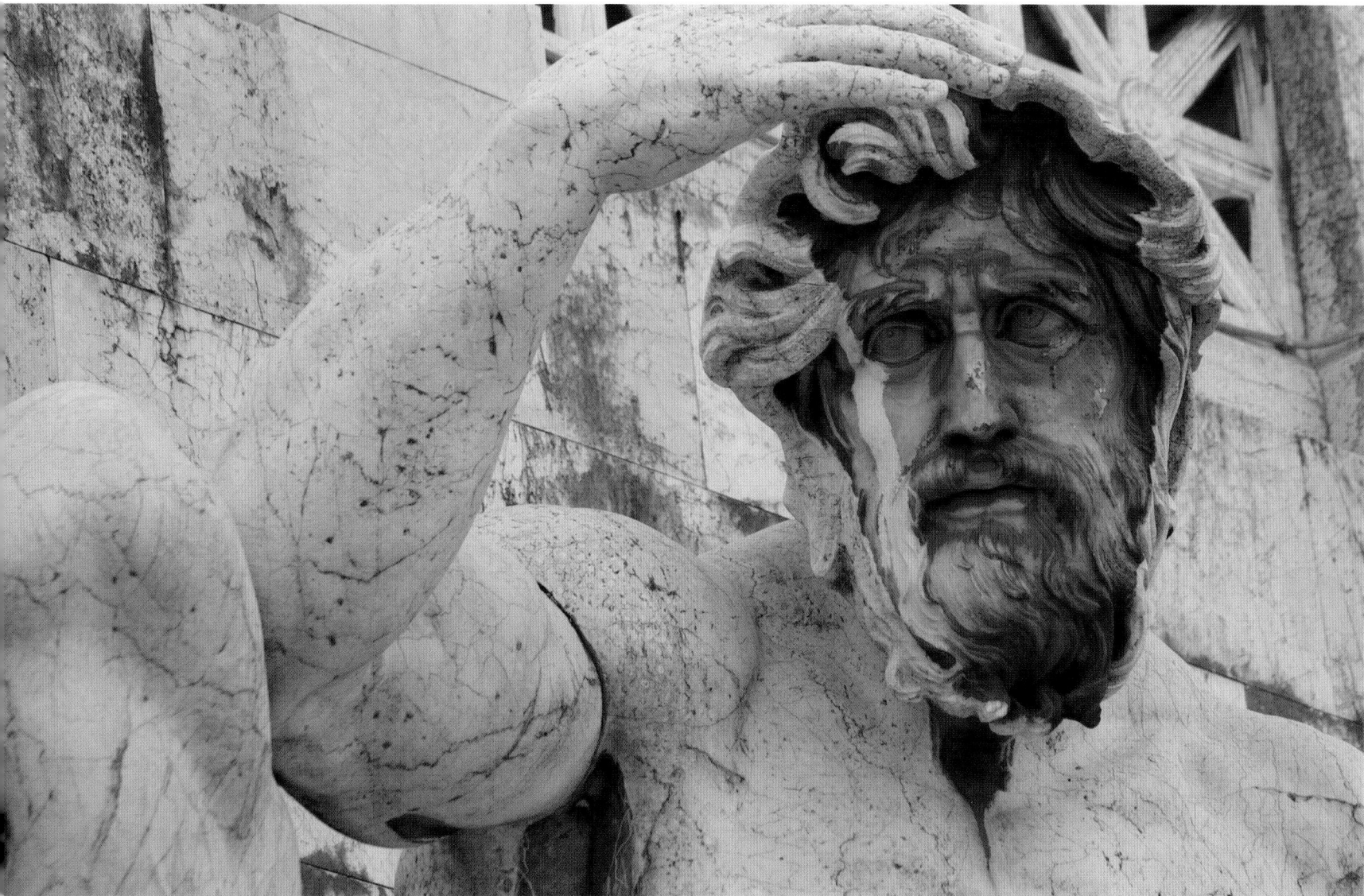

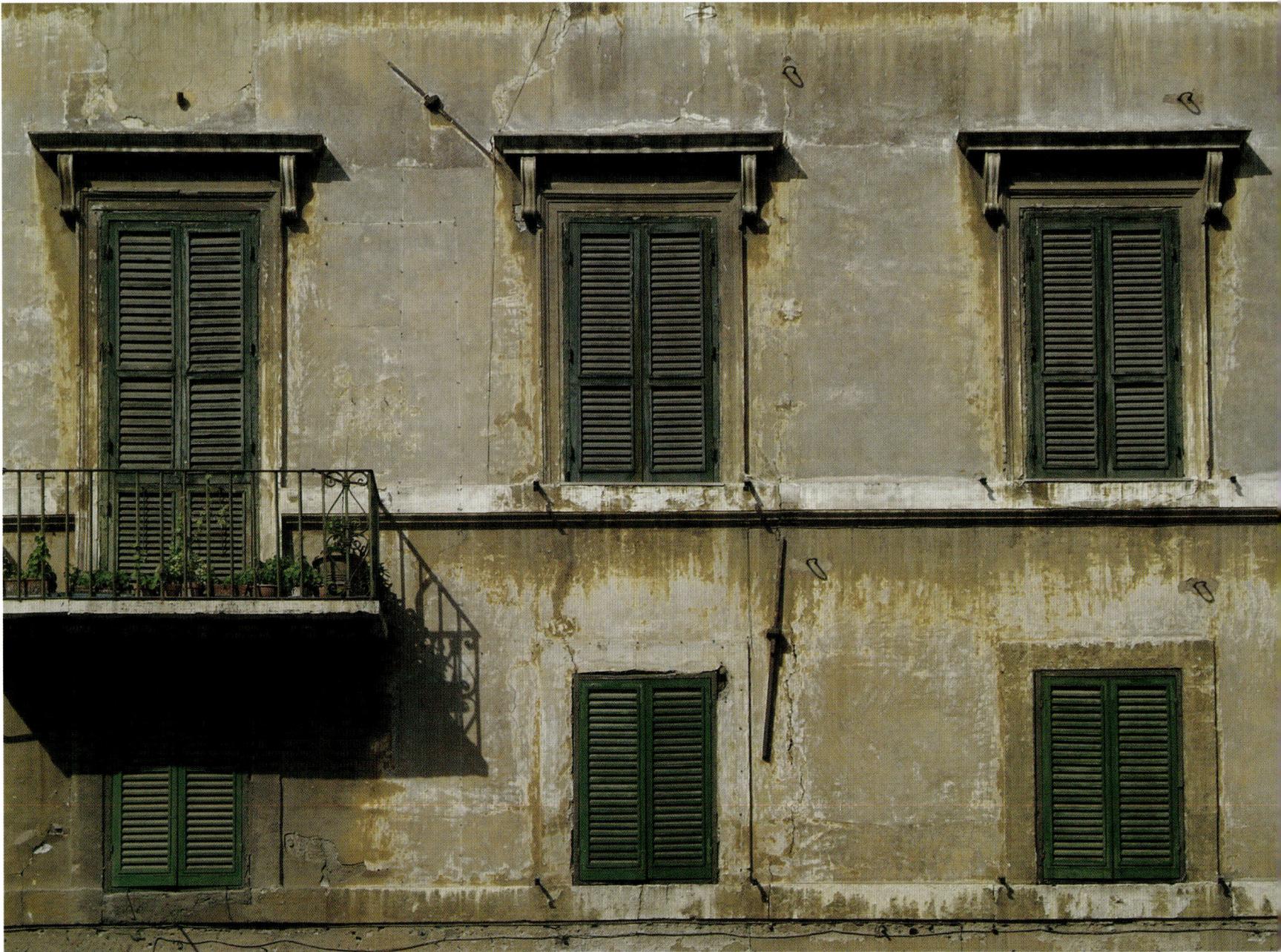

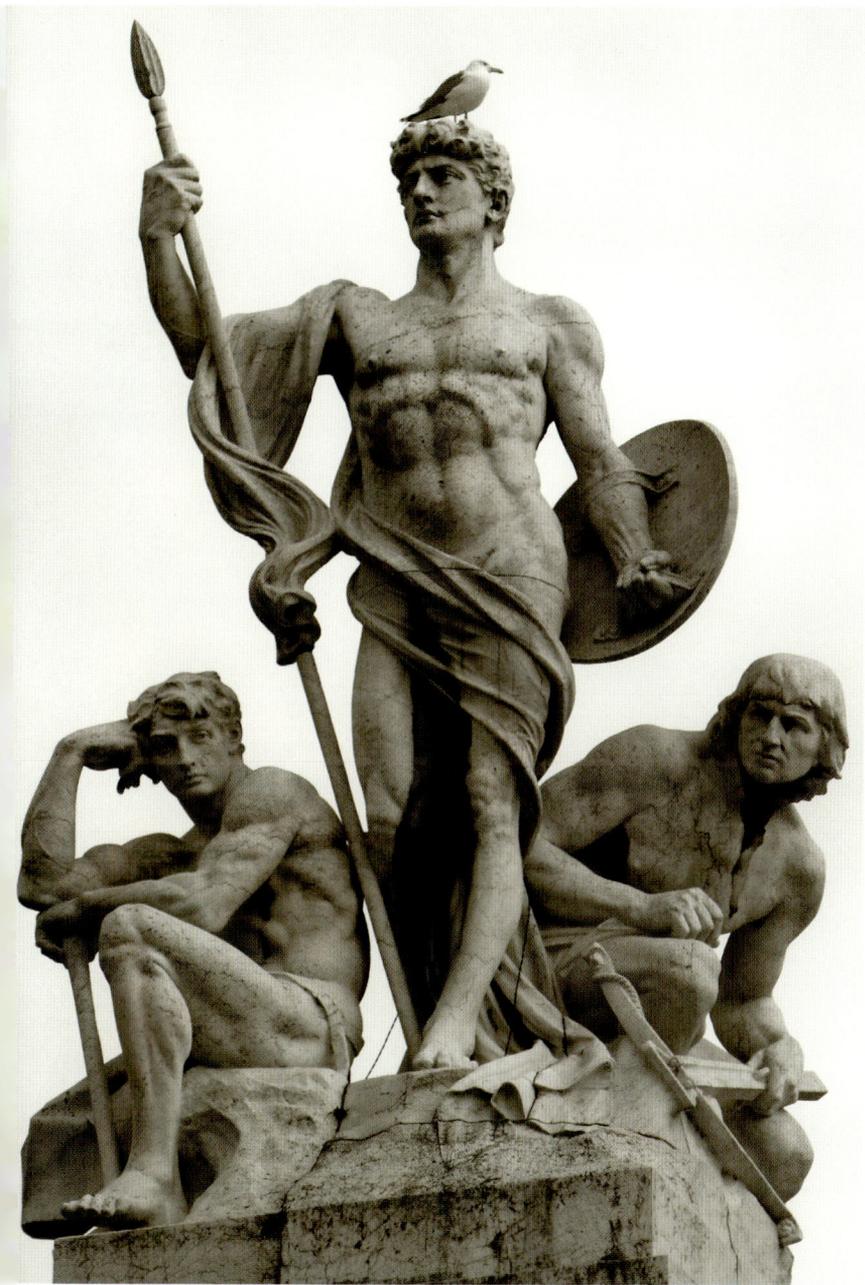
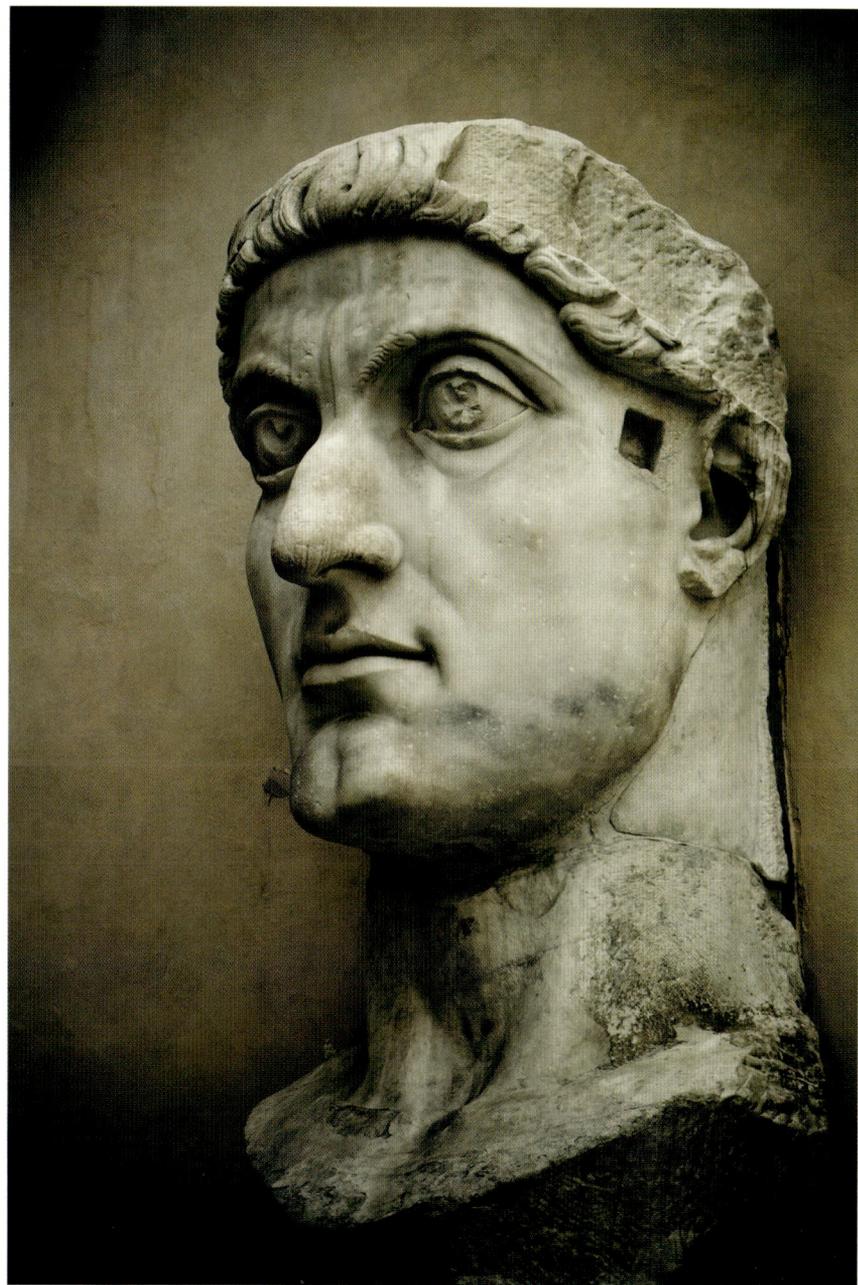

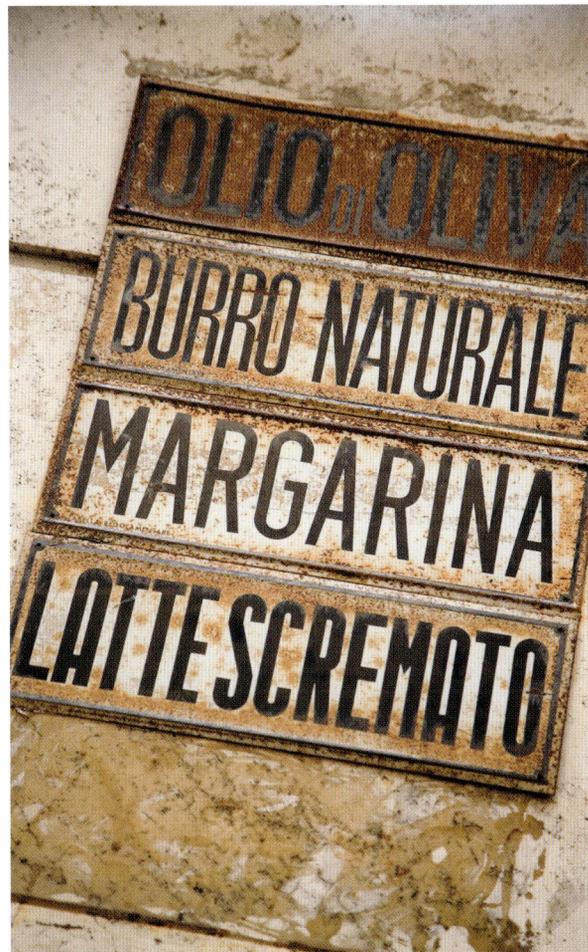
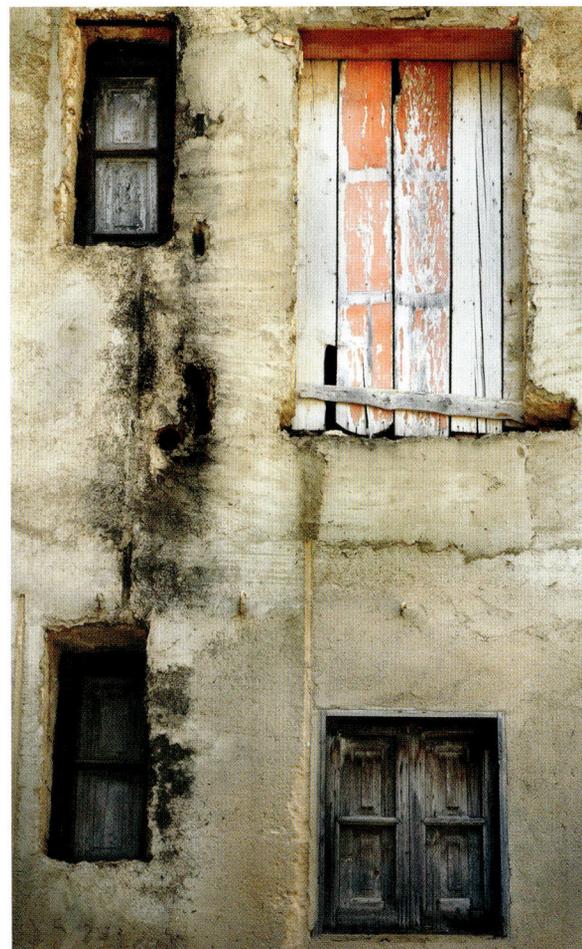

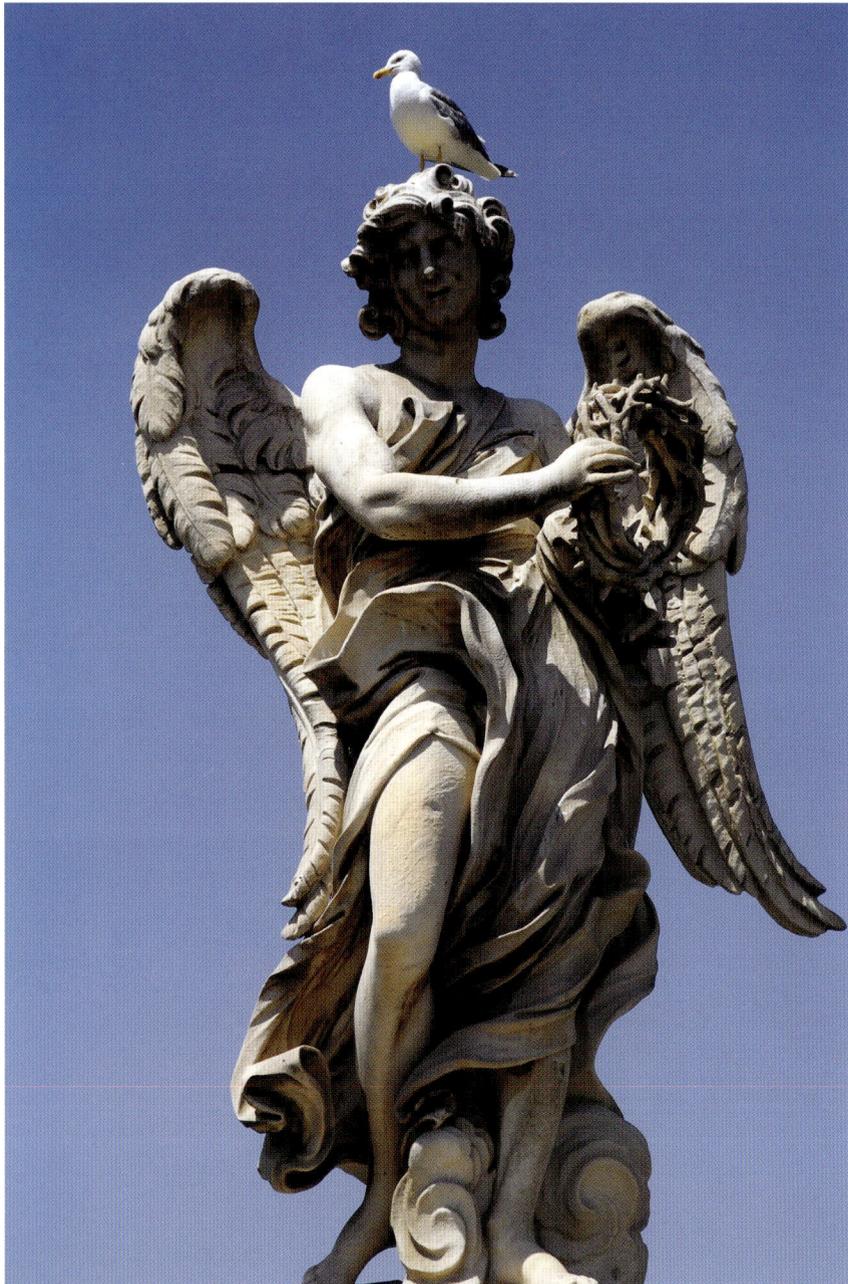

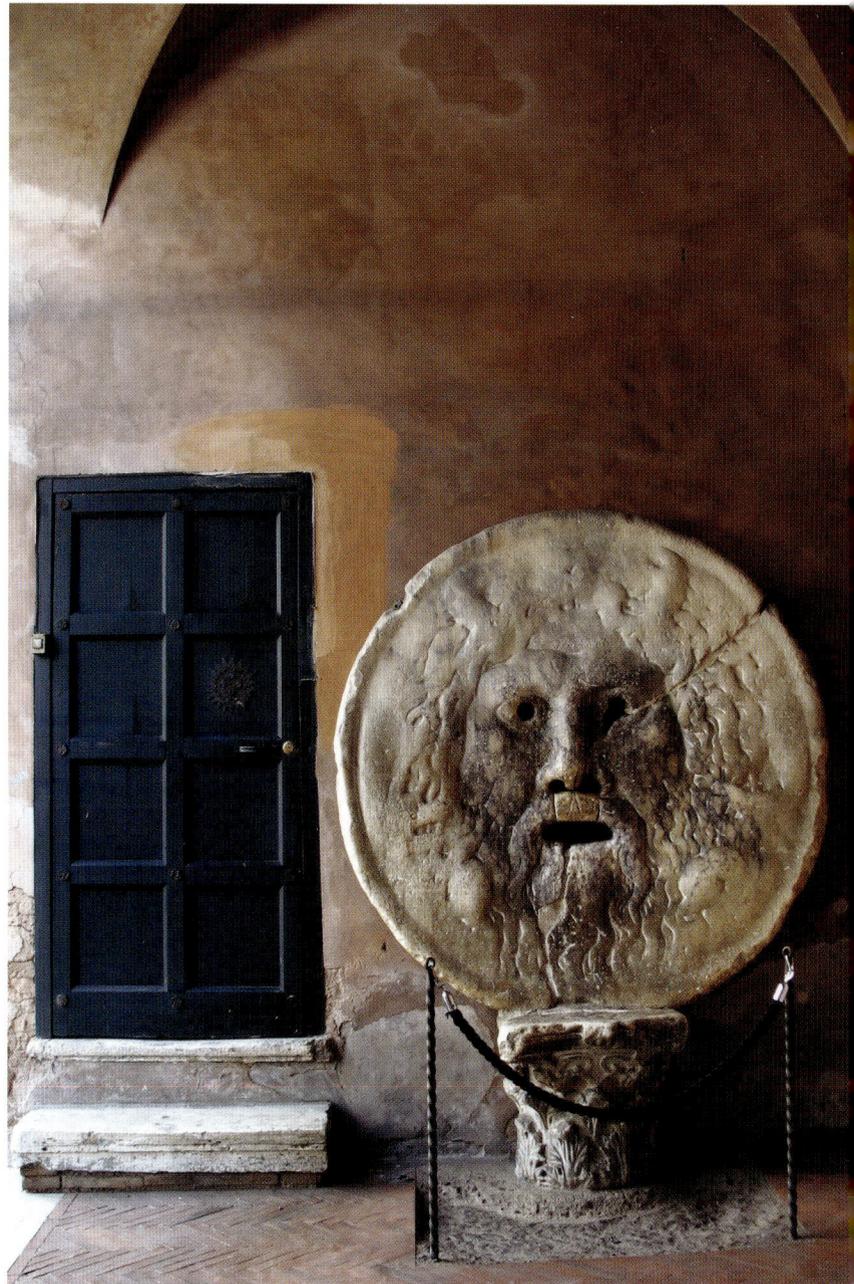

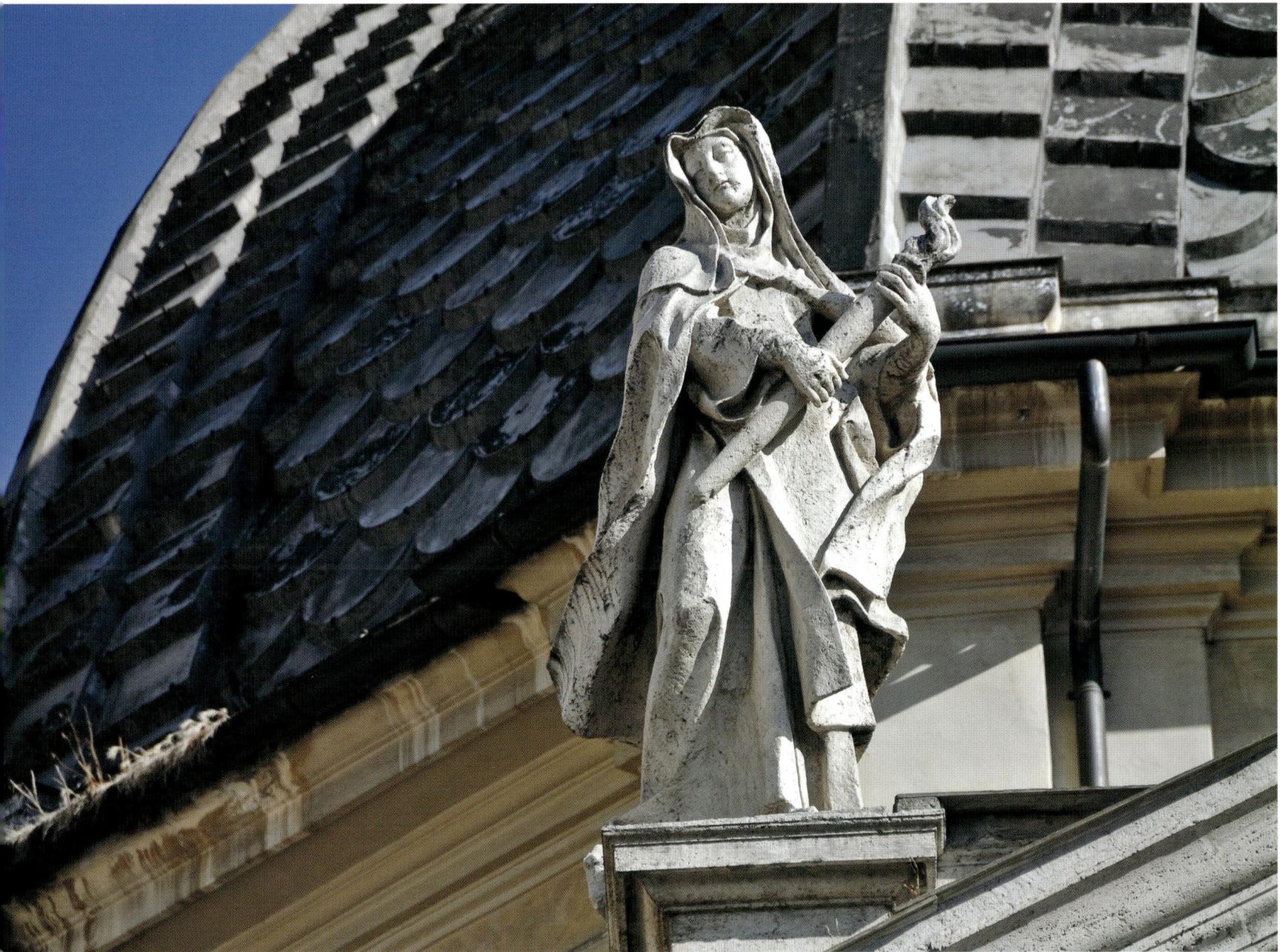

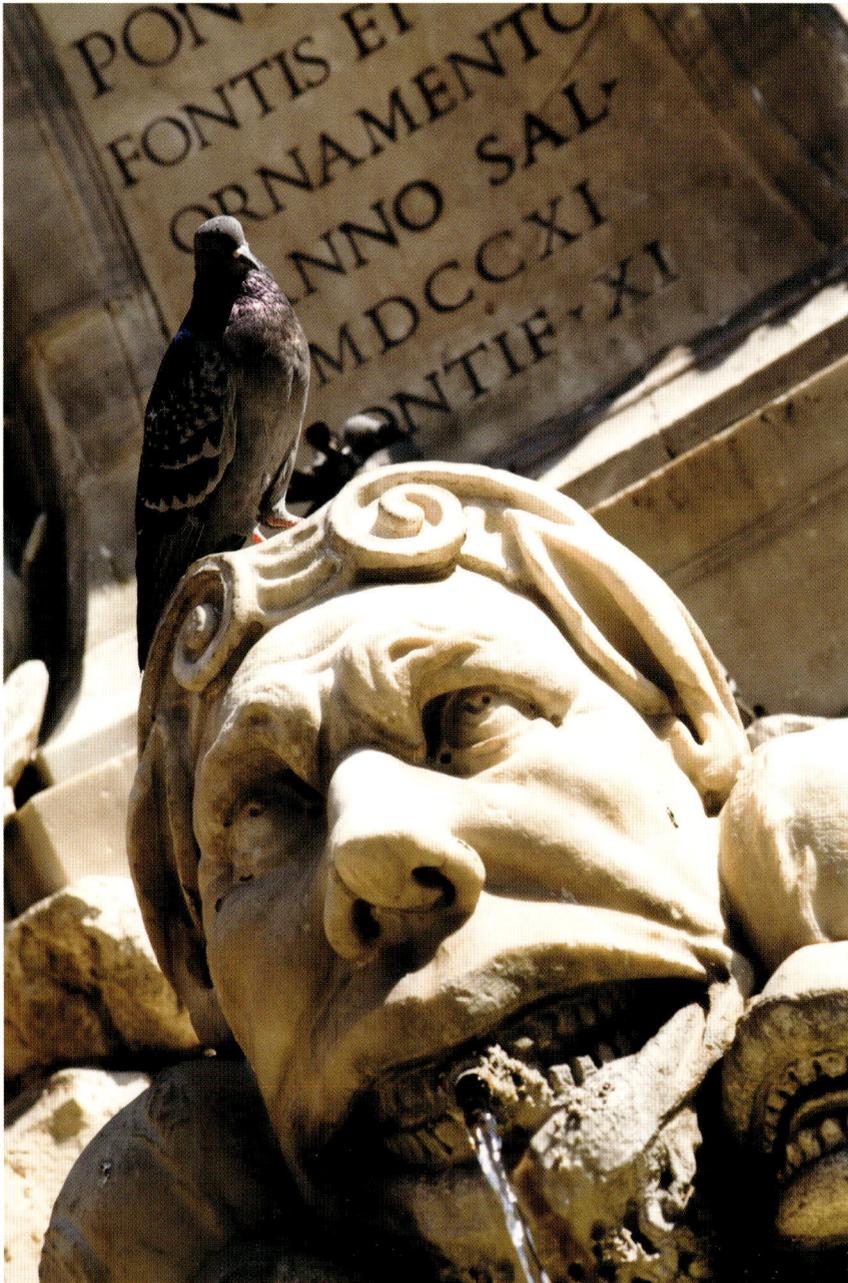

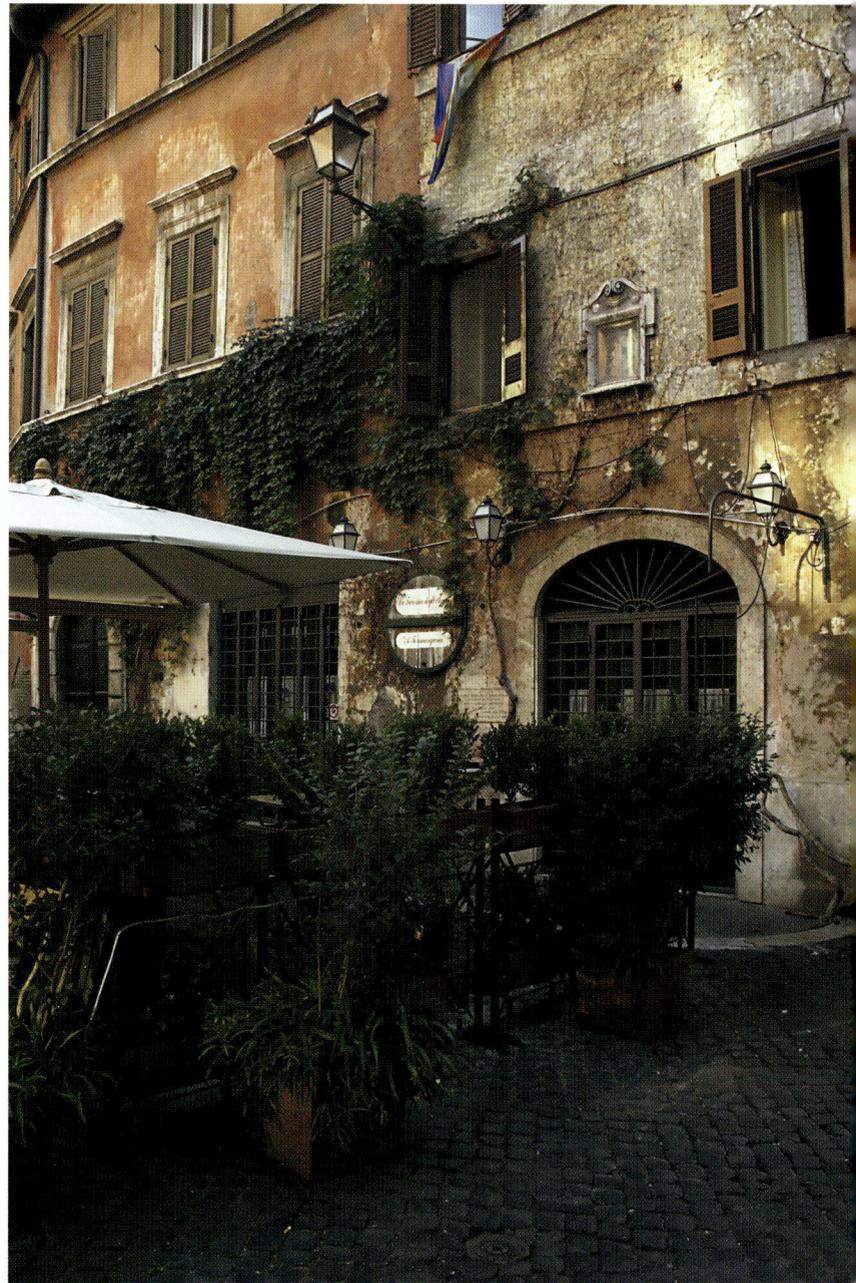

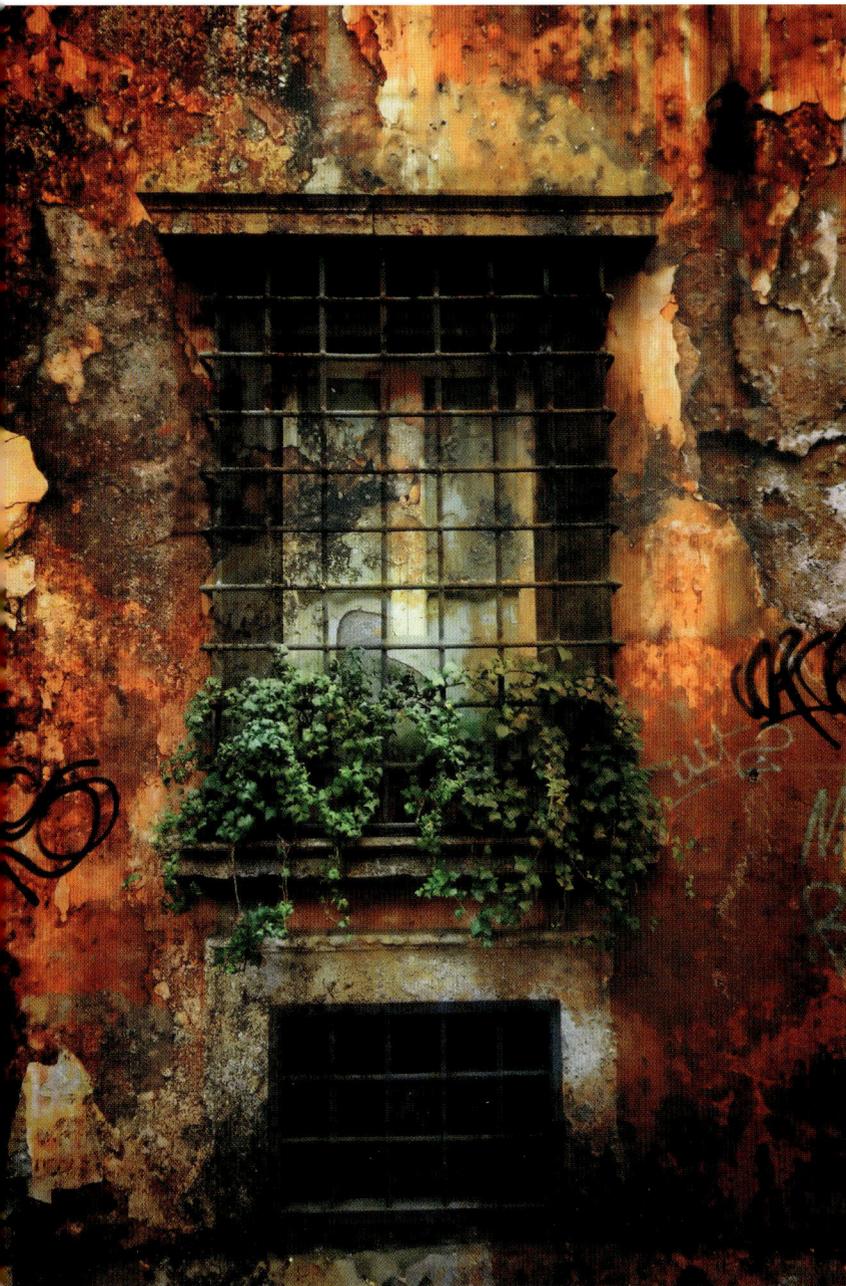
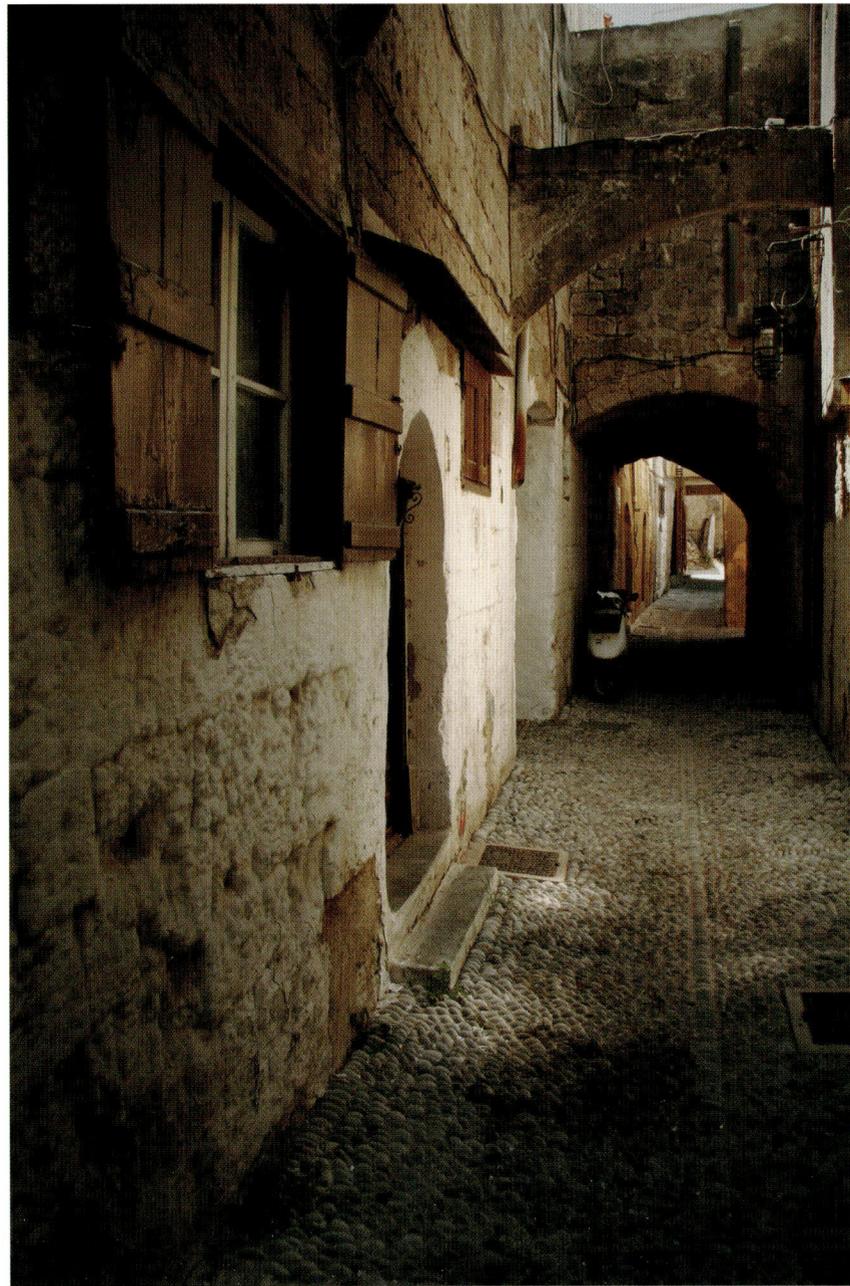

"When falls the Coliseum, Rome shall fall; And when Rome falls... the World."

Lord Byron

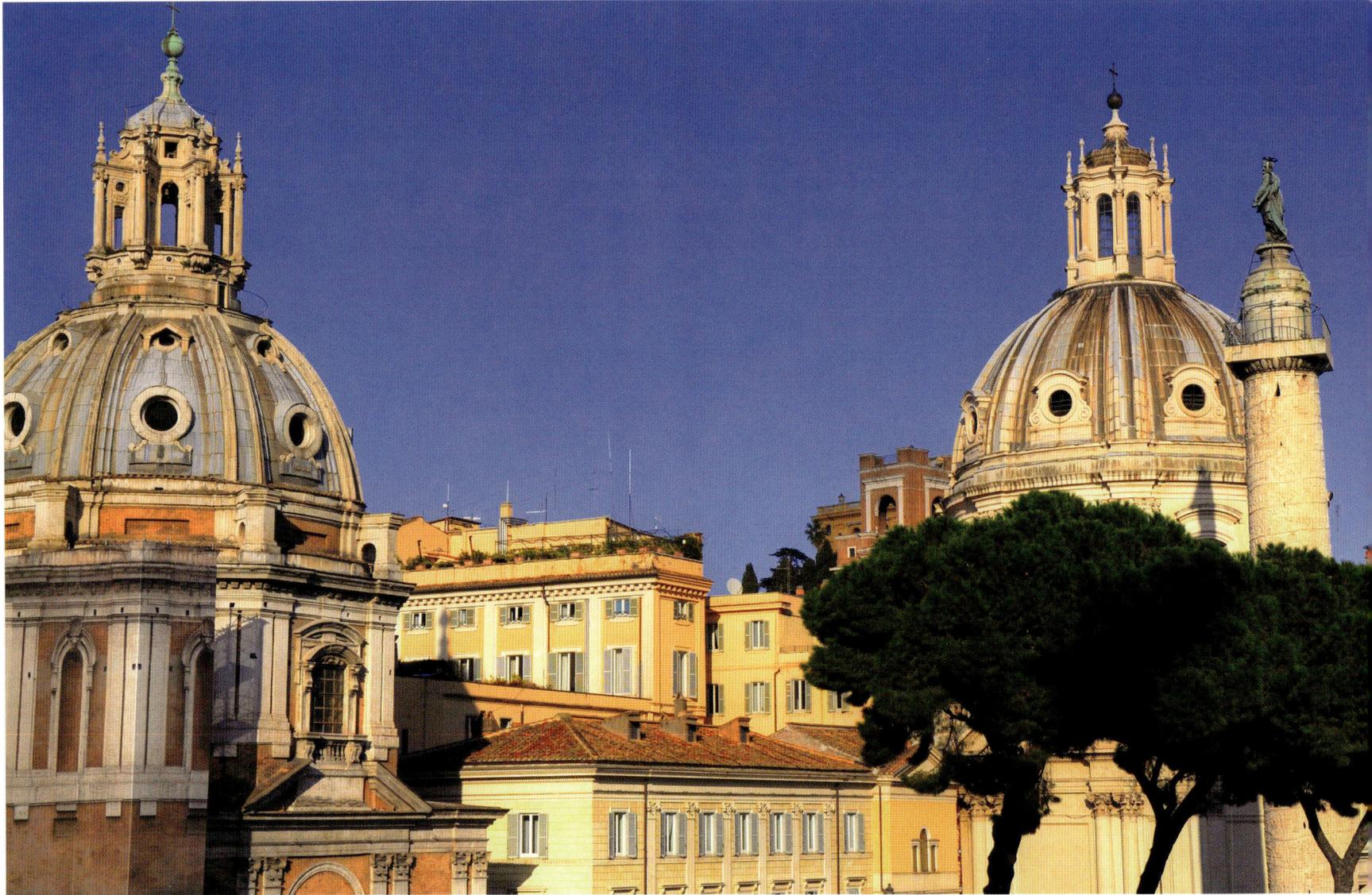

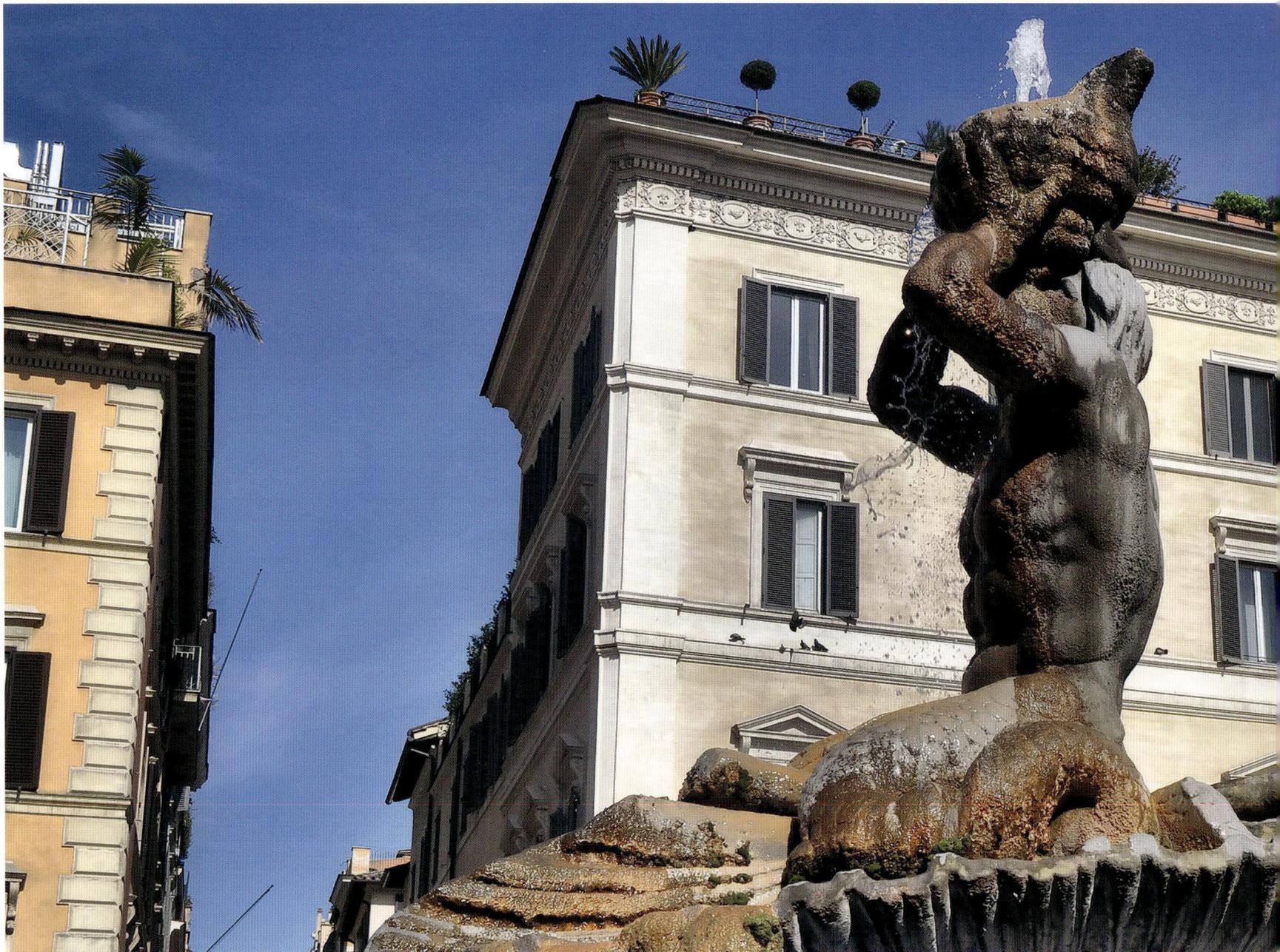

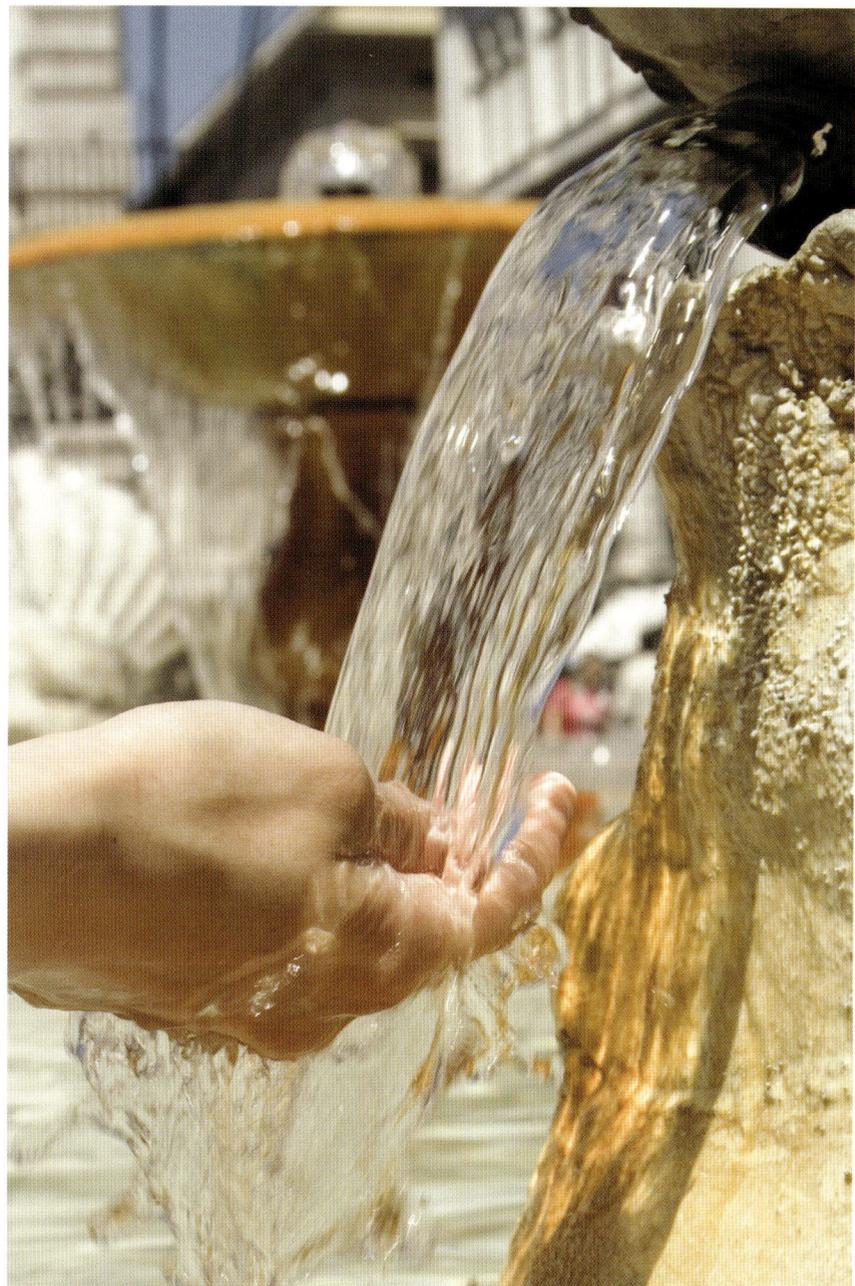

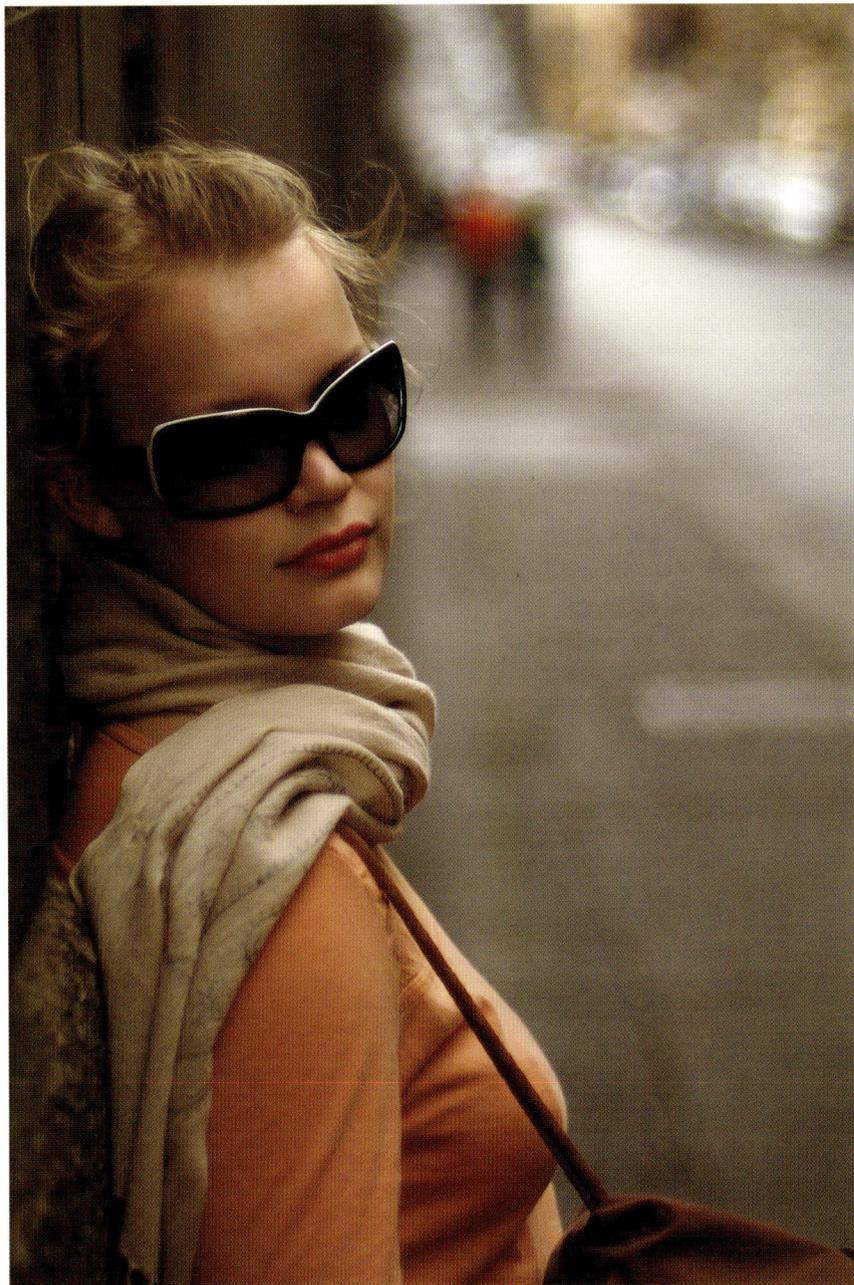

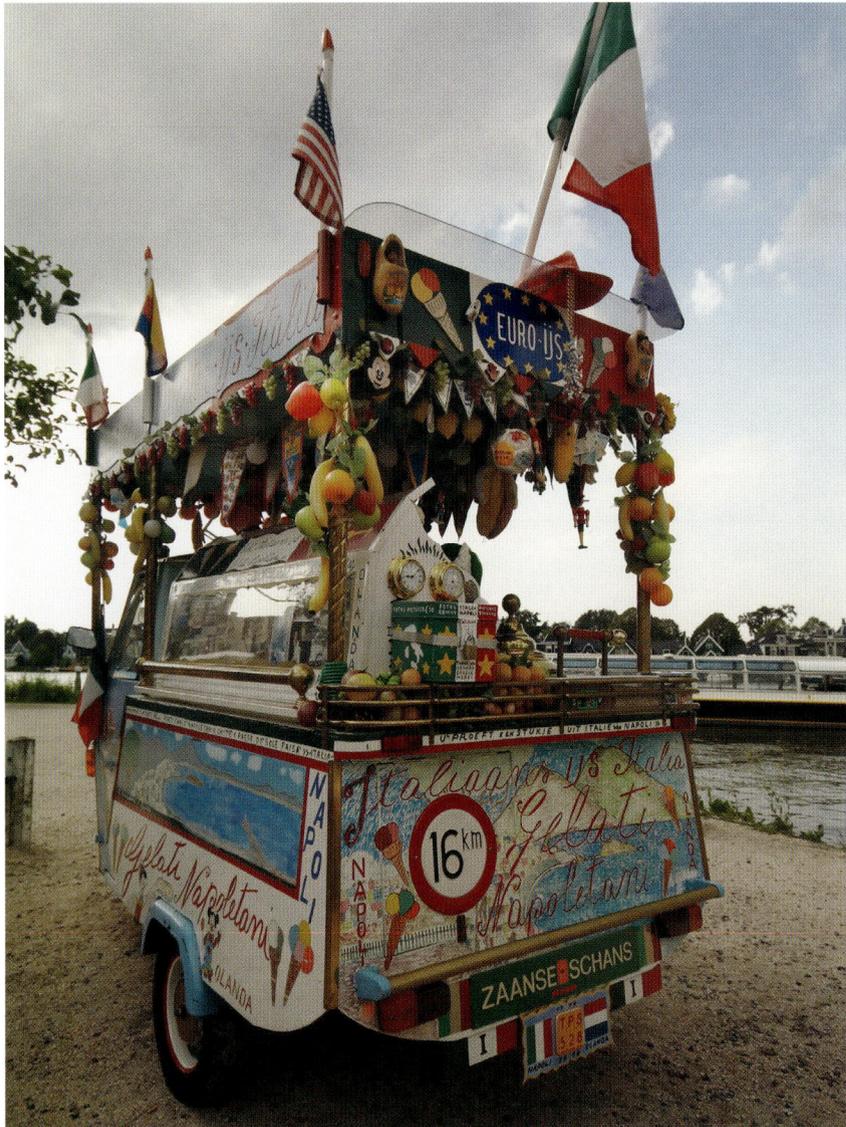

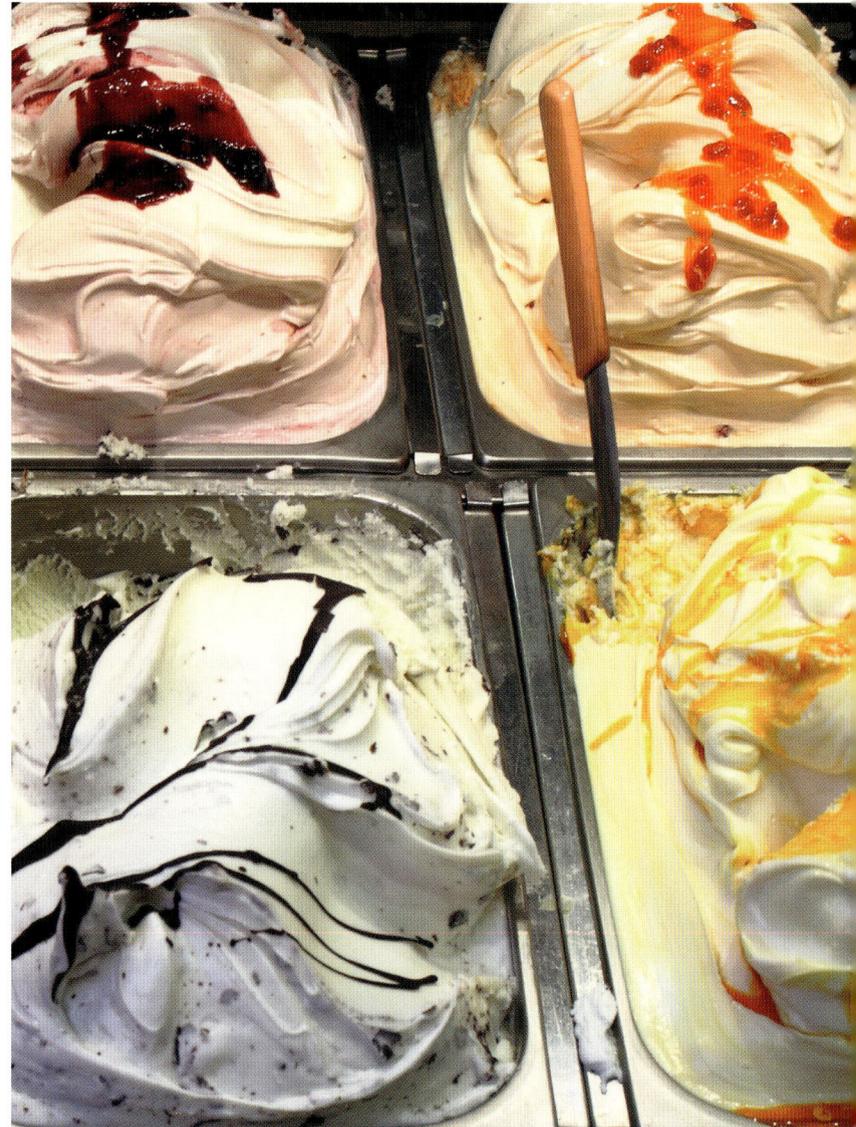

Ice-Cream

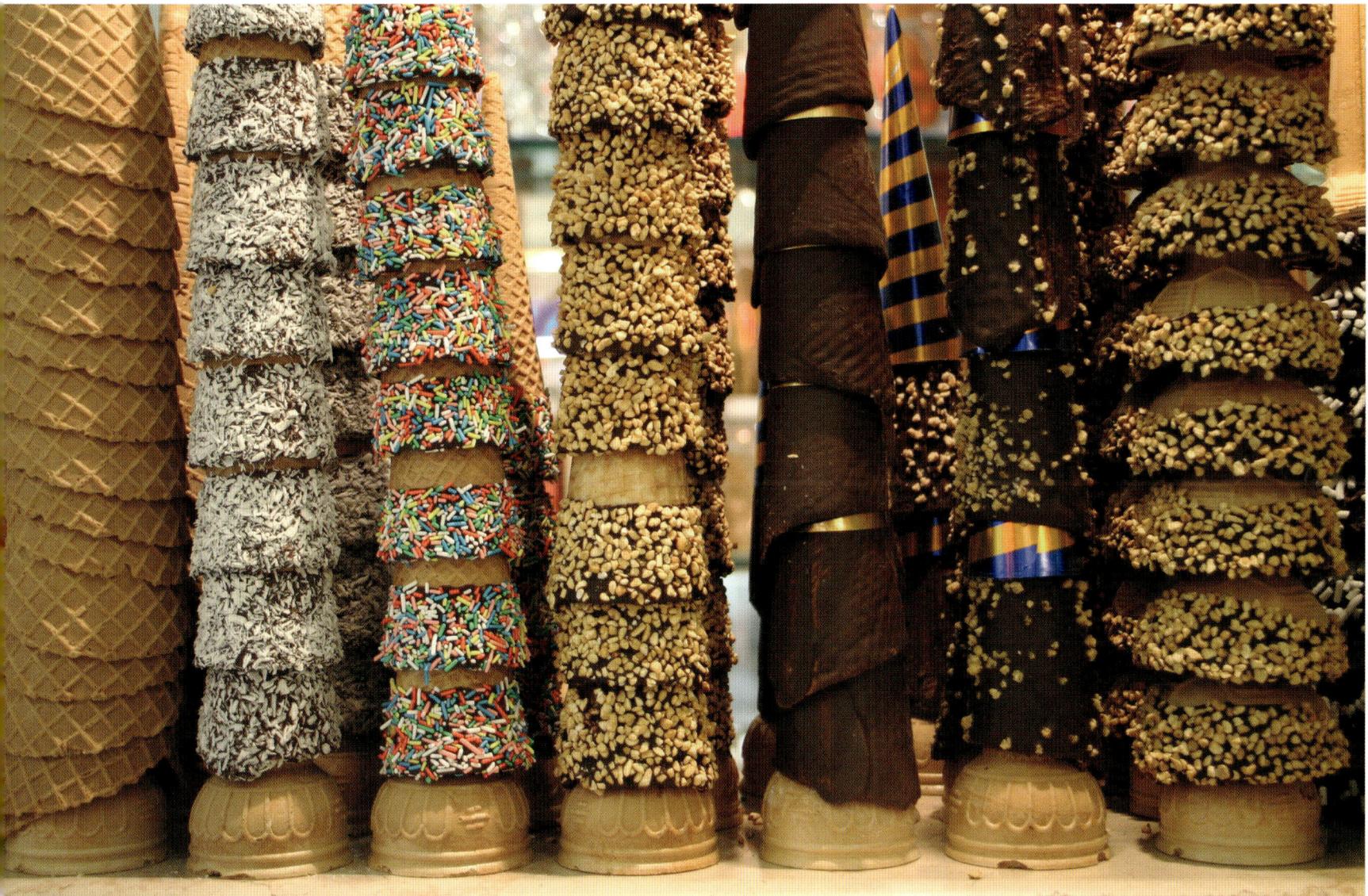

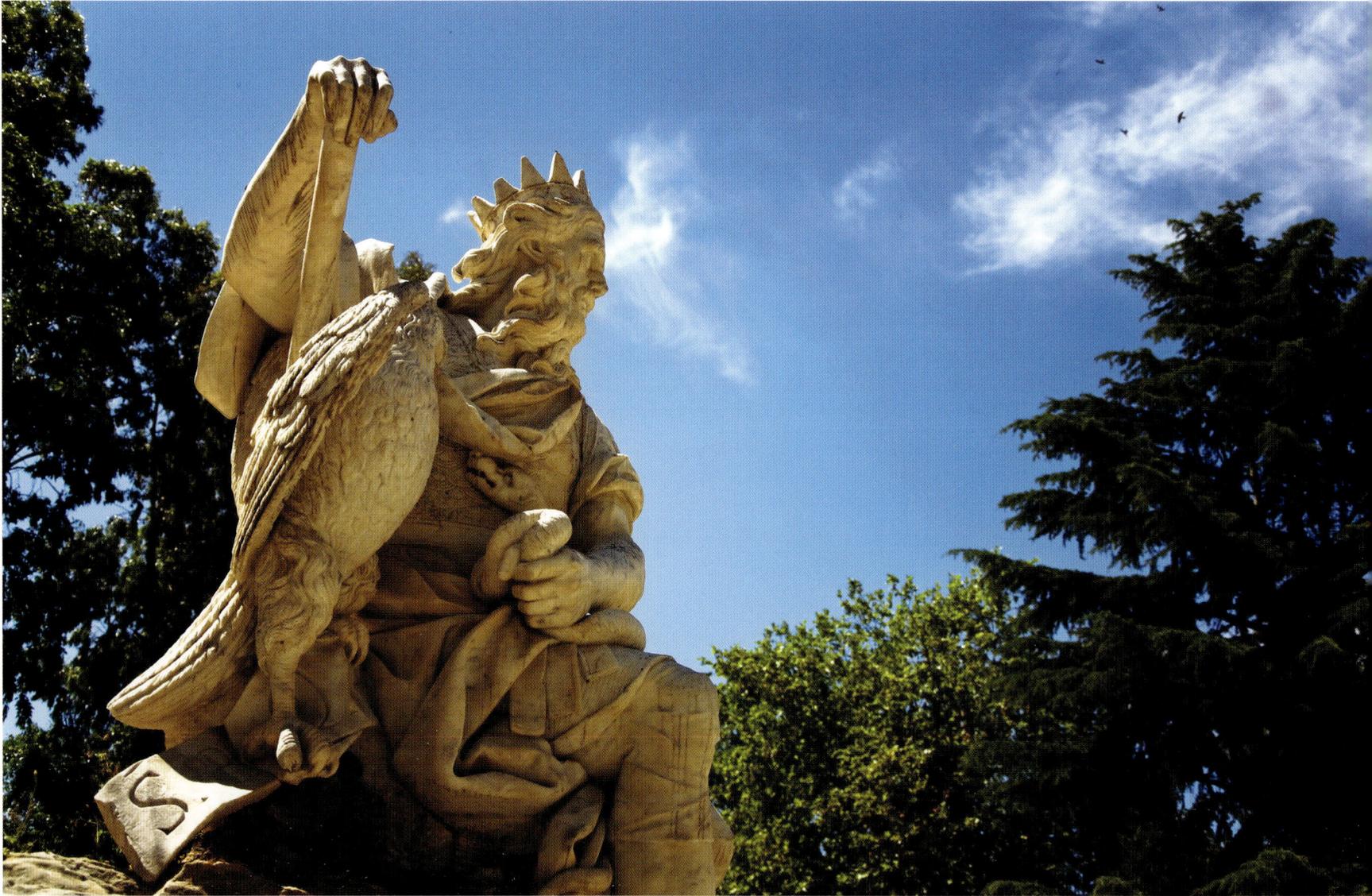

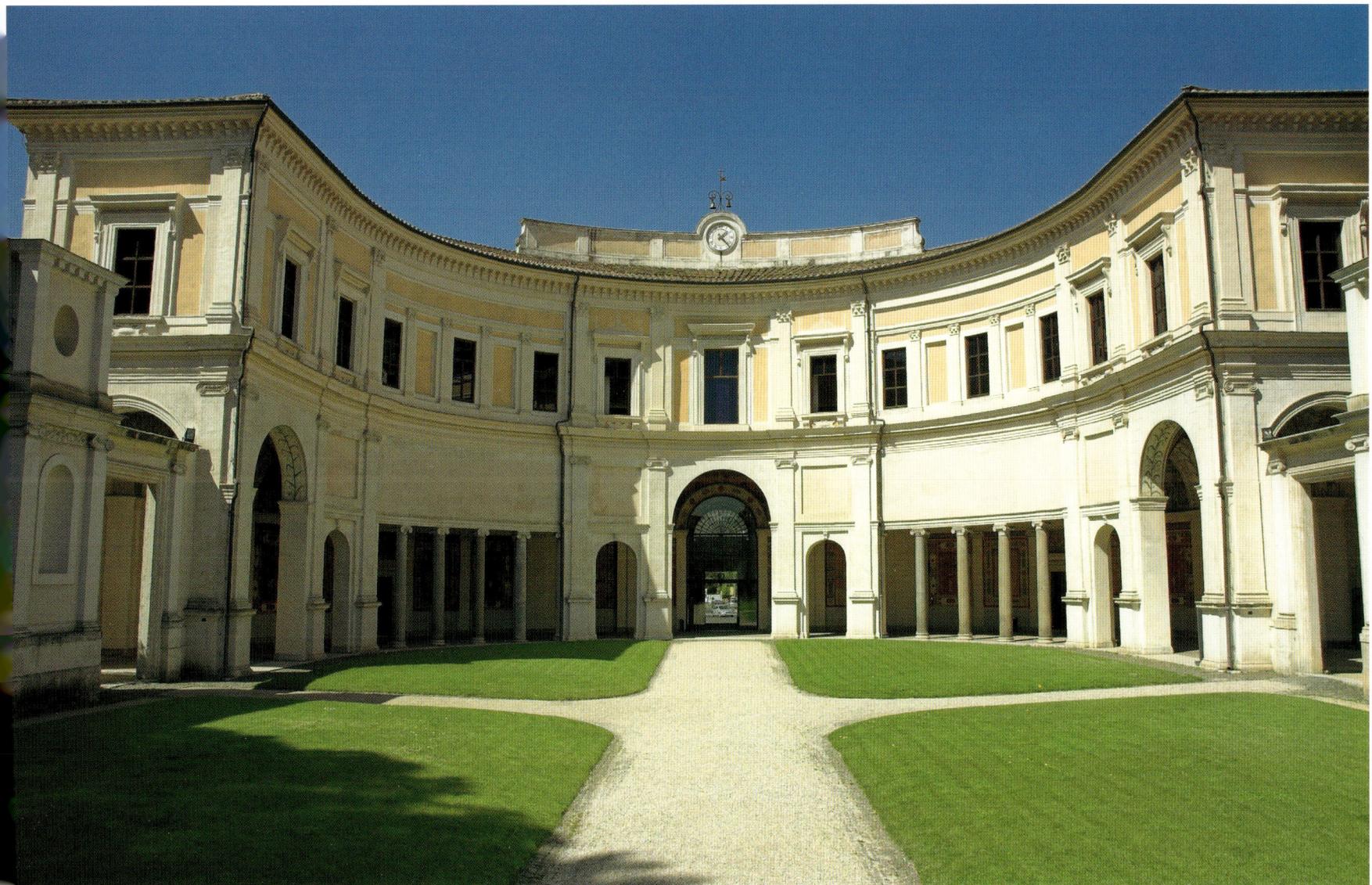

Circus Maximus

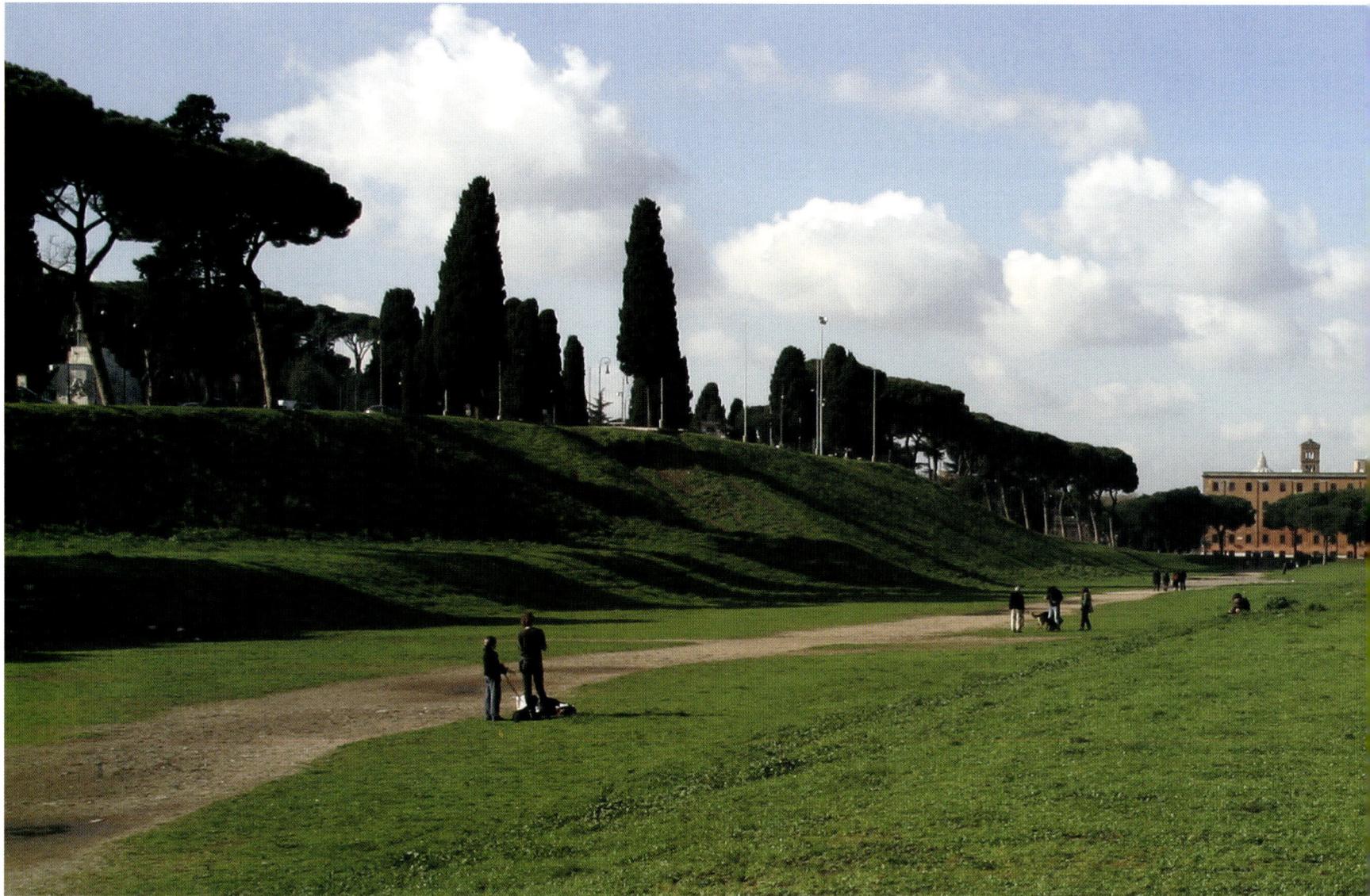

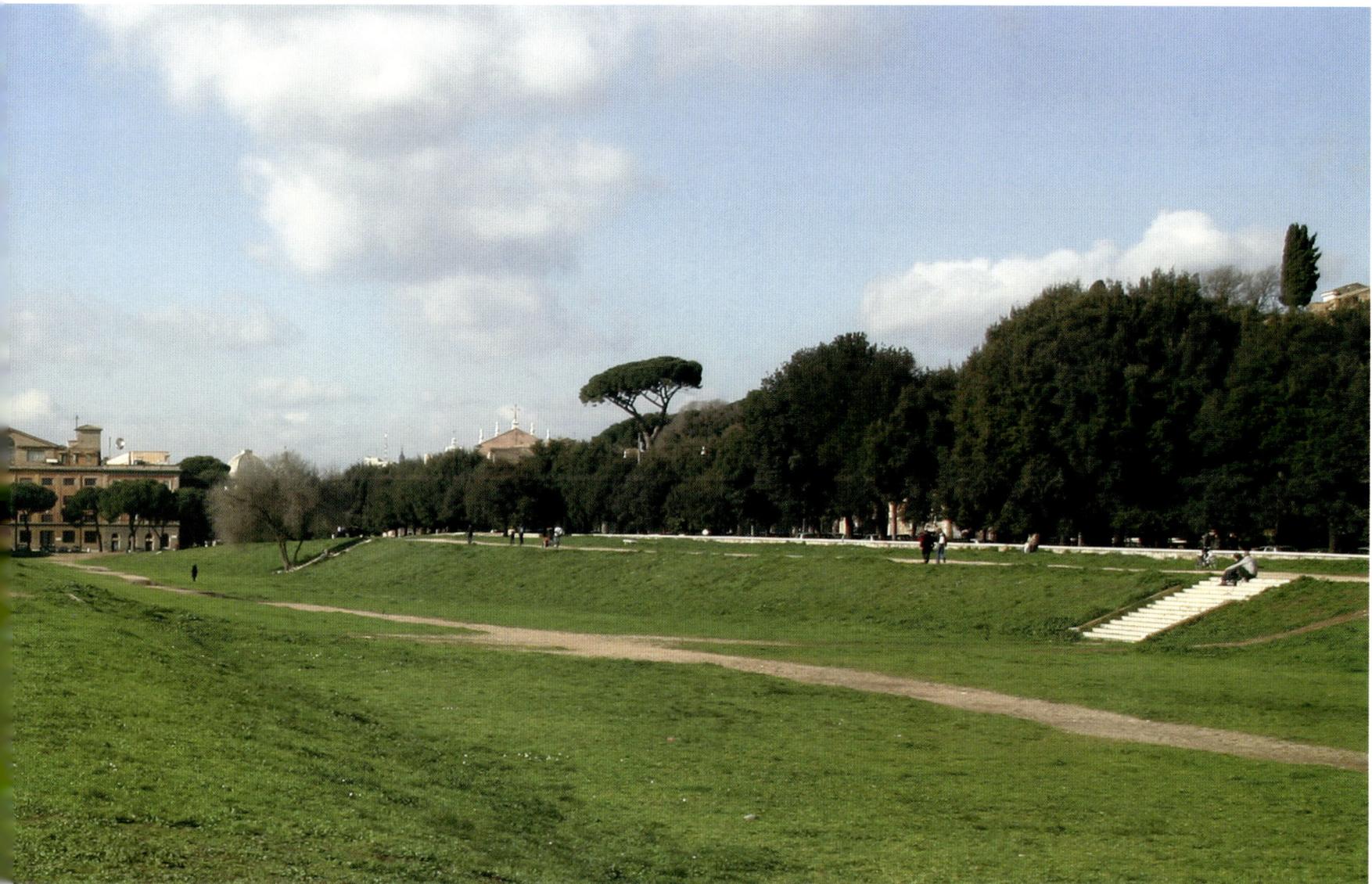

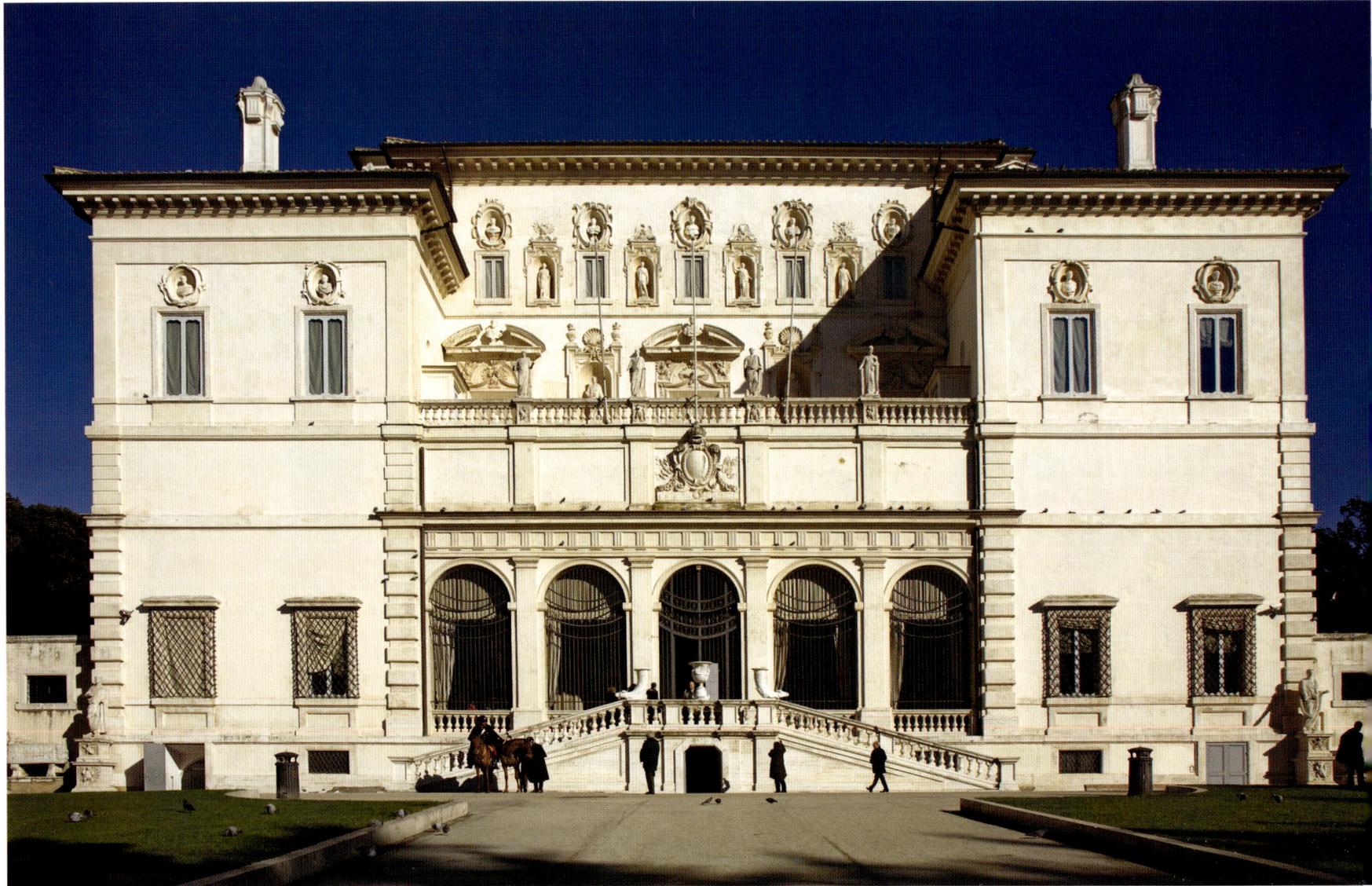

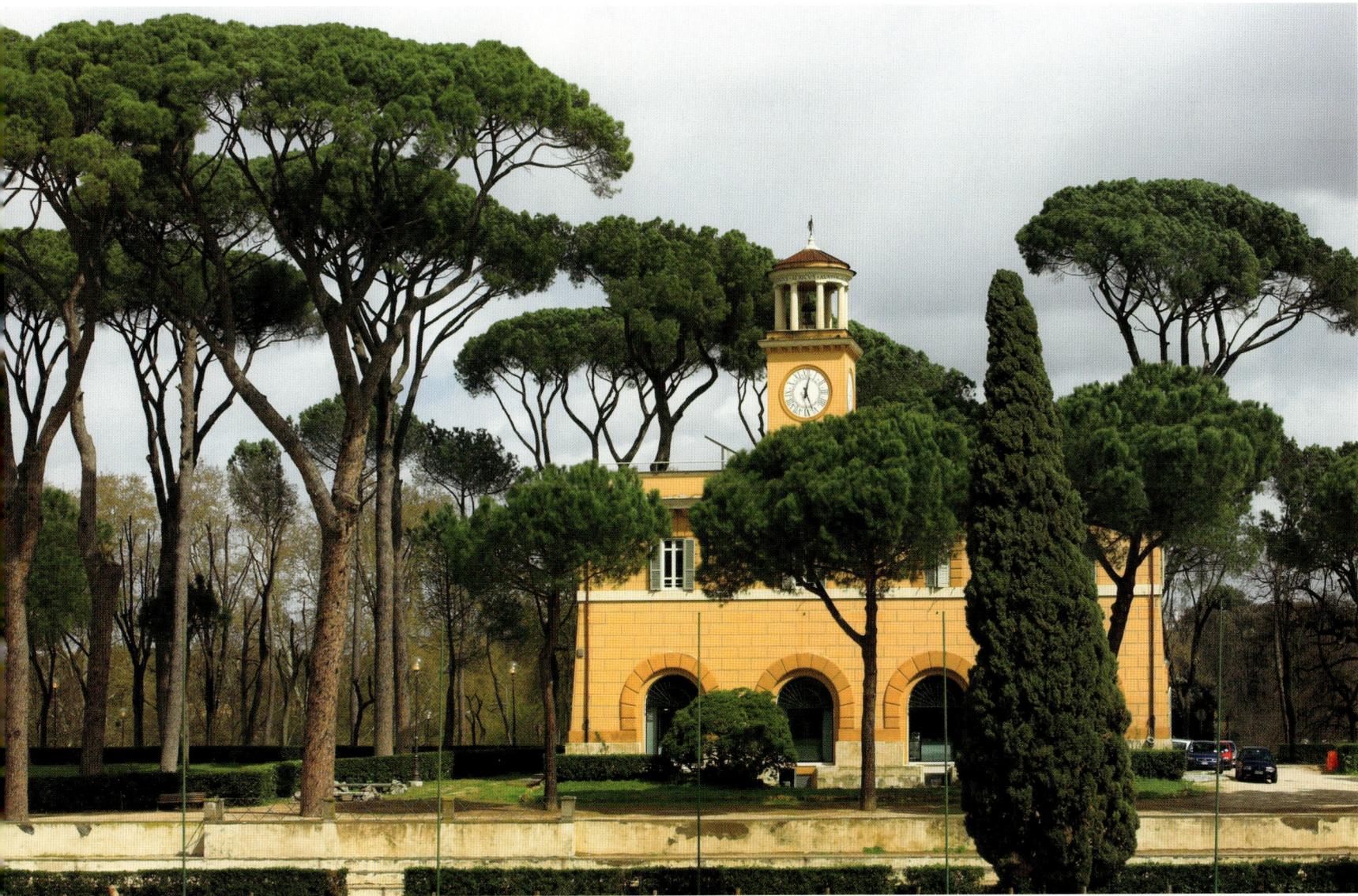

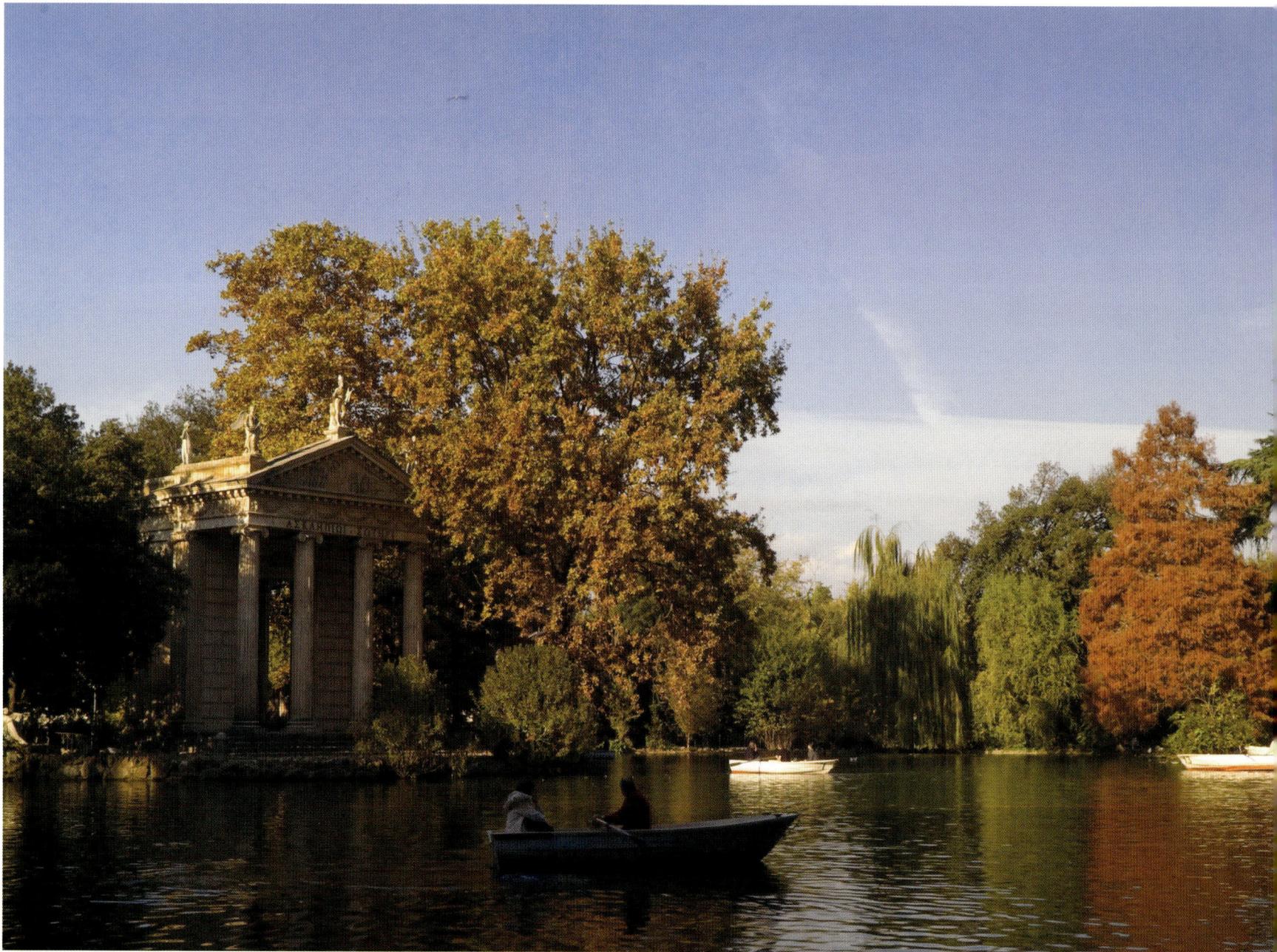

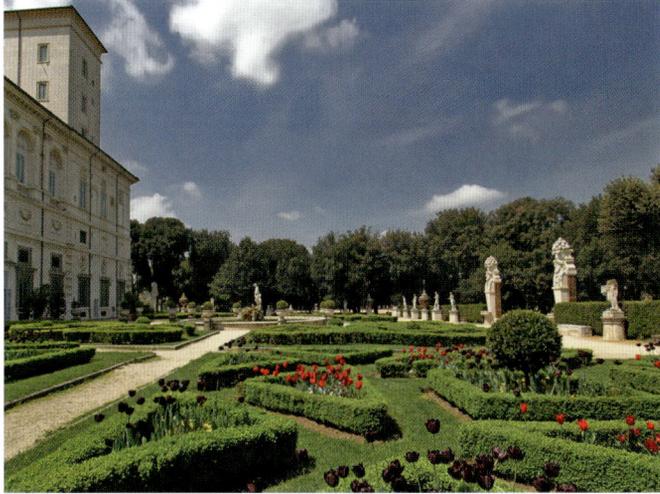
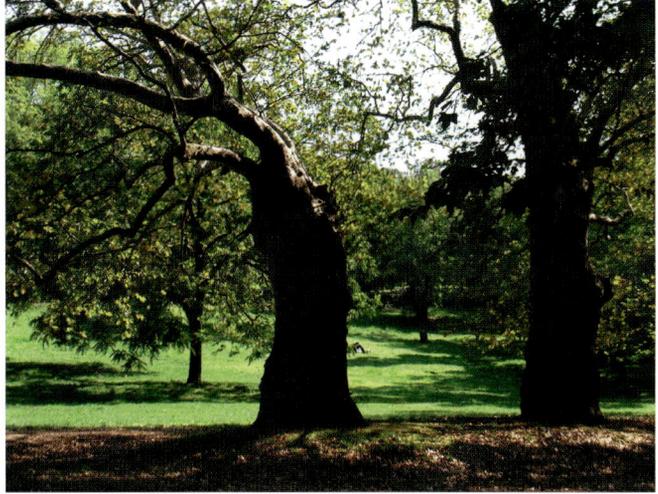

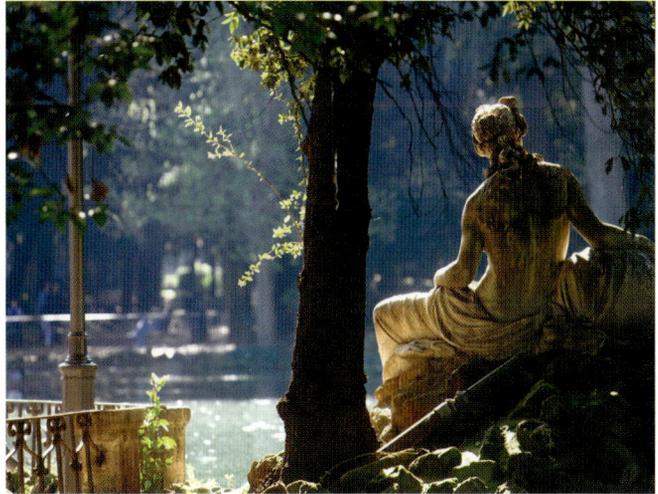

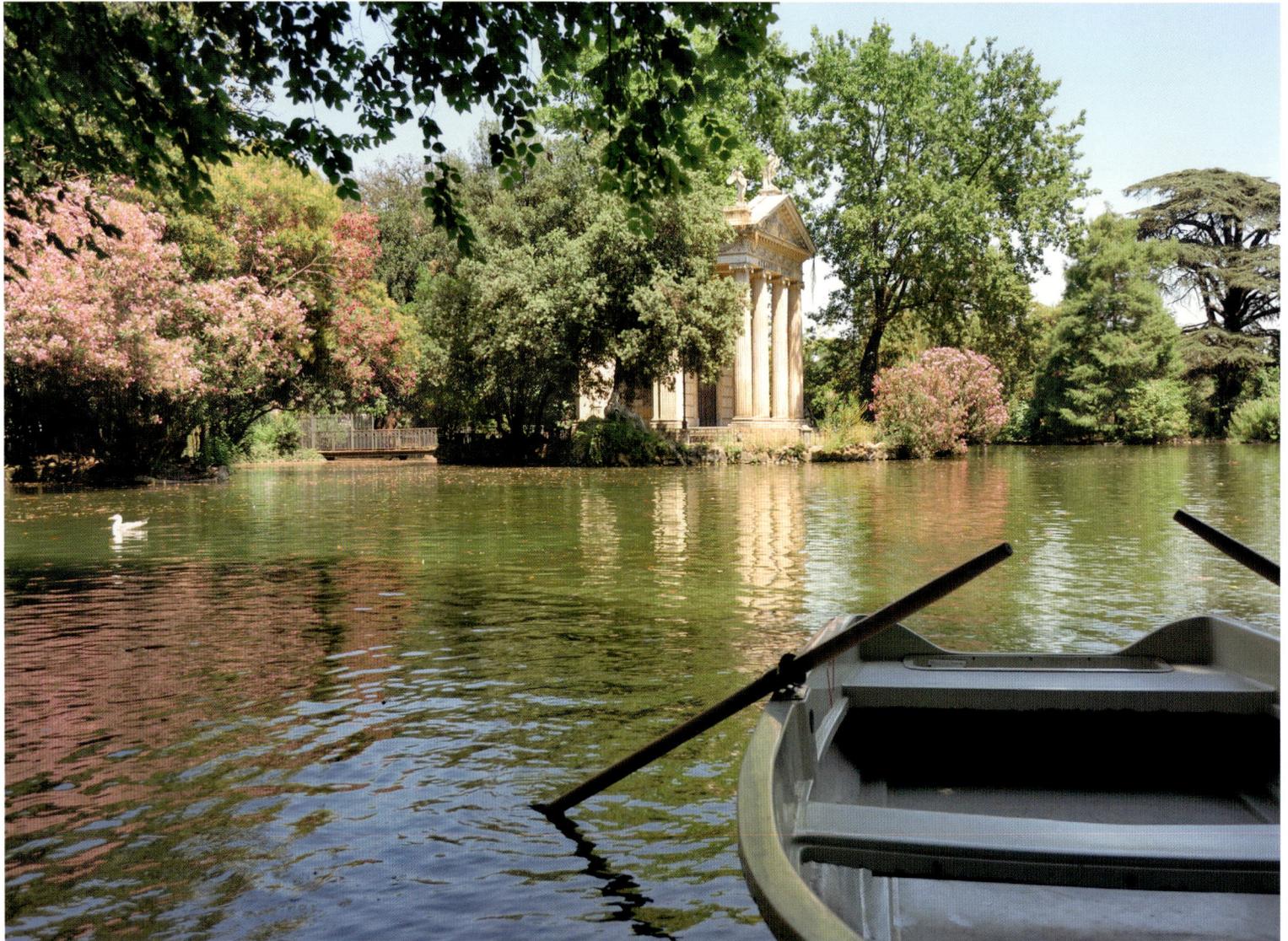

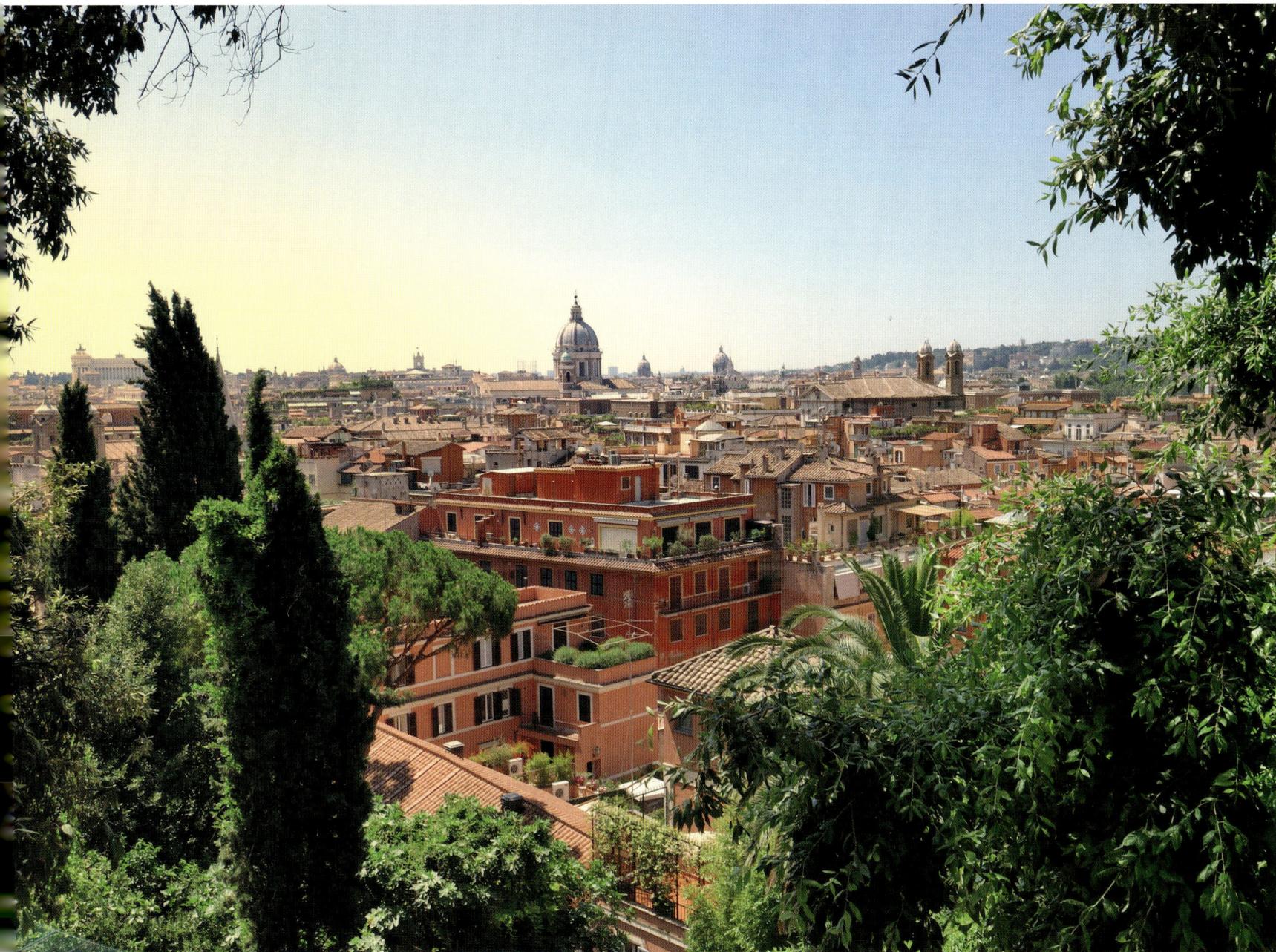

Rome is but nature's twin,
which has reflected Rome.
We see its civic might,
the signs of its decorum
in the transparent air,
the firmament's blue dome,
the colonnades of groves
and in the meadow's forum.

"Rome" by Osip Mandelstam

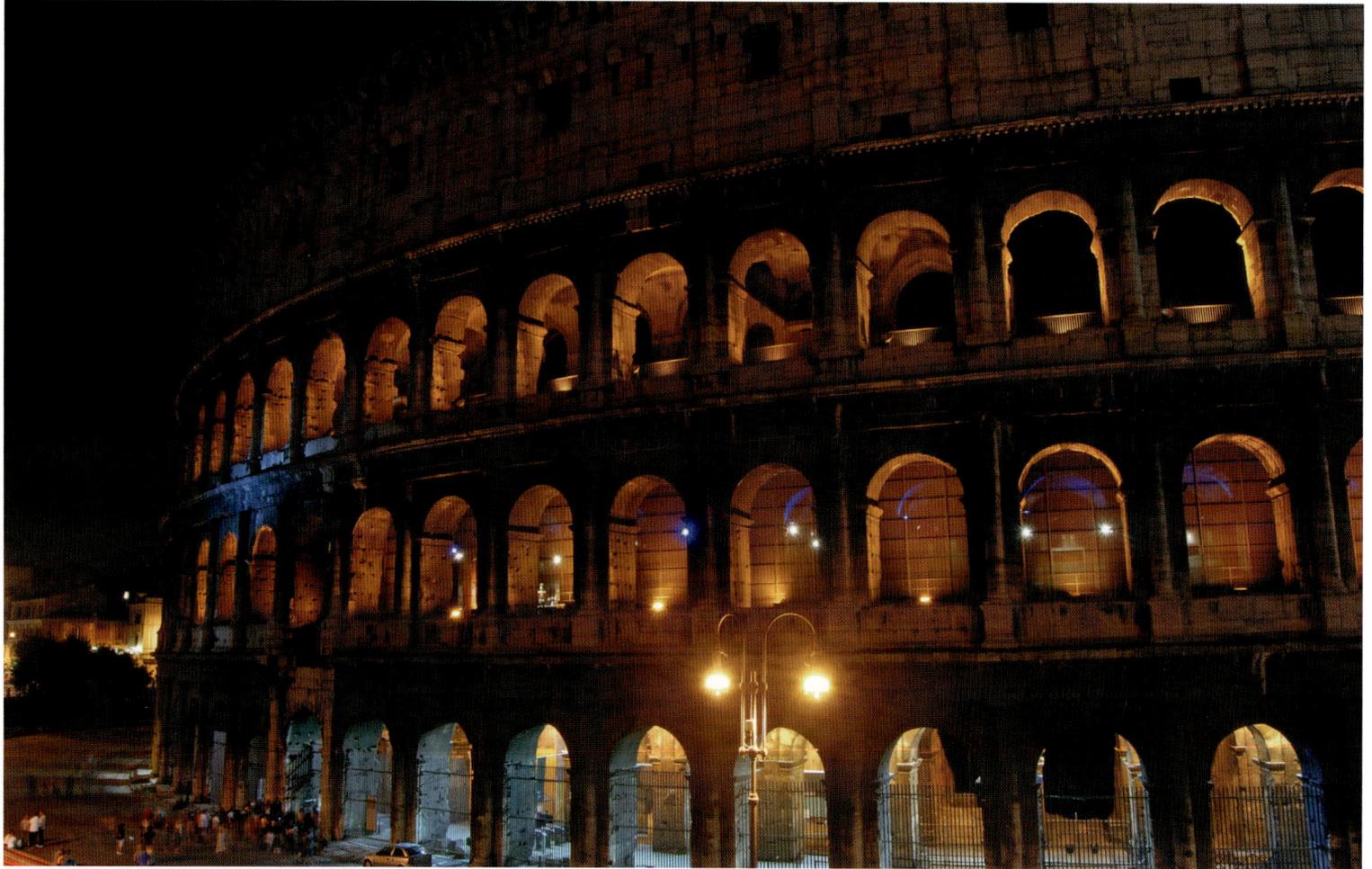

Nightlife

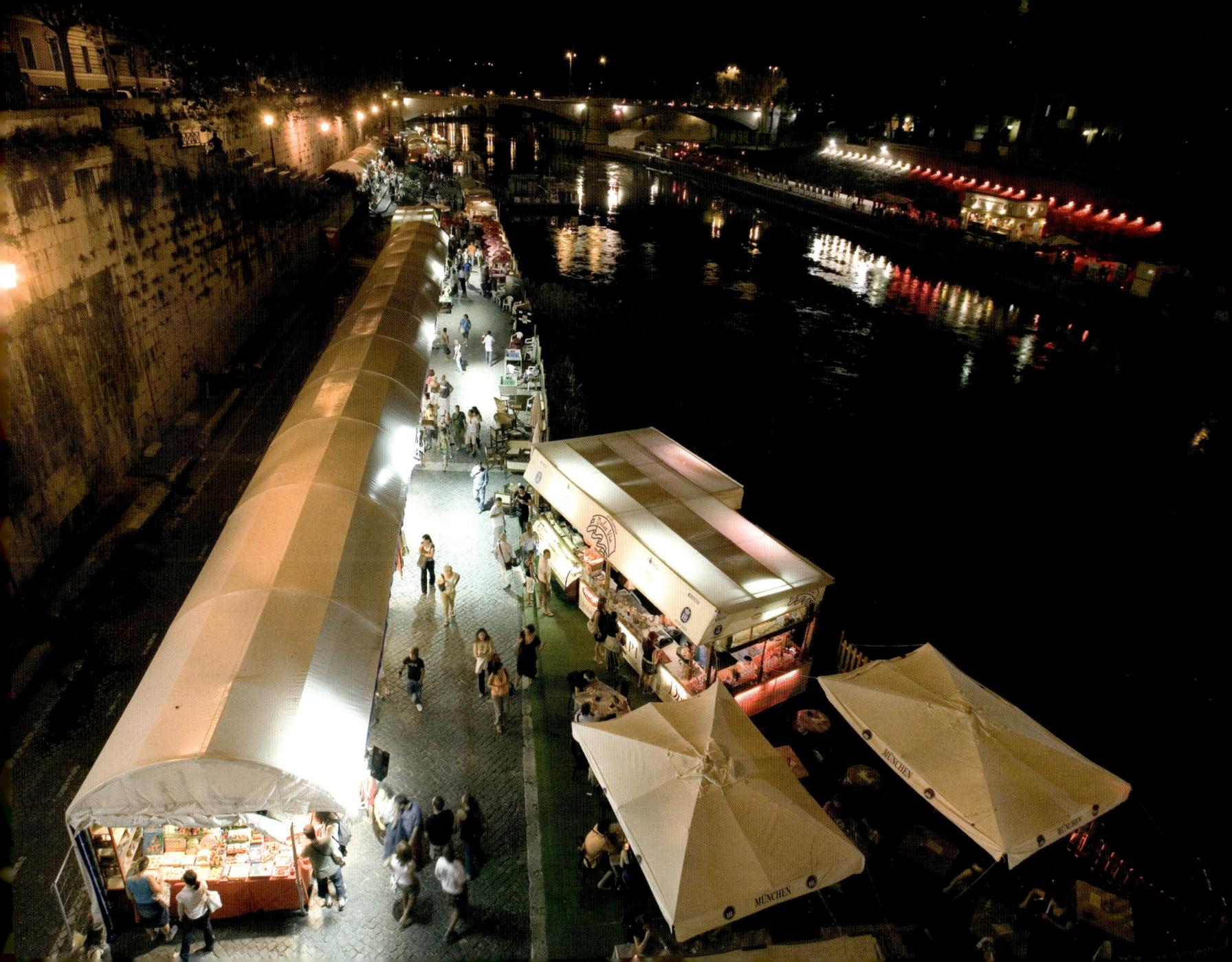

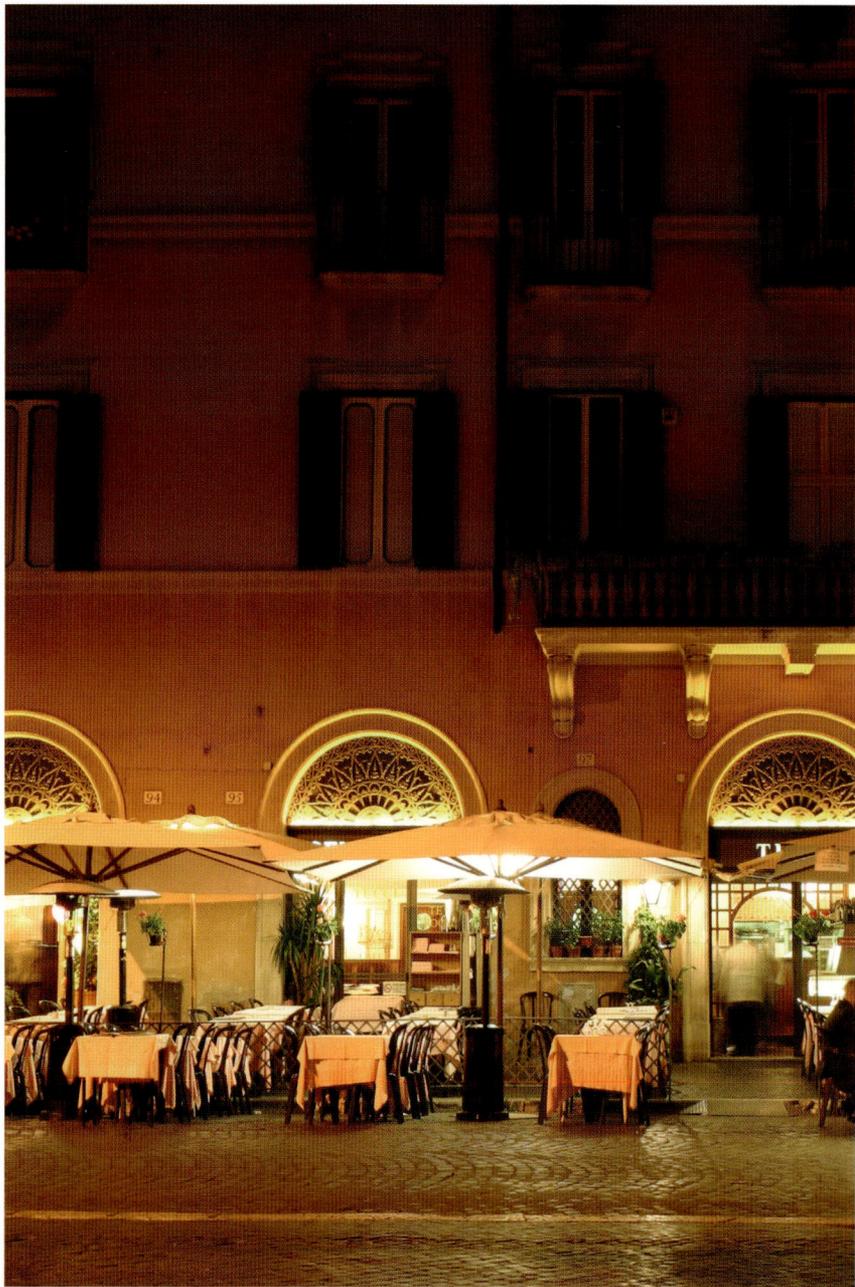
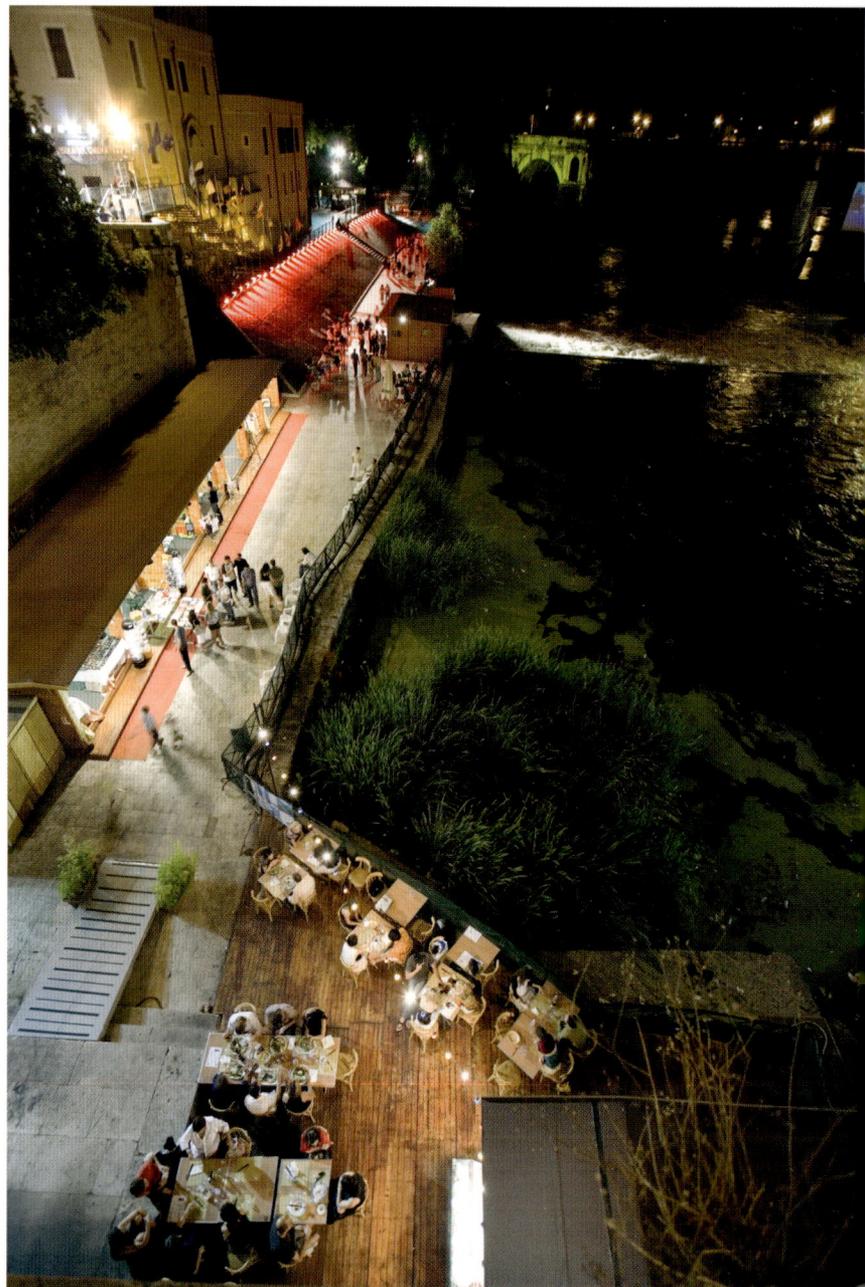

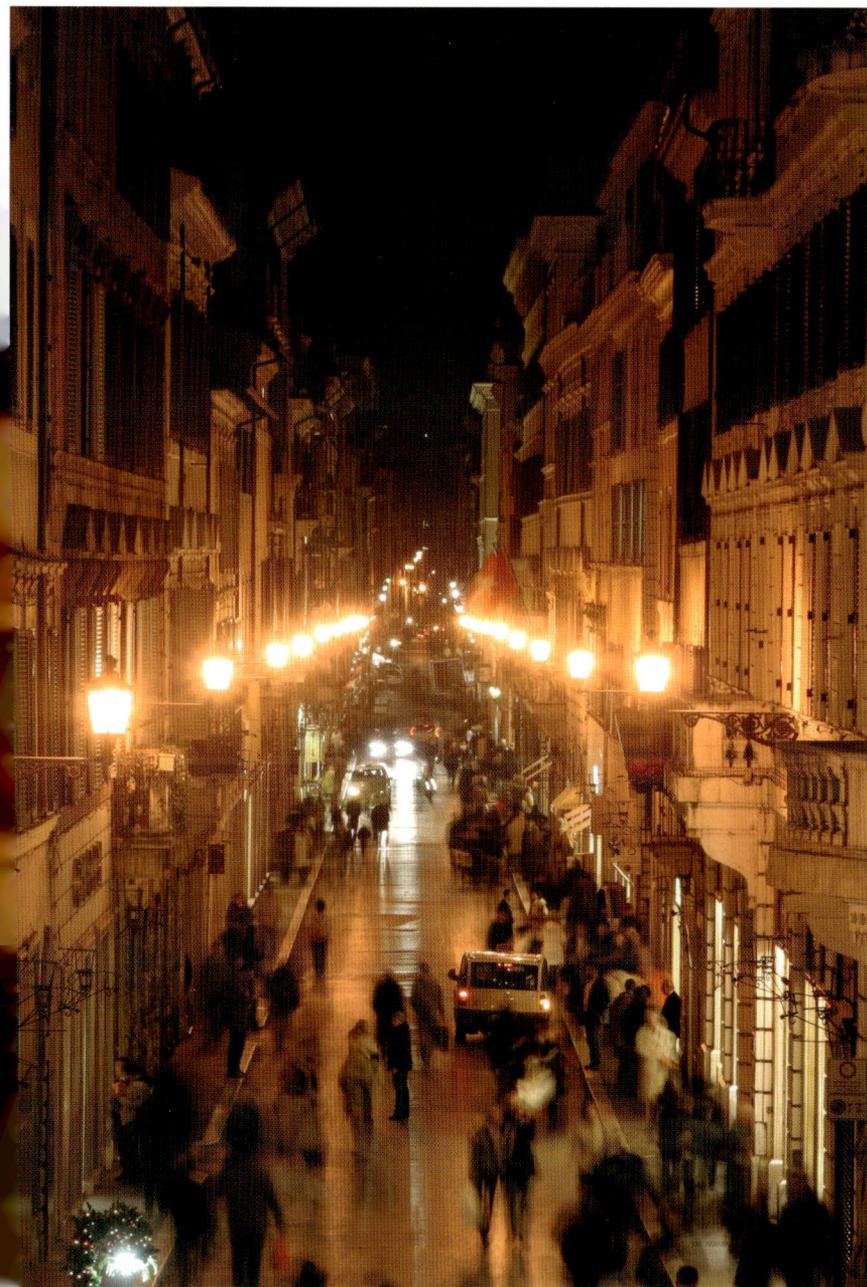
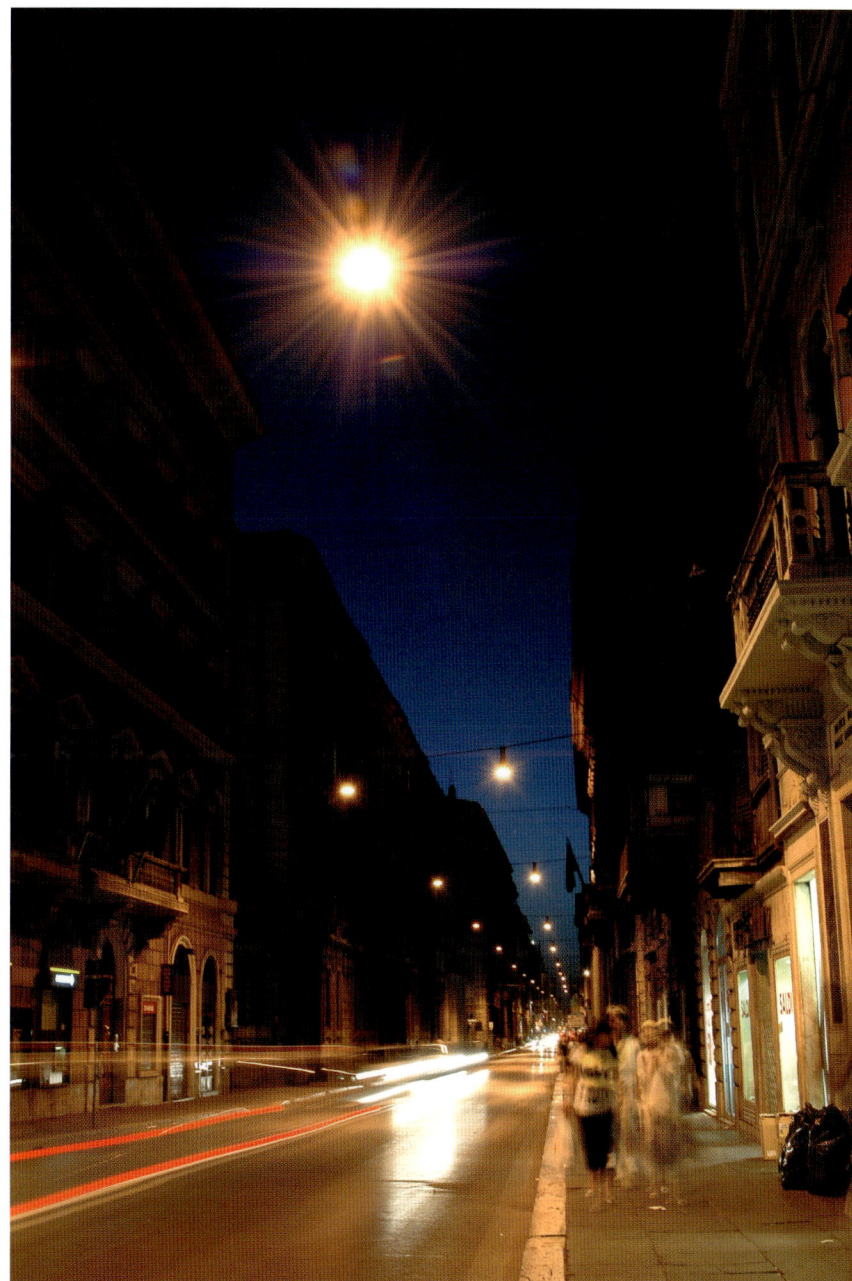

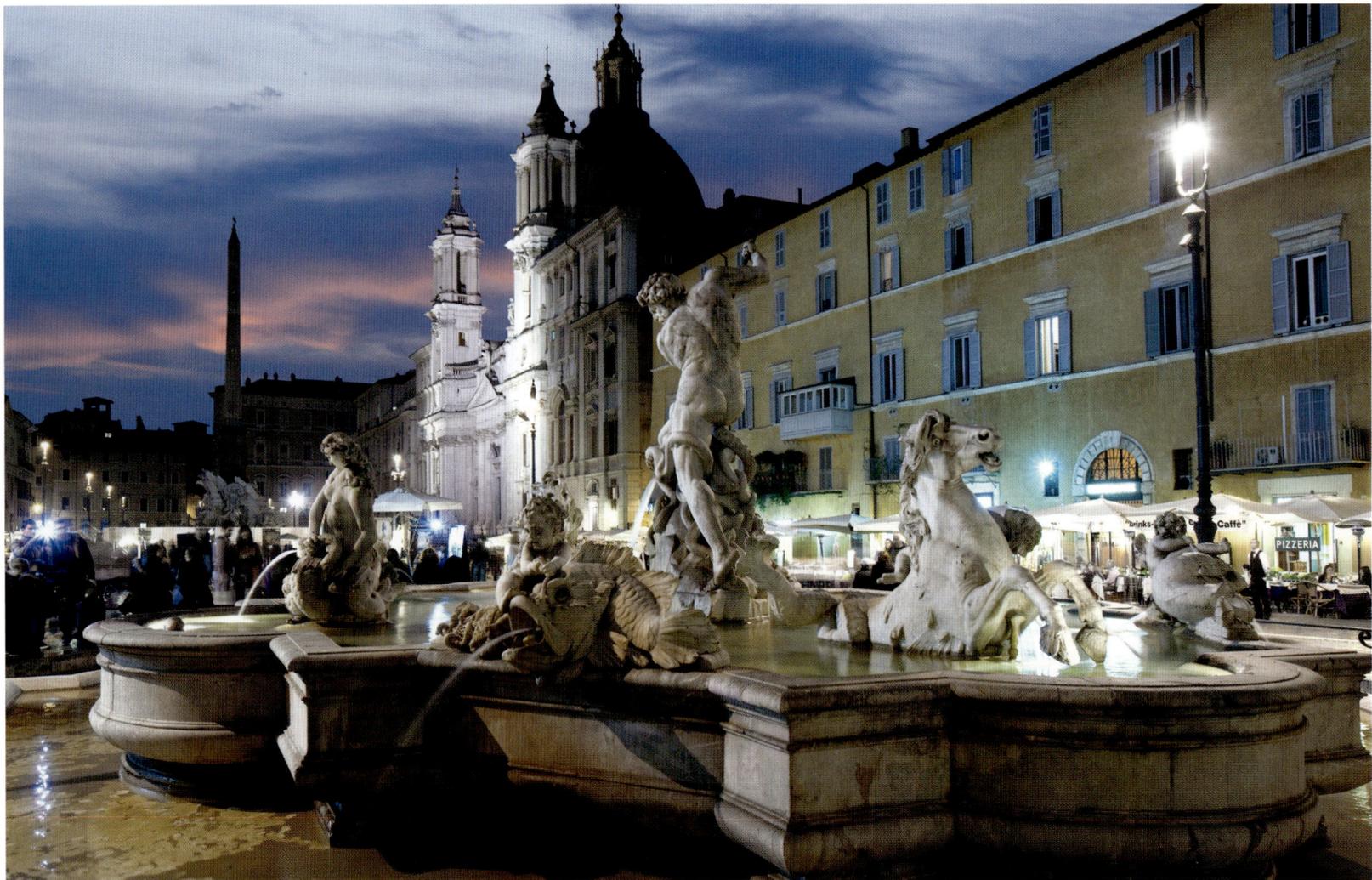

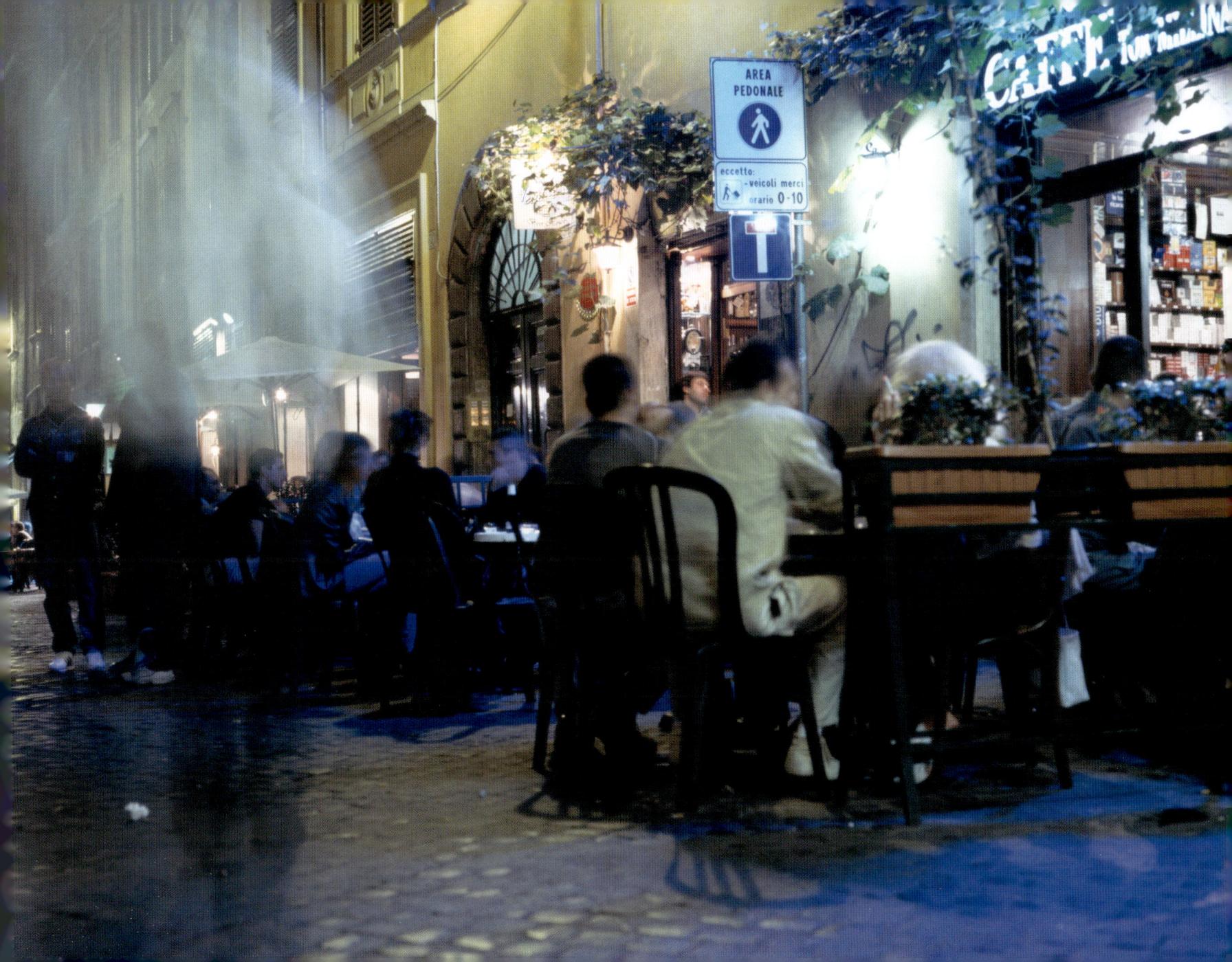

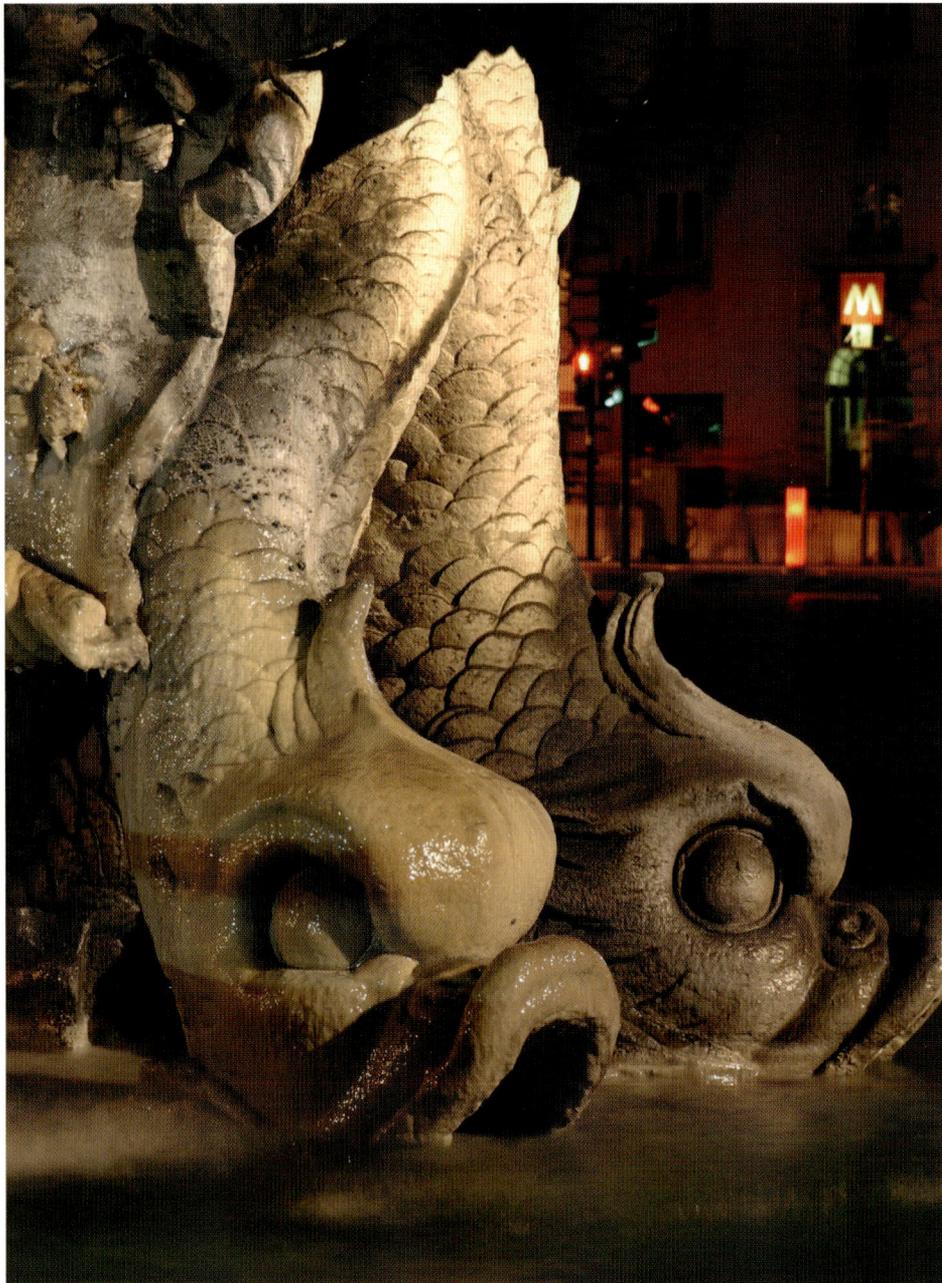

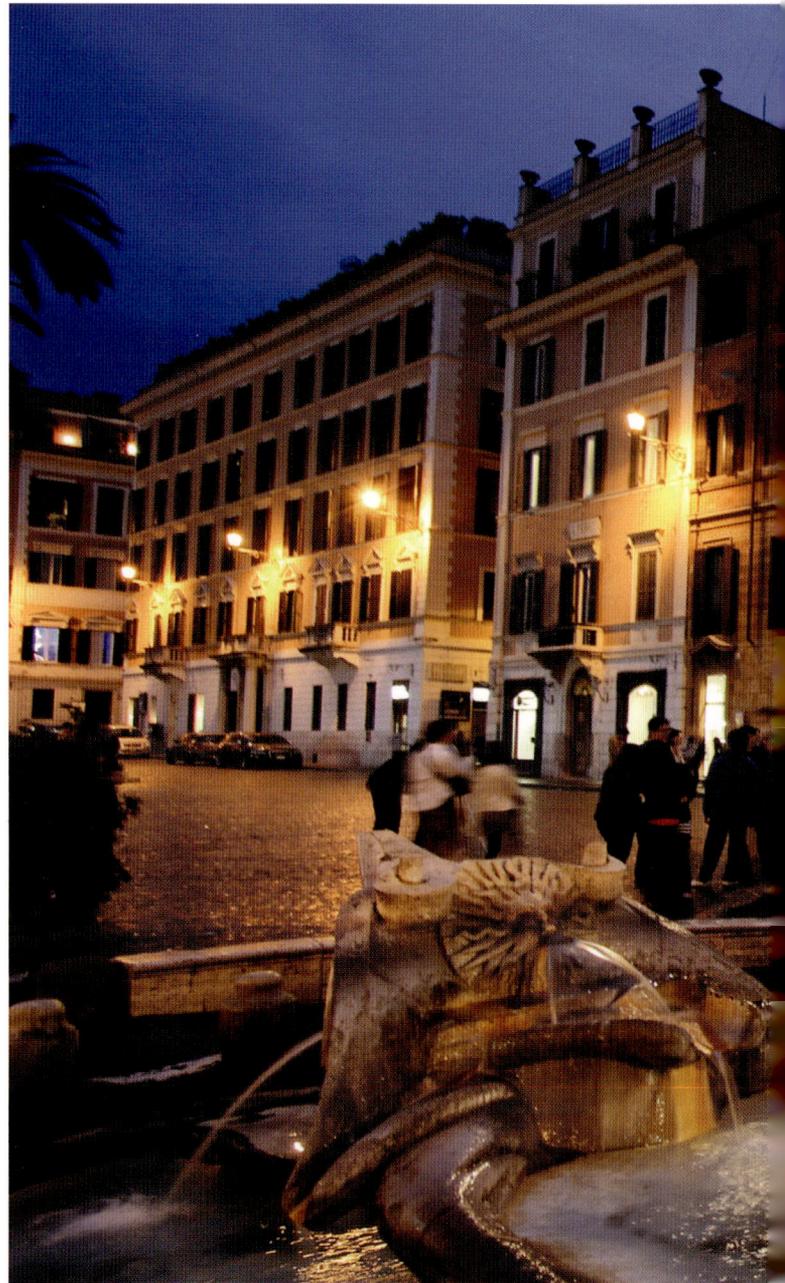

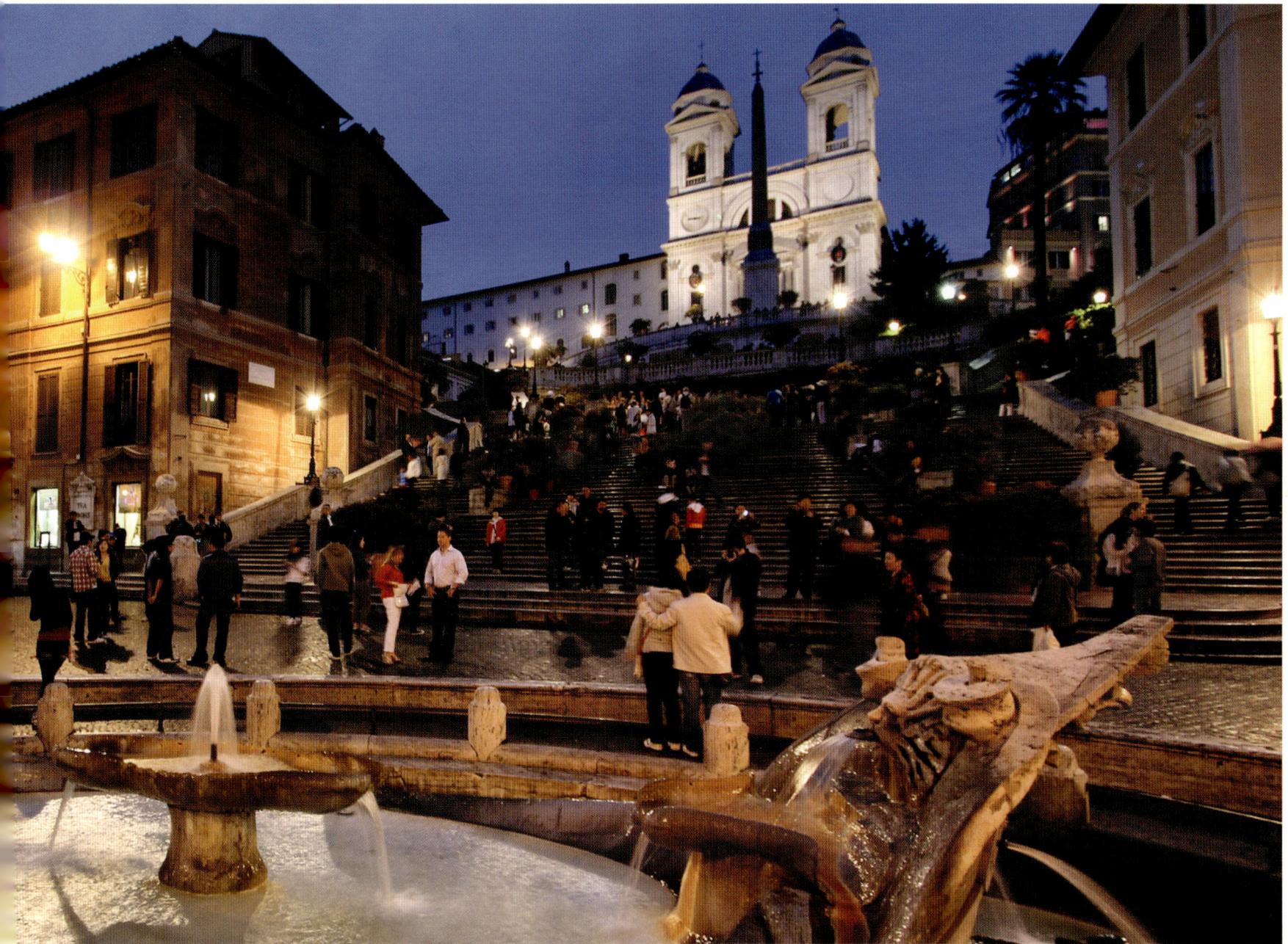

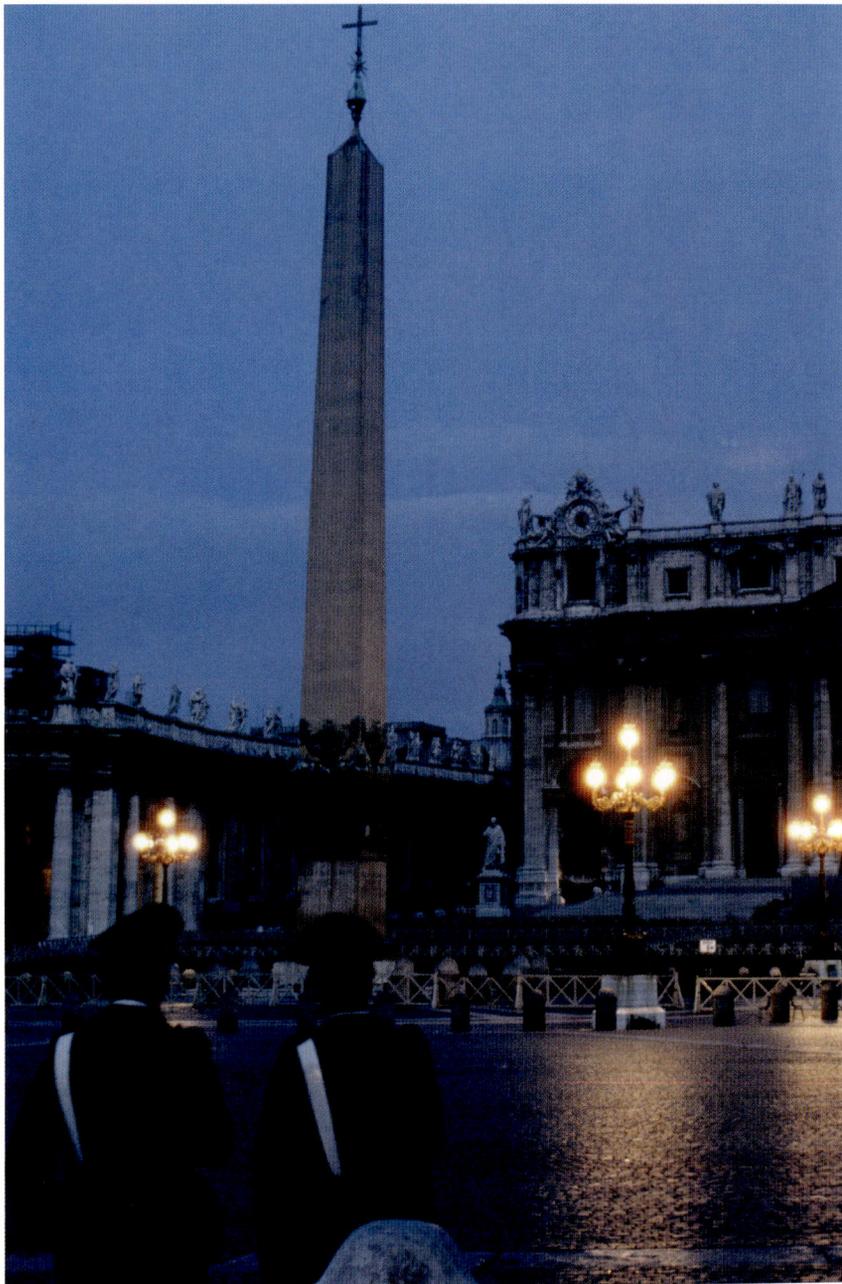

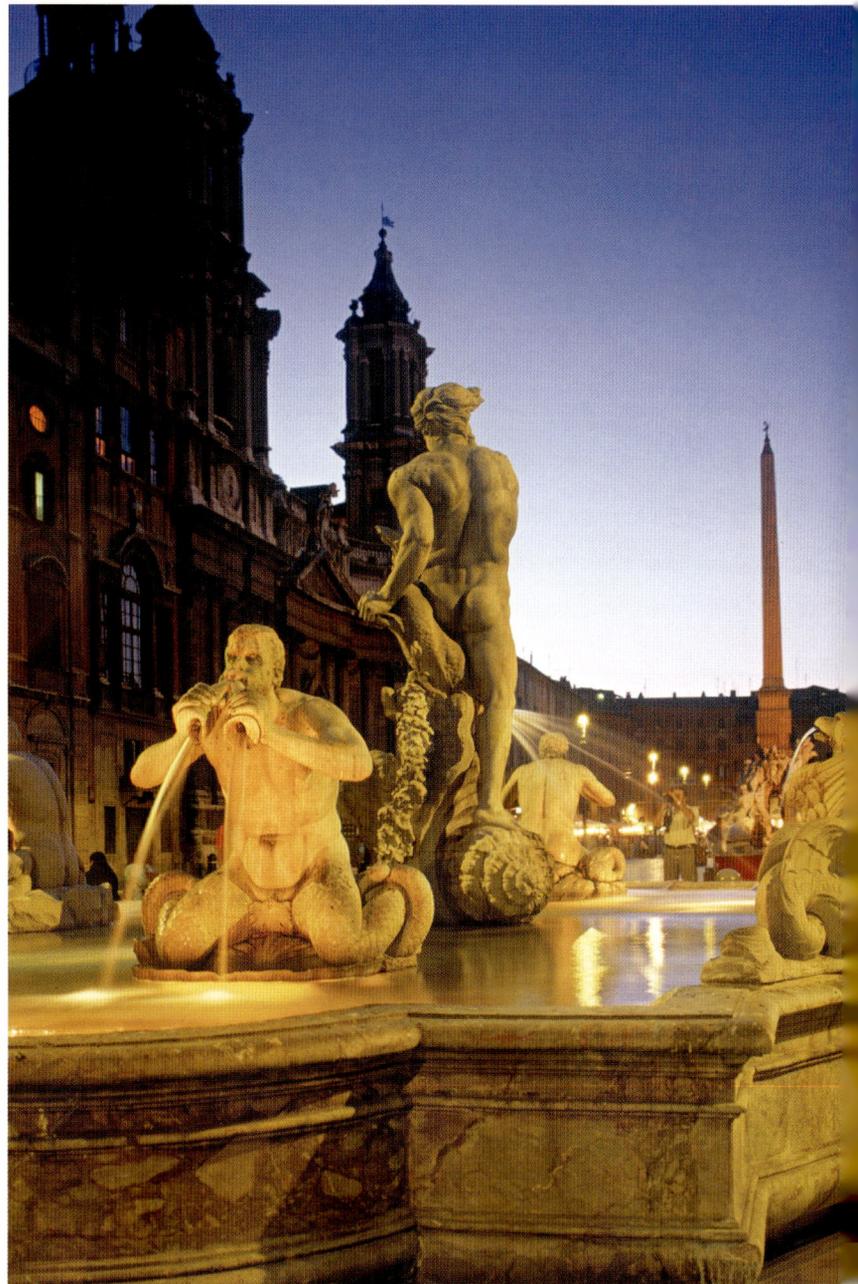

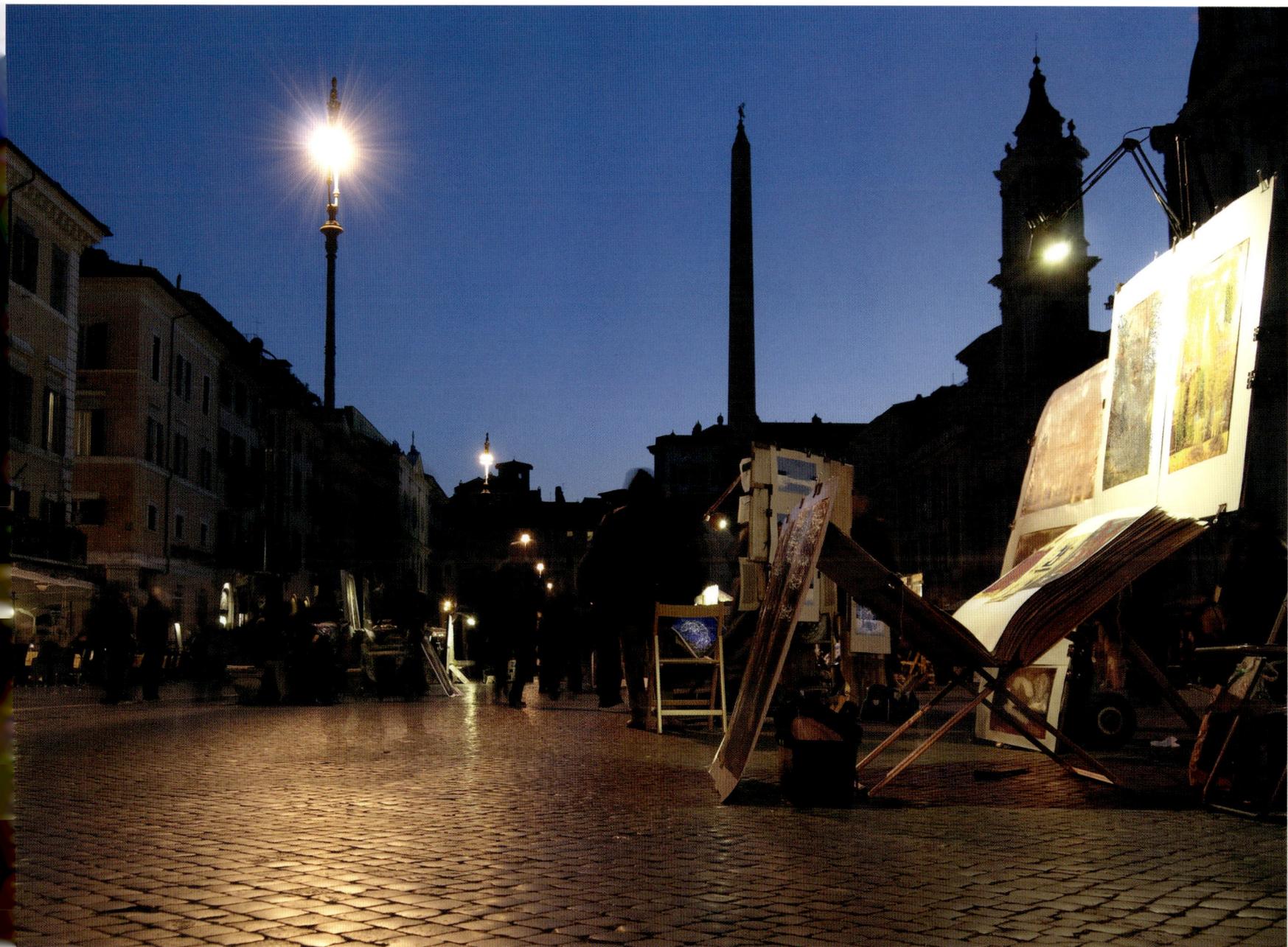

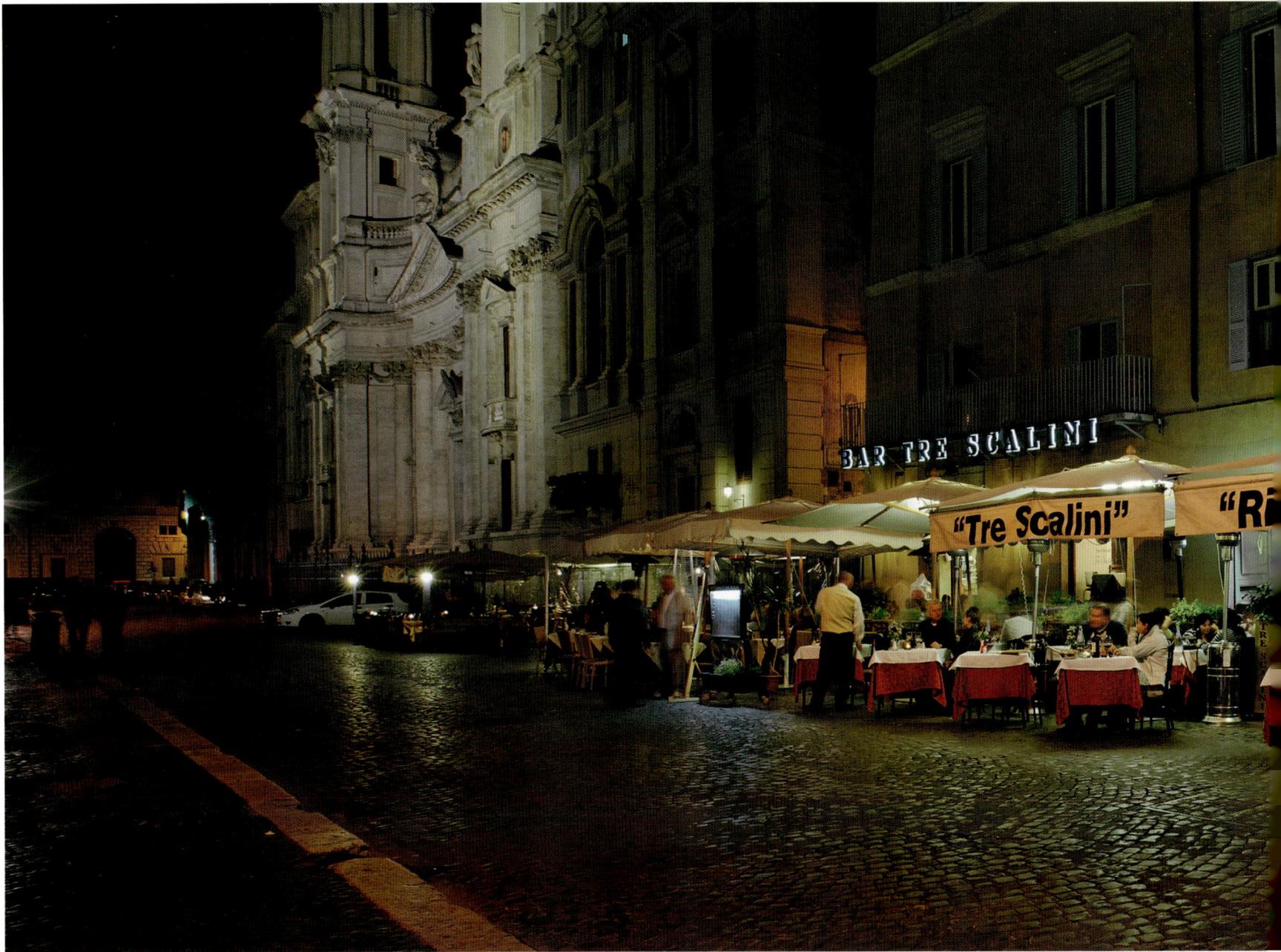

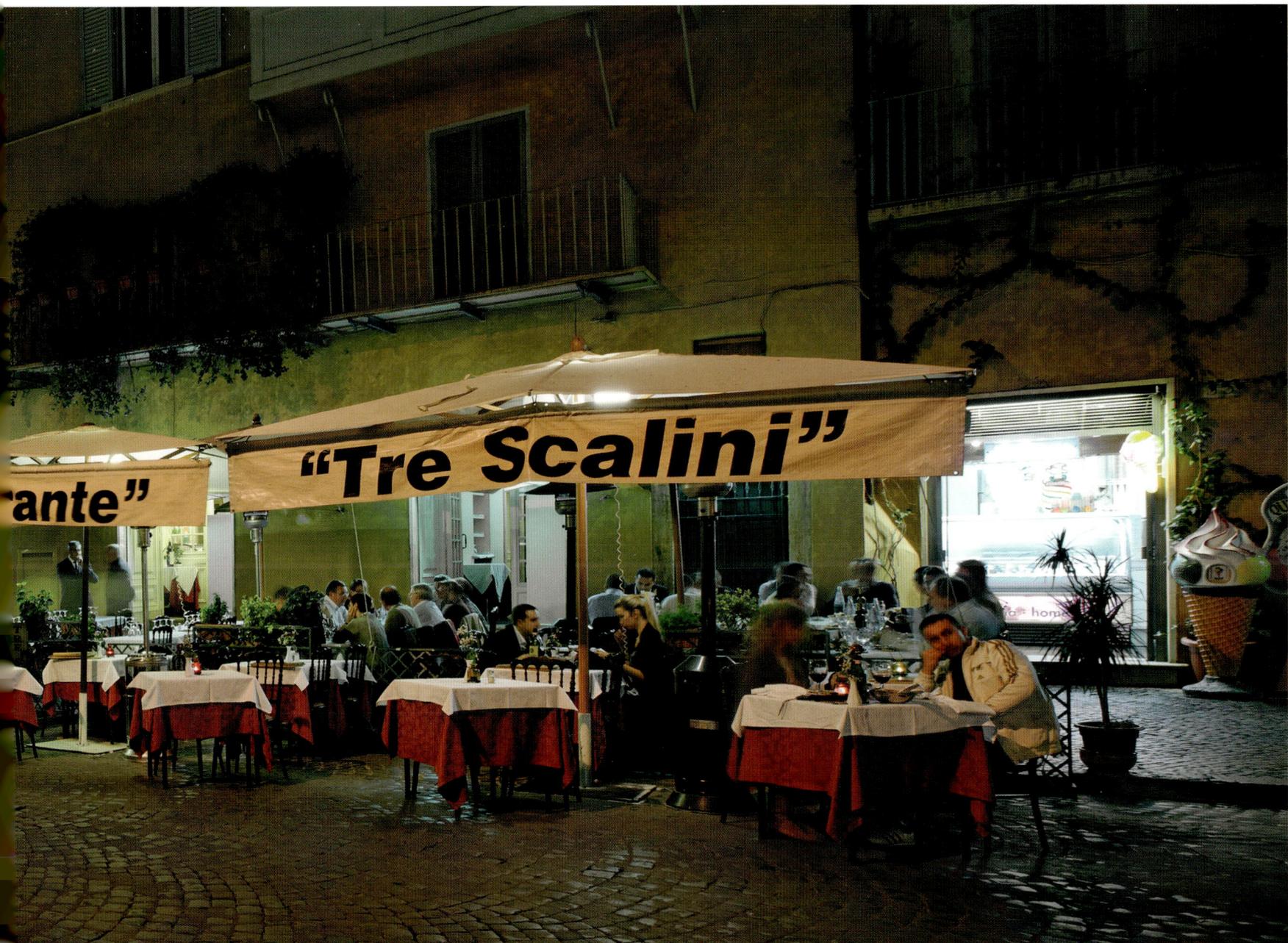

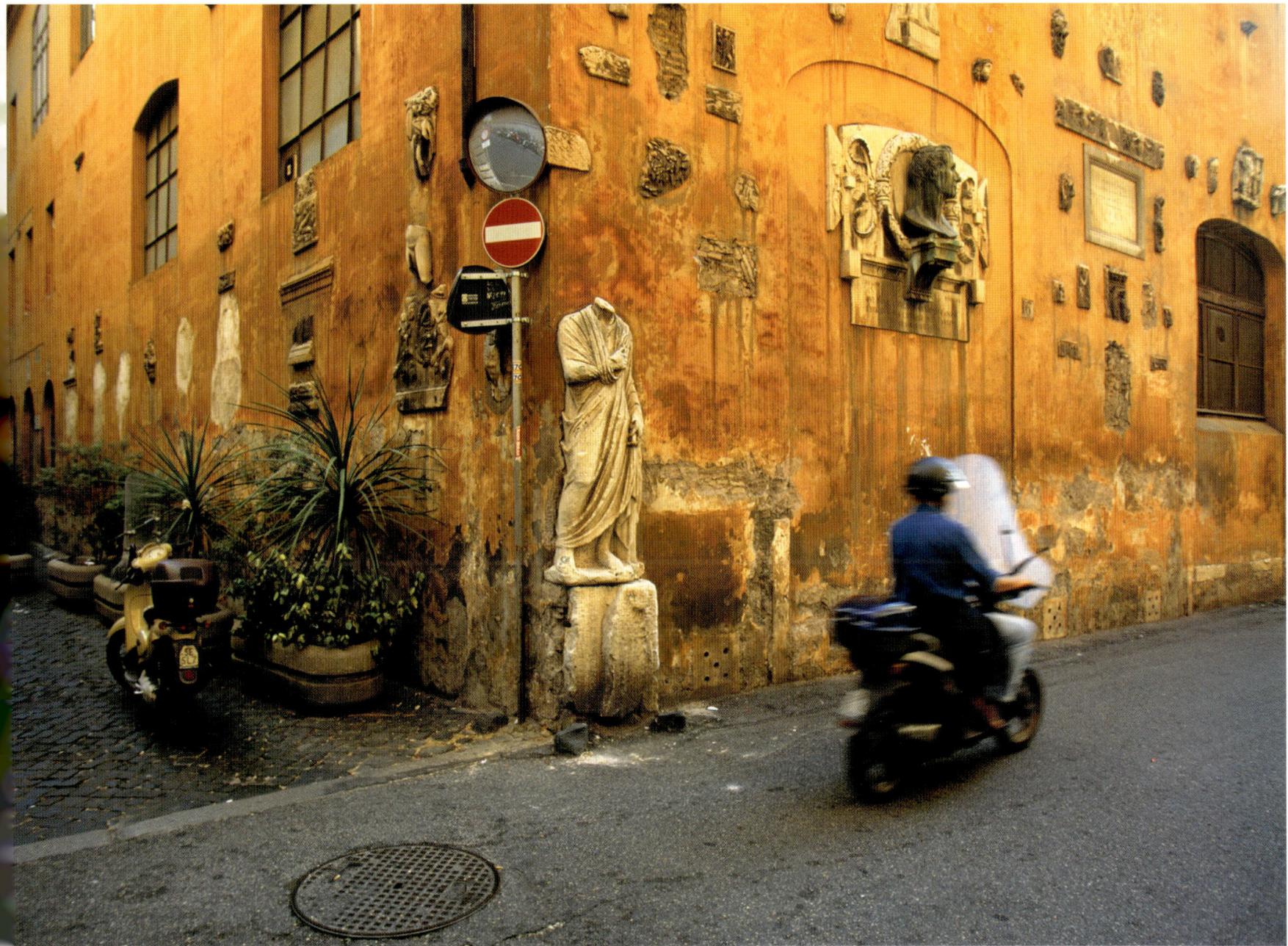

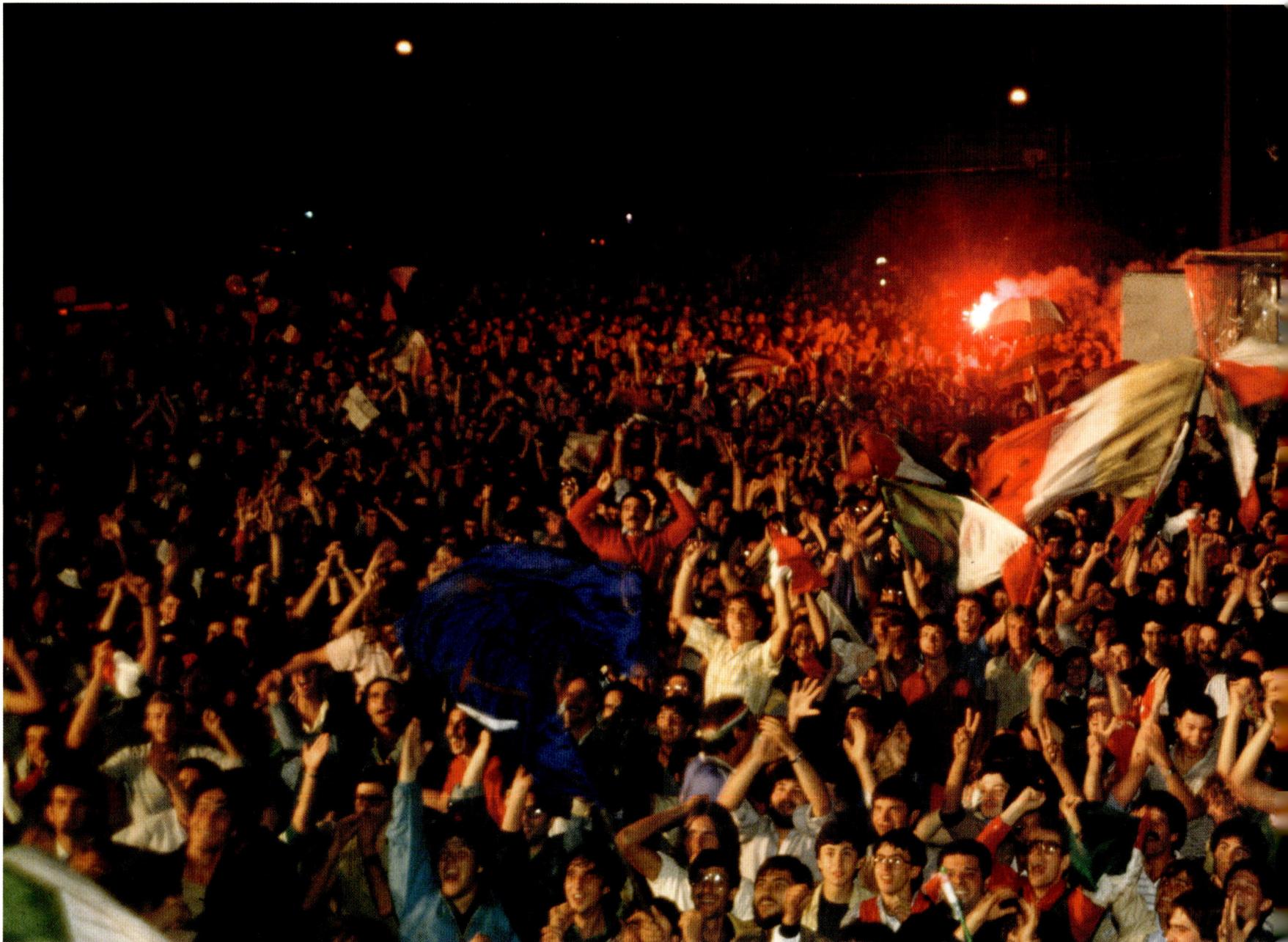

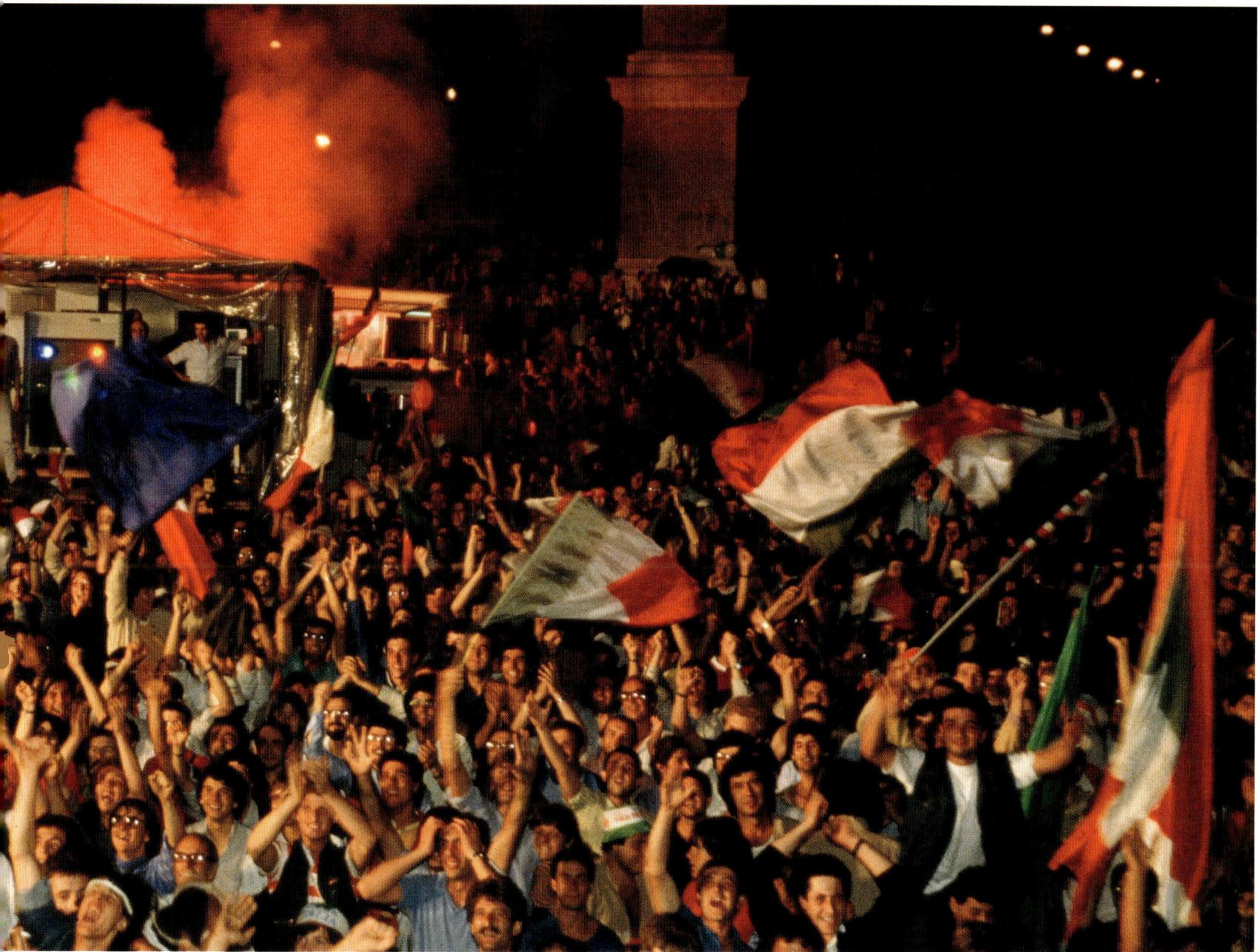

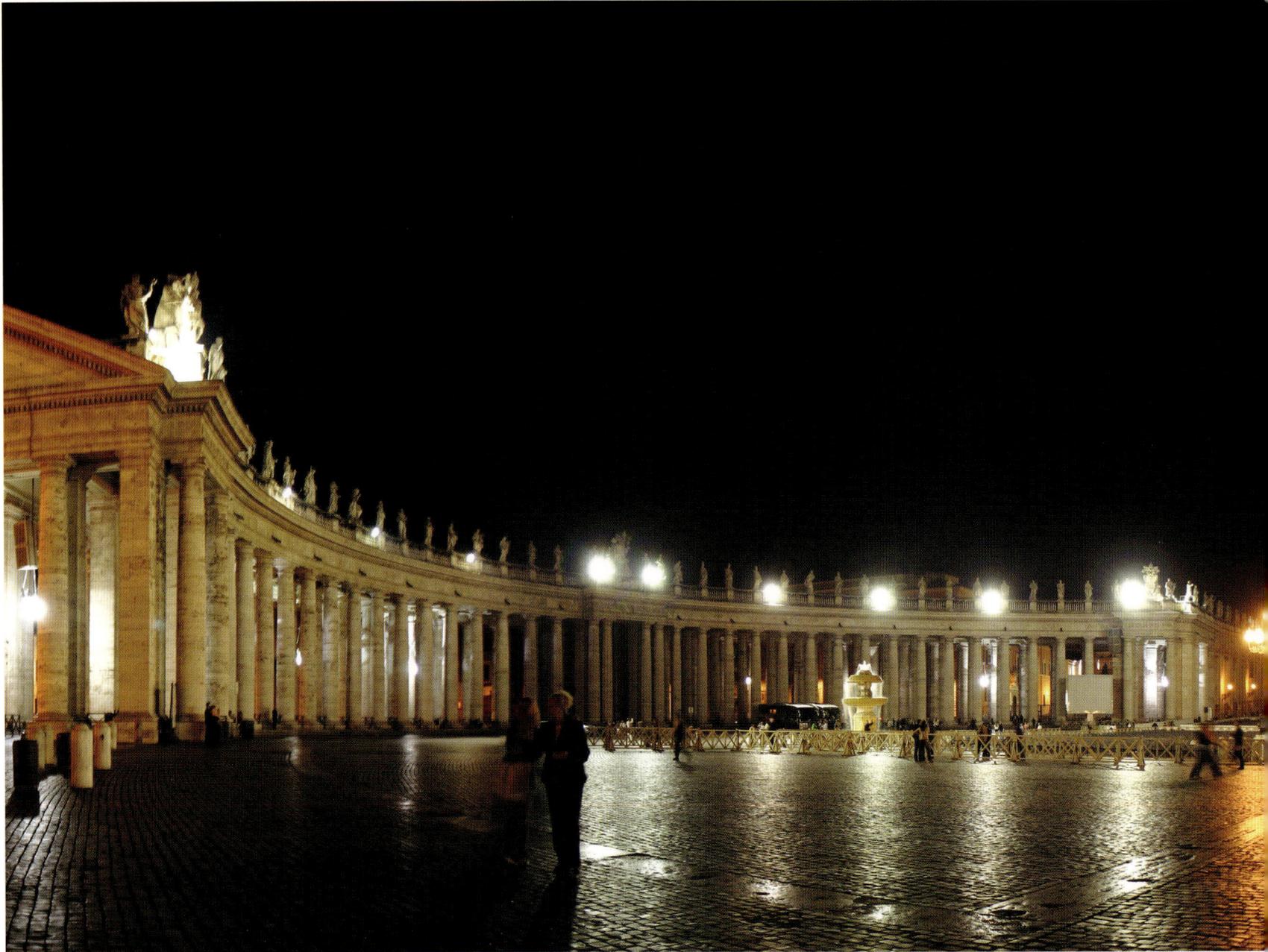

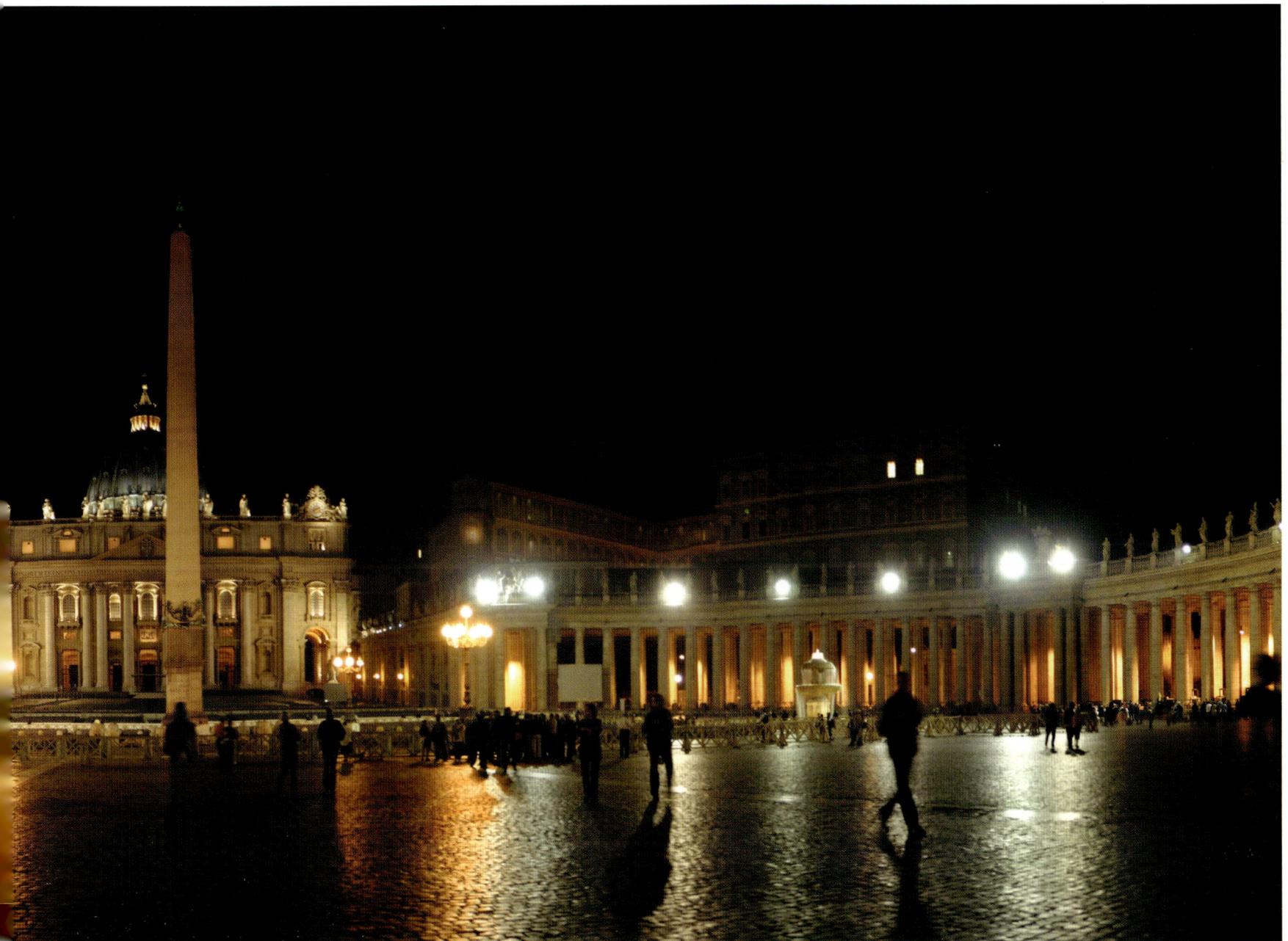

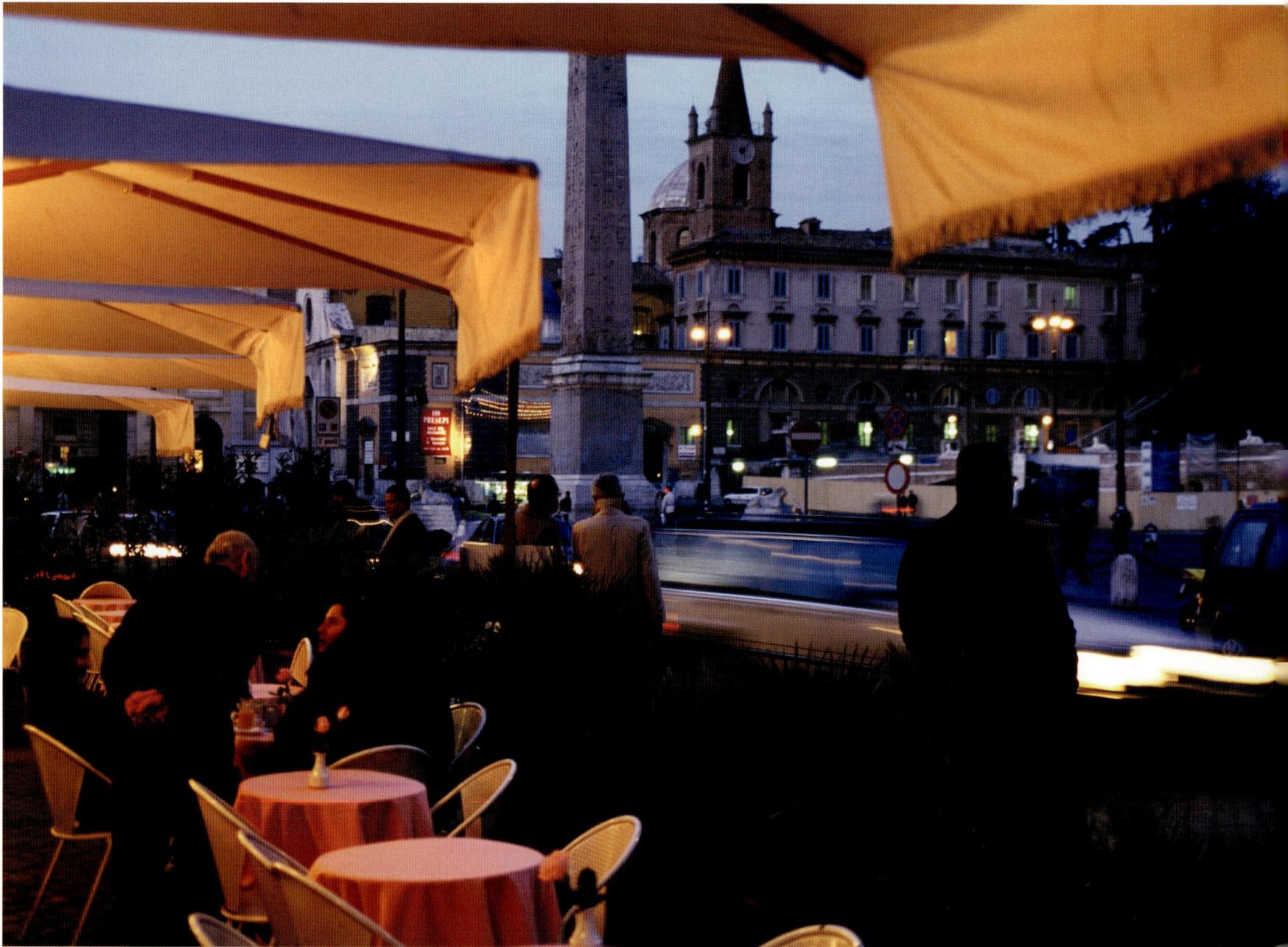

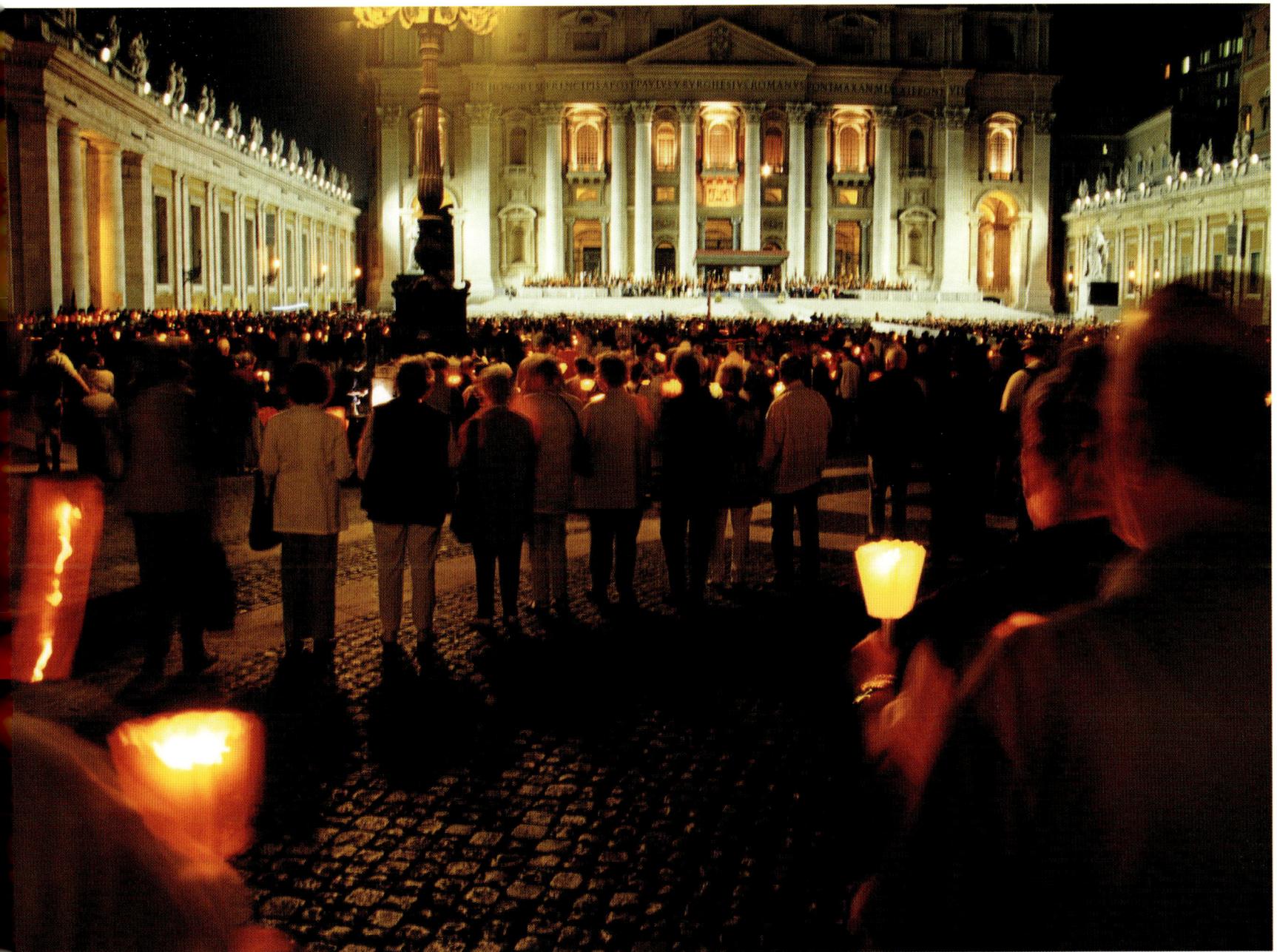

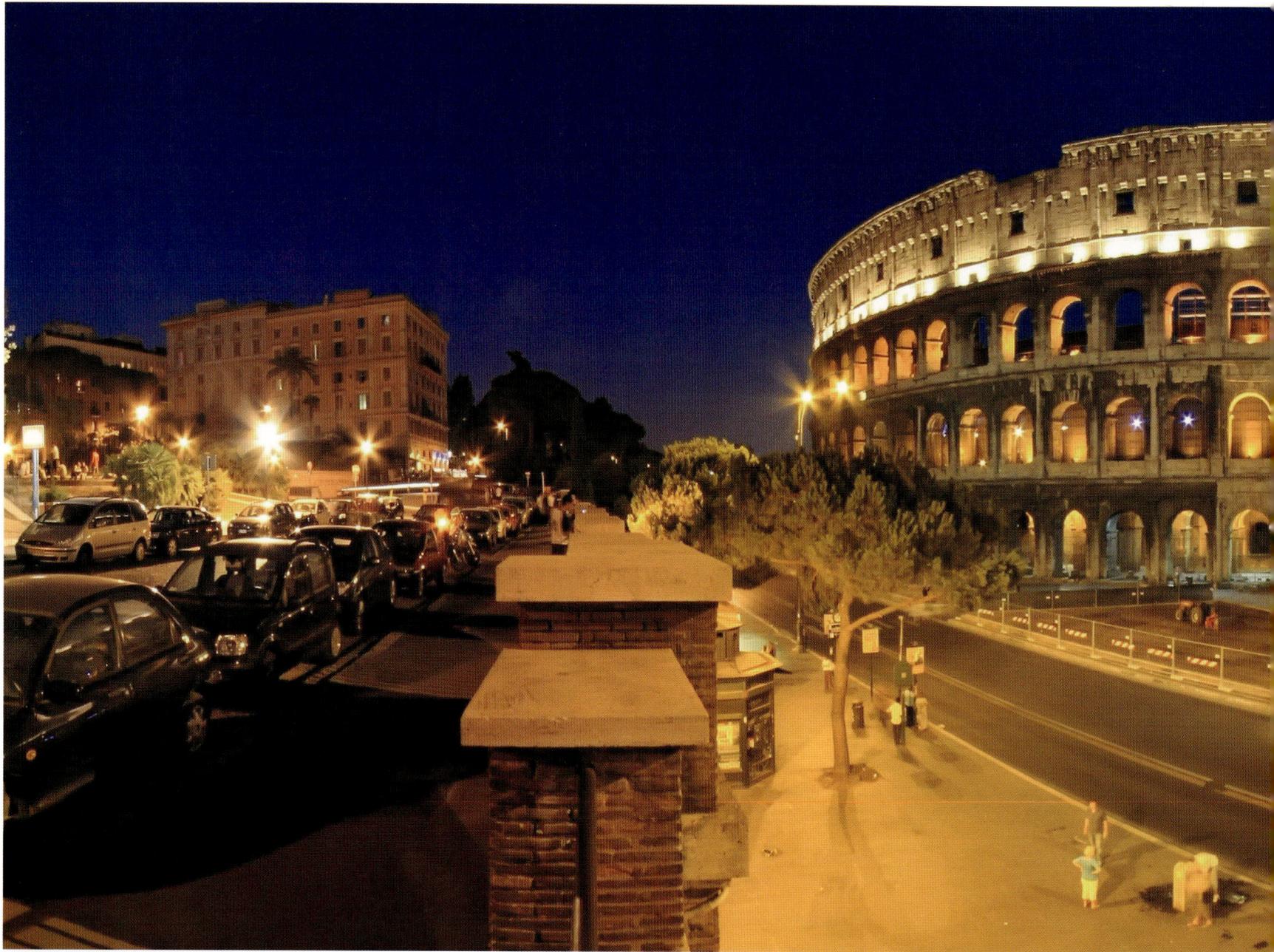

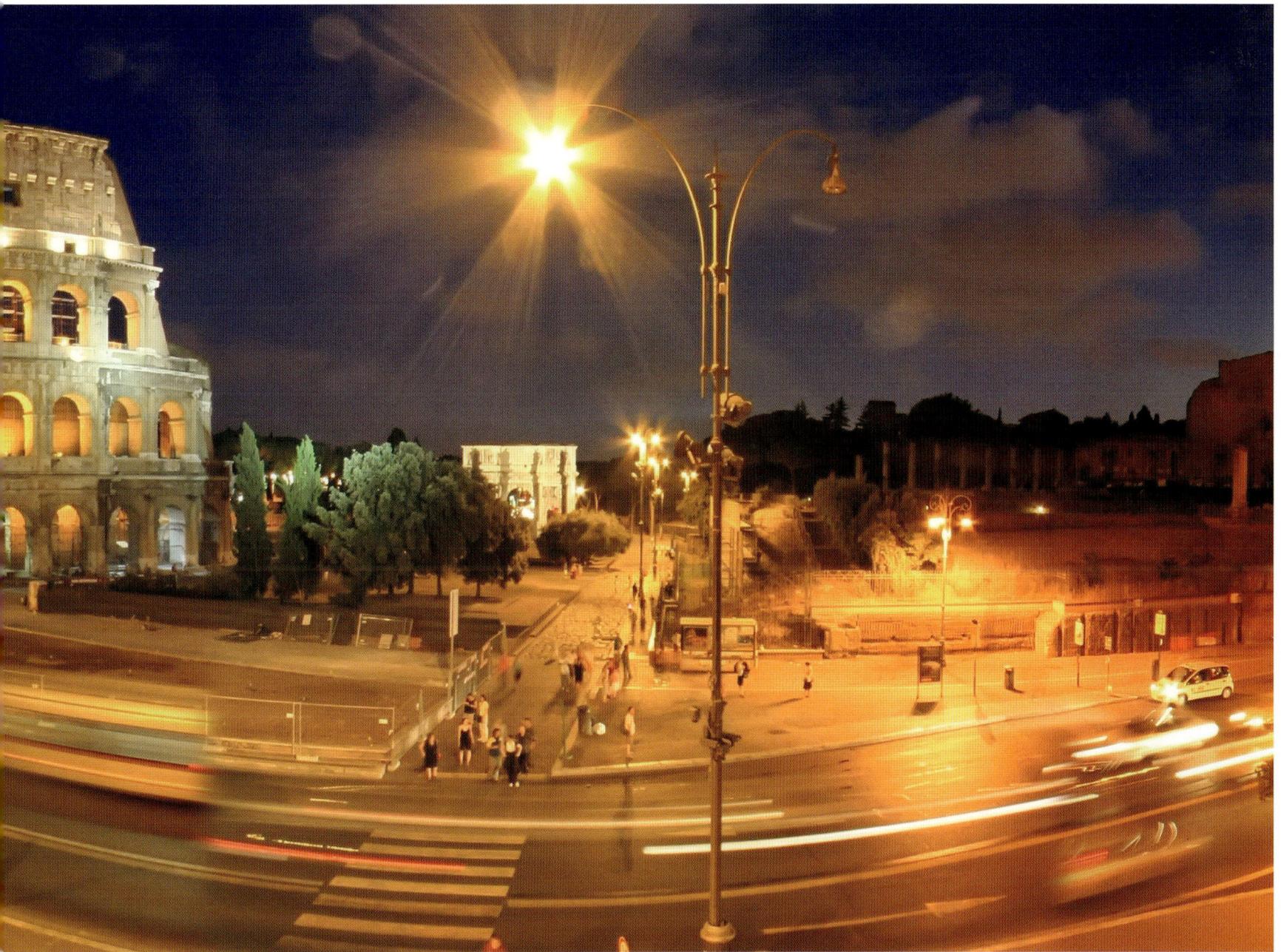

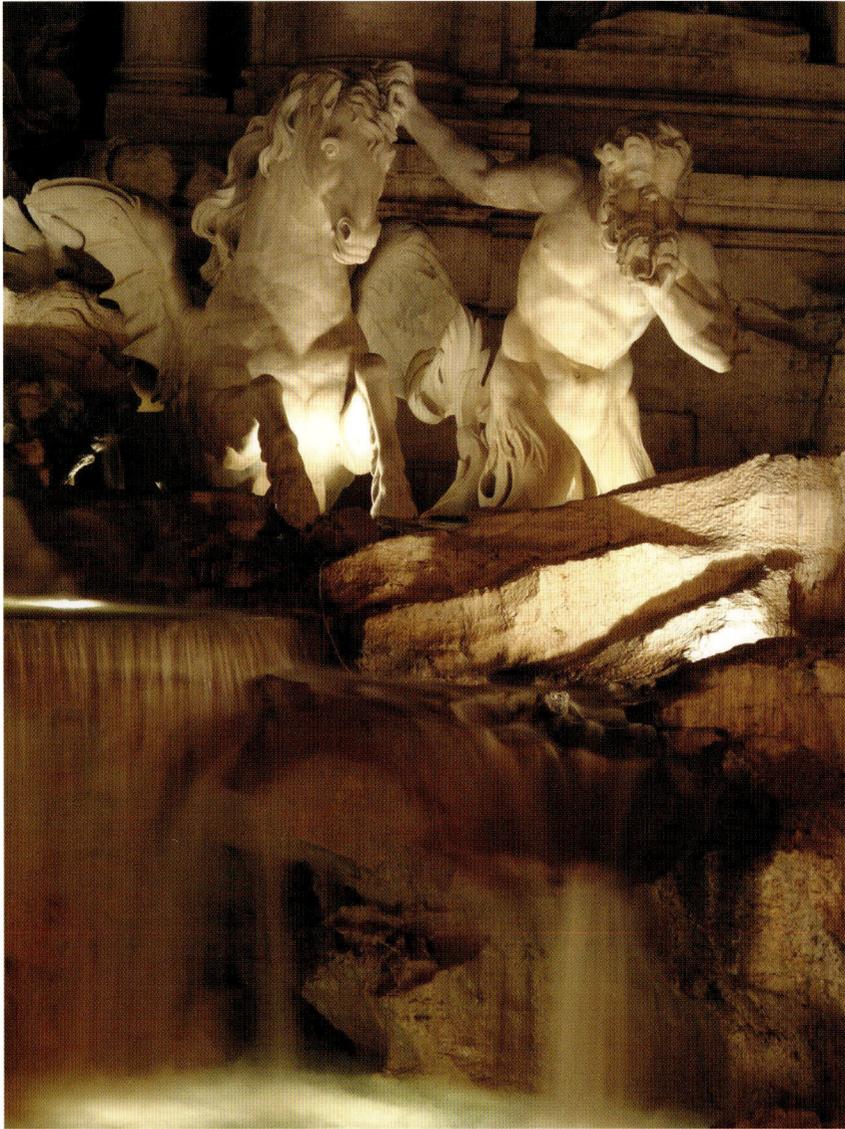
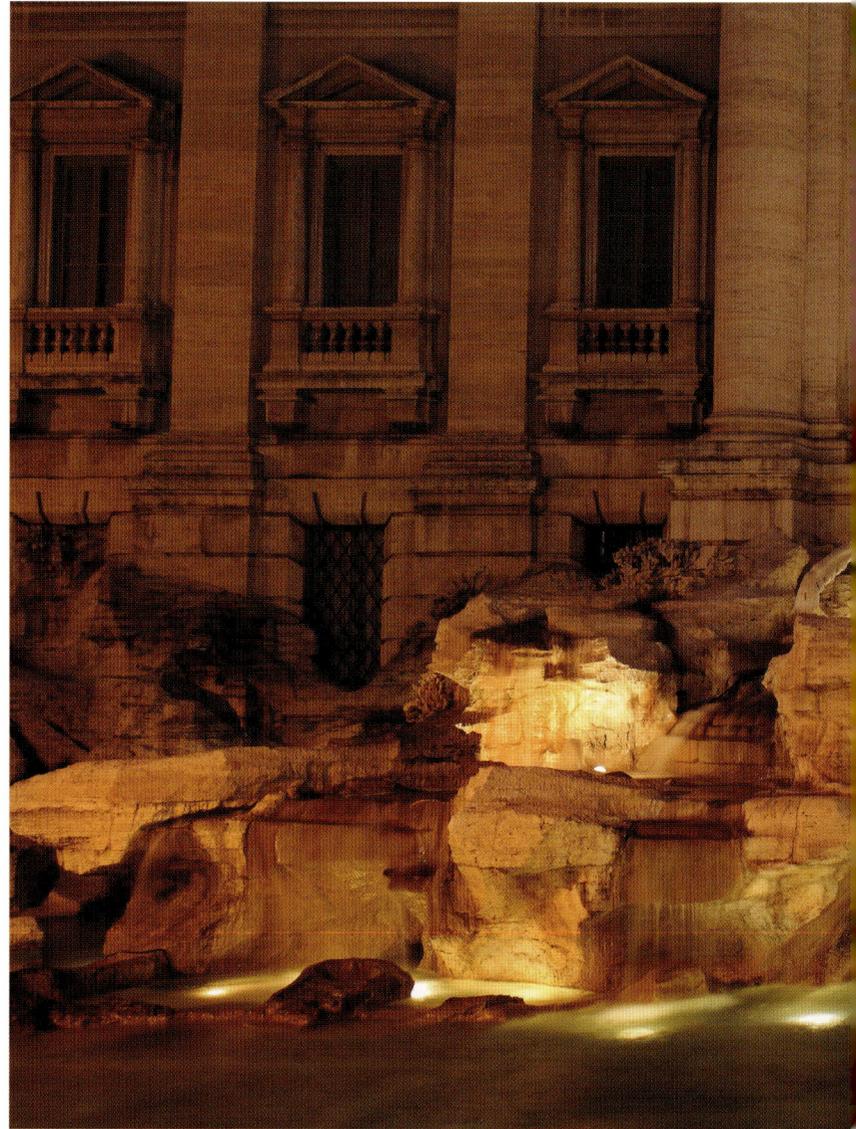

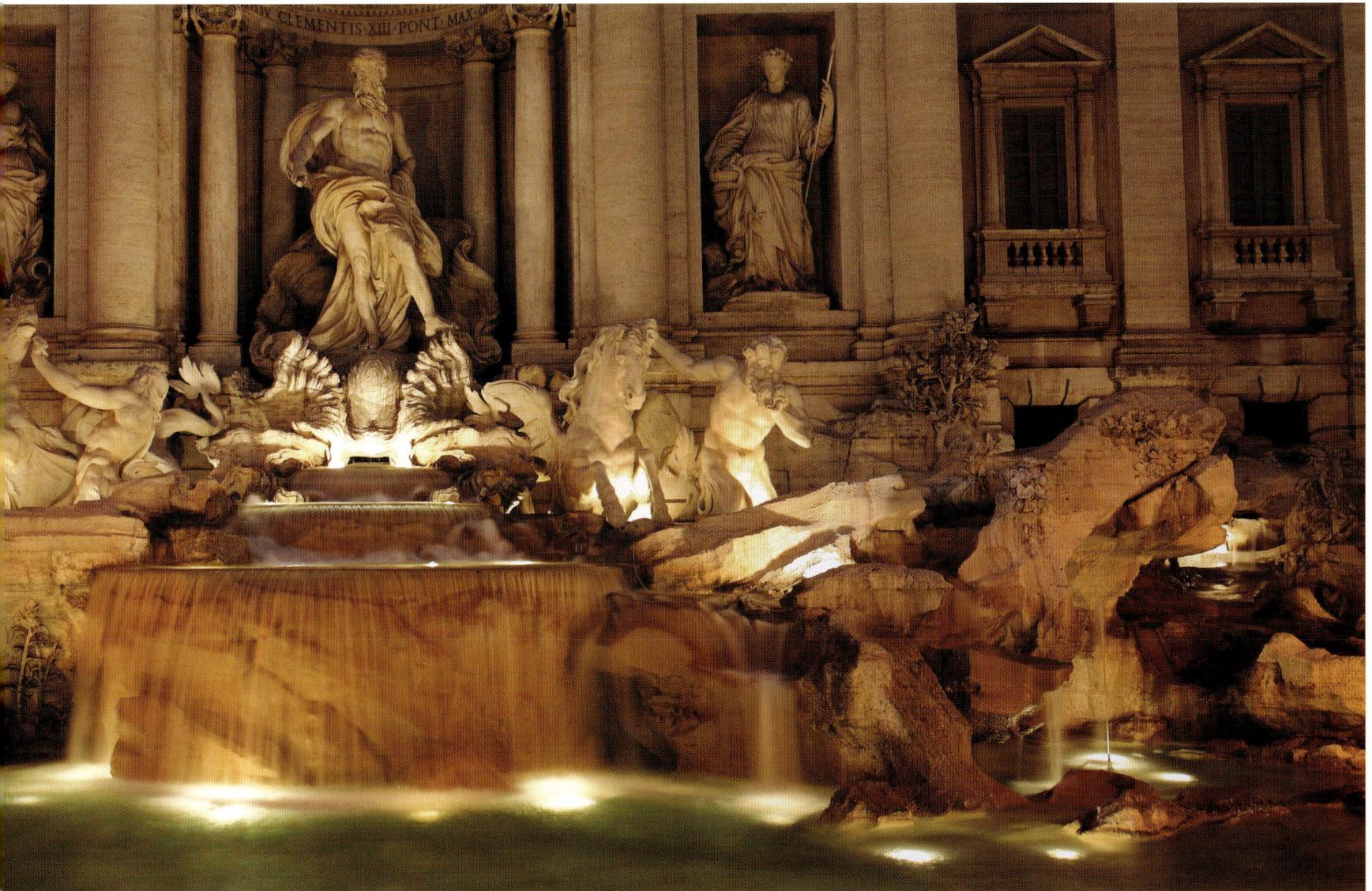

Down each avenue or via, street or strata
You can see'em disappearing two by two
On an evening in Roma
Do they take'em for espresso
Yeah, I guess so
On each lover's arm a girl I wish I knew
On an evening in Roma

"An Evening in Roma" by Dean Martin

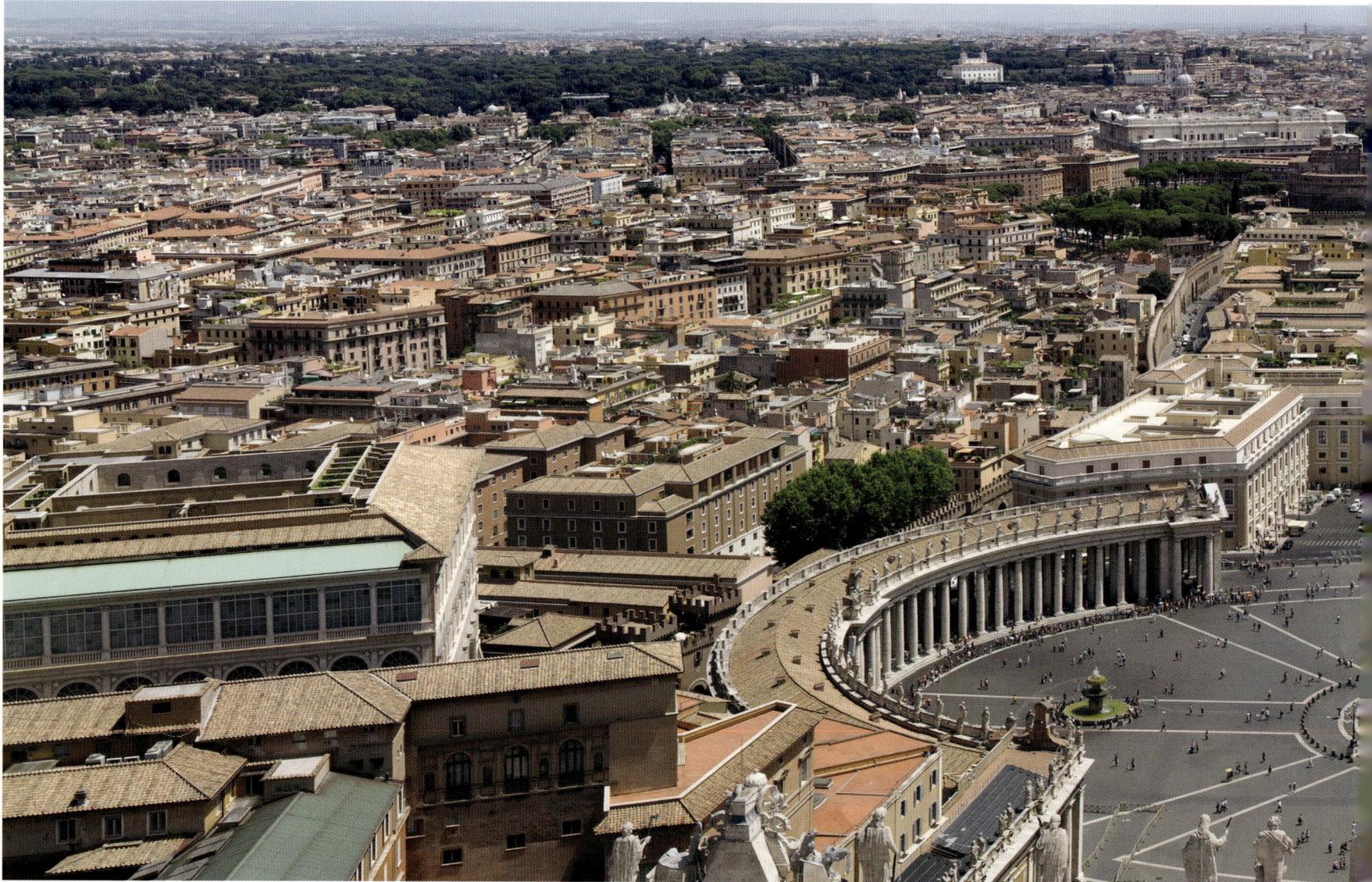

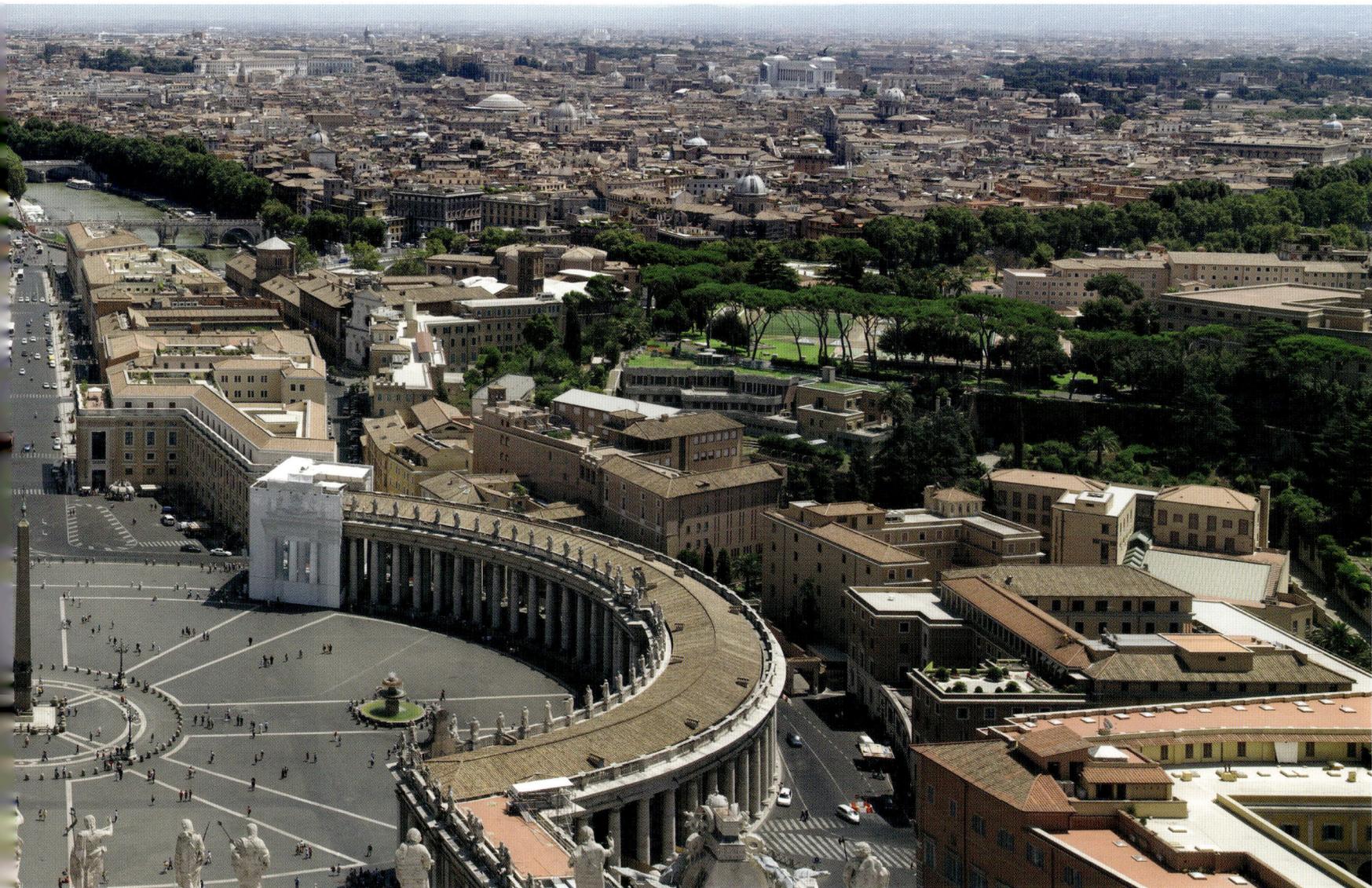

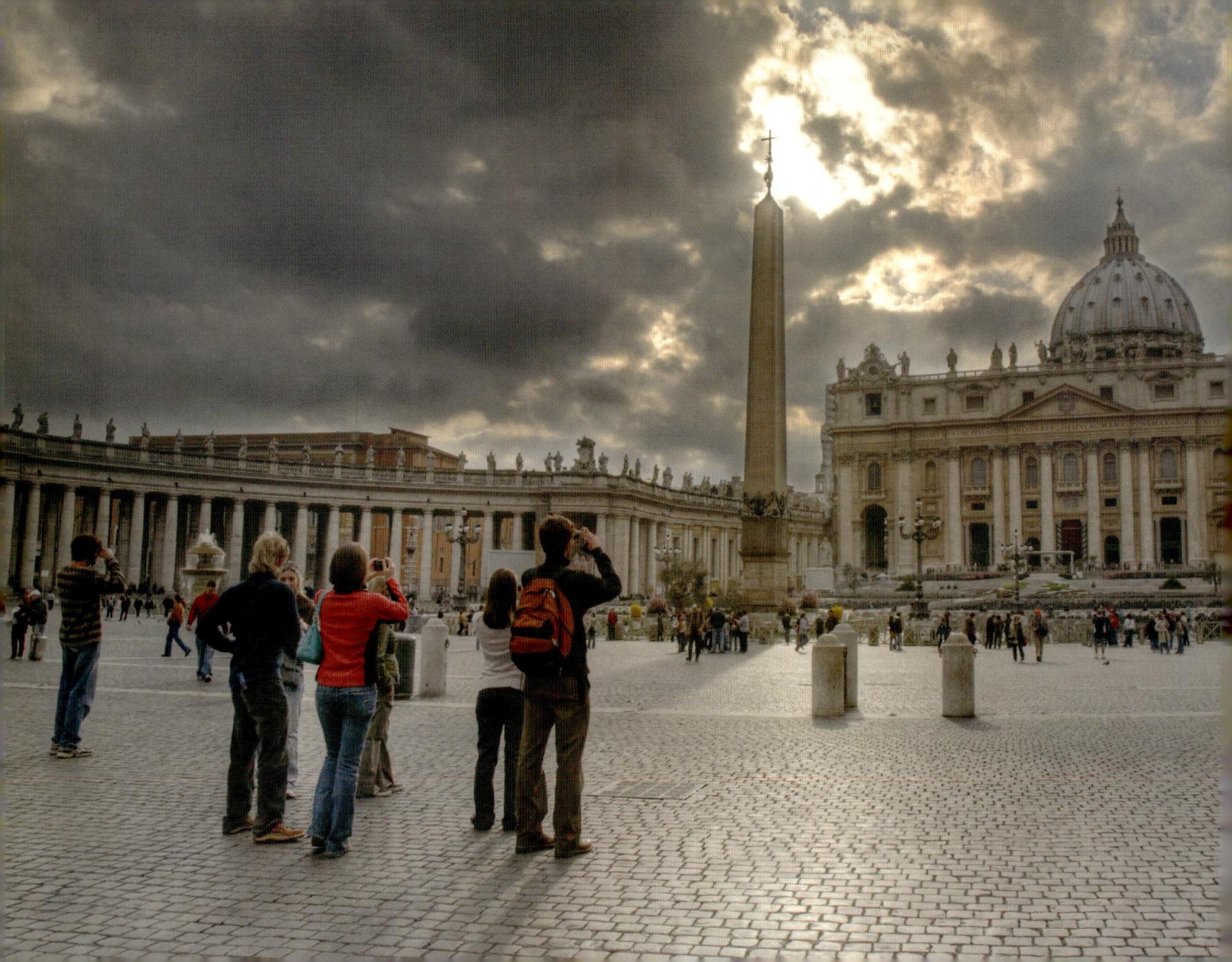

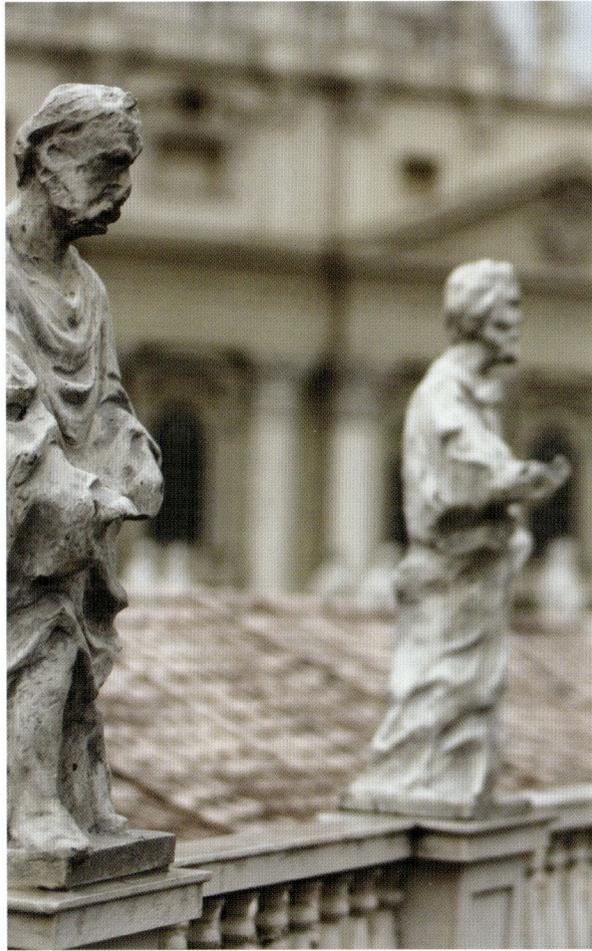

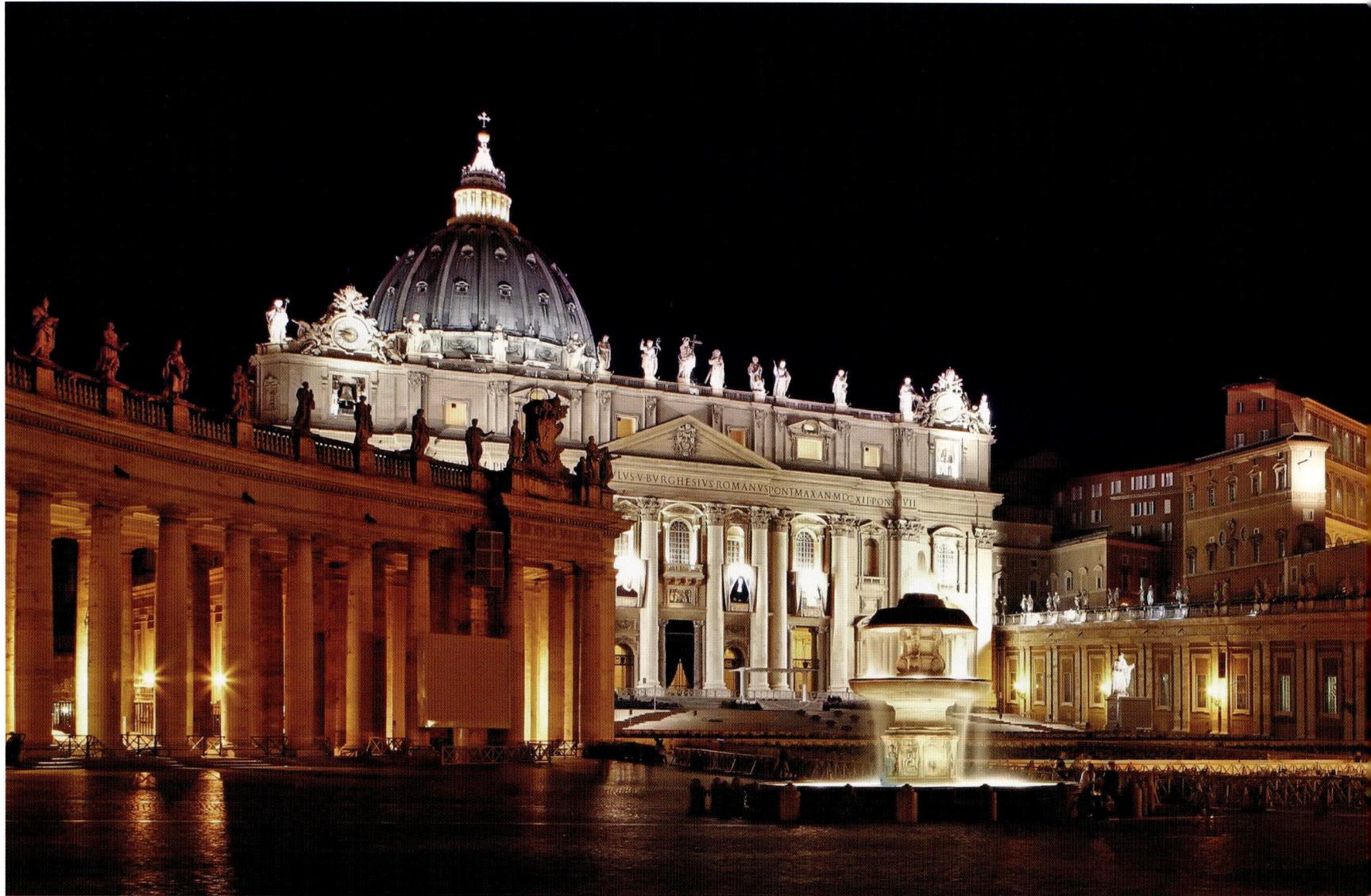

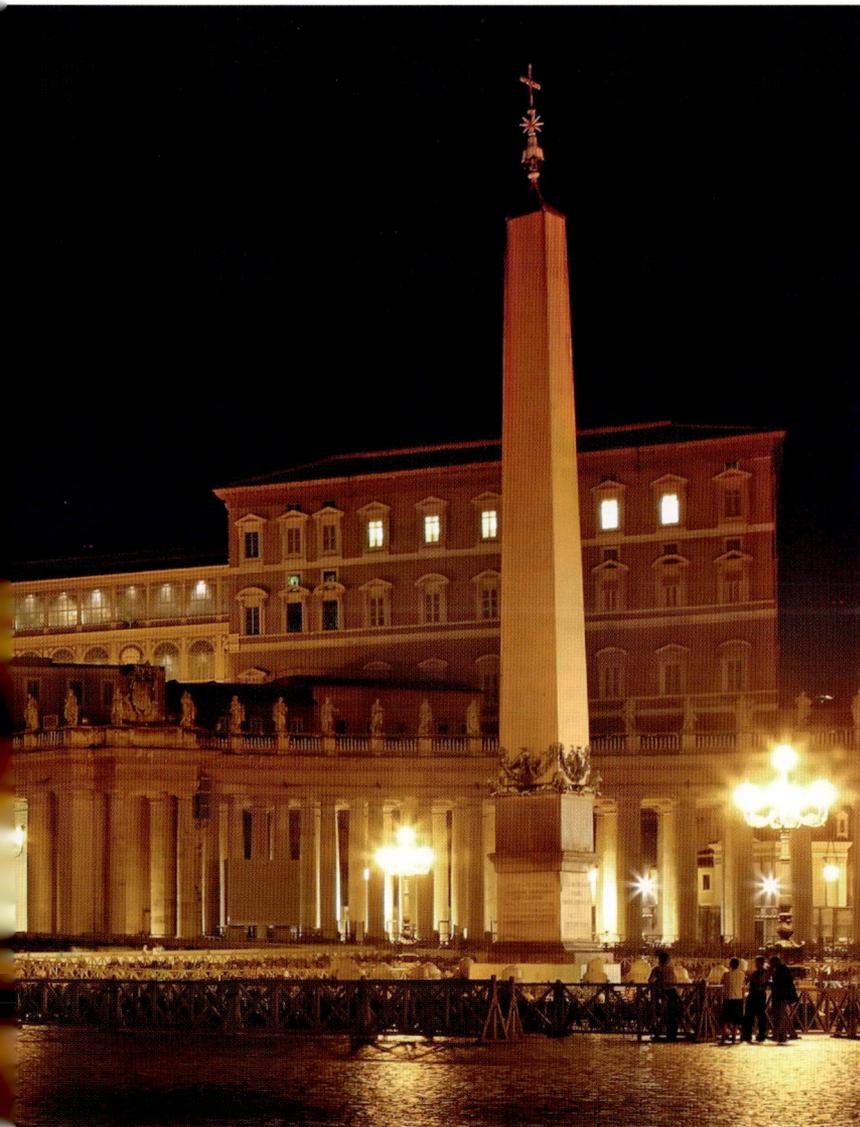

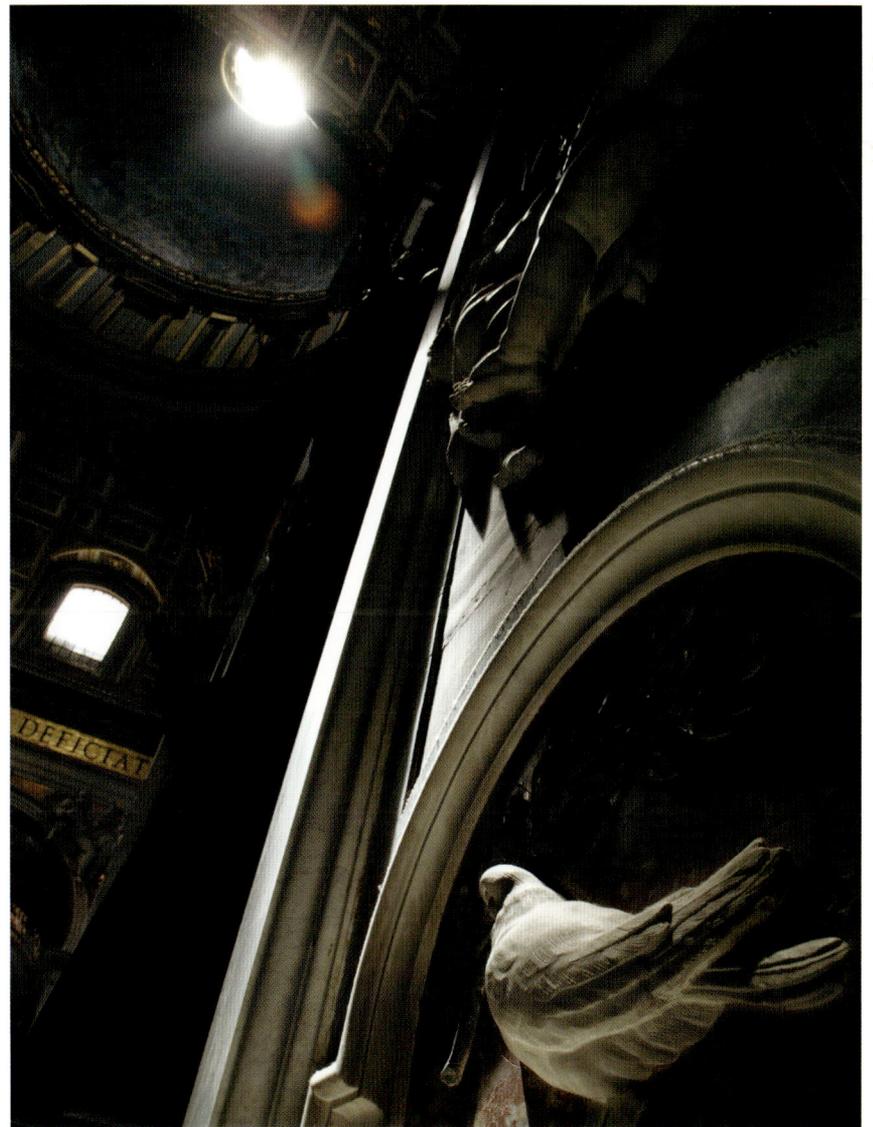

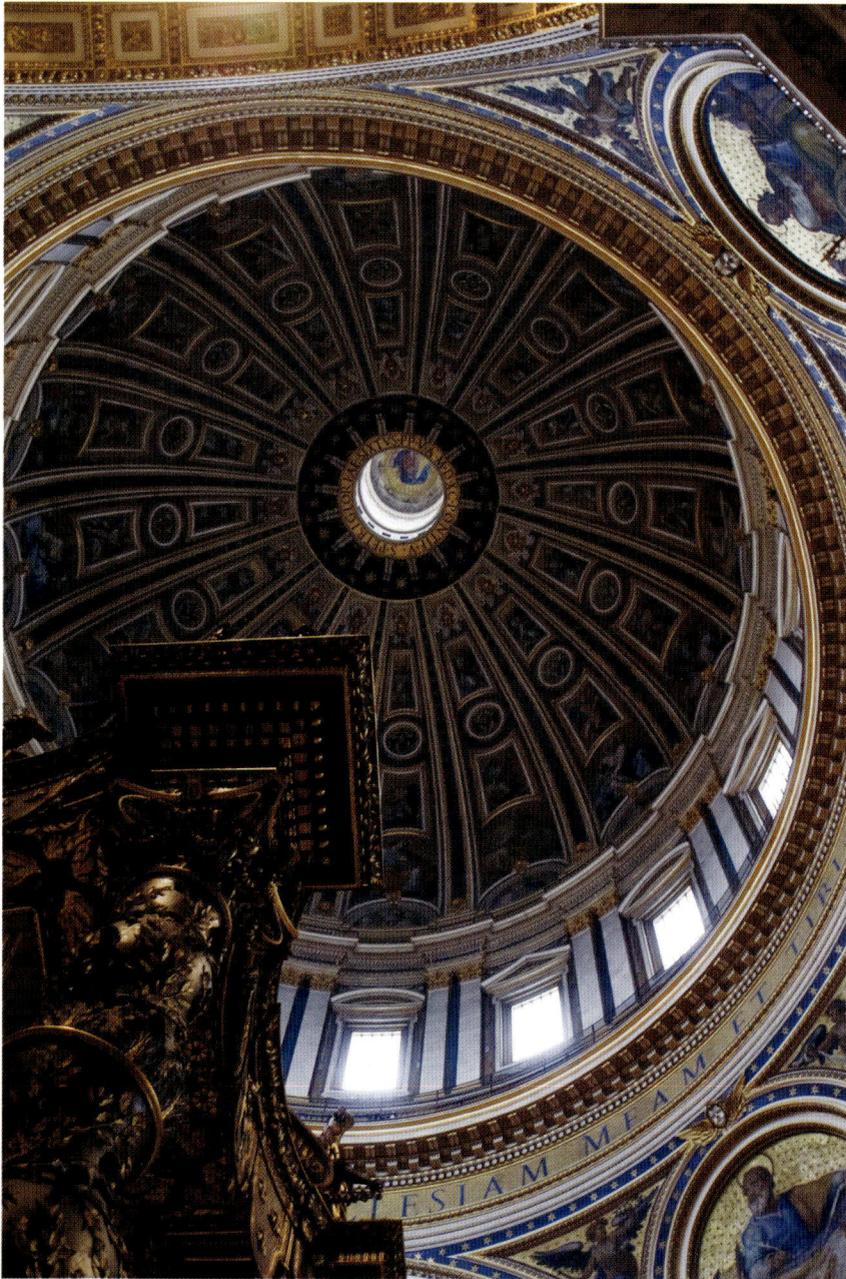
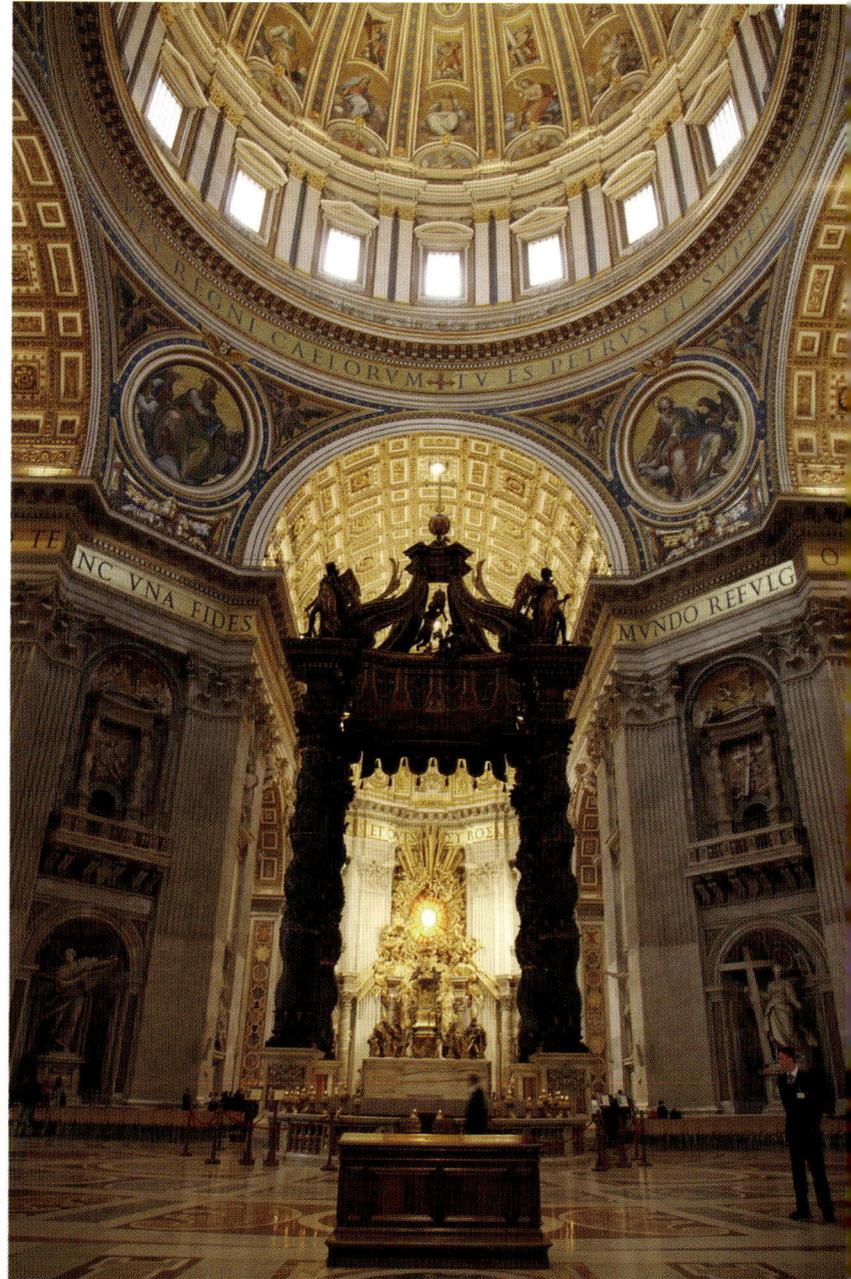

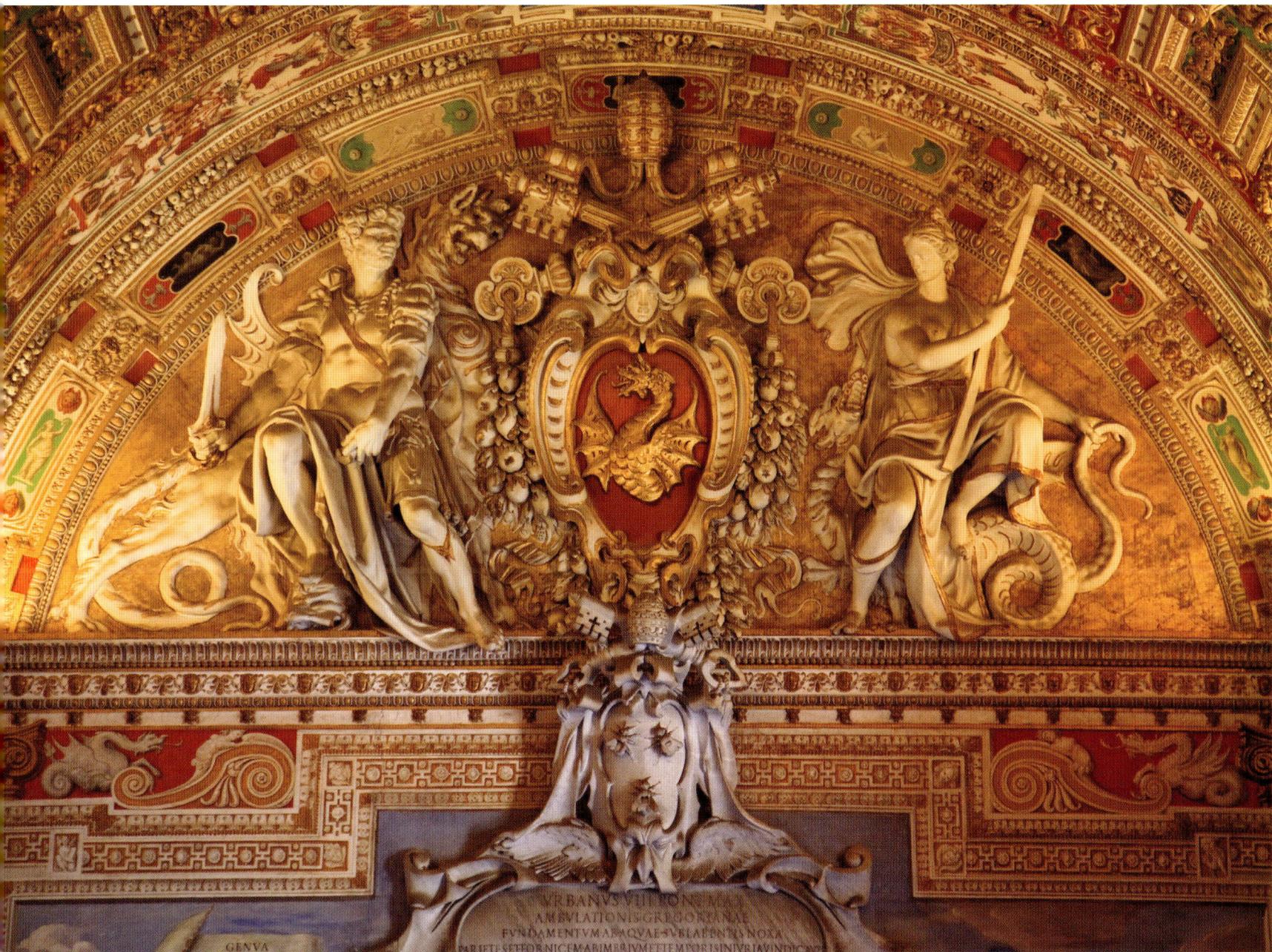

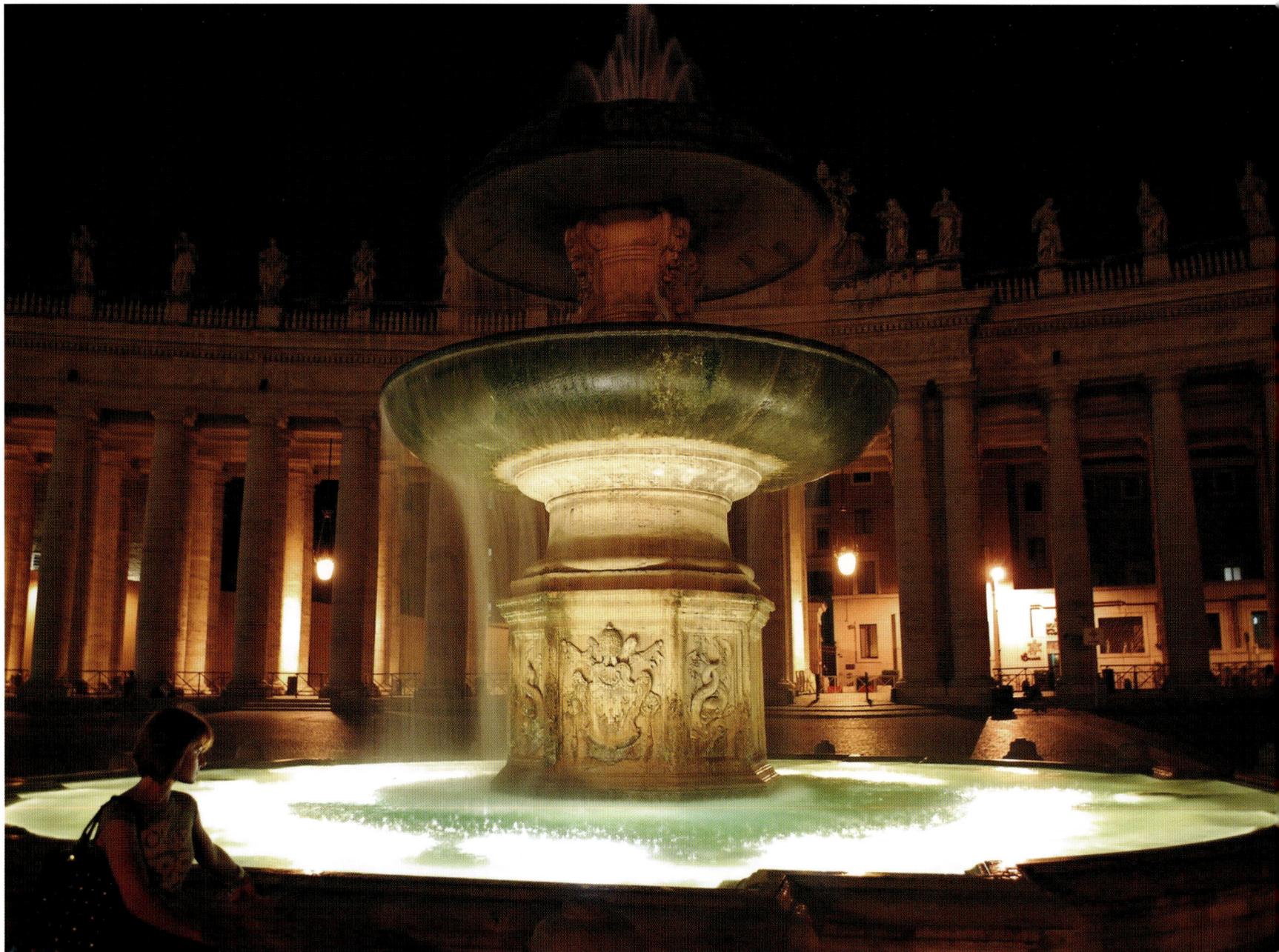

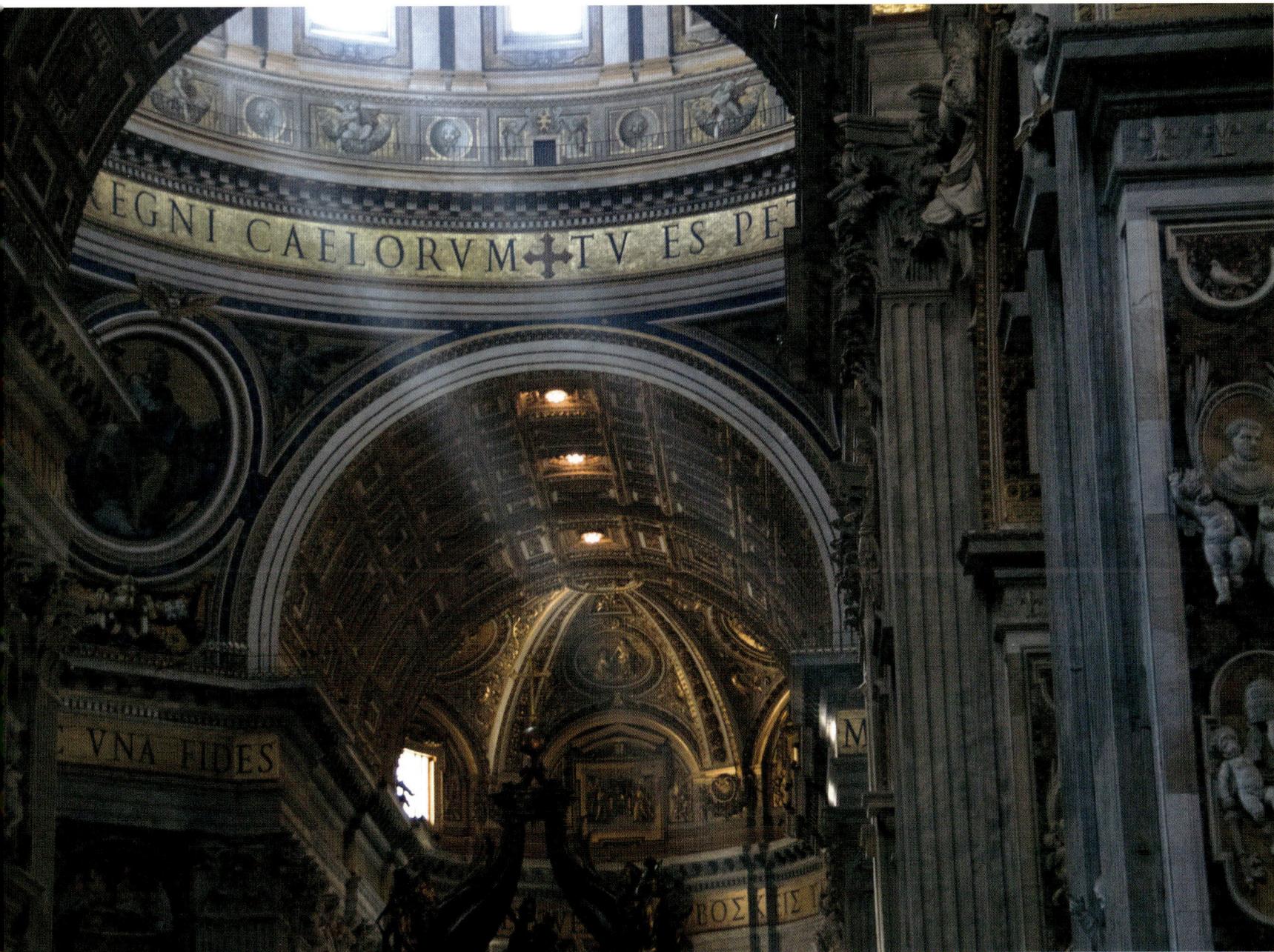

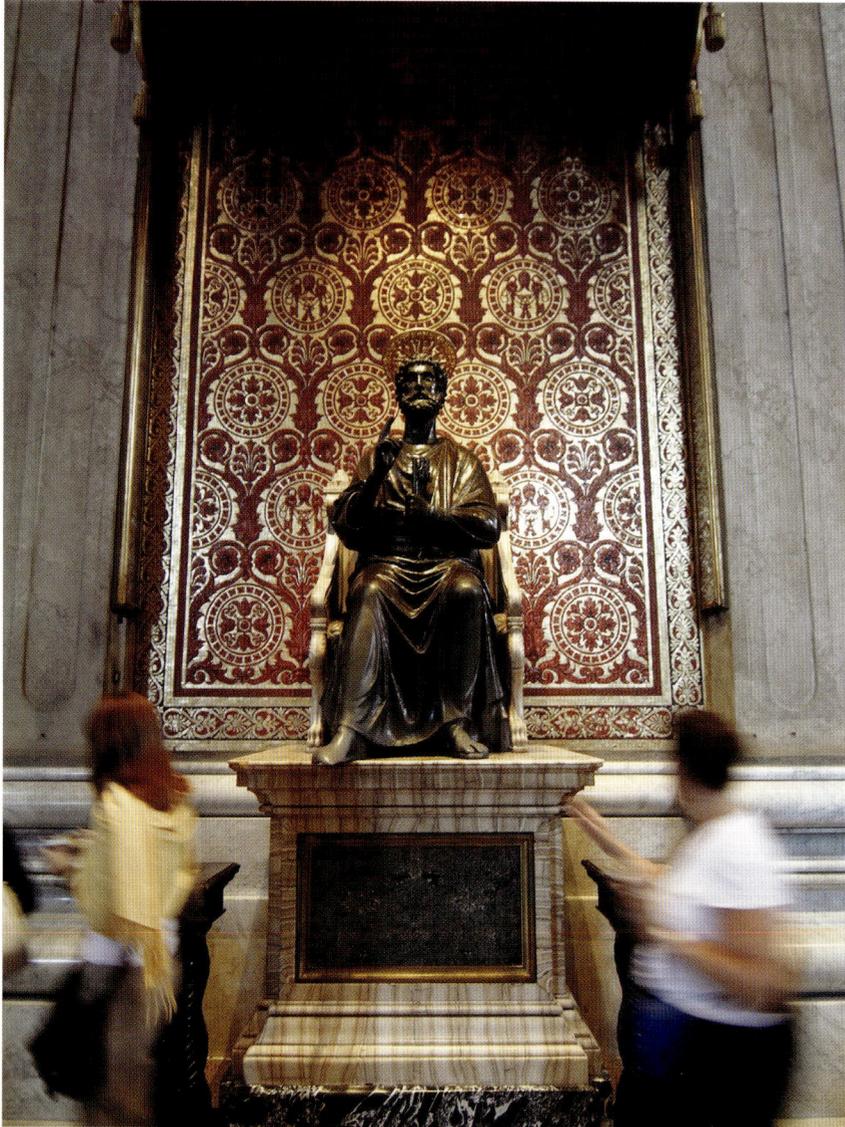

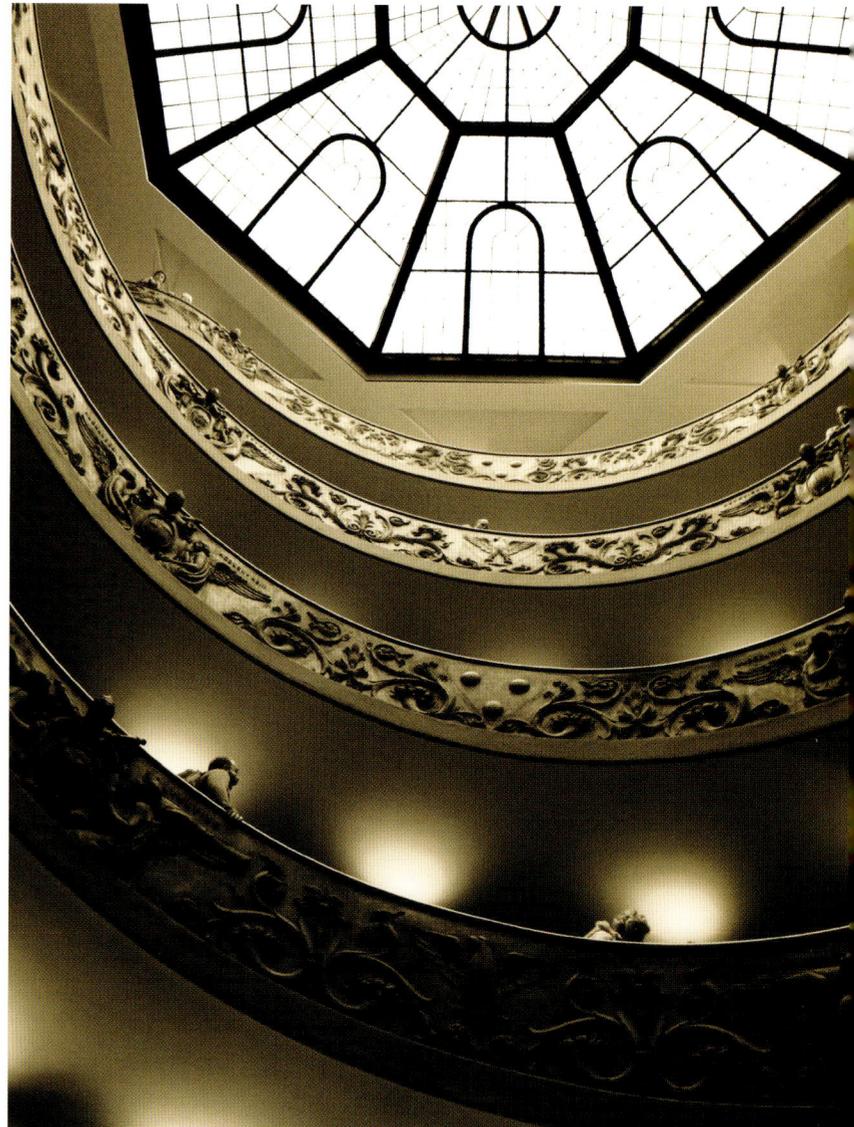

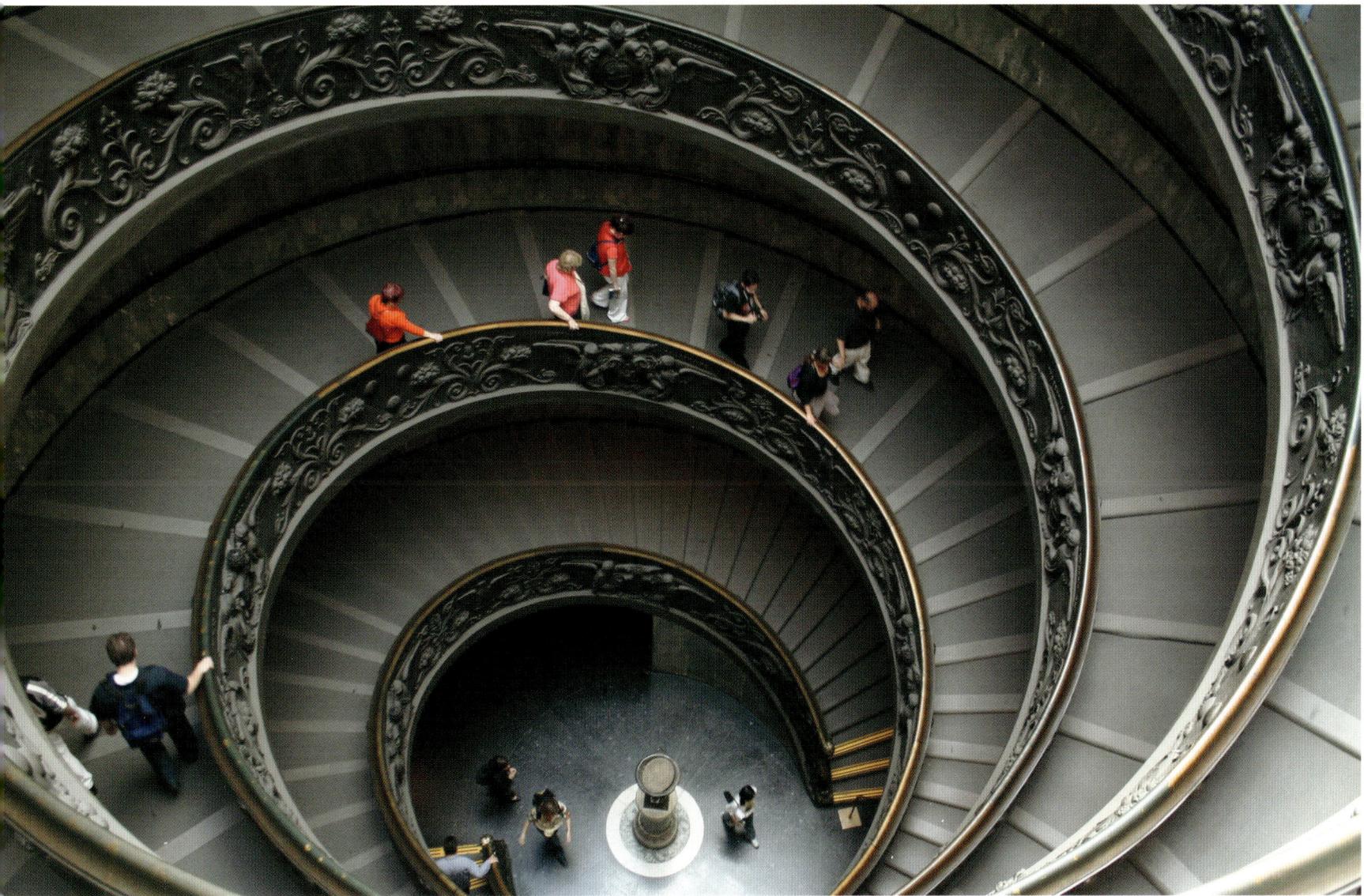

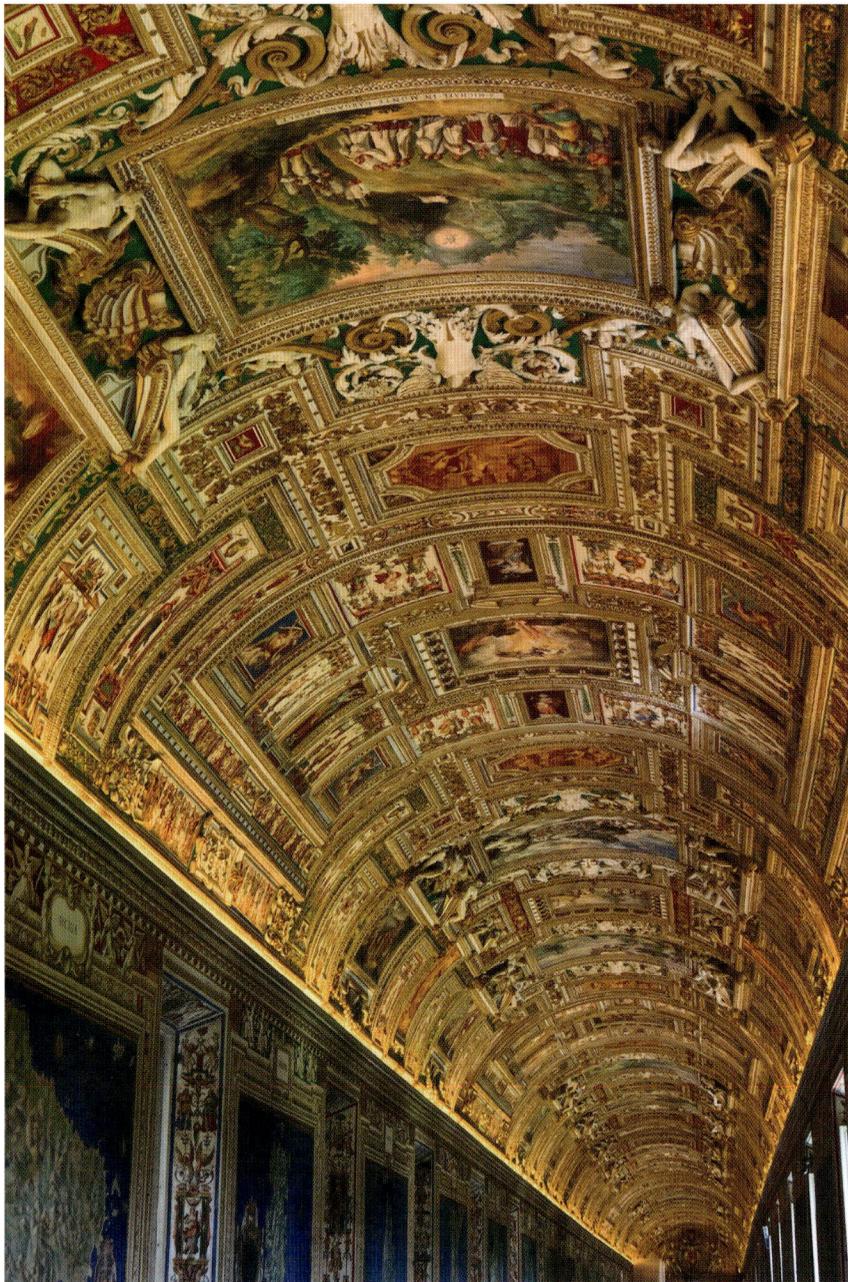

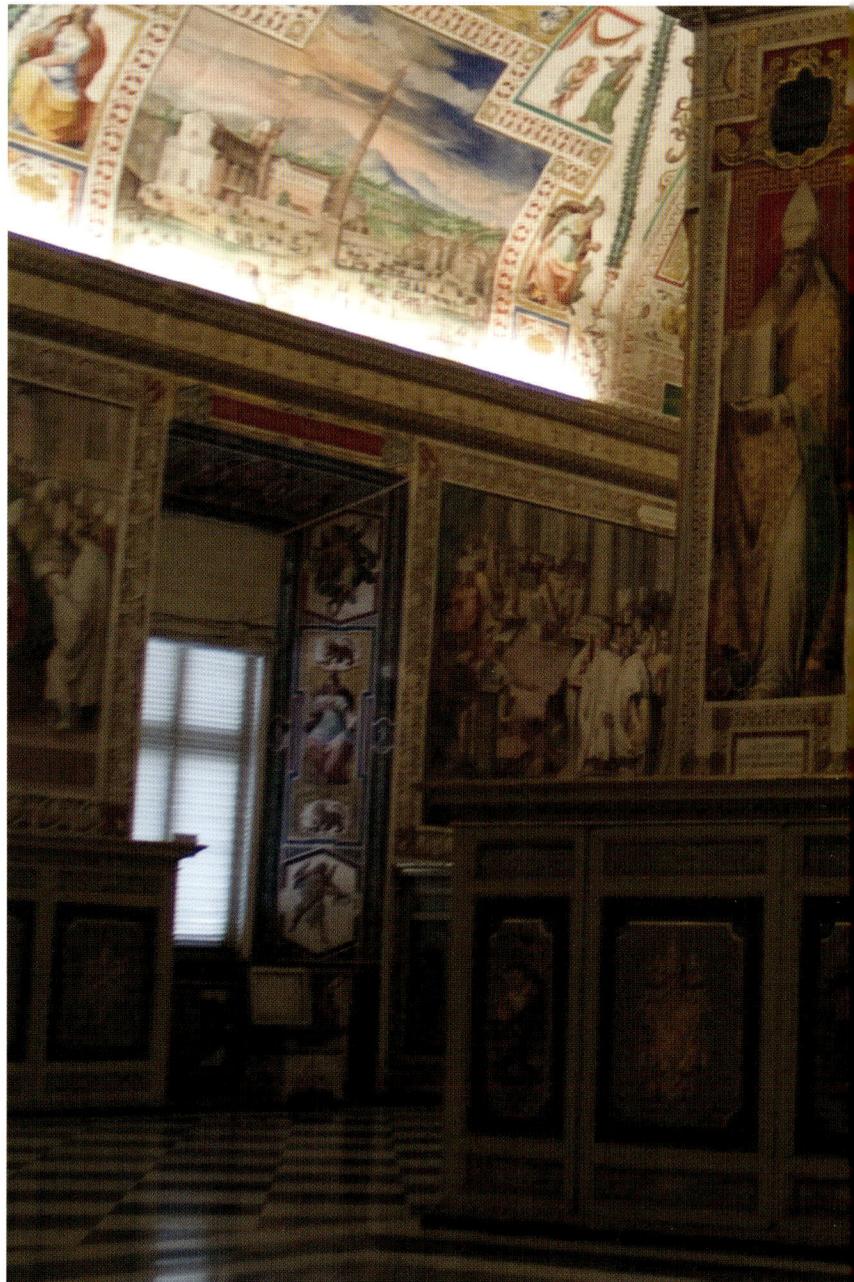

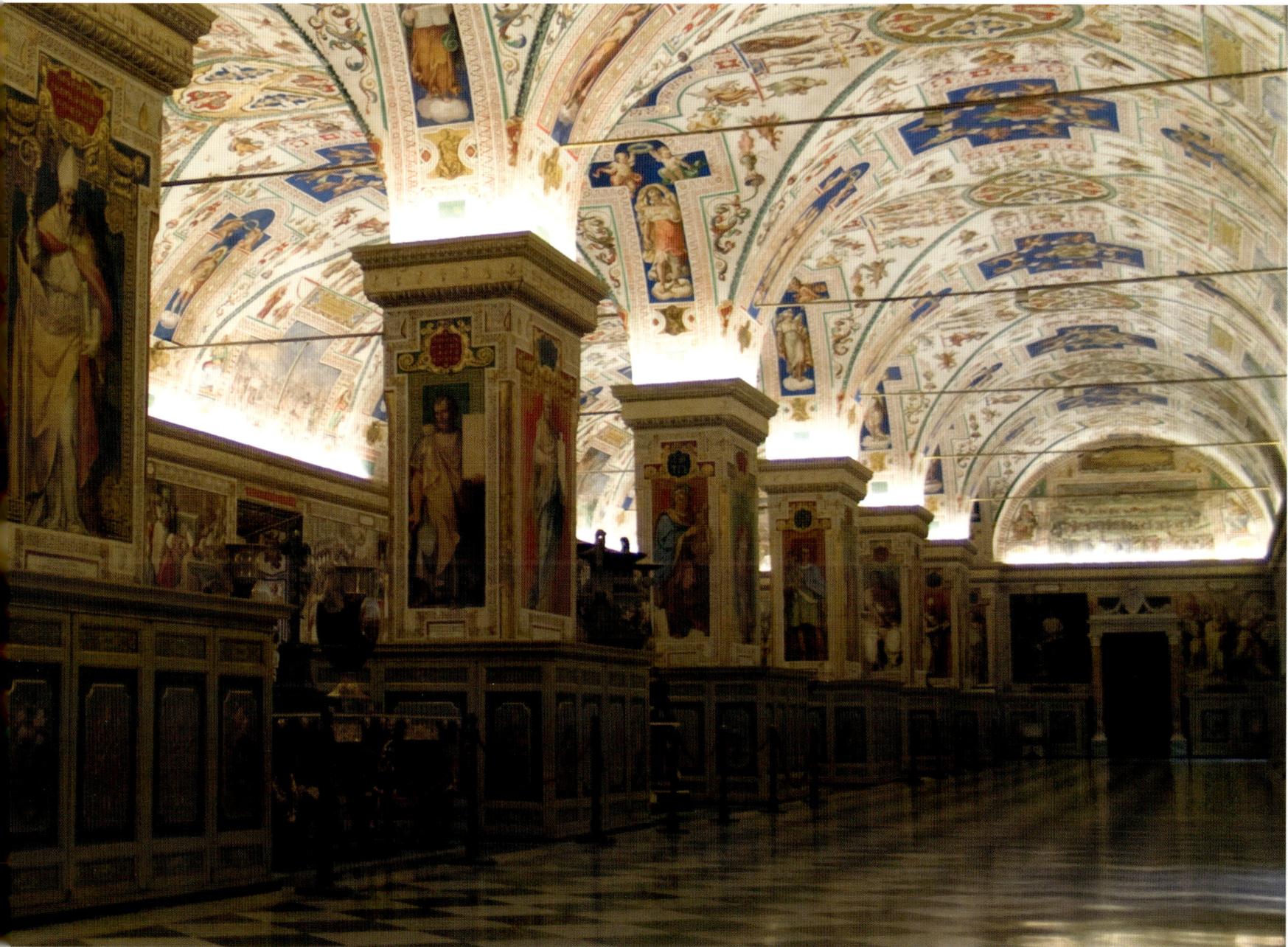

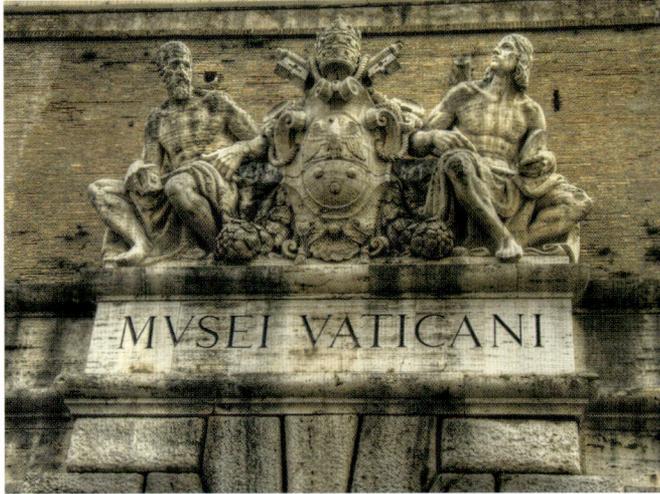
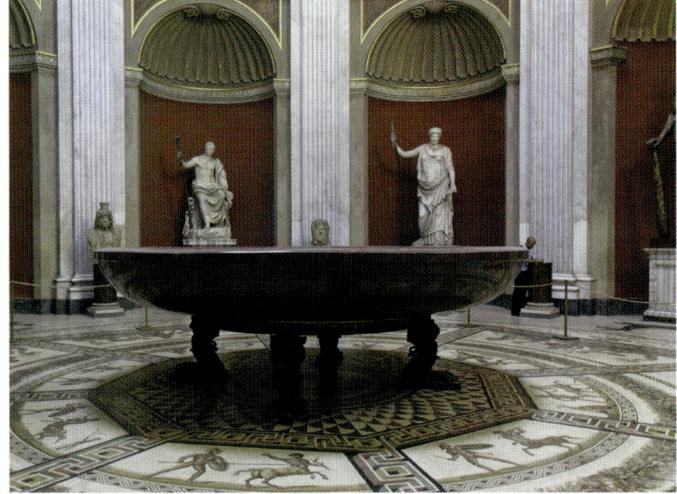
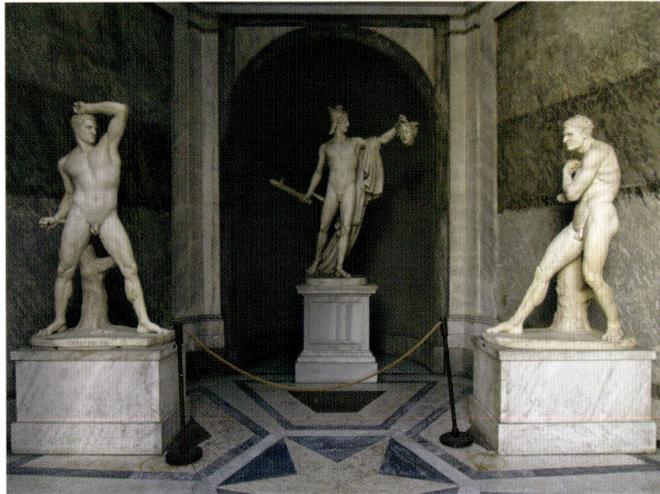
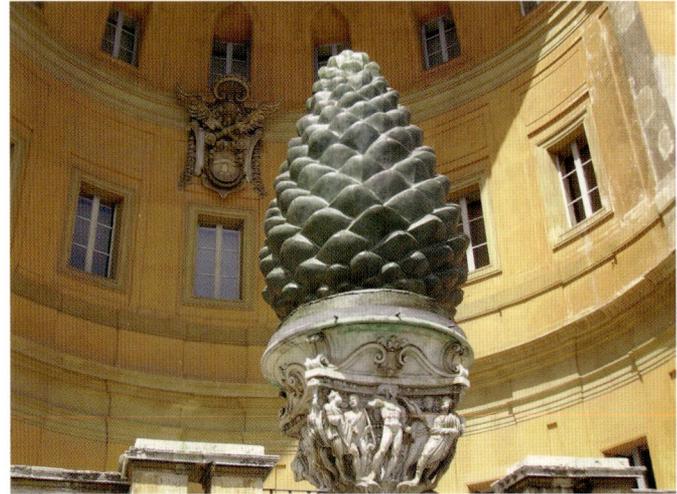

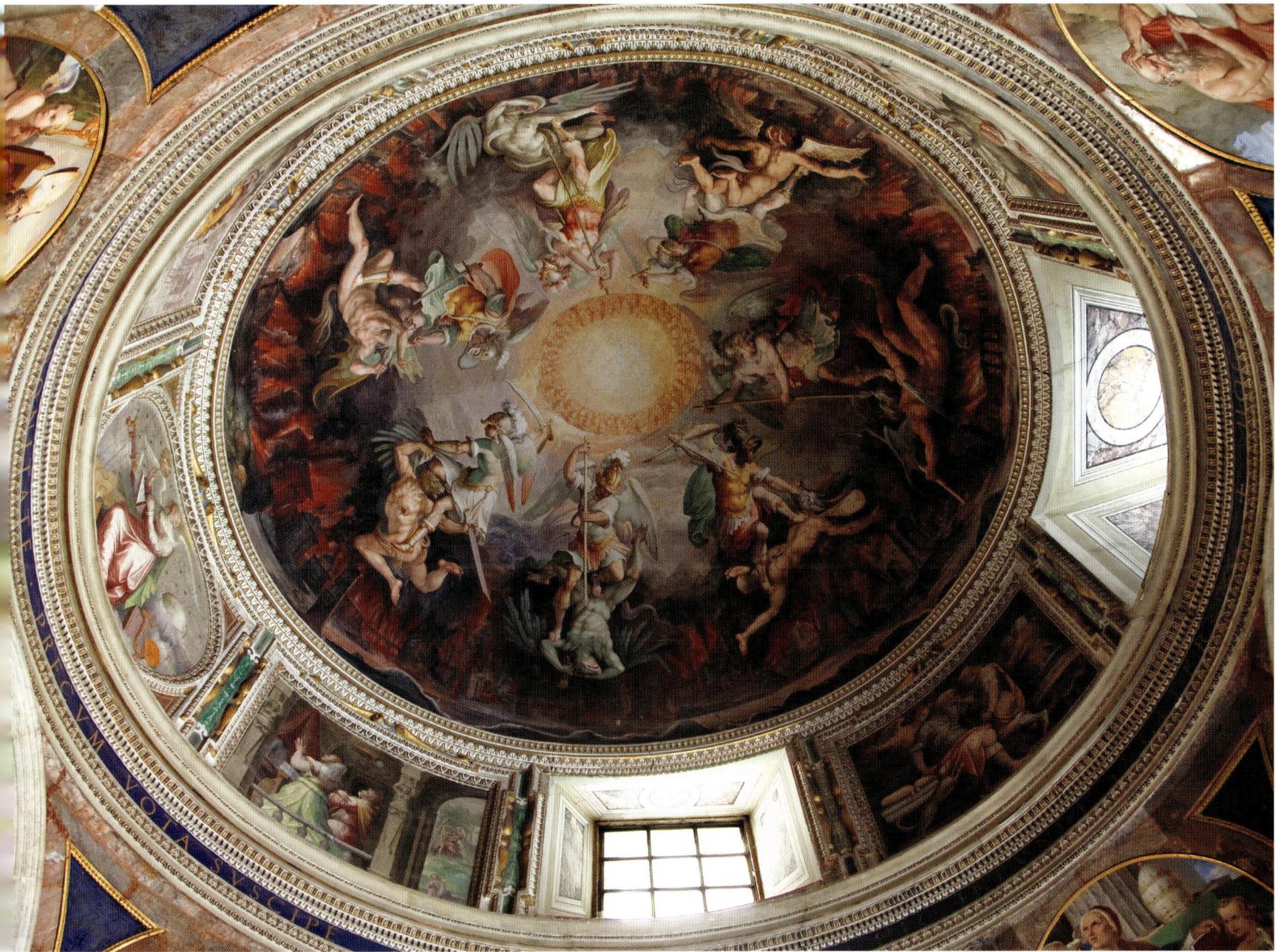

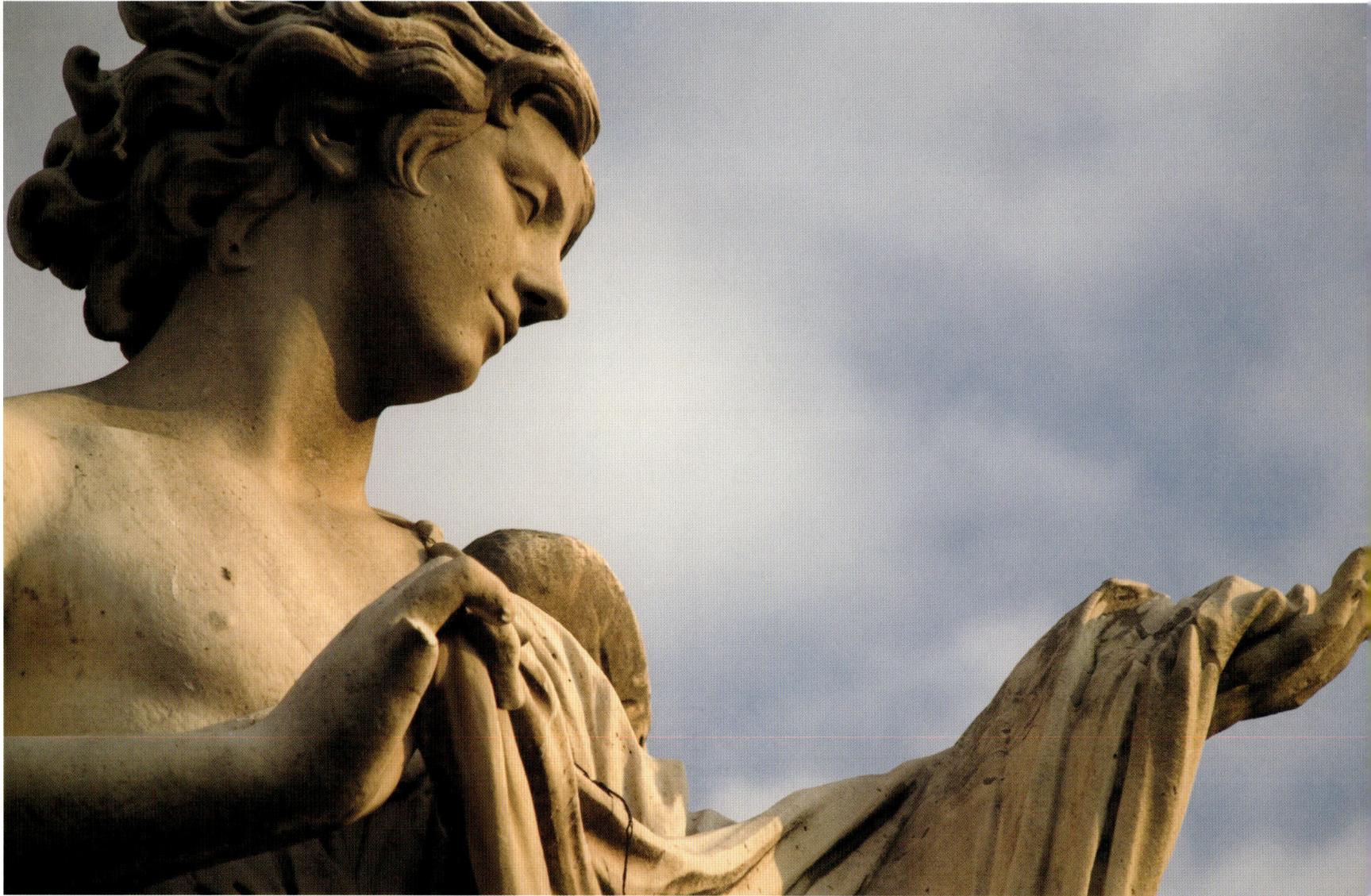

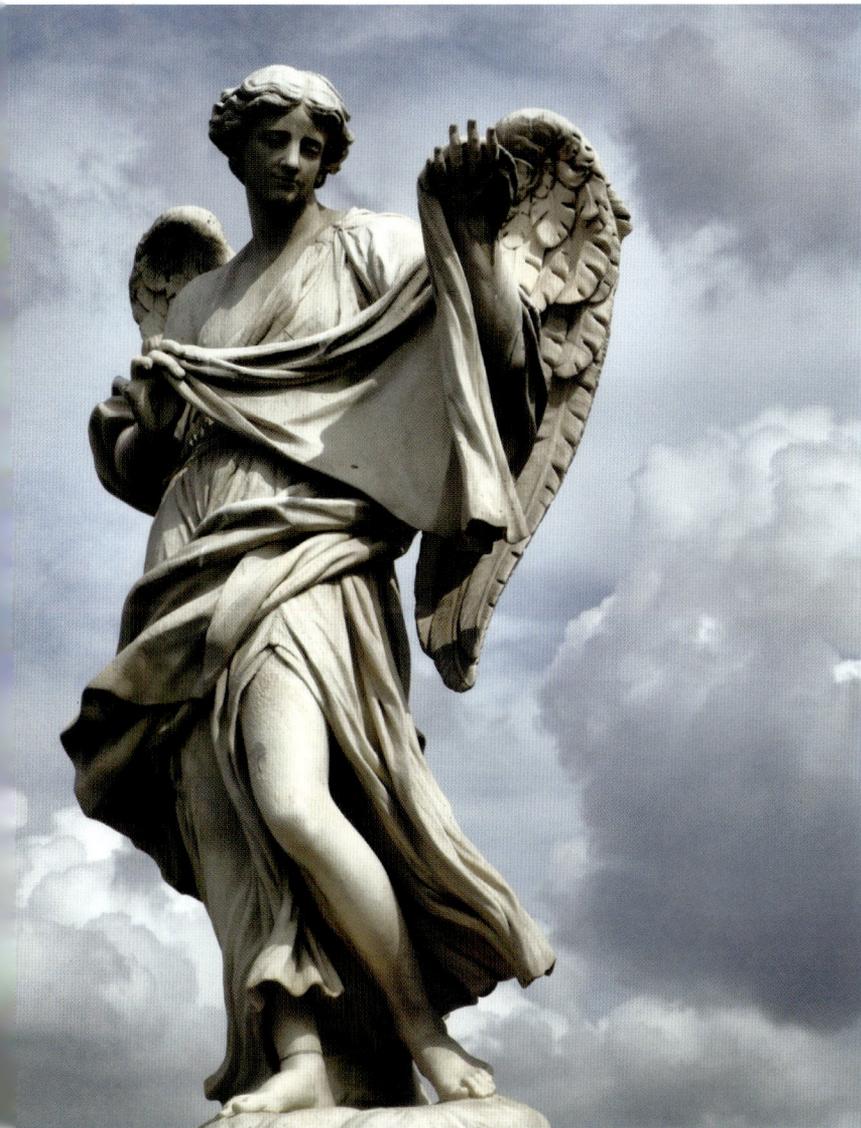
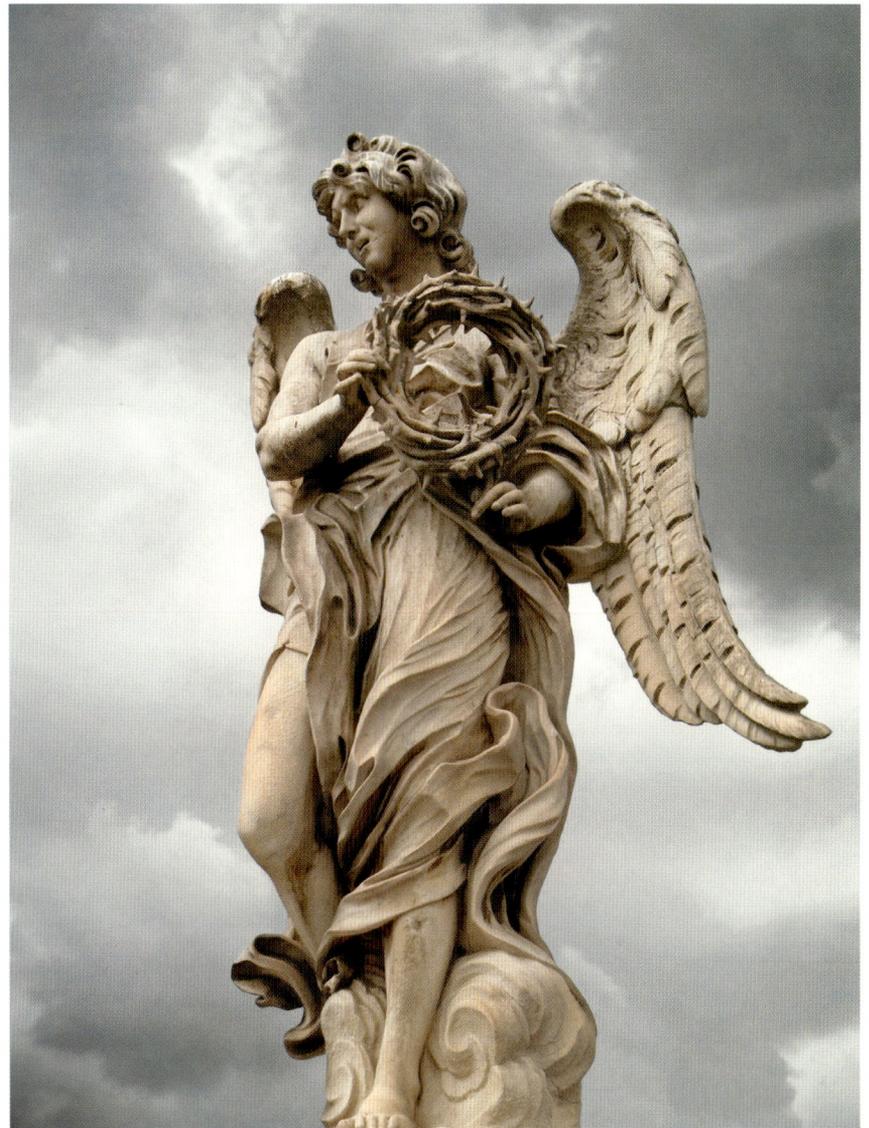

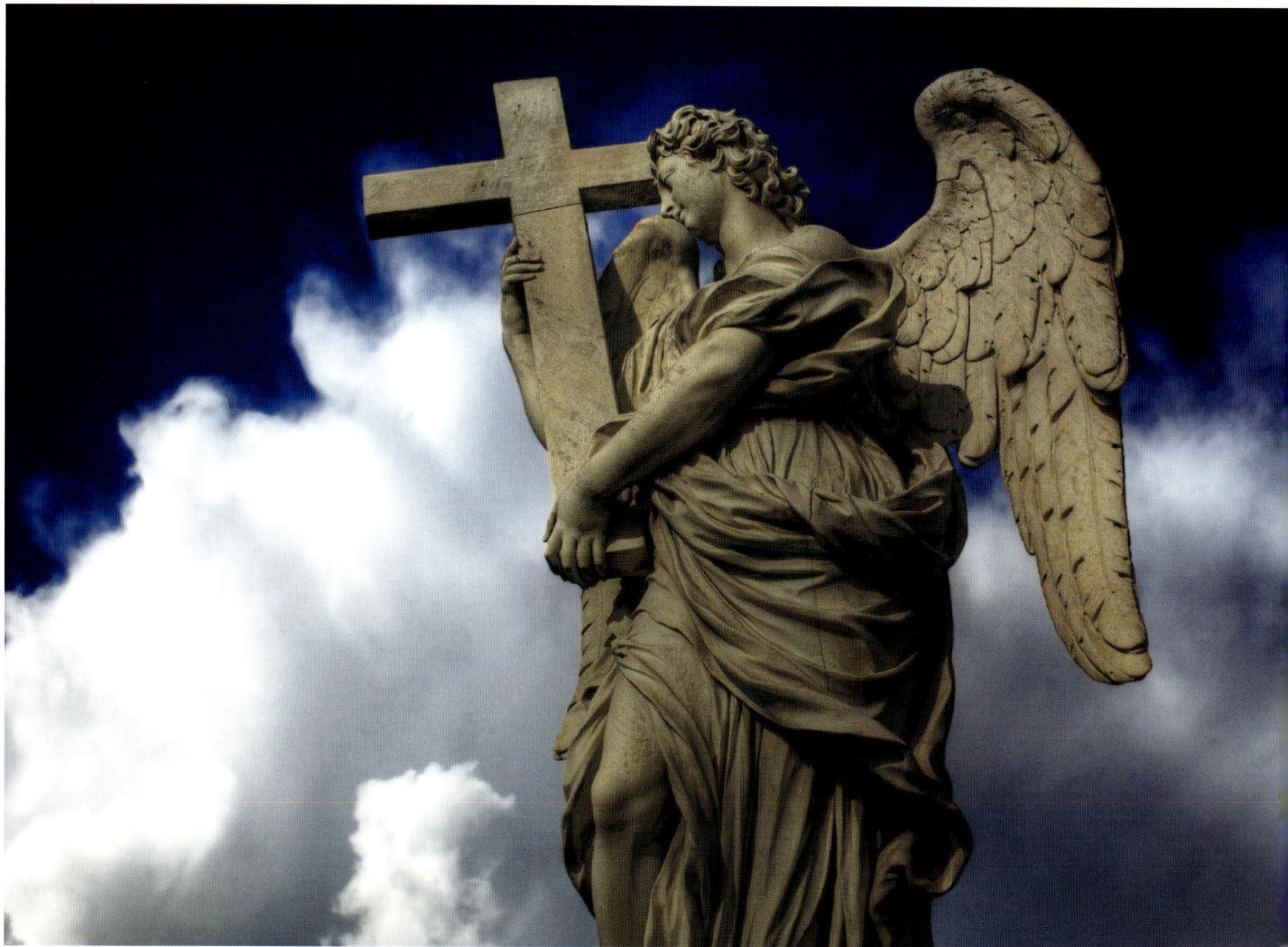

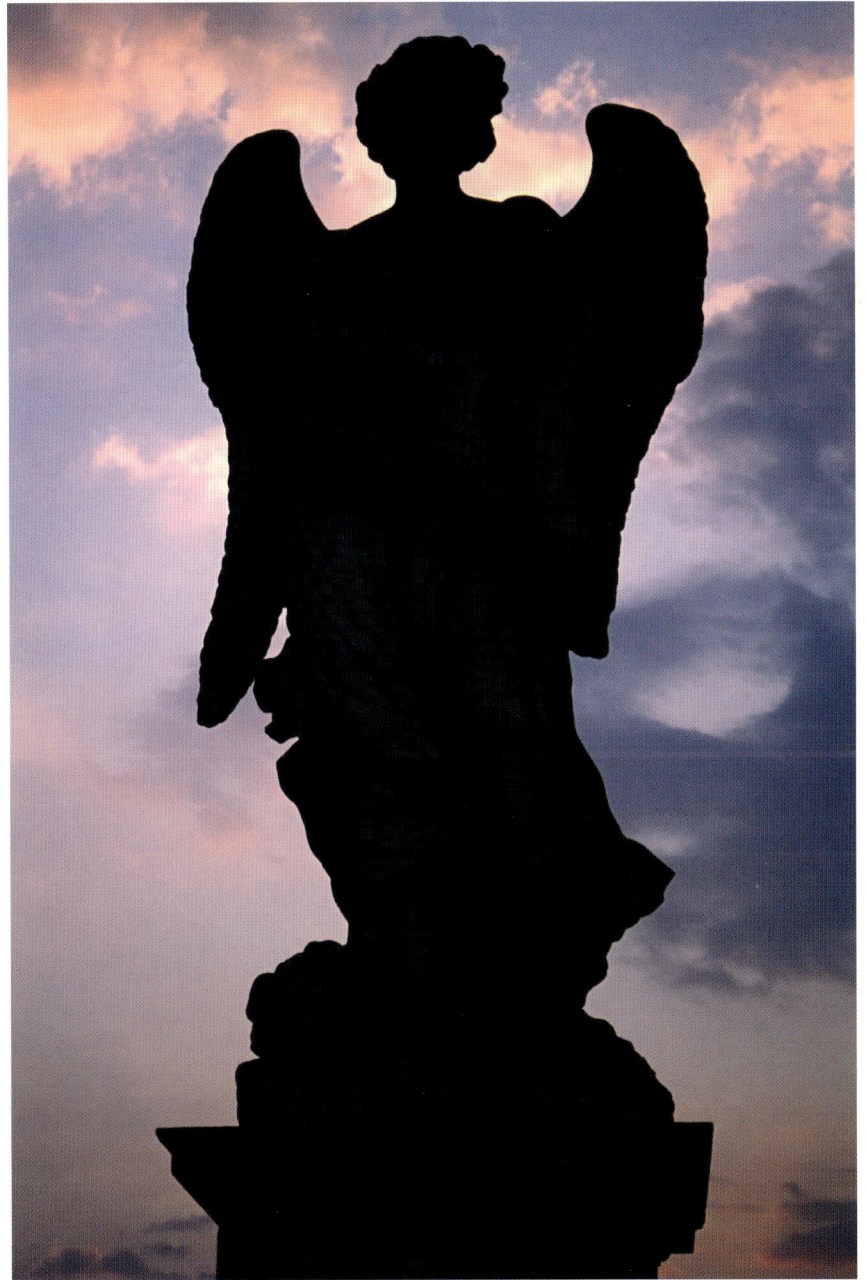

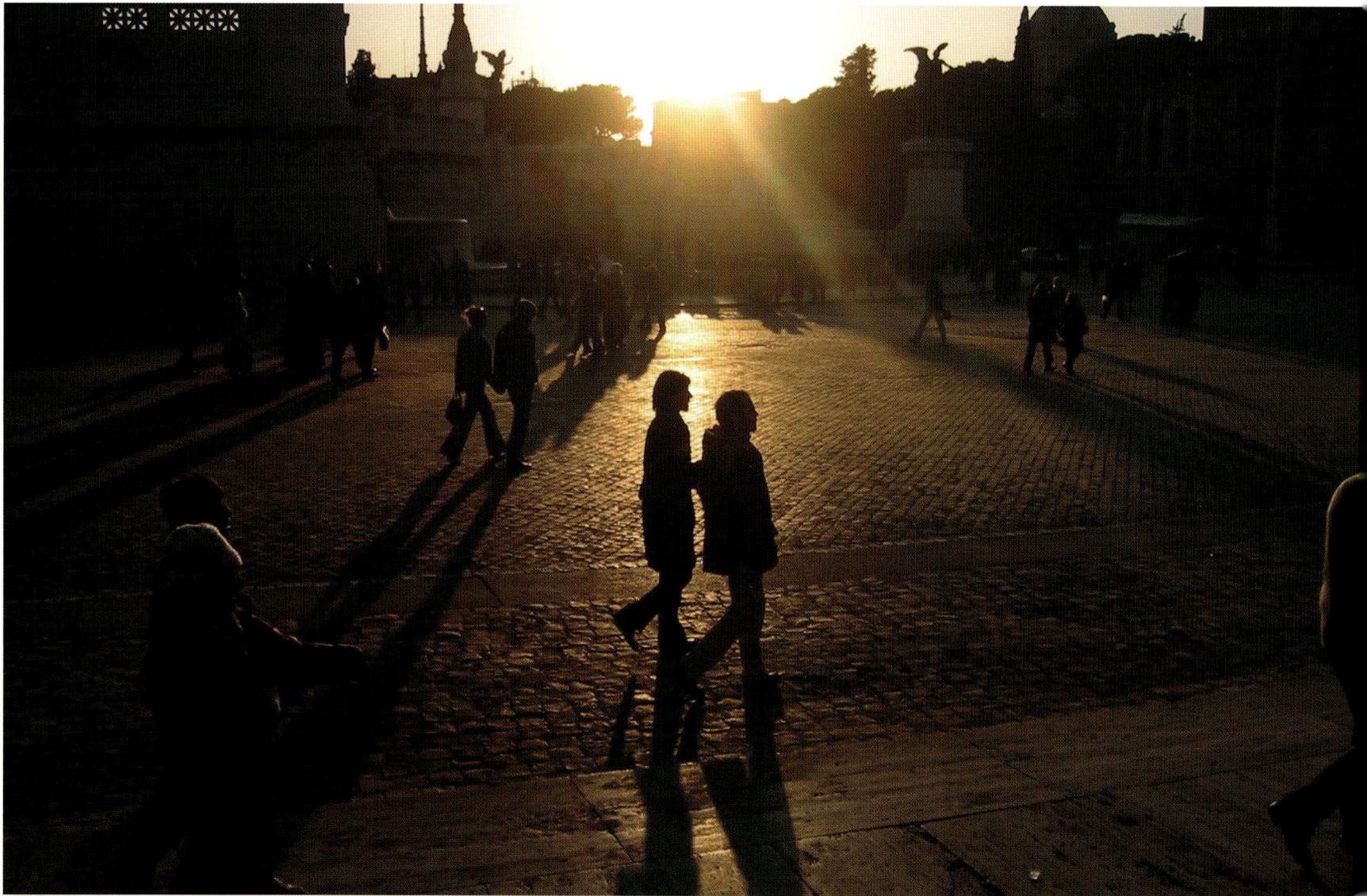

Sunset

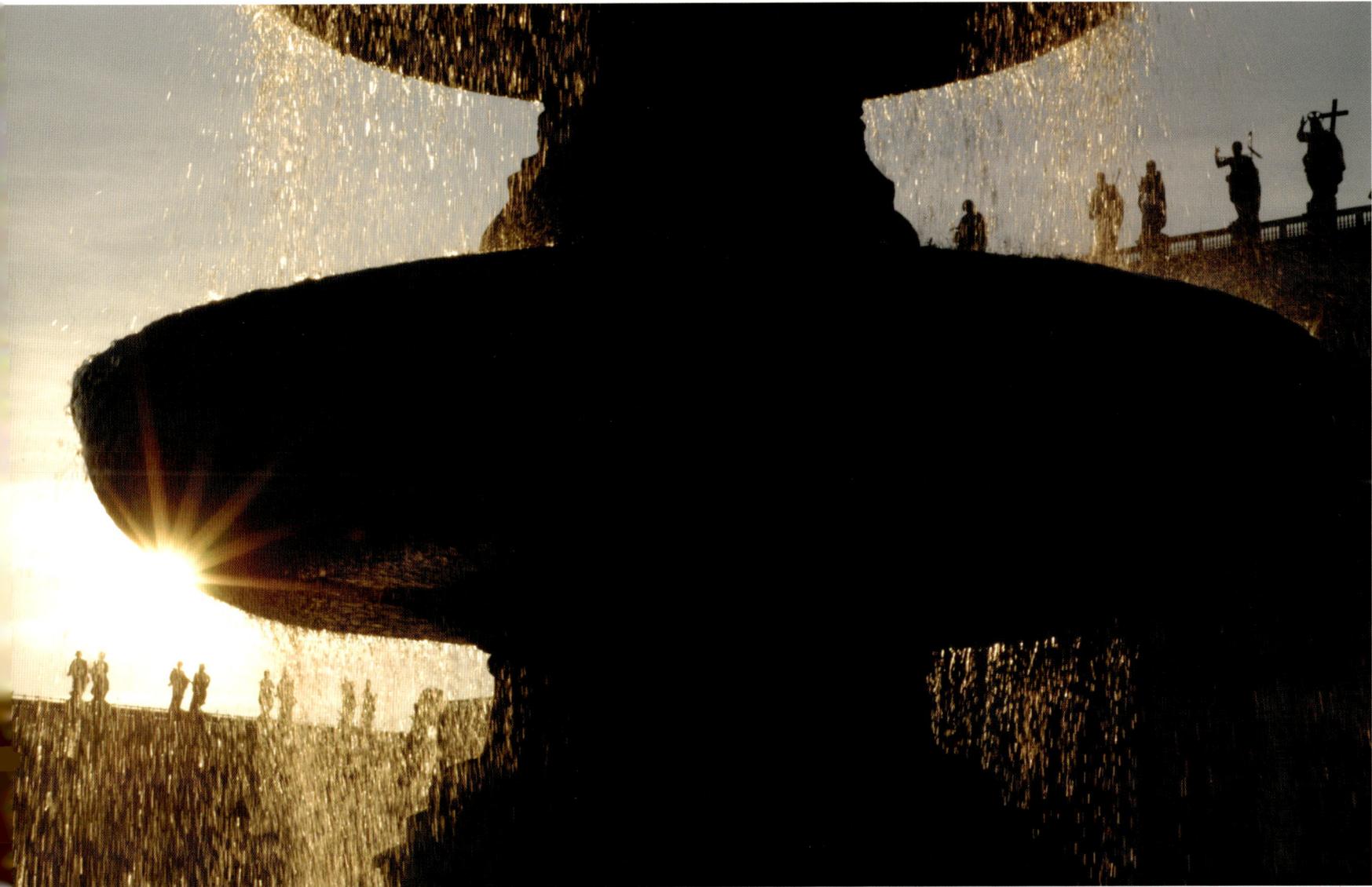

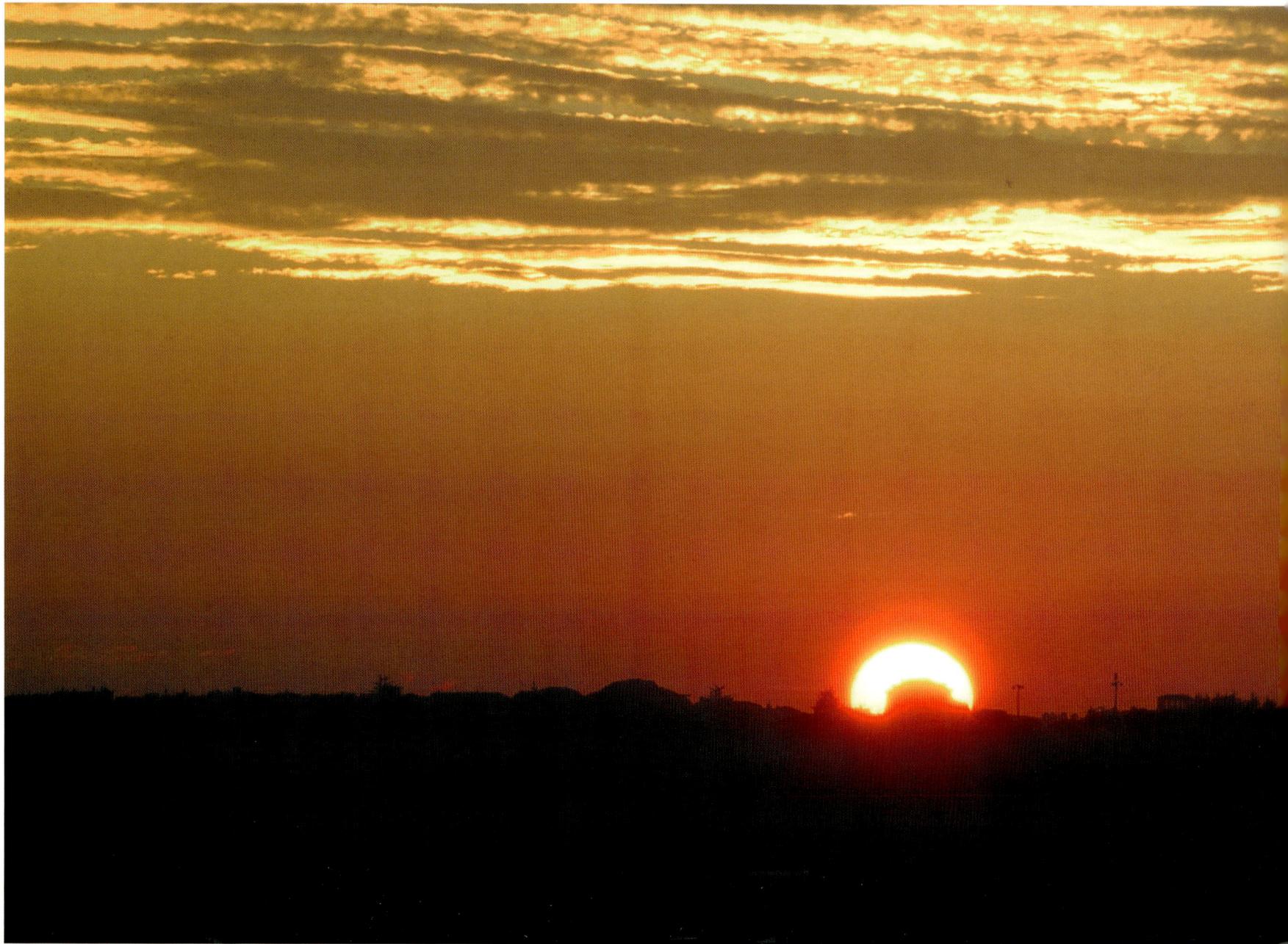

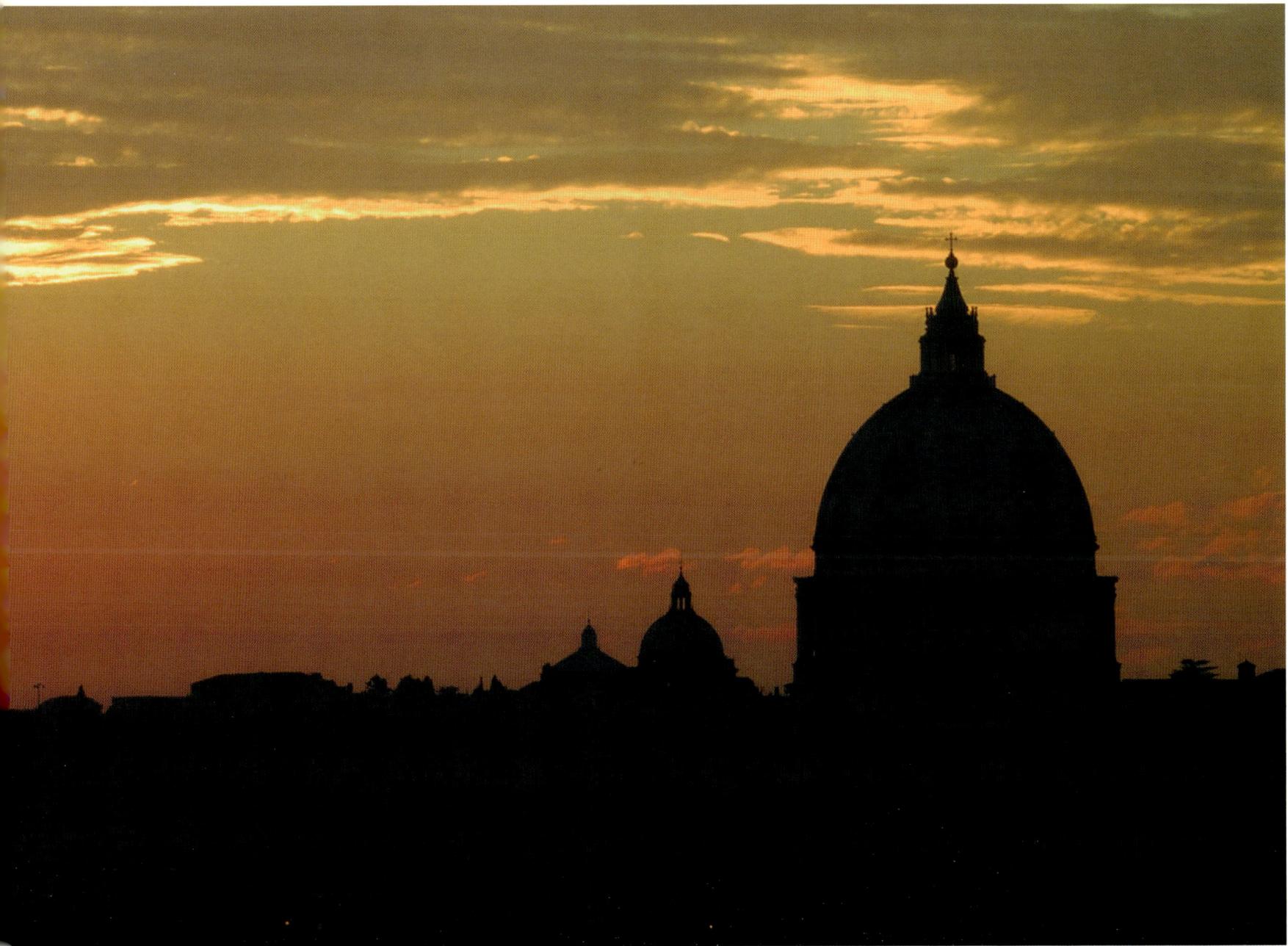

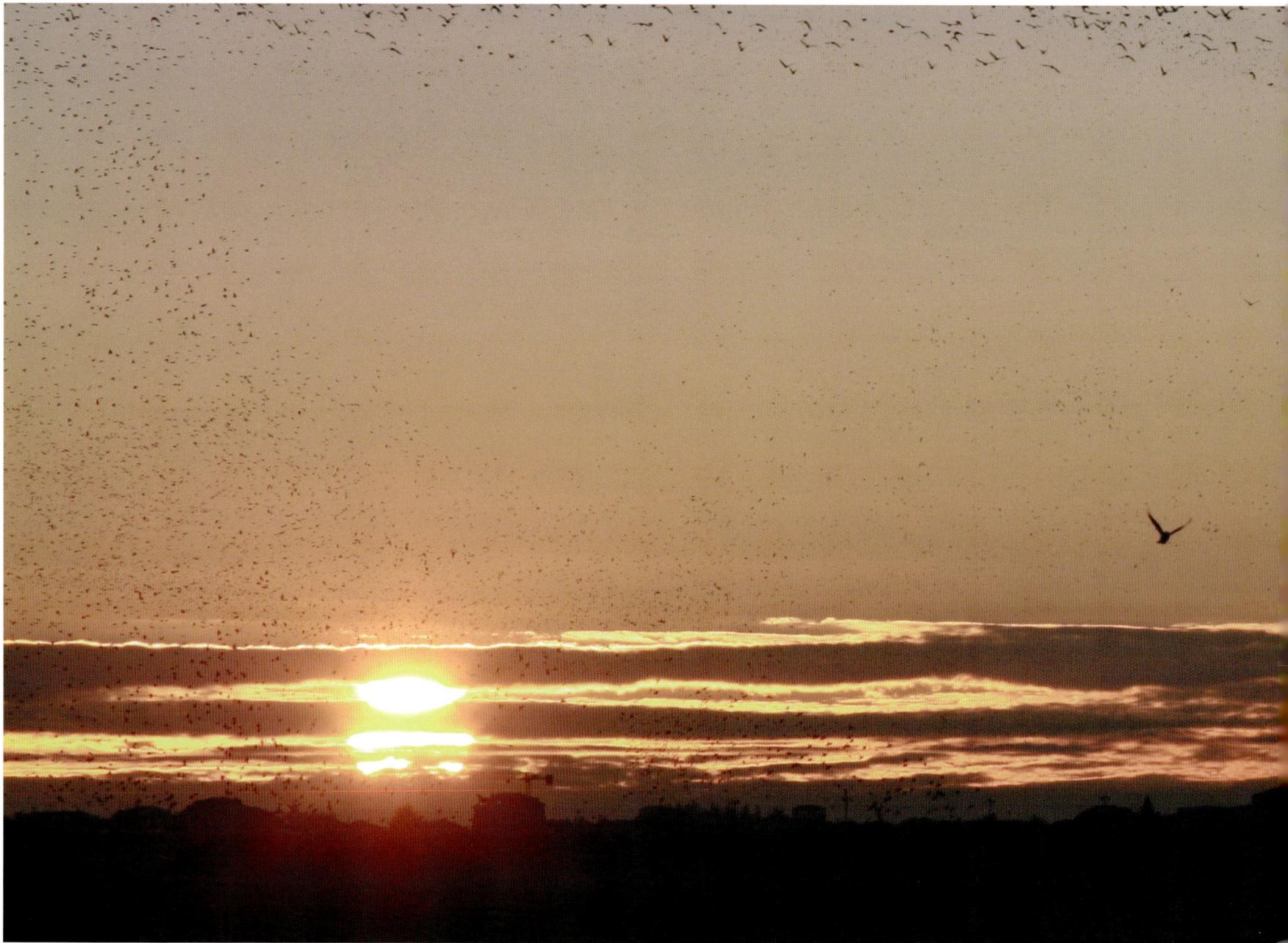

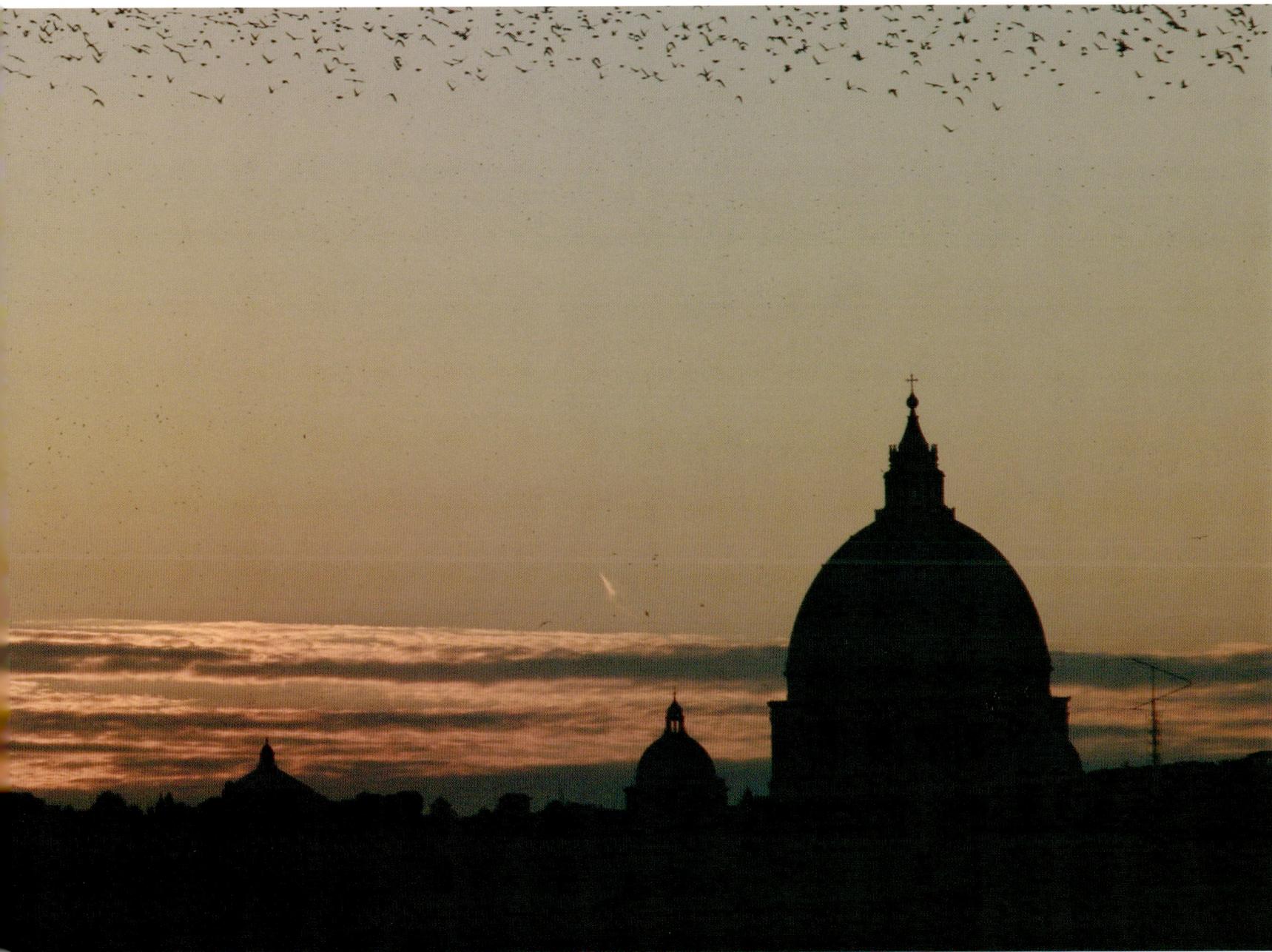

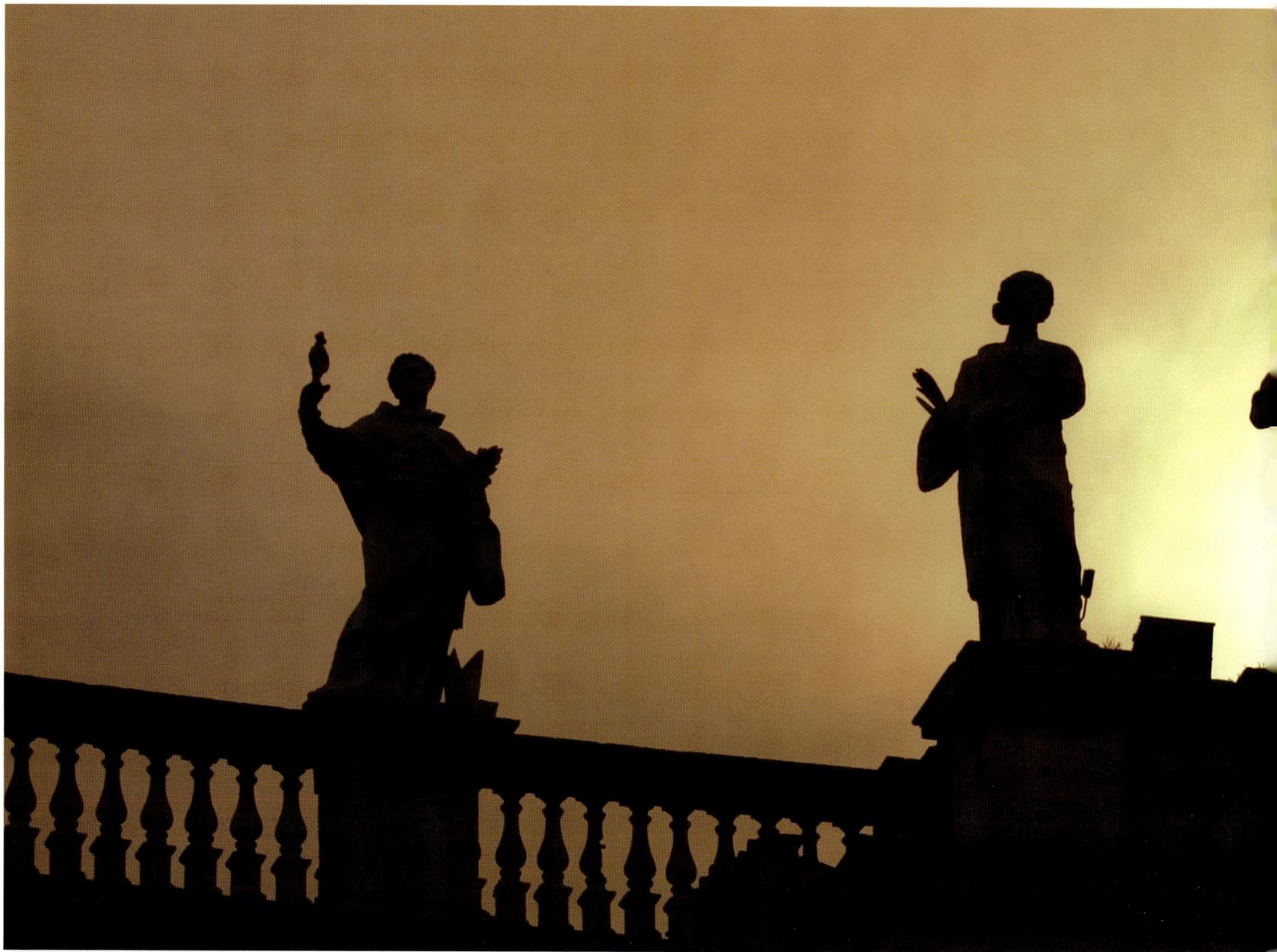

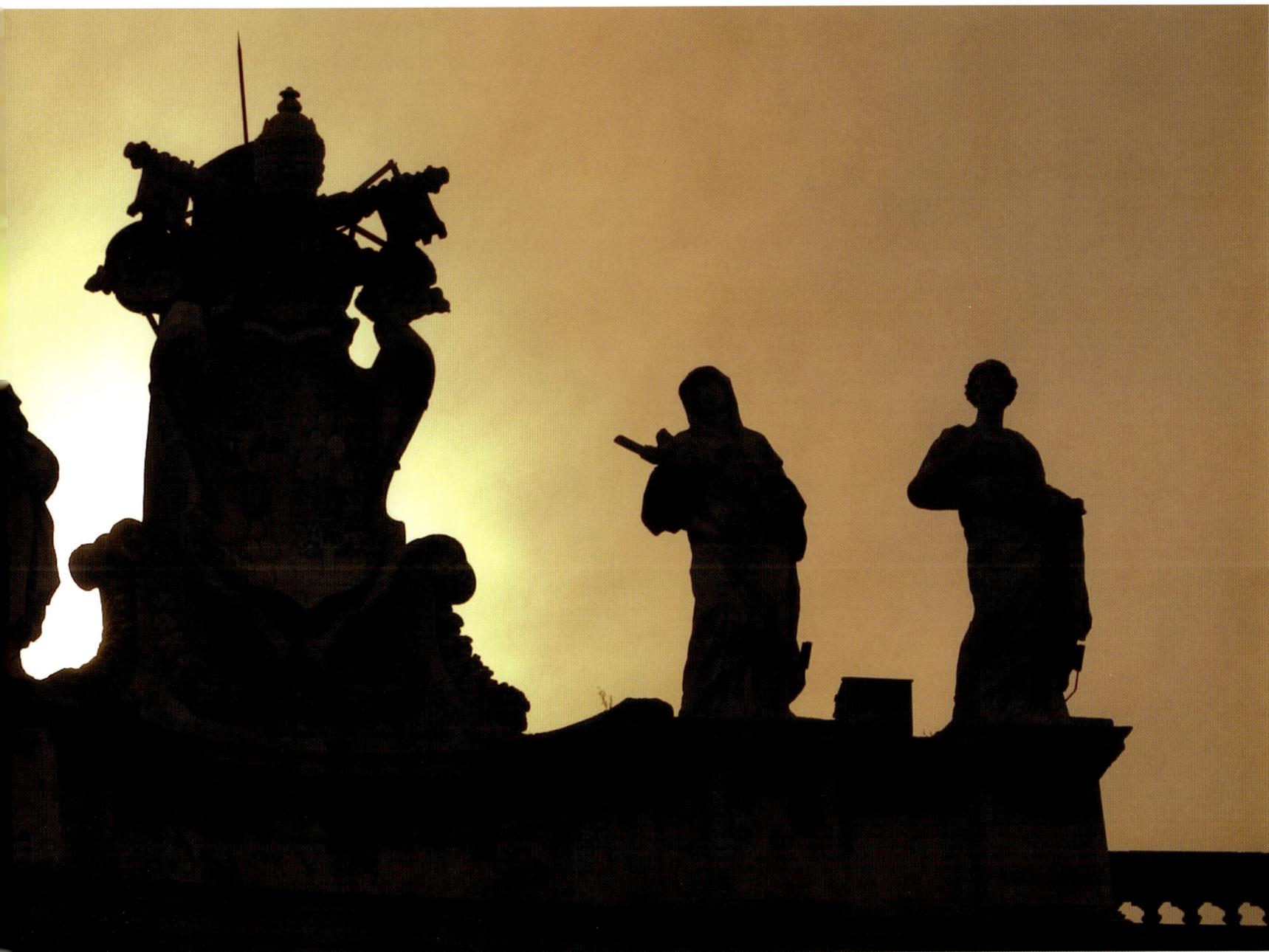

Rome Hot Spots

Restaurants & Cafes

Al Ceppo	www.ristorantealceppo.it	Via Panama 2
Antico Arco	www.anticoarco.it	Piazzale Aurelio 7
Augusto		P. de' Renzi 15
Crudo	www.crudoroma.it	Via degli Specchi 6
Dal Toscano	www.ristorantedaltoscano.it	Via Germanico 58-60
Il gelato di San Crispino	www.ilgelatodisancrispino.it	Via Acacia 56, Via Collatina
Il Fico	www.ilfico.com	Via di Monte Giordano 47
Ivo a Trastevere		Via San Francesco a Ripa 158
La Rosetta	www.larosetta.com	Via della Rosetta 8
La Taverna del Ghetto	www.latavernadelghetto.com	Via del Portico d'Ottavia 8
Riccioli Cafè	www.ricciolicafe.com	Via Della Coppelle 13
Ristorante Al Fontanone		P. Trilussa 46
Trastevere		P.S. Calisto 9a
Trattoria Da Settimio All'Arancio		V.d. Arancio 50-52

Markets

Campo de'Fiori Market - food market	Piazza di Campo de' Fiori
Castroni - dining & specialty shop	Via Cola di Rienzo, 196
Mercato delle Stampe - maps, books, cards	
Porta Portese market - flea market	Via Portuense & Via Ippolito Nievo

Shopping

Degli Effetti - fashion		Piazza Capranica, 75, 79, 93
Diego Percossi Papi	www.percossipapi.com	Via di Sant'Eustachio 16
Galleria Alberto Sordi		Via del Corso
Gruppo Clark - fashion		Viale Marconi
Joseph Debach	www.josephdebach.com	Vicolo del Cinque 19
Le Gallinelle		Via del Boschetto 76
Mia	www.miaviadiripetta.com	Via di Ripetta 224
Via Borgognon - fashion		Via Borgognon
Via Condotti - fashion		Piazza di Spagna

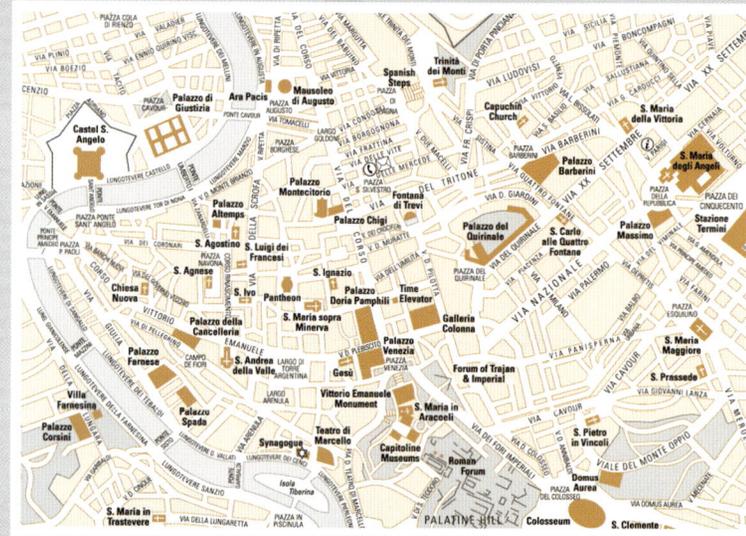

Via del Babuino - art dealers		Via del Babuino
Via dei Cappellari - carpentry		Via dei Cappellari
Via dei Coronari - antique shops		Via dei Coronari / Campo Marzio
Via dei Sediari - furniture		Via dei Sediari
Via Frattina - fashion		Via Frattina
Via Monti - vintage fashion		Via Monti

Highlights

Arch of Constantine		Via San Gregorio
Basilica of Saint Clemence	http://www.basilicasanclemente.com	Via Labicana 95
Basilica di San Giovanni in Laterano		Piazza San Giovanni in Laterano 4
Basilica of St Paul Outside the Walls		Via Ostiense 168
Church of St Peter in Chains		Colle Oppio, Piazza San Pietro in Vincoli 4A
Colosseum		Piazza del Colosseo
Monument of Victor Emanuel II		Scalinata di Trinità dei Monti
Pantheon		Piazza della Rotonda
Parco di Villa Borghese		
Piazza di Spagna		Piazza di Spagna
Piazza Venezia		Piazza Venezia
Saint Laurence's Basilica		Piazzale del Verano 3
Sistine Chapel		Viale Vaticano
Stadio Olimpico		Via Foro Italico
St Peter's Basilica	http://www.vatican.va	Piazza di San Pietro
St Peter's Square		St Peter's Square
Teatro Colosseo		Via Capo d'Africa 5/a
Teatro Costanzi		Piazza Beniamino Gigli 1
Teatro Dell'Opera	http://www.operaroma.it	Via Firenze 72
Trevi Fountain		Piazza di Trevi

Museums

Boncompagni Ludovisi Museum of Decorative Arts		Via Boncompagni 18
Roman National Museum		Piazza Sant'Apollinare, 44
Scuderie Papali al Quirinale	http://www.scuderiequirinale.it	Via XXIV maggio, 16
Vatican Museums	http://mv.vatican.va	Viale Vaticano